Faithful to the Task at Hand

Faithful to the Task at Hand

The Life of Lucy Diggs Slowe

Carroll L. L. Miller
and
Anne S. Pruitt-Logan

SUNY PRESS

Cover: Lucy Diggs Slowe when she entered upon her duties as the First Dean of Women at Howard University. (Moorland-Spingarn Research Center, Howard University)

Published by State University of New York Press, Albany

© 2012 State University of New York

All rights reserved

Printed in the United States of America

No part of this book may be used or reproduced in any manner whatsoever without written permission. No part of this book may be stored in a retrieval system or transmitted in any form or by any means including electronic, electrostatic, magnetic tape, mechanical, photocopying, recording, or otherwise without the prior permission in writing of the publisher.

For information, contact State University of New York Press, Albany, NY
www.sunypress.edu

Production by Eileen Meehan
Marketing by Fran Keneston

Library of Congress Cataloging-in-Publication Data

Miller, Carroll L.
 Faithful to the task at hand : the life of Lucy Diggs Slowe / Carroll L.L. Miller and Anne S. Pruitt-Logan.
 p. cm.
 Includes bibliographical references and index.
 ISBN 978-1-4384-4258-7 (pbk. : alk. paper)
 ISBN 978-1-4384-4259-4 (hardcover)
 1. Slowe, Lucy Diggs, 1885–1937. 2. Educators—United States—Biography. 3. African American women educators—Biography. 4. Women deans (Education)—United States—Biography. 5. Howard University—History—20th century. I. Pruitt-Logan, Anne S. II. Title.

LA2317.S6185M55 2012
378.009—dc23
 [B] 2011030209

10 9 8 7 6 5 4 3 2 1

To Carroll L.L. Miller, Marion Thompson Wright,
and Walter G. Daniel

and

To my husband, Harold G. Logan,
who persuaded me to complete Dr. Miller's book

—Anne Pruitt-Logan

Contents

List of Illustrations		ix
Preface		xi
Acknowledgments		xv
Introduction		1
1	The Early Years	7
2	The College Years: 1904–1908	21
3	Public School Teacher, Principal, and Tennis Champion: 1908–1922	39
4	A Call to Alma Mater and the Durkee Years: 1922–1926	79
5	The Dean of Women and President Mordecai Wyatt Johnson—The Early Years: 1926–1930	131
6	The Middle Johnson Years: 1931–1934	149
7	Dean Slowe and President Johnson—The Latter Years: 1934–1937	207
8	Shared Interests	237
9	Views and Philosophy	287

10 A Celebration of Life	325
11 The Things One Keeps	339
12 Conclusion	345
Notes	351
Bibliography	417
Index	429

Illustrations

Photographs follow page xviii

1. Carroll Lee Liverpool Miller
2. Marion Thompson Wright
3. Walter Green Daniel

Photographs follow page 78

4. Robert Price
5. Lucy Slowe when she graduated from high school
6. Dwight O. W. Holmes
7. Kelly Miller
8. George W. Cook
9. Lucy Slowe and her doubles partner in tennis, John F. N. Wilkinson
10. Lucy Slowe on tennis court
11. Lucy Slowe when she entered upon her duties as principal of Shaw Junior High School

Photographs follow page 206

12. Lucy Slowe as Dean of Women at Howard
13. J. Stanley Durkee
14. Lucy Slowe with friend and housemate, Mary P. Burrill
15. Thyrsa W. Amos
16. Mordecai W. Johnson
17. Emmet J. Scott
18. Lucy Slowe, with shovel at groundbreaking

x List of Illustrations

19. Group of dignitaries at groundbreaking
20. Truth Hall
21. Frazier Hall
22. Crandall Hall
23. Delegates to the 16th Anniversary Session of the National Association of Deans of Women
24. A student using the Health Service for women students
25. Lucy Slowe with her friend, Clyda Jane Williams of St. Louis, Missouri (seated)
26. Lucy Slowe with Charlotte Hawkins Brown
27. Members of Clark Hall Council (men's dormitory)

Photographs follow page 324

28. Two photos of Garden Parties at Dean Slowe's Home
29. Students who registered for Lucy Slowe's first course for Deans of Women at Howard University
30. Members of the National Association of Deans of and Advisers to Women in Colored Schools
31. Romiett Stevens

Photographs follow page 350

32. Stained glass window honoring Lucy Diggs Slowe
33. Lucy Slowe wearing a string of pearls

Preface

The story of Lucy Diggs Slowe is the saga of an African-American woman who, despite numerous difficulties and obstacles, including male chauvinism, became a spokesperson for African Americans, a leader of African-American women, an authoritative voice on the social and educational conditions and problems of African Americans, an individual who discussed racial problems frankly, and a legend in educational, social service, and community circles in the early decades of the twentieth century.

In August 1960, Dr. Marion Thompson Wright, professor of education at Howard University, accepted an invitation to write a biographical sketch of Lucy Diggs Slowe for *Notable American Women: 1607–1950 A Biographical Dictionary*[1] to be published under the auspices of Radcliffe College. Wright wrote in the Preface to the first draft:

> As the work on this progressed, there developed a conviction that a more detailed account of this educator's life should be written because she was one of the pioneers who had engaged in a continued effort to elevate the status of women in higher education. It appeared that such a study should not be delayed since many of the people who had associated with her were still living. On the other hand, very few remained who had known her as a growing girl. So limited were the sources of data on her early life that it was deemed advisable to attempt the story primarily of Dean Slowe as she was known during the last fifteen years of her life. It was during this period that she became widely known in educational circles through the varied activities in which she engaged in her efforts to upgrade the status of women members of college and university faculties and to improve the quality of education for women students.

Marion Thompson Wright did not live to see the study completed, for she died in 1962.[2] At that time, she had completed 228 pages of the Slowe biography handwritten in pencil on yellow legal paper—approximately two-thirds of the projected study. Her sources were limited to newspaper articles, journal reports, and letters from individuals who had known Dean Slowe. The original materials Wright used were not included in her papers. As there was no question of the integrity of Wright's work, only a sample check of her sources was necessary. After Wright's death, Dr. Dorothy Porter Wesley, the noted bibliophile, and I decided to complete the manuscript and to prepare it for publication. Complications arose, and time constraints delayed work on the document.

In addition, Slowe's papers had been deposited on an unknown date at Morgan State College (now University) in Baltimore, Maryland. However, on March 22, 1966, Morgan State College donated the Slowe papers to Howard University. These materials were made available for research several years later and are now on deposit in the Manuscript Division of the Moorland-Spingarn Research Center at Howard University. Thus, these papers constituted significant materials relating to Slowe that were not used by Wright.

I have attempted to use the Wright materials as they fit the thrust of the present manuscript—*Faithful to the Task at Hand: The Life of Lucy Diggs Slowe*—rather than Wright's emphasis on Slowe as an eminent figure in the field of student personnel administration. Although Lucy Diggs Slowe was a leader in the student personnel field, her activities and influence extended far beyond it to policies and practices in the education of African Americans through the educational levels, community and world affairs, and new and more significant roles for women in American life. My perspective, then, relates to Slowe as an African-American woman on the cutting edge of American education and American society. Thus, I give attention to the life span of Lucy Diggs Slowe and her influence and impact over the years.

<div style="text-align: right;">
Carroll L. L. Miller

10 May 1994
</div>

Addendum

Like Marion Thompson Wright, Dr. Miller died before his manuscript was presented to a publisher. He passed away on April 24, 2003. In

late 2002, he had asked me to edit it for him. Dr. Miller had performed yeoman's work in scouring Slowe's archival materials housed at the Moorland-Spingarn Research Center. In working on his manuscript, I set about to add context by exploring the making of Lucy Diggs Slowe. Although Dr. Miller drew heavily upon Slowe's materials housed in the Moorland-Spingarn Research Center at Howard University, I believed that they could be properly interpreted and appreciated only through an understanding of the context in which they are embedded. What was America like for African Americans during her lifetime? How did the answer to this question mold her into the woman who died a premature death in 1937? I have asked questions that have not been raised in previous biographical sketches. As an interloper in historiography, I hope that I have rounded out Dr. Miller's work.

Working on this biography brings to mind the interconnection of lives. On the one hand, as a student at Howard University 1945-49, I became acquainted with Carroll L. L. Miller. He was Associate Dean of the College of Liberal Arts from which I earned the bachelor's degree. He knew me and my later career well enough to include me in his book titled *Role Model Blacks: Known but Little Known.* (Muncie, IN: Accelerated Development, Inc., 1982). Carroll Lee Liverpool Miller was a scholar and educational administrator at Howard University for more than 50 years. He rose in the professorial and administrative ranks at Howard to become Dean of the Graduate School. When he retired in 1974, he left a position he had held for eight years. His reverence for Lucy Diggs Slowe derives in part from the fact that he was a student at Shaw Junior High School while she was its principal.

Marion Thompson Wright, on the other hand, was my teacher at Howard. It was she who urged me to enroll at Teachers College, Columbia University, immediately after completing my college work. I majored in psychology but did not want to pursue a doctorate in that field. During my junior year, I asked for Professor Wright's advice. She suggested developing a career in the field of guidance, which I could do with a master's degree. I explored this (unheard of) field during my senior year and became intensely interested in it. Thus, I matriculated at Teachers College. This revered mentor was the first African-American woman to earn a doctorate from Columbia University. She went on to become a full professor at Howard in 1950.

Still another connection with this manuscript comes from partial support I received from the Walter and Theodora Daniel Endowed Educational Research Fund in 2003. The "Walter Daniel" whose largesse

supports this fund was my teacher at Howard during my senior year, and he read every word I wrote about "guidance counseling." He asked the class to write lesson plans for a subject of our choice. I selected high school "group guidance." Upon returning the papers, he remarked that he did not expect that he would be down on his knees on the floor of his living room the previous Sunday reading the assignment that one student had handed in on "group guidance." Instantly, I knew he was referring to my paper, and I was delighted to see that I had earned an "A." So, off I went to Teachers College, Columbia University.

Upon earning the master's degree in 1950 in guidance and student personnel administration, I was appointed Counselor (Intern) to Women at Howard by then-Dean of Women Susie A. Elliott. My role at my *alma mater* was to teach senior undergraduates about counseling. These undergraduates, called Senior Mentors, had been selected by their peers to reside with and be guides for freshmen. Because I had been a Senior Mentor (one of Lucy Slowe's innovations) during my final year at Howard, I understood that they were elected because they were model women students who would exert a first-rate influence on the incoming freshman women. Yet they were not skilled in counseling. Thus, Dean Elliott had a dream that her Senior Mentors would be better able to shepherd their charges through the murky waters of college life if they learned counseling techniques.

My later career led me to become Dean of Women at both Albany State College in Albany, Georgia, and Fisk University in Nashville, Tennessee. I, therefore, inherited the influence of Lucy Diggs Slowe upon the student personnel field and the education of college women. Her influence even spilled over into my own teaching at Case Western Reserve University and The Ohio State University. It is no accident that, in 1964, I earned a doctorate, again at Teachers College. This time my field had been renamed "Higher Education."

It should come as no surprise, then, that I hold a special reverence not only for Lucy Diggs Slowe but also for each of my own special mentors named above.

Anne Smith Pruitt-Logan

Acknowledgments

Preparation of this book has taken more than eight years. Over that time I have become indebted to so many people that they are now legion.

I thank Thelma Austin who took Carroll Miller's 200-page manuscript that had been prepared with footnotes on a typewriter and scanned it so that I could access it by computer. That manuscript had been typed by Evelyn Harris and coordinated by Gwendolyn S. Bethea who continued to assist me while she served in the administration of the Graduate School with former Dean Orlando Taylor, another staunch and treasured ally.

Moreover, I am grateful to the Moorland-Spingarn Research Center at Howard University where Lucy Diggs Slowe's papers are housed. I relied heavily on Joellen ElBashir, Curator of Manuscripts, Ida Jones, Assistant Curator, Clifford Muse, University Archivist, and Richard Jenkins, Library Assistant. The staff opened their collections to me and assisted in untold ways. Two Howard University graduate students, Sherrie Wallington and Tameka Dunlap, participated in the Slowe research. Both employed their exceptional research skills in authenticating Miller's sources.

I owe a debt of gratitude for financial assistance to the Walter and Theodora Daniel Endowed Educational Research Fund at the Howard University School of Education through the efforts of Faustine Jones-Wilson and Veronica Thomas.

The completion of this book is due in no small measure to the loyal and dedicated assistance of Richard Weibl. He helped me more than he can know. He did everything from the reading of newspaper archives to taking photographs of tennis trophies not to mention visiting the Washington, DC, Registrar of Wills, *ad infinitum*. In other words, he performed the impossible at the appointed time.

I am grateful to Talley R. Holmes, Jr., who opened his home for interviews and photographs of his father's tennis memorabilia.

I was privileged that historian William H. Harris, who is currently President of Alabama State University, reviewed the manuscript and shared his own scholarship with me. He alerted me to individuals or matters that I would not have known about. Noralee Frankel, the American Historical Association's Assistant Director for Women, Minorities, and Teaching, and the consummate historian was a constantly efficient and encouraging colleague.

Karina Robinson had the skill of a miner when it came to ancestry. Beginning in 2004, she picked and shoveled her way through the Slowe and Price family's ancestry so that we could authenticate their lives. She traveled to Ft. Wayne, Indiana, to access the Allen County Public Library, and then to Salt Lake City, Utah, for genealogical research at The Church of Jesus Christ of Latter Day Saints.

To Theodore C. Delaney, at Washington and Lee University, I express my appreciation for access to the Rockbridge Historical Society Proceedings, and Asali Solomon who sent me to him. Those who have done so much to unearth the legacy of Lucy Diggs Slowe: Professor Patricia Bell-Scott at the Institute for Women's Studies at the University of Georgia; Linda Perkins, Claremont Graduate University; and Margaret Crocco, Teachers College, Columbia University. I am also fortunate to have secured superb editorial assistance from William Unger. Thanks to Earnestine Green McNealey, who authored the sixth and seventh editions of the history of Alpha Kappa Alpha Sorority, for her good counsel.

Librarians and archivists were unfailingly patient and helpful, and I thank all of them: Frank Webster and Jeffrey Walker of Gottesman Libraries, Teachers College, Columbia University; Bill Santin, Columbia University Transcripts Department; Megan Hibbitts, Archivist Columbia University Archives and Columbiana Library, Low Memorial Library; Mary Laura Kludy, Virginia Military Institute Archives; Miriam Meislik, University of Pittsburgh Archives; Ann Bowers, NAWE Collection, Center for Archival Collections, Bowling Green State University; Barbara Dickinson, the Stewart Bell Jr. Archives Room, Handley Regional Library, Winchester-Frederick County Historical Society; Howard University Founders Library; Kay Peterson, Scurlock Collection, Archives Center, National Museum of American History, Smithsonian Institution; Juliette Smith, Library Director, and Keith Winsell, Associate Library Director and Archivist, Talladega College's Archives and Savery Library; Diana Maul, Registrar, Teachers College Columbia University; N.Y.

Nathiri, Zora Neale Hurston National Museum of Fine Arts; Jennifer Lee, Executive Director, Clarke County (Virginia) Historical Association; Sandra Holyoak, Rutgers Oral History Archives; Mary McLeod Bethune Council House; the Washingtoniana Room of the Martin Luther King, Jr. Memorial Library in Washington, DC; Kiplinger Library of the Historical Society of Washington, DC; Mary Thomason-Morris, Archivist, Clarke County Historical Association.

Howard University alumni who matriculated during Lucy Slowe's tenure are inextricably linked to her; they remember her well. Thus, to the several Howard University alumni of the Class of 1938 who allowed me to interview them, I express my heartfelt appreciation. They include Daisy F. Douglas, Thelma Hyman, and Lorelle Wise.

I am immensely grateful to my wonderful friends. Those who generously gave their time and advised me personally were Clement Price, Rutgers University; Edmund Gordon, Teachers College, Columbia University, and Yale University; James N. Upton, The Ohio State University; John and Audrey McCluskey, University of Indiana; Gaetane Jean-Marie, University of Oklahoma; Patrick Swygert, Howard University; Jacqueline Irvine, Emory University; Phyllis Mabel, American College Personnel Association; Richard Herdlein, III, Buffalo State, State University of New York; Nesta Bernard, Howard University; Linda Tillman, University of North Carolina, Chapel Hill; and Frank Matthews, *Diverse: Issues in Higher Education*. Others who sustained me through discussion and did not lose faith as the years passed and who deserve special mention are Barbara Jackson, Delores Sykes, DeVera Redmond, Michelle Demond Davis, Flavia Walton, D. Kamilli Anderson, Lenda Hill, Thomas Battle, Elinor Des Vernay and Calvin Sinnette, Robert Gessert and the Water Babes.

I want to thank every member of my magnificent family for their patience and forbearance over the past eight years when I would shut my mind to everything but "the book." Some—including Leslie, Diane and Ralph Pruitt, Jr., Pamela Pruitt-Green, and Harold J. and Justin Logan—read various drafts, contributed invaluable content and resolved technological and publication issues. My husband, Harold G. Logan, to whom I owe so much, provided loving encouragement. He put his incredible store of general knowledge and his memories of Howard University, in addition to his respect for his mentor, Carroll Miller, at my disposal.

1. Carroll Lee Liverpool Miller (1909–2003). Senior author. A student of Lucy Diggs Slowe at Shaw Junior High School, he graduated from Howard University with the AB, 1929, *magna cum laude*, and the MA in 1930. He earned the Doctor of Education Degree at Teachers College, Columbia University in 1952. Beginning in 1931, he held various administrative positions at Howard: instructor in Education; counselor in the College of Liberal Arts; liaison officer for the Basic Engineering Section of the Army Specialized Training Program; and University Counselor to Veterans. In 1947 he was appointed Assistant Dean of the College of Liberal Arts, Associate Dean in 1962, and later Acting Dean. During this time he had risen to the rank of Professor, and in 1962–62, Head of the Department of Education. In 1966, he was appointed Dean of the Graduate School, a post he held until his retirement in 1974. He retired as Professor Emeritus in 1988. (Sources: Logan, Rayford W. *The First Hundred Years: 1867–1967*. New York: New York University Press, 1969, 472; Personal collection of Harold G. Logan; Moorland-Spingarn Research Center, Howard University).

2. Marion Thompson Wright. The Lucy Diggs Slowe biographer for *Notable American Women: A Biographical Dictionary*, which was prepared under the auspices of Radcliffe College. Wright earned a bachelor's degree in 1927and a master's degree in education in 1928, both from Howard University. In 1940 she became the first African-American woman to earn the PhD degree in History at Columbia University. She joined the faculty of the College of Liberal Arts at Howard in 1929. With the exception of the years 1933–1936, she taught continuously until her death in 1962. When she died she was Professor of Education and in 1961 the recipient of a Washington *Evening Star* grant to write a biography of Lucy D. Slowe. At Rutgers-Newark University, a lecture series—the Marion Thompson Wright Lecture Series—co-founded by Professor Clement Price, is named in her honor. (Sources: Logan, Rayford W. *The First Hundred Years: 1867–1967*. New York: New York University Press, 1969, 491; http://blog.nj.com/njv_mark_diionno/2010/02/marion_thompson_wright_lecture.html (Accessed November 4, 2011). Moorland-Spingarn Research Center, Prints and Photographs Dept. Howard University).

3. Walter Green Daniel earned the bachelor's degree at Virginia Union University in 1926, the master's degree from the University of Cincinnati two years later, and in 1941, he earned the PhD degree from Columbia University. He was appointed Assistant Professor of Education at Howard University in 1929 and became a full professor in 1946. He served as editor-in-chief of the *Journal of Negro Education* for seven years, beginning in 1963. In the spring 1973 issue of the *Journal*, Carroll Miller penned a tribute to Daniel, referring to him not only as an editor, but also as an exacting and revered teacher, astute educational administrator, and community activist. A later editor-in-chief of the *Journal*, Dr. Faustine C. Jones-Wilson—at Miller's funeral—recalled hearing Daniel stating that Carroll Miller was to be allotted anything he needed to bring his Slowe manuscript to publication. Hence, partial support from the Walter and Theodora Endowed Education Research Fund at Howard University has helped to produce this book. (Sources: Carroll L. Miller. "Editorial Comment Walter Green Daniel: Editor, Teacher, Scholar, Educational Administrator, Community Leader," *Journal of Negro Education*, 42 no.2 (Spring 1973), 103–108; Moorland-Spingarn Research Center, Prints and Photographs Dept. Howard University).

Introduction

Would an African-American woman have been as influential in American history as Lucy Slowe if she had dropped out of school after her parents died, leaving her orphaned, instead of going on to college? Would she have loved education as she did, if she had not had a loving aunt? Would she have had the courage to establish the first junior high school for African-American children in Washington, DC, if she had not rebelled against racism in tennis?

This book is an account of the life of such a woman—Lucy Diggs Slowe. It marches alongside her as she grows up in Jim Crow America. It explores the forces that called her to be a spokesperson for African-American women's rights, an authoritative voice on the social and educational conditions of African Americans, and a legend in educational, social service, and educational assemblies in the early decades of the twentieth century.

The story is bracketed on one hand by the litany of successes, problems, and grievances embedded in Slowe's experiences as the first dean of women at Howard University and on the other by the story of Slowe as an architect of women's organizations. It shifts from her early years as "Lucy" to her more mature years as "Miss Slowe" and finally to her university-administrator years as "Dean Slowe." Interspersed are her triumphs as principal of the first junior high school for African-American children in the District of Columbia and as the first African-American woman tennis champion in America.

Lucy Diggs Slowe's odyssey spans twelve chapters. The first chapter locates her birth in 1883—just twenty years after the end of slavery—in Berryville, Virginia. Her father died when she was six months old and her mother five years later, leaving her and her siblings as orphans. Her maternal aunt, Martha Price, took her and her sister, Charlotte, to live with the Price family in Lexington, Virginia where she enrolled the two of them in school. Because of Lucy's obstreperousness, however, Martha decided to remove her from her elementary school and teach her at home. When Martha became dissatisfied with the quality of education in Lexington, however, she moved the two sisters to Baltimore, Maryland, to reside with Martha's daughter

and her growing family, and, as their aunt and the family matriarch, she moved with them.

Lucy graduated from the Baltimore Colored High School as the second honor student. Along the way, she became acquainted with Dwight O. W. Holmes, a teacher, who would be a mentor for the next 30 years and who, years later, recalled a defining moment with this young student. When she was graduating from high school and anticipating college, and realizing that her family could not afford the expense, she asked Holmes if he knew of students working their way through college. He replied that he knew of boys who had done so, but not girls. Whereupon she replied that she would be a pioneer.

The second chapter begins in 1904 when Lucy entered Howard University on a scholarship. It emphasizes her academic prowess as an English major and her leadership in a prodigious stream of student activities—including debating, athletics, and music, and the founding of Alpha Kappa Alpha Sorority in 1908, the first sorority for African-American women. She also served as a chaperone for younger women students on shopping trips downtown. She had to work, and her employment brought her into close contact with professor of English George William Cook and his wife, Coralie. Her undergraduate years ended with her graduation in 1908 at the head of her class. Described as a feminist, she was taken by the blossoming women's suffrage movement.

Chapter 3 chronicles "Miss Slowe's" public school work experience. Her first full-time position was as a teacher of English at the school from which she had graduated, the Baltimore Colored High School. Simultaneously, she became a tennis champion. Winning seventeen trophies, she became the first African-American woman to win a major sports title. This achievement was recorded by the American Tennis Association (ATA) in 1917. Moreover, she earned a master's degree through summer study in Columbia University's Department of English and Comparative Literature. Her thesis was on the French bourgeois drama. Moreover, she took part in community activities, especially the NAACP, as well as social and literary clubs and the Du Bois Circle.

It was her excellence as a teacher in Baltimore that brought her to the attention of school administrators in Washington, DC. In 1915 she accepted an invitation to teach at the highly respected Armstrong Senior High School in Washington, and her outstanding record led her—in 1919—to become the founding principal of the District's first junior high school for African-American children. She fought public opposition to start this new type of school and was instrumental in naming it after the lionized Robert Gould Shaw. Lessons she imparted to junior high school students were about the importance of good character. Also, she initiated in-service training for

Washington, DC teachers and brought in professors from Teachers College, Columbia University, as the experts.

She rose to the presidency of women's organizations such as the College Alumnae Club and led them in protesting racial injustice. She became a member of the Howard University General Alumni Association. In the latter, she was the only female member of the Association's planning committee for the 50th anniversary of the founding of the University.

Slowe's fine record of achievements, her leadership of organizations, and her loyalty to *alma mater* led Howard University's President, J. Stanley Durkee, to invite her in 1922 to accept the position as the institution's first Dean of Women. Chapter 4 describes her efforts to shape this new position in higher education. It chronicles the process by which she was elected and was then warmly received at Howard University. To become skilled in the fledging position of Dean of Women, she attended summer sessions at Teachers College, Columbia University, in 1930 and 1931, and actually enrolled in a doctoral program. She joined the National Association of Deans of Women (NADW) and developed a close relationship with Teachers College professors and with Thrysa Amos, Dean of Women at the University of Pittsburgh.

Chapter 4 also gives an account of "Dean Slowe's" numerous challenges, including student discipline, gaining respect as a dean who was also a woman, creating a series of traditional campus activities, and calling for improved residential facilities and health care for women students. She placed herself on record as an advocate for equal rights for women. This chapter also notes her friendship with housemate Mary Burrill.

While serving as president of the College Alumnae Club, she ushered in another new organization, the National Association of College Women. Moreover, she played a major role at the national level of the YWCA and as the first African-American member of NADW. In the latter organization, she challenged its racist policies, such as requiring African-American members to use freight elevators and eat in separate dining rooms at national conferences. She received the first of several requests from the Howard University Board of Trustees to move her residence from her home with Mary Burrill in the Brookland section of Washington to the campus.

Chapter 5 chronicles Slowe's conflicts with Mordecai Johnson, the man who succeeded Durkee as President of Howard. Unlike his predecessor, Johnson's reactions to Slowe clearly could be termed chauvinistic. The chapter records tumultuous years in which she fought for her own autonomy and survival. For example, she threatened to resign over the failure of the University to sanction a male professor who insulted her and women students. She challenged the exclusion of women from any or under representation on policy-making bodies, and she questioned the efficacy of

the University's curriculum in preparing women students for a future in nontraditional careers. Through her allies in the National Association of College Women, her arguments for suitable living conditions for women students culminated in the construction of the three dormitories (also called residence halls) on what became known as the Women's Campus. She founded a national organization for deans of women in African-American colleges, and she became a peace activist as well as a religious leader.

As an advocate for equal treatment of women, the next chapter—Chapter 6—continues to chronicle Slowe's confrontations with the University President and the Treasurer. They are documented in a potent letter Slowe wrote to the Board of Trustees—headed by Abraham Flexner—in which she listed affronts by President Johnson and the Board to her authority as a dean. Seeing women students as disenfranchised, she demanded college courses that would prepare them for their roles in life after graduation. This chapter also highlights her professional activities in the City of Washington and the nation as a whole.

Chapter 7 describes Slowe's last years. She died in 1937 at age fifty-four, capping fifteen years as Dean of Women at Howard University. Her activities expanded, her national influence grew, and her philosophy became clearer. She resisted University Trustees' efforts to force her to give up her home in Brookland and move to the campus. She continued to endure operational clashes with the President, the Board, and the Treasurer.

The focus of the eighth chapter, titled "Shared Interests," is on Slowe's leadership roles in a variety of organizations. It reviews the part she played in numerous national groups mentioned but not detailed in preceding chapters. Her involvement shows that she learned to work publicly and collectively, sharing interests not only with colleagues in higher education but also with those concerned with improving the conditions of women and others of the disadvantaged groups. They include the National Association of Deans of Women, the National Association of Deans of Women and Advisers to Girls in Colored Schools, the National Council of English Teachers, and the Women's International League for Peace and Freedom, Alpha Kappa Alpha Sorority, and—with Mary McLeod Bethune—the National Council of Negro Women. Her affiliations also included the National Association for the Advancement of Colored People and the National Association of College Women.

Slowe was a dynamic and forceful orator and was widely sought after. Chapter 9 contributes to intellectual history by providing excerpts from a selected group of speeches.

Slowe's funeral is the subject of Chapter 10. Her death set off a wave of grief and mourning, and the chapter summarizes the host of statements made to honor her memory, including a portion of the eulogy offered by Dwight O. W. Holmes, unrestrained editorials in the *Afro-American* newspaper, and

actions taken following her death by the General Alumni Association to excoriate President Johnson for the way he dealt with her. To celebrate her struggles on behalf of women, the Howard Women's Club provided funds for a stained glass window in the University's Chapel in her memory.

Chapter 11 reviews the contents of Slowe's Scrapbook. Most of the items are newspaper clippings, programs, and invitations that focus on her perceptions of life, international relations, and racial discrimination and news reports of her speeches about higher education and women's activities. As a cache of what one keeps, it gives an even clearer glimpse of the kind of person she was.

The final chapter takes a look at what shaped Lucy Diggs Slowe. It offers a glimpse of her values, of the ideas that guided her, and of the issues about which she was most passionate. Also apparent are the tenets of her faith and how she perceived her role in life.

1

The Early Years

Berryville, Virginia, October, 1889

Lucy Slowe learned of her mother's death when she heard her oldest brother, John, say, "She's dead."[1] Both he and their Aunt Martha were overcome with tears, but Lucy, who was six years old at the time, reported that she was simply bewildered. So, she announced that she was going out to play with James Williams, her cousin and favorite playmate. When her aunt told her not to go because her mother had just died, Lucy wondered what her mother's death had to do with her playing! After all, when her pet chicken had died, she and James Williams had dug a grave, sung a song, and buried it—but they did not stop playing.

Fannie Slow,[2] her mother, had been gentle and easy with her because she was the baby of the family. She did anything she wanted to do, despite the protests of her brothers, John and Bill, and her sister, Charlotte. Her sister regarded herself as Lucy's boss, and Lucy felt she had a perfect right to "scratch her, pull her hair" and hide behind her mother's skirt.

Because Lucy's father had died five years earlier—and the children were now orphans—his sister, Martha, had traveled to Berryville from her home in Lexington to help with the arrangements.[3] On the day of the funeral, Aunt Martha dressed Lucy in a stiff white dress with a black sash. She kept the child close by her side so that she would not run out to the road to play. Once, while Aunt Martha, whom Lucy feared, was pinning on her long, black crepe veil, Lucy darted to the door, but she was not quite quick enough. "You little demon," Aunt Martha hissed, "What am I to do with you? If you don't stay right here, I will put you to bed for the rest of the day." After quietly waiting for Aunt Martha to finish dressing, she was led into the "front room," which was what they called the best room in the

house. Her mother lay in a black casket. The family—John, Bill, Charlotte, Aunt Martha, and Lucy—sat near the head of the casket and near where the minister stood. They joined Aunt Caroline, who had been her mother's helper when she made applebutter, and their "friends, enemies and relatives," who crowded themselves into the room as best they could. The minister and everybody but family members sang "Nearer My God to Thee," and he prayed and talked about her mother. Everybody cried but Aunt Martha and Lucy. Aunt Martha did not cry "because she was too busy watching" Lucy, and Lucy did not cry because she was "trying to figure out why Aunt Caroline wore a red bandana handkerchief on her head when everybody else wore black ones." Fanny (alternate spelling) Slowe was buried next to her husband in the Milton Valley Cemetery.[4]

Later, while they were eating supper, John agreed that the siblings would have to be separated because he could not get anyone to look after the girls. Moreover, Aunt Martha could not be expected to stay there in Berryville to look after them. He was candid about the girls' dispositions, acknowledging that Lucy needed a strong hand. Charlotte, on the other hand, was a good child. Because of this assessment—"Lucy was bad" and "Charlotte was good"—Lucy got mad at the whole family. She then made up her mind to give Charlotte "a good pinching" when they went to bed that night.

Aunt Martha concluded—"batting her eyelids rapidly"—that she would take both Charlotte and Lucy home with her and give them both a "Christian raising." Lucy did not know what that was, but she knew she was not going to like it, especially if Aunt Martha had to give it to her. Lucy rolled her eyes at her aunt, but said nothing, for her throat was getting tight. Lucy's eyes filled with tears because she knew she would have to give up at least three things: her pal—James Williams—the road up and down which they raced, and the mud hole in the yard. Her aunt did not believe in playing in the mud, or playing with boys, or running up and down the road.

Lucy had been born on July 4, 1883, to Henry Slowe and Fannie Potter Slowe.[5, 6] Her siblings were John, Nellie, Coltrop, Preston, William, and Charlotte,[7] all older than Lucy. According to the record of marriages in Clarke County, Virginia, Lucy's parents were married in Berryville, a Shenandoah Valley town, on January 15, 1867. At that time, Henry was forty-two years old and listed his work as restaurant keeper. Although Berryville was a farming community, and African Americans were just close to thirty years out of slavery, it was quite a feat for him to be a restaurant keeper. He had been born in Louisa County, Virginia, the son of David and Penny Slow. His bride was born in Clarke County to George and Ann Potter and was twenty-two years old when she and Henry married.[8] It is not known whether Lucy's parents and grandparents were slaves or free.

Lexington, Virginia

Whether Lucy wanted to or not—she was not consulted—two days after the funeral Aunt Martha and the girls started off for Lexington. To Lucy's mind, the trip from Berryville to Lexington probably felt like it was longer than 135 miles. Lexington was also located in the county where she was born. Berryville, however, was northeast, closer to the West Virginia line. Traveling was not easy in 1889. One could ride in a buggy or maybe a train if a railroad line had been constructed between Berryville and Lexington.

This could have been the saddest day in the little girl's life. She, Charlotte, and Aunt Martha arrived in Lexington one bright October afternoon. A sleepy old town, Lexington rested between two spurs of the Blue Ridge Mountains. Main Street was the principal thoroughfare, with the post office on one corner next to the bank that abutted the hotel. In front of the hotel, men lounged in chairs waiting for the evening mail to be sorted. Main Street also was home to a few stores that advertised general merchandise.

Lucy's journey probably took her past the large manor houses that still stood as vestiges of plantation society. Many had been erected long before the Civil War as the stronghold of a society built on slavery, and they had withstood the devastation of that war. Even today, a number of these homes remain.[9]

Lexington had been called "The Athens of the State." It was the town where "Stonewall" Jackson taught his Sunday School class [S.S. Class] for colored children.[10] The McDowells, the Massies, the Prestons, and many others who lived in those big houses had "curious ways," as Lucy later described them.[11] They were the folk who made the town historically famous.[12] These families are said to have been prominent white Virginia families.

Aunt Martha led the two girls through the business district and paused before her house that sat on a large plot of land. It came with a frontyard that bore a weeping willow and a walkway that was lined with rows of horse chestnut trees. The backyard was laden with apple trees; it was a real apple orchard. "Home at last," Martha was saying as they mounted the steps of the wide veranda. Louise, the girls' cousin "Lou," as they called her, ran out to meet them.

"Why didn't you let us know that you were coming today, Ma? I would have sent Tom to meet you. And who are these children?" exclaimed Cousin Lou. Martha said, "These are your Uncle Henry's children, and I have brought them home to live with us. Take them upstairs, Lou, and see that they wash their faces and hands clean before they come to supper."

Life with Aunt Martha was quite different from what it had been with her deceased mother. The pattern Lucy would subsequently follow was nurtured by the years she spent in the Price household. Martha was very strict. She was forty-five years old, tall, straight. and proud. Her sternness could have developed well before she married Robert Price, for she had worked for a rich white lady named Mrs. Pendleton. Serving as Mrs. Pendleton's maid, Martha assimilated culture, manners, stylish dressing, and all the characteristics of white society that she could possibly absorb. She believed that children should grow up to be God-fearing and to get a good education. She had pronounced ideas on dignity, morality, and religion, which she did not fail to impress on members of her family. When she brought Lucy and Charlotte into her home, she was a widow, and her sons, Will and Tom, and her daughter, Louise, supported her.

Presumably Martha's husband, Robert, had also influenced the Price home. Prior to his death, he had worked—from the 1840s through the post-Civil War era—at Virginia Military Institute (VMI) in Lexington as "a servant in the home of Superintendent Francis H. Smith. Smith family history credits Price, whom they called Old Bob, with gathering valuable personal and VMI papers and family silver and burying them in a gravesite just before the Union forces entered Lexington during 'Hunter's Raid' in June 1864."[13] So, as was characteristic of so many of the homes of African Americans who worked for white folk, aristocratic trappings were unmistakable. "Old Bob" no doubt believed in education and also personified dignity, as was the role for African Americans who were suitable enough to work as servants in white folk's houses. His son, William, had succeeded his father at the military academy, but Tom stayed at home and took care of the orchard while Louise looked after the house.

The girls were given a large room upstairs at the back of the house with two windows where they could look out over the apple orchard. When she saw the orchard, like kids everywhere, Lucy's greatest yearning was to climb one of those trees and eat those beautiful apples.

They soon gathered around the supper table: Cousin Will, a tall, reddish-brown young man with a kind face; Tom, a sixteen-year-old awkward boy whose black eyes were full of mischief; Cousin Lou, a young woman of twenty with a plump figure and full, round face; Martha, Charlotte, and Lucy. Aunt Martha told Tom, "I want you to take Charlotte and Lucy to school in the morning. They might as well start in at once, for I expect they are both far behind where they should be." Tom replied, "Why Ma, Lucy can't be behind, she's only five." Lucy was grateful to Tom for defending her. Martha rejoined, "Well, she ought to know her letters anyhow, and I am sure she doesn't know A from B. Her mother didn't start her bringing up as I would have done."

That night, after they had eaten supper and after decisions had been made that Tom would take the girls to school the next day, they returned to their room, and there, filled with grief and homesickness, cried themselves to sleep.

Aunt Martha made sure that her nieces had a good education. Schools in Virginia were segregated,[14] requiring that the sisters attend the school for African Americans. In Lexington, the Randolph Street School was the only graded school for those children.[15] The two girls had been enrolled only a month when the teacher sent a note home to Martha Price that Lucy had not learned her ABCs, and she had also been a nuisance for the teacher. Lucy detested school; she had never been still in her life, and Miss Harriet, her teacher, insisted that children had to be as still and as quiet as mice. Lucy's heart almost stopped beating. What would Aunt Martha say? All the boys and girls were staring at her, but she scarcely saw them. She began to feel rebellious and angry. Before she knew it, she told Miss Harriet, "I don't care if you do send a note home," whereupon the teacher punished her by sitting her in a corner alone. Was this behavior an early sign of stubbornness? Was she really recalcitrant? Or was it just being six years old?

Her aunt decided then and there that Lucy would be home-schooled. From nine in the morning until 12 noon, every day, including Saturday, Aunt Martha supervised the teaching, with Charlotte teaching the alphabet and Tom teaching reading, spelling, and arithmetic. After three years, Lucy returned to school and found herself far behind other children her age. Because of this break in grade level, she would be much older than her classmates when she later graduated from high school at age twenty-one.[16] This period must have been one of the defining times for Lucy: not associating with children her own age, giving attention to learning, taking orders from both her sister and her brother as well as her aunt. There was no father present to assume the traditional role of ruler of the house; Aunt Martha was quasi-mother and father; she was the rule-maker. Why should she not have an impact upon who Lucy would become later in life?

Lucy related another story[17] that illustrated her aunt's firmness. It was her recollection of John Hance. The son of Charles and Malinda Hance, John was about ten years older than Lucy.[18] As the story goes, John Hance was a cross-eyed[19] man who fascinated Lucy. He loafed at the post office corner every day. As groups of school children passed, he would glare at them, and they would run.

When John Hance died, Lucy wanted to view the remains. Her aunt emphatically forbade it. One day, on the way to school, however, a classmate persuaded Lucy to join her to see the corpse. When someone drew back the sheet, Lucy wrote, "One of those cross-eyes wide open glared menacingly at me. I was too frightened to scream."

That evening, Lucy's aunt instructed her to go upstairs and bring her eyeglasses, which were on the dresser. "I was afraid to go." Her aunt asked the second time. Lucy replied, "Yes, Aunt Martha, I heard you, but it is dark upstairs." Martha noted that Lucy had never been afraid of the dark before. Lucy burst into tears, and, when she was calm again, she told her aunt of her visit to view John Hance's remains.

"Aunt Martha listened with a look of suppressed amusement and said, 'I think you have been punished enough for your disobedience. I don't believe that I shall have any more trouble with your viewing remains, as you call it. I'll get my glasses myself.'" Lucy could have been genuinely afraid, or perhaps she was showing the earmarks of stubbornness, not particularly unusual considering her age.

Aunt Martha, of whom Lucy was dreadfully afraid, insisted that Lucy go to church with her every Sunday. Sunday was indeed a day of rest in Lexington. Everybody went to church. "Lucy, Lucy!" came the short crisp call up the stairs one bright July Sunday morning. "It's half past nine and time you were in Sunday School. Come down here immediately. Charlotte is ready and waiting for you." "Aunt Martha," Lucy pleaded, "I have a headache this morning. Can't I stay out in the yard in the cool?" "No!" came in an explosive tone, "Do you think that I am going to have a little heathen in my house? I never stay home from church and neither will you. Come down right now."

Down Lucy came and slowly started up the street with her sister to Sunday School and preaching services. The morning was hot and the outdoors alluring; hence, religious worship in a small church was torture for Lucy.

Martha's attitude toward going to church reflected a significant phenomenon of the late nineteenth century: African-American churches were enormously important organizations. The largest denominations were Methodist and Baptist congregations like the National Baptist Convention that was organized in 1895. Their churches became "solid and dynamic institutions,"[20] bringing the newly freed African Americans together not only to worship but also to make plans for the uplift of the race. In Lexington, Virginia, churches "occupied central places" in the lives of the African-American community. There "the community freely expressed its common culture and shared its common concerns . . . the churches became community centers in a very real sense."[21]

Lucy would later write that, "Religious worship in a small church was torture for me. I made up my mind that I would never know what the inside of a church looked like when I became a woman."

Continuing, Lucy noted, "There were some joyous times, even in my dignified Aunt's home." She was not allowed to run or to roll a hoop or climb a tree if her aunt saw her, but sometimes she did not see her. One

happy occasion came with the visit of James Stuart, the young man who was Cousin Louise's fiancé, and the departure of the bride to Washington, DC.

Lucy wrote, "We had just returned from seeing the bride off. How lonely the house seemed after Cousin Lou's departure. She had always been my friend, and many times I am sure her intercessions saved me from punishment. Now she had gone to Washington and I supposed I should not see her again."

"September slowly passed into golden October. The orchard hung heavy with red and yellow apples. I helped to pick them and store them in the cellar. One day, while I was sitting listlessly on a barrel in the cellar, Aunt Martha quietly entered. How long she had been standing before me, I did not know, for my mind was far away in Washington. I longed to see Cousin Lou, to see the big city, to stretch my wings, to fly."

"Is that the way you get your work done?" Aunt Martha was saying. I awoke from my reverie with a start.

"I was resting a little while," I answered.

"Only lazy people rest before their work is done," she added crisply. "Sit down again; I have something to tell you," she continued.

"I have been thinking that you and Charlotte have learned about all that you can learn in the school here, and so I have written to your brother about letting you both go to Washington to school." Lucy gasped, but was afraid to jump up and scream for joy, because Aunt Martha had a way of changing her mind about permitting her to do things, if she appeared too eager. Lucy wrote, "I sat as still as a mouse; but how my heart was beating!"

Martha continued, "I want you girls to have a better chance than I had, and than my children had. So, your brother, John, and I think it best to send you away from Lexington. You will live with Louise, and as soon as I can make some arrangements for Will and Tom here, I am coming to Washington, too." Lucy wrote that she "lived in a dream from that day until that memorable morning in the latter part of October, when I shook the dust of Lexington from my feet and faced the mysteries of the city of Washington."[22]

1895: The Need to Leave Virginia

In September, 1895, Aunt Martha told Lucy that because she and Charlotte had learned just about all they could learn in the Randolph Street School, she wanted them to move to a city where they could get a good education.[23] They had then been living in Lexington for seven years. Like so many families of that era, their aunt wanted the girls to have "a better chance" than she had had and even a better education than she had provided for her own children. This view of education was not unusual. Rather, it was

a typical mantra for the times. Once African Americans were free, "Black mothers walked ten, fifteen, and twenty miles to put their children in school. They sacrificed and stinted. They bowed down and worshipped the miraculous ABCs from whom so many blessings flowed."[24] Yet the quality of education in Southern states like Virginia was inferior to that available in most states farther north.[25] Thus, they had a decision to make: stay and submit their children to sub-standard education or leave. Aunt Martha decided to leave.

A bit of social and political history can help in understanding the setting that cradled Lucy. During those formative years in Lexington, Virginia, she was growing up in the aftermath of the Civil War. She was growing up in Jim Crow America.

The Civil War—also called the War Between the States—is said to have derived from several circumstances, one of which was disagreements among the states over the presence and economic value of slavery in the United States. Forced labor—slavery—of African Americans had been introduced into colonial North America in the 1600s.[26] For many years early in American history, wealthy Americans—especially Southerners—bought and sold slaves, a large majority of whom were brought from Africa.[27] Countless slaves worked at menial tasks, such as cotton farming and housekeeping, tending children, cooking, and yard work, while some others served at skilled tasks such as construction.

Throughout the first half of the nineteenth century, anti-slavery sentiment—abolitionism—grew in strength despite strong support of slavery among white Southerners. When the abolitionists and the slave holders reached an impasse, eleven Southern slave states seceded from the Union and formed the Confederate States of America. A sectional conflict ensued between the Confederacy and the Union, precipitating the Civil War. Fighting began on April 12, 1861, and lasted four years. In 1865 the Confederacy collapsed. The Emancipation Proclamation that freed the slaves had become effective on January 1, 1863. The War's end ". . . brought to a close a period of enslavement that had lasted for almost 250 years."[28]

Although the age of Reconstruction—when African-American and white people went about their daily lives as equals—ensued, "Jim Crow"—a codified system of laws and practices designed to subordinate African Americans to whites—was taking root. These laws set African Americans aside in a class by themselves. A "new" social order, reinforced through violence and intimidation, it affected schools, public transportation, jobs, housing, private life, and voting rights. Cutting across class boundaries, Jim Crow united poor and wealthy whites in a campaign of aggression and social control while denying African Americans equality in the courts, freedom of assembly and movement, and full participation as citizens.[29]

"The South universally hailed the disenfranchisement of the Negro as a constructive act of statesmanship. Negroes were viewed as aliens whose ignorance, poverty, and racial inferiority were incompatible with logical and orderly processes of government. Southern whites said that the Negro had done nothing to warrant suffrage."[30]

In the face of a culture that was as crushing and demeaning as this, what did African Americans do? They created "their own of everything"—a parallel universe. And, because they were not content for their lives, families, and institutions to be inferior in any respect, they set about to improve the quality of their group life as well as their achievements in business ownership and the professions.[31]

> The Negro church had become a solid and dynamic institution. Large numbers in almost every city belonged to the AME [African Methodist Episcopal], the AMEZ [African Methodist Episcopal Zion], the Baptist and the CME [Colored Methodist Episcopal] churches. The secret fraternal orders, the Masons, Odd Fellows, Knights of Pythias and others, had laid the basis for Negro insurance companies. In the same year, C. C. Spaulding and others organized the North Carolina Mutual Benefit Insurance Company. Two years later, Booker T. Washington and others organized the National Business League. There were four Negro banks, sixty-four drugstores and at least one millionaire. . . . By 1900, Negroes had more than $500,000 invested in funeral homes. The professional class had grown to more than 47,000. There were 21,267 teachers, 15,528 preachers, 1,734 doctors, 212 dentists, 310 journalists, 728 lawyers, 2,000 actors and showmen, 236 artists, 247 photographers and one black congressman.[32]

The word "Achievement" took on the form of a slogan. People heard it in churches and fraternal organizations. An African-American child growing up in an era like this could not help but be motivated to excel. The watchword of the African-American community was to get an education and "be somebody." African-American teachers—often called "professor"—were teaching their pupils the best that they learned from their own limited schooling. Moreover, they taught them to "hold their heads high" in the expectation that one day they would be accepted as equals by privileged white people. The biblical words, "Ye shall know the truth and the truth shall make you free," were often quoted as if they had been spoken directly to them. This, then, was the kind of environment in which Lucy was immersed.

Exhortations like these typically were heard on Emancipation Day, a celebration that became traditional for the first day of January each year at

least in the Eastern part of the United States. African Americans set aside this day once-a-year to not only celebrate the end of slavery but to inspire their people to move forward—not backward—in order to reach their goal of full equality.

Not only did 250 years of enslavement of African Americans plus the Civil War and its aftermath create the milieu in which Lucy Slowe grew up, another phenomenon is relevant. She was born on July 4, a day that is filled with meaning for America as it is the date America celebrates its independence from England. By the early 1800s, the traditions of parades, picnics, and fireworks were established as the way to commemorate the newfound freedom. It seems in keeping with the celebratory tone of July 4 that one of the biggest events on July 4, 1883, was the opening of Buffalo Bill's Wild West Show. Staged at the Omaha, Nebraska fairgrounds, it featured a herd of buffalo and a troupe of cowboys, Indians, and vaqueros who reenacted a cattle roundup, a stagecoach holdup, and other scenes drawn from Cody's own life on the frontier.[33]

Yet, thirty years before Lucy was born, Frederick Douglass, the acclaimed former slave and leading abolitionist, had given a starkly contrasting view of July the Fourth. It was a perspective that surely continued to resonate among freed African Americans even in the year of Lucy's birth. Douglass gave the speech at a meeting sponsored by (obviously an abolitionist group) the Rochester Ladies' Anti-Slavery Society in Rochester, New York, where he said, in part:

> What, to the American slave, is your Fourth of July? I answer: a day that reveals to him, more than all other days in the year, the gross injustice and cruelty to which he is the constant victim. To him, your celebration is a sham; your boasted liberty, an unholy license; your national greatness, swelling vanity; your sounds of rejoicing are empty and heartless; your denunciations of tyrants, brass fronted impudence; your shouts of liberty and equality, hollow mockery; your prayers and hymns, your sermons and thanksgivings, with all your religious parade, and solemnity, are, to him, mere bombast, fraud, deception, impiety, and hypocrisy—a thin veil to cover up crimes which would disgrace a nation of savages.[34]

Regardless, then, of the parades, picnics and fireworks and even the debut of Buffalo Bill's Wild West Show, Douglass' commentary on July the Fourth is the one that helped to produce the sense of outrage she was to feel about racial conditions in America. It was as if she had been branded by it. Another of Douglass' declarations—"Power concedes nothing without a demand. It never did and it never will"—was probably the drumbeat of the day. Throughout the 1880s in the South, whites removed African-American

officeholders and, by using intimidation, poll taxes, literacy tests, and violence, effectively robbed them of their rights as citizens. None would be surprised that the civil rights movements would capture the attention of this child once she became a woman. She had literally lived disenfranchisement. Frederick Douglass' commentaries then became the cradle in which she was laid, and this whole social and political history constitutes a significant backdrop to the life of Lucy Slowe as she moved into more of it as her aunt moved her up North.

Washington, DC, or Baltimore, Maryland?

Large numbers of African Americans who had been servants in white folk's houses did leave Lexington. They found homes in other states, determined to win distinction in the making of new American citizens.[35] Late in October, then, Martha Price gathered up her nieces, Lucy and Charlotte, and departed. If they traveled by train, they were required to board by separate stairs and sit in the Jim Crow—colored—section that was located in the front car that was closest to the coal-fired engine. There is no information concerning their sojourn in Washington. We next meet the sisters in Baltimore, Maryland, a city more than 200 miles north of Lexington. In Baltimore, the girls lived with Cousin Louise's family.

While Lucy was growing up in Baltimore, the city was becoming prosperous as a seaport and hub of the Baltimore and Ohio Railroad. This possibly accounts for the fact that the Price family had made its way—during what has been labeled the Great Migration—to this city along with hundreds of others displaced by the Civil War and its aftermath.[36] Baltimore—with 79,000 African Americans—had become one of seventy-two American cities with more than 5,000 African Americans.[37]

It was a metropolis with the obligatory racially segregated schools. In 1896, the year following Lucy's move to the city, the Supreme Court issued the *Plessy v. Ferguson* decision establishing the doctrine that was to legalize segregated schooling for the next fifty-eight years. Almost by definition, these schools set aside for African Americans were inferior to those for white children. Yet urban areas like Baltimore—unlike smaller rural areas—were ahead in educating their children. Some schools began to offer organized sports and other extracurricular activities. More and more women entered the teaching profession, and they started their own schools. Take Philadelphia, for example. Fanny Jackson Coppin became head of the Institute for Colored Youth in that city and trained teachers to work in the inferior schools provided for African-American children. She had graduated from Oberlin College in 1865.[38] In 1890, Jamie Porter Barrett also started a school in Philadelphia. Located in her home, it was called the Locust Street

Social Settlement. It became America's first such institution for African Americans. This system of schooling remained the law of the land until the *Brown v. the Board of Education* decision of 1954 that outlawed segregated public schools.[39]

In Baltimore, Lucy and Charlotte shared the home of Martha Slowe Price's daughter, Louise.[40] "Cousin Lou" was now Mrs. Louise Stuart, and her household consisted of her husband, James, and their two daughters, one of whom was named Martha. Martha Stuart (later Doali), who was obviously named for her grandmother, would later state that they were one happy family.[41] Martha Price, ever the attentive aunt, also moved into the Stuart residence. James Stuart supported this extended family, since neither his wife nor his wife's mother worked outside the home. Each summer, Martha Slowe Price would take her nieces back to Lexington for a vacation that they enjoyed immensely. Many years later, as a college student, Lucy would recall her experiences with the white folk during those summers in Lexington.

The Prices lived in a racially segregated section of Baltimore as a result of white citizens' determination to separate the newly arriving African Americans from white folk. "Municipalities gave sanction to this practice by enacting segregation ordinances."[42] Baltimore, along with Louisville, Kentucky, Richmond, Virginia, and Atlanta, Georgia was one of the cities that passed the first group of these laws.[43]

Baltimore was "a city that retained many of its Southern antebellum prejudices."[44] Children learned to recognize the sign "colored" even before they could read their names. Their lives depended on it. The town featured white-only schools, white-only cinemas, white-only libraries, and practically white-only everything else. Developments in the African-American community illustrate the strong need African Americans had to further the creation of a parallel universe. As a case in point, in 1892, *The Afro-American Ledger*—the first newspaper owned and operated by African Americans in Maryland—was established. In 1894, a group of leading African-American physicians opened Provident Hospital in Baltimore, a medical facility for their people.[45] African Americans opened the Lexington Savings Bank in 1896 for the African-American communities of Baltimore.

Lucy and Charlotte had been in Baltimore just one year before a group of middle-class African-American women founded the Colored Young Women's Christian Association (CYWCA). The creation of YWCAs in American cities was in response to the large numbers of migrants, primarily from Virginia—like the Slowes—and other states who were flocking to large northern cities.[46]

Because Baltimore was a racially segregated city, African Americans were not welcome at the YWCA branch organized by white women. Thus, the CYWCA came into being in response to the need for racial uplift. African-American families were not alone; their community was there to

evangelize and provide them with parental supervision just as occurred in white neighborhoods.

Lucy, at age 12, began attending public schools in this city up North. True to the segregationist policies of the era, her school was designated for colored only. The Colored High School of Baltimore—opened in 1885—had been housed in the old City Hall on Holiday Street. Two years later, it was moved to a new building on Saratoga Street, near Charles. The Colored Polytechnic Institute that the City established five years later was combined in 1900 with the Colored High School, creating an enlarged curriculum that included academic subjects, manual training, and teacher training. Lucy graduated from that high school in 1904. She experienced a couple of "firsts:" she was a member of one of the first classes in a new building, and the building had African-American high school teachers for the first time.

The Afro-American Ledger regularly ran articles about the education of African Americans, commenting favorably on the new facility and its faculty.[47] The high school had the largest enrollment in its history in 1901, with 250 students in attendance. Responding to the demand, an additional story was added to the building, and the shops were improved.[48]

Lucy was a bright student. Teachers and classmates remembered her for her scholarship and extensive student activities. Dwight O. W. Holmes, one of her high school teachers and her mentor for many years to come, noted that two girls—Lucy Slowe and Alethea H. Washington—placed number one and number two in each of their classes.[49, 50]

Holmes, who became Lucy's mentor, was in his thirties when he was teaching at the Baltimore Colored High School. He had earned the Preparatory Certificate from Howard University in 1896 and the AB degree in 1901.[51] His father, John Alexander Holmes, ". . . was pastor of Baltimore Methodist Episcopal churches for a number of years."[52] It is not surprising that Dwight would develop a special relationship with Lucy. His father had grown up in Lexington, Virginia, where, as a youngster, he had attended Sunday School[53] and where he joined the Methodist Episcopal Church.[54] The Holmes' acquaintance with Aunt Martha Price and her family was perhaps no accident, for their roots reached back to Lexington.

According to a high school classmate, Lucy was interested in a host of activities, including membership on the first basketball team organized for high school girls, student government, and the Girls' Club Program.[55] Basketball had just been introduced to America in 1891. Women were increasing their participation in sports, as the catch phrase, "The New Woman," was used to describe the women who rebelled against restrictive Victorian dress of the day.[56] Many women were also active in the suffrage movement. Thus, student government with girls participating was a sign of the times. It would not be until 1920, however, that women would finally

be given the right to vote, although, because of discrimination, African-American women who resided in the southern United States did not vote. Facts like these must have flooded Lucy's environment.

Lucy graduated in 1904 from the Colored High School as the second honor student at age 21, no doubt much older than her classmates. This was the largest class—28 girls and 12 boys—to finish that school. In the Class Day Exercises on June 4 at the Sharp Street Memorial Church, Lucy delivered the class oration, "A True Education." The title of her speech became a lifelong theme. At this point in her life, then, she already had her sights set on education.[57]

Holmes described how Lucy came to him shortly after she became his student to seek advice concerning her future. "Of only one thing was she certain then, that was, she intended to do something and to be somebody. The fact that she had no money and no place to get money did not seem to be a serious difficulty at all. 'Is it not time,' asked she, 'that students earn their expenses in college by working?' When I told her that I had known boys to do that but that girls so far had done very little to help themselves, she replied, 'Well, I'll be a pioneer.'"[58] She was on her way to discovering she could take control of her education, and from that she could learn to take control of her life.

Lucy had no way of knowing then that Holmes would remain a presence in her life over the next thirty years, helping to guide her, helping to open doors. Already, at age twenty-one, Lucy revealed that she was ambitious. She had an unflinching, pioneering spirit, the urge to achieve, to be somebody—all of the teachings that had molded Lucy at home, in church, and in school characterized Lucy throughout the rest of her life. She was going to "make a way out of no way." This incident epitomized a pattern as to how she would approach a challenging situation. Aunt Martha's nurturing was key to who she was. The stories about life with Aunt Martha help explain her proclivity to Christianity and church attendance, to manners, to morals, to scholarship, to refinement—qualities that remained with her to the end of her life. Aunt Martha set the stage.[59]

2

The College Years

1904–1908

School days! College days! These offer the time to make decisions, to adopt standards, to choose pathways—to build character. All after life will prove the value of whatever foundations are laid.

—Coralie Cook

Howard University

During the first decade of the twentieth century, Howard University awarded scholarships to the ranking male and female graduates of selected high schools. As fate would have it, because the valedictorian of the class of 1904 of Baltimore's Colored High and Training School declined the Howard offer, Lucy became the recipient[1] and thus began her serendipitous adventure in the world of education and human rights. When Lucy enrolled, Howard's College of Arts and Sciences had fewer than one hundred students, and her own class numbered nineteen.

Would she change while in college?

> Students do change in a number of ways during the college years. Many of those changes are independent of what students are like when they enter college . . . the nature and origins of these changes are frequently both psychological and

sociological . . . college and university campuses constitute powerful and highly varied settings for student change—developmental and otherwise.[2]

What Was the University Like?

To understand the impact of Howard University on Lucy Slowe, one need only to search for the institution's attributes, for, like students, college and university campuses are influenced by the character of the larger society. At the turn of the century, as far as race relations in America were concerned, segregation was still the order of the day. It had been to address the system of inequality produced by slavery that Howard University had been founded, and it was this scheme that defined the University's mission in the universe of higher education and, as a result, its impact upon Lucy Slowe.

Located in the District of Columbia, Howard was set on a hill. It occupied prime property, bounded ". . . on the west by Georgia Avenue, beginning at Florida Avenue; on the south by Florida Avenue, as far as Fourth Street, on the east by Fourth Street, as far as Elm Street; also on the east by Second Street, from Elm Street by the Soldiers' Home, then along Hobart Street to Georgia Avenue."[3]

One of the oldest and most prestigious colleges for African Americans in the United States, Howard opened in 1867 with the distinction not only of being located in the Nation's Capital but also of being chartered by an act of Congress for the purpose of educating "youth in the liberal arts and sciences." It bears the name of General Oliver Otis Howard, the head of the Freedmen's Bureau—a federal agency created during Reconstruction to provide for the education of the newly freed slaves. General Howard presided over the University from 1869 to 1873. From its beginnings, Howard set itself apart. Offering a broad range of educational opportunities as well as basic skills, it was widely regarded as a premier institution.[4]

The men and women who established Howard University were white and, for the most part, members of the Congregational Church. They had been interested in establishing a theological seminary. As time passed and it was necessary to appoint presidents, the three individuals who served as president during Lucy's undergraduate years were white: acting presidents John Gordon (1903–1906) and F. W. Fairfield (1906) and President Wilbur P. Thirkield, who was appointed in 1906. Gordon and Fairfield had been Congregationalists, while Thirkield was a member of the Methodist Church. He served during the last two years of Lucy's matriculation, thus playing a prominent role in shaping the University's culture while she was a student. He was the ". . . first and only President of Howard who was Methodist."[5] He held the AB and AM from Ohio Wesleyan University and the STB

from Boston University and had been President of Gammon Theological Seminary (for African Americans) in Atlanta from 1883 to 1900.[6] These "men of the cloth" in all probability created a spiritual climate at the university that also reflected the interests of the Congregational Church. The article cited below by Cobleigh is a case in point.

Although the University was a young and fledgling institution when compared with the icons of American higher education—institutions like Harvard and Yale that date back to the 1600s—it had already become an esteemed institution by the time Lucy enrolled. African Americans regarded acceptance at Howard as the pinnacle of achievement. As early as 1904, it was labeled as "The Capstone of Negro Education."[7] Rolfe Cobleigh, writing in *The Congregationalist,* noted at the time that Howard was the ". . . largest institution of college grade for Negroes in the world."[8] Certainly Lucy was aware of Howard's reputation and enthusiastic about enrolling. Moreover, Cobleigh added

> An ever increasing and eager host of would-be students are pressing at the gates. The student body is earnest, enthusiastic and studious. Interest in Howard University, not only among loyal alumni and old friends, but among new and substantial friends of education and of the colored people, is steadily increasing. Howard must go forward as the great university of colored Americans.[9]

The University offered numerous programs of study while Lucy was a student. Boasting four professional schools (Pharmacy, Dentistry, Medicine, and Law) the Theological School, the College of Arts and Sciences, the Teachers College, and the Academy, it also had a commercial department located in the College of Arts and Sciences.

Unlike many of the American colleges that were founded for women only at the turn of the twentieth century, Howard University was coeducational. "One of its most cherished traditions asserts that the first students were four white girls, the daughters of members of the Faculty."[10]

It was well known that scholarship at Howard was of the highest quality. The most celebrated African-American scholars—who were also effective teachers—were members of the faculty. During this era of segregation and discrimination, predominantly white institutions refused to hire them. Thus Howard was a Mecca for African-American scholars, many of whom had graduated from "the best white colleges and universities."[11] Among those scholars were ". . . Alain Locke, the first Negro to receive—in 1907—a Rhodes Scholarship to Oxford University; William J. Bauduit, Mathematician; [and] Benjamin Brawley, master teacher of English and author of note."[12] Other luminaries included the sociologist Kelly Miller, George W. Cook in English and Commercial Law, Lewis B. Moore in

Education,[13] and George M. Lightfoot in Latin.[14]

At Howard, "The Catalogue for 1903–1904 . . . stated that the scope of the Teachers College (established in 1901) was enlarged so that 'men and women desiring to become teachers may find here opportunity not before so easily accessible, and that the colored people in all sections may look here for well trained teachers in every grade of education'"[15] "The College Department [later] became the College of Arts and Sciences."[16]

One of the movements taking place in the larger society in which Howard was immersed has been labeled "The Revolt of Negro Intellectuals," and with the preponderance of African-American scholars at Howard—indeed, in the Washington, DC area—the University could not escape its impact. W. E. B. Du Bois' book, *The Souls of Black Folk*, had been published the year before Lucy enrolled at Howard, and, during her second year, he and other African-American intellectuals had started the Niagara Movement for Civil Rights. They organized at a meeting near Niagara Falls, New York—on the Canadian side because the interracial group could not get accommodations on the American side—on July 11–13, 1905. The quorum of twenty-nine men from every section of the United States except the Far West, led by Du Bois, William Monroe Trotter, and Clement Garnett Morgan, demanded abolition of all distinctions based on race.[17] This movement was a forerunner of the National Association for the Advancement of Colored People. Du Bois was calling upon those who had had the privilege of higher education—the intellectuals—to give leadership to African Americans' struggle for equal rights, and he labeled them "The Talented Tenth." The revolt characterizing this period was against the educational, social, economic, and political ideas of Booker T. Washington.[18] Many of the faculty members at Howard, including Kelly Miller and George William Cook, are said to have been "disciples" of Du Bois.[19]

By mid-September 1904, Lucy had settled into Miner Hall, the women's dormitory. Most of the young women whose homes were outside of Washington, DC lived in this venerable building. Constructed in 1867, it was one of the original Howard University structures. University publications[20] described the building as first class,

> . . . so as to give the girls as many of the comforts and conveniences of a well ordered home as would be practical in any school; with internal management that was sympathetic and motherly and conformed to the highest standards of Christian discipline and culture; having an exceptionally fine company of young women who came from the best of homes of the country; with the full assurance that they would be safeguarded by all the wholesome and refining influences of a well-ordered and refined home, while enjoying at the same time the larger benefits of

university life in the capital of the nation where the highest facilities of culture and improvement exist.

A reporter for *The (Washington) Evening Star,* on November 29, 1867, gave a graphic picture of the dormitory. He described it as being ". . . 202 feet long and thirty-seven feet wide. It was to have a brown Seneca stone foundation and basement and white brick upper stories . . . it would contain about 100 rooms for boarding students." In 1869, the Trustees named the building Miner Hall in honor of Myrtilla Miner who had contributed $31,000.[21] Miner (1815–1864) had been an abolitionist who overcame local opposition to establish and maintain the Miner School for Free Colored Girls in antebellum Washington, DC in 1851.[22]

A typical day for the 10–12 students who resided in Miner Hall in 1907 began at 6:00 a.m. with the sound of the chime from the Main Building. Their rooms had to be cleaned for inspection but not before their 7:30 a.m. breakfast and the recitation of prayers, the singing of hymns, and Bible study. Classes started at 9:00 a.m., followed by another fifteen-minute Bible session in Andrew Rankin Memorial Chapel. One hour for exercise came after four and a half hours spent in classes. Dinner was served at 5:30 p.m. and after that the girls could take part in extracurricular activities that had to end by 8:00 p.m. The one-hour study hour came next, with lights out at 10 p.m. Somehow these residents managed to include Wednesday night prayer meetings and Alpha Phi Literary Society meetings on Friday.[23]

"Well-ordered home. Christian discipline. Best of homes of the country." These appellations describe the environment in which Howard thought its women students should live. They characterized the "finer things of life" to which many African Americans aspired. They also typified the kind of home Aunt Martha Price maintained. That was the kind of atmosphere in which Lucy resided for all four years of her college career, easily taking part in the campus social, cultural, and extracurricular events. Because of what was surely a diversity of students in Miner Hall and her interactions with them, she almost certainly had many opportunities to examine her own social and political values.

The overall regimen at Howard, if like that in most predominantly African-American colleges of the day,[24] was severe. Personal conduct came under close scrutiny. "Both were aspects of white control of their institutions. . . . Being on one's best behavior was interpreted by black college administrators as meaning self-subjection to quasi-military regulation. Political orthodoxy was not less highly valued by dominant white society.[25] Students were being taught to willingly obey others and value conciliation. In their pursuit of equality, African Americans believed that these were the standards—the well-ordered home, the self-control—of white folk they had to prove that they, too, possessed."

Lucy realized while still in high school that, if she were going to attend college, she would need to help support herself financially. Thus, with limited financial resources, she worked both on campus and off. She did clerical work during the school year and held summer jobs. In addition, she earned extra money as soloist with several church choirs. Obviously, "something" (named "Aunt Martha") happened to change her mind about church-going while she was growing up in Lexington and Baltimore.

During her senior year, with a concentration in English, she held the on-campus job of student assistant to a distinguished professor and university leader, George William Cook, head of the Department of English. Her position, approved by the Board of Trustees on January 21, 1908, was to assist Professor Cook ". . . in correcting papers in his English course and, more important to assist in chaperoning girls."[26] The girls most likely looked up to her. After all, by this time, she was twenty-four years old.

This relationship with Cook was perhaps fortuitous but also defining for Lucy Slowe. Cook was a central figure in President Thirkield's[27] administration. By the time Lucy arrived at Howard, he had been elected secretary of the university with ". . . general supervision and direction of the work of the Superintendent of Buildings and Grounds, of the University Engineer, and of the Housekeeper. In addition, all employees outside of the teaching and office staff reported to him. His written approval was required for the payment of 'bills for labor, supplies, repairs and the like.'" Imagine how much Lucy—the student—could learn about management assisting a man who carried such a multitude of responsibilities and so much authority.

Although Cook had been born a slave in Winchester, Virginia,[28] he was the man who, in 1899, had developed the Department of English under the leadership of Jeremiah E. Rankin, President of the University from 1890 to 1903. He had also represented Howard University at the funeral of the abolitionist, Frederick Douglass.[29] His early education occurred in Harrisburg, Pennsylvania, to which his parents moved the family

> after the Union Army freed the former slaves. Later, at Howard University . . . Cook received the Preparatory certificate, the A.B. and A.M. degrees. Cook was appointed Tutor in Mathematics and Assistant Principal of the Normal Department [in 1881]. In 1887 he became Tutor in Mathematics in the College while continuing as Assistant Principal. Two years later he was promoted to Principal of the Normal Department, retaining this position until the Department was reorganized in 1899, at which time the English Department was established with Cook as Dean. On his recommendation, The Executive Committee [of the Board of Trustees] on July 11, 1902, authorized the establishment of a

Commercial Course in connection with the English Department. When a separate Commercial Department was established in 1902–1903, Cook became Dean of the Department and Professor of Civics and Commercial Law.[30]

Moreover, he played a major role in helping Howard to fall in line with the nineteenth century trend of normal schools becoming teachers colleges. He was active in the Du Bois movement as a member of the NAACP Board of Directors.[31] Regarded as "an aristocratic public servant,"[32] his active participation in the NAACP could have heightened Lucy's interest and determination to fight for equal treatment for African Americans. Lucy and her professor lived near each other. Cook and his wife, Coralie, resided in Miner Hall, as Coralie served as the building's superintendent. The couple devoted their energy to making a superb institution of higher education out of Howard.[33] This was a perfect setting for the development of a friendly relationship with Lucy Slowe, the undergraduate.

Lucy's Extracurricular Activities

As Howard shaped its intellectual and interpersonal environments to invite student involvement, Lucy easily chose to take part in a multitude of activities that were probably extensions of interests she had developed prior to enrolling. Yet she also sought out new opportunities and thus broadened her horizons.

She became acquainted with the esteemed Lula Vere Childers by virtue of her membership as a contralto in the University Choir. The quality of musical offerings under Childers' direction was outstanding—witness a special service in Andrew Rankin Memorial Chapel, the campus church. A writer in the *University Journal*[34] commented that

> on that Sunday afternoon, the Andrew Rankin Memorial Chapel was thronged to overflowing with a very appreciative audience. High praise was accorded Miss Lula Vere Childers, the Director, for the results of her efforts in training the singers. . . . Miss Lewis, the accompanist played with great expression and accuracy . . . while the solo work of Miss Childers, Miss Mamie Chase and Mr. William D. Giles commanded unstinted admiration. . . . The choruses were brilliant and with no exception the attack was perfect.

The University Choir likely did not perform the gospel music and jazz styles that were becoming all the rage in the early part of the twentieth

century and that were most likely enjoyed by large numbers of Howard students. President Gordon had appointed a new faculty member—Miss Childers—to lead the development of a concentration in music, presumably neither gospel nor jazz. Later, ". . . under the administration of President Fairfield, Childers was elevated to Instructor in Methods and Music in the Teachers College and University Director of Music."[35] President Thirkield reinforced this focus on music, and Childers became a force to be reckoned with both at the University and in the city of Washington, DC.[36]

At Howard, Lucy continued the interest in sports—especially tennis—that she had revealed in high school. Presumably while taking part in community activities as a child, she had been introduced to the game and was talented enough to continue playing as a college student. There is no reliable way to determine how the young Lucy—an African-American child—became involved in tennis, although the history of the sport in the United States is important.

Tennis was a fairly new sport to the United States. The record of the sport reveals that Mary Ewing Outerbridge of Staten Island "introduced it . . . in 1874. She purchased tennis equipment in Bermuda (and had trouble getting it through Customs!) and used it to set up the first U.S. tennis court at the Staten Island Cricket and Baseball Club that spring.[37] As far as sports go, tennis came after baseball, whose first recorded contest had taken place nearly thirty years earlier.[38] Unlike sports that involved teams, it is known that "Lawn tennis was popular among the well-to-do, who played avidly in their leisure time for health, competition and entertainment."[39] Thus, although tennis was a sport of the well-to-do African-American community leaders in a city like Baltimore—Lucy's hometown—were determined to play it also.

"As early as 1890, several Black families owned tennis courts. As a result, matches and tournaments began at Black colleges in 1895. . . ."[40] Knowing that tennis was popular among well-to-do white people, African Americans probably regarded it as a sign of equality. In the early 1900s, an "aristocracy of color" developed within the African-American community. "It reflected an upwardly mobile mindset based on . . . some real income and substance, patronage positions, [and] the professions of teaching and lawyering. . . ."[41]

Besides the health benefits, however, Lucy could have learned to enjoy tennis for its own sake, even as a hobby. She learned to be a fierce competitor. And she learned qualities of sportsmanship that would characterize the rest of her life—qualities like a sense of fair play, team work, courtesy toward teammates and opponents, and a striving spirit. At Howard, luck was on her side. It was during the administration of President Thirkield that organized sports received considerable attention.[42] Despite his

interest, however, athletics developed haphazardly. Several members of the faculty served as coaches. For example, "From 1892 to 1905, Charles C. Cook, another professor of English, voluntarily served as football coach."[43] Prior to this time—in 1893—participation in athletics was restricted by order of the Executive Committee of the Board of Trustees. Games were permitted on all days of the school year except Sundays, and the hours of participation were restricted. Play had to occur between the hours of three and seven p.m. in the summer and three and six p.m. in the winter. Other restrictions pertained to match games that had to be played—with not more than fifty outsiders present—in the presence of a faculty member.[44] While Lucy was in college, the University had no gymnasium. It was only following her graduation that the Board authorized President Thirkield to work with the General Alumni Association to raise, under its auspices, funds for such a facility. Due to insufficient funds, the building did not materialize until 1923,[45] but the University converted ". . . the first floor of Spaulding Hall into a 'very suitable gymnasium' with several hundred dollars worth of equipment."[46]

Yet Lucy had already become a good tennis player, so her talent led her to be elected President of the Women's Tennis Club, of which Professor George M. Lightfoot was sponsor. Not unlike Professor George C. Cook, Lightfoot, a warm and kindly gentleman, filled dual roles; he taught Latin for forty-eight years, beginning in 1891.[47] He had graduated from the Preparatory Department in 1887 and had gone on to earn the AB degree from what was considered to be one of the best Ivy League institutions, Williams College.[48]

In addition to music and tennis, Lucy took part in intercollegiate debating,[49] an activity that teaches one to handle arguments effectively. It requires one to organize a response, to be polite, and to be sure of one's facts. Like the attributes of sportsmanship, skills such as these that Lucy developed as a debater would later serve her well.

The Christian Endeavor Society was another organization in which Lucy played an active role. In various Protestant churches, this was a group of young people organized to do Christian work. Christian Endeavor groups were united in a corporation called the United Society of Christian Endeavor that was organized in 1885. The parent society was founded in 1881 at Portland, Maine, by Reverend Francis E. Clark, a Congregational minister.[50]

She was President of the Christian Endeavor group during her junior year and led a "well attended prayer meeting" on Christmas morning, 1906.[51] During the next academic year, the Society sponsored a Thanksgiving Social[52] and a masquerade party.[53] It can certainly be assumed that Aunt Martha's niece reexamined her religious values, changing from one who would "never

set foot in a church" to membership in a faith-related organization and soloist in a church choir.

Howard University was an institution that required students to attend vesper services on Sunday evenings. President Thirkield actually ". . . conducted 'revival services' for the students. He was obviously pleased . . . that as a result of the Day of Prayer for Colleges about 200 students 'gave themselves in reconsecration to Christian life and service.' "[54]

The Culture Club was another one of Lucy's interests. Members held discussions with prominent speakers, thus expanding their intellectual and social horizons.[55] Could it be that women's suffrage was one of the Club's topics? Might they have also been discussing Du Bois' Niagara Movement? Howard's policy was to bring outstanding public figures to the campus to speak. An important event during the time Lucy Slowe matriculated at the University was the first Founders Day held November 15, 1907, to inaugurate Thirkield. Among the speakers were President Theodore Roosevelt, British Ambassador James Bryce, and Andrew Carnegie.[56]

The extent of Lucy's activities included not only music, sports, debating, culture, and religious activities but also those of a social nature. In her junior year, she stood in the receiving line for the New Year's Day Reception given by the young women who lived in Miner Hall.[57] It was customary that, when one of the Miner Hall residents turned eighteen, the girls prepared a formal supper, and, in 1908, Lucy participated.[58]

A recognized leader, she served as vice president and secretary of Alpha Phi Literary Society. One product of her interest in literature is a poem that she wrote at age twenty-three when she was only a sophomore. It is titled "Heroes Unrequited" and was published in *The University Journal*.[59] During the period of Thirkield's administration, the *Journal* was regarded as an "ephemeral student publication" that provided an outlet for students who were interested in publishing.[60]

Heroes Unrequited
By Lucy Diggs Slowe

To storm a fort, to take a town,
To fight 'gainst hosts and win renown,
To snatch from Neptune's dark Abyss
A precious soul and bear it forth,
Would give the doer an honored seat
Beside her majesty, Queen Fame,
There to bask in her sunny smiles,

There to gaze in calm delight,
On erstwhile friends in obscure night,
Is the reward for brave deeds done,
Is the recompense duly won.
But who deigns to look on humble things.
Who plods life's way from morn till eve?
Who dares invite to Fame's retreat
Those countless souls who bear the brunt
Of this world's ills and murmur not?
No, 'tis not, 'tis not, say one and all,
For humble folk to scale Fame's wall,
And sit among the dazzling few.
That places reserved for those who stand in bold relief,
Apart from simple toil and grief—
For those and only those.
Fame has not seat for a mother dear,
Who sheds o'er son a scalding tear,
Denying self her dearest wish
That he may be the better armed to fight
For palm and champion right.
No couch has Fame for weary youth
Who longs to rest from care and toil
Endured too early that he may
Among the learned sages stay
Awhile to drink from fountains pure
And sparkling, to learn the more.
How to climb to that great source
Of all our knowledge and not be lost
In his attempt—no more!
No, mother, thou canst not rest in peace and joy,
Beside hero of fort and town;
No, youth, thou canst not recline
On downy couch to rest thy weary limbs.
But, mother, youth, plod on their way,
To go at the close of day,
From sacrifice and care and toil
From earth's tumultuous strife and broil
To that House of Fame sublime.[61]

Listen closely to her. Isn't she writing about the need to lead, to sacrifice, and even at this early age, to eschew rest? Her literary talent is unmistakable.

Lucy Slowe and the Founding of Alpha Kappa Alpha Sorority

Lucy's talent as a student leader was perhaps most far-reaching in her role in founding and serving as the first president of the first chapter of the first sorority for African-American women—Alpha Kappa Alpha (AKA). AKA is an organization that has become one of America's distinguished and preeminent women's groups. Lucy's peers regarded her as ". . . serious, hard-working, conscientious and efficient in all that she did. . . ."[62] They were proud of her "ability as a singer." She was one of the people they would call on when they felt they needed someone to uphold the dignity of the group.[63] Her numerous extr-curricular activities reached a peak in the founding of AKA, and it was to be one of the most laudable and enduring achievements of her life. This group of college girls was "eager to make a contribution that would live forever. . . ."[64] "They searched for elements that would best convey a group of women with shared values committed to pooling their strengths and talents to improve their lots and make a difference for themselves and their people."[65] Marjorie Parker writes that

> Ethel Hedgeman, a member of the junior class, returned from the summer vacation (1907) with the inspiration and desire to organize a sorority. She discussed the idea with a number of her classmates and associates. . . . Ethel told them of her plan to form an association of women students through which the talents and strengths of these students could be organized for the mutual benefit of all.
>
> After a period of exchanging ideas and pooling suggestions, the group of nine started to work to crystallize the preliminary organization. In this group were the Burke sisters (Beulah and Lillie), Margaret Flagg-Holmes, Marjorie Hill, Lucy Slowe, Marie Woolfolk Taylor, Anna Easter Brown and Lavinia Newman.
>
> Satisfied that a sorority could be a valid part of college life, it was agreed that recognition by the university administration should be the first objective. Accordingly, they turned their attention to a written constitution. The assignment for the first draft was given to Lucy Slowe.
>
> . . . The constitution, developed by Margaret Flagg, Lavinia Newman and Ethel Hedgeman from the draft by Lucy Slowe, was adopted as read. (Feb. 21, 1908). . . .
>
> Perhaps the most important item of business transacted at this meeting (Friday, February 28, 1908[66]) was the selection of the first permanent officers of the group. Although Ethel Hedgeman was the natural choice and the overwhelming favorite for

the office of president, the newly adopted constitution stipulated that the president should be a member of the senior class, and so on Ethel Hedgeman's motion, Lucy Slowe was elected as the first president of Alpha Kappa Alpha.[67]

On February 25, 1908—to celebrate their momentous creation—Lucy Slowe hosted a party for the members.[68]

In the context of the early twentieth century, the organization of a sorority at an African-American university surely represents the creation of a support system for young women. A chapter of a Greek-letter organization for men—Alpha Phi Alpha Fraternity—had been established at Howard a year earlier. The fraternity had its origin at Cornell University in 1906. Both these female and male students were departing from what was typical for teenagers of their day and choosing to do something that the vast majority of their peers would not—or could not—consider doing, which was leaving home to go to college. When Ethel Hedgeman—a student—brought the idea of a Greek-letter organization for women to her friends at Howard, they were aware that sororities were present on the campuses of white colleges. In fact, she had been inspired by her English teacher, Miss Ethel Robinson, who was aware of a sorority at her *alma mater*, Brown University.[69] They knew that, because of the color of their skin, they were not going to be able to establish a chapter of a white sorority at their African-American institution. Thus they had to create their own. As was the case with African Americans of their time, they did create their own, with none other than Lucy Slowe as their first president. The group they organized was to become Alpha Chapter, the Sorority's first undergraduate chapter.

Graduation

In 1908, Lucy, at age twenty-five, graduated from the Howard University College of Arts and Sciences with the Bachelor of Arts degree in English. Her record as an exceptional student led her classmates—when they met in May, 1908—to name her the first honor student. She later delivered the valedictory[70] at the Commencement Exercises held at the First Congregational Church, where President Wilbur P. Thirkield awarded the degrees.

Summing Up

The four years at Howard had an impact on Lucy, and she left an imprint on the University as well. Marion Thompson Wright observed that

Lucy Slowe told her teacher, Dwight Holmes, that she would be a pioneer and do what few women of her time had done, work her way through college. Her graduation in 1908 from the school of her choice demonstrated that these were not idle words. During her stay in the institution, she revealed herself as a person of varied interests and of significant leadership ability. Although she graduated at the head of her class, she developed aspects of her personality other than the intellectual. In later years, she stressed the contributions that out-of-class activities could make to the development of initiative in planning and implementing activities and of social skills. She had learned the possibilities through experiences that were part of her life outside the classroom. The activities in which she participated show the extensive aspects of campus life as engaged in then and as carried out in the present. The emphasis may be different, the values of organizations might not be the same, but the fundamentals are similar.[71]

She was not untouched by *alma mater*. One member of the faculty with whom she had a very close relationship—Coralie Cook—drew a vivid picture of this young lady's development. Cook had not only been the superintendent of Miner Hall but was a noted civic leader, activist and rhetorician. In 1880, she had graduated from Storer College, and she taught there between 1882 and 1893. She also attended Emerson College and the National School of Oratory in Philadelphia.[72] As a professor of English at Howard, she held the chair of oratory. She was a founder of the National Association of Colored Women in 1896, an organization that sought to demonstrate the power of African-American women by example and to improve the conditions of millions of impoverished African Americans. A feminist, she befriended Susan B. Anthony and was a strong supporter of women's suffrage. After a while, she separated from Anthony, believing that the National Woman's Suffrage Association had "turned its back on" African-American women.[73] Cook served on the District of Columbia Board of Education for twelve years, a position to which she was appointed in 1914. Around 1913, she and her husband committed to the Baha'i Faith, a religion that—as was promised in the Holy Scriptures—was expected to unite African American and white believers.[74]

In a handwritten, undated, five-page manuscript, Cook wrote to a Miss Walker: "In response to your request, I am handing you this 'recollection' of one of our dear friend's school days."[75]

LUCY DIGGS SLOWE—STUDENT

Looking backward to the years when Lucy Slowe was a student in Howard University—one recalls many other women, who

went with her in and out of the doors of Miner Hall. Young, thoughtful, purposeful, it was a daily pleasure to know and contact them. No one among them all stands out more distinctly than the subject of this sketch.

School days! College days! These offer the time to make decisions, to adopt standards, to choose pathways—to build character. All after life will prove the value of whatever foundations are laid.

Lucy Slowe was ever busy about her foundation and those who knew her best recall her appearance and conduct. She was always well-groomed and her attire, for classroom or for some social function, may some time have hinted at a limited purse—but was distinctive for being in good taste.

In the young women's dormitory where character and conduct are being daily tested the superintendent found her not only reliable but a real help. In a short time her influence upon the other occupants became apparent and it grew to be a custom to consult with her respecting the many problems that had to be considered. By the time she had become a senior, Lucy Slowe could be trusted to chaperon "Miner Hall girls" not only in the "reception room" but on shopping tours downtown.

Lucy Slowe was on the alert to keep up the "tone" of the hall and had an almost uncanny way of discovering visitors and giving them such attention as gave a good impression of Howard.

This young woman was a real student. She had come to study. She wanted to study. If lights had to go out when the "retiring bell" rang there was nothing to prevent early rising. Many an odd hour was spent in the library devouring books and magazines not in the curriculum but interesting to her alert mind. She grew to have courage, to form opinions of her own, to comment on her own actions at times of controversy. All this did not lead her to undervalue the opinions of others and she might often be heard to say—"Now, I hope I am right."

Early she chose to espouse "Women Rights." She [Lucy] seemed instinctively a feminist but knew how to maintain a friendship with a man student that gave to both nobler ideals and to exact from herself a way of living that would justify all her claims for her sex.

To describe Lucy as a feminist is to place her in the mold of Anna Julia Cooper or Sojourner Truth and the women who led the abolitionist movement and advocated for the rights of women. Indeed, "During the period 1890–1920, African American women organized on the national level, aiming to 'lift as we climb.'"[76] Lucy was attending college just as

the Women's Suffrage Movement came into full bloom. African-American women, including outspoken activists Ida B. Wells-Barnett, Mary Church Terrell, and Coralie Cook, espoused ideas about advancing the race by improving the lives of African-American women. At Howard University, it would have been next to impossible to ignore their influence. As an achiever, not only in her course work but in extracurricular activities as well, one could predict, even at this point in her life that Lucy would break out of the circumscribed female roles. She was competitive rather than passive, independent and dominant rather than submissive.[77]

Cook continues,

> Friendships with this thoughtful ambitious girl were formed, too, with some of her instructors who discerned in her promise of leadership and service. It is well known that these ties were never broken but were carried on and out, into the great world of struggle and achievement until one or the other answered the call to service in "The Great Beyond."
>
> Everything in the college life claimed this orphaned girl's attention. She was an excellent tennis player, a booster for football and enthusiastic in support of inter-collegiate debates.

As Cook related Lucy's childhood experiences with white people in Lexington, Virginia, she was not surprised that Lucy found it easy to form helpful interracial contacts. "Experience," she wrote, "had taught her what 'Fact-Finding Conferences' often fail to know—the Divine Law of the Oneness of Mankind."

> And so it was that this young girl, almost alone in the world, played her part in growing, day by day, nearer to the goal she had fixed for herself; sharing as she gained; lifting as she climbed; blazing trails for any ambitious girl to follow despite handicap, knowing as Abdul Baha has reminded us that "God is her helper and God is invincible."

Inclusion of the phrase, "The Oneness of Mankind," hints that Lucy Slowe might have subscribed to Baha'i, as did the Cooks.[78] The Oneness of Mankind is a concept from the Baha'i Faith that was founded and shaped by Baha'u'llah. He

> focused his teachings on a fundamental principle of unity: unity or oneness of God, religion, and mankind. Baha'i tenets revolve around the principle that mankind must unite in a spirit of peace and harmony. Animosity and strife between the races must

be eliminated just as all other prejudices must be condemned and abolished. Other principles include the equality of women and men, compulsory education for all children, eradication of extremes of wealth and poverty, and the belief that the primary purpose of religion is the promotion of concord among the peoples of the world.[79]

Coralie Cook continues.

> During the years immediately following graduation, Lucy often returned to the University to visit her friends, one of whom was Vivian Johnson Cook—a friend from Baltimore who enrolled at Howard in the fall of 1908. In recalling some of Lucy's visits, Vivian said that although Lucy was then a young teacher experiencing her first year in her profession, her return to the campus and to Miner Hall—the girls' dormitory—seemed like that of a 'long tested, highly esteemed older daughter.' With her old friends—the upperclassmen—she shared her year's experience as a teacher. She gave guidance to younger students when questions were asked. She discussed college life and its offerings, opportunities, and responsibilities in relation to the future.
>
> To the younger students, she seemed perhaps somewhat removed, because of her lofty bearing, her keen intellect and evident command of both self and situation. However, there was a basic attractive serenity that each one felt who touched her. She was really inexperienced in years, but she was mature, rich and vital in her interests, approach and outlook. The effectiveness of this basic seriousness combined with sufficient light attractiveness to hold the interest of the girls on campus, gave early evidence that Lucy Slowe was a natural leader with intellect and character. Other graduates returned to campus, but few made the impression that was left after Lucy Slowe's visits. She had found and expressed the direction in which she would travel in life.[80]

Vivian Johnson Cook, who later became an educator and school administrator in Baltimore, and Lucy Slowe would be associates in the National Association of College Women (NACW), an organization that Slowe later helped to found. NACW sought to improve the quality of education offered in Negro schools and to better the status of women students and staff members in institutions of higher education. Vivian Johnson Cook also became a leader in Alpha Kappa Alpha Sorority and, with Lucy Slowe, a disciple of Mary McLeod Bethune in the National Council of Negro Women.[81]

It is well known that college does impact students; they are different people when they graduate—either for better or for worse, but they are different. Students bring a collection of experiences accumulated prior to coming to college. Yet once they arrive, their involvement in both academic and nonacademic activities acts upon them. In college, Lucy Slowe perfected the ability she would have for the rest of her life—to lead.

Primarily, the changes derive from students' involvement with the opportunities at hand, including faculty, other students, and the college climate. Lucy came face-to-face with faculty members, such as George William Cook and his wife, Coralie, Dwight O. W. Holmes, the matron at Miner Hall, and her peers, such as Vivian Johnson Cook. Seemingly, they all became very good friends.

Following graduation, Lucy Slowe's next step would be to put her bachelor's degree in English to good use as a teacher. She probably had no idea where her skills as an organizer and her ability as an athlete would lead her.

3

Public School Teacher, Principal, and Tennis Champion

1908–1922

As Lucy Slowe returns to Baltimore and later moves to Washington, DC, the small interlocking world of African-American people serves her well.

The First Teaching Position—Baltimore, Maryland, 1908

After completing her college work, Lucy became a teacher of English. Although her career carried her into other ventures, she never forgot her love of literature. Her first taste of teaching as a paid professional occurred in Baltimore, Maryland, where—fresh out of college—she received an appointment to teach English and history in the Baltimore Colored High School; she had returned to the school that nurtured her.[1]

She would later write, "I chose the teaching profession, and have continued to follow it, because I was happier in that profession than in any other, and because it gave me opportunity, from my point of view, to work with a large number of human beings in whose welfare I have always been interested."[2]

Lucy had now become "Miss Slowe"—tall, slim, poised, and stern. Although it is not known how Lucy Slowe dressed at the time, it is known that women's skirts grew shorter to accommodate stepping into the new automobiles and the trolley cars. The popular hobble skirt measured a yard around, necessitating a knee-high slit at the side to make walking possible. The high-buttoned shoe lasted throughout the first decade of the 1900s.[3]

Miss Slowe secured the teaching position with ease because of the quality of her academic work—valedictorian of her college class—as well as the dearth of well-trained African-American teachers. As a Howard graduate, she was regarded by employers as a real catch.

She was a hit with pupils at the Baltimore Colored High School. Many years later, her students shared their recollections with Marion Thompson Wright.[4] They remembered her as a superior teacher and a strict disciplinarian. She was the epitome of poise and forbearance. She had a keen sense of humor as revealed in an incident reported by one student.

> There was a student, whose passion for drawing often caused him to default in writing out his thoughtful responses and reviews of certain chapters of "The House of Seven Gables." Out of the clear blue, one morning Miss Slowe called upon him for such a report. Feeling the teacher's combination of expectancy and power to draw the best from her pupils, he rose quickly, took a notebook from his desk and read from its empty pages a rather brilliant composition. However as he passed Miss Slowe at the end of the period, she quietly said, "Next time, put it in writing."

Just out of college and starting her first job as a teacher in Baltimore, she lived with her close-knit extended family—Aunt Martha Price and her cousins, the Stuarts, including James and Louise and their daughters, Martha and Mable—at 1116 Division Street.[5] The Stuarts and Slowes subscribed to values that were animating many African Americans—education, work, family. By now, Cousin Louise was also a teacher, Louise's husband was working as a hotel waiter, and her daughter, Martha (Doali), was a teacher as well.[6]

Not content with just a college education, Miss Slowe decided that her next step up the academic ladder would be to earn a master's degree.[7] The question she faced was where to go for graduate study. Georgetown, The Catholic University of America, and the University of Virginia were all nearby. Why not study at one of those institutions? It is not known whether she ever attempted to enroll. It is conceivable that she might not have even inquired, since, within Jim Crow America, African Americans knew "their place." They knew that they would not be admitted, even if they applied; so, why bother—these were Southern graduate schools.

"Those who sought advanced training were obliged to go north."[8] Thus, Lucy applied and was admitted to Columbia University. Rather than interrupt her fledging teaching career, she went to summer school, enrolling in 1911 in the Graduate School of Arts and Sciences and returning for the next three summers. She matriculated in the Department of English and Comparative Literature that was under the administrative control of the Faculty of Philosophy, and, in 1915, earned the Master of Arts degree.[9] True to her love for the discipline of English, her thesis was titled "The Use of Prose in the Bourgeois Drama."[10] Found in French literature, bourgeois drama was serious drama written in simple prose that emphasized moral instruction in modern social contexts.[11]

To earn the master's degree was extraordinary, for few African-American women had attained such a high level of academic achievement, and none had earned the Doctor of Philosophy degree. It was fully six years later that the first PhD degrees were awarded to African-American women—Eva Beatrice Dykes who earned the degree in English Philology at Radcliffe College; Sadie Tanner Mossell, who earned her degree in Economics at the University of Pennsylvania; and Georgiana Simpson whose degree was in German from the University of Chicago. (Dykes and Simpson later became professors at Howard University.)[12]

An advanced degree helped put Lucy on the road to becoming what has been labeled an "aristocrat of color."[13] Church affiliation also distinguished aristocrats of color from other African Americans with "an extraordinarily large percentage of the upper class [worshipping] in Episcopal, Presbyterian, Congregational, and Catholic congregations."[14] In Baltimore, Lucy Slowe was a member of the Madison Street Presbyterian Church, where she sang contralto in the church choir. She was also a paid soloist in the choir at St. Francis Catholic Church.[15]

She had an active social life. Playing whist and dancing were two of her favorite pastimes. As a member of the Foster Whist Club, she played in tournaments in Washington and Wilmington, Delaware. A card game that was popular in the late nineteenth and early twentieth centuries, whist was characterized by elaborate and rigid rules detailing the laws of the game. Considerable study was required to master the etiquette and methods of play.[16]

Marion Wright reports that Lucy had many friends but few romantic interests; she was always able to secure escorts when she needed them. There is an indication that she had felt a deep attachment for a man in her early years. Her social life is further illustrated by a New Year's night dance in 1914 at which she entertained a large number of friends at the Odd Fellows Hall in honor of "Miss Lewis" of Washington, her house guest. In addition to playing cards and dancing, she also enjoyed the theater.[17] She and her friends might have been listening and dancing to "Alexander's

Ragtime Band" (Irving Berlin), "Can't You Hear Me Callin', Caroline?" (Caro Roma, music; William H. Gardner, lyrics), and "By the Beautiful Sea" (Harry Carroll, music; Harold Atteridge, lyrics). She also enjoyed visiting with a host of friends. Presumably she kept in close touch with Dwight O. W. Holmes and his wife. Mrs. Holmes' mother also knew Lucy well; she had been in charge of the girls in Miner Hall when Lucy Slowe lived there.

Turning to her literary interests, it is said that during the early part of the twentieth century people read everything they could get their hands on. This, coupled with the fact that Lucy majored in English at Howard and was active in the Literary Club, made it reasonable that she would join Baltimore's Browning Club. Organized by Carrington Davis—the Principal of one of Baltimore's secondary schools, and the husband of Lonia Davis, a member of Lucy's whist club—this club sought to develop a more complete understanding of Robert Browning—a British poet of the nineteenth century. A member of one of the Baltimore clubs that Lucy joined described her as independent in her thinking, courageous in expression, honest in her relations with friends, and forceful in her leadership.

She also joined the Du Bois Circle,[18] a women's literary group that had been founded in 1906 by a group of Baltimore's leading African-American citizens. In fact she joined the year it was founded.[19, 20] The men in the city had been inspired by Du Bois' Niagara Movement to hold an organizing conference on racial problems. The women's group—labeled the Du Bois Circle—that emerged from the organizing conference (that was restricted to men) devoted itself to the ongoing study of issues affecting African Americans.[21] Clubs bearing Du Bois' name were springing up in other cities. The Detroit club, for example, started in 1912, and there was also one at Cornell University.[22] In all probability, the members were avidly reading everything Du Bois wrote, particularly a magazine titled *The Crisis*, and meeting to discuss his ideas. By the winter of 1911, he had published *The Quest of the Silver Fleece*, his first novel, as well as *The Souls of Black Folk* (1903), his book that established the intellectual basis for the civil rights struggle.

Because the impact of *The Crisis* was far-reaching, its evolution bears examination. It was the organ for the distribution of a set of principles that would galvanize African Americans and liberal white people around the so-called "Negro problem" in America. It debuted in 1909, the year prior to the formal beginning of the NAACP. The founding of the NAACP—precipitated by the 1908 race riot in Springfield, Illinois—took place amid near dissolution of the relations between white liberals and African-American activists. When the issues were resolved, an office was opened, with W. E. B. Du Bois, the only African-American officer, as director of publicity and research.[23] This meant that Du Bois was editor of its periodical, *The Crisis*.

When the first issue of *The Crisis* appeared in 1910, "One thousand copies were rapidly sold, and the circulation figures increased until they reached 1,000,000 per month by 1918."[24] "Under Du Bois' editorship, *The Crisis* became the first influential black magazine. Acidulous, sarcastic and witty, Du Bois pushed the black protest in his famous column, 'As the Crow Flies.' The magazine also used artwork by black artists and presented stories on Negro achievement."[25]

Du Bois' influence was unmistakable. He made "the black press one of the dominant elements in the life of the black community."[26] Furthermore, most African-American teachers and lawyers—located primarily in Washington, Brooklyn, New York, Baltimore, and Philadelphia—fit the criteria he established for the "Talented Tenth": they esteemed professional success, and they placed a premium on manners and sending their children to good schools in the North. They bitterly resented "the bargain that Booker Washington and his supporters had struck with the White South." These professional people believed that African Americans could not make progress without the ballot.[27]

"Overwhelmingly, the Talented Tenth thought and spoke Du Bois. Its civil rights organizations, colleges, clubs, and Greek letter and professional societies were increasingly imbued with and guided by his ideals and goals."[28] As he wrote for *Atlantic Monthly*, "The power of the ballot we need in sheer self-defense. . . . Work, culture, liberty—all these we need, not singly, but together gained through the unifying ideal of Race."[29]

People who read *The Crisis* were forced to face their prejudices about women's suffrage. Just as white women eschewed African-American women's participation in their suffrage organizations, so did African-American men. Yet Du Bois was adamant about the importance of votes for women. He featured a column titled "Women's Club," written in October 1911 by Addie Hunton, and followed it with the "Women's Suffrage Symposium" in September, 1912. "Framing the debate in dogmatic racial terms, Mary Church Terrell's piece, 'The Justice of Women's Suffrage,' found it 'difficult to believe that any individual in the United States with one drop of African blood in his veins can oppose woman suffrage.'"[30]

Because Lucy Slowe had been a student at Howard University during this period of intense race consciousness, pronouncements like these could not have been new to her. She learned from the tone of *The Crisis*. If anything, membership in the Du Bois Circle served to sharpen her beliefs about the plight of African Americans in America and about the need for women's suffrage for African-American as well as white women. To be sure, she had grown up hearing about women's suffrage. "Some in the suffrage movement saw parallels between the position of women and that of the slaves. In their view, both were expected to be passive, cooperative, and obedient to their master-husbands. Women such as . . . Harriet Tubman,

and Sojourner Truth were feminists and abolitionists, believing in both the rights of women and the rights of blacks."[31] She had heard about race riots between whites and African Americans and the lynching of African Americans, and she was experiencing daily the inequality brought on by segregation and discrimination. Too, she had heard about the importance of economic development, desegregation of railway travel, and the host of other injustices heaped upon African Americans. It was at this point that she might have quickened her determination to become an activist.

She took part in lively discussions at the Du Bois Circle meetings where the Washington-Du Bois controversy was alive and well. She insisted that college-trained women had a responsibility to improve community life. Her belief in equal rights and equal opportunity led her to fight against segregation and discrimination both between the races and between the sexes. She was, indeed, a trailblazer, for at that time few women, and especially African-American women, dared to speak out about issues of this sort. Women were to be seen—not heard.

Because community consciousness was an integral part of Slowe's life, she devoted a substantial amount of her time to civic activities. When the Baltimore branch of the NAACP was formed in 1912, she was a "natural," as a member of the so-called African-American upper class, for membership.[32] Lucy Slowe served as assistant secretary of the Baltimore Branch of the NAACP, and her friend and former teacher, Dwight O. W. Holmes, served on the Executive Committee.[33] In 1915, this Branch of the NAACP gave her the occasion to set forth her views on women's suffrage and racial equality in what is perhaps one of her first speeches on record. The occasion was a meeting held at the Sharp Street Memorial Church. The meeting almost certainly drew a large crowd of African Americans who were deeply concerned about all of the issues she raised. She spoke on the subject of "The Relation of the National Association for the Advancement of Colored People to the Suffrage Movement" reported *The Afro-American* in its issue of October 24, 1915. She said women needed the right to vote, as they were taxpayers and homemakers and were deeply interested in all movements for civic betterment. She affirmed that the NAACP's purpose was to break down discrimination of all kinds and against all people. Therefore,

> it [the NAACP] was in favor of universal suffrage because it could not support the one without supporting the other. It knows only too well that the voteless group in any republic is a helpless one. To a large extent the Negro in this republic is voteless and, therefore helpless.[34]

Her views were presumably strengthened by the stand that *The Crisis* was taking on votes for women. Du Bois ". . . cared passionately about

women's rights and determined to make 'Suffering Suffragettes' wince under plain speaking. . . ."[35]

Issues in the Baltimore community were not Miss Slowe's only worry. She was also concerned about her career. Thus, shortly after that speech, *The Afro-American* of November 8, 1915, announced that she had resigned her position at the Baltimore Colored High School to accept a similar position in Washington, DC, where she would receive twice the salary paid her in Baltimore.[36] She had attracted notice in the whole region for her teaching. Roscoe Conklin Bruce, Associate Superintendent for Colored Schools in Washington, had heard about Miss Slowe's teaching effectiveness and encouraged her to take the examination for a position in the high schools of the Nation's Capital. Her extraordinary talent led the District of Columbia to recruit her. She was extremely well prepared, having earned—in the same year—her master's degree at Columbia University. . . ."[37]

Her resignation prompted perhaps the first of many newspaper accounts of Lucy Slowe's importance. In an editorial concerning the compensation for teaching in Baltimore, the editor stated, ". . . with the resignation of Miss Slowe, teacher of English in the Baltimore High School and secretary of the local branch of the NAACP, the system loses an excellent instructor and the community an active worker. It is with genuine regret that her friends see her depart to a similar position in the Armstrong Technical High School of Washington."[38, 39]

Miss Slowe's resignation had followed that of a "Professor Houston," and in both cases it was stated that it was not only a matter of salary but also disagreements with the principal that made the action not only advisable but necessary. Wright noted:

> The rumored difficulty between Miss Slowe and the principal was to be one of several stories of conflicts between her and administrative officers. She was a woman of strong convictions who held tenaciously to the principles she believed to be the right ones. She argued her positions with fearless logic. She debated the issues not with feminine grace but in the manner of a man to man argument. She was aggressive and relentless in the pursuit of the goals she sought to implement. But in the process she commanded the respect and esteem of those with whom she associated.[40]

She had learned well the art of debate during her undergraduate days at Howard just as she had learned through athletics to be a formidable opponent.

When she departed from Baltimore, she left behind a cadre of very unhappy pupils. She had spent seven years with them, received her initiation

into the teaching profession, and had impressed everyone with both the quality of her teaching and her extensive community activities. She had revealed herself to be a leader and a pioneer, and her experience in Baltimore was a harbinger of things to come.

Returning to Washington, DC

Armstrong Manual Training High School: 1915

After seven years in Baltimore, Miss Slowe returned to Washington, DC, as a teacher of English at Armstrong Manual Training High School.

What was the Nation's Capital like? It was just like Baltimore, in that it was a rigidly racially segregated community. Woodrow Wilson, who had been elected President of the United States in 1912, set the tone. African-American Washingtonians were dismayed at Wilson's election. Conditions for African Americans were not improving; in fact, they were worsening.

Some Southern Congressmen even boasted

> ". . . that they had two goals: to put 'niggers' in their place and to get rid of 'likker.' Negroes were further dismayed by the numerous bills introduced in Congress for segregation on street cars in the Nation's Capital and for Federal prevention of intermarriage between Negroes and whites." None of these bills became law, yet it was clear that Wilson supported them.[41]

The first Congress of Wilson's administration received the greatest flood of bills proposing discriminatory legislation against blacks that had ever been introduced in Congress. "At least twenty bills advocated the segregation of the races on public carriers in the District of Columbia, the exclusion of blacks from commissions in the army and navy, separate accommodations for black and white federal employees, and the exclusion of all immigrants of African descent. . . . Although most of the legislation failed to pass, Wilson, by executive order, segregated Negro federal employees so far as eating and rest room facilities were concerned, and phased out most of them from civil service."[42]

The fight for women's suffrage was still going on. The infamous Night of Terror occurred on November 14, 1917—two years after Lucy moved to the District. It was precipitated by women who stormed the White House in Washington, DC, protesting the fact that women were not allowed to vote in national elections. Suffragists had been arrested and thrown into prison in the Occoquan Workhouse in Virginia, where they ate rancid food and

were denied medical care and refused visitors. An investigation was launched into conditions at Occoquan and the activities of its superintendent, W. H. Whittaker, whose special cruelty was well known. On November 14, he and his workhouse guards greeted thirty-three women protesters, and began beating, kicking, dragging, and choking the group, which included at least one seventy-three-year-old woman. Women were lifted into the air and flung to the ground. One was stabbed between the eyes with the broken staff of her banner. Women were dragged by guards twisting their arms and hurled into concrete "punishment cells." This tragedy no doubt, led to the 19th Amendment to the Constitution that permitted women to vote.[43]

The summer of 1919 witnessed twenty-five race riots. James Weldon Johnson, a leading African-American author and poet, and an early civil rights activist, labeled it "The Red Summer" because of all of the interracial strife.[44, 45] One of the worst riots occurred in Washington, DC. This was also the year of the "red scare," so labeled because of bombs that exploded at the home of Woodrow Wilson's Attorney General and at the banking firm of J. P. Morgan and Company, killing thirty-eight persons and injuring many more.[46]

For the moment, set aside the District's white racism, and countenance all that is taking place on behalf of women's suffrage. When Lucy Slowe returned to the District of Columbia as a resident—seven years after graduating from Howard—she became a citizen of what was for African Americans the social and cultural capital of the entire country.[47] Indeed, the parallel universe had been created. Washington, DC, had Howard University and federal government jobs that were attractive to African-American intellectuals. African Americans owned and managed more than 300 businesses and civic institutions. They designed, built, and financed many of their own buildings. Every aspect of the community followed suit. They had a building and loan association, a savings bank, and the Whitelaw Hotel—a good hotel where African Americans were welcome rather than rejected because of the color of their skin. This was a proud and elegant community that flourished despite, or perhaps even because of, Jim Crow.[48]

For African Americans, U Street, Northwest was their "Broadway," filled with good theatres and clubs. It was also a sector of the city in which many of them lived. Banned from the downtown entertainment venues, African Americans found that their only places for recreation and relaxation in the city were these clubs in the neighborhoods in which they lived.

Constructed in 1910, the Howard Theater was in full swing, showcasing musical, theatrical, and comedy talent. It was the nation's first full-sized theater built for African-American audiences and entertainers. Baroque in design, it contained 1,200 seats, with a balcony and eight boxes. Backstage there were dressing rooms for 100 performers.

The 12th Street YMCA, founded in 1853, was the first full-service YMCA established for African-American men and boys. Anthony Bowen, a former slave turned prominent African-American educator, organized the Y—first on 11th Street and then at the True Reformer's Hall on U Street. The 12th Street location represented tremendous community fundraising efforts to the tune of $27,000 that, along with private contributions, made the $100,000 structure a reality. Jesse Moorland, who later became a Howard University trustee, was instrumental in securing the funding for this structure.[49]

Continuing to create their parallel universe, the community formed a self-sufficient educational system good enough to attract African-American students as well as teachers from all over the country. These schools for African-American children were the only ones in the country under the control of African-American administrators. They were considered the best available for the race in the United States.[50]

Washington, DC developed a prosperous African-American middle class that forged a strong society of churches and newspapers. Also created in the city was a socially exclusive small group of African-American people. In a December 14, 1902, *Saturday Evening Post* article, the poet Paul Laurence Dunbar wrote, "Here exists a society which is sufficient onto itself—a society which is satisfied with its own condition, and which is not asking for social intercourse with whites. Here homes are finely, beautifully, and tastefully furnished. Here comes together the flowers of colored citizenship from all parts of the country."[51] Despite a semblance of middle-class society, "Actually, the larger majority of African American Washingtonians, mostly former southern agricultural workers, were living in sub standard housing situated in tubercular places like Groats and Blagden alleys, or in wretched stable-like quarters formerly occupied by slaves, servants and horses."[52] This, then, was the District of Columbia that greeted Lucy Slowe in 1915.

Armstrong Manual Training High School

In the early part of the twentieth century, there were only two public high schools for African-American children in Washington. One was Armstrong Manual Training High School, and the other was Dunbar High School. Built in 1902, Armstrong was founded on the educational principles of Booker T. Washington, who advocated industrial, craft, and domestic skills training for African Americans. He urged his people to do three things: get an education, work hard, and pull themselves up by their bootstraps.

The school was named after Samuel C. Armstrong. Born in Hawaii in 1839, he was a soldier and educator who devoted his life to the well-being of Native and African Americans. He commanded an African-American regiment in the Civil War.[53] He was considered "sternly handsome."

"With Yankee grit he . . . founded and structured Hampton Normal and Agricultural Institute in 1868 so that Negroes and Indians could learn the lessons of humility, cleanliness, thrift, and above all, the love of the white race. . . ." His prize pupil was Booker T. Washington.[54]

In November of Slowe's first year at Armstrong, that prized pupil died. Booker T. Washington's passing was an event that distressed the African-American community. Washington, although he publicly supported segregation while privately working against it, had become by now arguably the most high-powered African-American spokesperson. It was a sign of the regard in which he was held that over 8,000 people traveled to Tuskegee, Alabama, for his funeral, held in the Tuskegee Institute Chapel.[55]

Because Armstrong was a technical high school, Washington's death prompted—or perhaps (more accurately) renewed—discussion of how the school's role fit, or failed to fit in with his views. Armstrong's new building was the envy not only of educators but also of the entire community. During the period of Lucy Slowe's tenure, many Washingtonians considered the Armstrong educational program a source of genuine pride. Three years after Washington's death, on February 23, 1918, the *Washington Bee* editorialized,

> There is something in the very name Arm-strong suggestive of achievement. There is something in the general appearance and architecture of the building that suggests compactness, economy of space, lack of unnecessary detail and utility.
>
> Everywhere one sees evidences of necessary and practical additions and improvements made by student labor just as one sees in the administrative office the use of every available inch up to the ceiling and back in the alcoves. . . . There is a brevity and directness of the speech and the questions of the students such as one finds associated with the handling of materials in construction work, yet the humane side of the students' nature is kept uppermost through the occasional rhetorical exercises and assemblies for purely cultural and social purposes.

Armstrong was regarded as a fulfillment of the philosophy of both Booker T. Washington and Frederick Douglass because, according to the *Bee*'s editor, he believed students at Armstrong were meeting the economic and industrial needs of the World War that was then raging in Europe. As a supporter of Du Bois' ideas, this might have been one of the first controversies Miss Slowe encountered in her Washington, DC, teaching career.

Armstrong's principal was Dr. William H. Davis, who had been appointed because of his legendary teaching skills.[56, 57] Like Davis, Lucy Slowe was a conscientious and successful teacher who met her obligations with dispatch and efficiency. She was so effective that during her fourth

year, 1919, she became Armstrong's first vice-principal, with the title Lady Principal or Dean of Girls. The next year she succeeded Davis as principal.[58]

Former Armstrong teachers remembered Lucy Slowe as a superb manager—a fine, calm, intellectual person—and an effective administrator who commanded respect. Pupils recalled her as a loved and respected supervisor. Those who had caused disciplinary problems in other schools were influenced by her pleas for them to be constructive rather than negative and to identify with the general program of the school.[59]

Organizer of the First Junior High School—1919

One of the more important changes in secondary education in the early part of the twentieth century was the introduction of the concept of the junior high school. Approximately a decade after the first junior high school had been established in Berkeley, California, the Board of Education of the District of Columbia decided to give this new type of educational organization a try. Thus, at the beginning of the 1919–1920 school year, the Board approved the establishment of a junior high school, but only for white children.

Ever alert to any policy that would disadvantage African-American children, Dr. J. Hayden Johnson—one of three African-American members of the Board—asked if a junior high school for African-American pupils was to be opened also. Another of the African-American members was Coralie F. Cook,[60] both of whom undoubtedly guarded against any hint of racial discrimination. Superintendent Thurston[61] replied that he had not recommended one mainly because of the difficulty that would have been involved in securing teachers. Yet he added that he saw no reason why there should not be an African-American junior high school; all that was required was for Roscoe Conklin Bruce, the Assistant Superintendent in charge of African-American schools, to arrange his teaching staff so as to carry on the work of a junior high school.[62]

The following week, the Board of Education approved the superintendent's recommendation to establish a junior high for African-American children consisting of grades seven and eight in the old "M" Street High School building, and they named it the "M" Street Junior High School. The building had been vacated when the new Dunbar High School was opened. Lucy Slowe of the Armstrong Manual Training High School was appointed principal.[63] Actually handpicked by Miss Slowe,[64] teachers transferred to this building were from among the best in the system.

Initially, Miss Slowe faced rough sailing in this new venture, both from within the school system and from community activists. It was a daunting task. People took extraordinary steps to halt it. The principal of another school was adamant in advising parents not to send their children to this

new school, for she was of the opinion that the merits of this unit had not been sufficiently demonstrated to warrant any of her children transferring to it.[65] While a few principals sent their disciplinary cases to the junior high school,[66] others sent their brightest students.[67]

Within a month, people outside the school system voiced opposition as well. In particular, the idea of a junior high school also aroused the ire of W. Calvin Chase, the respected editor of the *Washington Bee*. His newspaper was a weekly, published from 1882 through 1922. During its run, it was the oldest secular newspaper in continuous publication in the country. He served as editor, beginning a few months after the paper's launch until his death in 1921. In the style of the great nineteenth-century editors, Chase, a quintessential "race man," used the newspaper to voice his opinions about all issues relating to African Americans.[68] At one of the community meetings concerning a school problem, Chase arose and asked permission to offer a motion. He was invited to the stage, where he stated that he was present to make a motion that he thought was in the best interest of the African-American children in the grades. He claimed that there was a conspiracy against the African-American children in the public schools, and he was present to warn them of the dangers that confronted them.[69] He then moved that the Parent's League request that all children who had applied for transfer from the eighth grade to the junior high school apply to return to their elementary schools and that parents instruct all children not to report to the junior high school. The motion passed.

At another meeting, a woman protested the prevocational and vocational training for African-American children in the new junior high school. She insisted that only the kind of education given at Dunbar High School should be given these children.[70] Her comments reflected the Booker T. Washington–W. E. B. Du Bois controversy over the appropriate education for African Americans. Booker T. Washington had delivered his "Atlanta Compromise" speech, in which he preached not only achievement but, to the dismay of some, separation of the races. That speech precipitated the extensive debate between Booker T. Washington and W. E. B. Du Bois that had surfaced with Du Bois' publication of *The Souls of Black Folk*.

The woman was referring to *the* Dunbar High School, the standard for all other comparisons. Originally, this institution had been called the Preparatory High School for Colored Youth and later the M Street High School. Founded as the first public high school for African Americans in the United States and the first public high school for any student in the District of Columbia, it honored Paul Laurence Dunbar, one of the most acclaimed writers at the turn of the twentieth century. He was a Washington native born in 1872, and he lived in the city from 1897 until 1902.[71]

Despite community action against the junior high school concept, Lucy Slowe refused to retreat from her plan to get her junior high school up

and running. Instead, she met with parents, telling them that the negative attitudes toward the school came about because people misunderstood the purposes of this new unit. Staking out a position as a supporter of the junior high school idea did not stop her from gaining the support of the community. She had established herself as one who could balance her work on the one hand and fight for her beliefs on the other.

Since she had become a part of the community and since she had established herself as a person they could trust, these sessions stymied the stiff opposition that had been developing. Miss Slowe projected gravitas. By virtue of her personality, her sincerity, her dedication to her work, and her managerial ability at the high school, her colleagues, pupils, and others liked her. Thus, they were confident that she would be a fine leader for the junior high school.[72]

When it opened, the junior high school program was largely academic, with an emphasis on the humanities and the social sciences. It did not emphasize science and manual work because the science laboratories and shops had not been renovated since the high school students had moved two blocks away to the new Dunbar High School. This might have caused the transfer of some students to Dunbar High School at the end of the eighth grade.

Just as Lucy Slowe's students at the Baltimore Colored High School had praised her, so Armstrong's pupils also noted that there were no disciplinary problems in her classes. Thus, it is not surprising that pupils in this junior high school remarked that the atmosphere in their school was conducive to orderly conduct and self-control.[73]

While she was teaching at Armstrong, Lucy Slowe had taken advantage of in-service training programs—a series of conferences for faculty development led by local experts on topics associated with student learning—offered by the central administration. Once she became principal of the junior high school, she took the next step and created a major program for faculty development. "She established the Columbia Extension Centre at the Junior High school and more that 300 teachers of the Washington public schools . . . studied in this centre in the [first] two years of its existence."[74] She found herself embracing the concept of progressive education. Its leading advocate, John Dewey, had carried his philosophy of education from Chicago to Teachers College, Columbia University, when he was appointed to the faculty in 1904. Lucy invited professors from Teachers College—where many programs were framed by Dewey's philosophy—to conduct the in-service training program she introduced to Washington, DC, teachers.[75] During critical periods of the twentieth century, Teachers College was in the vanguard of important advances in education.

Essentially, Dewey maintained that schools should be more effective agencies of a democratic society than they had been since the inception

of state systems of public schooling in the 1830s. He called for the abandonment of authoritative methods and an emphasis on learning through experimentation and practice.[76]

The progressive movement held that "each individual should be recognized for his or her own abilities interests, ideas, needs, and cultural identity, and . . ." that schooling ought to enable ". . . individuals to understand and participate effectively in the affairs of their community in a collaborative effort to achieve a common good." [77] These were radical ideas, and, although they were renounced by many, Lucy Slowe became a convert.

In 1920, the staff of the white junior high school joined the African-American teachers in taking the extension courses. After the first year, however, white teachers separated themselves from the African Americans and continued an in-service program on a segregated basis. Nonetheless, it was the principal of the M Street Junior High School who introduced in-service education to Washington, DC.[78] This was another "first" for Lucy Slowe.

Miss Slowe's carefully selected teachers had no uncertainty about the M Street Junior High School's goals. As a consequence, Slowe developed team spirit among her teachers. They worked with their pupils on an individual basis and helped them crystallize their educational and life goals. Slowe encouraged them to try new procedures and to be creative. She got to know all 400 of her pupils as individuals. She promoted a host of activities, from subject-matter clubs to glee clubs and athletics—a favorite Lucy Slowe theme.

A gifted writer as well as a proponent of the junior high school concept, in 1921 she wrote an article titled "The Junior High School: An Opportunity," for *The Howard University Record*, a publication of her *alma mater's* Board of Trustees.[79] She described the evolution of this new type of secondary school, its philosophy, its structure, and its curriculum, noting its positive characteristics and offering rebuttals to its critics. She wrote:

> Opportunities for meeting individual differences, for longer preparation for college or the professional schools, and for training in a specific vocation are all aims which the junior high school is seeking to attain. If it accomplishes only a small part of the above program, the junior high school is justified and merits the support of all progressive educators.[80]

Articles by her pupils in the M *Street Junior High School Review*, the school's publication, reveal how the progressive ideals to which she subscribed were operating.[81] The first issue, published in May, 1920, included Miss Slowe's article on the purpose of the junior high school. In noting benefits of a junior high school, she pointed out that seventh and eighth

grade pupils were placed in their own building, giving them more freedom than they could have in a building with younger children. It was important to her that they could begin making their own rules and living by them. This type of school also helped—in her view—the transition these pupils were expected to make to the senior high school. They could also tailor their courses to their interests and be distinctive in other ways, for example, by selecting foreign languages and science. In the final paragraph, Slowe noted the Creed of the School:

> This school stands for the development of the highest ideals of character. Wisdom and worth are handmaidens here. Trustworthiness, dependability, regard for one's word, deference to elders, consideration of one's comrades, respect for one's self are the watchwords. Truth is our cornerstone. Character is our completed structure.[82]

In composing a creed for the school, Slowe reflected her training in Christian principles. The poem titled "My Creed" that had been published in *Harper's* magazine in 1907 conveys the same ideas. Written by Howard Arnold Walter, it begins with "I would be true, for there are those who trust me . . ."[83] and is the wording of a familiar hymn.

In the same issue of the *Review*, an eighth-grade student, A. B. Chavious, set forth a pupil's view of the M Street Junior High School:

> As students of the Junior High School, our aims are higher and the heights to be attained loftier than ever before in our school life. We are realizing that we must begin now to pave the way and we are dreaming dreams of our future. We also see that if we press forward with faith and courage never hesitating at the difficulty of our task, we will in time reach the height we have in view.
>
> We, boys and girls, have places to fill in life and there is work for us to do. Let us be prepared to fill any position that may be opened to us. We must press onward as we grow. We must develop our minds and learn above all to govern ourselves that we may be ready to do the great work in life. If our future is to be worthwhile, if we are to make better men and women to take the places of our fathers and mothers, we must begin now in our everyday school life. Our aim is to make this school superior to any other Junior High School as ours is the first Junior High School, and upon us is laid the duty of blazing the way. We must press on; standing at the foot, gazing at the sky, will never get us anywhere. We must ever try.

> The strong must help the weak and teach them that opportunity will not linger around their door and continue to knock. Each must make the best of his chance now and must not wait until too late.[84]

The *Review*'s editor-in-chief, Paul B. Miller, was also paying close attention to Lucy Slowe. In that May 1920 issue he wrote:

> Student government is one of the privileges offered by the Junior High School. . . . Its success depends on the way in which the students support the movement. They must understand thoroughly that the class officers are not "bosses," but merely co-workers for the purpose of having a better homeroom and school. They must understand thoroughly that the only way to make such a plan a success is to make as their motto "Obedience"! The students vote for the officers they think will be best suited for the positions and for those who will perform their duties faithfully. The officers are mere wall fixtures if they have not the cooperation of students.[85]

Paul's father was Kelly Miller, a distinguished and highly respected professor at Howard University and Dean of the College of Arts and Sciences.[86] The fact that Professor Miller would send Paul to this junior high school reflects the regard with which he held this new concept. Miller, in 1890, after teaching mathematics briefly at the M Street High School, had been appointed to the Howard University faculty. Like Lucy Slowe, he was also a Howard alumnus, where he earned a Master of Arts degree in Mathematics in 1901 and a law degree in 1903. While Lucy Slowe was an undergraduate, Miller was professor of mathematics and sociology, but he taught sociology exclusively after that, serving from 1915 to 1925 as head of the new sociology department.[87]

The *Review* gives even more insights into how Lucy Slowe's M Street Junior High School was implementing her principles. The Editor-in-Chief for 1920–21 wrote:[88]

<div align="center">Our Objects</div>

> Our first object in making this publication is to let you who read it know what we are doing and what we aim to do. We hope that its contents will be of interest to you and that we can count you among those whom we call "friends."
>
> Our second object is to develop literary talent in our school. We lay no claim to any distinction along this line, and we hope that all who read this record of our hopes, achievements and

aspirations will feel towards it as they would toward a young child, that its greatest fault is non-experience and that we need their encouragement, friendship and good will.

It is our desire that all our students be "'model" students with qualities of character well worth imitating. It is our aim to make this a "model" school, instilling in the pupils who come here, principles and ideas true and broad enough, to deal with any phase of life.

One year later, an editorial echoed similar ideas:[89]

The editors of the Junior High School Review want this to be not merely a school paper publishing the happenings of our school, but rather a magazine that children will delight to read wherever they may be. . . . It is to be a wide-awake magazine filled with the best current literature for, and by boys and girls. We want children everywhere to get the habit of reading the Junior High Review.

Lucy Slowe's imprint is unmistakable, as the editorial continued,

[l]ooking about we find that we have but few first class magazine writers and publishers. We feel this is due to the fact that our children do not get into the habit of expressing themselves easily in writing. This is also due largely to the fact that they have no incentive. They think, "What is the use?" What magazine will publish our efforts? It is just our purpose to satisfy this felt need; to offer the opportunity to the boy or girl who feels the desire to write.

We know that a great step forward has been made when we offer our children a magazine in which to publish their stories, poems and editorials, but more than this we offer special training in journalism through our Reporter's Club to pupils who show marked ability along this line.

As much as we need trained writers, however, we need appreciative readers, for it is true that one is practically useless without the other. It is for this reason that we are so proud of our busy salesmen, the pupils, in all sections of our school who get readers. They sell that you may read what our children write. More than mere sales we want readers. If we have some good grown up customer who buys a copy and "hasn't time" to read it, we thank you for the sale, but ask that you give it to some boy or girl who will most surely be delighted with its contents.

Besides capturing the junior high school's philosophy through newspaper editorials, reports on the school's activities illustrate the range of out-of-class experiences that Miss Slowe made available. The principal insisted upon exposing her pupils to people who could serve as role models—individuals who could motivate them to achieve and "be somebody." She wanted them to know that they could rise above the circumstances of their birth.

During her inaugural year—1919-20—Lucy Slowe invited individuals who had exemplary careers to give talks at the school.[90] One was Colonel Charles Young, who, in 1889, had the honor of being the third African American to graduate from the U.S. Military Academy at West Point. Born in 1864 to former slaves in the little hamlet of Mays Lick, Kentucky, he finished West Point in spite of the hatred, bigotry, and discrimination he encountered as an undergraduate.

He and Du Bois were good friends, having cemented their relationship during their days on the faculty at Wilberforce University.[91] Young, who had been assigned to Wilberforce by the War Department as professor of tactics and military science, also taught French and Mathematics.[92] When World War I started, he held the highest rank of any African American and he was the first of his race to reach that rank. In order to go into active duty, he was required to take a physical examination, following which his doctors said his blood pressure was too high. Young and his comrades, his supporters, and the African-American news media believed otherwise. On June 22, 1917, Young had been retired, under protest.

> The following year he rode a horse from Wilberforce, Ohio to Washington, DC—a trip of 500 miles—to demonstrate his fitness for active duty. Once there, he appealed to the Secretary of War for immediate reinstatement and command of a combat unit in Europe. He was, indeed, reinstated and promoted to full Colonel. He was sent, however, to Camp Grant, Illinois. By this time, the War was nearly over.[93]

Other speakers who could serve as inspirations, motivators, and role models for the pupils included George Brown of Omega Psi Phi Fraternity, whose motto was "Friendship is Essential to the Soul," and a Miss Edwards of the Howard University Medical School, as well as a group of students from the University.[94]

Another distinguished visitor whose views no doubt fit perfectly with the principal's was Judge Johnson of the Supreme Court of Liberia, a West African country that had special meaning for these pupils because freed slaves who had been sent to Africa by a colonization society in the United States landed in Liberia in 1822. Others who had been freed from slave ships bound for the United States joined the former American slaves in Nigeria.

His country is the world's second oldest independent nation of mainly black citizens. Only Haiti is older. As the junior high school's second year ended, Dwight O. W. Holmes, by now Dean of the School of Education at Howard University, accepted an invitation to be the commencement speaker.[95]

The school had a plethora of clubs, including the Girls' Athletic Club, the Dramatics Club, the French Club, the Science Club, the Girls' Glee Club, the Student Government Council, the Social Uplift Club, the Orchestra, the Boys' Glee Club, and the Art Club. As was the District's policy, the principal was required to submit the list to the Superintendent of Public Schools. All were approved. The activities of each group were reported periodically in *The Junior High School Review*. Other groups formed organizations as individuals found common interests.[96]

In addition to provocative speakers and lots of clubs, the pupils were exposed to cultural events, and they took trips to local institutions of interest. Associate Editor of the school's paper, Martin Cotton, wrote in the fall, 1920 issue of the *Review* that "One of the aims of our principal, Miss L. D. Slowe, is to make the students of the Junior High School realize and appreciate the beauty of music and with the cooperation of all, her aim will be accomplished."[97]

The *Review* reported on musical and theatre productions for the fall of 1920. The First Assembly on October 13, 1920, featured Miss M. L. Europe, pianist and music teacher at Dunbar High School, and Mrs. C. M. Murray, mezzo-soprano, followed on October 27, 1920, by a piano and violin recital by Miss Europe and Paul Mason, violinist from Dunbar. The chorus of the Junior High School sang the first number on the program, the African-American spiritual, "Deep River."[98] They were also featured on the next program. Presented on November 3, 1920,[99] it included the Boys' Glee Club, the Girls' Glee Club, the school's chorus, and individual pupils. The Junior High School Orchestra showed "a remarkable degree of progress." Music Week at the school was an especially enjoyable time. The Dramatics Club presented its first play, "Three Pills in a Bottle,"[100] in which the senior author of this book, Carroll L. L. Miller, one of Miss Slowe's pupils, played the lead.

Turning to race relations, it is no surprise that representatives of the school attended the Race Amity Conference at the First Congregational Church in Washington. These conferences were sponsored by Baha`i. The 1921 conference, attended by pupils from M Street Junior High School, was the first of its kind in the United States, and is reported to have been organized by Agnes Parsons, a Washington socialite. While on a pilgrimage in Haifa in 1920, Mrs. Parsons had been asked by Baha`i's leader to organize this event in order to "labor for amity and unity between the white and black peoples,"[101] surely a theme embraced by Lucy Slowe. Alain Locke, a Howard University professor of philosophy, would take part. It is well known that

Locke's philosophy was based on multiculturalism, ". . . probably stemming directly from the Baha`i principle of unity in diversity."[102] A picture taken at a Race Amity conference showed large numbers of both African-American and white people in attendance.[103] A prominent exponent of Baha'i was Louis Gregory, who made his home in Washington. He devoted himself to "unify[ing] the white and black peoples of the world and to aid[ing] in establishing the oneness of humanity."[104]

Perhaps Lucy Slowe had become a believer in Baha`i principles, as they were consistent with her strong views about race relations and the pursuit of equality among the races in America. Living in Washington, she likely had close contact with her good friends, George William and Coralie Cook, who had become Baha`i adherents a couple of years prior to her return to the city. Moreover, the notion that she sanctioned such a trip for her pupils is compatible with Coralie Cook's assessment of Lucy's college days.

Under Miss Slowe's leadership, three additional types of events emerged: visits to local sites of interest, athletics, and the Cadet Corps. *The Junior High School Review* regularly reported on the trips to Washington locations of local and national importance, among them the Filtration Plant, the Library of Congress, the Corcoran Gallery of Art, and the Weather Bureau. Louise Jefferson, then a junior high school pupil, who later became a well-known commercial artist in New York City, wrote, "On Wednesday afternoon, November 24, more than one hundred pupils of the M Street Junior High School, accompanied by their teachers visited the Filtration Plant at McMillan Park Reservoir. . . . The excursion was under the supervision of Mr. Logan, of the Science Department, who gave a scientific exposition of the structure and use of the plant." There followed a detailed description of the filtration process. She ended the article with, "On leaving the filters, we went to the pump-house to see the large hydraulic engines which pump the water."[105]

There are several reasons why these pupils became so proud of their accomplishments. Frank W. Ballou, then Superintendent of the District of Columbia Public Schools, W. L. Houtson, member of the Board of Education, and Dwight O.W. Holmes expressed warm praise for the copies of the Thanksgiving issue of *The Junior High School Review*. The superintendent commended the editor and his staff for the artistic appearance of the paper and for the good things it contained. Houston expressed appreciation for the kind of work that was being done, and Holmes complimented them on the excellent quality of the school from which it had come.[106]

Name Change to Shaw

Then, in 1921, following two years of being known as the M Street Junior High School, this fledging unit gained a more formal name—Shaw Junior

High School in honor of the lionized Robert Gould Shaw. The story of Shaw's heroism in the Civil War as well as his regard for African Americans fit perfectly with the views Slowe endeavored to impart to her pupils. Shaw had led the first regiment of African-American troops organized in a Northern state, the 54th Regiment. The son of a prominent white Boston abolitionist family, he was tapped by Massachusetts Governor John Andrew for what was a most unusual assignment.[107]

All the previous eleven colored regiments had been raised principally from *freed slaves* in occupied areas. Shaw went about the organization of his command, recruiting *free African Americans* from all over New England and some from beyond. The regiment was mustered into service on May 13, 1863, with Shaw as its colonel, and was sent to the South Carolina coast to take part in the operations against the cradle of secession, Charleston.

> On July 18, 1863, he led the 54th, in conjunction with two brigades of white troops, in an assault on Confederate Battery Wagner. In the unsuccessful charge, the black troops proved themselves to be fully capable of standing up to enemy fire but lost about one quarter of their men, including Colonel Shaw. The rebels in the battery were so outraged by the Union commanders arming blacks that they decided to insult the white officer by burying him in a common grave with his black enlisted men. But Shaw's parents, when they heard of it, were pleased and believed that was the way their son would have wanted it.[108]

With this kind of gallantry and belief in the ability of African Americans, Miss Slowe might have exerted considerable influence in the selection of "Shaw" for the new name of her school.

Under their new name, Slowe's pupils took part in athletics. Their exploits in track meets were particularly noteworthy. The school year 1921–1922 was a banner year; witness an article about Shaw's Track Team.[109]

> Shaw Junior High School track team has made a grand showing this year, first on the Howard campus, Saturday, May 13; then at Hampton the following day.
> And finally, the great victory was won on May 25, at Howard campus. The events were as follows: 100-yard dash, won by Roland Richardson; running high jump; William Henderson third; running broad jump; Henderson, second; the 220 yard dash, won by Roland Richardson.
> The second 220-yards were won by Henry Goodwin. Frederick W. Williams, second; and Brown, third. In the 100-yard dash, Junior got first, second and third places.

> But the greatest thing of the meet was the relay race in which Junior's relay team won by a long distance.

Shaw girls also participated in several sports, including schlagball, (German for "hit the ball") a game that originated in Germany. It called for "a 'bowler' to throw a ball to a 'striker,' who hit it with a club and then tried to run around a circuit of bases without getting hit with the ball by a defender."[110] They played in the annual schlagball championship, winning second place in 1922.[111] Twelve girls formed a tennis club; as a lover of tennis, Lucy Slowe must have been absolutely delighted with this development.

The High School Cadet Competition was a memorable occasion. Shaw fielded companies in 1921 and 1922. Prior to the 1922 competition, Miss Slowe wrote:

> We, Principal, Faculty and Students of the Robert Gould Shaw Junior High School, expect our boys to do their best. If they win the drill we shall be happy; if they do not win, we shall be satisfied in knowing that only a better company defeated them. No man should feel bad when he is beaten by his superior. If he has done his best, has used his talents to their full capacity, he has no cause to feel any regret if some one with more capacity defeats him. So we at the Junior High School expect our boys to live up to their determination to drill to the best of their ability, whether they win or whether they lose. We shall be happy, indeed, if our boys are adjudged the best company in the regiment; but we shall be among the first to congratulate any other company that beats us for this signal honor. May the best company win![112]

Indeed, Miss Slowe had learned the rules of sportsmanship well, and she was making sure her pupils learned them also.

By way of the "Principal's Page," *The Junior High School Review* provided Miss Slowe with a vehicle for sharing her ideals and philosophy with her pupils. Knowing that they were very young—possibly between twelve and fourteen—she adopted a style that would appeal to them. Of course, faculty, parents and members of the community were reading the paper as well and absorbing the Slowe principles. In June, 1921, she wrote:

> On Work Well Done
>
> Can you at the end of this eventful year say, "I have done my work well?" Can you say "I have been faithful to my duty each day of this year?" Have you that keen satisfaction which comes

only in knowing that you have done your best? Have you that joy which comes to those who through striving hard achieve definite results? If you can answer "yes" to these questions, then you have found the secret of real happiness; for true happiness and real success come only with doing your duty; with being faithful to the task in hand; with working hard to accomplish a bit more each passing year.[113]

In the Fall of the next school year, she penned an article on one of her favorite subjects:

Have You a Hobby?

How many leisure hours do you have in the course of the day? If you stop to count them, you will find that you have many free hours at your disposal. What use do you make of these hours? Do you stand around on the corner of the street looking aimlessly up and down the thoroughfare? Do you sit in neighbors' houses indulging in "small talk"? Do you gaze in a half-dazed fashion out of your window, having absolutely nothing to do? If you have been spending your free hours in any one of the above mentioned ways, you have been wasting valuable time. It is possible to spend your leisure in such a way as to get rest from toil and profitable recreation at the same time.

There must be some one thing that you like to do more than any other thing. You, most likely, have a hobby. If, per chance, you have not, cultivate one.

If you like flowers, make a hobby of growing them. Learn all you can about them. . . .

If you like birds, tramp in the woods, observe them closely. . . .

If you like games, choose one wholesome sport, and become the very best player that you can. . . .

If you must spend your working hours indoors, choose a hobby which will take you into the open. Get acquainted with the great outdoors. If you make the sky, the water, the earth your hobbies, you will become big in mind, strong in body, and an altogether better man or woman.[114]

For sure, thoughts the principal expressed in this article had been developing over a long period. Many who enjoy athletics do so for its own sake. It becomes a way to use leisure time constructively.

Just before the Christmas holidays in 1921, she composed

The Real Christmas Spirit

> As the Christmas season approaches, are you thinking of the real meaning of Christmas or are you thinking of the unimportant manifestations of the Christmas season? Have you thought of the true significance of the practice of giving? Do you know that kindness of feeling should be back of every gift you make? Do you know that kindness is the most valuable gift that you can make? The poorest boy or girl may be the richest, strange as this may sound, if he or she has the real Christmas spirit—the spirit of giving of oneself that someone else may be made happy. You need no money at all to possess the real Christmas spirit, you need only to be rich in kindness, rich in sympathy, rich in service to those whose lives touch yours. . . .[115]

It would not be an overstatement to suggest that reverence for Christmas derived from Lucy Slowe's growth and development in a Christian household. Until she became an adult, the little girl who said she would never see the inside of a church did not realize how impressionable she had been. Perhaps those years in Aunt Martha's home led her also to begin singing in a church choir in Baltimore. Thus, she brought those ideals to the education of junior high school pupils. They reverberate in her article that follows, titled "On the Formation of Right Habits," that she penned in April the following year.

> Do you know a person in your neighborhood who is successful in his work, who is respected and well spoken of by all who know him? What traits of character have brought him success and the esteem of his fellows? Has this person the reputation for being late in getting to his work, in staying away when he does not feel like going to it, or for doing it in a careless half-hearted way? If were known to be a man who was frequently late, who was irregular in attendance, who did not do his work well, would he be respected by his fellows? You know too well that he would not be.
>
> Now examine yourself. What sort of reputation have you among your classmates and teachers? Can they respect you? Are you punctual and regular in your attendance and faithful in the work which you have to do each day? If you are not commanding the respect of your associates now . . . the chances are that you will not stand out as one of the successful and respected citizens of your community when you grow into manhood or

womanhood. You are determining now your success or failure in life by the kind of habits that you form. Which shall it be—Success or Failure?[116]

Miss Slowe completed three years as principal of Shaw Junior High School in June 1922, and that same year Shaw graduated the first class that had joined her as principal. Under the title "Three Years," she wrote:

> Three years ago, a group of six teachers and forty pupils began building the Robert Gould Shaw Junior High School. Since that time, the builders have increased from six to twenty and from forty to four hundred, respectively. Teachers and pupils determined that the school should be built on rock, not upon sand; so they chose "TRUTH" as the cornerstone upon which to build "CHARACTER" the completed structure. Just how high this structure has risen, and just how strong it has become, depend upon the growth toward knowledge and worth which the boys and girls who have attended the school have attained. If those of you who have worked under the supervision of the teachers for these three years have shown no improvement in work and worth, we have builded (sic) poorly; if, on the other hand, you are more earnest in purpose, more dependable in word and act, more refined in behavior, more useful in your several communities—then we have builded (sic) well.
>
> You boys and girls are our building material, and our building is strong or weak as you are strong or weak. These three years have made their impression on you, and you, in turn, on those with whom you have come in contact. Has the impression been good or bad?
>
> As you go forth from the halls of this building, go forth with the determination that, as far as you are concerned, the Robert Gould Shaw Junior High School shall be built of enduring material, and (sic) everlasting monument to "TRUTH"—the foundation of strong "CHARACTER."[117]

Unquestionably, the school, under Slowe's direction, did not simply follow vocational studies; it prepared pupils for college and professional schools. Furthermore, according to editorials in the school newspaper, she was holding dear to homespun virtues—to inspire the youngsters to be trustworthy, strong, and brave, yet humble in character. One of Slowe's close friends said that Frank W. Ballou, who was superintendent of schools, "gave Miss Slowe a hard time." Her idealism came into conflict with the conditions of that day and situations she encountered as she attempted to move toward the realization of the goals she set for herself and the school.[118] This could

have been one of her first experiences with sexism in the workplace. Was she being given a "hard time" because she was a woman? Was it because she was teaching African-American children to reach for the heights?

In a series on "Marylanders Who Have Made Their Mark," *The Afro-American*, in 1921, carried a sketch of Lucy Slowe, the only woman included in the series.

> Miss Lucy Slowe, principal of the M Street Junior High School in Washington tells students to have a goal and then work toward it. Going to school is much like a football game. The occupation, business or profession which you want to follow when you become a man or woman is your goal. You must have before you at all times, just what you wish your goal to be and you must make every effort to reach that goal.
>
> Ask yourself—What will you choose as your goal? Then, let nothing stand in your way of reaching it.
>
> Any goal that you choose can be aided by punctuality and regular attendance at school and by careful preparation of every piece of work assigned by your teacher.
>
> What is your goal? Are you spending every effort toward reaching it?[119]

In 1921, she accepted yet another leadership position. She was elected president of the Columbian Educational Association of the District of Columbia, an organization of more than 500 teachers.[120] While she was principal of Shaw Junior High School, she held that office from 1922 to 1923.[121]

Community Alumni

As Lucy became acclimated to her new role as teacher and later principal in Washington, DC, she joined the Howard University Alumni Association. She was so devoted to her *alma mater* that she played a prominent role in publicizing one of the University's anniversaries that would occur in 1917. Because the year 1917 marked the first fifty years of Howard University's existence, it was appropriate for the institution to observe it with a special celebration. Called the Semi-Centennial, it was to be a spectacular occasion. The Board of Trustees accepted the Washington, DC Alumni Association's offer to publicize the events among their fellow alumni throughout the nation. This Association formed a committee of twelve that included as chair Robert A. Pelham, an outstanding newspaper publisher, Shelby J. Davidson, a celebrated inventor, who chaired the General Alumni Committee, and Lucy

66 Faithful to the Task at Hand

Slowe, the only woman member.[122] The *Washington Post* reported that plans for the celebration would be discussed at a "get together and rally" at Andrew Rankin Memorial Chapel on Thursday, January 24, 1917. Thus, despite her important and demanding responsibilities in the public schools, she found time to take part in alumni activities and, in this case, to disseminate word about the University's commemoration among "Howardites" near and far.

> Extended over three days—March 1, 2, and 3—the observance took the form of a sociological conference with the theme "The Significance of the Fifty Years of the History of Howard University, and the Advancement of the Colored Race with which it is Connected." Educators, college presidents, and sociologists—including Roscoe Conkling Bruce, Benjamin Brawley and Kelly Miller—made up the group of distinguished and thought-provoking speakers.[123] Mary White Ovington, the prominent, white "liberal New York social worker and strong supporter of the NAACP . . ." was a closing speaker of this particular conference, and W. E. B. Du Bois closed out later events in June.[124, 125] The Conference produced a major finding—that African Americans needed a "race leader," and that cooperation with members of other races was essential.

The Semi-Centennial managed to inspire alumni to pledge the sum of $10,000 for the Alumni Gymnasium, while Shelby J. Davidson urged the University to spread the word about the conference. He wanted alumni everywhere to be just as inspired as were those in attendance. Newspapers reported that alumni "filled the pulpits" as they broadcast their message in sermons in the African-American churches.[126] For Lucy Slowe, this had been an opportunity to deepen her relationships with fellow alumni and to interact with celebrated supporters of the University but, perhaps more importantly, to champion Howard University and to deepen her resolve to become *one of*—if not *the*—race leader.

The War Effort

On the heels of the Centennial—April, 1917—the United States formally declared war, first on Germany and then on Austria-Hungary, plunging the nation into World War I.[127, 128] The entire country was mobilized behind the war effort. African-American men enlisted in throngs, yet the indignities of discrimination and segregation accompanied their efforts at patriotism, so much so that riots involving the soldiers and white citizens took place in cities where soldiers were encamped, creating severe morale problems. The

widely publicized Houston riot—which one of Lucy Slowe's organizations was later to protest—took place on the night of August 23, 1917.[129] The Houston incident was emblematic of the worsening racial conditions in the United States. As individuals and groups, African-American women from all over the country fought against the racial conditions that were deteriorating under President Wilson. Their petitions on two occasions to the President were to no avail. In fact, on their second visit to his office, they were asked to leave. "Women circulated petitions, lobbied sympathetic congressmen, issued protests in the press, held public meetings with white leaders, and used the court system to stop regressive federal, state and local legislation."[130]

Simultaneously, thousands of African-Americans had migrated from the South to large Northern cities, thus giving them opportunities for industrial employment that they had not enjoyed before.[131] On the home front, then, African-American men and women showed their support for the war effort by working in factories producing supplies and equipment for the soldiers and producing and conserving food. To serve African-American soldiers, African-American women took part in services similar to the Red Cross and set up hostess house programs akin to those of the YWCA. They created ". . . employment services, training bureaus, and social, educational, and recreational services to serve the communities."[132]

African-American "teachers encouraged student contributions [to fund-raising campaigns] as evidence of patriotism . . . ," and African-American "schools participated in war savings stamp programs."[133] Although it is not known which of these activities captured Lucy Slowe's attention, it is not unreasonable to believe that she did take an active part in such a wide range of activities not only to support the war effort, but also to expose racial injustices. By this time, Lucy Slowe had become active in the College Alumnae Club (CAC) where one of the strong leaders in the war effort was Mary Church Terrell.

The College Alumnae Club

During the period when Lucy Slowe was introducing the junior high school to African Americans in Washington, DC, and participating in the Howard University Alumni Association, she accepted an invitation to join the prestigious College Alumnae Club (CAC) of Washington, DC. Almost immediately, the members noticed her leadership qualities and, in 1919, elected her to be president, an office she held for two years.

CAC consisted of college-educated African-American women who, because of their color, were barred from joining comparable organizations. This group united ". . . to stimulate among high school girls the desire for a college education. Other objectives were to promote . . . a closer personal

and intellectual fellowship, to stimulate one another to high professional attainments, and to exert an influence in various movements for the civic good."[134] CAC was a force in the growing response of African-American women to the ". . . increasingly complicated social welfare demands on community resources, a reaction to the growing racism of the late Nineteenth Century, a need to build a national reform network, and a mission to demonstrate the abilities of Black Women."[135]

The white counterpart of this group was the Association of Collegiate Alumnae (ACA). To be precise, African-American women graduates of predominantly white institutions, such as Oberlin, Brown, and Smith, could join ACA.[136] In this racially prejudiced society, however, most African-American college graduates were barred from joining because their degrees were from African-American institutions, not the Oberlins, Browns, and Smiths of the world. Accordingly, these minority women formed their own organization—CAC.

The women who started CAC were distinguished in their own right. The first president had been Mary Church Terrell, and she was still active when Lucy Slowe joined. Actually, CAC's first meeting had been held at her home in Washington, DC, on March 11, 1910. It is vital to know who she was. A highly respected activist in the African-American community, she was also a charter member and first president of the National Association of Colored Women, a group that had organized in the late 1800s to improve conditions in the African-American community. She became nationally known both for her support of women's suffrage and for her opposition to racial segregation. In addition, she was one of the founders of the National Association for the Advancement of Colored People.

During World War I, Terrell, like many African-American women, had been active in support of the soldiers and women in general. She had helped found the "Women Wage Earners Association in Washington, DC, to organize and protect women workers through improved wages, working conditions, and adequate housing."[137] Furthermore, she helped organize the War Camp Community Service that, following the Armistice of November 11, 1918, had established centers to provide services and recreation for the returning soldiers.

Mary Church Terrell's husband was Robert Heberton Terrell, whom Woodrow Wilson had appointed judge of the Municipal Court of the District of Columbia,[138] a position that elevated him and his wife in the eyes of African-American Washingtonians.[139] Listed among the outstanding graduates of Howard University, Judge and Mrs. Terrell were part of the cadre of noted African-American activists in the intellectual, cultural, and social life of Washington.[140]

Mrs. Terrell was not the only distinguished CAC sponsor. CAC's sponsors and members represented the elite of Washington's African-

American community. They came from privileged homes and—like Terrell—were regarded as the African-American *crème de la crème*. They were members of the African-American aristocracy, highly educated or married to men who held prestigious positions or both. That many of them were teachers—but unmarried—reflects an expectation—at least in urban areas—for many women educators and "most formally educated women at the time" to believe "that they had a special responsibility to their respective communities which they alone could fulfill."[141] "No longer merely mothers in the home, but now 'mothers of the world,' black and white women were thought to have brought to the public domain the domestic instincts and virtues traditionally deemed so important to the home."[142] The roster also included people like the novelist Jessica R. Fauset, and Ida Gibbs Hunt, who attended the Pan Africa Conference in Paris in 1919 to assist W. E. B. Du Bois.[143] Hunt also attended the International Congress of Women in Zurich to inform women of the world about racism in the United States.[144] In addition, Anna Julia Cooper—who had articulated—in her book, *A Voice from the South*, African-American feminist thought as early as 1892, Mrs. Sterling Brown—wife of a Howard University faculty member, Mrs. Ethel H. Just—also wife of a Howard University faculty member—and Miss Lula V. Childers—Howard University faculty member—were members during CAC's first year.[145]

The women who were listed as sponsors suggests that, by the time Lucy Slowe was invited to join CAC, education and personal refinement helped to determine her place on the social scale. Presumably she had "arrived" and was being regarded as a member of "real society." What a powerful network she had joined! To be sure, Washington, DC, prior to World War I, was considered the "Mecca of the colored aristocracy."[146] This privileged class had grown following Emancipation out of "the ranks of free people of color and privileged slaves and . . . (constituted) a mulatto elite . . . that had moved in disproportionate numbers into positions of leadership."[147] In the early twentieth century, this aristocracy was characterized also by the extraordinary emphasis its members placed on education and culture.[148] "Mary Church Terrell, whose husband was an honor graduate of Harvard, was certain that the next best thing to being married to the president of the United States was being the wife of a Harvard man."[149] Although John Quincy Adams had defined "aristocracy" as "The rich, the beautiful and well born,"[150] the wealth represented by this group was not great as compared to whites; they were primarily "working aristocrats."[151]

After Lucy Slowe was elected president of CAC, its ". . . sphere of influence extended beyond Washington for the college women of Baltimore joined with the Washington College Alumnae Club during her presidency."[152] No doubt Lucy Slowe still had close ties to Baltimore.

By 1922, Mrs. Lucy Messer Holmes (called "Lu"), Dwight O. W. Holmes' wife, had followed Lucy Slowe as CAC's president. This creates

another connection that had been started in Baltimore between the Holmes family and Slowe.[153] Dwight Holmes had been appointed to a professorship at Howard University in 1919,[154] and thus he and his wife had moved to Washington. Another connection is palpable in the fact that a Mrs. E. P. Messer held the position of housekeeper at Miner Hall from 1903 to 1910. She was probably Lucy Messer Holmes' mother, which suggests she knew Slowe while she lived in Miner Hall! The position of matron of Miner Hall, the female dormitory, had become an administrative position starting in 1870.

Because Mary Cromwell, a CAC member, had proposed that a federation of college women be formed, Lucy Messer Holmes wrote to Cromwell on January 12, 1922, requesting that she meet with a group of CAC members to hear about this federation idea. Mrs. Holmes wrote "It is my belief that the Club will wish under your guidance to make your dream a reality."[155] Miss Cromwell replied in 1923.

> Then, while we were thinking about giving up the Club, Miss Slowe, a new president, with determination, vision and purpose, brought the Club to know it had a mission, a *raison d'être*, a goal toward which we could strive. . . . With the guidance of Miss Slowe and Mrs. Holmes as President, during the past four years, we realized that the Club, too, had arrived. With this realization has come a deep responsibility. Inspired by the work of the American Association of University Women, we feel that we can render like service for Negroes. While almost all of us have qualifications which will permit us to be members of the American Association of University Women—a few availing ourselves of this opportunity—we deem it a pleasure and also a duty to organize an association composed of Negro women.[156]

It is fortuitous that Cromwell cited the American Association of University Women (AAUW). That organization—of which Slowe was a member[157]—had pioneered the movement for equity for women in education. As it might figure into later developments, it is significant to note here that AAUW had originated in the Association of College Alumnae (ACA) that subsequently merged with the Southern Association of College Women to become AAUW in 1921, and that its method of creating powerful committees that performed college surveys focusing on the education of women students would become a model for CAC.[158] Interestingly, it was as a result of an ACA survey that the University of Chicago had been prompted to appoint a dean of women. "Writing on behalf of the Association of Collegiate Alumnae's accreditation committee in 1913, the University of Chicago's dean of women, Marion Talbot, recommended that coeducational

colleges give the dean of women both regular faculty rank above that of instructor as well as the opportunity to teach."[159] One of the organization's surveys of institutions two years prior to Talbot's recommendation found that forty-four had deans of women who also held nominal faculty positions.[160]

> Gradually, CAC's membership grew. Its membership roster carried more than 100 names representing Atlanta University, Boston University, Columbia University, Cornell University, Dickinson College, Fisk University, Howard University, Stanford University, New York State University, Oberlin College, The Ohio State University, Radcliffe College, Smith College, The Sorbonne, The University of Chicago, The University of Kansas, The University of Michigan, The University of Pennsylvania, The University of Vermont and Wellesley College.[161]

The roster of CAC members serves to verify African Americans' decades-long determination to be educated. It comes as no surprise, then, that they would address the educational, racial and economic ills of America.

CAC's activities varied from efforts to organize Parent-Teacher groups in the high schools to participation in the fight for women's suffrage; from the establishment of stamp centers for the war effort to the contribution of $110 and periodic entertainment to a social settlement; from a study of parliamentary procedure to sending a letter to President Wilson asking for clemency for the Houston Soldiers.

The Club's letter to the President of the United States referred to actions taken by the government following the Houston race riot. In 1917,

> ... the men of the Twenty-fourth Infantry became involved in a riot with the white civilians of Houston, Texas. After much goading and many insults by the white citizens, the black soldiers were disarmed when it was feared that they would use their weapons in defending themselves. Refusing to be outdone, the soldiers seized arms and killed seventeen whites. With only a slight pretense of a trial, thirteen Negro soldiers were hanged for murder and mutiny, forty-one were imprisoned for life, and forty others were held pending further investigation.[162]

CAC might have suspected that their letter would be dismissed, but they could do nothing less than register their protest.[163] The Houston riot was not an isolated incident. Riots involving African Americans and whites occurred on a regular basis as white hostility toward African Americans persisted.

CAC's deep involvement in protesting racial injustices began to stiffen Lucy Slowe's intense interests in the betterment of race relations and the

advancement of women. It invoked her tremendous organizational and leadership skills, both of which had been growing and developing even as she moved through and out of college and into the professional life of an educator. And it created a powerful network of strong, like-minded associates. Later Slowe would serve as Chairman of CAC's 1925–26 Constitution Committee, Chairman of the 1929–30 Inter-Racial Relations Committee, and hostess at the Annual Reception to New Members on November 18, 1933.

Match Point

Although on the one hand Lucy Slowe was doing a remarkable job as a teacher in Baltimore, rendering outstanding service in the Washington, DC public school system, and serving as a community activist in both cities, on the other hand she took time to play tennis. She did not just *play* tennis; she excelled at it. When she was an undergraduate at Howard, she joined the Women's Tennis Club, only to see her interest blossom over the years. She even encouraged the girls at Shaw Junior High School to play. Her family used one word to describe her interest in tennis: "insatiable." A fellow tennis player, who was a graduate of the Howard University School of Dentistry, laughingly told Marion Wright when he remembered Lucy: "She may have been Lucy *Slowe*, but on the tennis court she was Lucy *Fast*."[164]

Lucy Slowe won seventeen cups in tennis,[165] playing in tournaments under the aegis of the American Tennis Association (ATA). Because all forms of association in American life—even sports—were racially segregated, it was necessary for African Americans who wanted to compete in tennis—and in any other sport, for that matter—to create their own organization, another sign of the parallel universe. The ATA, then, was formed in 1916 and is reputed to be the oldest African-American sports organization in the United States.[166] It was organized at a meeting held at the YMCA in Washington, DC. Prior to its formation,

> . . . it had been the custom for [African-American] players from Baltimore, Washington, New York, Pennsylvania and the New England States to participate in invitational interstate tournaments. The first of these tournaments was held in 1898 in Philadelphia under the auspices of the Chautauqua Tennis Club. [But, then the U.S. Lawn Tennis Association issued a policy statement formally barring African-American tennis players from its competitions.][167] In 1916, the matches were played in New York City, with the ideal Tennis Club and the Turf Tennis Club acting as host, on courts located on West 138th Street. . . . [In

the face of these discriminatory policies,] the Association Tennis Club of Washington, DC and the Monumental Tennis Club of Baltimore, MD formed a temporary organization with Mr. D. O. W. Holmes as Chairman. . . . On November 1, 1916 a letter was sent to all of the Negro Tennis Clubs known to be functioning throughout the United States, inviting them to send representatives to a meeting to be held in Washington, DC on November 30, 1916. It was at this meeting that the plan for permanent organization was approved.[168]

Here again Dwight O. W. Holmes—a year after Lucy Slowe moved to Washington—played a major role in one of the most significant events in her life, this time starting an organization that would enable her to achieve a firm footing in a sport she dearly loved.

In August 1917, the first National Championship Tournament was held at Druid Hill Park in Baltimore, MD, with Monumental Tennis Club acting as host. There were only three events: Men's Singles, won by Talley Holmes; Women's Singles, won by Miss Lucy Slowe; and Men's Doubles, won by Talley Holmes and Sylvester Smith.[169]

Talley Robert Holmes, like Lucy Slowe, was a college graduate. He earned a degree in mathematics from Dartmouth College in 1910 and ". . . served as an interpreter and intelligence officer in World War I. Upon returning to Washington, DC, he taught German, French, Latin, and mathematics in the District school system."[170] He would go on to study law at Howard University and earn a degree in 1924. He would also become Lucy Slowe's fellow Washingtonian as the owner of the Whitelaw Hotel, the largest hotel available to African Americans in Washington at the time.

The Afro-American had announced in its September 16, 1916, edition that the annual open-to-all National Tennis Tournament would be held in Baltimore, Maryland. The venue would be the Druid Hill Park Courts.[171] The paper pointed out that it was not unlikely that the national singles champion, Talley Holmes of Washington, DC, as well as the national mixed doubles champions, Miss Lucy D. Slowe and Dr. John Wilkerson, would be seen there in action for the first time that session.[172] How did Lucy Slowe dress for her favorite game? What did she look like? One report holds that women tennis players were "[w]earing ankle-length skirts, long-sleeved high-neck blouses, and leather tennis shoes."[173] Not Lucy Slowe, as one picture shows. Her photo (see image 10) shows that she did wear an ankle-length skirt, but no high-neck blouse.

In 1917, *The Afro* reported that, although Miss Slowe had been the victor for the second consecutive year, the champion's laurels were not easily won. She was compelled to play her best to defeat her strong opponents.[174] Since she liked a "good game," the strong competition was undoubtedly satisfying. A later news item stated that she won five cups that season and the championship cup of New York for two successive seasons.[175]

In October, 1917, *The Crisis*—the NAACP publication edited by Du Bois—reported the same information, adding "Her triumphs include the ladies singles cup in Philadelphia and New York, the ladies double [sic] cup with Miss Florence Brooks of Philadelphia in that city, and the mixed doubles cup with Talley Holmes in Philadelphia and New York."[176]

As one who could balance competing demands—a "multi-tasker"—she accomplished this feat the same year she joined an all-male committee of Howard alumni to organize the Howard University Semi-Centennial celebration. Moreover, she seemed not to be concerned about cultural debates about women athletes. On the one hand they were celebrated as the quintessential modern women and on the other as a disgusting deviation from proper femininity. And questions were being raised about whether men were naturally or physiologically women's superior.

Simultaneously, America was becoming awestruck by the "modern athletic girl." *Lippincott's Monthly,* in 1911, glowingly described the modern athletic woman: "She loves to walk, to row, to ride, to motor, to jump and run . . . as Man walks, jumps, rows, rides, motors, and runs." Some doubted that the resemblance was a change for the better. In 1912, the *Ladies' Home Journal* published a piece whose title—"Are Athletics Making Girls Masculine?"—signaled alarm at the very possibility. The article posed the question in its starkest terms: Would female athleticism turn women into masculine facsimiles of the opposite sex? On the other hand, might women "feminize" sport, eroding the boundary between male and female realms? When women competed seriously as athletes, they threatened men's exclusive claim to "masculine" qualities of physical aggression, strength, speed, and power. Women's participation in sports suggested that physical differences between the sexes might be an artifact of culture rather than a law of nature.[177] A thought such as this suggests Margaret Mead's plea for "a less arbitrary social fabric."[178]

When, in 1917, Lucy Diggs Slowe won the singles title at the first American Tennis Association (ATA) national tournament, she became the first female African-American national champion in any sport.[179]

The September 13, 1918, edition of *The Afro-American* reported that, when Lucy Slowe won the women's singles at the Baltimore Club's Tournament that year, she teamed with John Wilkerson to win the mixed doubles. Several good teams, it was said, lined up in the mixed doubles, but these two formed a better-balanced team than any of the others."[180] The next

year, Miss Rae of Jamaica, British West Indies, defeated Miss Slowe, who was twice within a point of winning the first set.[181] The following year, Miss Rae again defeated Miss Slowe, while Mr. Dark and Miss Rae defeated Mr. Wilkerson and Miss Slowe.[182] Slowe played hard, becoming the champion for the subsequent two years—1921 and 1922.[183] Although she also enjoyed golfing and hunting, the only indications of her interest in these other sports are found in her personal notes penned in 1919.

In 1924, she hung up her tennis racket for good. There is no record of her return to competition.[184] It can be said, then, that she retired as the women's champion.

Leaving Shaw Junior High School

In June, 1922, Lucy Slowe announced her resignation as Shaw's principal to accept the position of Dean of Women at Howard University. Garnet C. Wilkinson, an African-American and the first Assistant Superintendent of Public Schools of Washington, DC, wrote the Superintendent of Schools on July 5, 1922, "It was at the request of school authorities that Miss Slowe accepted the principalship of the Shaw Junior High School. It is to her credit that that institution achieved so much in the few years of its existence. Miss Slowe brought to it a ripe scholarship and a rare bit of enthusiasm for this new type of organization in our school circles."[185]

Wilkinson's evaluation of Slowe was to be respected. He was a committed educational and civic leader. Born in South Carolina in 1879, he moved to Washington as a child. He attended Birney Elementary School, M Street High School (where he later taught), and Howard University, where he earned a law degree. He served as principal of Armstrong High School and Dunbar High School and, in 1924, became the first Assistant Superintendent in charge of African-American schools. He served in this position for a quarter of a century. Under the organization of the Washington, DC public schools before *Brown vs. Board of Education*, the white superintendent of schools led two separate systems, but Wilkinson, the Assistant Superintendent for Colored Schools, effectively ran that division.[186, 187]

Slowe's impact upon the junior high school students was deeply rooted, witness the fact that in 1936—fourteen years after she left Shaw—one of her former students wrote to her: "I can now appreciate the interest you and Miss Pelham took in me. I am sure that your great kindness was the factor in keeping me in school. You could have easily suspended me from school when I was in Shaw, because I was always getting into something. Thanks again for your kindness."[188] In just a few days, Miss Slowe replied:

It has been a long time since you were that "troublesome boy" in Shaw Junior High School and judging from your career the troublesome boy did not foreshadow the man. Your subsequent career has certainly justified all the interest that Miss Pelham and I took in you and I know that she is just as happy as I am over the fact that you have developed into a very useful man.[189]

Introspection

In 1919, during the time she was excelling in practically everything she touched, Lucy Slowe, in a personal note, raised questions about her perceptions of self. In the note that follows she described what she perceived.

> There are too many of me for me to know each one; and yet I feel each clamoring for a hearing from the depths within me. Which shall I listen to, above all others? One, an abrupt, frank, insistent self telling truth, though truth may not be wise? Or one a vigorous self, following life to the great outdoors, in hunting, golfing, (sic) tennis, hikes and all the like? Or one demure, lonely, loving solitude, the evening stars, the sunset glow? Or one, a mother self; a self which feels life's eternal pulses beat wildly sometimes; mildly ever? All these are me; pray tell me which shall become articulate? Which shall lift its voice above all others? (sic) Which shall be the voice triumphant guiding me on to full expression of that best and noblest self,—that portrait of God divine?[190]

She dedicated this message to "my good friend M. P. B. [Mary P. Burrill] whose sympathetic encouragement induced me to write these lines. I dedicate them with the hope that some day I may show my better self to the world."[191]

The two of them might have met and developed their friendship after Lucy Slowe joined the faculty at Armstrong in 1915. At the time she penned the note—1919—Lucy Slowe and Mary Burrill were good friends who, in 1918, had begun sharing the same address—1758 T Street, Northwest, in Washington, DC.[192] In 1922, Slowe moved to 1744 K Street, Northwest, and in 1923, Burrill joined her at that address.[193]

Like Slowe, Burrill was a teacher of English. She taught at the M Street School that later became Dunbar High School. Considered a great teacher, she taught speech and dramatics in addition to English and was regarded as an outstanding playwright. She became well-known throughout the District of Columbia for directing classical plays and inspiring numerous students. Born in Washington, DC, about 1882, the daughter of John H.

and Clara Burrill, she was a year older than Slowe.[194] She had graduated from the M Street School, earned a diploma at Emerson College of Oratory in 1904, and, in 1929—after she and Slowe moved into their Brookland home—received a Bachelor of Literary Interpretation degree from the same institution.[195]

Foreshadowing her later life, when Slowe wrote the note about her feelings, she seemed to be overwhelmed, even distressed. Was this an honest assessment of her abilities—all of which she excelled in and enjoyed? Was it a need to focus? As Lucy Slowe's career led her to Howard University, she said goodbye to one self and she greeted another. Which self triumphed in her subsequent notable achievements? Did Lucy Slowe's performance as a teacher that produced rave reviews from her pupils and colleagues alike, her ability to convince a community to accept a new educational structure and then make it work, and her uncompromising position on morality set the tone for her administrative style and leadership at Howard University?

Lucy Slowe was now thirty-nine years old, and, in this short span of just under four decades, she had made her mark as a student, a teacher and educational administrator, and a community leader as well as an athlete. It is clear that she had a host of friends, that she was wide awake to events in the District of Columbia, that she was respected, and that she was anxious to give students her all, regardless of the setting.

Her educational, her athletic, and her community prowess provide a hint of her later role at Howard. Her history as a former teacher and administrator would serve her well. It would not be business as usual. She would challenge sexism in the previously private enclave of university administration. She would exemplify a striving spirit, she would argue, she would insist on fair play, she would be courteous. The University's venture with Dean Lucy D. Slowe lasted fifteen years and divides into four phases: the Durkee Years, 1922–1925; the Early Johnson Years, 1926–1929; the Middle Johnson Years, 1930–1932; and the Latter Johnson Years, 1933–1937.

4. Robert Price. Martha Price's husband who worked as a servant in the household of Supt. Francis H. Smith at Virginia Military Institute from the 1840s through the post-Civil War era. The picture is labeled "Old Bob." Smith family history credits Price with gathering valuable personal and VMI papers and family silver and burying them in a gravesite just before the Union forces entered Lexington during "Hunter's Raid" in June 1864. (Source: Virginia Military Institute Archives)

5. Lucy Slowe when she graduated from Baltimore Colored High School in 1904. (Source: Moorland-Spingarn Research Center, Howard University)

6. Dwight O. W. Holmes. Lucy Slowe's mentor, and organizer of the American Tennis Association, a registrar and a dean of the School of Education at Howard University, and President of Morgan State College (now University) 1937–1948. He delivered the eulogy at Lucy Slowe's funeral. (Source: Moorland-Spingarn Research Center, Howard University)

7. Kelly Miller. Howard University professor of Sociology and Dean of the Junior College. 1889–1935, whose recommendation to President Johnson that one of the new dormitories for women be named Lucy Diggs Slowe Hall was rejected. (Source: Moorland-Spingarn Research Center, Howard University)

8. George W. Cook. Howard University professor of English for whom Lucy Slowe worked as a student, Dean of the Commercial Department, Secretary and Business Manager, 1881–1932. (Source: Moorland-Spingarn Research Center, Howard University)

9. Lucy Slowe and her doubles partner in tennis, John F. N. Wilkinson. He worked as an assistant in the Library of Congress Law Library, 1857–1912. (Source: Moorland-Spingarn Research Center, Howard University)

10. Lucy Slowe on tennis court. (Source: Moorland-Spingarn Research Center, Howard University)

11. Lucy Slowe when she entered upon her duties as principal of Shaw Junior High School, the first junior high school for African-American children in Washington, DC. (Source: Moorland-Spingarn Research Center, Howard University)

4

A Call to Alma Mater and the Durkee Years

1922—1926

A Skiff to Sail an Untried Sea

When Dean Slowe assumed her function at Howard University, she was given a skiff to sail an untried sea without chart or compass. She at once entered upon her task with determination to solve this new problem in education.[1]

—Kelly Miller's tribute upon Lucy Slowe's death

In 1922, Lucy Diggs Slowe accepted the offer to become Dean of Women at Howard University.

Background of Appointment

The Howard University Board of Trustees considered appointing a dean of women for more than two years. As early as 1913,[2] women students had petitioned the administration to create such a position. At that time, thirty-three young women requested a "college woman of broad culture, refinement, and executive ability to be called Dean of Women, who shall have

general supervision of the women students of the University and who shall direct them in all womanly activities and foster on them high standards of scholarship and refinement, etc."[3] That the president at that time, Stephen M. Newman, opposed such an appointment could reflect an opposition to women holding deanships. He was on record as opposing employment of married women. Two years earlier, he had received Board approval of his recommendation that ". . . any female teacher who thereafter married while teaching at the University would be considered as having resigned her position."[4] America had a long-standing policy approving of spinster teachers rather than those who married.[5]

Interest in the welfare of women students even preceded the students' petition. There was in 1890, the Ladies Committee—of which George W. Cook was a member—that was charged with responsibility for supervising conduct in Miner Hall. In 1900, after three members resigned, a Board of Lady Managers was appointed by the Board of Trustees "to cooperate with the Matron [Mrs. Kendall] in promoting the best interests of female students and to advise the President [Rankin] . . . on the appointment of a Matron and a Housekeeper."[6] Coralie Cook had been one of the committee members.

In 1909, during President Thirkield's administration, ". . . Miss Marie Hardwick . . . was . . . unanimously elected preceptress . . . at a salary of $550 in cash and $150 for room and board."[7] In general, the term "preceptress"—used to denote a female teacher who might be considered a governess or principal of a school—was not without precedent in higher education.

Finally, at a meeting of the Board on February 7, 1919, the offices of Dean of Men and Dean of Women were authorized. The following June, President J. Stanley Durkee announced the appointment of Edward L. Parks as Dean of Men and Helen Tuck as Acting Dean of Women and Instructor in Physical Education.[8] Tuck served as Acting Dean for three years.[9]

Parks was no stranger. A white minister, he had held a number of positions at the University, including the university chaplaincy to which President Thirkield had appointed him in 1907.[10] The Board appointed Parks—who, within one year, had also become Dean of the College of Liberal Arts—Assistant to the President in 1908 as well as assistant to Treasurer George H. Safford.[11] Prior to coming to Howard, Parks had served as president of Simpson College—a United Methodist college in Des Moines, Iowa—for six years, beginning in 1880. He left there to join the faculty of Gammon School of Theology in Atlanta. His experience prior to Simpson had included teaching at Northwestern University and serving as a pastor in Chicago. Simpson College credits him with eliminating the college's debt, doubling student enrollment, and increasing the faculty.[12] Thus, with his experience in educational administration, Thirkield likely found him to

be a man he could rely on to assist in bringing about the changes he was instituting at Howard.

Another significant action taken by the Board in 1919 was the appointment of Dwight O. W. Holmes, registrar and professor of Education.[13]

The Position of Dean of Women— Historical Perspective

The position of Dean of Women was an anomaly in higher education in the early years of the twentieth century. According to Herdlein,

> The idea of an individual concerned with the health, welfare, and personal development of students goes back to the early 19th century when the first coeducational college was established at Oberlin (Ohio) in 1833. Oberlin was the first institution to establish such a position in the form of a *lady principal*. The position went through various stages until the title of Dean of the Women's Department was created in 1894. The turn of the century brought with it increasing enrollments and the introduction of female students onto many campuses. . . .
>
> It was evident during this early period . . . that an increasing number of presidents recognized the practical need for formal supervision of the extra curriculum as well as the university's responsibility for the physical, social and spiritual development of students. Both local and national pressure was exerted on colleges to make some provisions for the changing nature of the academic enterprise. Holms (1939) mentioned that in a survey sent out in 1911 to 55 institutions, 44 had deans of women or women serving in that capacity. The majority of women had been appointed since 1901. Consequently, there was a general awareness that higher education in this country was experiencing: "a changing and enlarging student body with less interest in intellectual things, a more complex and elaborate social life within the college, less intimate relations between faculty and students, and more problems of so-called discipline." (Mathews, 1915, pp. 6–7)[14]

Continuing to trace the history, Clifford wrote, "In 1874, the Illinois Industrial University (later the University of Illinois) established the preceptress to the female students."[15] What is more, Marion Talbot—at the highly regarded University of Chicago—had ". . . recommended that

coeducational colleges give the dean of women both regular faculty rank above that of instructor and the opportunity to teach."[16]

It would be surprising if Howard University's president and trustees were unaware of this trend. To be sure, thirty-three women students had brought it to their attention with their 1913 petition. Could they have known about the Association of Collegiate Alumnae's 1913 recommendation? On balance, the development of institutions and practices and the regulation of life in general among African Americans seem to have mimicked "the best" of white society.

Invitation to Lucy Slowe

Faced with these actual events, it was January 21, 1922, when Howard's President, J. Stanley Durkee, wrote to Lucy Slowe. As the consummate alumna, she had attended her *alma mater's* commencement exercises in the spring of 1921 and later joined her friends at a dinner in Miner Hall. She had also been a member of the alumni committee to plan the Semi-Centennial of the University in 1917.[17] Durkee wrote:

> The time has come when I may speak with you very frankly regarding the suggestion I made at the little dinner in Miner Hall at commencement time last year. Now I feel I can openly discuss with you the question as to whether you would consider a call to Howard University as Dean of Women.
>
> I should very much like to have a good chat with you before the semi-annual meeting of the Board of Trustees which comes February 7. I am leaving the city to be gone until the 29th of January. On Monday, the 30th or any day during that week, at your convenience, I would certainly like to have a good conference with you over the matter. I am writing, thus, frankly so that you may be considering it from every angle and therefore be in a position to talk with me of all the difficulties, possibilities, etc.[18]

Was this a rare opportunity? Indeed it was. It was not easy for women to land jobs at colleges or universities. In this case, Lucy's friends, such as Dwight O. W. Holmes, who had been appointed University Registrar in 1919, could have prompted Durkee's letter, or it could have been her College Alumnae Club acquaintances. It is not beyond imagination that many of them were instrumental in recommending her to President Durkee and the trustees. In the early years of the twentieth century, about the only way a

woman could be appointed to a faculty position was to exploit institutional and family connections.[19]

Slowe's response dated January 26, 1922, stated, "I am writing to say that I shall be glad to talk with you on Tuesday, January 31 at 11 o'clock in the morning."[20] Presumably, Slowe's plans to keep the January 31 appointment failed to materialize for the worst snow storm—in fact, a blizzard—to hit Washington, DC, occurred on January 28, 1922. Labeled the "Knickerbocker Storm," it incapacitated the entire northeastern United States for days.[21]

In the meantime, Slowe took President Durkee's advice seriously, and she did, for sure, consider his proposal from every angle she could think of, such as salary, faculty rank, and specific responsibilities so that when they did meet, she could raise the appropriate questions. Following the aborted meeting, Durkee responded to Slowe on March 2, 1922.[22]

> I presented your name to my committee at the time of the meeting of the Board of Trustees and after speaking very frankly of your superior qualities for such a position, they did what I would expect them instantly to do—namely, turn to me asking what salary. When I named the conditions you gave to me of $4,000—they said very frankly, even though we want Miss Slowe badly as we do, yet we cannot consider such a salary. The feeling was, as I suggested to you it would be, that we could not for a moment think of going beyond the salary of a dean, even if they granted that much.
>
> I am, therefore, writing you very frankly, Miss Slowe, to express my sorrow that I am not able to secure you for this great work which needs you so much. Still it is due to you for me to say exactly what I have. I recognize your position, just as you laid it to me and I honor your decision.
>
> I know that I can always call on you for advice and counsel and the joy is that always you have the interest and love of Howard in your heart.

President Durkee's remark about salary reflects the fact that securing adequate funds for faculty salaries was not a frivolous concern; it was one of the major issues plaguing the trustees.[23] Repeatedly, they received petitions from the faculty to create a definite salary scale in order to deal with their meager salaries.[24]

In asking for a salary of $4,000, Lucy might have been examining her options in the public school system. To be sure, she was well thought of as principal of Shaw Junior High School, and, at the rate her career was

progressing, she could easily be in line for appointment as a high school principal. While her salary at that time as Shaw's principal is not known, it is known that the average high school principals' salaries and expenses at the time was $4,567.[25] President Durkee's salary in 1923–24 was $4,050, and he was the highest paid officer of the University.[26] Lucy might also have been at a turning point in her life and considering her choices, such as remain in the public school system or move on into higher education, or become a professional athlete that was not lucrative at all. In spite of everything, Howard was her *alma mater* and she loved it dearly. She had strong beliefs about the education of women, about morality, and about achieving racial equality. Wouldn't the deanship at Howard University provide a platform for pursuing her goals? Didn't "Dean of Women" have a nice ring to it?

Because she knew who she was, in her reply to President Durkee on March 9, 1922, she was brusque in her reference to the Board but candid about her interest in the position:

> I, too, am very sorry that your committee did not see things in the light that you did, but you know that frequently people with vision are seriously handicapped in their plans by having to wait for people who are half-blind to improve their power to see.
>
> I am deeply appreciative of the confidence which you have in me and because of it and of my desire to serve these young women, I am almost tempted to make the necessary sacrifice in the cause of real service. There are one or two considerations which hold me back, but I may be able to find my way around them. It might be well for me to talk with you again, if you have not made a final decision in the matter. If you have, it is all right with me.
>
> If I can be of any service to you at any time, do not hesitate to call me.[27]

Imagine what a blow it was to Lucy when she was denied the salary she requested. The very next day, however, she followed up with another letter (dated March 10, 1922)—perhaps reflecting on the brusqueness of her first letter—in which she complimented him on his vision for Howard. In the last sentence she states, "I shall be pleased to talk with you at some time convenient to you."[28]

Although the low salary was below her potential worth as a school principal,—she had probably learned about the low salaries paid Howard professors—it appeared that Lucy Slowe was prepared to work out a compromise. Salary, however, was probably not the only thing she had to think about. She had to think about what the move would cost her emotionally.

She also might have considered where the change in jobs might lead her. By this time, she perhaps had a pretty good sense of who she was.[29] And so she prepared herself to discuss the conditions under which she would come to Howard as Dean of Women. Durkee followed up on May 9, 1922. "I want to see you for another good chat. Would you call up my secretary and arrange an appointment convenient to us both?"[30]

Slowe's Acceptance

Apparently, the conference was successful, for Slowe wrote on May 31, 1922:

> Dear Dr. Durkee:
> I have been going over in my mind the various points brought out in the conference I had with you on May 12th. In order that I may be sure that my understanding is correct, I am setting down the several agreements covered for your verification and endorsement:
> 1. It is agreed that I be appointed to the position of Professor of English in the School of Education with administrative duties of Dean of Women.
> 2. It is agreed that the salary for the two positions shall not be less than $3200.
> 3. It is agreed that I be permitted to name a confidential Clerk whose entire time will be spent in my office.
> 4. It is agreed that the suite of rooms now used by the Acting Dean of Women be placed at my disposal, but that I shall not be required to live on the campus.
> 5. It is agreed that all women in charge of girls in the University shall be directly responsible to me in all matters affecting the girls in their care.
> 6. It is agreed that all policies pertaining to the women in the University shall emanate from my office with the approval of the President.
>
> Under such conditions as these, I shall be happy to work with you in building up a fine morale among the women in the University.[31]

Without question, Lucy Slowe did her homework; she familiarized herself with the conditions under which deans of women were employed at other institutions. But, she also did some soul-searching to familiarize herself with the kind of person she really was. It would not be farfetched to assume

that she reviewed this possibility with confidants in her African-American circles in Washington.

There is no record of a reply from President Durkee. Yet Board minutes show that "Miss Lucy D. Slowe, B.A. (1908), was elected the first Dean of Women (and Associate Professor of English) at the Annual Meeting of the Board on June 6, 1922."[32] Her salary was set at $3,200 and her address listed as 1744 K Street, Northwest, Washington, DC.[33]

Slowe must have assumed that the conditions stipulated were acceptable. Little did she know that several items—faculty rank; her living arrangements; and policies pertaining to women students—would entangle her in major controversies.

Within six months, then, the appointment was made final. Lucy appeared to be comfortable with the arrangements when she wrote the President one month later, on June 15, 1922.

> All of your communications have been received and the contents carefully noted. I am glad to know that the Alumni and friends of the university approved so heartily your judgment in inviting me to take up this important work in Howard. I assure you that I shall exert every effort to build up the proper sort of spirit among the women of Howard.
>
> It will please you to know that the women graduates of Howard living in Washington have already pledged me their support and have indicated their willingness to be of real service to me and to the girls on the Hill.
>
> You will also be pleased to know that several members of the Board of Trustees have expressed their pleasure at my coming to the University, so you can see that you can feel justified in what you have done. I am doubly glad for all these expressions, for they spur me on to my utmost endeavor and justify you in asking for a salary commensurate with my responsibilities. I presume that you had no difficulty getting the full salary of $3500 which you hoped for, since the Board backed you in everything so splendidly. I should like to have a conference with you before you leave the city, also at an early date with Dr. Scott. . . .[34]

The "Dr. Scott" to whom she referred was Emmett J. Scott, who held the position of secretary-treasurer-business manager, to which he had been appointed in 1919. His selection signaled an important change in the central administration of Howard that President Durkee brought about in his very first year. Durkee had begun reorganizing the central administration less than a year after he became president. "The offices of Secretary-Treasurer were combined for the first time since 1898. . . . To this position was added that

of Business Manager. Thus, Scott was a very influential person.[35] Described as fastidious and resourceful[36]—Scott had been at Howard only three years when Lucy Slowe was appointed. He had come to the university following his role as a special assistant to the "U.S. Secretary of War in charge of Negro affairs" at the start of World War I. It was here where Scott became a liaison between African-American soldiers and the War Department.[37] Previously, he had been personal secretary to Booker T. Washington. From that position, in 1912, he was elected secretary of Tuskegee Institute. He became widely recognized as the leader of what was later to be known as the "Tuskegee Machine," the group of people close to Booker T. Washington who wielded influence over the African-American press, churches, and schools in order to promote Washington's views.[38]

Lucy would later write that whenever she changed positions, she did it because she saw "opportunity for financial advancement and for larger service."[39] She received neither the salary nor the faculty rank she sought, but she accepted the position anyway. She was skilled at creating networks and connecting with her friends—Howard alumni and members of the Board. As noted in her letter to Durkee, Lucy quickly shared the good news with women alumnae. Members of the Board, who were, of course, aware of the decision, probably spoke with her on their own volition.

The Announcement

The date was June 16, 1922. The weather was fair with gentle winds and a temperature that barely reached 88 degrees.[40] It was on this day, when the University was holding its Commencement ceremonies, that President Durkee announced to prolonged cheering that Miss Lucy Slowe had accepted the appointment as Dean of Women and associate professor of English at the University.[41]

Washington educators were taken by surprise because Slowe was the beloved principal of the Robert Gould Shaw Junior High School. Quoted in *The Washington Tribune*, Garnet C. Wilkinson, Assistant Superintendent of Washington DC schools, said it well: "The public schools suffer a great loss in Miss Slowe's resignation. However, we are happy because she is well placed."[42]

For Slowe, this occasion on the campus of the University for which she had such high regard was a long way from Lexington, Virginia, where, as an orphan, she had gone to live at Aunt Martha's house. With President Durkee's announcement, Lucy was now moving, at age thirty-nine, into a top administrative position at her Alma Mater—the esteemed Howard University—an institution she knew and revered. It was the University many regarded as the Capstone of Negro Education.[43]

The fact that the crowd cheered—and surely burst into applause—when President Durkee made his announcement speaks volumes about Lucy Slowe. *The Washington Tribune* reported on her rise through the schools of Baltimore, her matriculation at Howard and Columbia University, and her popularity as a Washington educator. In addition to Garnet C. Wilkinson's expression of regret and as a testimonial to her fine service, the Columbia Extension Centre presented her with a gold locket and chain.[44] Lucy Slowe was surely that "college woman of broad culture, refinement, and executive ability" for whom the women students had petitioned. Lucy Slowe had been tested in the crucible of Howard University as an undergraduate and in the city of Baltimore as a teacher. Her former students loved her. Her associates in the College Alumnae Club admired her leadership ability, and the Howard alumni in Washington regarded her as a true daughter of Howard. Members of the boards of education of both Baltimore and Washington had commended her as an educator. The trustees held her in high regard. So, why not cheer! Howard was getting what it wanted and what it sorely needed.

The Man Durkee

Who was this man Durkee? James Stanley Durkee served as President of Howard University for eight years, beginning in 1918. His credentials were impressive.[45] Born in Carleton, Nova Scotia, in 1866, he received his AB degree in 1897 from Bates College in Maine. After serving as a Baptist preacher from 1898 to 1909, he was called to the pastorate of the South Congregational Church in Boston. He continued his academic studies while preaching. In 1905, Bates College conferred upon him the MA degree, and, in 1906, he earned the PhD at Boston University. It was during his fourth year at Howard that he asked Lucy Slowe to join his administration. According to Dyson:[46]

> Durkee devoted his energy while President of the University to centralizing the authority of the University in the President's Office. To that end, a university registrar was appointed, the Office of Secretary and the Office of Treasurer were united and a new officer, called secretary-treasurer was elevated to a university official in control of finances of the professional schools as well as of the academic departments; the authority of the dean of men and that of the dean of women was broadened; an alumni secretary was appointed; the university council was organized, composed of representatives from all departments of the University, both professional and academic. All of these

administrative officers and councils were directly responsible to the President. Before Durkee's administration, the professional schools were practically autonomous.

A more recent history of Howard refers to Durkee as "The Compromiser." Logan wrote in 1967 that

> The term *compromiser* is one of those words which may have diametrically opposed meanings. A compromiser achieves what is possible to obtain, or he yields to expediency and thereby makes more difficult the attainment of desirable goals. President J. Stanley Durkee was a compromiser in both meanings of the word. He had the misfortune to be President of Howard University during one of the frightening periods of American history, of 1919. . . . On the other hand, his administration coincided with an exhilarating era—the emergence of "The New Negro." The negative aspects of his compromising were more evident in the former case than were the positive aspects in the latter.[47]
>
> With the exception of Presidents Johnson and Nabrit [who followed him], Durkee was in many respects the most dynamic President in the history of the University. This conclusion is based upon the number of his significant proposals which were adopted. . . . For the first time sabbatical leaves were approved. . . . The Board at the same meeting voted that as soon as practical graduate work leading to the A.M. degree would be established, and that a summer school be established as soon as it could be done conveniently. . . . The Board also recommended the criteria for promotion, namely, moral character, spirit of cooperation in university ideals, advanced degrees, scholarly publications and proved efficiency. With slight modifications, Howard University in 1967 still endeavors to use these criteria for merit promotions and increases in salary. . . .
>
> In order further to improve the educational program, the Board finally voted to discontinue the Academy. . . .[48]

Numerous other changes took place during the Durkee years, including modifications in the educational structure in the schools and colleges, reorganization of the central administration, faculty organization, and plant expansion. The authorization for the appointment of the first Dean of Men and the first Dean of Women was another significant change. As the Dean of Women, Lucy Slowe became a member of the committee to arrange for quarterly meetings of the general faculty as well as a member of the Faculty Council whenever discipline cases of women students were on the agenda.[49]

"President Durkee definitely looked upon Howard University as an institution primarily, indeed almost exclusively, for Negro students."[50] Support for this position may be found in the Annual Reports of the President of Howard University to the Secretary of the Interior from 1919 through 1925, in which he was intent upon preparing African Americans to "gain expert knowledge and practice in Commercial and mercantile life."[51] He regarded as equally important the preparation of African-American physicians, teachers,[52] and lawyers.[53]

Still another view of Durkee and Howard University appeared in the statement of one of Durkee's Board members, Rolfe Cobleigh, Managing Editor of *The Congregationalist*, an important publication of the Church.[54] *The Congregationalist* titled its issue of July 27, 1922, "The Education Issue." Appropriately, it contained four articles on the subject. It is not unexpected that a treatise on Howard University would appear in this document, as Congregational ministers in Washington DC, had played a leading role in establishing the University, holding meetings at the First Congregational Church, and securing its charter that had been granted on March 3, 1867, by the United States Congress.

Cobleigh observed that President Durkee came to the institution at a "time of crisis for Howard University." He found the University decentralized by the

> too independent power of deans of various departments, and two secondary schools occupied the campus with college departments. Kindly, tactfully, but firmly, a unified system of administration was developed by President Durkee . . . During the past year, its high standards of scholarship have won its acceptance on the approved list of Colleges and Preparatory Schools of the Middle States and Maryland which is the highest rating.
>
> . . . In recognition of this evidence of progress and the erection of a new Home Economics Dining Hall Building . . . and the high quality of work done in the various departments, the Trustees of the University in June [1922] expressed their commendation and "hearty confidence" in the administration of President Durkee, and their "cordial approval of the energy, sound judgment and administrative efficiency of the President and other administrative officers." Whatever opposition may have arisen, the new policy is fully vindicated, as attested to by the fact that the total enrollment has steadily increased since the secondary departments were discontinued, rising from 1,360 in 1918–19 to 1,954 in 1921–22, and all records were broken at the last commencement when 245 degrees were conferred upon graduates in various departments.[55, 56]

Cobleigh declared that, overall, the more responsible positions at Howard University were "remarkably well filled," and some of the professors had become famous through original research and authorship, including Professors Ernest E. Just in biology and Kelly Miller in sociology. He considered Howard fortunate in having a strong and loyal Board of Trustees.[57, 58]

This, then, was J. Stanley Durkee—the man who brought Lucy Diggs Slowe back to Howard University.

Howard University in 1922

Was the Howard University of 1922 different from the Howard Slowe left fourteen years earlier? Much can be learned from official documents. For example, a report to the federal government regarding appropriations provides information about finances. Howard began receiving federal appropriations in 1879 for both current expenses and capital improvements. They had risen steadily from $63,200 in 1908 to $190,000 in 1922, although there was no appropriation that year for capital expenditures.[59]

The 1921–1922 Catalogue revealed that

> [t]he young women of Miner Hall and Howard Hall are under the charge of a competent preceptress. The authorities of the University advise that all young women whose homes are not in Washington should room in Miner Hall or Howard Hall. They cannot assume responsibility for any young woman who lives in the city and goes back and forth, without proper chaperon, for classes.[60, 61]

While many of the students at Howard were from poor families that could not afford to send them to isolated residential colleges, many did have fairly well-to-do middle class parents. It was learned that $30 would be sufficient to purchase textbooks, but that a girl's wardrobe—unless she wanted to be significantly embarrassed—would cost at least $455. One observer noted that despite the fact that for the most part African-American people were living in straitened circumstances, and that their children had to get jobs to stay in school, it was worth it to send them to Howard because of the full social and athletic life available at the university. Howard, for its part, was a place that did not limit a university education to what took place in the classrooms.[62]

When Lucy Slowe returned to Howard in 1922, she found several new buildings.

> In 1910, a science hall was erected and named Thirkield Hall in honor of the President of the University. . . . In 1910, a Carnegie Library, a gift of Andrew Carnegie, was erected. The next year, the applied science building . . . and a central heating and lighting plant were erected. These buildings were all of red brick and stone, with all modern improvements. Architecturally, they are late American with touches of the colonial.[63]

Just prior to Lucy's taking office, the university dedicated the new dining hall and home economics building. The rest of the campus remained as it was during her college days with Old Main, Clark, Miner, and Spaulding Halls, and Rankin Chapel still in use.

While there might not have been extensive changes in the institution, the world had moved in new directions with an accompanying impact on higher education. Howard did not escape the effects of new movements and was caught up in the transition with new values, new opportunities, and new demands for racial and sexual equality.

Dean of Women Lucy Diggs Slowe

Here she was, back at her university. It had its largest enrollment ever. There was no shortage of student activities, rules and regulations about financial aid, and housing for women students. All of this would come under her purview. She arrived with energy and vitality and fine character. It was the position as *the dean*—as *the dean of women at Howard University*—that gave Lucy Slowe the chance to advocate both for women and for her race as never before. She was the product of the struggle for both racial equality and women's equality. She had witnessed both racial inequality and sexism face-to-face. Now she had a platform. Perhaps this return to *alma mater* had a direct impact upon her motivation to be a spokesperson for equality for women, or perhaps not, but from that point on she appears to have accelerated her energy, to have become more adamant, and to have extended her authority to effect higher education. Her life—as a child, as a college student, as a teacher and administrator, as a community activist—had programmed her for her work. She now becomes Dean Lucy Slowe, with emphasis on the title, "Dean."

Establishing herself was paramount. So, shortly after she was appointed, to give her the standing she needed at the university, the president placed her on solid footing by establishing her authority in a letter to her and one to the deans of the various professional schools, both dated May 2, 1923.

You were called to Howard University as Dean of the Women of the University. I am, therefore, asking that you consider all the women of the University as under your care and guidance.

You have authority naturally to call all the women together, consulting with them in the way you desire and seeking their cooperation in every possible way. I am informing the Deans of the professional schools and enclosing a copy of my letter to them.

In his letter to the deans, he wrote that

Miss Lucy D. Slowe was called to Howard University as Dean of all the women of the University. It is very necessary that someone have helpful contact with every woman in every department of our University life. I am, therefore, asking that you cooperate with the Dean of Women in every way in making it easy for her to call together the women of your school. And I am asking, too, that you see to it that the women recognize her as Dean and respond in the best and most cheerful way possible.[64]

Within her first year, she purchased a house in Brookland,[65] a section of northeast Washington that was extremely desirable for many middle-class African Americans. In response to housing discrimination, they had formed their own enclaves.[66] Her friend Mary Burrill moved into this house at 1256 Kearney Street, Northeast with her. Slowe described the lot as "100 by 140 feet, with six large maple trees on it. . . . [She] planted 50 rose bushes and put in a rock garden with many different kinds of flowers in it. . . . And, [she] made numerous improvements . . . to make it . . . suitable for entertaining students."[67]

Painting a mental picture of Dean Slowe, a former student, Margaret Grooms, who attended Howard for four years beginning in 1926, described Dean Slowe as stylish in dress but also unobtrusive and unassuming. The Dean never left the campus without a hat. "Her clothing was plain but showed an informal elegance of style and quality." Sometimes at dinners, Grooms insisted, they used to sing the "Y" song, which goes:

> They say that Dean Slowe
> She ain't got style
> She's got style all the while
> She's got style all the while
> All the while, all the While.[68]

In contrast to a student's view of Slowe's dress as stylish but unobtrusive, a Cleveland, Ohio reporter for the *The Afro-American* newspaper had

a very different impression. Writing in her weekly column, Thelma Louise Taylor described Slowe's visit to Cleveland in glowing terms. The occasion was a breakfast given by the president of the Cleveland Alumnae Club. Taylor introduced her report by stating that

> Dean Lucy Slowe . . . has completely captured the city of Cleveland. Her combination of brains and charm made her irresistible as well as delightful company. . . . Dean Slowe was most attractive, wearing a black velvet dress with V-line collar of ecru lace—a large ecru flower on the left shoulder, a large black velvet hat with the brim caught back with a gold flower and pulled well down over the eyes, black slippers and gunmetal hose completed the costume.[69]

In photographs, Dean Slowe seemed to be intense and self-confident—stern and poised—as one of her junior high school pupils had described her—very serious, in fact solemn. She wore her hair brushed back in an attractive bun at the neck. Her skirts extended well below her ankles, and her formal photograph showed her wearing a string of pearls. Indeed, she wore her office well. "She walked with a slight stoop and sometimes looked down, quite a bit. I sometimes used to think that she must have known personally every stone and gravel, cement block and blade of grass from one building to the other," wrote Grooms.[70] Daisy Douglas—Class of 1938—remembered seeing Slowe taking long strides when she walked—what she termed "loping"—around the campus.[71]

Yet, not consistent with the fact that several women students had petitioned for a dean of women, some women students resented this newcomer, for her presence implied that their conduct warranted closer supervision. It would require repeated explanations of the functions of this particular type of administrator as a person whose primary concern was the problems and status of college women in order to lessen their suspicions and bring them to accept the Dean of Women as a specialist in the education of women. Certainly this is the way Dean Slowe regarded her new job.

Howard was not the only institution where the office of dean of women was strange. Presidents at some other universities, in an effort to be in step with the times, did appoint women to this new type of position, but they did not give them the authority or power they gave deans of men. As a result, Lucy Slowe, as a member of a comparatively new group of administrative officers, once again filled the role of pioneer. These neophytes were painfully trying to work their way toward a definitive understanding of what was to be their role and function in higher education.[72]

Regardless of any resentment on the part of a few of the women students, she was greeted warmly in an editorial in the November, 1922, issue

of the *Howard University Record*. The *Record*, which had been a monthly publication with joint faculty and student participation for fifteen years,[73] stated that among the many faculty changes, "One of the most pleasing has been that of the appointment of Miss Lucy D. Slowe as Dean of Women. . . . Miss Slowe comes to Howard University full of zest for her work and the influence of her fine character is expected to be felt throughout the University student life."[74]

A reporter on undergraduate student life praised her in the same issue of the *Record* under the title, "The New Howard Woman."

> A new day has dawned for the women of Howard University and through them, for the University itself. For is not the inevitable law, that a good woman is the foundation stone of all civilization. At work in the University, there is a new force that will bring help, inspiration, guidance and culture into the life of the women here. Already a coveted view down the long avenue of time has revealed the NEW HOWARD WOMAN as she is conceived by Dean Lucy Slowe, the new force on the University faculty that must make itself felt far down through the ages.
>
> Dean Slowe is the answer to a spiritual need in the life of women here, for information and guidance in science, literature, mathematics, a woman might seek the aid of any number of professors of the highest rank; but for those indefinable problems of etiquette, grace, culture, the avenues of help are not clear.
>
> In a meeting for all women of the campus at Miner Hall on October 10, Dean Slowe sounded the keynote of her future policy in these far-reaching and vital words:
>
> INFORMATION IS NOT THE END AND AIM OF A WOMAN'S COLLEGE LIFE, BUT THE INDEFINABLE SOMETHING OF REFINEMENT AND CULTURE THAT SPELL CHARM IS EQUALLY VITAL.
>
> The New Howard Woman, according to her conception, is a woman intellectually alert, spiritually alert, and of extreme culture and refinement.
>
> Culture is no more inherited than is knowledge. One may inherit tendencies toward culture, but to develop these tendencies or to create them, there must be just as systematic and conscious effort as one gives to acquiring knowledge. In this effort we must have the help and guidance of those who know. We, the Women of Howard University, welcome dean [sic] Slowe with eager, open

arms, and consecrate ourselves to this sacred task of evolving the NEW HOWARD WOMAN—a woman intellectually alert, physically alert and of extreme culture and refinement.[75]

Dean Slowe's First Four Years

"I Came to Do a Job"

In 1922, college attendance was a privilege reserved only for the few, and although women were going to college in miniscule numbers, Slowe embarked upon a campaign to enrich the education of those who did attend. The rhythm of her activities at Howard University never varied from the pace that she followed prior to accepting the deanship, neither inside nor outside the university.

To complicate matters, Lucy Slowe's early years occurred during the last years of President Durkee's administration. Despite his organizational skills and ability to compromise, various groups, both within and outside the university, opposed him. Faculty complained of inadequate salaries, alumni were in an uproar because he was not "black enough," that his reorganization was dismantling some of their favorite deans, such as Kelly Miller, and students rebelled against compulsory chapel attendance. In a setting such as this, Slowe had her work cut out for her. Her goals were daunting. She wrote in her first annual report:

> When I took charge of the Office in September 1922, it was necessary for me to effect an organization and map out a course of procedure before any work could be done. I found it necessary to draw up all office forms for property [sic] keeping vital records of the women and to organize the various persons dealing with the women into a working group with one purpose and one method of procedure.
>
> In order that the work might get underway in the best possible manner, with the least delay, I visited in November some of the largest coeducational institutions in the country. . . . I conferred with Deans of Women concerning methods of conducting their offices and methods of dealing with the problems of the women students. This trip gave me a vision of the proper scope of the work here, and of the way it should be developed. . . . I have endeavored to lay foundations upon which the future of the women of the University can be constructed with confidence.[76]

Student Personnel Work and the National Association of Deans of Women

Dean Slowe understood that to become oriented to this new type of work and to make progress in it she had to affiliate with the most important professional organizations. Clearly, from her previous work in Baltimore and Washington, she was a very political person; she understood networking. So, during her first two months as dean, she violated segregation rules and applied for membership in a white organization—the National Association of Deans of Women (NADW). She wanted to learn about "the best" for her university. They admitted her.

Knowing her supposed "place" as an African American, she must have been acutely aware of her role as the lone person of color in the Association: she had to be punctual, clean, and dress impeccably; she had to speak properly, and be courteous. Yet, membership brought her into contact with other women who were trying to create a niche for themselves as spokespersons for the education of women college students, and she wanted to do that, too. She affiliated with deans like Thyrsa Amos at the University of Pittsburgh, with whom she later interacted a great deal, and professors at Teachers College, Columbia University, like Sarah Sturtevant. NADW members were engaged in a burgeoning field called "personnel work." Lucy remained an active member for the entire time she was at the university. With the professional advice of fellow deans and the support of NADW, she took off on an auspicious career at Howard.

Lucy Diggs Slowe considered herself a professional person. She based her work on the concept of "personnel work"—or, more precisely, "student personnel work"—in higher education. In order to understand more fully her commitment to this field, consider the factors that influenced her after she accepted the appointment of Dean of Women. She did hit the ground running, trying to learn all she could that would clarify, at least in her mind, just what her responsibilities were. As she participated in NADW, she surely absorbed the ideas of Esther Lloyd-Jones, a distinguished member. Lloyd-Jones probably gave talks at NADW meetings about the variety of units that were part of the "personnel office," as the dean's office was called, recommending functions such as admissions, counseling, placement, and research. Lloyd-Jones, in 1929, published these ideas in her book titled *Student Personnel Work at Northwestern University*, which was regarded as one of the most influential book on the deanship.[77] Lloyd-Jones would later become a professor of "student personnel work" at Teachers College, Columbia University, and an NADW leader. Lucy was one to quickly identify important constituencies, to reach out to them, and to secure them as allies.

As early as 1925, three years after Slowe accepted her job, the Division of Anthropology of the National Research Council met in Washington, DC, to discuss problems of vocational guidance. The fourteen institutional representatives requested the American Council on Education to sponsor a study of personnel practices in colleges and universities. The survey was designed to determine what colleges and universities were doing to assist students in their development as individuals. The results, published in 1926—four years after Slowe's appointment—focused national attention on the importance of a new concept, "student development." Active in discussing these issues at the national level was none other than Thyrsa Amos whom she had visited at Pittsburg. Indeed, in 1937, Amos and Lloyd-Jones were members of the committee of nineteen that finally accepted the report titled *The Student Personnel Point of View* for publication. That booklet became the authority—the so-called bible—for professionals in the field of student personnel work for decades to come. It set forth the philosophy that

> One of the basic purposes of higher education is the preservation, transmission, and enrichment of the important elements of culture: the product of scholarship, research, creative imagination, and human experience. It is the task of colleges and universities to vitalize this and other educational purposes as to assist the student in developing to the limits of his potentialities and in making his contribution to the betterment of society.
>
> This philosophy imposes upon educational institutions the obligation to consider the student as a whole—his intellectual capacity and achievement, his emotional make up, his physical condition, his social relationships, his vocational aptitude and skills, his moral and religious values, his economic resources, and his aesthetic appreciations. It puts emphasis, in brief, upon the development of the student as a person rather than upon his intellectual training alone.[78]

These ideas were powerful: assist students to develop to the limits of their potential and in making their contribution to the betterment of society! Consider students as a whole—their intellectual capacity and achievement, their emotional makeup, their physical condition, their social relationships, their vocational aptitude and skills, their moral and religious values, their economic resources, and their aesthetic appreciations! Develop students as persons rather than their intellects alone! With Slowe, these concepts had far-reaching effects. She not only absorbed them, but indeed she internalized them and made them her mantra, both from attending NADW meetings as well as through correspondence with Amos. Lucy Slowe returned to

Teachers College, Columbia, in the summers of 1930 and 1931,[79] to take courses in student personnel work. Arguably, it was the foremost place to do academic work in that field. Teachers College actually admitted her to the PhD program.[80] Thus, the stage was set for Lucy Diggs Slowe as a student personnel administrator.

Because she wanted to learn first-hand how deans of women's offices were organized and how they functioned, besides going to NADW and studying at Teachers College, Columbia, she visited a number of colleges and universities. In November of her first year, she made a trip to the University of Pittsburgh, Oberlin College, Cornell University, and Swarthmore College.[81] To motivate her students and help her staff understand how the personnel field was functioning elsewhere, she also invited experts to come to Howard to share information about their programs. Notwithstanding, she also wanted them to observe her procedures. As her first year was coming to a close, an example of her approach is clear in Thyrsa W. Amos' visit to Howard on May 7, 1923. Amos, a white woman, gave at least three talks. She addressed members of sororities and made a plea for unity, friendliness and fair play. She said, "Place Howard first, your sorority—second." She also talked with all women students on "Vocations for College Women" and stressed the idea that ability with courage and courtesy will bring success in any line of work. Later she spoke to all women of the University on "Being Somebody." In order to be somebody, she stressed that it is necessary to find health and keep it; to find knowledge and share it; to find work and do it; to know Christ and practice His teaching.[82] Not satisfied with having her address only Howard women, Slowe accompanied Dean Amos to Dunbar High School so that teenagers could hear her. Amos urged them to place proper value on essentials in life, give each its appropriate emphasis, and to keep growing open minds.[83]

Slowe quickly established her presence in NADW. "Our own Dean Slowe has attended each of those [NADW] annual meetings, where she is a true representative of Howard womanhood,"[84] reported *The Howard Alumnus*, whose editor was The Reverend Emory B. Smith, President of the General Alumni Association.[85] *The Hill Top*—the student newspaper—of March 15, 1924, reported that she shared with students in chapel on March 7, 1924 highlights of the NADW conference that she had attended the previous month.

Rather than taking up matters that pertained only to deans of women and women students, she reported there were topics on the agenda for faculty consideration, and others for student consideration. "There should be subjects (in the curriculum) dealing with human relationships and subjects that give attention to the relationship with the divine. . . . Dean Slowe wishes the students at Howard to realize that other groups of students are thinking in lines beyond the confines of the college. They are working on

plans to bring about better human relations and plans to abolish war. They are more liberal in thought than their guides."[86]

In February 1925, Slowe took a trip to New York City at the invitation of Teachers College, Columbia University. The *New Haven Union* reported that she gave a lecture about race relations at a gathering of women who were studying in the master's degree program to become deans of women. This was one of Dean Slowe's early comments on race relations. According to the *New Haven Union*,

> Dean Slowe made a plea before the women who are in training to become deans of women . . . for better race relations between colored and white college women in this country. Dean Slowe contended that only through the process of investigation, curiosity and openmindedness could white and colored people learn to know one another. Prejudice can be dissipated by turning the light of knowledge upon those who suffer from it, as well as upon those who impose it. . . . Colleges should be places where students of all races would come together for the purpose of discovering what is good in members of different racial groups, in order that misunderstanding due to ignorance might not arise.[87]

The *Teachers College Record*, a publication of Teachers College, in 1925 summarized activities associated with the preparation program for women deans. A class titled "The Advisers' Club" brought the graduate students in contact with distinguished women of different races. At the last meeting of the term, *The Record* reported that ". . . Miss Lucy D. Slowe, dean of women at Howard University, Washington, D.C., spoke with charm and power on "How College Women Can Help to Eliminate Race Prejudice."[88]

Being invited to speak to a class of prospective deans of women at Teachers College, Columbia University suggests how quickly she had gained the attention of her white colleagues, presumably through NADW. She had been dean at Howard, and thus a member of NADW, less than three years. To the Teachers College professors, she must have been a natural born speaker.

She was becoming widely known for her ideas as well as her forceful oratory. According to *The Howard Alumnus* in its May 15, 1925, issue, she spoke at the University of Pittsburgh, a white university, at the invitation of her friend and colleague, Dean of Women Thyrsa Amos, where she gave two addresses to women students: one on "The College Woman's Responsibility in Race Relations" and the other on "The Responsibility of the College Woman to Her Community."[89] It was highly unusual for an African-American woman to give such a talk before white students. Obviously, Slowe and Amos were creating a professional relationship that both could trust.

Creating Alliances

Ever the dynamic speaker as well as one who found it easy to create informal relationships with people, one month after she met with the Howard women students, she called an assembly of male students so that they, too, could know what she was all about. Captioned "Slowe Speaks to Howard Men," a reporter for the *Howard University Record* wrote

> Although the date was Friday, the thirteenth yet the superstition as to day and date were forgotten when Miss Lucy D. Slowe addressed the male students of the University. From her opening sentence to her closing challenge, there was the closest attention given by the audience of men. Her subject was well chosen: "What A Howard Man Ought to Be." "Young men I came to do a job" was her greeting. She then pleaded for a better social cooperation between the sexes at Howard University, stressing the complexity of the social problems here. "The aim of education is not to turn out mere encyclopedias; it is not to give to the world men with information and knowledge only; but rather to furnish the world men with information plus. To mere information must be added character, the proper attitude toward women and the social graces." She erected as the criterion of conduct, not mere right or wrong, but rather good taste. Admitting that the atmosphere at Howard is not all that it should be, she yet expressed her confidence that a healthy tone would soon characterize OLD HOWARD and closed with the suggestion of definite ways in which the ideal HOWARD MAN can be realized.[90]

This would not be the only time she petitioned men students. Four years later, for example, Lucy Slowe made it a point to plead with the young men to establish and elevate the tone of the University. An article in the February 25, 1926, issue of *The Hilltop* reported that "Dean Slowe made her annual appeal to the young men of the University. She urged them to do all within their power to raise the intellectual and moral standard, since it was the young men and not the women who set the pace."[91]

Continuing to reach out and build support during these first months, Slowe believed that the best way to proceed would be to assemble a network of women. She sought the advice of each and every woman associated with the university, framing her meetings around a topic that was sure to prompt interest. She called all women members of the faculty, she called the wives of all male faculty members, and she called the wives of all university

administrators. She asked them to join her for a conference on the conditions affecting women students at their university. They met the dean and formed themselves into what became known as the Women's Cooperative Council of Howard University.

> . . . this council met once each month for the consideration of various phases of women's life in the University. The Council entertained all women students, has had one meeting with the heads of houses in which our women live in the city, and has entertained all women members of the present graduating class. The members have also acted as official chaperons at various student functions."[92]

Within the first five months of her appointment, the new dean seemed to be trying to "move heaven and earth" in order to solidify her program and to expand the horizons of Howard students. She sent personal invitations to visitors to be her guests, and, when she made speeches away from the campus, she extended invitations to her hosts to visit Howard University. On campus she initiated what would become a major phase of her program, the building of significant traditions. The annual Women's Dinner evolved as one of the most memorable of these traditions. Designed to bring together for a festive occasion as many Howard women as possible—students, staff members, faculty wives, alumnae, and women members of the Board of Trustees—she hoped that all these groups would be encouraged to cooperate in a concentrated effort to promote the welfare of women students. In this way, she began to strengthen relationships among women students and at the same time unify the campus community.

> On Friday, November 3, 1922 and on every first Friday in November for many years, the first Friday was the occasion of the Annual Women's Dinner. The first event was well advertised through the use of "throw-a-ways." The Committee on Arrangements consisted of thirty-one undergraduate and graduate women who promised an enjoyable evening to all who accepted the invitation to be present. The fee was modest, one dollar for alumnae and fifty cents for undergraduates.[93]

Significantly, alumnae also accepted the invitation.[94] Dean Slowe sent a special letter to the men of the university in which her sense of humor—evident in her junior high school teaching—reappeared. It could be that making light of life was helping her to survive her leadership role.

To the Men of the University:

 The women of the University are having a dinner Friday night, November 3, in the new Dining Hall. One of the requirements for admission to this dinner is that you be a member of the female sex. This naturally bans all men in the University, with the possible exception of waiters, from the floor of the dining hall.

 We are indeed sorry that you must miss so much fun, but you may retaliate on us whenever you desire by having a men's dinner. If you had thought of this first, you could have had the laugh on us, but your thoughts are evidently concerned with more weighty matters than eating. Just to show how much fun we women can have when you men are not present, we are going to invite you to stand in the balcony of the dining hall to look down on us. From this point of vantage you can force us women to do the usual thing—look up to you. This will more than compensate you for missing our dinner.

 Be this as it may, we cordially invite you to come to the balcony at any time after 8 o'clock, Friday evening to see "a twentieth century wonder," Howard women enjoying themselves without the company of men.

"The Women's Committee on the First Annual Women's Dinner" signed the letter.[95]

A reporter for the *Howard University Record* described the event.

Brilliant in every respect was the assembly of 250 women, students and alumnae of Howard University in the first annual Howard Women's Dinner, Friday evening, November 3 in the University's new Dining Hall. The affair was planned by Dean Lucy D. Slowe, who had as her motive the unifying of the women of the various departments of the University and the coming together of the undergraduate and alumnae in a common bond of sympathy and fellowship.

 It was a meeting of youth and experience when the alumnae threw off their cares and problems and entered into the spirit of the occasion by giving yells and singing the college songs. . . . The affair served to help awaken a woman's consciousness which is one of the first steps toward the evolution of the New Howard Woman.[96]

Still another account of the First Annual Women's Dinner indicates that Dean Slowe conceived the idea and put it immediately into action with

the assistance of a corps of efficient and enthusiastic women students and alumnae of the University. . . . There were songs, "screams" as Dean Slowe is known to call feminine attempts at yelling, and wonderfully inspiring speeches directed by the remarkably gifted toast-mistress, Miss Bertha McNeil, and the students who would sing "Stand Up" to whomever they wished to speak. From Dean Slowe's speech that set forth her high conception of the women's job in the University, throughout the entire list there was help and inspiration. . . .

As painful and unheard of as it was, the dinner was planned without including the men. We were favored however, with the presence of many in the balcony, among them the President of the University and some of the Deans. They had come to gaze down on us in response to the 'invitation which had been sent to them.'[97]

Howard men sent two responses:

I am very grateful for your kind invitation to view from the vantage point of balcony your dinner of November 3rd in the new dining hall. It was my pleasure to accept this invitation and to receive the inspiration which must necessarily come from seeing a large body of loyal and devoted women meeting each other and pulling together in the cause of the Greater Howard. In many respects, it was the most impressive scene that I have had the pleasure of witnessing in the affairs concerning the University and I believe it is the beginning of a new day.

As usual, the women took the lead. It is my sincere hope that the men will follow. The sight which I witnessed was beautiful, for how could a whole be other than beautiful when made up of beautiful parts? But the beauty of the occasion was second in my esteem to the lessons taught and to the inspiration given to all Howardites. I thank you for Howard and for myself. May this be the beginning of a long series of such occasions. Signed: A Man in the University[98]

Another Howard man wrote:

In many respects, it was the most impressive scene I have had the pleasure of witnessing in affairs concerning the University and I believe it is the beginning of a new day. . . . The whole affair gave the women a new conception of what it means to be a student or an alumna of Howard University. We look for-

ward with pleasure to the Second Women's Dinner and many other such affairs that must create and develop a new force for a Greater and Better Howard.[99]

To be sure, a tradition was taking shape, as the Second Annual Women's Dinner was held on November 9, 1923. Students writing in the *Howard University Record* declared it a huge success.

> All of the speeches were inspirational and helpful. Mrs. Coralie F. Cook, with her usual richness of ideas, left this germ of thought with the group: "Great women all over the world are thinking of women." Dean Slowe struck again the note that she has so often sounded that the ideal college woman is a woman whose body is strong and vigorous, whose mind is keen and alert, whose heart is trained.[100]

Coralie, Dean George William Cook's wife, headed the Committee of Sponsors. *The Hilltop* headline on November 10, 1924 exclaimed,

> "Dean Slowe Weeps Tears of Joy at Realization of Her Pet Hobby."
> The Third Annual Women's Dinner was held in the New Dining Hall, Friday, November 7. The large lively attendance was enlivened by the volume of many yells and songs. The alumnae guests were greatly impressed by the spirited entrance of youth represented by Howard women of today.
> The evening was spent in speeches, songs and class stunts. . . . Each class showed exceptional ability and originality.
> Miss Hilda Davis delivered the Address of Welcome, and Mrs. Kelly Miller responded. Dean Slowe made a few pointed remarks and introduced several prominent guests.[101, 102]

Davis was at that time a student in her third year at Howard, and she was also serving as president of Alpha Chapter of Delta Sigma Theta Sorority, the second sorority for women students at Howard.[103] Because Davis certainly showed promise as a student leader, she impressed the dean, and, in her later career, it would be difficult to overestimate Slowe's influence.

Annie Miller's role on the program illustrates how Dean Slowe had succeeded in garnering support from faculty wives. Miller was married to the distinguished Howard professor, Kelly Miller.[104] As was perhaps Dean Slowe's habit, her remarks were incisive, and she was delighted to recognize guests whom she wanted the women students to know about.

If the Women's Dinner was a growing tradition, so was the Women's League. During her first year, Dean Slowe established this organization that

was scheduled to meet every Friday in Library Hall. It was designed to safeguard and promote the interests of women of the University.[105] It was such an important initiative that *The Hilltop*—in its inaugural issue on January 22, 1924—noted that a group calling itself the Women's League had formed in the spring of 1923 and that the organization appeared to be a brilliant undertaking.

> ... the young women of Howard University realized one of their biggest hopes in the framing of a substantial skeleton for the organization of the Women's League. ... The various phases of the work to be accomplished by the organization were well mapped out and a constitution adopted. The long drawn out procedure of this work took the time and attention of the organization up to a few days of Commencement, so that there was not ample time for the election of officers.
>
> When school reopened in the autumn, the young women could scarcely wait to finish their registration and class adjustments before taking up the threads of the Women's League. ... The League shall be the governing organ in all matters pertaining to the Women of the University. It shall use all means at its disposal to raise the general standards socially, spiritually and intellectually. Its program for the year contains a series of lectures by such prominent speakers as John Erskine.
>
> From the earliest stages of its development it has been guided over many hard places by the very efficient supervision of Dean Lucy D. Slowe without which the progress which has been made would have been impossible.[106]

By focusing on the Women's League, this new student newspaper was living up to several of its goals, including unifying "Howard spirit," forming and influencing "student thought," and encouraging "worthy school enterprises."[107]

A third occasion that Dean Slowe hoped would become a tradition was the Christmas Vesper Candlelight Service that she offered for the first time in December, 1922.[108] Because she wanted to get over to students the importance of good works, the service included Henry Van Dyke's "The Other Wise Man." Presumably in pageant-form, it was staged by Mary Burrill.[109]

According to Reverend Mark Connolly:

> There is no doubt in reading this Christmas story ("The Other Wise Man") that the author was telling us that there are so many Christ-like people in our own life that have to be ministered to.

The journey of Artaban to see Christ is a reminder that Christ, in the person of the homeless or the forgotten elderly, is in our midst. Van Dyke has told us that the most beautiful words that we can hear are the words "as long as you did it to them, you did it for me."[110]

Discipline, Durkee, and the Student Council

Although the Dean of Women seemed to be off to an awesome start, January 1923 brought her first disagreement with President Durkee. The situation involved discipline, a matter that was to consume an enormous amount of her attention. In a letter to President Durkee dated January 22 of that year, Dean Slowe reminded the president that he had promised to discuss no matters of discipline with women students before she heard their cases. As it happened, a young woman had gone to the president's home and discussed her case with him on the day before she had an appointment with the Dean of Women. Further, Durkee had promised to talk with the "matron" about the case. ("Matron" was the term used to refer to the person in charge of a dormitory.) Slowe was forceful when she wrote:

> If students find out that you, either directly or indirectly, are going to handle their infractions of rules, my office has no function and I become a figurehead whom the students will soon disregard.
>
> Surely no student should know that you would call the Matron in the University and discuss with her infractions of rules when you have a Dean of Women to whom all Matrons, by your own order, are directly responsible. If the students feel that they can go over my head and if the Matrons know that they are responsible to you instead of to me, again I become a non-entity in the University.
>
> When students come to you with cases of discipline, you can strengthen discipline in the whole University by impressing upon them the necessity of seeing me and impress upon them the fact that you will hear cases from me and not from them. . . . You should make them understand further that you impose absolute confidence in me. If this isn't done, they will flout me and I might as well, so far as my influence is concerned, leave the University. Unless this procedure is followed students will not respect me and my decisions and there will be no improvement in conduct on their part and no strengthening of morale in the University. I should never be placed in the embarrassing situation

of having students feel that cases of discipline are personal and not University cases against them; and they can only feel that the cases against them are University cases if every member of the faculty and every officer of the University support the Dean of Women in the handling of women's cases.[111]

The student arrived late for her appointment, but Dean Slowe heard her case anyway. The Matron to whom the student had been insolent on two occasions was also present. In light of the fact that the student had three infractions prior to this one, Lucy Slowe suspended her for the remainder of the quarter; she was to pack her belongings and go home. Yet the student hid in a vacant room overnight, refusing to depart, prompting Dean Slowe to describe the situation at Howard in the following way:

> A most unhealthy condition, so far as discipline is concerned, prevails in this University. There seems to be absolutely no respect for authority on the part of students; for it has come to my attention that Miss ___ was advised by students not to obey my instructions and, furthermore was aided in hiding Monday night in the dormitory by groups of girls. She herself admitted that several girls knew where she was but she refused to give me their names. As long as there is no respect for authority in this institution, so long are we going to find ourselves handicapped in the larger work of the University,—the building of character and respect for orderly government on the part of students.[112]

Action taken in this case incensed the student body, for according to *The Washington Tribune* (an African-American newspaper), on the evening of January 29, 1923, the president of the Student Council called a mass meeting to discuss the means whereby the power of the Dean of Women could be diminished. The Student Council argued that the academic faculty should have a say in the dismissal of young women from the university. A number of students spoke on the matter as well as on how they could curb the dean's power. Students felt that their misdemeanors did not justify many of the penalties imposed.[113]

This was not the first time Dean Slowe's disciplinary action had prompted the Student Council to speak out. During the second month of her first year, Dean Slowe had sent a letter, dated October 15, 1922, to the Academic Council, the body charged with the responsibility of acting on matters of academic discipline. The Council had been formed in 1920 upon the president's recommendation to the Board. Members included the president, secretary-treasurer, registrar, and the Board of Academic Deans. In this case, she called to the attention of the Academic Council a hazing

incident that occurred in Miner Hall on the night of October 11. Because of her personal investigation, Dean Slowe had received from the girls involved a voluntary agreement to engage in no more initiation activities after that year. The girls had recommended the suspension of any individual who broke this agreement. The Academic Council voted to approve the manner in which the Dean of Women had handled this matter.[114]

There was also the need for action to assure campus safety during the evening hours. The dean wrote a letter to the administration in which she made recommendations about policing the campus at night. A copy of the letter became a part of the record of the Academic Council.[115]

The suspension of a young woman during the first two months of the dean's appointment precipitated the first anti-Slowe action by the Student Council. At its regular meeting on October 25, 1922, the Student Council acted on a case that had been presented by a group of young women, protesting the suspension of a female student. As was policy, the Student Council passed resolutions that they then presented to the Academic Council. The Student Council argued that (1) the decision to suspend the young woman was made by one person, Dean Slowe, (2) that this was unprecedented, and (3) that there should be a distinction between rules governing young women who reside in the dormitories and those in the rest of the university. The resolution was signed by both the Student Council president and corresponding secretary.[116]

The Academic Council voted to endorse the action of the Dean of Women.[117] The Council then voted ". . . to delegate to the Dean of Men and the Dean of Women the power to discipline to the extent of the separation of a student from the University for a term of not more than one quarter, and that the Dean of Men and the Dean of Women file with the Registrar a secret record of each case for future reference."

It took just one short year for Lucy Slowe to develop a reputation: "the Dean is a disciplinarian." The experiences and commentary of Marion Thompson Wright shed light on this point. When Wright—then Marion Thompson—arrived at Howard as a freshman in September, 1923, "the Dean as a disciplinarian" was the way she regarded Lucy Slowe, as she was told on more than one occasion that Dean Slowe had sent three students home during the previous year. Wright decided that she would do everything she could to avoid coming to the dean's attention.

When she returned to her dormitory from class one afternoon and found a note under her door advising that the Dean of Women wanted to see her the following afternoon, Marion Thompson turned into a frightened and puzzled young woman. She wondered "what on earth she had done to merit this invitation?" During those days, there were so many "silly rules and regulations" that it was easy enough to violate any one of them. For the ensuing 24 hours, she was a bundle of nerves.

At the appointed hour, an anxious Marion went to the Dean's Office. The secretary sent her in to see Dean Slowe. To her surprise, it was another aspect of the "Dean's Work" that had prompted the summons. Lucy Slowe was getting to know new students. She had observed Marion and wanted to learn more about her. Slowe was especially interested in the girls' vocational goals since she had accepted vocational guidance as one of the important tasks of a personnel dean. Because Marion had decided that she would make herself a nonentity as far as the dean was concerned, she did not know Lucy Slowe. She soon learned that the dean focused on knowing her girls, especially those who were being elected to leadership positions on the campus. In reality, it was through these young leaders that she implemented her program.

As an undergraduate, Marion did become a leader: corresponding secretary of the Student Council for three years; president of the Women's League during her senior year; secretary of Kappa Mu Honor Society; and organizer and president of Mu Lambda Debating Society. After she graduated, she remained at Howard for four more years, becoming a graduate student and instructor in the School of Education. These wide-ranging activities brought her into frequent and close contact with Lucy Slowe where she learned a great deal about the dean's goals.[118]

Pertinent to a description of Slowe as a disciplinarian is Marion Thompson Wright's conversation with her in the 1930s when both of them were attending a summer session at Columbia University. One of their conversations turned to a discussion of the three young women Dean Slowe had suspended in 1922. Slowe expressed regret at her intemperance. Wright reminded her that the young women had later thanked the dean for having saved them from a course of conduct that might have had unfortunate results. To this, Dean Slowe offered a stern self-criticism: "I wonder, Marion, if I could have kept them at Howard and saved them." Marion Wright observed, "Here was revealed a characteristic that more than once evidenced itself in the words and actions of Dean Slowe. She made a continuous study of the position she held. When in her consideration of actions she had taken, she became convinced that she had erred in her judgment, she was not afraid to admit it to herself and to others."[119]

Thus, Lucy Slowe came by her reputation as a disciplinarian honestly. When she assumed her office at Howard, there was already concern about the general conduct of some of the young women. She believed it was necessary to establish the authority of her office in order to bring about changes in student behavior. She therefore took what the students considered disastrous action. Although the administration supported her, the dean, on occasion, did question her own procedures.

Wright, as she thought seriously about the students' protests, believed that students were "testing the limits"—groping their way to a "definition

of their place" in the power structure of the university. They wanted to be a *"self-governing* body in fact as well as in theory, to become a potent force in running the affairs of the institution. They were jealously concerned about what they insisted were their prerogatives in a democratic society."[120] Wright suspected that Slowe believed that if college students are to become intelligent citizens and workers, they must secure the necessary skills for assuming such responsibilities through active cooperation with members of the school staff in the conduct of school affairs.[121, 122] Wright added, "It is quite probable that the 'testing of the limits' by the first Student Council might have been in some way the cause of unrest that came to the attention of University officials."

The "general attitude of the student body or the feeling of unrest" that seemed to exist on campus was a sentiment that President Durkee called to the attention of the Academic Council in the early part of February, 1923. He told them about a student mass meeting held a few days earlier whose goal was to raise money to pay off indebtedness occurred when foreign students visited Howard.

He then asked Dean Slowe to share her plans concerning student government. The dean is reported to have reviewed her actions regarding discipline from the time she had accepted the deanship up to that moment, enumerating in detail the many obstacles she had encountered. She agreed that student morale was at its lowest and suggested that the Council adopt some procedures for improving the mood. As a consequence the president appointed a committee of three composed of Dwight O. W. Holmes, Dean of the School of Education, Lula Vere Childers, Director of the School of Music, and H. D. Hatfield of the School of Applied Science to investigate and report on what they felt would improve morale in not only the student body but in the faculty as well.[123]

A few days later, the Student Council asked for permission to bring to the Academic Council the opinions of the student body on discipline that included a stay of execution in matters of discipline and the right of all students to appeal. The Council voted that a committee of three deans be appointed to consider the Student Council's petition and that the Student Council be advised that the Academic Council should approve the Committee's findings. Deans Kelly Miller of the College of Arts and Sciences, Dwight O. W. Holmes of the College of Education, and Dudley Woodard of the School of Liberal Arts were appointed to this new committee.

On February 13, in its petition to the Academic Council, the Student Council made a strong and lengthy argument for preserving fundamental rights, and protested vigorously against the Dean of Men and the Dean of Women having sole power to suspend students from the university with no opportunity for appeal. They declared such power to be in direct contradiction to all principles of justice and insisted that the policy of centralizing

disciplinary authority in single persons to be an open indictment against the character and judgment of all the other members of the faculty, an assumption that all sense of moral justice resides in the persons of the Dean of Women and the Dean of Men. Thus, the Student Council recommended that ". . . a council composed of not less than five members, two from the student body and three from the faculty, other than the Dean of Women and the Dean of Men be required to pass on all cases of discipline involving suspension in which the student wishes to appeal from the decision of his Dean."[124]

Three days later the committee of three—Miller, Holmes, and Woodard—reported that cases of discipline arising among the young women should be handled by the Dean of Women and those arising among the young men would be handled by the Dean of Men. The Council preserved the students' rights to have a hearing before the Academic Council. Moreover, the report confirmed that the Board of Trustees had placed discipline in the hands of the Academic Council.[125]

Less than a month later on April 4, the Academic Council ruled that when the Dean of Men or the Dean of Women, after investigation and a hearing, suspended a student for a quarter, the dean, upon the announcement of the discipline to the student, would state to him or her that he or she had the privilege of a hearing before the Academic Council. If the student, before the interview with the dean was over, announced to the dean that he or she desired a hearing before the Academic Council, this request would be immediately communicated to the President of the university, and the Academic Council would be convened and the hearing held as soon as practicable. In the meantime, the student would be temporarily suspended pending action of the Academic Council. Further, the Council noted that, by action of the Board of Trustees, the Dean of Men and the Dean of Women were Council members and that the Council had neither the authority nor disposition to limit their voting.[126, 127]

Continuing with the issue concerning the handling of discipline, a group of faculty women petitioned the Academic Council to create a Women's Board—composed of five women members of the faculty with the Dean of Women as Chairman—to hear matters of discipline that were not disposed of by the Dean of Women. This Board would act in place of the Academic Council for final settlement of cases. They argued that the best interests of the university could be served in this way. The request was signed by "Nine Women Members of the Faculty.[128]

A proposal like this reflects Dean Slowe's leadership and persuasive abilities. She knew how to draw in her support. She and her friend Lulu Vere Childers were among the nine who signed the petition.[129] She firmly believed in enlisting women members of the university community in the business of promoting the welfare of women students. She was convinced

A Call to Alma Mater and the Durkee Years *113*

that there are matters pertaining to women students that could best be handled by women rather than men.[130]

In response, the Academic Council voted that the President, the Dean of Women, and the Dean of Men formulate a "request to the Board of Trustees for separate discipline whereby all cases involving men will be handled by a committee of men members and all cases in which female students are involved be handled by a committee of female members of the faculty. In cases where male and female students are involved in the same transaction, these two committees will act jointly."[131]

The Howard community seemed to be constantly engaged in conflict. If it was not between faculty and administration, it was between faculty and students or between students and administration. Wright reported, spring seems to be a time of heightened activity along lines not designed to meet faculty approval. Dean Slowe complained to the Academic Council of young men who made [a] practice of disturbing meetings held on campus.[132]

The students complained against faculty members. Articles in *The Hilltop* and mass meetings severely criticized what student leaders chose to call inefficient instructors. They declared that these teachers should be dismissed from the university.[133]

Buttressing this analysis by Wright, an article in the March, 1924, issue of the *The Hilltop* was captioned "A New Day Wanted: Freedom! Power!! Responsibility!!! Student Council Presents New Constitution After Fifty-Six years of Faculty Control."[134] Another was captioned "Student Council Makes Much Needed Recommendations: Students Soon to Make Demands Directly to Academic Council and President."[135]

When Dean Slowe brought the situation of student unrest to the Academic Council on April 16, 1924, the Council called for a required meeting of all male students and urged all male members of the faculty to attend as well. The purpose was to discuss in depth the matter of discipline at Howard.[136] With regard to the students' charge of inefficient teachers, the Council took their protests under advisement.[137]

The next month, near the close of the academic year, Dean Slowe, in her role as secretary of the Faculty Committee on Student Activities, reported on the Student Council's proposed new constitution. She announced, and the Academic Council agreed, that the students had not used self-government in such a way as to warrant any extension of their powers. Further, she reported that the proposed constitution contained elements that encroached upon the "sphere" of the trustees and the faculty. The report urged students to reconsider their constitution for possible changes and, furthermore, to confer with a faculty committee for suggestions.[138]

Although immediate student reaction to the Academic Council's edict was not reported, a student strike did begin a year later on May 7, 1925. Echoing the *Hilltop*'s headlines of March, 1924, calling for freedom,

power and responsibility, the strikers were ". . . aggrieved by the recently adopted '*ex-post facto*' special rule which permitted the expulsion of students after twenty absences from ROTC or courses in physical education during one quarter."[139] Among the demands students sent to President Durkee was that the "20-cut" rule be eliminated, ". . . that students on strike be reinstated without penalty, that all branches of compulsory education be reduced to two years, that the Student Council control all social activities of students, and that there be student representation on the Academic Council."[140] When students voted to return to classes a week later, the faculty voted in special session that they were ready to consider student complaints and grievances.[141]

Was student unrest at Howard an isolated case? Not in the least. Rebellion among these students is said to have been a sign of opposition to the severe regimen and close scrutiny of personal conduct to which the predominantly white faculty and administrators subjected the students at African-American colleges. Despite efforts at pacification at colleges such as Tuskegee Institute and Fisk University, rebellion was a hallmark of the era.[142, 143]

Although Dean Slowe's role as a disciplinarian began in her first year, and although student unrest persisted, she could reflect on her first year as one of which she was proud. Her first Annual Report to President Durkee—submitted on May 23, 1923—shows just how extensive her work had been. She reported that she had created the Women's Cooperative Council and the First Women's Dinner. She stated that the most serious problem with which her office had to deal was that of housing of women students. She contended that, in addition to severe crowding, more dormitories were sorely needed in order to instill proper ideals of living and conduct. She reported:

> When I came to the University, I discovered that more than one hundred undergraduate women were living in houses in the city for which the University was in no way responsible. The living accommodations had never been inspected by any one connected with the University; the heads of the houses felt no responsibility to the University for the women who lived in their homes, and the women themselves felt no responsibility for living up to the University rules and regulations.

Regarding housing, she recommended that all freshmen women be required to live on campus, even if this meant the displacement of upper-class women. To resolve the housing problem, she wrote:

> Just as soon as it can possibly be done, dormitories should be built and every woman who does not live with her parent or

legal guardian should be compelled to live in a University dormitory. This should apply to professional women as well as to undergraduate women; however, professional women should not be housed with undergraduate women. In my judgment the problems of housing and health are two of the most pressing problems which the University must solve in connection with its women students.[144]

Of her many priorities, housing was at the very top.[145] The issue of women's health was a close second. She pointed out that women were entering the university without a physical examination by a university officer "with all the evils naturally attending this lax policy." She argued that this situation was compounded by the fact that the university had no resident or visiting physician for students.

In her annual report, she also expressed a concern about work-study opportunities and the need for a bureau of vocational information for college women. She decried the quality of women students' social life, which she found unorganized and undirected, adding that

[t]wo forms of social activity alone flourish—going to movies and dances. As a result, much of our social life has gone from the campus to the city. . . . Outdoor recreational interests, literary interests, community interests, musical interests exist in a very limited way, and these phases of University life must be stimulated and developed to a much greater extent.[146]

If the dean was disturbed that her students were frequenting "moving pictures and dances," consider what was available. College students, including Howard University students, were very social animals. This was the Age of the New Negro. The students Dean Slowe was fretting over were no doubt going to the Howard Theatre that had opened just a few years prior to her accepting the teaching position at Armstrong. Located at Sixth and T Streets, Northwest, it was just a stone's throw from the campus.[147] It was at that theatre that the Howard University Dramatic Club gave Supper Shows.[148]

Students were also frequenting U Street, Northwest, to have a good time at the Lincoln Theatre and the Lincoln Colonnade. The theatre was brand new, having opened in 1922, and it too was in the Howard University neighborhood. It was considered U Street's most elegant first-run movie house. In addition to movies, the Lincoln also hosted vaudeville shows and amateur competitions.

The Lincoln Colonnade, a public hall located below and behind the theater, hosted popular events, including "battles of the bands" featuring

local and national entertainers, as well as annual balls hosted by social clubs. In 1924, the Washington *Afro-American* proclaimed that the Lincoln was "perhaps the largest and finest for colored people exclusively anywhere in the U.S."[149]

Dance crazes included the Charleston, the Black Bottom, and the Shimmy. Jazz was hot! Bessie Smith sang the Blues, but most of the best-selling pop hits were sentimental ballads, such as "I'll Be With You in Apple Blossom Time" and "I'm Just Wild About Harry." Students were probably also enthralled by Bessie Smith's singing of "Down Hearted Blues." Other recording artists of the day included Ida Cox, Joe "King" Oliver, Louis Armstrong, Jelly Roll Morton, and Sidney Bechet.[150]

The year that Slowe accepted the position of dean, silent pictures were the rage. Titles released that year included *Beyond the Rocks*, starring Gloria Swanson and Rudolph Valentino; *Nanook of the North*, a documentary; *Oliver Twist*; *The Prisoner of Zenda*, starring Lewis Stone; and *Robin Hood*, starring Douglas Fairbanks.[151] It was not until four years later that the first talking picture, *Don Juan*, starring John Barrymore, premiered on Broadway. Then movies really became big business.

Hence there is a strong likelihood that these were the entertainment outlets for Dean Slowe's young ladies while she was doing all she could on the campus to strengthen the intellectual climate. After all, one of her many roles was chairing the Lecture Committee.[152]

Several weeks after Dean Slowe submitted her first annual report, she received a letter from President Durkee complimenting her on her work. He wrote on June 7, 1923, "I, again, want to express to you my gratitude for the remarkable work you have accomplished this year at Howard."[153] In the same month, Emmett J. Scott, secretary-treasurer of the university, informed her that the Committee on Teachers of the Board of Trustees had voted that she be advanced in rank from Associate Professor to Full Professor.[154] And, indeed, she gained the status she had sought at the outset, but the impasse over a salary increase persisted as securing funds for salaries continued to plague the Board. In this connection, she joined other faculty members in signing what was a second "memorial" to the Board requesting that a salary scale be established for each faculty rank. Faculty members were extremely dissatisfied with the discrepancies and inequities. Back in 1921, prior to Slowe's appointment as dean, the members of the Academic Faculty had sent a "memorial" to the Board in which they asked for a standard salary scale for each faculty rank. The Board did little about it at the time. Following the second memorial in the fall of 1924, five percent of the faculty did receive small salary increases.[155]

Three years into her deanship, Lucy Slowe asked for a telephone for her office. Little did she expect that the Board of Trustees Finance Com-

mittee would recommend that her request be denied, but on February 6, 1925, it did. The Finance Committee's recommendation was approved by the Executive Committee ten days later. Although the denial must have been disappointing, she was undaunted. She might have been comforted by the fact that she was not alone; a colleague, St. Elmo Brady, professor of chemistry,[156] had made the same request, and they turned him down as well.[157] But, he was a faculty member without administrative responsibilities at that time whereas she was a university administrator! How her office communicated with the rest of the campus community, let alone the outside world, is a mystery.[158]

What else did she do in addition to serving as the dean as well as a faculty member? She helped to prepare prospective graduates for their responsibilities to the university after they received their degrees. Consequently, she served on the committee to plan the Alumni-Senior Charter Day Dinner held on May 2, 1925. This event is said to have been originated by The Reverend Emory Smith, field secretary for the General Alumni Association.[159]

Lucy Slowe's Philosophy

Lucy Slowe always focused on the development of the individual. It was a principle of the progressive movement, a principle of student personnel administration, and a concept that became an indelible mark of her work. Her lecture before Howard freshmen on May 4, 1925 illustrates this point and echoes the article she wrote for the *Junior High Review* on the importance of having a hobby. *The Hilltop* reported that she said:

> If you tell me what you do with your leisure time, I shall tell you what you are. In our American life, there is not a more pressing problem than what we do with our leisure. Into the Universities also has come this problem of the leisure of students. It is just as pressing a problem as his studies. . . . Almost every student has some time in which he can do what he pleases.
>
> The college ought to be the place for the setting of examples. . . . The spirit of play is a healthy spirit. It is perfectly logical and natural for you to wish to play. The kind of play that intelligent human beings do should be different from the play of savages and animals. It is a question of propriety. . . . In your leisure, I hope that some provision has been made for the expanding of your mind, your body and your spirit by spending more time in the open. I hope that your leisure time has some

place in it for the "by-products" of the classroom—clean books, music, drama and literature. In our social life on campus, we should set the example for other people.¹⁶⁰

Another Disagreement with Durkee

Shortly after she submitted her first annual report, Dean Slowe was told, presumably by some of her friends in the community, that President Durkee had requested Dean George W. Cook and his wife, Coralie, to vacate their home at the north end of Miner Hall in order that more rooms might be available for women students. Dean Slowe was shocked when she learned about Durkee's actions; she had made no such recommendation, although she had made the point that more housing was required. Immediately, she attempted to contact him but learned that he was out of the city. She roundly excoriated him in a letter dated June 17, 1923, writing:

> I am writing you upon a matter which has received my careful attention and consideration . . . and I hope that you will take my advice in the matter and let things remain as they are for several reasons. I do not need to tell you that anything that I advise is for the purpose of enabling us as administrators to put over a constructive program without using up our energies in defense of policies of questionable benefit to the University. All this refers to the proposal of asking Dean and Mrs. Cook to vacate their rooms in the north end of Miner Hall.
>
> When I wrote my Annual Report as Dean of Women . . . I had in mind the need for building new dormitories. . . . I had no idea of asking the Trustees to request the home of Dean and Mrs. Cook for dormitory purposes. If I had wanted that I would have recommended it directly and would have told Dean and Mrs. Cook that I was going to do it.
>
> In the first place, I request and advise that you leave things as they are, for I am not prepared for the supervision of more girls in Miner Hall. . . .
>
> In the second place, those remote wings of Miner Hall, the North and the South, are a source of concern to me . . . but the presence of Dean and Mrs. Cook in the North end of the building is a source of protection and help in supervision. . . .
>
> In the third place, I am putting in for next year a new system of sponsors for the girls and have built the system around women who live on the campus. Mrs. Cook is chairman of the Committee on Sponsors, and has 25 girls under her care who

will go to her home at stated intervals for the touch of home life which they need. . . .

In the fourth place, the housing of twenty odd girls in Dean Cook's house will not relieve our housing situation to any appreciable extent. . . .

In the fifth place, the rumor that I had requested the Board of Trustees to oust Dean and Mrs. Cook . . . has produced a very unfavorable, if not hostile, reaction against me among some of the women of the community whose support and confidence I must have, if I am to carry [out] the progressive work of the Office of the Dean of Women. . . .

I think that you have confidence enough in my integrity to know that what I am saying is being said because I believe it right, and because of my genuine interest in the advancement of Howard University.[161]

The Cooks were among her dearest friends. Imagine how she must have felt that a couple she treasured learned via the rumor mill that she wanted them to move. She promptly put an end to the gossip and, no doubt, was successful in making amends.[162]

Thus, in the first year of her fifteen-year tenure as Dean of Women, Lucy Slowe gave precise meaning to her role; she was an administrator responsible for the education of women students. To do her job, she connected with all whom she regarded as her constituents—both women and men students, women faculty, and the wives of faculty members—and established traditions she regarded as essential for the building of morale and esprit de corps. She took the few difficult disciplinary cases in her stride. A reporter for the *Howard University Record* noted in November, 1923:

In the first issue of the *Record* last year, we said that a new force had come to Howard University that would make itself felt down through the years, particularly as it pertained to the womanhood of Howard University. The force is at work calmly, quietly, unostentatiously, but nevertheless, forcefully, definitely, surely, and the result must be far reaching. Judging from all the plans, suggestions, organization, Dean Slowe forgot for hardly one little moment this past summer the building and preserving of a finer womanhood at Howard.

She has come back enthusiastic, patient, longing to help and guide. The young women have come back too, with a new desire to cooperate and see this structure of womanhood grow.

One of the many fine things that Dean Slowe was instrumental in bringing about is a physical examination for the young

women before registration and incidentally for the whole student body. This formed a very long, trying ordeal, but it will be one more sure telling part of this structure of a womanhood, physically, mentally, and spiritually fit.

That article also praised the dean for organizing the Women's League and starting the Howard Women's Dinner. It wished ". . . her a year of satisfaction for service rendered as a net result of fine, strong, pure up-looking womanhood."[163] Although the action of the Academic Council amounted to something of a rebuke to students, it seems that "when all was said and done," they welcomed and appreciated Dean Lucy Diggs Slowe's initiatives.

Pollyanna Revue Controversy

Slowe was not automatically a workaholic. She knew it was important to relax and to use her leisure time productively. So, during the holiday season, on Christmas night, 1924, she attended a performance of "The Pollyanna Revue," a benefit for the Phyllis Wheatley YWCA held at the Lincoln Theatre. Not only was this to be entertaining but it was also to benefit a good cause, the "Y." *The Washington Tribune* reported that a cabaret scene, the Apache dance, and the Hula or Hawaiian dance were featured and that an eight-year-old child sang ragtime songs with a teacher. The Revue also included suggestive jokes by a comedian.[164] Slowe neither relaxed nor enjoyed the show. Rather, she was embarrassed and incensed. She must have fumed over the show so much that after the holidays were over, on January 13, 1925, she wrote Martha McAdoo, executive secretary of the "Phyllis Wheatley," as the "Y" was popularly known, in part that

> [t]here were certain features of the entertainment given for the benefit of the "Y" which I think should have no place on a program sponsored by persons of refinement and by persons who are supposed to hold up before our young people ideals of modesty, of decency and of culture. I think the suggestive jokes . . . were an insult to persons of refinement; I think the Hawaiian dance was an exhibition of coarseness. . . . I think that the six girls in the dancing chorus gave an exhibition that was not creditable to young teachers and prospective teachers; I think that the placing of that little child on the stage to sing ragtime songs and to demonstrate ragtime dancing was reprehensible; I think that having a man knock a woman down on the stage, pick her up and fling her from him is not an exhibition that the Y.W.C.A. ought to sponsor.[165]

Simultaneously, Dean Slowe arranged for a conference with Garnet C. Wilkinson, Assistant Superintendent of Public Schools, in which she raised the question of the professional dignity of individuals in the teaching profession. Upon receiving Lucy Slowe's letter, Wilkinson turned to the Officers of Divisions 10–13, the African-American divisions, for advice, whereupon they said this was not a matter within the province of the Public School Administrators.[166]

When Wilkinson relayed that decision to Dean Slowe, she was irate. On January 14, 1925 she wrote to Wilkinson:

> It is evident from your letter that you and the officers missed the only point in my unofficial interview with you. . . . It was from the standpoint of professional attitude and dignity of teachers in their relations to the children and the community that I talked with you.
>
> It would have been preposterous for me to have come to the Assistant Superintendent of Schools to complain about or criticize the Pollyanna Club. I have intelligence enough to communicate directly with the Club if I wished to criticize them without having the Assistant Superintendent of School instruct me to do so.
>
> It was not my purpose in talking with you to criticize the Pollyanna Club. . . . My sole interest in the matter, so far as your office was concerned, was a professional one based upon my being a member of the teaching profession.
>
> I know as well as you do that the Pollyanna Club is made up of reasonable people. . . . You may rest assured that if I felt it was my duty to say anything to the Pollyanna Club concerning its activities, I would say it directly to them and not to you.
>
> . . . I made no suggestion concerning action. I cannot agree, however, with the school organization in saying that officers should not call matters of public policy in which teachers are involved to the notice of teachers.
>
> . . . I am much surprised at your official opinion on the whole matter expressed in your written communication to me, for in my private conversation you were in complete agreement with me as to . . . the desirability of all of us who are in the teaching profession holding up the highest standards of amusement to our young people.
>
> It is my opinion that a school organization should be composed of persons who are a guide to both parents and students on matters affecting directly or indirectly the ideals of the children

in our community, and none of us who are in the teaching profession can afford to evade this responsibility.[167]

Slowe, believing in candidness and confronting an issue directly, sent copies of her letter to the president and secretary of the Pollyanna Club and officers of the Public Schools whom the assistant superintendent had consulted.

Although it is not known whether she sent a copy to *The Washington Tribune*, the paper did take up the controversy, just as it had when she was championing the idea of a junior high school. The paper reported on January 24, 1925, that

> The controversy . . . brings to light not a new idea, nor a new responsibility, but the name of one in the profession of training young minds, who, in the person of Miss Slowe, has a broad vivid sense of the duty and responsibility which the teacher owes to the community and to the whole social and educational strata of humanity. . . .
>
> We heartily agree with Miss Slowe in her suggestion of an impropriety, for it is the teacher's individuality, his dignity, his self respect which commands the world. These are his pearls of great price, his treasure, the secret of popularity, the touchstone of success. His accomplishments and possession matter little. Yet if he does not realize, as Dean Slowe says, "that certain things are in keeping with professional dignity and certain things are not" he cannot demand respect, nor can he create in the child a desire to learn.[168]

Without question, the newspaper was subscribing to Dean Slowe's values that were also the values of the "real [Negro] society," that is, placing a premium on good manners and conservative tastes.[169] Another news article in *The Washington Tribune* dated February 7, 1925, was captioned "Assistant Superintendent Wilkinson Makes Belated Reply—Agrees Yet Disagrees with the Dean of Women."

> In a statement to the Public School Teachers of Divisions 10–13 at the Teachers' Institute at the Dunbar High School last Friday, January 30, 1925, Garnet C. Wilkinson, First Assistant Superintendent in charge of public schools, claimed that his letter to Miss Lucy D. Slowe, in which he advised her that school officers were not concerned with the propriety of teachers and normal school students sponsoring and participating in a show

A Call to Alma Mater and the Durkee Years *123*

like the "Pollyanna Revue" with professional entertainers, had been unfortunately and incorrectly interpreted.

Wilkinson, on January 30, shifted his position.

The First Assistant Superintendent believes that the character, conduct and deportment of teachers must always be above reproach on and off the job.
 Believes that he has the right to assume that its teachers in Divisions 10–13 are moral. States that action against an individual teacher and groups can justly and will be taken when an individual teacher or teachers, to his certain knowledge or belief, offend against the moral code.
 Believes that it is unmistakably and clearly the duty and responsibility of every teacher to censor the conduct and deportment of school children both during and after school hours.[170]

In addition to the news article, an editorial in the same issue of *The Washington Tribune* declared "Wilkinson Seeks to Compromise."

In his release of January 30, he (Wilkinson) attempts to prove that he was and is right in his position; that Dean Slowe was and is right in her contention, and that the public "interpreted the whole affair."
 . . . We appreciate the fact that he has changed his opinion, though he was tardy in expressing it.[171]

In writing about the controversy, the newspaper did serve to create community support, and it confirmed for Dean Slowe that she was on the right track; she was stressing so-called "aristocratic instincts."[172]

The Washington Tribune was not alone in picking up the story; it became national news. *The Chicago Defender*, dated January 31, 1925, published a sketch of a teenage girl that was captioned: OH, YOU KID! WHY'D YOU DO IT? Below the sketch appeared the name, "Mrs. Isabella Webster" along with the following commentary:

When she played the part of the "kid" in the "Pollyanna Revue" she created a sensation, but when Dean Lucy Slowe of Howard [U]niversity viewed the cabaret scene and the Hula dancing she deemed that it was obscene. The review caused a fluttering among the Washington, D.C., society folks and the church people are all eyes and ears regarding the outcome of what is rumored to be a very embarrassing situation as many school teachers took

active part in the revue, which was recently given for the benefit of the Y.W.C.A.[173]

Move the Dean to the Campus

With the Pollyanna storm behind her, then came the bombshell that concerned her living arrangements. Emmett J. Scott, writing on June 19, 1925, for the Howard University Board of Trustees, informed Dean Slowe that, at its meeting on June 2, the Board

> [v]oted: That the Dean of Women be informed that it is the judgment of the Budget Committee (if the Executive Committee approve) that the best interests of the young women in Miner Hall and other women of the University, will be subserved if she take residence in Miner Hall, in the living quarters provided for her at considerable expense, to better protect the young women, especially during the evenings and nights when watchful care is most needed and that she be requested to do so.[174]

It can be assumed that Slowe had discussed the question of her residence with President Durkee in May, 1922, for her letter accepting appointment to the deanship affirmed their agreement that she not be required to live on campus.

The very day she received Scott's letter—apparently furious—she wrote the Executive Committee of the Board requesting "a conference with the Committee from time to time on matters purely of interest to the Women of the University. Such a procedure might be of mutual benefit to us in putting over the work in which all of us are so tremendously interested."[175] Several days later, as she was probably becoming more infuriated, she wrote to the Board again and this time raised questions concerning the basis for this action.

> I should like to know upon what the Budget Committee based its judgment in coming to the conclusion that the best interests of the women of the University would be served by the presence of the Dean of Women on campus. If the members of the Committee will consult some outstanding authorities on the function of the Dean of Women, they will discover that in the judgment of women who have had years of experience with university women's problems that the best interests of women students are not served by the presence of the Dean of Women on campus.
>
> The Dean of Women is too valuable an officer of the University to have time devoted to minute details of dormitory

administration, when her time should be occupied with the larger problems of housing, social conditions, health, vocational guidance, discipline, student self-government, associating the University in women's affairs with other universities and making contacts for the University with various agencies outside its walls. . . . I should like to refer the Board of Trustees to the American Association of University Women, representing every first-class university in the country, for its opinion of a Dean's living on campus.

In the next place, it is a reflection on the Women students of the University that they need some one to watch them at night or at any other time to compel them to do right because someone is watching. When I find students who cannot be placed on their honor, I ask them to withdraw from the University, a course which in several instances I have already followed. Any other course of action would be contrary to sound educational practice in enlightened communities and could not be defended by us.[176]

She went so far as to contact the headquarters office of the American Association of University Women (AAUW) about this matter. AAUW was one of those women's organizations whose standing she had come to respect. She reached a sympathetic ear in Mina Kerr, AAUW's executive secretary, who herself had been a dean at Wheaton College[177] in the early twenties and at Milwaukee-Downer College as well.[178] Milwaukee-Downer was a pioneering institution for women's education.[179]

Kerr sent a letter to Durkee supporting Lucy Slowe's position. AAUW, in 1921, had established the Committee on Educational Policy as branches throughout the country began to make education a priority, and the organization spoke out on behalf of equity for women and girls. Kerr wrote:

From 1900–1915, practically all deans lived on campus. During the past ten years, there has been a strong and rapid movement away from this custom. More and more presidents and boards of trustees have come to realize that women deans like men deans, women professors like men professors, do better work on the whole for students when they have some separate home life, some time away from their work for rest, study and thought.

The Deans of Women at most universities, such as Wisconsin, Pennsylvania, Illinois, Cornell, Pittsburgh, do not live on the campus, but in their own homes as do men deans and men professors, (sic) this movement has come with the extension of the work of the deans of women to the larger problems of health, housing, social ideals and conditions, curriculum, relations

to the outside world and consignment of the minute details of the dormitories to the heads of halls under the direction of the dean of women.[180]

Mina Kerr's letter summarized the history of faculty women's struggles with presidents and boards of trustees regarding their places of residence.[181] As a seasoned academic administrator and executive at a prominent Washington association, she, no doubt, knew that the nineteenth century notion that faculty women should live in college buildings—their presence was expected to solidify their special relation to their students—was changing. Led by the example of female professors at Wellesley College, women faculty were beginning to live apart from their students; they had ". . . responsibility solely for a student's intellectual development."[182] To be sure, there was present in many colleges a person called a housemother who held no other duties: ". . . her modest income and board compensated her giving her sole attention to students' personal lives and communal well-being."[183] Kerr probably also was aware of the fact that President James Taylor at Vassar had fought one of his faculty members, Lucy Salmon, on ". . . her campaign for the right of women faculty to live outside college halls."[184] Although rigid practices regarding faculty women's residences were being relaxed, one way to understand what was influencing the trustee's thinking was to look at the composition of the Board. There were eighteen members, including one woman—Sara W. Brown, a physician.[185] Presumably, their collegiate experiences were alien to the one that was developing in twentieth-century higher education. In their college days, there probably was a matron or housemother who lived with the girls, but their colleges almost surely had no woman with professorial rank who was a dean and at the same time a specialist in women's education.

Continuing to marshal support for her case, in December Slowe submitted a memorandum titled "The Outline of Duties of the Dean of Women" to President Durkee. She argued that the Dean of Women ". . . is an administrative officer in the University, interested primarily in the education of women in the broadest sense." The Dean of Women at Howard University works with seven basic areas: scholarship, health, housing, vocational guidance, employment, social life, and student self-government. "The Dean of Women at Howard University conducts her work in keeping with the seven functions in so far as the limited help and funds provided her will permit." She spelled out her work in each area.

> Scholarship: She examines from time to time the records of the women students to see if they are doing their work in a satisfactory manner. . . . She confers with those who are not keeping

up with their work and curtails their extra-curricula activities accordingly. . . .

Health: The Dean of Women, working through the Physical Education Department and through the nurse, follows up the report of the medical examiner for each woman student. . . .

Housing: She sees that the number of women in each dormitory is kept in proportion to the sanitary facilities provided. She supervises through student committees the government of each house. . . . She sees to it that women living in the city are properly housed, taking care to have the places where they live inspected frequently.

Vocational Guidance: The Dean of Women attempts to interview each woman in the University at least once a year in reference to her future career. . . .

Employment: The Dean of Women devotes much time to finding suitable employment for women who must work their way through school. . . .

Social Life: All of the Social Life of the University is headed up in the Office of the Dean of Women. . . .

Student Self-Government: The Dean of Women has aided the Women of the University in working out a system of self-government for the women and supervises in general the activities of the Women's League.[186]

Furthermore, Slowe advised the president that she not only held weekly meetings with women at large but also met with them in small groups, and she even held conferences with women students in the professional schools whenever her many duties with the undergraduate women permitted.

Continuing, she listed her several committee assignments plus her work with national organizations, especially the YWCA, in which she served on the "National Executive Committee of the Student YWCA which brings Howard University in contact with practically every college and university in the country in which women are trained. She is a member of the National Council on Colored Work of the YWCA which maps out the policies of colored associations throughout the United States and which serves as a connecting link between white and colored associations."[187] Slowe reported to the president that she appointed dormitory directors who were responsible for the women in their buildings and that, regularly, she held conferences with these staff members regarding "general and specific policies in dealing with the women."[188]

Apparently impressed with Slowe's explanation of her work, Durkee reported it to the Board of Trustees, and, on December 9, 1925, he wrote to

Slowe: "Thank you for your letter and outline of duties of Dean of Women. I shall order the 'bench' for you instead of a 'chair.' Your duties are certainly legion! This report is just what I want for the Executive Committee."[189] The matter of residing in Miner Hall seemed to be settled, for Dean Slowe retained her off-campus residence and dismissed the idea that she should move to the campus.

Durkee's Resignation

If Lucy Slowe's four years at Howard had been full of challenges, six years had been even more so for President Durkee. He was said to be have been so overwhelmed by the various conflicts at the university that, in 1924, he accepted the presidency of the Curry School of Expression in Boston, an institution that barred African Americans, by the way. He had concentrated so much authority in his office that he usurped many of the vested interests. Although he remained at Howard for two years after agreeing to join Curry, he was unable to quell the concern about his having accepted that presidency while trying to manage Howard University. Thus, two years later, he decided to pack his bags and leave; he ended his tenure at Howard, a step precipitated by faculty and administrative opposition to the way he had concentrated authority. In addition, his lack of experience with African Americans may have "contributed to his downfall."[190] Subsequently, he even resigned from the Curry School.[191] On June 30, 1926, Durkee became pastor at Plymouth Congregational Church in Brooklyn, New York. Concerning Howard, he wrote to a friend, B. F. Seldon, at the University of Toulouse, on June 20, 1927 that

> ... I did give everything I possessed of time and talent and prayer and effort to Howard University. I might say, in the words of Theodore Roosevelt, "I did the things that had to be done, which no one else would do!" I knew that those who could not see would fight. I did hope that I might be spared to put Howard University into the class of one of the greatest of American Universities. Our colored people would not permit that, so I turned away to a greater task—which is the task here at Old Plymouth Church.[192]

The end of the academic year 1925–26 also brought to a close Lucy Slowe's first four years as Dean of Women, whereupon she entered into the era of Howard University under the leadership of The Reverend Doctor Mordecai Wyatt Johnson. He became the institution's first African-American president, continuing a long line of "men of the cloth." Dr. Johnson

was a minister in the tradition of African-American preachers of his day. His views of the roles of women in American life seemed to be diametrically opposed to Dean Slowe's. She soon would learn that her four years with Durkee were simply rehearsals for the eleven years to follow. The period of her tenure with Mordecai Johnson was extremely tense. Although she accomplished a great deal, one wonders what the program for women students would have been like under conditions that were more favorable for the Office of the Dean of Women.

5

The Dean of Women and President Mordecai Wyatt Johnson— The Early Years

1926–1930

To Keep My Self-Respect

Johnson: The New President

Following the resignation of President Durkee, the Board's numerous deliberations centered mainly on whether Howard could afford to have an African-American president. Not whether it had sufficient funds to pay him—not whether African-American men were qualified—but rather, in the year 1926, when African Americans were believed by the vast proportion of Americans to be inferior, whether the U.S. Department of the Interior would work with and respect a man of color. The trustees knew that there were men who were qualified—with the administrative ability and skill to move Howard forward—to hold the job. After their first choice, John A. Gregg, Bishop of the African Methodist Episcopal Church, turned them down, they appointed Dr. Mordecai Wyatt Johnson.[1] Thus, with round-the-clock deliberations and with a very active rumor mill on the campus, in Washington, DC, and in the African-American community in general,

Lucy Slowe undoubtedly learned a great deal about the man who would be her boss, a man who at age thirty-six was seven years her junior.

Johnson became President of Howard University on September 1, 1926. Who was he? He was well-educated, having earned an "A.B., from the University of Chicago in 1913, a B.D. from Rochester Theological Seminary in 1921, and an S.T.M. from Harvard University in 1922. Ordained a Baptist minister in 1916, Johnson served as pastor of the First Baptist Church in Charleston, West Virginia, 1917–1926" immediately prior to accepting the appointment at Howard.[2] He was born in Paris, Tennessee, January 12, 1890, and named for his father, Reverend Wyatt Johnson. "He received his early education at the Academy of Roger Williams University, Nashville, Tennessee, and Howe Institute, Memphis. . . . Young Johnson was graduated from the [Atlanta Baptist] College in 1911, and taught English, history, and economics there until 1913 when Atlanta Baptist College received a new charter and a new name, Morehouse College."[3]

"Very few of those who have known President Johnson hold neutral views about him; the vast majority are fervent admirers or bitter critics."[4] "There is, however, one view about him on which friends, adversaries, and neutrals tend to agree—that he possessed a 'Messianic Complex'"[5] and was, perhaps, to be revered as a messiah. A Messianic complex is not just the general wish—be it overt or covert—to redeem the world or to improve the conditions of the world, but it includes another component just as important; that this private person can become the redeemer of the world.[6]

Johnson's ". . . anger, witnessed by many Administrators and Faculty members, was sometimes furious and frightening; when controlled, it was an effective weapon to overpower his adversaries. In addition, his unquestioned skill in debate, which enabled him to discover and exploit weaknesses in the arguments of his adversaries, upset or silenced them."[7] It can only be inferred from some of his actions in Board meetings that he lost his temper.[8] Anything remotely controversial was not written down; only the decisions, not the debates, were recorded.[9] Although he could be witty, he seldom used wit. He was highly regarded for his oratory.[10]

Johnson perhaps dealt with women in the chauvinistic manner that was the norm for male-female relationships; that is, women were "expected to exhibit behaviors that conform to common societal beliefs about the female's role in the public sphere. Acceptable characteristics include being passive rather than competitive or self-assertive and submissive rather than independent and dominant.[11] Women were to be seen, not heard. They were not expected to question authority. In public deliberations, they were not due titles, such as "Miss," "Mrs." "Dr." and certainly not "Dean." Robert Stepto recalls that his aunt, Inabel Lindsay, who became Howard's first female academic dean was referred to as "daughter Lindsay" in business meetings with President Mordecai Johnson.[12]

While Johnson was not particularly enthusiastic about faculty participation in operating the university, he did champion academic freedom.[13]

> ... [A]t the beginning of his administration, President Johnson was particularly desirous of completing the Medical School Endowment Fund, raising an Endowment and Building Fund for the School of Religion, retiring the University's deficit, raising teachers salaries and increasing the number of teachers, having a survey made of the Medical School and of the Law School—in brief, he was especially concerned with accreditation.[14]

Slowe-Johnson Salary Controversy

A strong administrator, Johnson was involved in a number of controversies involving both individuals and national issues.[15] In the early period of his administration, he had personal clashes involving Dean of Women Slowe, Vice Dean of the Law School Cobb, Dean of the College of Dentistry Donawa, and Secretary-Treasurer Scott.[16] Thus Slowe was not necessarily singled out.

Almost immediately upon taking office, on October 7, 1926, Johnson's Board of Trustees' Executive Committee denied Slowe's request for a salary increase, as it did again on October 24, 1927.[17] Dean Slowe asked the Board of Trustees to authorize part-time student help for her office—perhaps motivated by her desire to handle the extensive program she had designed. On March 9, 1928, however, they denied that request as well.[18]

In the spring of 1929—three years into Johnson's tenure—Slowe and Johnson sat down for a conference. Neither the reason for the conference nor who called it is known. In that meeting, she discovered that records from the secretary-treasurer's office had placed her at the rank of Associate Professor, whereupon she gave President Johnson the letter Emmett Scott had sent her in June, 1923, stating that she had been advanced to full professor.[19] In an April 10 letter to Johnson, she asked—now that he understood that she was a full professor rather than an associate—for the appropriate increase in salary. The next day, Johnson acknowledged receipt of her copy of Scott's letter. Nevertheless, the president stated, "In response to the request contained in the last paragraph of your letter [meaning salary], I beg to remind you of our recent conversation in which this entire matter was fully covered.[20]

Dean Slowe wrote to President Johnson on January 30, 1930, listing her responsibilities and requesting a salary comparable to other deans. She pointed out the inequality that existed, noting that while her salary was $3500 annually, another dean earned $3900 and still another, with only

a bachelor's and aaster's degree earned $4150.[21] Both were men, as the university had no women deans. Was this discrimination based on gender?

Slowe and Student Discipline

Johnson had not been at the university two months before students protested about one of Dean Slowe's strict pronouncements. *The Hilltop*[22] of November 24, 1926, reported that she had opposed the participation of young women in cheering demonstrations, an action that led students to declare, "The opinion of the Dean is wholly illogical and without basis. Because women's voices are naturally high pitched and weaker than those of men is no reason why a large proportion of our women students who love their Alma Mater, should not prove that love and loyalty as best they can."[23] This was a continuation of that rebelliousness exhibited in previous years. The young women continued to "yell."

This, after all, was the era of the Roaring Twenties. They might have considered Dean Slowe's Victorian idea of decency hypocritical. The twenties were giving rise to, among other things, the Harlem Renaissance, during which African-American authors, artists, and musicians received their first serious critical appraisal. Years later, Margaret Grooms, a former student, recorded her recollections of the girls' refusal of Dean Slowe's requests.[24] She reported how Slowe had to persuade them to buy tickets to their own recital-lecture-concert series, and at Christmas she had to almost beg them to be in their own Candlelight Procession. She had to advise them that they should go to chapel to listen to outstanding speakers. Grooms explained why they balked; that they ". . . were younger and sometimes thought it smarter to stay away."[25] Regarding Slowe's disciplinary role, Grooms remembered that ". . . Dean Slowe might be seen anywhere in the city where Howard women might be tempted and at strange hours."[26] "Going in the city" was the way Howard students' referred to going off-campus. On more than one occasion, the dean told "her girls" that if the sermons delivered in the chapel services were not sufficiently interesting to stimulate them to attend the religious services on Sunday, the beautiful music rendered by the choir should be sufficiently rewarding to invite their attendance.[27]

Another view of Slowe's concern for good taste comes from former student, Alice Jennings Archibald, who related the following remembrance in an interview about her Howard student days. It provides a glimpse at the color-caste system in the African-American community that awarded preference to those who appeared to be mulatto. When questioned about social life, Archibald recalled that ". . . there were some girls who were going to start a Blue Veins Society. If you looked at the veins in your hands and you could see them, you could join the group. In other words,

you had to be fair [light-skinned] to see the veins in your hands. Well, the dean broke that up in nothing flat. . . . [I]t was so ridiculous, the girls who were trying to start it were not that fair they needed to start a Blue Vein Society, so that was out."[28]

Addressing manners and good taste was one matter; what might be considered sexual harassment was another. Dean Slowe had to deal with an incident of impropriety on the part of a male member of the faculty that had been called to her attention by a parent. Professor Clarence Mills of the Department of Romance Languages, in a course in French Literature in the Seventeenth Century, had discussed Racine and certain matters relating to sex mentioned in one of Racine's plays. In January, 1927, according to Dean Slowe,

> A parent complained to me that Prof. Clarence Mills used improper and sometimes vulgar language in his class room with women students present. She said that she was going to take the case to President Johnson. I asked her to let me confer informally with Prof. Mills to see if I could straighten the matter out and thus prevent a formal complaint against him. The parent agreed and I sent for Professor Mills the next day. We talked the matter over in my office and he left in good humor after thanking me for bringing the matter to his attention rather than to the attention of President Johnson.[29]

The next day, January 11, 1927, Clarence Harvey Mills who was Head of the Department of Romance Languages,[30] sent a letter to Dean Slowe. He wrote, in part,

> Dear Madam,
> If you insist on blackmailing my character and attacking my name, I will take you to the courts of Washington and make you prove beyond a reasonable doubt these various assertions of which you are the recipient from paid stool pigeons.
> I wonder do you realize that many of these same girls, who are so incensed over some vulgarity I am supposed to have uttered, will leave you in order to spend a whole evening in a cat house with some of the very members of the Student Council whom you are egging on to prefer charges against me!
> . . . You forget that you are merely the Dean of Women and not the custodian of morals of the male teachers of Howard University. . . .
> Since you seem to be in cahoots with the mulatto Negroes of Washington for my job, I want to assure you can get it for

the asking; I happen to be differently situated from the rest of you Negroes—I still have youth, ambition and a brain.[31]

Professor Mills questioned Dean Slowe's power as a dean. He also attacked the presence of her network of associates in Washington. Calling them "mulatto Negroes" reflects on a widely known situation within the African-American community, that is, the color line. Again, the issue surrounding fair-skinned African Americans comes up. Mixed-race African Americans, who tended to also to be fair-skinned, were often more privileged than those who were dark skinned. It had been common practice among white slave owners to cohabit with slave women and to see to it later that their offspring—mulattoes—had the best education, clothing, manners and other accoutrements of white people. The color-caste system in the African-American community was almost as stratified as Jim Crow. The lighter-skinned folk were often in the leadership of communities like Washington, DC. Moreover, Mills questioned the Howard girls' integrity by writing that they would spend a whole evening in a "cat house," meaning a brothel. Typically, the sexuality of African Americans was stereotyped as promiscuous.[32] Cultural myths developing out of slavery made it imperative that African-American women be portrayed as almost bestial in their sexuality.[33] They existed "under the stigma of inferiority and immorality."[34]

Slowe had—in this and previous jobs—proven that she would not tolerate such nonsense. Thus with this shocking letter from Mills before her, she called in several male officials of the university for advice. One member of the group was Dudley W. Woodard, Professor of Mathematics and Dean of the College of Liberal Arts, the college in which Professor Mills taught.[35]

Several of Slowe's associates who saw the letter suggested that Dean Woodard accompany the Dean of Women to the Office of the President. Both of them went to President Johnson and presented the letter. The President seemed to be shocked by the contents of the letter. Dean Slowe—consistent in placing a premium on good manners and polite conduct—thought that the professor should leave the university for "he was unfit to teach the students and unfit to associate with the faculty."[36]

President Johnson and Dean Woodard agreed that all publicity should be avoided and that Professor Mills should be permitted to finish the winter quarter and then be quietly released by the university. Yet, two days after the first Mills letter, Dean Slowe received a second one, dated January 13, 1927. Whereas in the first letter he had addressed her as "Dear Madam," the second was addressed "Dear Dean Slowe." Mills wrote:

> Under the pressure of a severe mental strain bordering on a nervous breakdown, I wrote you on the date of January 11 a letter, the contents I myself am shocked at after more sober

reflection. I request that you be magnanimous enough to return the said letter to me in the presence of such authorized persons as you designate so that I may destroy it and offer to you a verbal apology which is certainly due you. I wish to assure you further that I was neither advised to write such a letter by any person or persons nor have I discussed the contents of it with any one except the President and Dean Woodard.[37]

Despite receipt of Mills' second letter with its conciliatory tone, Slowe was not enthusiastic about keeping him on. It was during the winter quarter—January through the middle of March—when these events occurred. Several weeks after that quarter ended, Dean Slowe noticed that Professor Mills had begun his work for the spring quarter. When she inquired about his continued presence, she learned that several faculty members maintained that the professor was sick and should be permitted to remain at the university. President Johnson called a conference of the deans and the registrar and asked them if they thought the professor should stay. Only one of the several deans supported the retention of the professor; the others said that they did not know enough about the case to express an opinion. Dean Slowe wrote in a memorandum about the case,

> I told the President at this conference, that under no circumstances would I agree to Prof. Mills' remaining in the University. I told him that either Prof. Mills would go or I would go. I said that if he was so sick that he did not know what he was doing when he insulted me and the students of the University, he was too sick to remain on the staff. If he was not sick, he was unfit to remain. I said that I resented having the responsibility for separating Prof. Mills from the University put on my shoulders, for I felt that even if I recommended that Prof. Mills be retained, the President ought not to agree to it.
>
> After this conference some of Prof. Mills (sic) friends brought pressure to bear on me to change my opinion, but I could not do this and keep my self-respect, or the respect of worthwhile people who might know about the case.[38, 39]

Dean Slowe did not follow-through on her threat to leave Howard. Subsequently, when presented with the case, the trustees did give Mills a year's leave of absence with half pay. He spent the year at the University of Chicago, where he earned the PhD degree.[40] At a meeting of the Board of Trustees on June 7, 1927—after the academic year had ended—President Johnson ". . . called attention to a 'certain situation' involving a Faculty member and recommended that his services be discontinued. The Board

voted that he be given indefinite leave of absence and that, in consideration of his ill health, he be allowed half-pay for one year, beginning with 1927–1928."[41] Although there is no reliable way to determine who the president was referring to, it seems plausible that it was Mills. Thus, although President Johnson did recommend that Mills be fired, the Board disagreed.

In Lucy Slowe's mind, the Mills incident negatively affected her tenure at Howard, for she wrote, "From the time this case happened down to the present it has seemed to me that there has been a change in the President's attitude toward me." In a revised version of her notes, Slowe wrote "From the time this case happened down to the present, I have not had the cordial support of the President." This case perhaps created the first fissure in their relationship.

She added that she always believed that her exclusion from the Board of Deans had its roots in this matter. She was direct when she wrote:

> He [meaning the President] has never sympathetically studied the real work of the Dean of Women and still seems to have a wrong conception of her function. He confuses her with a matron. He seldom comes to any function sponsored by the Department of the Dean of Women and cannot have first hand knowledge of her work. I have tried in every way to correct this but can get no co-operation from the President.[42]

There is no evidence that University administrators or Mills responded to the parent who called this situation to Slowe's attention.

The battle over Mills revealed Slowe's tenacious manner that had been unmistakable in both her experience with the principal with whom she disagreed at the Baltimore Colored High School and the encounters she had with Wilkinson and Durkee. And it would be revealed again.

Talladega

Lucy Slowe regularly shared information about her activities with her students. Her ". . . platform posture was excellent. She used few gestures—just a lift of the hand here or there. The effectiveness came through the voice—a sonorous, low, clear one. Whatever lecture notes she used were never noticeable so that she created the impression of speaking directly to each member of the audience."[43] In one of her addresses, she told Howard students about her visit to Talladega College. When, on November 20, 1927, she spoke about the visit, she told them that she had traveled to Talladega to be the guest of the Board of Trustees at the dedication of two new buildings—the science hall and the dining hall. She described the institution as "an intellectual oasis in the State of Alabama."[44]

Talladega is an African-American college that had been founded just two years prior to Howard. Its history is grounded in the efforts of two former slaves who, with other freed men, regarded ". . . the education of our children and youth as vital to the preservation of our liberties, and true religion as the foundation of all real virtue, and shall use our utmost endeavors to promote these blessings in our common country." Like so many other colleges for African Americans, the Freedmen's Bureau and the American Missionary Association provided financial support.[45]

Dedication of two buildings—Silsby Hall of Science and Fanning Hall, the College Refectory—was an auspicious occasion, taking place at the time of Talladega College's sixtieth anniversary. To attend the two-day event—November 12–13, 1927—the trustees had invited "One of the most notable groups of educators of National repute and of representatives of leading Negro Colleges that has come together in recent years."[46] The 102 individuals listed as "Special Guests" represented colleges and universities as well as philanthropic groups, such as the American Missionary Association and the General Education Board, and included scientists of note. The elaborate program of events included morning worship on Sunday, November 13, and a conference on the teaching of the sciences in "Colleges for Negroes." Lucy Slowe was the only representative listed from Howard University.[47] It is interesting to note that the address for the dedication of Silsby Hall was given by Juliette Aline Derricotte, a 1918 graduate of Talladega, and Slowe's associate as national secretary of the YWCA.[48] Also noteworthy is the fact that the keys to the building were presented by Trustee George W. Crawford, a 1900 graduate who was also a Howard University trustee.[49]

Three years later, Talladega College invited Slowe to return, this time to spend a week as college pastor. By this time, Juliette Derricotte, who by then had the distinction of being the only woman trustee at her *alma mater*,[50] might have been instrumental in extending the invitation. To Slowe's credit, Talladega's Dean of Women, Marion V. Cuthbert, complimented her in a letter to President Johnson for her work at the college, where she spent several days in January, 1930, as College Pastor. Cuthbert thanked Johnson for permitting Dean Slowe to serve in that capacity and added, "We have not had a pastor this year to whom the students warmed so thoroughly as to Dean Slowe. Her messages at College Chapel were powerful in their simplicity and pungent bits are still being quoted around the campus."[51, 52]

Traditions: Unifying the Campus Community

Lucy Slowe realized that the problem of educating women students was more than one of discipline. Among the traditions she established was her annual invitation to groups of students to meet with her at her home around an open fire or under the trees on her lawn for conferences on various subjects.

She believed that some of her "most effective work was done around her fireside away from all that suggests college routine and official authority." She was usually on the campus daily—unless something unusual [took her] away—from 9 a.m. to 4:30 p.m., and she held evening meetings with students both in the dormitory and at her home.[53]

Margaret Jean Grooms recalled that Slowe always held a reception at her home for departing seniors. This was among her traditions. A treasured invitation to (the reception) stated

> Dean Lucy D. Slowe
> at home
> In honor of
> Women of the Senior Class
> Wednesday Evening June the Fourth
> Nineteen Hundred-Thirty
> Five to Seven o'clock
> 1256 Kearney Street, N.E.

Assisted by members of the Junior Classes, Dean Slowe graciously entertained her departing girls, their parents and friends. . . . Those of us who lived in the "Dorm" and who were fortunate enough to get to 'assist' Dean Slowe on such festive occasions were always sent back to the 'Dorm' in a taxi laden with the remaining delicacies of the evening. How welcome they were!

Dean Slowe liked to serve mixed cookies, Grooms continued,—tiny ones, little squares and oblongs of pound cake variously iced, ginger-ale with scoops and scoops of ice cream floating around in the huge punch bowl. Sometimes tea and cakes. Pistachio ice-cream and raspberry—you know in those huge clumps cut about four to the quart instead of the stingy twenty-four. For faculty affairs she usually liked something hot—chicken a la king—or any food that you can think of, but you must think of something extra good. Dean Slowe was generous. A hungry student could easily tell that she frequently brought or prepared for twelve as though she expected many, many more. That was not extravagance[;] that was generosity for all the leavings went to the girls and those leavings were not crumbs.[54]

Traditional activities like these were reinforcing the unification of the campus community.[55] She pursued the creation of traditions by strengthening the Women's League. At the university, the League had become a strategic instrument for saturating women students with the principles and qualities

she regarded as critical for an educated African-American college woman. *The Hilltop*, in January 1927 reported on the Women's League that was now being led by that earlier-terrified undergraduate, Marion Thompson.

> The Women's League of Howard University is an organization composed of all women students. The organization was perfected four years ago and since then under Dean Slowe and able staff members has done much. The League sent a representative to the annual meeting of the National Student Federation of America.
> The Women's League also sent students to the New Windsor Conference on International Relations, Conference on the Causes and Cure of War and the National Student Conference in Milwaukee.
> Dean Slowe's interest in promoting world peace and international cooperation is apparent in the activities where Howard women were represented.
> The Women's League has also done its bit toward furthering school spirit by sending to the football team on the eve of each of its greatest battles either telegrams or letters dependent upon whether the game was away from or at home—of confidence and loyalty.
> At the last Vesper Service before the Christmas Session, the Women's League had its Annual Candlelight Service. . . . The most outstanding achievement of the quarter was the Annual Women's Dinner held on November 5.[56]

During the fall of 1927, Dean Slowe directed a variety of student activities. *The Hilltop* reported on October 7 that

> [t]he Women's League of Howard wishes to extend to each and every student, both new and old, a hearty welcome to Alma Mater. The Women of the University have arranged a calendar of a few of the important events of the school year.[57]
> The Women's League entertains new students in the Assembly Room of Miner Hall.[58]

"The League sent delegates during 1926–1927, and probably in later years, to white and colored colleges. Only two colored schools, Howard and Fisk, were represented at the second annual meeting, January 1927, of the National Student Federation."[59]

As had by now become a custom, the Annual Howard Women's Dinner was held on the first Friday of November, 1929. From her position as Dean of Women and using her network developed in years of leadership

and activism, Lucy Slowe built support for this event. She took pride in making sure that Howard women students were exposed to outstanding African-American women.[60]

She had been successful in bringing Charlotte Hawkins Brown, president of Palmer Memorial Institute, to the university to deliver the main address. Brown had founded Palmer Memorial Institute in Sedalia, North Carolina around the turn of the century. As an essayist, short-story writer, and lecturer, she was a strong anti-segregationist and advocate for African-American cultural pride and identity. The same age as Lucy Slowe, she served on the national board of the YWCA. Slowe might have shared with those gathered at the dinner the fact that Brown's speech at a 1920 interracial meeting in Memphis, ". . . in which she detailed the everyday examples of disrespect which Black women regularly endured from southern white men and women and challenged the Christian principles of the white female delegates, was one of the key moments in the difficult struggle to create a working relationship between Black and white women."[61] She often told of the times she had been ejected from Pullman berths and first-class railway seats in the South and that she would never ride in a freight elevator in New York City buildings.[62]

Speaking about Howard women, Brown called them "the flower of womanhood of a struggling race." Of the Dean of Women, she said, "Dean Slowe represents to me, my ideals of Negro womanhood. . . . Dean Slowe is making her influence felt through her attempts to shape womanhood not here in the University alone, but to shape womanhood in America."[63] Slowe was no less an admirer of Brown, for one of the last letters she was to write was one to this president of one of the finest finishing schools for African-American girls in the United States. On April 27, 1937, Slowe penned a letter to congratulate Brown on the completion of thirty-five years of service at an institution that ". . . has the respect of educators all over this country."[64]

Slowe continued still another custom that came to characterize student life at Howard: a Christmas vesper service. *The Hilltop* reported that on December 15, 1929, Mary P. Burrill—once again—presented the Annual Christmas Vesper Candlelight Service in Rankin Chapel that Slowe had started in 1922. It was her eighth.[65] This event was one of Dean Slowe's favorites.[66] The Candlelight Service had become so well-known and so highly regarded that "Some 400 visitors were unable to gain admission. . . . The Choir sang three selections from Handel's *The Messiah*, Miss Childers directing, and Miss Louise Burge and Miss Carolyn V. Grant, soloists."[67] "Miss Slowe liked to hear the singing of the Howard Students' Choir under the able directorship of Miss Lulu Childers, and few songs gave her greater pleasure than "Homing."[68]

A song for piano and voice, the words could be Slowe's own:

>All things come home at eventide,
>Like birds that weary of their roaming,
>And I would hasten to thy side,
>Homing.
>O dearest, I have wandered far,
>From daybreak to the twilight gloaming;
>I come back with the ev-'ning star,
>Homing.
>Thy art my hunger and my need,
>The goal and solace of my roaming.
>Be thou my haven when I speed!
>Homing!
>All things come home at eventide,
>Like birds that weary of their roaming.
>And I would hasten to thy side,
>Homing![69]

Three additional activities that were strategic to Dean's Slowe's program came into being. First, the women of the university at a special service established the Women's Loan Fund, a project of the Women's League, on Sunday, April 13, 1930. "Each class collected its sacrifices and placed these through a representative upon the altar. They were received, acknowledged and placed under the care of the Dean of Women, Miss Lucy D. Slowe." Dean Slowe hoped that the amount of money should steadily increase ". . . in order that the greatest good might be done for the greatest number," reported *The Hilltop*.[70] Slowe empathized with needy students. This initiative must have warmed the Dean's heart, for now she could assist students who might themselves be like the impoverished Lucy Slowe of 1904.

"May Week" was next on the list of events that had become customary. In the same issue *The Hilltop* reported that May Festival was started in 1926 solely with the crowning of a May Queen. But now the Festival would be a week long.[71] May Week became a time to honor and inspire womanhood.[72] This, too, originated with Dean Slowe.

The Hilltop regularly reported on the Dean of Women's office. Take, for example, an article from the October 9, 1930, issue. She gave the official welcome to freshman women on Monday, September 29. She pointed out that there are three levels on which one could rest achievements—the animal plane, the intellectual plane, and the spiritual plane. The animal level she defined as physical pleasures. The intellectual level she described as academic achievement. The spiritual level she called the soul—the

indefinable and intangible thing. She said it was her sincere hope that these girls would reach the spiritual plane by the time they completed their education at Howard.[73]

Dean Slowe's views, expressed in this speech to freshmen, reflect the philosophy she presented to her junior high school students, especially in her piece titled "Have you a Hobby?"[74] A memorable Slowe admonition was, "Young women you will look back upon your four years here as the richest experience of your lives, use it wisely, expose yourselves to all the culture possible." Freshmen women were often initiated by hearing her quote liberally from Fosdick's *Twelve Tests of Character*, for she was a passionate believer in his philosophy of 'long ropes and deep [strong] stakes.' "[75]. Slowe admired Harry Emerson Fosdick, and her scrapbook contained a clipping that reported one of his sermons in which he listed six tests of goodness: tests of common sense, of sportsmanship, of one's best self, of publicity, of one's most admired personality, and of foresight.[76] Clearly, she regarded these qualities as essential for a meaningful life.

Characterized as perhaps the most prominent liberal Baptist minister of the early twentieth century,[77] Fosdick's writings were regarded as moving and persuasive. This brings to mind the 1920s Prohibition era in the United States and Slowe's beliefs about smoking among women students. In 1924, the Young Women's Christian Temperance Union explored the issue of young women's smoking by querying officials at colleges and universities. According to the Survey report, Dean Slowe had written that, at Howard University, she had not discovered any smoking and that she did not believe that the habit existed. Slowe stated that she believed that it rested wholly with the mothers as to how prevalent the habit becomes.[78]

Between January and May, 1929, Dean Slowe added to the intellectual and cultural life of the university by managing the "Cultural Series." She featured such renowned artists as the concert pianist Tourgee DeBose, the lyric soprano Elizabeth Sinkford, and the poet Countee Cullen. Campus organizations included the Howard Players, the Men's Glee Club, and the Women's Glee Club.[79] Unmistakably, her 1924 endorsement of Cullen's work in a letter to Frances Williams, the national secretary of the YWCA, affirms that she was definitely committed to bringing him to Howard. Slowe's series was part of the larger university's offerings that included Marian Anderson in 1929.[80]

The academic year 1929–1930 saw Howard women, with the Dean of Women's encouragement, playing a significantly more influential role in university life than they had when she took office. *The Hilltop* reported on November 7, 1929 that four women were on the Student Council; the Girls' Glee Club was a success; and the debating sorority—Mu Lambda Lambda—groomed its members for freshman-sophomore debates and competition with Wilberforce University.[81]

To make sure that her program was not limited to women students who resided on campus, the dean called on November 13, 1929, the first meeting of the women who lived not in campus residence halls but off campus. She had two goals in mind: to engage all women in the activities offered by the university and to enable them to come into closer contact with each other. She talked about the relationship between Howard women and the university. "Each Howard woman should remember that on entrance to Howard University . . . she becomes subject to the ideals of the University. . . . Women set the standards. . . . Our aim here at Howard is to set for ourselves high standards and through our own conduct to impress these standards on others."[82]

Slowe kept busy with many other activities. Often, recalled Margaret Grooms, Dean Slowe would work late in her office in Miner Hall and drop in on their famous preceptress Miss Marie I. Hardwick's "Mailcalls." If they were singing and making merry, Slowe would join in and then share her keen sense of humor. Frequently, she reminded them that a dean was not a policewoman.[83] "Busy though she was, some days she could be seen standing on the side line thoroughly enjoying the 'gym' classes, playing hockey, tennis, or whatever the game might be, but always too wise a diplomat to take sides and usually she left before the end, suspecting which side would be the winner."[84] She made sure that women students—both on-campus and Washington residents—had a full set of out-of-class activities, not only intramurals, but in competition with other colleges—both African American and white. She enjoyed them, too.[85]

Explaining Her Role

As she was coming to the end of her fourth year as a member of President Johnson's cabinet, Slowe wrote to him on January 30, 1930, on the subject of her office and included comparative information about the office of dean of women at other universities. Whether Johnson asked for this information or whether Slowe initiated it is not known. Regardless, her lengthy letter sought to help Johnson understand the meaning of this relatively new post in American higher education. One can surmise that her interactions with Johnson suggested that he really did not understand her role—or, at the very least, the way she viewed her role. She had several major issues with the president. One centered on the incident involving Professor Mills and another pertained to the fact that she had not been appointed to the Board of Deans. Furthermore, on two occasions, she had been denied a salary increase, and she had also been denied funds for student help in her office.[86] It is conceivable that she had had other problems as well. The tone of this

letter seems to be polite and designed to provide information, and it shows that she had a well-articulated mission. She wrote that

> [t]he education of women in a coeducational institution had become such an intricate and difficult problem that a woman who would study woman's place in the modern world, and assist young women in preparing for it was needed sorely in Howard University.
>
> . . . The very nature of the work placed the Dean of Women in one of the most strategic and important positions in the University. The Dean necessarily became an important member of the Board of Deans, the President's advisers and the policy makers of Howard University. The Dean had to be a student of education, a student of University administration and a student of the affairs of the world in general.
>
> The position was new at Howard and not so old in any institution. The first Dean of Women became a pioneer with all the handicaps of every pioneer. . . .
>
> The Dean . . . realized that she had a most difficult task and set about doing the task with the utmost fervor and devotion. . . . The truth is, however, that for six years she bore the burdens of the new and undeveloped position alone. She found low morale and frequently low moral standards in the University, but knowing that sound character is at the base of an individual's usefulness, she placed her major emphasis upon raising morale and morals. The pain, the suffering, the discouragement of the situation are known to some extent by you. However, she persisted and believes that some success has come to her efforts, aided in a great measure by your own belief in the same moral principles that she believed in.
>
> In the meantime, she sought out the finest examples of successful deans and associated herself with those organizations and institutions specializing in the broad fields of women's education. . . . The spirit of the pioneer is with her still, for her task has just started.
>
> How the position of Dean of Women is to be regarded in the future after all this pioneering effort has been made, is now her chief concern. . . . She must still fight to keep the position, in the eyes of the educational world, in the eyes of the faculty and students, from slipping into a place of insignificance. In order to do this, she must continually impress upon the administration of the University the real meaning of this new field in education. The coordinating of the life activities of women students inside

the classroom and outside the classrooms is one of the most difficult tasks that one can undertake. Such varied interests . . . call for the highest type of educational statesmanship. . . .

The Dean of Women in American universities is fast becoming one of the most important cabinet officers and deans, themselves want only women in the position, who can take their place as experts in women's education.[87]

Slowe believed that higher education required a special type of education for women and that, for one, she would be one aid in breaking this new ground. Although she understood fully how innovative this position was in American colleges and universities, she assumed that her institution—her Howard University—would want to align itself with the finest, most up-to-date practices in higher education. Thus, she wanted these ideas to be embraced by the president of her university.

No record of Johnson's response was found. He might have regarded it as presumptuous of the Dean to think that he was unaware of her role. On the other hand, he might have been magnanimous and regarded it as very thoughtful of her to send him this information. After all, she had been appointed not by him but by his predecessor. Thus, he had not been involved in justifying her appointment.

As new as the role of dean of women might have been to the president, it was still equally new to the campus at large. Thus, Slowe used the student newspaper—*The Hilltop*—as a platform, much as she had done when she was principal at Shaw Junior High School. One of her articles appeared under the title "What Does a Dean of Women Do?" Repeating the areas she had listed on numerous other occasions, she included housing, health, social life, education for worthy use of leisure, and educational and vocational guidance. "The main work of the Dean of Women," she wrote, "has to do with life outside the classroom. All of the topics are closely related to effectiveness and efficiency in the classroom and in life after college days have ended. . . . Her activities pointed to the development of the individual. . . . It is the people that count."[88]

One can see the concept of progressive education permeating her speeches and writings. In respecting diversity, she meant that each individual should be recognized for his or her own abilities and interests. Like progressive educators, she insisted not only on intellectual or scholarly development but on the emotional, artistic and creative aspects as well.[89]

In regard to her emphasis on health, the realization of one of her dreams finally came in her eighth year. The student newspaper noted that the university had finally appointed an official university physician. Slowe had long been concerned about the health of Howard women and had pressed for this position. Recognizing this achievement, at the end of the

year, a reporter for the paper paid her the highest of compliments, writing that

> Howard University is most fortunate to have as her Dean of Women, a woman of great energy, versatility and foresight; an outstanding woman in the fields of education and social service, a woman generally admired and loved by all who know her well and appreciate the depth of her character and strength of her mind. This woman is Lucy Diggs Slowe.[90]

Concern about the well-being of women students was not new in higher education. California institutions seem to have led the way. There had been a lone warrior—Clelia Duel Mosher—at Stanford University at the turn of the century who pleaded for attention to the health of women students.[91] As early as 1891, "a group of 'co-eds'" at the University of California at Berkeley had approached a woman physician practicing in Berkeley, asking that she give them the physical examination necessary to participate in the gymnastics that the men took for granted.[92] After two years of volunteered service, Mary Bennett Ritter, M.D. was paid by the only woman member of the board of regents, Phoebe Hearst, who next financed the building of a women's gymnasium. As a result, the position of woman medical examiner became established.[93]

Taking into account the host of programs she managed after four years in the Durkee administration and four more with Johnson, Dean Slowe was still busy trying to help the Howard University community to identify with her. Although she had written—as late as her eighth year—to President Johnson concerning the Office of the Dean of Women, questions persisted. Was the Dean of Women considered to be on the same level as the academic deans? What was the place of the Dean of Women in decision making that affected the women of the University? How was the Dean of Women expected to function at Howard University?

6

The Middle Johnson Years

1931—1934

Turbulence

When Lucy Slowe was appointed to the deanship at Howard University, she made the fateful decision to use her talents to improve the education of African-American women and to further the cause of racial equality. She was intent on strengthening colleges and universities that served African Americans and bringing to the attention of African-American women the distinctive roles they were required to play in their communities. Most of all, she was determined to define the role of dean of women. In her view, a role of this type was necessary not only for Howard University but for all colleges that served African Americans. Truly, her leadership role was born. As far as Howard University was concerned, she had no inkling of the turbulence to follow.

Slowe's Successful Program: Shared Passions and Common Goals

Unlike her relationship with the Howard University administration, Lucy Slowe and Howard students and faculty seemed to fit like a glove. Because she had come with class and grace, she seemed to have been successful in creating shared passions and common goals. To this end, an article in *The Afro-American*, March 21, 1931, reported that a testimonial reception had

been held to honor her. Women students and faculty gathered in Miner Hall and presented Slowe with a silver card tray engraved with her initials. They were proud of the fact that she had been invited to speak at the NADW convention and at Teachers College, Columbia University. Further, the article reported:

> It is not only the women students whose lives she enriched, but the men students and faculty as well. The occasion is the outward manifestation of a feeling of esteem and regard for Dean Slowe that has developed over a period of years. . . . We have gathered together all of the affection and esteem we have for you and put them in this basket of flowers. Although their color may die and their beauty fade, you will find concentration in their fragrance, through the years to come, this affection and esteem.[1]

Another tribute occurred at the 10th Annual Women's Dinner in November, 1931. *The Hilltop*[2] reported a diamond brooch, in the design of a friendship circle was presented to Dean Slowe. It featured ten diamonds set in platinum—one for each of her ten years at the University—and it was presented in appreciation for her ten years of service to Howard women. The mounting was arranged so that a similar stone could be added for each year of Dean Slowe's official relationship with the university. According to *The Hilltop*, Sarah Sturtevant, professor of Education at Teachers College, Columbia University, spoke on vocational guidance as it related to the office of the dean of women, and Professor Ralph J. Bunche, assistant to President Johnson, spoke briefly in Johnson's absence.

Surely graduating seniors were pleased with Lucy Slowe. The 1931 *Bison*, the senior undergraduates' yearbook, noted at the end of her ninth year that

> Howard University is fortunate to have as its Dean of Women, Lucy Diggs Slowe, a woman whose untiring efforts, versatility and foresight have made her outstanding in the field of education and social service. Dean Slowe is a woman greatly loved and admired by all who know her well and appreciate the depth of her character and the strength and breadth of her mind. She has, we believe, become the intellectual and spiritual leader of the women of the campus, creating a desire in them for wholesome recreational activities in art, literature and music. Her work has touched practically all phases of the student's life and her interest in student activities has been deeply manifested.[3]

Although these tributes showed that students valued her initiatives, Slowe refused to rest on her laurels. She created another program—the Men-

tor System—which she presumably learned about from Thrysa Amos, who, in 1925, had instituted a similar program at the University of Pittsburgh.[4] She wrote in her Annual Report (1930–31) that twenty senior women students who were thought to be of "fine character, personality and attitude toward life" were selected to be guides for freshmen women. They went through a brief training period so that they would be comfortable advising freshman girls.[5, 6]

The Mentor System derived its name from Greek mythology. The tale is told in Homer's epic poem, *The Odyssey*, that Odysseus, when he planned to be away from home for several years, would leave his son, Telemachus, in the trusted care of his friend, Mentor. Thus the Howard University Senior Mentors served as friends, guides, and supporters for the newly matriculated freshman women.

Dean Slowe continued to innovate. She learned about the personnel programs that were taking shape in what she called "the best colleges"— meaning white colleges—and she brought them to Howard. A case in point is freshman orientation, a system that was just being introduced in higher education in the 1930s.[7] In adapting what she observed to Howard, she reasoned that the

> orientation of freshmen in an urban university where large numbers live in their own homes and in rented lodging must be carried on throughout the whole first year because of the heterogeneity of the student body and the crowded schedules which make it difficult to find a common hour when any considerable number of them can meet.[8]

She focused orientation during the fall and winter quarters on freshmen living on the campus in Miner and Howard Halls, and in the spring on those living off-campus. For Freshman Week, she required students to arrive two days before classes started in order to give them a perspective of college life and to challenge them to do their best. They had conferences with Senior Mentors, a sightseeing trip on Sunday afternoon, and an informal get-together on Sunday evening. She invited male freshmen and their parents to join her for breakfast at 6 o'clock in the morning in Rock Creek Park—Washington DC's urban park—on the first day of classes. This was an idyllic location that epitomized Slowe's love of nature. Extending twelve miles from the border of Maryland to the Potomac River, the Park offered a range of opportunities, including picnic facilities and hiking trails. An outing like this gave these new students an opportunity to commune with nature. In this setting, house government officers—who were dormitory officials—presented the ideals of student government and conducted a beautiful ritual to induct the new students into the responsibilities of dormitory life. Following this outing, the Senior Mentors joined them at a theater party.[9]

Slowe reported, in addition, that she managed not only women's activities, such as the Women's League and the Inter-Sorority Council, but also organizations that included both men and women, such as the Student Council. She seemed to value the notion that, in supervising all social affairs, she had the opportunity to influence "the social ideals" of both groups.[10]

What is more, she started emphasizing vocational guidance. Because the women students knew so little about vocations and because she had such a small staff, Dean Slowe, in her budget request, asked for a vocational guidance counselor for women. It is not known whether vocational guidance was being handled by anyone prior to Lucy Slowe's efforts. What is known is that the preparation program for deans at Teachers College emphasized the value of vocational guidance and placement in a student's college education. Surely the vocational guidance movement was afoot, having emerged around the turn of the twentieth century.[11] Slowe's office had already managed a part-time employment service for women through her secretary, who shared her limited time for what the dean's staff regarded as a very worthwhile activity. Her secretary reported that 81 of the 111 young women who applied for work were placed, and they earned a total of $2,508.64. These data do not include the unreported employment of women who lived off-campus. The dean noted that 322 women lived off-campus, with 110 living in rented quarters.[12]

Also, Slowe maintained contacts with parents, alumnae, and student organizations. As the three new residence halls for women would be opening for occupancy in the 1931–32 academic year, she anticipated giving a special report on their operation.[13]

Since Dean Slowe scrutinized student activities, she knew when rule infractions were afoot. In early 1933 when she discovered that the Student Council charged "checking fees" at dances, as secretary of the Faculty Committee on Student Activities, she immediately asked the Committee to investigate. The Committee ruled that no more checking fees would be allowed by any student group that promoted dances on campus. The *Hilltop* reported (Feb 3, 1933) that "Dean Slowe admitted that prior to this investigation, the Faculty Committee was ignorant of the fact that a check fee was being charged by the Student Council. She also stated that no reports or returns of the check fee had been made by the Council."[14] Although the meaning of "checking fees" is not known, to Slowe, they constituted a procedure that should not be condoned.

Slowe/Johnson Correspondence

The section that follows derives first from correspondence between Lucy Slowe and Mordecai Johnson and later between Slowe and the Board of

Trustees. Although considerable correspondence between Slowe and Johnson was found in Slowe's papers in the Moorland Spingarn Research Center at Howard University, Johnson's papers limited correspondence with Slowe to his replies to only two invitations. On November 6, 1931, she invited President and Mrs. Johnson to join a group of students for dinner when Anne Wiggin, executive secretary of the International Student Service, visited the campus. Slowe explained that Wiggin would be speaking to students interested in international problems of students. She also invited the president and his wife to meet for tea on December 16, 1931, when Mary McDowell was to visit the campus.[15] The visitor was, perhaps, the Mary McDowell who was a leading women's suffragist and, having been inspired by Jane Addams at Hull House, established the University of Chicago Settlement in 1894.[16] In correspondence that was very cordial, Johnson expressed regrets but did not offer to send a representative.

Disagreements between Dean Slowe and President Johnson emerged, leading to the strong suggestion that Dean Slowe and the president were on a collision course. She seemed to be in continuous correspondence with him and the Board of Trustees. Was the conflict between the Dean of Women and the administration becoming broader and more intense? "President Johnson has not been accused of being weak. On the contrary, the longer he remained in office, the more determined he was to assert his will."[17]

Lucy Slowe felt compelled to write and speak on numerous occasions about the place of a dean of women on a coeducational campus. She firmly believed that a dean of women—whose purview was all women at an institution—should command status and power equal to that of other deans. Obviously, she believed that the president was deliberately slighting her by not including her in deans' meetings. Thus, she wrote to him on February 28, 1931. The tone of her letter was courteous and noncombative but candid in the sense that she based her need to attend deans' meetings on educational principles, not on hurt feelings. She wrote:

> My own position in the life of the University is so interwoven with every division in which women students study that it is absolutely necessary that I be in closest touch not only with the makers of policies, but that I have some part in them both academic and general. . . .
>
> This practice of having the Deans who interpret the University ideals to the students outside the classroom joined closely to those Deans who interpret those ideals inside the classroom is the soundest sort of educational procedure. Two meetings of the Deans have been called this year to which the Dean of Men and the Dean of Women were not called.
>
> Since I have not had the great advantage of being present in the Deans' meetings this year, I have feelings of uncertainty

as to policies and procedures and believe that this uncertainty is detrimental to the great interests of students whose education I am helping to direct.

From my point of vantage above all divisions of the University, I can see the organization as a whole; I can see better than any academic dean, the working of his school as reflected in the lives of women students. . . . I can conceive of no good that can come from dividing the Board of Deans; I know that great harm will come from the introduction of this practice.[18]

She had other worries. One was insufficient staff. Considering the fact that she was trying to build a program, she needed to increase the size of her workforce. Thus, she requested a person to visit homes in which women residing off-campus lived. She was also concerned that the president accused her of playing politics. Presumably they had discussed these matters. And, so she wrote a letter to him March 17, 1931, in which she defended herself as well as her team.

You denied my request for a Visitor and said people on my staff did not work hard enough. I protested that they were all overworked. You said that some one told you that the Assistant to the Dean of Women said, "I am not going to work myself to death!" I observed to you that it was unfair to Miss Houston to judge the amount of work that she does on hearsay remarks and gossip, and suggested that the person reporting Miss Houston alleged remarks had an ulterior motive in doing so.[19]

On this same day you charged me with playing politics when the faculty voted to put me on the Committee to Study Personnel after you had indicated that you did not want me on that Committee. I said to you that I resented that remark, that it was untrue. . . .

From the first incident, the conclusion must be drawn that someone in the University carried to the President conversations and remarks of colleagues, without the knowledge of the person making the remark. If this sort of thing is allowed to go on, seeds of suspicion and hatred will be sown and a terrible harvest of antagonism and bitterness will grow up in Howard University.

The second incident impugned my own motives and the motives of the faculty. . . .

Unless there can be an opportunity for expressing the widest sort of differences of opinion, we no longer have an educational institution, we no longer have a group of sincere and honest people seeking the best way of doing things. . . .

> In the interest of establishing and maintaining mutual confidence and respect among ourselves, will you not discourage all talebearing and all rumors of political cliques in the University? . . .
>
> I do not engage in politics of any sort. When I differ with you I differ openly and above board. Even if I had not heard you say you wanted us to differ with you, I would differ just the same, for that is the only way open to me to be honest with myself and with those I work with. . . .
>
> I trust that these suggestions may be taken in the spirit in which they are given, for I am certain that we can have no real University life unless it is built on mutual confidence and respect one for another.[20]

Although she grew weary of the constant gossiping, she had to tolerate it, surely realizing that the informal system of communication in organizations—like colleges and universities—is hearsay. It is widespread and powerful, and it can function in both positive and negative ways.

Johnson did not acknowledge her February 28 letter until a month later. In his response, he apologized for not replying earlier but refused to deal with the issues: conception and status of the Dean of Women.[21]

Because Lucy Slowe was single-minded when it came to solidifying her role at the University, and in light of the fact that she had not received a reply to the letter concerning the deans' meetings, she wrote the president still another letter. Adopting another means of addressing the issue, she asked him—in a letter dated March 24, 1931—to bring what had now become her treatise on the conception and status of the Dean of Women at Howard to the attention of the Executive Committee of the Board of Trustees[22] scheduled to meet on Thursday, March 26.

She contrasted her situation in her current year with the way it was conceived in 1922 when Durkee appointed her, and she was courageous enough to set the record straight in a lengthy letter sent directly to the Board of Trustees.

> Gentlemen:
>
> I am writing to take up with you some matters having to do with the <u>conception</u> of and the <u>status</u> of the position of "Dean of Women" in Howard University.
>
> When the Trustees appointed me to the position of Dean of Women in June, 1922, they through the President of the University, Dr. J. Stanley Durkee made me a Dean with the standing and status of the Academic Deans in Howard University. They had already established this status for Dr. Parks, the Dean of

Men, at the time of his appointment in 1917. Dr. Parks was a member of the Board of Deans, met with them, and deliberated with them on matters of general University policy.

When I was appointed in 1922, I was made a member of the Board of Deans, met with them and advised with them and the President on general policies, particularly as those policies affected the education of women whose special interests I represented.

The Trustees very wisely saw that in a co-educational institution it was necessary to have the women's point of view taken into account in all matters affecting the education of students, for a large percentage of the students are women. Therefore, they selected as Dean of Women one who had had fourteen years of experience in educational work including five years of administrative experience as Assistant Principal and Principal.

Dr. Durkee informed me that the Trustees wanted a woman who would be a student of education, especially women's education. There would have been no need of bringing such a woman to Howard University to head a woman's division unless she would have opportunity to meet with the policy makers of the University where educational viewpoints were expressed.

All during the administration of Dr. Durkee, the Dean of Women was called to meetings of the Deans when other Deans were called. There was no division in the Board of Deans and no differentiation in status so far as discussing University policies was concerned.

But the situation in the present administration seems to be changing so radically from what it was when I began my tenure as Dean of Women; the status of the position seems so different from that voted me by the Trustees at the time of my appointment that I feel constrained to call the attention of the Executive Committee to this situation."

1. In 1928–29 when the twenty-year program for the expansion of the University was being discussed, in spite of the fact that the most momentous changes affecting women students were involved, the Dean of Women was not included in the group of Deans who considered these matters.
2. From the beginning of the present administration down to September 1930, it was customary for the Academic Deans, the Dean of Men and the Dean of Women to meet with the President periodically for the discussion of matters of general interest to the University. But beginning with September 1930, the Dean of Women has been omitted from every conference which the President has held this year with the

other Deans. In meetings where such matters as <u>Budget</u> and <u>Personnel</u> needs for the next two years were discussed the Dean of Women was not invited to be present. It is impossible for the Dean of Women to represent the interests of the great body of women students in this University if she is excluded from the policy-making group in the University.
3. Even in matters affecting the social life of the University where one would expect the Dean of Women who in most large institutions serves as "University Hostess," to function, the Dean of Women at Howard University has been excluded. Last year when the faculty entertained the Trustees at dinner, the Dean of Women was not included with the Academic Deans in arranging for the dinner. Every Dean in the University except the Dean of Men and the Dean of Women was placed on the Committee which arranged the Trustees' dinner.
4. Arrangements are now being made for a dinner in honor of Representative Crampton (sic) and again the Dean of Women is excluded from the Committee of arrangements.
5. In the matter of salaries, the Dean of Women has descended from a salary $400 above that of the Academic Deans in 1922 to the lowest paid Dean of the same academic rank, on the "Hill." Many professors who carry no administrative responsibility and whose positions do not comprehend the whole University, as does that of the Dean of Women, are paid in some instances $500 more than the Dean of Women.

It is not pertinent to the case of the Dean of Women in Howard University to argue that in many universities such a condition in reference to salaries exists. The Dean of Women had her status and salary basis fixed at the time of her appointment and this should not be changed except by direct vote of the Board of Trustees.

In view of the conditions set forth above and in the interest of the efficiency of my work with the women students in Howard University, I am respectfully requesting the Executive Committee to reaffirm my status as Dean in Howard University with the similar rights and privileges enjoyed by the Academic Deans.

Furthermore, I am requesting that this status be emphasized and doubly confirmed by awarding to me the same salary as that awarded to Academic Deans with professional rank similar to mine, and qualifications similar to mine.

It is intolerable to contemplate that the status of one's position in a university depends upon the interpretation given

it by any President who happens to occupy the office. I cannot believe that it is the intention of the Trustees to sanction a re-interpretation of the position nor do I believe that they would favor doing by indirection what they have never voted to do.

With deep appreciation for your early consideration of this matter, I am

Very truly yours,
Lucy D. Slowe
Dean of Women[23, 24]

She was unwavering as she cited numerous examples of her exclusion from decision-making situations. For Slowe, impartial treatment—especially regarding salary—when compared with other deans whom she listed was not negotiable.[25]

Johnson, actually disturbed by both Slowe's approach to the Board of Trustees and the tone of her letter, replied to her, requesting documentary evidence concerning her status as Dean of Women. She wasted no time, responding the next day

I am writing to say that all matters pertaining to status and conception of my position were discussed by Dr. Durkee and me in his office. I assumed that as President of the University, he spoke with authority. We went over the whole question of scope of work and meaning of the position . . . and agreed that I should have the standing and status of other deans on "The Hill" which status was already established for Dr. Parks.[26, 27]

New Residence Halls for Women

Despite controversies with President Durkee and the Board, Slowe had also been directing her attention to perhaps her most urgent concern—designing new residence halls for women. Creating the Women's Campus, to consist of three buildings, had occupied most of her waking hours for the nine years she had been at Howard. She was sentimental about Miner Hall where she lived as a student. Yet, ". . . her extremely fine sense of fitness and proportion enabled her to know that dear old Miner Hall was no longer adequate."[28] Wanting nothing but first-rate facilities for her girls, she conferred with a number of people, among them Dean Thrysa Amos[29, 30] and Howard University Architect Albert Irvin Cassell.

As the buildings were being readied for occupancy, Slowe shared the good news with Thyrsa Amos and sought her advice in a December 12, 1930, letter.

Each dormitory is to house one hundred women with a separate dining room. I am thinking of heading each dormitory with a college woman who has had some training in personnel work and of having a housekeeper for each one who not only knows the practical business of housekeeping, but who has some ideals of household management which can be imbibed by the girls.[31]

Amos replied within a week.

I do think that you should have a college woman at the head of each group, one of real refinement and one of real culture, who would give as much by *being* as she would by doing. Perhaps a general housekeeper for the three would be better than having a housekeeper for each one, but a general housekeeper with an assistant to the dormitory director might be a good idea . . . the assistant to have certain training in institutional management which would be valuable and at the same time certain training in work with people which would be equally valuable to the head of the houses.[32]

To receive this kind of advice from a person of Amos' stature was remarkable. Amos has been called "The Dean of Deans."[33] Much of Amos' philosophy can be seen in Slowe's initiatives at Howard, as she was one of Slowe's closest friends in the profession.

On March 13, 1931, Cassell, who had been conferring with Slowe, submitted to President Johnson detailed information on the obligations of the university about the dormitory project. He addressed first the framing of a contract for those portions of the expenditures for which the university would be responsible out of its private funds. He then outlined how Dean Slowe had worked with him over several months and consulted with the Division of Institutional Management of Columbia University regarding minimum personnel required to operate the buildings. Also, he gave a detailed analysis of anticipated revenue and expenditures.[34] A person of stature at Howard, Cassell was a graduate of Cornell University and head of the Department of Architecture. He had joined the faculty in 1920.[35] Several years earlier, he had designed—with William A. Hazel—the university's home economics building, the university's gymnasium, armory and athletic field, and, the College of Medicine building.[36]

On June 5, 1931, the cornerstones for the new residence halls for women were laid,[37] and Slowe spoke. What an extraordinarily thrilling moment that must have been for her. She felt as deeply about the residence halls for women as she felt about the university at which they were located. Because her concern about the young women who would move through those halls

was deep-seated, she reached way back into her treasure chest of values and summoned her long-held emphasis on character. She said,

> The great purpose of this educational institution—the awakening of a new spirit of mind, a new mode of thought, a new standard of life, a new vision of light—can be achieved only by putting in place in the life of each student the cornerstone of unselfishness, generosity, of truthfulness, courage, righteousness and high endeavor. It is for us to lay our spiritual and intellectual cornerstone in the lives of the students of Howard University as artistically, as durably, as this stone is laid today.[38]

Dean Slowe emphasized how important it was to educate young people. She declared that, within the new buildings, the ultimate purpose of education would be experience in harmonious group living on the highest possible plane. Therein, constant building of a more difficult nature must go on.

As if an answer to prayers, three new residence halls—called Dormitory #1, Dormitory #2, and Dormitory #3—were completed and became the New Women's Campus.

Turning her attention to the formal opening of these residence halls, in December Slowe summoned her female network for assistance. She asked the members of the Faculty Women's Club to provide articles that would be most needed by the women students—tea sets, punch bowls, punch cups, magazines, [and] newspapers. . . . She also told them she was giving a tea on December 5 at her home in Brookland.[39]

Evidently her friends complied, for *The Hilltop* dated December 10, 1931, carried four front-page headlines: "1500 attend Opening of New Dorms;" "Floral Gifts Received from Friends of the University;" "Real Festive Air Prevails;" and "Dean Slowe, Assistants and All Girls Act as Hostesses."[40] Without question, it was an occasion worthy of celebration.

Dean Slowe's Annual Report for 1931–32 reveals the great expectations she had for high-quality residential life. Although she had seen to it that the buildings met modern standards for college residence halls, she had another challenge. She wanted to make sure that

> the dormitories have been organized and operated on the philosophy that: 1) the dormitory properly managed is a laboratory for practical education in human relations; 2) group life will express itself best through flexible organization; 3) the test of the success of the organization is not that nothing irregular happens, but whether or not the group is learning individually and

collectively to think and act with conviction and is teaming to meet problems with intelligence and good judgment.[41]

A student government organization was established in each building in order to move responsibility to the place where it belongs—"on the student"—and to give the greatest possible freedom for development. She intended to foster—through students and faculty working together—a means of educating students in intelligent self-direction.[42] In outlining significant achievements for 1931–32, Slowe added,

> For over fifty years women students had been housed in a barracks-like building which was in no way conducive to inculcating proper living standards in a group which needed training in the refinements which should characterize a well-ordered home. It is especially gratifying to the Dean of Women to be able to report that after nine years of pleading for adequate housing facilities for women, they have now become a reality.
>
> Howard University now has residence halls second to none in the country so far as arrangements of space and completeness of conveniences are concerned. The standards for student housing in the University will be copied by many schools throughout the country to the great advantage of students everywhere.[43]

When the question of naming the new women's residence halls surfaced, Kelly Miller—regarded by some as "Howard's most distinguished faculty member"[44]—thought that alumnae should be considered, and so he offered to the President the name of Lucy Slowe. He wrote on February 9, 1932, that

> [i]t is most appropriate that any University should hold up its own graduates for exemplification of those who are to follow. Dean Slowe's name can hardly be overlooked in this connection. Looking at the matter wholly impersonally, the basic principle, aside from personalities, cannot be gainsaid.
>
> Lucy D. Slowe, Dean of Women, is without doubt the leading alumna of Howard University. By consensus of disinterested opinion, she is regarded as perhaps the most effective and influential colored woman now functioning in the sphere of higher education. As head of the Women's Department of Howard University, she has the signal opportunity of impressing the better and finer phases of life upon intelligent Negro womanhood and of giving that department of Howard University

place and recognition in the sisterhood of American female and coeducational colleges. There is no feature of our work that is more important than this. How well she is fulfilling this function is a matter of record and common report. . . .

"The Lucy Slowe Hall" would be most inspirational to the great body of Howard alumni, and most especially to the female contingent thereof.[45]

The leading alumna of Howard University? The most effective and influential colored woman now functioning in the sphere of higher education? A recommendation with these superlatives—coming from a member of the faculty—enlarges the ovations Slowe was receiving from students. Yet, although Miller had been on the faculty for nearly forty years, his influence was declining,[46] which probably explains why there is no record of President Johnson's reply or reaction to the letter. In the end, the powers that be did not name one of these residence halls for Lucy Diggs Slowe.

Finally, three names were selected: Truth, Crandall, and Frazier. Sojourner Truth was a zealous African-American abolitionist, and Prudence Crandall was the white founder of a school for colored girls in the 1830s. Julia Caldwell Frazier had been a teacher and civic leader.[47] She graduated from Howard University in 1887 after taking literary courses and received additional education at a school in Martha's Vineyard, Clark University, Tuskegee Institute, and Columbia University.[48]

The academic year 1931–32 ended with Dean Slowe insisting on adequate staffing in two residence halls. She had previously raised the question of requiring all young women whose parents did not live in Washington to live in the residence halls. There were more girls registered for housing in the fall of 1932 than could be accommodated in one of the buildings; the other two had no staff.

Dean Slowe wrote in her 1931–32 annual report that the residence halls were centers of "cultural activities which strengthen and extend the influence of the classroom." They were focal points for "social intercourse of the highest order to provide valuable lessons in cooperative living, and to stimulate high academic performance."[49]

As the 1932 Summer Session ended, an article appeared in the local African-American press—*The Afro-American*—about self-government in the new residence halls. Reporting on the first year of life in these buildings, the headline read "Howard Women Run Themselves in New Dorms,"[50] and it also described the buildings, both interior and exterior.

> The women students living in the dormitories have been organized to function under "A Student House Government Association"; the whole responsibility of the conduct of life rests with the

students themselves. For freshman women, the mentor system is used in order to simplify adjustment in the difficult first year period. . . . From five to ten freshman women are assigned to each mentor for guidance.

According to a statement made by Dean Slowe, scholarship results indicate that at the end of the first year of living in the new residence halls, those women living on campus have a better chance for study than those living off campus.

The Dean of Women at Spelman College, a school for African-American women in Atlanta, Georgia, commented in a letter to Dean Slowe on November 12, 1931, that "I have been hearing glowing reports about your new residence halls and how much they will mean to the development of your campus life at Howard. I think you have done a big job to get such first class equipment in your school. You have set high standard; which many of our institutions need to follow."[51]

Lucy Slowe's prediction that the women's residence halls would become models for higher education was being realized. They had generated a great deal of interest and had helped to raise the visibility of Howard University. Harriet Hayes, a faculty member in the program for Advisers of Women and Girls at Teachers College, Columbia University, asked for photographs and architect's sketches of "the very practical closet-wardrobe lavatory arrangements in the new student dormitories." Hayes was preparing an article for *American School & University* on good features of new residence halls.[52] *American School & University* served school and university administrators responsible for construction, design, planning, retrofit, operations, maintenance, and management of educational facilities.[53] Slowe wrote Hayes that the photographs would be sent in a few days and added, "I am glad that Howard University had something which you thought worthwhile."[54]

In February, 1932, Slowe showed off the buildings to delegates who attended NADW's 16th Anniversary Session in Washington, DC. Framed by the three new buildings, the gathering is pictured on the Howard women's campus. (See Gallery #3).[55]

Even President Johnson boasted about the new residence halls. Writing to the alumni, he said, "The University this year [meaning 1932] will celebrate her birthday by dedicating three new women's dormitories which have been recently erected at the cost of $770,000. These dormitories were opened for use at the beginning of the current school year and are said to be among the best equipped dormitories for Negro youth in the United States."[56]

Shortly after the residence halls opened, Johnson—on Dec. 12, 1931[57]—asked Dean Slowe to draft a reply to a letter from a young woman who was seeking a job at the University. He was considering recommending

her for a position as educational director for one of the buildings. The nature of this request seemed to irritate Slowe, for she replied *directly* to the applicant and sent a copy of her reply to Johnson. Further, on December 16, 1931, she wrote to the president, calling his attention to "the policy expressed by the President that Deans would recommend personnel for their divisions."[58] Apparently Slowe's letter prompted President Johnson to raise questions about the work of the Dormitory Directors. Dean Slowe replied that each director taught a course in the Department of English and had a special assignment, contrary to the president's assertion. She further indicated that the young woman applicant did not have the qualifications for the position as educational director, neither by training and experience nor study in the personnel field. Furthermore, she had neither experience with college women nor teaching experience.[59]

Prior to the opening of the buildings, Dean Slowe had requested the Board of Trustees to require that all women whose families were not in Washington to live in the residence halls, but the Board ignored the request. The residence halls for women had been open for a year, and the Board still had taken no action on her request.

The Question of the Girls' Morality

It was not enough for the women students to have a new campus and sparkling new residence halls; they had to be respected. Thus, when Dean Slowe learned that President Johnson, at a meeting of the University Council[60] on February 24, 1932, said that a certain man had asked him if he should send his daughter to Howard, she felt that it spoke volumes about Howard women. She was always alert to comments about Howard women and certainly sensitive to any that were negative. It is reported that the president turned to several men present and asked, "Would you send your daughter to Howard?"[61] To Dean Slowe, that statement was like a slap in the face, so much so that the next day she wrote the president

> Since your question seemed to imply that they should not send their daughters to Howard, I should like to know—What was your reason for asking them that question? Why is it not safe for parents to send their daughters to Howard?
>
> I believe that there are as fine women students at Howard University as there are at any university in the country; indeed, I happen to know that the women are much finer in manners and standards of conduct than in many Negro and white schools. I feel it is unfair to the good name of students of Howard for you to suggest to a group of men faculty that this is not a safe

place for their daughter. If it is not safe for their daughters, it is not safe for sons. If it is not a safe place for our students all of us should find out why it is not and set about immediately to make it safe.[62]

The president's question lends itself to at least two interpretations. One is the suggestion that women students might not be well-protected. It is not known whether the safety of Howard women had been in question. The other—full of innuendo—is that Howard women might be perceived as morally loose. It was not unusual for Howard to be regarded by some as a "party school." Many women students were known to frequent campus dances and movies, theatres on U Street, and fraternity houses on Third Street, NW.[63] In the 1920s and 30s, lots of college students were said to be "neglecting their studies and focusing 'on theatre-going, card parties, dances, all-night sprees, gambling and anything to get a thrill out of life.'"[64] The latter suggestion was Slowe's interpretation of Johnson's question. Obviously, she thought that the president—of all people—should not be asking questions that would disparage his own women students, especially in the presence of a group of men. Although Howard did have a "party" image, it also was regarded as an institution of the highest academic quality. So students partied hard and they studied hard.

The Ovington Incident

A couple of months later, another Johnson-Slowe "war of words" ensued. It was precipitated by the visit of Mary White Ovington of the NAACP. A white woman, she was one of the reformers who had helped found the National Association for the Advancement of Colored People (NAACP) and was thus regarded as a very good friend of African Americans. Apparently, Johnson had extended an invitation to Ovington to be a university guest and to stay in one of the women's residence halls while she was in Washington for the NAACP meeting. She had also written Dean Slowe, whom she had probably known at least since the university's semi-centennial in 1917. To be sure, her outspoken leadership on race relations and participation in NAACP efforts made her a valuable ally. Dean Slowe would have preferred a letter from the president advising her that he had invited Ovington to be a university guest. Although Slowe was available to meet Ovington when she arrived, she arranged for Miss Houston, her assistant, to be there instead.

It seems that on May 17, Johnson and Slowe had a heated telephone conversation about the fact that Houston rather than Slowe had welcomed the guest. Johnson questioned, "Do we have to put everything in writing

before you people over there can understand anything?" Although he indicated that the Ovington matter was settled, he must have provoked Dean Slowe and her assistant, for they pursued it. They were compelled to challenge Johnson with further discussion.

Thus, Joanna Houston, on May 19, 1932, wrote to Johnson that "Between October, 1931 and May, 1932, more than 50 guests have been housed in the dormitory. In no case have names been forgotten."[65] She then cited incidents relating to the handling of guests, such as waiting up for guests to return at night due to the lack of keys and bringing breakfast from the cafeteria for guests who did not wish to go there or who were late. Houston continued,

> In none of these cases has it occurred to me to complain. I consider it a privilege to serve the University in this capacity, despite the fact that all that I have mentioned has been added to a schedule of serving students which permits me no time for either recreation or self improvement—not even on holidays.
>
> I sincerely hope that what I have written will be taken in the spirit in which it is written. I have no complaint to make, nothing to prove, nothing to defend, I am not asking for relief from any of my duties; all that I have done I shall gladly continue and whatever else occasion demands. I feel, however, that efficiency can be greatly hampered and all the pleasures extracted from discharging the many duties here, for which there is no other compensation, if the President of the University fails to understand the conditions under which and the spirit in which we do our work.[66]

Slowe bridled at anything that impugned her dedication to duty. Because Slowe, like Houston, was offended by the president's reaction, on May 25, 1932, she followed up with her own letter to Johnson.

> There is only one phase of the whole matter that is regrettable . . . and that is your apparent anger when you talked with me about the matter over the phone on the morning of May 17th when you received my letter. I do not know why you appeared so angry, but surely you would not have talked with me as you did, had you been composed. You characterized my staff as dumb and stupid; you suggested that I was out of office when I should have been there, in spite of the fact that I teach one hour a day, have committee assignments which take me to various places on campus; and have official duties that sometimes take me off campus just as all other officials have.

You said further that I should be prepared to accept anyone you sent over to the guest room whether their names were Mary Jones, Susie Smith or Sam Squidunk, tobacco chewer and tobacco spitter. While it is true that we have had one man in the dormitory who fitted into the last category, I saw no reason for referring to him on this occasion.

It has been my experience that in dealing with my associates, courtesy and forbearance are more conducive to harmonious work than vituperation and scolding.[67]

Johnson wrote to Slowe on May 26, 1932, that "It seems that all of the courtesies in connection with Miss Ovington's coming have been carefully taken care of by Miss Houston."[68] Apparently the president's letter ended the discussion.

The Tancil Incident

In the academic year 1932–33, incidents that tested Dean Slowe's relationship with the top administration seemed to have picked up where they left off in the previous year. Take the case of Elaine Whitney Tancil, who had been appointed to a staff position in a residence hall in 1931.[69] She was not reappointed in 1932, supposedly because of a decline in student enrollment. Slowe wrote to the president on November 11, 1932, that Tancil had given up a permanent position at another school to accept a position at Howard.[70] In a five-page letter to Johnson, she wrote, "The Tancil non-reappointment on the basis of enrollment is the only case in which enrollment has resulted in personnel reduction."[71]

Prior to addressing the Tancil case, on November 25, 1932, she had asked Sarah Sturtevan—Professor at Teachers College, Columbia University—to do her a favor by discussing the Tancil case with Thomas Jesse Jones, a member of the Board of Trustees.[72] Sturtevant had, no doubt, been one of Slowe's Teachers College professors and, surely, was a leader in NADW. She was one of the scholars who had initiated the Teachers College program for preparation of deans of women, a recognized authority in the field of student personnel work, and one of Thrysa Amos' allies.[73] Jones, a white minister, had been elected to the Board in 1915.[74] Now in New York, he was an influential executive of the Phelps-Stokes Fund, and he was an outspoken member of the Board.[75] Established in 1910, the Fund he was leading was a foundation that "manifested a special though not exclusive interest in Negro education. It gave considerable attention to the improvement of existing institutions of proved experience and assured stability, and made specialized

studies of educational institutions and problems, the results of which would help plan future educational programs."[76]

Jones had a related connection to Dean Slowe, that is, through her community activities. He might have known that Slowe's National Association of College Women's (NACW) Standards Committee had built its work on the shoulders of a report he had authored around 1916. The Committee cited his finding that "Of thirty-three institutions of supposed college grade, only *three* were given a college rating; the other thirty were almost equally classed as 'college and secondary institutions' or merely schools in which a few college subjects were taught."[77] To be sure, Jones was aware of—and possibly sympathetic with—Dean Slowe's goals at Howard and perhaps for higher education of African Americans in general.

Perspective on the Tancil Case can be drawn from actions taken by the University to adjust to the impact of the Great Depression that was weighing heavily on everyone's mind. The *President's Annual Report to the Secretary of the Interior for 1931–1932* ". . . made the first reference to the effects of the Depression. Under normal conditions, an enrollment of 2,781 students would have been expected for that year; because of the Depression, the total enrollment reached only 2,464."

> The effects of the Depression were even more evident in the President's *Report for 1932–1933*. Enrollment fell 571 below that for 1931–1932; the University suffered loss in income from the Federal Government and from private sources. Heavy curtailments of planned expenditures were made in materials and in educational and scientific equipment. Teachers' salaries were reduced and reductions in teaching personnel became imperative.
> Since the Federal Economy Act of March 20, 1933, reduced salaries, the Executive Committee [of the Board of Trustees] on October 14, 1932, had voted that employees of Howard University would have to accept a reduction of 8 1/3 percent in salaries. . . .[78]

Additional evidence of the Depression's impact on the university is found in Slowe's papers. They include a letter from Johnson dated July 5, 1932, calling a meeting for Thursday, July 7, for all ". . . those members of the university family who, along with me, have suffered some loss of payment in connection with their salaries for the month of June. . . .[79] Presumably, he intended to share information about finances with the university employees.[80]

The Chairman of the Board of Trustees, Abraham Flexner, wrote Dean Slowe about the Tancil case on November 25, 1932, that "The matter is one which I believe will be handled justly by both the President and the Executive Committee at their meeting today."[81]

A week later, Slowe wrote to Johnson. She argued for justice and fairness. She said that she had been *first* informed of Miss Tancil's case on November 5, 1932. There were more young women than "Dormitory # 1" (as the buildings were first known) could accommodate and yet not enough to fill "Dormitory # 2." Eventually, Tancil was reappointed but at less than half the salary she had earned the previous year, whereupon Dean Slowe protested the salary reduction.[82]

Another view of Tancil—who was in charge of dormitory #2—surfaced in an article in Slowe's scrapbook. It stated that Tancil's ". . . rules governing conduct at meal hours riled male freshmen and sophomores. . . . Her rules indicated that men wear coats instead of sweaters at table, clean their shoes before entering the room, and park books, papers, and pencils on the outside."[83]

The women's campus, with three sparkling new buildings, was the talk of the campus, indeed of the nation. It was the culmination of one of Lucy Slowe's struggles. Despite this recognition, the dean was not satisfied that the administration—the president and Board of Trustees—understood her actual role.

Slowe and the Board of Trustees

In the 1930s, two men who would play a major role in the Slowe-Howard University administration conflicts over the next several years had been elected to the Board of Trustees in the person of Abraham Flexner, who was a Jew, and Channing Heggie Tobias, an African American.

Elected in 1930, Flexner became Chair of the Board on April 19, 1932. With Howard University under supervision by the U.S. Department of the Interior, Flexner was able to meet with the Secretary of the Interior, who—for much of the time Flexner was chairman—was Harold Ickes. Flexner chaired the Board "during one of President Johnson's most controversial periods."[84] Born in 1866 in Louisville, Kentucky, he was an educator who had graduated from Johns Hopkins University at age twenty. After nineteen years as a secondary school teacher and principal, he took graduate work at Harvard and at the University of Berlin. In 1908 he joined the research staff of the Carnegie Foundation for the Advancement of Teaching and, in 1910, wrote a report, *Medical Education in the United States and Canada*, which is generally known as the "Flexner Report." He was highly regarded for this report as it hastened much-needed reforms in the standards, organization, and curriculums of American medical schools. From 1912 to 1925, Flexner was a member of the General Education Board, serving as secretary after 1917. He was director of the newly organized Institute for Advanced Study at Princeton at the time he chaired Howard's Board.[85]

170 Faithful to the Task at Hand

The other man who would be powerful was Channing Heggie Tobias. Elected to the Board in 1931,[86] he served for twenty-two years. Regarded as a "... 'Christian statesman,' ... (and) noted for his ability to calm ruffled waters,"[87] he was born in Augusta, Georgia, and went to school there. He earned a BA from Paine College in 1902, a BD from Drew Theological Seminary in 1905, and did special work at the University of Pennsylvania. Gammon Theological Seminary conferred on him the honorary degree of Doctor of Divinity in 1924.

Most of Tobias' career up to this time had been devoted to the YMCA that he joined in 1911. Previously, he spent six years as professor of Bible Literature at his *alma mater*, Paine College. He had also served for twelve years as student secretary of the International Committee of the YMCA. He was appointed as senior secretary of the YMCA's Colored Work Department in September, 1923, a position he held for twenty-three years, when the YMCA abolished separate programs for African-American men. During those years, he also held a number of other YMCA positions relating to race relations, including member of the Executive Committee of the National Interracial Conference and associate director of the Commission on Interracial Cooperation. He was a delegate and a speaker at the 1926 World Conference in Finland and traveled to YMCAs throughout the world during his career.[88]

To gain perspective on Flexner's role as Chair of the Board, it is necessary to introduce information about a major issue in which the university was embroiled in the early 1930s. Howard University came under investigation by the Department of the Interior, related first to the specter of Communism involving its president and then regarding inappropriate use of federal appropriations. Moreover, Representative Robert S. Hall of Mississippi charged that "'continuous tumultuous' conditions existed at the University as evidenced by frequent resignations and 'violent separations' of important members of long standing, all this reportedly due to the 'arrogant and overbearing disposition' of President Johnson and 'his meager experience in executive and educational matters.'"[89] On a visit with Secretary of Interior Harold Ickes on October 25, 1932, in his attempt to retain the Department's "... 'confidence and goodwill he [Flexner] expressed the feeling that orderliness and good will must prevail on the campus among all connected with the University.'"[90]

Signing a Letter during Investigations

Possibly related to the federal investigations, Slowe received a different type of request from President Johnson, dated February 24, 1933.

Mr. E. W. Martin, Director of the National Allied Democratic Advisory Council, transmitted to President Hoover under date of February seventeenth, a letter in which he spoke of a matter which has been brought before this Council from a Committee of the Faculty of Howard University, wherein charges of mismanagement, malpractice, misappropriation of funds and padding of payrolls have been made and Mr. Martin over his signature has given your name among others as witnesses.

The Office of the Secretary of the Interior is requesting certain action on this matter not later than today. In order that our reply to the Interior Office may be as accurate as possible, will you please advise: (1) Whether you have united with or do unite with the National Allied Democratic Council in making the above charges and (2) Whether you have authorized Mr. E. W. Martin, Director of that Council, to certify your name to the President of the United States as one of the witnesses in support of said charges.

Please favor the University by letting me have your written reply today.[91]

As requested, Slowe replied that day. "I am writing to answer 'No' to both of these questions."[92] The Secretary of the Interior, to whom Mordecai Johnson reported, was Ray L. Wilbur.

Flexner's correspondence hints that he and Johnson were of one mind when it came to conducting the affairs of the university. If President Johnson was described as arrogant and overbearing, Abraham Flexner seemed to be prone to similar behavior. Flexner's *modus operandi* had become clear in correspondence he conducted in February 1933, with Dr. Sherwood L. Catlett, president of the Howard Alumni Association. He wrote that

I do not believe it is your function to deal directly with members of the faculty—forgive me for being so candid. In my judgment, no small part of the trouble at Harvard [sic] University is due to the fact that there are entirely too many "cooks!" I believe that any communication which you wish to make regarding strictly University matters should be sent either to President Johnson or to me. As long as members of the faculty feel that they can go over President Johnson's head or my head with a grievance or complaint, there will be discord which I am sure is the very last thing you would wish. . . .

There is a further fact, namely, that the most serious difficulties at Howard are difficulties of which I believe that you

and the alumni are in total ignorance. . . . I welcome your cooperation, but you will not cooperate with me if you remain in private communication with members of the faculty individually, be they right or wrong. I suggest, therefore, that if any member of the faculty has told you that he does not feel free to talk, you refer that communication or any subsequent communication to me, and you may be sure that I will see to it in the proper way that men are enabled to tell what they know![93]

Catlett replied

Your letter of February 24 in which you make the amazing statement that what concerns the faculty of Howard University is none of my business, has been received. You would not have written such a statement to the President of the Columbia Alumni Association or the Princeton Alumni Association. You would have more respect for their opinion. I would have you know that as President of the Howard Alumni Association, I have as much right to be concerned with the affairs of my Alma Mater as a Columbia man or a Princeton man has to be concerned about his. . . .
 We as the constituted body of graduates whose degrees are valuable or not as the reputation of the University is good or bad, have a perfect right to talk to anyone at the University on the condition of affairs there, and we intend to exercise that right. We intend further to insist upon freedom of speech for the faculty which is their right.[94]

 Catlett's reply suggests—in referring to Columbia or Princeton—that he regarded Flexner's response to be racist. Certainly, Flexner's disdain was apparent.
 Flexner, according to an editorial in a paper (source not given) dated March 24, 1933, is alleged to have made a statement at the Charter Day Dinner, an august event that the university holds annually in March to commemorate the institution's founding. He said, "Howard must live up to the standards of excellence to which other universities are held—desiring no help or suggestions from underlings within the University or alumni without."[95] The editorial pointed out that Flexner wished the public to withhold judgment about administrative decisions until a study was completed. A question arose about the nature of the study and who was undertaking it. There is neither a record of who raised the question nor of Flexner's reply.
 Time and time again, Slowe's requests to the Flexner Board fell on deaf ears. Some of her petitions pertained to the fostering of student life. She

submitted on February 3, 1933, three requests to the Board.[96] First, "That the Trustees pass legislation to require all out-of-town students to live in the women's dormitories unless they have legal guardians in the city." Although this was not the first time she had asked for this ruling, the trustees still refused to support her position. Secondly, she asked "That the charges for heat, light and power used in the dormitories not be charged to students and thus reduce the cost of dormitory living." Thirdly, she asked "That 100 dormitory scholarships for new students at $90.00 each or the cost of room rent be made available for new students." There is no record of the Board's action on the last two petitions.

It is clear that the Depression was taking its toll on both the university's ability to secure needed resources and on students' ability to pay their way. Yet there is no evidence that policy changes brought on by the university's financial difficulties were shared with the Dean of Women.

The Dean and the Treasurer

With regard to Slowe's own authority, the Board of Trustees brought about a major alteration in the operation of her office by transferring responsibility for the physical upkeep of the residence halls and the operation of the dining halls away from the [Dean of Men and the] Dean of Women to the university treasurer. Johnson wrote Slowe on February 16, 1933, ordering the change. "The Treasurer will take over the management of the dormitories on March 1, 1933," he wrote, "in accordance with Article 3, Section 5 of the new by-laws of the University defining the duties of the Treasurer."[97] This was a reversal of the 1931 advice on management that Thyrsa Amos had given Slowe prior to the opening of the residence halls. The Board had appointed Virginius D. Johnston as treasurer effective January 1, 1933.[98] The affected personnel included the housekeepers, janitresses, and others working under the direction of the housekeeper in the residence halls, and the dietician, steward, clerk, cooks, waitresses and other people engaged in similar duties in the dining rooms. President Johnson asked Slowe for any "constructive" suggestions relating to the transfer. That very day, Slowe replied that she found it impossible to formulate an opinion concerning the transfer within five or six hours and requested a delay in the action.[99] No delay was granted.

The issue of the treasurer's management of the residence halls escalated. Slowe, replying to Johnson's request for suggestions, on March 11, 1933, sent him a five-page tome in which she protested the action and pointed out that there was no deficit in food services and that experts in the student personnel field supported the original plan for administering the women's residence halls. She cited Sturtevant and Hayes' book titled

Deans at Work as well as her personal visit to the Institutional Management Department of Columbia University. She laboriously traced the development of the residence area at Howard, citing actions approved by the Board, and asked to appear before the Board's Executive Committee.[100]

What can one do when one has been made to feel unimportant or worthless? One can fight back, and so she did. With the evident disempowerment of the Dean of Women, Lucy Slowe, not prone to retreat from controversy, sent a letter on March 24, 1933, about the conception and status of the Dean of Women, not to Johnson, but directly to the Executive Committee of the Board of Trustees. The Executive Committee—chaired by Jesse Moorland—was empowered to manage the affairs of the University between meetings of the board, including power to manage the budget.[101] The content of this letter was the same—in fact, it was a duplicate—of the one she had asked Johnson to present to the Board two years earlier on the same date in 1931.[102]

Jesse Edward Moorland had been a member of the Board of Trustees for twenty-six years. "He was a member of the Executive Committee . . . and Chairman of the Committee after December 1932." He was an African-American minister, an alumnus of Howard's Theological Department, a community executive, and a civic leader. Born in 1863 in Coldwater, Ohio, he was the only child of a farming family.[103] As one of two black international secretaries of the YMCA's Colored Men's Department, he was well-known for fund-raising campaigns for $100,000 YMCA buildings in Washington, Chicago, and Philadelphia.[104]

In response, President Johnson reported the Board's action to Slowe. He wrote on March 27, 1933.

> The Trustee Committee on Instruction and Research is being requested to more definitely define the duties of the Dean of Men and the Dean of Women.
>
> The President requests by April 3—
>
> 1. A copy of any definite statement which you have received from time to time from the Board of Trustees, defining or describing the duties of the Dean of Women.
> 2. A statement setting forth in exact language—the definition of the duties of the Dean of Women which you would like to have adopted as the official definition of the Board of Trustees.
>
> If you care to submit, in addition thereto, a memorandum justifying your definition, I shall be glad.[105]

Dean Slowe's reply was dated April 3, 1933.

I am sending herewith information on the duties of the Dean of Women at Howard University which you requested for the Committee on Instruction and Research of the Board of Trustees. This information is needed as a result of questions raised over the relation of the Treasurer of the University to the management of the Women's Residence Halls.

In order that we may keep before us the point at issue; namely, what is meant by "management of dormitories" in Article III, Section 5, which defines the duties of the Treasurer, I wish to make the following statement:

1. The Treasurer's relation to the Women's Residence Halls shall be a financial one; that is, he shall collect all charges for room and board; he shall sign all contracts for food and supplies; he shall call for and receive, through the Dean of Women, such reports as he shall deem necessary in connection with his office.
2. The Dean of Women shall have sole charge of all personnel in the Women's Residence Halls; that is, she shall recommend them for appointment or dismissal, and they shall be responsible to her for the performance of their duties.

I believe that this arrangement is logical and that it will result in the efficient management of the dormitories from every point of view. It places financial responsibility with the Treasurer and makes the Dean of Women responsible for the people who must touch the students in their daily life.

Passing from this specific question to the general question of the duties of the Dean of Women, I am enclosing herewith, at your request:

3. A copy of the agreements entered into by Dr. Durkee and me before I accepted the position of Dean of Women at Howard University.
4. A copy of the letter, under date of May 2, 1923, sent by Dr. Durkee to all Deans in the University stating that I had been appointed Dean of all the women in the University.
5. A copy of the letter, under date of May 2, 1923, which Dr. Durkee sent to me stating to me definitely that I was called to Howard University as Dean of all women in the University and giving me authority to consult with the women students and call them together whenever I saw fit.
6. An outline of my duties submitted to the Executive Committee of the Board of Trustees at their request on December 9, 1925.

7. A copy of the letter from the Executive Committee under date of July 13, 1931, authorizing me to recommend for appointment all personnel in the women's dormitories.
8. A statement setting forth in language customary in connection therewith a definition of the duties of the Dean of Women.
9. A memorandum justifying this definition.[106, 107]

Insubordination

On the heels of her letter to the Executive Committee, Slowe received a note from Flexner accusing her of insubordination. He wrote that

> Dr. Moorland has brought to my attention that you have disregarded certain requests or orders from the Executive Committee. . . . I beg you to be on campus next Thursday so that you may be able to appear before the Board whenever you are summoned. . . . I am sending a copy of this note to Dr. Johnson, with whom, however it does not originate. It originates with me."[108, 109]

Considering Flexner's correspondence with Catlett as precedent, this method of dealing with Slowe is demeaning but not surprising.

Immediately upon receipt of Flexner's letter, April 8, 1933, Slowe sent him a telegram. "Received your letter of April 7 and will comply with request. To date, I have not at any time disregarded requests or orders from any Trustee Committee."[110] Slowe interpreted the clause—"you have disregarded certain requests or orders"—to mean she was being tried for insubordination. No information could be found regarding what transpired regarding this matter at the April 14 Board meeting.

Flexner's next request—April 14, 1933—was for a copy of the letter that President Durkee had sent to Lucy Slowe setting forth the terms on which she had been invited to be Dean of Women.[111] Four days later Slowe sent Flexner a copy of the memorandum that she had sent to Durkee prior to accepting the position in 1922. Excerpts follow.

> You will note that Item Four in an agreement expressly states that I should not be required to live on the campus. If there had been any mis-statement of the agreements in the conference, Dr. Durkee would have informed me on receipt of my memorandum.
>
> As I stated to you and Dr. Moorland, I was persuaded to come to Howard University because the President thought that

the difficult task of organizing and directing the interests of women students should be done by an alumna. . . .

I am also sending you an outline of the standard duties of the Dean of Women and a memorandum explaining some of them. Columbia University assisted in setting up my office and has aided in its direction during the eleven years I have occupied it. . . .

I wish to thank you for giving me the opportunity of explaining the situation to you and your sympathetic attitude and fairness in settling the matter once and for all. I wish to assure you of my desire to do every thing in my power to promote the best interests of Howard University.[112]

Flexner's response on April 24, 1933, to Slowe's April 18 letter was in two parts. The first related to the powers of President Durkee and the second to news reports of Dean Slowe's meeting with him and Moorland. The first part raises the issue of the termination of the services of Dean Slowe and the second the requirement that the Dean of Women live on campus.

My attention has been called by counsel to the fact that Section 7 of the Act of Incorporation of Howard University gives the Board of Trustees the power to remove any professor, tutor or other officer whenever in the discretion of the Trustees such action is required in the interests of the University. While nobody is thinking of removing you, it is plain that President Durkee's letter exceeded his authority and is not binding upon the present or future Board of Trustees.

I examined with interest the material you sent me. . . . I do not think that it is an argument for the position which you take, in as much as Dean Matthews states "It is usually unwise for the Dean of Women to reside in the hall or to be mistress of it." Dean Matthews does not say that it is always unwise for the Dean of Women to reside in the Hall. President Jones of Fisk is distinctly of the opinion that the Dean of Women should live on campus, under the conditions which exist at Fisk University. In other words, every institution is an individual problem. . . . I think it would be hard to justify residence on the part of the Dean of Women at a distance of two miles. On the other hand, I concede that the Dean of Women ought not at the same time, be mistress of a hall burdened with the minute details of the latter.[113, 114]

The second part of the letter referred to the conference with Dean Slowe.

> I was a good deal surprised to learn that the interview between you, Dr. Moorland and myself had been reported in some newspapers in Washington. Perhaps I should say [more] shocked than surprised, I said nothing to anyone. Dr. Moorland gives me the same assurance. Is it possible that you either gave out the interview or told it to someone who did give it out? I am not saying that you gave the interview out directly or indirectly, I do say that neither Dr. Moorland nor I did it.[115]

Several days later, on April 27, 1933, Slowe received another letter from Flexner that included the sentence, "If the persons now connected with Howard University cannot conduct its affairs with the dignity that is characteristic, we will say of Fisk University, we have no other recourse except a change in personnel."[116]

Lucy Slowe prepared what appears to have been a draft of her reply to Flexner that reveals the impact his letter had on her.

> I have your letter of April 27th and have carefully read its contents. I regret very much that you doubt the accuracy of my statements, but I wish to affirm their truth.
>
> In order to keep the record straight, I wish to relate in detail what happened after I received your original letter of April 7. In that letter certain statements occur:
>
>> "Dr. Moorland has brought to my attention that you have disregarded certain requests or orders from the Executive Committee.
>> "I beg to ask you to be on the campus next Tuesday, so that you may be able to appear before the Board whenever you are summoned."
>
> When I read the statements, I knew that I was about to be tried for alleged insubordination. Quite naturally, I was perturbed over so serious a charge and over having to appear before the Board to defend myself. My professional reputation, built-up over twenty years, was at stake. . . .[117]

Slowe's indignation is unmistakable. Apparently, a copy of Slowe's earlier draft letter did reach Flexner, for he wrote on May 11, 1933, "How in the world could you have interpreted my brief letter as meaning that you were to be tried for alleged insubordination passes my comprehension. . . . And now may I say in conclusion that if you are wise, you will do everything in your power to cultivate on the Howard campus an entirely different spirit."[118]

Physician for Women

Upon learning that the physician for women students—Dorothy Boulding-Ferebee—would not be retained, none other than the women students of the University wrote a letter on May 2, 1933, to university officials asking that they reconsider. Flexner replied two days later to "Miss Upshaw," presumably the student who headed the student group.

> In the last resort, Howard University, like any other university worthy of the name, has got to be conducted by those who are responsible for its solvency. If you and your associates could raise the money for an additional assistant I assume the board of trustees would accept it. As far as the board of trustees is concerned we are doing everything in our power to be fair and reasonable. Persons who object can withdraw—be they teachers or students.[119]

In a "bitter exchange of letters," the women students replied to Flexner asking for his resignation, and they also appealed to the alumni for support. The May 13 edition of *The Afro-American* followed with a front page article titled "Howard Coeds Fight for Women Doctors."[120] Students reminded Flexner that the "university exists for students" and that if African Americans are to be trained to be leaders, they must be able to express their views. They also cited cases of faculty members who were given severance pay as they departed, despite having "disgraced" the university. Furthermore, they stated that his attitude was tantamount to imposing a regime of "slavery" inasmuch as he insisted upon "thrusting" his ideas upon students regardless of the fact that they were in opposition.

When they asked for advice from alumni, they included a copy of the letter they had sent Flexner and asked if they were "satisfied with the tone of that letter."

The students' action pushed Flexner, on May 12, 1933, to raise with Slowe a question about her relationship with Howard women students.

> Something is certainly wrong in the relationship between you and them (Howard women) if . . . a crowd of girls sends me such a communication as I received from them last week. There could be no stronger evidence of the importance of your being on the grounds and getting their confidence in such wise that they will not take such silly steps without conference with you. . . . The doors of Howard University are open to qualified students who wish to come, as well as for students who wish to go elsewhere if

not satisfied with conditions at Howard University. This applies completely to restoring upon the campus the spirit that ought to animate an institution of higher learning. Immature outbursts can be expected and forgiven. The Howard students and some members of the faculty have done things which cannot be described in these terms.[121]

Addressing the problem, Slowe wrote to Flexner on May 14, 1933, and sent a memo to Johnson. In her letter to Flexner, she wrote,

> May I say that there is the most wholesome relationship between the women of the University and the Dean of Women.
> The case in question was taken up directly by the women of the University with President Johnson and not with the Dean of Women because the officer whose dismissal they objected to was not under the control of the Dean of Women.
> Unfortunately, the two engagements with the President which the young women arranged through his office were not kept by the President, nor was the matter referred to me.
> The facts above stated do, in my judgment, account for much of the present condition. I am giving careful consideration to the case and am enclosing herewith copies of letters which I have sent to the president and to the Chairman of the Faculty Committee on Discipline.[122]

In the May 12 memo she sent to Johnson, she wrote,

> In re: The Women Students' Protest Against the Dismissal of Dr. Dorothy Boulding
> As Dean of Women, I called into question the women whose names appeared signed to the letter sent to President Johnson and to Dr. Flexner on May 3, 1933.
> Those women stated that they made two attempts to have a conference with President Johnson, but were put off both times. They stated further that they received from Dr. Flexner an answer to their first letter which they considered insulting. They stated further that they answered his letter without reference to anyone on the campus because they felt that that was the proper thing to do, since he had written directly to them. They stated further that they received an answer from their letter to Dr. Johnson on May 8, but up to the present time have not been called into conference with him according to their request. They stated further that they sent to Dr. Flexner a petition, protesting

the dismissal of Dr. Boulding and requesting her reinstatement, signed by 307 women.

They explained the fact that they put their letters in the newspaper by saying that they wanted no garbled account of what they were doing to go to the newspaper and they therefore sent their communications to the papers themselves.

The students said that on many previous occasions they have expressed their opinions in editorial form and in other ways and in *The Hilltop* and in other newspapers. They said further that students had not been called to account for such expressions of opinion.

If in the judgment of the President the interests of the university have been harmed by what the students have done, I recommend that he refer the whole matter to the Discipline Committee for investigation and report.[123]

Students had the temerity to suggest that the chairman of the Board of Trustees resign! And they pursued the issue in a letter they sent Dean Slowe on May 17, 1933. The last sentence of Flexner's letter to the group—that "Persons who object can withdraw be they teachers or students" prompted their retort. It was and still is an insult to all students.[124] Flexner's early meeting with Secretary Ickes probably precipitated the angry letter above regarding the women students' grievance. In point of fact, Howard University students were doing nothing unusual; they were at least forty years behind the women students at the University of California at Berkeley who requested a woman physician. (See Chapter 5.)

Regardless of the mounting difficulties at Howard, Slowe had strong support from the registrar, Frederick Wilkinson, as shown in his letter of May 19, 1933. The Committee on Discipline, in the case involving the correspondence that had gone on between the women of the university and Dr. Flexner, voted

[t]hat the Committee on Discipline congratulates the Dean of Women on the splendid way in which she has handled this most difficult situation at this critical period, and it is the unanimous opinion of the Committee on Discipline that nothing more should be done in this case and considers her handling of the case as final.[125]

In June, the Board of Trustees did abolish the position of physician for women. Yet the issue did not stop there. Five months later, in October 1933, Lucy Slowe's NACW sent a letter to the Board requesting that a woman physician be employed at the university.[126]

Live on Campus

At the same time as she was defending herself against the charge of insubordination, another issue resurfaced. On May 4, 1933, Slowe received a letter from Emmett Scott, secretary of the Board, advising her that "The Trustees voted at a meeting in New York City on April 28, 1933 that beginning with the Academic Year—1933–34, the Dean of Women shall reside on the University Campus, that the matter of providing suitable quarters for the Dean of Women be referred to the Executive Committee with power."[127]

Thus, when the Chairman of the Board wrote to her on April 24, he and other trustees were contemplating requiring her to move from her house, but they did not take formal action until April 28. In contrast to the Board that eight years earlier had ordered Slowe to move, there were at this time more than 20 members, including two women. At least eight of those who previously asked her to move—including Jesse Moorland—were still on the Board.

Dean Slowe responded to Flexner in a conciliatory manner on May 6, 1933, that

> I have received from the Secretary of the Board of Trustees, Dr. Scott, the vote taken at the meeting of the Board on April 28 which requires the Dean of Women to live on the Campus.
>
> Because of the large amount of money which I put into my own home during the eleven years I have been Dean of Women and because of the financial loss which will attend the sale of my home at this time, I regret that the Board of Trustees deems it wise to take the above mentioned action, but I will comply with the wishes of the Board.[128]

Mabel Carney, one of Slowe's acquaintances from Teachers College, Columbia University, wrote Slowe on May 3, 1933. Concerning the controversies in which Slowe was embroiled at Howard, Carney stated that Trustee Thomas Jesse Jones would support Dean Slowe; he was "greatly impressed" with her "personality and ability." Carney advised that Slowe would win her point if "She played graciously for a little time now." Carney's conversation with Jones presumably alerted her to the less-than-accommodating attitude Lucy Slowe was taking in response to the Trustees' orders. Because it was no secret by now that Lucy Slowe was strong-willed, Mabel Carney's admonition was doubtless designed to give "a word to the wise."

Replying to Carney on May 12, 1933, Slowe thanked her for her help. "I appreciate more than I can tell you the counsel which you and your associates have given me; in fact I do not know what I would have done

without you. You may rest assured that I shall do everything in my power to merit your continued confidence."[129, 130]

Where Would She Reside?

Slowe sent a letter to the president dated May 16, 1933 that addressed the controversy over where she should live.

> I submit suggestions to you concerning the choice of a house for the Dean of Women: 1) First Choice—the Kelly Miller House and 2) Second Choice—the Cook House.

Kelly Miller's house was located at the edge of the Howard campus on a corner at 2225 Fourth Street, Northwest.[131, 132] George William and Coralie Cook resided at 341 Bryant Street, Northwest.[133]

> I understand, of course, that the Trustees plan to furnish the house entirely, including all the necessary hangings and linens (except personal linens) and also maintain the house providing maid service, light and power, telephone and the upkeep of the grounds surrounding the same.
> Because of the nature of the entertainment which the Dean of Women is called upon to do for students, faculty and the University's guests, it is necessary for her to have a home of considerable size to accommodate these people.[134]

Slowe was equating a campus residence for her to the type of accommodations that institutions typically provided for their presidents.

The requirement that she reside on the campus prompted a letter from Slowe to the Chairman of the Board of Trustees in which she indicated her investment in her home in Brookland. Immediately, Flexner assured Slowe that the Board would try to prevent any loss in the sale of her home. He wrote that

> I feel sure that the Board will do everything in its power to see to it that you do not suffer financially by reason of the transfer of your residence to the campus, though as you know, I have myself no power to make any promises as to what the Board may do or be in the position to do. . . .
> I should be very glad if you would prepare for me a careful statement setting forth the financial situation in which the

184 Faithful to the Task at Hand

Board places you. Meanwhile, I cannot but believe that your presence in easy reach of women students will enable you to exercise a wholesome influence more effectively than in any other circumstances without violating in any way the privacy to which you are entitled.[135]

Letters of Support

The Washington, DC, community, as well as the higher education community in general, was becoming aware of Slowe's predicament at the University. Undeniably, Slowe had cultivated friendships among some of the most highly regarded individuals in educational administration. Thus letters began to flood the university, in all probability, to the president and Board with copies to Slowe.

Students, alumni, faculty and staff were not the only ones who respected her. She had support in the broader Washington, DC community as well, as noted in these excerpts. In a letter dated, May 12, 1933, her friend, Coralie Franklin Cook, wrote about Dean Slowe.

> All that she has acquired during her pilgrimage from "The Bottom Up" has been transmitted into terms of helpfulness and inspiration for the women and girls committed to her care.
>
> Her goodness follows her horizon's rim.
>
> It is hoped that the present New Deal, seeking a way to serve not only the citizens of color but the nation will find a place in its Bureau of Education or its women's Bureau or wherever else wisdom may dictate where the superior qualities and qualifications of this fine woman may function and bear fruit.[136]

Cook's letter intimates that she is proposing that Slowe would be more valuable and more appreciated and even more appropriately placed if she were hired by the Roosevelt Administration rather than Howard University. Cook could easily make such a proposal as she was well thought of in the Washington community. She had served as a member of the District of Columbia Board of Education for twelve years beginning in 1914.[137]

Roscoe Conkling Bruce, another Slowe ally, writing "To Whom it May Concern," on May 15, 1933, emphasized Slowe's personal loyalty to Howard, and he said he considered Dean Slowe "a woman of intellect—rich in initiative, steadfast in her basic convictions; . . . can not be constrained by fear or favor to say one word that she does not believe justified. . . . She is no sycophant."[138]

Sarah Sturtevant also supported Slowe by writing on May 15, 1933, that

Dean Slowe is appreciated for ability, wisdom and vision. Outstanding in policy and practice as to demand the respect and support of those who are interested in the development of fine community life for the girls and indirectly the boys on the campus of Howard University.[139]

She continued,

My initial meeting with Dean Slowe occurred at a meeting of the National Association of Deans of Women in Cleveland in 1923. Dean Slowe spoke on race relations—a speech that won the respect and consideration of those present. The National Association of Deans of Women regarded Dean Slowe as the outstanding Dean of Women in Negro Colleges. The Deans of Women are familiar with the fine work which is going on at Howard University and appreciate Dean Slowe personally for her ability, wisdom and vision.

Dean Slowe's efforts at Howard University to provide the women at Howard with counsel, opportunity and direction, as in the best colleges and universities, are commended.[140]

On May 11, Slowe had asked Carney to give her opinion of her "work with women and in the field of Education."[141] Carney concurred with Sturtevant.

Miss Lucy D. Slowe . . . stands well to the top of her particular phase of education when compared with the best white women in the same field. . . . One reason for Dean Slowe's outstanding leadership is her broad and varied experience in the education of women. Another is the special preparation and unceasing study she devotes to her work. Still a third is to be found in her pleasing personality, good poise and rare judgment. . . . I commend her whole record and achievement most heartily.[142]

Concern About Her Tenure and Use of Her Network of Supporters

One might wish that Slowe's only worries were Board confrontations and women student petitions. Not so. She was also faced with the question of her own tenure. Were the actions of the Board and those of the president initial efforts to remove her from the position of Dean of Women? To clarify her status in the student personnel field and among deans of women, Slowe corresponded with respected leaders in her profession. One was Thrysa Amos,

with whom she corresponded at length. Slowe asked her to write a letter that could be used to substantiate her standing among deans. The two of them exchanged drafts until Amos produced a statement that satisfied Slowe. In one of their exchanges, Slowe asked Amos—in a revision—not to spell 'negro' with a lower case 'n' but rather to capitalize it thus: "Negro."[143] In her final version, Thrysa Amos, president of NADW, wrote on May 19, 1933:

> The Negro Dean whose work is most outstanding is that of Lucy D. Slowe of Howard University. I have known her for a number of years and have followed her work at Howard and in the National Association of Deans of Women with great interest and delight. Her intellectual appreciation, her breadth of view, have won even those who might have had some reservations [or] racial attitudes.
>
> I know personally of Miss Slowe's work on the campus at Howard from two sources—personal visits to the campus where I observed her work and contact with her in my classes at Columbia.
>
> Miss Slowe stands for the finest ideals of womanhood, and from my observation, I sincerely believe that she is doing an outstanding piece of work among Negro women.[144]

Slowe explained to the chairman of the Board of Trustees on May 20, 1933, what she perceived to have precipitated her problem with the president of the University.

> My first difficulties at Howard arose over a moral issue and have continued to the present day. I am sending a photostatic copy of the letter which was the occasion for these difficulties. . . . [Here Dean Slowe is referring to the case of Professor Mills.]
>
> I was very hurt on Monday afternoon May 15 when in your telephone conversation with me you said that some trustee had told you that there would be no peace at Howard University as long as I was on campus.
>
> Since such a statement might influence you against me, and since you have not known me long enough to discover my qualities and attitudes, I am taking the liberty of sending some letters containing the opinions of me held by persons under whom I have worked and with whom I have long association.
>
> I have tried to do my duty at Howard by standing for high moral ideals and sound principles in connection with my work. . . .
>
> I hope you will keep an open mind about me, until I have had the opportunity of demonstrating to you that I am sincere in my devotion to my Alma Mater and to its best interests.[145]

When she returned to her office the next day, she found another Flexner letter. Not denying his statement about Slowe's personality and the Howard situation, but also being charitable about the entire state of affairs, he wrote on May 24, 1933 that

> Nothing was further from my mind to give you pain in my remarks over the telephone. I meant what I said only to show you that talk of that kind or of the kind I quoted to which I am paying no attention, has come to me regarding practically everyone on campus.

Flexner seemed to be reflecting on his knowledge of the many controversies occurring within the Howard University community. Johnson, who was a strong administrator, had controversies in the 1930s when, with the support of the Board, he dismissed Vice Dean Cobb of the Law School.[146] Dean Arnold B. Donawa of the College of Dentistry had been dismissed in 1931.[147] A controversy had arisen in 1931 regarding Secretary-Treasurer Emmett Scott's competence, although Johnson had praised him three years earlier.[148] Moreover, conflicts abounded. There were student-faculty conflicts and faculty-administration conflicts.[149] In Slowe's case, she had twice been denied salary increases, she had been denied part-time student help in her office, and now she was being asked to move to the campus. To be sure, Slowe seemed to be the kind of person who was determined to prevail in the face of opposition.

Flexner continued,

> This is a part of what you call the background. . . . I am interested in the foreground . . . interested in taking the institution as it is . . . and improving it as far as our resources permit. Let us forget the past and work forward from the present. I know that that is easier for me to say than for you to do. Yet I am firmly convinced that in no other way will we get rid of the tension that has arisen in respect to almost every aspect of Howard University life.
>
> I may add that I have heard of your ability from many sources. I hope that you can be as magnanimous as you are able and that you can forget everything that has gone before and cooperate toward the upbuilding of a new and worthy Howard.[150]

To Flexner's request for information about her home, Slowe answered on June 2, 1933, that she was not asking for any special financial arrangement and that she did not want to sell her home because she wanted to live in it during summer vacations and in her retirement. In a three-page letter, she added that she would accept any personal loss in carrying out the

trustees' order to move to the campus. She again stated her agreement of 1922 with President Durkee for which she had no evidence. Obviously, she assumed that Durkee had agreed with the conditions she stipulated when she accepted the position. She described her house, the lot, the improvements she had made, and the visits to her home by students—their fireside chats, their conferences under the trees on the lawn. She emphasized the urban nature of Howard. She closed by writing ". . . whatever the final disposition of the case is, I shall continue to do in the future what I have done in the past—my best work for the women of Howard University."[151]

Women Students' 1933 Petition

As May, 1933, gave way to June, women students questioned the direction in which the university was moving and requested that Dean Slowe forward a letter from them to the president. In their letter to Slowe on June 9, 1933, they wrote:

> We feel deeply grateful to you, Dean Slowe, for all that you have done to make our lives fuller and richer. Those of us who are leaving will always look back on some of the happiest days that we have spent here, and remember you as the guiding influence which made such days possible. We feel that our lives have been truly enriched for having known you.[152]

The students listed their grievances and reported that, although they had tried, they had been unable to see the president. Their concerns included the stress on material development at the university at the expense of spiritual development; the need to retain the woman physician; and the need for a trained dietician for the dining halls.

Consider what was happening at the university at this time. By the end of 1935, the University was completing

> . . . the fourth of the ten-year program approved by the Government. This development program grew out of a report submitted by the Special Committee on Financial Support to the Board of Trustees on November 15, 1930. The report pointed out that an adequate financial program was a "prime essential" for the future development of the University . . . the necessity for maintaining high standards of scholarship and achievement required an adequate and systematic program of financial support over a period of from ten to twenty years.[154]

Accordingly, the president and Board were intent on building a first-rate university that in turn required the acquisition of accreditation and infrastructure, including buildings, laboratories, more full-time faculty, and improved salaries for faculty. Yet for students this kind of message was not credible; they felt frustrated that their needs and interests were not being addressed.

When Dean Thyrsa Amos learned about the turmoil at Howard, she contacted a friend, Margaret T. Corman, who was executive secretary at the Yale University Graduate School in New Haven, Connecticut, and asked her to interview George W. Crawford, an African American who had been elected to the Howard University Board of Trustees in 1926.[154] Crawford, also a Talladega trustee, was by now a distinguished[155] member of the NAACP Board of Directors.[156] He was a Yale graduate who had embarked on an outstanding career in law and real estate[157] and was certainly a Du Bois protégé.[158] No doubt Amos thought Crawford would be sympathetic but also candid about the situation—including her place of residence—in which Slowe was now embroiled.

The issue of the dean's housing had now taken center stage. It had been eight years since the Board began what seemed by now to be a pestering of Slowe about where she should reside. "On June 16, 1933, the Executive Committee voted that the president be authorized to have put 'into modest and satisfactory condition,' including furnishing, 'a suitable suite of rooms' in the eastern half of 328–330 College Street, it being understood that the entire premises to be occupied by Dean Slowe would be satisfactorily renovated."[159]

On the day the trustees issued the order for "a suitable suite of rooms," Corman reported to Amos (June 16, 1933) on her conference with Crawford.[160]

> Mr. Crawford assures me that the Trustees of Howard have not thought of asking Dean Slowe to live in one of their dormitories. He feels himself that if he were a member of the faculty he would not wish to be a resident in the dormitory and can well understand that this is not the best thing for her to do. On the other hand, the Trustees feel that her residence within a couple of miles from the campus is too remote for her influence to be felt as they would like to have it. Accordingly, they are preparing to fix up one of the houses which they own on campus property to make it available to her. Mr. Crawford spoke very highly of Miss Slowe's work and his definition of the responsibilities and functions of a dean seem to be a very high one. . . .
>
> I should feel that so far as Mr. Crawford was concerned, Miss Slowe need have no anxiety about the future of her position.[161]

Crawford's perception of the housing debacle reflects the less-than-enlightened understanding lay trustees often hold of issues that are not grounded in their own specialty, in this case jurisprudence. His views are well-meaning, full of approbation, but ill-informed about what seemed to be the political machinations of the Board leadership.

Afterward, on June 19, 1933, Amos wrote to Slowe, saying, "Personally, I think it would be splendid for you to have a house of your own on campus and if they make it satisfactory for you. I hope that you can find a way to dispose of your own home or to rent it to your advantage."[162]

Slowe felt that Amos got the "letter" but not the "message"—the fact that the trustees had the audacity to force her to change her residence after eleven years of service. In her reply to Amos, she wrote, "Under ordinary circumstances, the changes would be on my side, but so much has gone into the present place that it entails too much personal sacrifice for me to break it up. The whole situation from my point of view is brought about by vindictiveness and this should never be allowed to have play in an educational institution."[163] Slowe was sure that the methods the president and trustees were using to get their way were morally wrong. She was convinced that this hostile attitude dated back to the incident with Professor Mills. Although that incident was closed as far as the university was concerned, she seemed not to be able to get it out of her mind.

Later that summer, she wrote directly to Crawford but only after considerably more interaction with Board members and the president. Turning the matter over in her mind, Slowe was convinced that she had no alternative but to let Johnson know how she felt about the recommended house that was at the dead end of College Street. She informed him on June 26, 1933, that "The house is situated on an unpaved, blind street next to the University dump. Trash and dirt are hauled to this dump every day and burned." On the day she visited the location, a worker was burning trash, she wrote, and "great clouds of offensibly [sic] smelling smoke were enveloping the suggested home of the Dean of Women. . . . Next to the University Dump is the property yard of the Water Department of the District of Columbia where empty carts, trucks, tools, etc., are kept. . . . The interior of the house is most inconveniently arranged with a basement kitchen and dining room and two rooms on each floor above." Dean Slowe then suggested that the house occupied by Mrs. Allen or by Professor Tibbs be made available to the Dean of Women.[164, 165]

The next month, the Board chair replied to Slowe's June 26 letter to the president. He indicated that the Board of Trustees unanimously approved the order that the Dean of Women live on campus. He also cited the petition suggesting that he resign sent to him by students. He held that said petition suggested that she should have been within reach. He continued,

Had you been [within reach], I do not think that the girls would have written or sent a communication of that character. The fact that Howard University is urban . . . emphasizes the need of the campus being the one place where the students assemble. . . . It is therefore the one place in which the Dean of Women can keep her eyes on the activities of the girls.[166]

"Keeping one's eyes on the activities of the girls" is clearly the definition of a "matron's" or preceptress' role—the kind of responsibility that was defined in the earliest days of Oberlin College or even Howard University.

Slowe had already sent a letter to Trustee Moorland asking him to inspect the suggested house on College Street.[167] Five days later, ignoring her request that he inspect the house, Moorland, seeming to stiffen, simply confirmed the final decision when he replied that the Executive Committee had approved the use of the College Street house by the Dean of Women and that the president of the university had been given authority to carry out the decision.[168]

As she continued to brood about her predicament, Slowe evidently began to feel profoundly alone. The next step she took was on August 17 when she unburdened herself by confiding in Crawford directly. She described a meeting the president had called two days earlier.

I want you to know of a conference with President Johnson on August 15. He called me in and told me that the Committee was willing to give me another house, but that they would not allow me money for a housekeeper. I told him that it was customary for the Dean to be allowed upkeep and something for services when she is required to live in a University house. He said Howard could not afford it. I told him that I could not afford to take $40 or $50 out of my salary to pay for a person to care for the house. He then said that he would suggest that I move into the dormitory.

. . . It looks as if the President has created this dilemma for me to force me into the dormitory where he thinks a dean of women should be. He does not want the Dean of Women at Howard to have any administrative standing; he has always wanted her to be a matron. This is why he took me off the Board of Deans in spite of the fact that the nature of my work—as shown in my annual report—relates to every school in the University.

. . . I asked the President to put in writing just what the Executive Committee proposed to do about the house, but he refused to do this. He said that it was sufficient for me to have an

understanding with him. I WANT NO MORE UNDERSTANDINGS WITH PRESIDENTS, FOR MY PRESENT TROUBLE IS DUE TO MY HAVING AN UNDERSTANDING WITH DR. DURKEE.

... It is obvious to me and to many people in the University that the President is seeking a way to humiliate or inconvenience me, so that in desperation I will give up the Deanship. He showed this very plainly when he placed me next to the University dump. He suggested to me on August 15th, that I devote myself to teaching and then I could stay home. It means nothing to him that I am one of the few trained and experienced Deans in the country.

... [H]e is determined to put up such conditions as will take from me all joy in the work and force me to give it up. THAT IS HIS AIM.

... Howard women graduates all over the country are writing me about the matter, for they see in it not the mere change of residence for the Dean, but a change in the status of the position.

... Maybe I have no right to say these things to you, but I must trust somebody and I don't know whom to turn to. There is not a single man in my own family to confer with, and no woman can cope with this situation alone. If Dr. Slowe—my brother—were living, things would have been very different.[169, 170]

Slowe was so concerned about the prospect of being forced to move to the campus that she took another step: she shared her concern with her network of friends. Several acquaintances talked with members of the Board of Trustees. One very dear friend, Clyda Jane Williams, spoke with Moorland and reported to Slowe on August 23, 1933.

1) Moorland is not kindly disposed toward Slowe. 2) Slowe has put over her program through special advocates on the Board of Trustees. 3) Slowe's attitude is: "If you won't do what I want done, I am strong enough to make you do it." 4) Slowe likes the platform 5) Slowe is organizing opposition in D.C. and about the country in order to carry her point in the current controversy.

Moorland treated the house situation as a minor matter. ... The *Afro* nettles Dr. Moorland who feels that Slowe feeds information to the paper.[171]

Clearly, Moorland and others on the Board now recognized what an indomitable woman Lucy Slowe was. From her debut as dean, she had

her struggles and her challenges. Throughout she had been an activist; she advocated for students, she advocated for faculty, and certainly she advocated for her position as a university administrator. She had also organized political action through a host of organizations. What she had demonstrated was empowerment—a core theme of African-American feminism[172]—that quality that Coralie Cook had recognized many years earlier.

Publicity

In the meantime, word was getting around. The rumor mill was active. Exacerbating the situation, *The Afro-American* newspaper on July 22, 1933, printed an article with the headline, "New Orders to Dean Slowe Termed Persecution." The article declared, "Quarters situated on the University service-yard or dump have been assigned to the Dean of Women for her residence. . . . The obvious purpose is to force her out for no woman who is unwilling to imperil her self-respect would accept the squalid quarters set aside for the Dean of Women."[173] The article continued, "Howard University is forcing Dean Lucy Slowe to move into campus property. This action viewed from any angle is the most vindictive step ventured thus far by the War College on the Reservoir."

"Reservoir" refers to the location of the Howard campus just south of the District of Columbia's McMillan Reservoir. Howard's *Alma Mater Hymn* refers to it as "the lake." The university had probably acquired the moniker "War College" because of the conflicts that were erupting in nearly every quarter—students and trustees, dean and president, dean and trustees, and assorted faculty controversies.[174]

Continuing her battle, Slowe followed up earlier communications with Moorland. Although she probably surmised that he was not one of her supporters, she continued to keep him in her sights. In a letter dated August 3, 1933, she raised a question concerning both the Tancil case and her own housing problem. Johnson had informed Slowe that she had no right to appeal to the Board of Trustees and that he was going to have her reprimanded by the full Board. Yet she wrote that

> I told him that my conception of my duty to a subordinate on my staff [Tancil] made me appeal and that my conscience would not let me do otherwise. I wonder if this order put through the Board is the reprimand he promised. . . .
>
> The action [living on campus] reflects on Howard women. People will think that they are so badly behaved that I am supposed to watch them. . . . Howard women have developed a keen pride in the good name of Howard Women and have built up a

fine system of self government which functions so well that the students themselves recommended the supervision of several of their fellows from the University.[175]

She resumed her battle. In a letter dated August 18, 1933, Slowe raised questions with Johnson about the proposed housing and the exact order enunciated by the Executive Committee. "What houses were placed at her disposal? What provisions were made for furnishing the house? What provision was made for the upkeep of the yard and house? What provision was made for heat, light and telephone service? Did the Executive Committee consider providing a housekeeper?"[176]

Although there is no record of a reply, one month later, on September 22, 1933, Dean Slowe does refer to a reply, stating in a letter to Johnson:

> Since you have refused to give me in writing, the things which the Trustees agree in reference to the house which I have been ordered to occupy saying, "the giving of such information in writing would not be for the best interests of the University," I am not willing at <u>this time</u> to assume responsibility of a house.
> I shall take quarters in Dormitory 3 by the opening of school in accordance with the vote of the Trustees on April 28.
> I am now making a formal request of the Board through you for the house now occupied by Mrs. George W. Cook as the future home of the Dean of Women. The house is near the women's residence area and is more suitable for the home of the Dean of Women than any other house that has been offered her.
> The house which Mr. Gough has just vacated is not as well situated as the Cook house, since it is some distance from the women's area . . .
> I am, also, requesting that the Trustees provide for the furnishing of the house, its upkeep, heat, light and telephone service and a housekeeper. Pending their decision on these specific things, I shall reside in Dormitory # 3.[177]

Word of the turmoil at Howard University spread rapidly, especially as it related to the Office of the Dean of Women. It created a groundswell of support for Slowe in the form of letters from a multitude of individuals and groups. Writers addressed their communications directly to the Board of Trustees, with requests in some cases for meetings with members of the Board or its committees. Illustrative of these are the following excerpts.

> I have heard of no reason given why you have reversed the policy established at the time of the appointment of Miss Slowe as Dean. . . .

> To demand in the face of well known facts that the Dean live on campus seems to reflect on the women students at Howard.
>
> We as colored people, do not play merely to a colored audience. Certainly, it would be most unfortunate publicly to stigmatize the women of our largest institution of higher education for a measure of self-government granted the men of that institution.
>
> If in 1933, they require a closer supervision than was thought necessary ten years ago, certainly it must be that they are retrograding rather than progressing in the dignity and strength of self-control.

Charlotte Atwood, a founding member of Slowe's College Alumnae Club and a graduate of Wellesley College, former faculty member at Howard[178] and a former faculty member at Dunbar High School,[179] continued,

> Certainly there is more at stake here than a mere change in administrative policy. . . . May I not respectfully urge you to make public a clear, unequivocal statement of your reasons for your change in policy.[180]

Marion T. Wright, a Howard alumna, had sent a letter on October 11, 1933, to Trustee Tobias asking for his support. Her interest, she explained, was to see the turbulence quieted and causes removed. Specifically, she wanted him to know how concerned Howard alumnae were about the state of affairs at Howard—the lack of morale and the unrest. She begged for conditions that would inspire teachers and reduce fears of insecurity and persecution. She wanted the institution to leave a positive impression on its students.[181, 182]

As support for Lucy Slowe grew, Eva M. Holmes wrote Flexner on October 4, 1933, to request a meeting.[183] Holmes was secretary of the National Association of Dean and Advisers to Women in Colored Schools, an organization Slowe had founded. He replied that "The Board of Trustees never receives committees."[184] He suggested that she communicate with the three alumni trustees.

Alice Nelson Williams, Chairman of the *Ad Hoc* Committee on Women Students in the District of Columbia, wrote Flexner on October 18, 1933, and advised him that she represented a committee composed of women who were alumnae of Howard and also citizens of the District of Columbia; that Howard University was supported by public funds; and that concerned citizens should be able to confer with the Board of Trustees.[185] Flexner, on October 20, then asked for a list of the universities whose trustees grant audiences to miscellaneous committees.[186] There is no record of the Board ever giving a hearing to the committee.

Mission to Educate Women Students

Despite the fact that mayhem seemed to be building at Howard, Slowe never retreated from her mission to attend to the education of women students. It is clear that she was urging them, among other things, to be trustworthy. She preferred to rely on their honor rather than on strictly enforced rules. An article in *The Hilltop* on September 25, 1933, captioned "Dean Slowe Says Honor System Used," quotes Dean Slowe as saying, "The young women should have little difficulty adjusting to University life as there are no set rules to complicate matters. There are a few dormitory customs and general campus ideals to guide a student in her freshman perplexity. The basis of dormitory congeniality is based on cooperation." A pamphlet issued by Slowe's Office states that "The dormitories are designed to offer an environment that is conducive to real scholarship and to the formation of fine noble and lasting friendships among those who seek the truth together at Howard University. None of this can be achieved without that beautiful give and take spirit which is the soul of cooperation."

The Hilltop article continues, "Dean Slowe's chief occupation does not consist of watching the women of the University and punishing them for their misdemeanors. The honor system prevails at Howard and every young woman who comes here is assumed to be a lady. There is no 'tattle-tale' system here. Students consider Dean Slowe as a confidential friend and advisor."[187]

Slowe received non-stop coverage in the media. In October, *The Washington Tribune* drew attention to the Howard Mentors,[188] and *The Hilltop* wrote about the Women's Dinner.[189] In the following February, the student newspaper carried an article about the Dean's Dinner for officers of the Women's League and the YWCA.[190]

Use of the Press

Slowe firmly believed that the status her department under the Johnson administration should be made public through a press release rather than as the result of unsubstantiated, piecemeal comments. To that end, she prepared a memorandum on the Department of the Dean of Women on October 9, 1933,[191] in which she stated that the Women's Program had been handicapped since the administration of President Johnson began. Listing eight points, she laid it all out:

> 1) The Dean of Women was no longer on the Board of Deans and therefore not a party to discussing educational policies and

thus faced difficulties in interpreting policies to students; 2) The salary of the Dean of Women showed a differential with that of academic deans; 3) The President delayed a recommendation that all out-of-town women students live in the new dormitories beginning September 1931; 4) Heat, light and power now charged to dormitories (although provided by the Federal Government) result in higher room rent; 5) Treasurer given responsibility for management of the dorms with (a) dietician replaced by man without scientific training in foods, (b) students who work in the dormitories are responsible to the Treasurer, (c) housekeeper dropped and are [sic] former educational director now in charge of housekeeping, d) only one dormitory has an educational director; 6) Dining rooms open to male students (the university commons) and the Treasurer is not responsible for the conduct of male students in the dormitories; 7) The physician for women students dismissed; 8) Total budget for expenses for the Dean of Women's Office is $205.62 with no money for programs.

There is no record of who received this memorandum, yet it was authoritative, at least from Lucy Slowe's point of view.

The NACW, Lucy Slowe's nationwide constituency, entered the fray. Because its committees regularly identified issues considered reflecting inadequate standards or questionable policies in colleges for African Americans, on October 14, 1933, the Executive Committee asked the branches to support a letter to the Board of Trustees of Howard University. The Executive Committee was both challenging and protesting all backward steps in education taken in the name of economy and endangering the progress of Negro education. The Standards Committee proposed this letter because of steps taken to reorganize the academic areas of the university.[192] Thus, the conflict was growing. On the one hand, members of the Board of Trustees were being bombarded with these letters, while, on the other hand, Lucy Slowe was confronting them on the identical matters, and they knew that she was one of the NACW's leaders. Such tactics surely deepened the negative views some Board members harbored of the Dean of Women.

In addition to letters from the branches, the Standards Committee sent its own letter to Howard University officials. Dated Oct 17, 1933, it first highlighted the university's progress in meeting the needs of women. However, it stated that

> ... the status of women is in jeopardy due to: 1) lack of instruction in social service, 2) discontinuance of the School of Education, 3) changes in the School of Applied Science, 4) the need for a woman physician and a trained dietician, and

5) the question of the need for residence of the Dean of Women on Campus.[193]

This was a strategic move. Several of the points raised here were at the center of the numerous controversies between the dean and the president. The NACW's letter also stated that the women's residence halls did not meet standards, for each needed a resident head with faculty rank, and each needed a student personnel worker who was not the housekeeper or dormitory director.[194]

As this litany of publicity, discussions, and correspondence throughout the summer of 1933 implies, the Howard University administration was blocking Lucy Slowe at every turn. Until now, she had been able to use her influence with her network of thoughtful and powerful women to bring pressure from outside the university, an approach that university officials and the Board disliked intensely. Moorland's assessment of Slowe says it all, as does Flexner's comment to the effect that there would be "no peace" at Howard as long as Slowe was dean.

Yet no one, regardless of rank or station in life, intimidated Lucy Slowe. She did not hesitate to write to prominent government officials, including the various sitting presidents of the United States. So why should the administrative officers and trustees of Howard University frighten her? She was a persistent woman. She was a prominent woman, a woman of influence and power. She could go to the phone or write a letter and reach the powerful people she wanted to reach.

Bethune Correspondence

A lot of people in the wider African-American community were aware of the strained relationships between Dean Slowe and the Howard University administration. Because she believed in seeking the advice of well-placed acquaintances, late into the fall of 1933, she corresponded with a person she regarded as her friend, Mary McLeod Bethune.

Arguably the most powerful African-American woman in the United States, Bethune was at that time serving as president of Daytona Normal and Industrial Institute for Negro Girls (now Bethune-Cookman College), that she founded in 1904. She was a leader in the African-American women's club movement and, in 1924, had ". . . achieved the highest office to which a Black woman could then aspire, the presidency of the National Association of Colored Women (NACW)."[195] She was a delegate and advisor to national conferences on education, child welfare, and home ownership. She had an extremely wide circle of acquaintances among very influential and well-placed individuals. She was a very persuasive woman who could "effect contacts to facilitate her recommendations."[196] No doubt Dean Slowe knew

her well from her network of women's organizations outside the university. Thus she was an appropriate person for Slowe to contact for advice and an individual to intercede with the trustees and even President Johnson if such actions were necessary.

The letters that follow illustrate the power of this woman—Bethune—and the members of the Howard University Board whom she could summon at will. They join the others in a swift demonstration of support for embattled Lucy Slowe in her struggle against the president and Board.

The first letter available is from Bethune to Slowe.

> I realize as never before the great handicap under which you are, handling such a position as Dean of Women of our outstanding college for women in all the world. We count your position particularly at this time the most strategic one and I hope and pray that the handicaps may be removed and that your work may be found unmolested. I realize that in order to have this come through, some real work has to be done and may I assure you that whatever I may have in influence and faith may be used.
>
> I am just from Cleveland where I had a chance for an unmolested, frank conference with Dr. Garvin. May I say to you candidly that he has observed more than he has expressed and assures me that time will take care of the entire situation. As to the salary condition, there is to be, as I understand, a standard set-up, according to positions and all salaries adjusted in the January meeting. I gave Dr. Dillard full information and he is to have a frank conference with the President of the Board, calling his attention to some things, he may have had the wrong explanation of.

Charles H. Garvin, a physician from Cleveland, Ohio, was elected to the Howard Board in 1931.[197] Dr. Dillard is most likely James Hardy Dillard. A white southern educator,[198] he was the former president of Tulane University.[199] He had served as president of the Negro Rural School Fund, also known as the Anna T. Jeanes Fund, that had been established by a one-million dollar gift from Anna T. Jeanes. He was credited with having done much to improve African-American education and interracial relations.[200]

Bethune continued

> Mr. Tobias and I are to have a conference this week. I shall use my own sane methods to get certain things to the attention of those who need to know them and I am sure of results.
>
> Just be patient and understand that we are with you. I think that the demonstration the girls made at your twelfth anniversary dinner and their sentiment as is expressed all over

the country ought to give you great cheer. Keep your head up and stand by your task. All will be well.[201]

Bethune's letter—a warm one—reveals that she not only knows members of the Board and other strategically placed white leaders but is also aware of Slowe's program. Slowe's reply shows how Bethune's letter buoyed her spirits.

> When I found your encouraging letter here, I picked up fresh courage and a new determination to see things through.
> I have every confidence in your judgment and feel that what you have done is of the utmost value to the women's program here. I am satisfied to leave things in your hands to manage as you see fit, for I know that your experience in overcoming obstacles will stand you in good stead in the situation.[202]

In her next letter, Bethune reports on her conference with Tobias.

> I know you will be tickled when I say that Dr. Tobias spent the entire evening with me until twelve at night. We went over the situation very carefully. He understands thoroughly and is standing right by you. He told me that you are not threatened at all by the Board; that you are substantial and steadfast. There need be no fear. He was startled over the salary condition and he is Chairman of the Salary Committee. He will look into it with deep interest and also the situation of the dormitory and your handling of the problems there. They simply want you to stand firm and be as cooperative as possible. You have done the wise thing to this point. Just be steadfast and cautious and all things will work out. Keep up your courage and your faith and in the proper time the proper adjustment will come. Keep out of the newspapers if you can. Let us try to quiet things down ourselves. People who are in position to help have understanding minds and things will be properly handled. Just know that I am with you every step of the way. My prayers and suggestions and advice mean something on some matters, and this is one of them.[203]

Slowe replied to Bethune.

> I am very glad that you were able to discuss the situation with Dr. Tobias because I feel that he is one of the most outstanding men on the Board.
> It was very kind of you to mention the salary question, for it would be very difficult for me to mention a thing of that sort

where I am so personally concerned. Of course I feel that my treatment in this respect has been shameful, but maybe justice will come at last.

I had to smile over the reference to newspapers. As a public woman you know how difficult it is to keep something from the newspapers if they want to get it. I have never directly or indirectly given anything to the newspapers, although some people have charged me with doing so. I have simply treated those charges which, of course, have been anonymous with the contempt that they deserve.

I do wish that the Board of Trustees would so handle affairs here that the conditions of which the newspapers write would not exist. You know too well that human beings will try to get justice in some way and if proper channels are not set up for them, some of them will use what appear to be improper channels. My fondest wish for Howard University is that proper channels will always be set up for giving even the humblest person her justice. From my point of view, this has not been done.[204]

Contrary to her declaration to Bethune, Slowe did, indeed, issue a press release on October 9, 1933, about the Department of the Dean of Women.

To say the least, Lucy Slowe feuded relentlessly with President Mordecai Johnson and the Board of Trustees. This recital of correspondence shows that she was struggling to hold on to her authority and status. Yet the president and the Board were continually eroding her prerogatives and power. She fought hard for what she viewed as her rights as a dean. Her insistent refrain—that is, the difference between what she was led to believe by Durkee versus what later developed—she hoped would ensure her of the Board's consideration.

To be sure, she did not move to the campus from her home in Brookland. Despite conflicts over where she should reside, or conflicts over a physician for women students, or even the status of her tenure, Slowe kept her eye on her program—the Office of the Dean of Women. She was an inner-directed woman. It was not what happened outside her but what was happening inside that made the difference. She survived assault by the president and the Board of Trustees because she learned how to separate what was happening to her from the essence of who she was.[205]

Annual Report 1932–33

Slowe wrote forcefully the tenth time she prepared her Annual Report to a President of Howard University. Consider her goals. During 1931–32,

she had pushed for improved health services and professional dormitory management. Her program cried out for additional staff, especially a vocational counselor, in view of the fact that the young women had little if any knowledge of numerous fields open to them.[206]

She called attention once again to student health but this time with respect to implications of physical examinations for participation in physical education classes. She wrote:

> Frequent complaints have been made by students that their work in physical education is too strenuous, but because the Department demands such work students have to take it. The physician to women . . . should decide what type of exercise is suited to each student. . . . It is almost useless to examine the students if the follow-up treatment which so many need is not given.[207]

She highlighted a second area—student housing—when she wrote that

> [t]he proper housing of college students is now a major concern of colleges, for most college administrators realize that a residence hall supervised by a person of superior education, personality and character is the place where the student gets some of her most important training. . . . The management, educational and business, of women's residence halls, calls for intimate knowledge of women's needs, and means of meeting these needs. . . . For two years, the operation of the women's dormitories was the responsibility of the Dean of Women and all personnel in the buildings were operated on a budget approved by the Treasurer who handled all funds and paid all bills. A profit was made even in these abnormal times. . . . This arrangement unified control of personnel and was of tremendous advantage to the students living in the buildings for there was one set of ideals and standards throughout the household and all persons had to live up to the same requirements. . . . The employed personnel also benefited by unified control for they all had the same source of authority which prevented confusion and conflict in their work.[208]

Her report continued with a lengthy discussion of the rationale for a women's campus and a criticism of what she perceived to be an effort to convert the Women's Campus into the University Commons.

Because Lucy Slowe was a member of the faculty, she divided her time between her office and the classroom. The *Howard University Bulletin* listed her as a teacher in the summer session of 1932, spanning the period

July 1–August 15. Her name appears as both an administrative officer—Dean of Women—and professor of English. She taught English 3—Composition. According to the *Bulletin*,

> This course is prescribed for students who have made a grade of D in English 2. Constant drill is given in written and oral composition. The written work consists of short and long exercises dealing with the kinds of writing discussed in the classroom. *One half unit.* Hour: 11:00 to 12:00.[209]

Further, the *Bulletin* records that

> [a] unit is the credit gained by the successful completion of a course of study covering . . . approximately fifty-seven hours of lectures or recitations . . . each course . . . yields one unit and each minor yields a half unit toward graduation.[210]

Thus the dean spent approximately twenty-eight hours teaching in the summer of 1932.

Women's activities had become well-established, as later *The Hilltop* noted. The Women's League, for example, had held its first meeting of the academic year 1932–1933 on October 7, 1932. The article reiterated earlier descriptions, reporting that "[t]he aim and purpose of the League is to bring about a group consciousness among Howard women. Finer Womanhood is the Ideal of the League."[211]

It was customary for student groups to hold meetings in which they not only invited distinguished speakers to campus but also made use of the university's stellar faculty. Slowe participated fully, as she regarded these events as central to the development of the whole student—a central student personnel concept. A case in point is her invitation to Sterling A. Brown, professor of English at Howard, to review *Angel Pavement*—a novel by the famous British novelist and playwright James Priestly—at a tea in Women's Dormitory Number 3 on Sunday evening, October 23, 1932.[212] *Angel Pavement* was a best seller in the 1930s. Just thirty-one years old, Professor Brown had already become a celebrated writer and folklorist following stints as a faculty member at both Fisk and Lincoln University in Missouri. He had accepted a position at Howard University as professor of English in 1929 and remained there for forty years.[213]

Not only was Slowe's invitation to Brown an example of the quality programming she sought for women students, it reflected her own proclivities. She had a high regard for good literature. Indeed, to enrich their college life, she intended to expose her students to both outstanding professors and superb writers.

Shortly thereafter, on the customary first Friday in November, women once again gave the campus another inspiring demonstration of love and solidarity. The Eleventh Women's Dinner was held with over 300 in attendance.[214] On November 10, 1932, *The Hilltop* referred to this event as "the second decade of family reunions."

Slowe described the numerous activities of the Office of the Dean of Women in this Annual Report, showing that she was delivering on the high expectations students voiced when she was appointed. She noted that her ten major areas included Academic Guidance, Character, Leadership and Social Guidance through Freshmen Orientation and the Supervision of Student Activities that included both the organizations of women and those of women and men. In addition, she listed Educational Guidance, Financial Aid for Women, Housing of Women, and Contacts with Parents of Local Women. Moreover, she named Contact with Alumnae, Hospitality of University to Women Student Organizations, Contacts of the Department with the General Public, and Administrative Responsibilities.

In her pioneering spirit, Slowe was a visionary and a trailblazer, recommending "[t]hat the University develop those courses which attract a large number of women students. . . . There should be at Howard a strong Department of Social Service. . . . Courses in Pre-School Education should be provided and an experimental Center for Negro children developed. . . ."[215, 216]

Her administrative difficulties were not vanishing with the years; instead, they appeared in new forms.

Annual Report 1933–34

The Dean's Report to the President as her eleventh year ended specified major problems in the operation of her office, one of which was reduction of personnel. She wrote that it was next to impossible to carry on the legitimate work of her department. She added,

> It was necessary to curtail or abandon that which is usually promoted by the directors of the dormitories and to throw on the Dean of Women much dormitory routine which consumed valuable time that should have been given to the general welfare of all women students. However, in spite of these hardships, the Dean of Women held together the skeleton of her program for women and finished the year with some of the traditional activities for women in tact.[217]

Regardless of reduced personnel, Slowe and her staff were unrelenting in carrying out an extensive and demanding program.

The Dean of Women has had the cooperation of most of the members of the Women's Faculty Club which has met with her at a series of monthly luncheon meetings. At these meetings, problems of women students were discussed and plans for assisting the students were laid. Several teachers have given voluntary service to the activities of the students which has been of inestimable benefit to the Dean of Women. The practice of talking over the extracurricular activities of the women students with the members of the faculty has been instrumental in bringing about greater appreciation of the life of students outside the classroom on the part of large number of teachers. . . .

The Dean of Women uses every opportunity to supplement the work of the classroom by interesting students in the value and place of studies in their University program. Because numbers of students come into the University with little idea of what courses they should pursue, of how to study and of how to budget their time, it is always necessary to give some guidance in these matters.

Much of the time of the Dean of Women has been taken up with the educational guidance of individuals. Many students voluntarily seek the advice of the Dean of Women on their program of studies in relationship to their future careers. These individual conferences have given the Dean of Women her best opportunity for knowing students intimately. Frequently students come in to discuss the choice of a major, but wind up with a discussion of her whole life's plan and philosophy.

The Dean of Women has been forced to confine the major portion of her time to freshmen. . . . She believes it highly important to guide carefully freshmen for they may make serious errors in the choice of studies which may handicap them in their future work.

During the course of the year, groups of senior women were called into conference for the purpose of discussing with them the problems of women students from the standpoint of those who had spent three full years at the University. Many valuable suggestions for improving the academic and social life of the women were given by the seniors.[218]

Slowe's office monitored the academic progress of Howard women and recommended the appointment of a committee composed of representatives of each school and college and the Dean of Men and the Dean of Women to "serve as a clearing house of information on conditions affecting the academic progress of students."[219] She involved other groups—such as the Inter-Sorority Council and the Student Council as well as parents of young

women who did not live on campus—in her work. With her usual insight and forethought, Slowe made a number of recommendations for improving women's education. For instance, "That the University develop those courses which attract a large number of women students and offer vocational training of special interest to women."

She was lightyears ahead of her time and progressive in her outlook. Her ideas would ripen into social work education. Slowe was so convinced that "There should be at Howard University a strong Department of Social Service,"[220] she repeated it in the annual report of 1933–34. A recommendation like this speaks to her ability to empathize with people in need. It is reminiscent of Slowe's own development. As far back as her childhood in Baltimore, she was probably the recipient of the efforts of social agencies. As an adult, she had involved herself in volunteer work that ministered to the welfare needs of the various communities in which she lived. She knew first-hand the importance of producing African Americans who were well educated in the field of social service. In reality, she was arguing for a school of social work that was finally established at Howard in 1935.

Continuing, she stated, "There is a need for courses in Parental Education, not only to supply well-trained teachers, but also to prepare students for intelligent parenthood. These should be open to both men and women." In addition, she specified "Courses in Pre-School Education should be provided and an experimental center for Negro children developed at Howard University.[221] She was proposing a pre-school center and an experimental center, indicating a concern for research on African-American children. To be sure, she was, indeed, ahead of her time.

The extensive challenges the Dean of Women encountered did not prevent her from creating and maintaining contacts with parents and alumnae. She wrote in her 1933–34 annual report that

> Keeping in touch with parents of students is an important and helpful activity of the Department. Since over half of the women students live with their parents in Washington, the Dean of Women has been able through individual and group conferences to know a large number of the mothers of the students. This year, as in former years, the members of the sophomore class who live in the dormitories invited all the mothers of students who live in Washington to be their guests on Mother's Day. . . . The Dean of Women has had numerous conferences with local and out-of-town parents and has carried on a large volume of correspondence with parents on matters affecting their daughters. . . . The Dean of Women has been in constant touch with the alumnae and has many evidences of their interest in women students.[222]

Dean Slowe taught three courses that year.[223]

12. Lucy Slowe as Dean of Women at Howard. (Source: Moorland-Spingarn Research Center, Howard University)

13. J. Stanley Durkee, President of Howard University, 1918–1926, appointed Slowe as first Dean of Women. (Source: Moorland-Spingarn Research Center, Howard University)

14. Lucy Slowe, seated in chair, with dear friend and housemate, Mary P. Burrill, seated on the arm of the chair. (Source: Moorland-Spingarn Research Center, Howard University)

15. Lucy Slowe's friend and colleague in student personnel work, Thyrsa W. Amos, Dean of Women at the University of Pittsburgh, pictured at her desk. (Source: University Archives, University of Pittsburgh)

16. Mordecai W. Johnson. President of Howard University for eleven years of Lucy Slowe's deanship, beginning in 1926. (Source: Moorland-Spingarn Research Center, Howard University)

17. Emmet J. Scott. Howard University Secretary-Treasurer and Treasurer, when Lucy Slowe was appointed. He served until a year after her death. (Source: Moorland-Spingarn Research Center, Howard University)

18. Lucy Slowe, with shovel, at laying of the cornerstone for the dormitories that became Truth, Crandall and Frazier halls, June 5, 1931. (Source: Moorland-Spingarn Research Center, Howard University)

19. Group of dignitaries at cornerstone laying for new dormitories for women, June 5, 1931. (Source: Moorland-Spingarn Research Center, Howard University)

20. Truth Hall. Women's dormitory, named for Sojourner Truth. (Source: Scurlock Studio Records, Archives Center, National Museum of American History, Smithsonian Institution)

21. Frazier Hall. Women's dormitory, named for Julia Caldwell Frazier. (Source: Scurlock Studio Records, Archives Center, National Museum of American History, Smithsonian Institution)

22. Crandall Hall. Named for Prudence Crandall. (Source: Scurlock Studio Records, Archives Center, National Museum of American History, Smithsonian Institution)

23. Delegates of the 16th Anniversary Session of the National Association of Deans of Women visit Howard University, February 18, 1932 pictured in front of the three new dormitories for women. Lucy Slowe, front row, fourth from left. (Source: Moorland-Spingarn Research Center, Howard University)

24. A student using the Health Service for women students. (Source: Scurlock Studio Records, Archives Center, National Museum of American History, Smithsonian Institution)

25. Lucy Slowe in her garden with her friend, Clyda Jane Williams of St. Louis, Missouri (seated), Slowe is standing. (Source: Moorland-Spingarn Research Center, Howard University)

26. Lucy Slowe with Charlotte Hawkins Brown, President of Palmer Memorial Institute, at the 25th Anniversary of Palmer Memorial Institute, Sedalia, NC. Circa 1927. Brown is in academic regalia. Slowe is on the left. (Source: Moorland-Spingarn Research Center, Howard University)

27. Members of Clark Hall (men's dormitory) Council who invited Lucy Slowe to speak at their forum on war and peace in November 1934, who presented her with roses at the Women's Dinner in 1935 and a loving cup at the Dinner in 1936. (Source: Scurlock Studio Records, Archives Center, National Museum of American History, Smithsonian Institution)

7

Dean Slowe and President Johnson—The Latter Years

1934—1937

Advocating for What Is Right

The period captioned "The Latter Years" is, in reality, the last years, for Lucy Diggs Slowe died in 1937. These were the years during which her activities expanded, her influence extended, and her philosophy clarified. She argued for human rights and especially women's rights; she fought for fairness, justice, and equality beyond the barriers of sex, race, or ethnicity; she demanded quality education for all youth, especially African-American youth. Despite pressure to conform to women's role expectations, she was outspoken. She did not alter her goals or her position on issues and practices that derived from bias. She was a woman in the forefront of progress toward a world in which ability, merit, and quality of performance would be the only criteria for movement in, through, and upward in the economic, social, cultural, and intellectual sectors of modern society. Although her conflicts at Howard persisted, she was an inner-directed woman; preoccupied with doing what she regarded as right.

Operational Clashes

Although Slowe worked diligently on issues she thought should concern African-American women in general, her work on behalf of all students at Howard was always front and center. She continued to be concerned about what would be best for the student body as a whole. In a January 6, 1934, letter to President Johnson, for example, she challenged a proposal to convert the University Dining Hall building into a home for the Law School. She wrote:

> If the Dining Hall is taken over by the Law School, the students will be left without any place to carry on their activities. I sincerely hope that the administration will give serious consideration to retaining the Dining Hall as a Student Union Building on the campus and that more and more we shall center all general university social affairs in that building.
>
> It would be manifestly detrimental to the interests of students to leave them unprovided (sic) with a place to carry on their legitimate activities.[1]

Despite Slowe's objection, the Law School did occupy the former Dining Hall for a number of years until a new Law School building was provided on the main campus. Later the Law School moved to West Campus on Van Ness Street, Northwest.[2]

Management and the Women's Residence Halls

Slowe had been alarmed when, on March 1, 1933, President Johnson removed management of the residence halls from the Offices of the Dean of Men and Dean of Women and gave it to Treasurer V. D. Johnston. He had been appointed budget director on February 19, 1931, and had become treasurer on January 1, 1933.[3] In the end, constructing these buildings had been a concept that Slowe originated. She had overseen their design, and she was determined to supervise their management. She protested the president's action and requested reconsideration.

Not only had the trustees' action diluted her authority, she could cite several incidents to support her view that her power was to be shared with an inept and incompetent colleague. She regarded Treasurer V. D. Johnston as an ineffective and inefficient manager. For example, there was the National Student League (NSL) conference during the Christmas holidays of 1933 that precipitated several major issues. Joanna R. Houston, Slowe's assistant, wrote Slowe that, on December 26, she went to Crandall Hall (one of the

women's residence halls, earlier Dormitory #2) at 1:00 p.m. where some 200 people were gathering for lunch. "The entire first floor was a cloud of smoke," she wrote. "Several smoking stands had been placed in the parlors." She had never seen smoking in the parlors. In fact, it was prohibited. She described the condition as unorganized and not ready for the 200 people who had arrived. She wrote that "The group was sent to the dormitories without the courtesy of even a notice, verbal or written, to the person responsible for the young women who lived there. . . . Thought was given only to giving the visiting people food and a place to sleep. Their other needs were all unattended and gave us who live in the dormitories the most embarrassing set of problems we have ever had."

Houston then quoted several students.

> The Conference met here without any definite plan as to place of sleeping and resting so that the women's dormitory was made a lounging place for their use.
>
> Took as complete possession of the place as they would have had they owned it. Thus, began a three day reign of terror.
>
> Indeed the NSL tornado will long be remembered as the most destructive in the history of the women's dormitories for our eyes had not seen and our ears had not heard.[4]

Upon investigating the matter, Slowe learned that the Faculty Committee on Student Activities did grant NSL permission to hold its discussions on the university campus. The understanding, however, was that their activities would be confined to the chapel. "It was made clear that no sanction was given for using Clark Hall, the Men's dormitory, or the Women's dormitory." She stipulated that because students who could not go home for Christmas had been transferred to one building, Dormitory # 2 (Crandall Hall), this large group could not be accommodated. She was surprised to discover that V. D. Johnston had granted NSL permission to use Dormitory # 2 as its headquarters as well as a place to eat.

With a copy to President Johnson, Slowe sent a letter to the Treasurer—dated January 11, 1934—about the conditions that prevailed during the NSL visit. She stated that NSL members also smoked in Dormitory # 1 (Truth Hall) against regulations and used the basement of the building for various activities. She protested the use of the women's residence halls without conferring with her. Also, she cited two additional instances when men used the residence halls without checking with her office: housing a male visiting debating team and the football banquet.[5]

As management problems involving the women's residence halls persisted, Slowe was not one to let go. She sent two letters—one on March 6 and the second five months later—to Trustee Tobias. An appeal to Tobias

was quite in the Slowe style—that is, to go to a higher authority. And so, in her letters, she pointed out unacceptable conditions in the operation of the residence halls by listing examples that typified the treasurer's management policies and practices. In her second letter,[6] she stated that

> 1) The Treasurer determines what activities should go on in the women's dormitories; 2) the Treasurer, through the Housekeeper on his payroll, makes room assignments of young women in the dormitories; 3) the Treasurer assumes that women's dormitories must be used for all university functions; 4) the Treasurer has placed men in the women's dormitories as workers and boarders with attendant problems; and 5) the Treasurer has replaced the graduate dietician by a steward with no training in dietetics. The trend today is away from considering dormitories as business ventures to looking at dormitories as educational centers.[7]

Upon reviewing her complaints, Tobias evidently urged the Board to look into the matter. Thus,

> ... a Special Committee of the Board (Jones and Tobias) reported on October 23, 1934, 'a rather unfortunate misunderstanding' on the part of the President, Treasurer Johnston, and Dean of Women Lucy D. Slowe, concerning their respective responsibilities for the use of University dormitories, dining rooms, and general assembly rooms. Thereupon, Flexner appointed Jones, Hawkins and Dr. Brown to correlate the responsibilities of the parties in question.[8]

It was evident from the moment of Slowe's appointment that she had allies on the Board. Perhaps it was fortunate, then, that one committee member, Jones, had first-hand knowledge of her work. Also, she knew Sara Brown, who had been the first woman and first alumnae member of the Board, as well as a fellow member of Slowe's CAC.

To complicate the troubles associated with housing and dining services in the women's residence halls, the treasurer brought a person named Elizabeth Reed to campus for three days to examine his staffing and management of the dining facility that was in one of women's residence halls. There is no information on Reed's credentials. Slowe was not informed of the visit, nor was she invited to confer with Reed. Seeing it as an incursion, she complained to Sarah Sturtevant in a letter dated May 4, 1934.[9]

In her Annual Report to the President for the academic year 1933–34, she reflected on the year by writing that

[t]he year 1933–34 has been the most disastrous year, so far as the work with the women students of Howard University is concerned, in the history of the Department of the Dean of Women. This condition was due to two chief causes; first, the taking of control of the women's dormitories as a unit from the Dean of Women and placing it in the hands of the Treasurer of the University. . . .

Later, Slowe asked Trustee Thomas Jesse Jones to intervene. She reminded him that, on January 21, 1935, he, Sarah Brown, Treasurer V. D. Johnston, and she had met in the President's Office to work out an agreement under which the treasurer and Slowe could collaborate in managing the women's residence halls. Despite said agreement, Johnston—the very next year—recommended, and the trustees approved, the appointment of a Household Manager, considered by Dean Slowe to be insufficient [sic inefficient?]. According to the 1935 agreement, the treasurer was to neither appoint nor continue to appoint any person "whose conduct shall be established as objectionable in the light of the educational and social objectives of the Dean of Women." On April 2, 1936, Dean Slowe asked Jones to do what he could to have the recommendation for Household Manager rescinded.[10] Although Jones was one of Slowe's allies, on June 1, 1936, he advised her that he regretted that he was unable to change that appointment.[11]

The Murphy Appointment

Differences with the treasurer were almost trivial compared to what occurred next. In March, 1934, Dean Slowe had recommended to President Johnson several women to become educational directors in the residence halls. Yet it was not until September 14, close to the opening of the academic year, that he approved just a few of her recommendations. Six months earlier, however, two of the women whom Slowe recommended had accepted positions elsewhere. Among the names she had submitted was that of E. Louise Murphy, whose appointment the president did not approve. Murphy had been involved during her undergraduate days—along with over 300 women—in protesting to the chairman of the Board of Trustees the discontinuance of the services of the women's physician. To plead Miss Murphy's case, on October 3, 1934, Dean Slowe wrote to President Johnson, stating that Louise Murphy had

> graduated from Howard with honors, worked to support herself during her undergraduate years, had fine moral character, was

> dependable, a pleasing personality and knows student life at Howard . . . we would be taking a very narrow attitude and unwholesome precedent, if we penalized a graduate by denying her the right to work because she was one of a large group that expressed its opinion on a matter which it believed vitally affected it. . . . The young lady had a successful year as a teacher in Virginia. The incident referred to was almost two years old.[12]

Slowe would write in her next Annual Report—for 1934–35—"Although all the members of the staff were appointed a few days before the opening of the University and were inexperienced in their work, they have done as well as could be expected under the circumstances."[13]

Murphy sent a letter to Slowe two years after she was denied the job in which she raised the issue of vindictiveness, apparently on the part of President Johnson: "I sometimes wonder when people will learn to practice what they preach. How can a person preach love and at the same time portray such a vindictive spirit?"[14] Later, Dean Slowe wrote to Moorland about the Murphy matter.[15]

The Cold Shoulder

Despite the fact that Slowe's program was receiving rave reviews on campus, and despite the fact that she was advising women who were serving in the deanship at a multitude of colleges—both African American and white—and despite the fact that her program was arguably the envy of those deans—she was snubbed by the administrative leadership of her own institution. Again, Lucy Slowe was not alone in her clashes with President Johnson. Both Emmett Scott and Kelly Miller were *persona non grata* as well,[16] as the following incident suggests.

The three of them were among the members of the "out-group," according to *The Washington Tribune* of March 16, 1935, which reported that on March 13,

> Dr. Emmett J. Scott, Howard University secretary, Dean Lucy Slowe, and former Dean Kelly Miller were not among the invited guests to attend a dinner in honor of President Mordecai Johnson, president of the university, and members of the faculty at the Willard Hotel. . . . Oscar Chapman, assistant secretary of Interior, entertained about 50 people in the Cabinet Room of the hotel. The dinners are annual affairs given by Mr. Chapman in appreciation of the fine work that is being done in education at the university.[17]

Apparently, the Chapman dinner was given at a time when the university was being investigated for alleged misuse of appropriations from the federal government.[18] Flexner had been back and forth with Secretary Ickes regarding federal funds. "On November 27, 1934, the Executive Committee . . . voted to return PWA (Public Works Administration) any sums disallowed by the General Accounting Office."[19] The next week, Flexner reported to the Executive Committee that he had informed President Johnson that he had conferred with officials of the Department of the Interior and of the PWA in order to clear up any existing difficulties with respect to the building program. Board meetings and conversations around this issue seemed to be never-ending.

Furthermore, the Executive Committee of the General Alumni Association was furious about conditions at Howard and made a number of proposals to address the situation. They included the need to establish a fixed salary schedule, to establish a probationary period of two years for teachers, to avoid recurring reorganization, and to be aware of dissatisfaction among educators with elimination of the School of Education. They called for preparation for social workers and closer consultation with the General Alumni Association when major changes were being considered.

The Next Two Years

Apparently exasperated with the wrangling at Howard—those involving Lucy Slowe were not the only ones[20]—Abraham Flexner resigned from the Board, effective March, 1935.[21] Around this time, the Board took a step that no doubt encouraged Slowe. They made concessions to her in the form of a salary increase and possible participation in the retirement plan. Secretary Emmet Scott informed her in a letter dated April 20, 1935, that her salary would be increased from $3500.00 to $3700.00 as of July 1, 1935. Further he advised her that "Participation in the retirement plan was obligatory for Professors, Associate Professors, Assistant Professors and Administrative Officials who on June 30, 1934 had attained the age of 45 but not the age of sixty years."[22] The newly elected chair of the Board was Thaddeus F. Hungate, auditor of Teachers College, Columbia University.[23]

Following Flexner's resignation, the Board of Trustees did not take a softer line. Although they did grant Slowe a salary increase, they seemed to be intent on raising questions about her work. "For reasons not recorded in the Minutes of the Executive Committee on May 17, 1935, this Committee requested the Finance Committee to study the budget of the Dean of Women's staff with a view to recommending a reduction in annual costs."[24] Jesse Moorland chaired the Budget Committee, and V. D. Johnston was the university budget director.

The quagmire in which the treasurer and the Dean of Women were involved continued unabated during 1935–36. Slowe wrote, on January 15, 1936, to the Board's Finance Committee protesting the increase in the cost of board from $20.00 to $22.50 per month, effective February 1, 1936. This increase occurred mid-year without any warning. The same month that she asked the Finance Committee to rescind the increase, she also requested that they conduct a study of food costs and the operation of the dining department.[25]

On April 24, 1936, Emmett Scott wrote Slowe that the Board, approving the recommendations of the Committee on Instruction and Research, had denied two of her major requests at its April 14 meeting. They denied her request that the position of housekeeper under the treasurer be abolished and a new position with the same duties be created under the Dean of Women. Moreover, they denied her request for an assistant dean of women. They did, however, accept the resignation of an educational director in the women's residence halls and suggested that the position be filled by a graduate from an institution other than Howard University. In addition, the secretary's letter stated that the Committee on Instruction and Research had requested the president "to try to iron out the difficulties between the Dean of Women and the Treasurer."[26]

On the same day, *The Washington Tribune* reported that President Johnson had appointed a committee to investigate the room and board situation. Although this issue had been called to the Board's attention three months earlier, presumably, the situation intensified when—a few days earlier—waiters and other student employees in the dining halls went on strike. The newspaper reported that the student body as a whole resented the arbitrary increase in board and lodging that had become effective mid-year. The committee was chaired by Benjamin E. Mays, Dean of the School of Religion, and included Lucy D. Slowe, Registrar Frederick D. Wilkinson, Dean Russell A. Dixon of the College of Dentistry, and William B. West, Dean of Men.[27] West, an African American, had succeeded Edward L. Parks as Dean of Men in 1926, in all probability the year Parks retired.[28]

The article in *The Washington Tribune* took on mammoth proportions. It was captioned with one title and two subtitles: "Johnston Alone in Fight For High Fees At H.U.; Under Fire By Committee for Rate Raise: Deans of Schools and Colleges at HU Take Lead in Protesting Rise in Student Fees for Room and Board; Parents Not Considered When Fees Advanced in Middle of the Year. Compare fees to Other Negro Schools that Don't Receive Federal Aid 'Unjustifiable' Committee Says." Presumably, the committee met with the university treasurer about the mid-year fee increase in room and board charges and then reported its initial findings and recommendations to President Johnson.

... the committee has recommended that the order of the finance committee, increasing room rent from seven to ten and fifteen dollars a month, and increasing board to $22.50 a month, be suspended until the committee can investigate the matter further. The committee also suggested in its report that no increase in student fees should be made during the course of the school year, it being pointed out that consideration should be given to the parents of the students who make out their budgets without allowances for sudden and unexpected increases in fees. . . .

Howard University is the most expensive Negro institution in the world. Its board is paralleled only by Atlanta University, but Atlanta University charges $50 less than Howard University for tuition per year. Board in the average Negro university is $15–$18 per month, and no government support is given them.

The treasurer has justified the increase in room rent and board by contending that the dormitories and boarding department have been operating on a deficit and that the increase was necessary to balance the budget.

The committee investigating the situation has pointed out that at Howard University, the government gives its dormitories, equipment, heat, light, power, pays for the help and gives allowances for repairs, and consequently students who live in the dormitories should pay less than students in other colleges that have to pay for their own buildings, equipment, heat, light, and power, etc.

It was further pointed out by the committee, referring to the boarding situation, that the government pays for the dining halls, furnishings, the silver and chinaware, pays for the help, and permits them to buy staple food at government prices. These things being true, the committee contends there is no excuse for the dining hall operating on a deficit.

If it is operating on a deficit, it is due to inefficiency in management and bookkeeping, and should not be taken out on the students.

In reaching a decision as to the proper fee to be charged for boarding, the committee revealed, each building is held responsible for its own upkeep. . . .

In Clark Hall, the men's dormitory, the cost of upkeep, help, heat, light, and power and other expenses are summed up, and the sum total is divided among the number of occupants in the building, and what that sum comes to is the fee that is assessed the occupants per month. This, the committee contends, should

not be, in view of the fact that the government meets these bills. What is being done with the money collected form (sic) the students which is said to be used for these items or what is being done with the money appropriated by the government for these items are questions that the committee is propounding at Treasurer Johnston.

Why charge boarders $22.50 per month when the only item they are called upon to meet is the cost of food which is purchased at government reduction?

When pressed by committee members concerning these points, the treasurer is said to have replied that the excess money is used for other university purposes. This, the committee contends, should not be. The students should be charged only what it takes to operate the buildings and boarding department, and that their board and room rent should no (sic) be used to operate other departments of the university.

The treasurer, in a dilemma, is said to have sent a letter to the university steward, discontinuing his services. This, the committee halted, with the argument that if the deficit is due to the inefficiency of the steward, that it is not [unreadable] increase the board rate.

To appoint a new steward and at the same time increase the board rate, it was contended, is to predict that the new steward will likewise operate on a deficit. In this case, the present steward might as well be kept. There is no need of swapping the devil for the witch, it is contended.

It was also brought out in the committee meeting that the board increase has never been approved by the executive committee of the board of trustees or the trustees themselves, yet it is being charged to the students' accounts. This in itself is irregular, the committee pointed out, it generally being the custom for the executive committee to approve all fees and advance in fees promulgated by the committee on finances. . . .

Howard University is only one of fifteen Negro colleges that are rated class "A." Formerly it was necessary for students desiring to attend an "A" class college to come to Howard, or Fisk Universities. That day has passed, the committee pointed out students are now selecting schools nearer their homes with less fees because they are often [unreadable]–ed class "A." This fact, the committee contended, should be given consideration when the finance committee considers advancing the already exorbitant fees now invoked.[29]

The newspaper report captured the reasoning and arguments Slowe had presented to the Board previously. It also highlighted the treasurer's inefficiency, the same point she had been doing her best to make all along.

Aunt Martha's niece could not be intimidated. Slowe did not hesitate to turn to experts for advice. In the face of this challenge, she solicited advice from Dr. Mary deGarmo Bryan of the Institutional Management Department of Teachers College, Columbia University, regarding the responsibility of the household manager in the residence hall, who had been appointed by the treasurer, for inspecting student rooms or for training them in proper housekeeping. The treasurer and housekeeper had maintained that these responsibilities belonged to them. According to Dean Slowe, the housekeeper's work was directly related not to financial management but rather to the educational program of the residence halls.[30] There is no record of deGarmo's response.

Student Activities

Although little information is available concerning Slowe's work during the academic year 1934–1935, *The Hilltop* did report—on November 2, 1934—that she persisted in her efforts to expose "her girls" to new jobs for women. Thus she presided over the Thirteenth Annual Women's Dinner on the first Friday in November and featured Clara B. Bruce, assistant resident manager of the Dunbar Cooperative Apartments of New York City. Bruce spoke on "New Fields for Negro Women Other Than the Traditional."[31]

"The Dunbar" without question was well-known among the African-American intelligencia. A nonprofit cooperative apartment complex built specifically for African Americans, it was a place Howard girls needed to learn more about. Located in New York City's Harlem, the Dunbar Apartments are bounded by 7th and 8th Avenues and West 149th and 150th Streets.[32] That section of New York embraces the area of Manhattan north of 96th Street and joins the narrow northern handle of Manhattan known as Washington Heights.

The first large garden complex in Manhattan, the Dunbar contained a nursery school, playground, retail stores, and a branch of the Dunbar National Bank, Harlem's first bank to be managed and staffed by African Americans. The apartments were financed by John D. Rockefeller, Jr., and "it was a prototype structure for both the public housing projects of the Depression years and for later middle-income housing." Prominent African Americans who lived at the Dunbar Apartments included W. E. B. Du Bois, Paul Robeson, and Arctic explorer Matthew A. Henson.[33] The location of this complex on "Sugar Hill" is significant in African-American history, for that

section of New York was the finest residential enclave for African Americans in the city. It was home of the emerging Harlem Renaissance. "The appellation [Sugar Hill] came to represent all that was 'sweet and expensive,' signifying that one had arrived economically and socially, at the summit of New York's African American culture. . . . On Sugar Hill . . . Harlem's would-be 'sassiest' goes to town." The apartments included paneled walls, parquet floors, electric refrigeration, colored tile baths, luxurious lobbies, elevators and doormen resplendent in uniforms.[34]

It might be expected that the Howard women students were not only interested in nontraditional fields for women, but they probably were well aware of the Dunbar and Sugar Hill and were anxious to meet the lady who played a leading role in operating the place.

Another event later that month was scheduled by the young men of the university in their residence at Clark Hall. They conducted a forum on the subject of war and peace. Aware that Slowe was a peace activist, they asked her to be the principle speaker. As reported in *The Hilltop* on November 17, 1934, she talked about the impact of the World War on men, women, children and African Americans. She discussed the parts various treaties played in the settlement as well as whether the War did any good. "Leaving the present behind, a survey of the future was taken. What the next war would mean to the attitude of the people toward it and its effects upon the people were taken up in this part of the talk."[35]

Later that month, *The Hilltop* reported, under the caption "Women Dined by Dean Slowe," that Slowe sponsored a banquet on November 15, 1934, to which she invited campus women officials as well as representatives from the Women's League, Student Council, *The Hilltop*, and various classes and sororities. The reporter stated that

> Dean Slowe is endeavoring to get rid of the inertia in women on the campus, to make them take a place as individuals in this institution and to prepare themselves for their debut after college.
>
> Discussion was held concerning the problems of campus women and the possibility of correcting current evils. Individual effort on the part of every woman to be an individual and not merely a woman following the mass is the solution.[36]

As was her custom, Slowe shared with students some of the activities in which she was involved outside of the university; she was determined to let them know that women could stand up for what they believed in and be heard in their communities. On one occasion, she told the members of the Women's League about her attendance at the Tenth Conference on the Cause and Cure of War. *The Hilltop* reported on February 15, 1935, that not only had she considered the brutal physical effects of war, but she had

focused on the economic and social effects as well. "Today," she said, "we are realizing the aftermath of the world turmoil of 1914–1918. The present waste of idle men, stored and rotting material and starving thousands are growing worse." Dean Slowe also spoke of the suffering of minorities.

> In Baltimore, 65% of the Negroes are on relief while in the nation's capital 68% of the Negroes exist on charity. It is the minority group which suffers all over the world. . . . In the munitions marathon, millions of dollars are expended. Money is drawn from educational enterprises, health and public service as a whole. Malnutrition forming a weak foundation of a growing generation will result in wretched and discontented citizens in years to come. The press and world leaders build up hatred among races and nations and the munitions manufacturers prosper with all.[37]

Slowe rejected the use of conflict for the resolution of problems and rather favored peaceful approaches. She stressed the need for understanding peoples and events and for the conference table to replace the battlefield.

Clearly, by 1935 Slowe had solidified the Women's Dinner as an annual event. *The Hilltop* of November 13, 1935, reported on the Fourteenth Women's Dinner, that took place on Friday evening, November 1.

> Four hundred women students, graduates and friends attending the dinner joined in college songs and cheers. . . . One of the special features of the Howard Women's Dinner is the annual presentation of a "Friendship Circle to Dean Slowe" by the women students of the University. The Circle has placed in it fourteen diamonds, one being added each year, to represent the years of service that Dean Slowe has given to the University. . . . Another feature of the Dinner was the presentation to Dean Slowe by the Clark Hall [a men's dormitory] Council of a bouquet of fourteen beautiful roses to represent her fourteen years of service to students of the University. . . . Frances Grant was the speaker on this occasion and addressed students on "Value of College Training!" She noted that there are three general groups in college: those who go because it is the thing to do; those who go in order to prepare to get a job; and those who go in order that they may be of more service to their fellows.[38]

The Friendship Circle and the fourteen roses—both extremely gracious expressions from students—must have let Slowe know that her concern for them was truly appreciated. Students really liked her.[39] Later she was to

show how touched she was—but also how deeply confrontations with the Howard administration had affected her—in a letter to Sue Thurman, who was away in India. She wrote, "One of the loveliest things that happened at the dinner was the presentation to me of fourteen beautiful roses by the Clark Hall Council. I wonder if brickbats aren't commoner for men to give Deans of Women than roses. I can tell you that I treasured those flowers more highly than I can ever express."[40]

The fact that Slowe invited Grant to speak illustrates once more the dean's interest in peace and also how determined she was to expose Howard women to successful role models—particularly women—who were taking leadership positions in world affairs. Frances Grant, of Bordentown, New Jersey, had founded the Pan-American Women's Association in New York (PAWA) five years earlier. It was a volunteer, nonpolitical, educational, and cultural organization "for the purpose of uniting the women of the Americas in a common effort for the advancement and understanding of the peoples of this hemisphere." "The PAWA can be seen in the context of . . . Pan-Americanism, the belief that the peoples of the Western hemisphere are bound by common cultural ties and mutual interests. Originating during Woodrow Wilson's administration, the concept was further developed through Franklin D. Roosevelt's Good Neighbor policies."[41]

In 1935, an event that must have made Slowe exceedingly happy was the opening of the Howard University School of Social Work (HUSSW) as an autonomous unit. She, along with E. Franklin Frazier, chairman of the Department of Sociology, had urged over and over that this unit be established. Time and time again, she had even written about it in her annual reports. The first "basic curriculum" had been offered in the Department of Sociology and was directed by Frazier, who had previously served as director of the Atlanta University School of Social Work. He was a pioneer in advocating standards for social workers and insisting that they be properly trained. The "basic curriculum" conformed to the 1932 accreditation standards of the American Association of Schools of Social Work. The HUSSW Web site—listing Slowe as one its founders—graphically describes conditions that led to the School's founding:

> . . . there was a strong appeal for social work education at Howard from African Americans employed in the District of Columbia's New Deal programs. Few of the recognized schools of social work in America—and none in Washington, D.C. were open to African American applicants. A 1932 study undertaken at the request of the Washington Council of Social Workers revealed that of 69 persons newly employed as social workers only five were graduates of schools of social work, 10 had completed one course in "social work training" and the rest were completely untrained."[42]

The 1936–37 academic year mirrored previous years, as it was filled with lectures, forums, dinners, and parties. Slowe was especially interested in the student Christian movement as reflected in her work with the YWCA. She was also one of the sponsors of the Student Christian Conference held at Howard on December 4 through 6, 1936. It was organized by the Intercollegiate Christian Councils of Howard and Lincoln Universities. Lincoln was a four-year African-American institution in Chester County, Pennsylvania. Established in 1854 as the Ashmun Institute, it had been renamed Lincoln University in 1866 to honor President Abraham Lincoln.

The conference grew out of "a desire on the part of a number of students in the Young Women's and Young Men's Christian Associations to discuss at length the larger problem of religious adjustments as experienced by college people of their day." Speakers included Reinhold Niebuhr of Yale [Niebuhr was a theologian and historian], who spoke on "The Bases of Religious Faith;" William H. King, National Secretary, YMCA on the "Relevancy of Religion to the Problems of the Underprivileged;" and James H. Robinson of Union Theological Seminary on "Modern Challenge to Christian Idealism." Dr. Howard Thurman was faculty advisor to the Conference Committee.[43] Thurman was another Howard staff member who had confrontations with President Johnson. Howard University had called Thurman to become its first Dean of Andrew Rankin Chapel and to radiate from that high citadel of learning a "conscience" for the nation's capital.[44, 45]

Earlier that year, to highlight the kind of "finer womanhood" Slowe was eagerly wishing to promote among women students, she sponsored the Mother-Daughter Banquet[46] on March 6. She gave a talk titled "The Value of Companionship between Mother and Daughter." Her program featured the Girl Reserves and included an "aesthetic dance" and a play and solos and ended with a Toast to Mothers. No doubt Margaret Jean Grooms—when she included activities like these in her remembrances—spoke for a host of Howard women.[47]

Another one of Slowe's long-established customs was the Gift Service held each Palm Sunday. *The Washington Tribune* of April 3, 1936, announced "Women's League to Hold Annual Gift Service."

> The traditional service was inaugurated by the women for the purpose of building-up through their own efforts, a fund for the use of women students who are in financial difficulties. . . . Every year every woman registered in the University is asked to add something to this fund, no matter how small the contribution. Every class through its representative, puts its gift on the candle lighted altar and through the President of the Women's League, these gifts are presented to Dean Slowe who receives them in the name of all Howard women.[48]

Despite the fact that administrative and professional challenges were ubiquitous in the academic year 1936–37, the Dean of Women's program was uninterrupted. The Fifteenth Annual Women's Dinner took place. Tradition was broken and precedent established, according to *The Hilltop* of November 11, 1936, when, again, the Clark Hall Council honored Dean Slowe. These men presented a gorgeous loving cup to Dean Slowe. It was beautifully engraved and presented as "a token of the ideal relations existing between the men and women of the University."[49] Some folk noticed that Mrs. Johnson, wife of the president, was not there. *The Washington Tribune*, editorializing on November 13, 1936, raised the question of why the wife of the president of Howard University refused to attend the Howard Women's Annual Dinner. "She has been there ten years and attended only one of the annual affairs. Is it because of the strained relations between the President and the Dean of Women?"[50]

Another ritual that was a highlight for women students was Illumination Night. It was a fun-filled occasion they organized annually for Halloween. It took place as scheduled, as did the Fifteenth Annual Candlelight Service at Christmastime.

On Wednesday, June 9, 1937—a typical June day in Washington with gentle south and southwest winds[51]—Slowe entertained the women of the senior classes at a Garden Party from five to seven at her home. In a picture of Slowe at a garden party she appears to be wearing the feather-light white cotton dress that was very stylish in the 1930s. [Photo courtesy of *Flash*.] This event was another of the traditions she initiated.[52] She obviously loved to entertain at home. She had received Thrysa Amos in her home, along with senior women students, in June 1933.[53] It was the kind of affair that Margaret Jean Grooms had warmly recalled.[54]

Slowe wanted all of the events she had started to grow, develop, and thrive. The Women's Dinner and the Gift Service, the Christmas Candlelight Service, and Illumination Night all had become traditions, as she wished. She added to them her annual Garden Party and Mother-Daughter Banquet and the Crowning of the May Queen with the accompanying May Festival. They were important rituals that bound the women students to the campus. Despite the significance of academic achievement, rituals like these became classic Howard University observances.[55] Women graduates many years removed were sure to recall participating in—or, at the very least—witnessing every single one of them.

Surrogate Mother

To illustrate how extensively known and favorably regarded Dean Slowe was in the larger Howard community, on October 24, 1936, she received a

request from Dr. H. Whyte Cameron, the father of one of Howard's male students. He wrote:

> I have a son . . . a freshman at Howard University. I know that you are Dean of Women and in charge of the Ladies, but knowing you so well, I take this opportunity to ask you if you will be good enough to have a motherly oversight of my son. I shall be extremely glad whenever you meet him to give him good advice that he will keep straight and be a credit to me, his home, and my Alma Mater, Howard University.[56]

Slowe replied November 20, 1936, that "I shall be pleased to talk with him. . . . I am very glad to know that the sons and daughters of our graduates are returning to the Alma Mater of their parents and thus, building up a fine tradition in the University."[57]

During this same period, on November 24, 1936, Slowe received a letter from someone who must have been a keen observer—a Mrs. Sally Alexander—congratulating her on her years of service.[58]

Insights and Emphases

Dean Slowe began her 1934–1935 Annual Report by stating how she viewed a college education. A college education was a mantel, she believed, that carried with it certain responsibilities. Throughout the educational world, she wrote,

> . . . administrators and teachers are examining social, economic, and political conditions in their relation to college curricula. One can hardly read an educational journal or scan a newspaper but that he sees some question raised in reference to the part the college trained person must play in using his theoretical knowledge to solve the practical problems of the world today.

She was resolute when it came to broadening the horizons of women students. Thus, she scheduled workshops to inform women students about a range of career opportunities. She added that

> [a]fter these general meetings were held, the women were divided into groups and some expert in the field chosen by the group was asked to come in to confer with the group. For example, Mrs. D. O. W. Holmes, an experienced social worker, conferred

with the group interested in this field. Dr. Brawley talked with the group interested in the literary field.[59, 60]

Another focus of Slowe's program included the academic performance of the young women. A study initiated by her office revealed that students attributed their academic difficulties to several things. The most frequently mentioned were heavy academic load and attitude of the instructors. In her Annual Report, she wrote that

> [a]s the causes of failures are studied, the conviction grows that more careful guidance should be given, especially to freshmen who furnish the largest number of probation students. It appears also that some teachers need to take a more sympathetic attitude toward their students and to realize that it is bad pedagogy for a teacher to announce to a class before he knows them, that a certain percentage of them will fail.[61]

Slowe considered the social guidance of students one of her most difficult tasks. She was intent on developing in students a sense of personal responsibility and a commitment to the constructive use of leisure. Her concern about social guidance was not restricted to women students. In the 1934–35 Annual Report, she noted:

> Since all social affairs attended by both sexes must be registered in the Office of the Dean of Women, there are many occasions when the Dean of Women comes in direct contact with large groups of men students and discusses with them matters having to do with campus ideals—social and moral.
> The Department of the Dean of Women has worked with: (1) The Student Council on various problems of student life on the campus; (2) Four classes on their extra-curricula activities and has advised both men and women on matters of program and procedure (as Secretary of the Faculty Committee on Student Activities); (3) Approved and supervised all social activities attended by men and women; and (4) Has arranged and participated in discussion groups composed of men and women interested in subjects ranging from problems of marriage and the home to international relations.[62]

Because the United States was burdened with the Great Depression of the thirties, the demand for financial aid was greater than ever. She objected stringently to the university procedure imposed on women students who needed assistance. She wrote that

> [i]t was impossible to supply part-time work for all the women who applied for it, although every effort was made to find work for them, both on and off campus. Indeed so many students entered the University with insufficient funds and so many heart-breaking problems arose after they had been allowed to register that the Dean of Women questions the wisdom of permitting new students, in particular, to enter without paying their first semester's tuition in full . . . the whole procedure in finding work for women on the campus should be changed. The Committee on Scholarships has been handling the employment of women on the campus. Women who need work must be interviewed by the Chairman and he decides whether they are eligible for work and attempts to place them. This arrangement is so unsound and so contrary to University practice that it should not be allowed to go on at Howard University. Women's employment in coeducational colleges is in [the] charge of the Dean of Women or some other woman appointed for this purpose. The financial and personal problems of women in first-class colleges are never investigated by men. Women interview women students and report their findings to the appropriate committee. . . . Even in the awarding of tuition scholarships, the interviewing should be done by a member of the staff of the Dean of Women and her findings reported to the committee. It is frequently embarrassing to women students to have to reveal to men their intimate personal needs, and so far as possible universities do not subject their women to this embarrassment.[63]

She called two additional matters that distressed her to the attention of the administration. The first was that it was undesirable to house undergraduate and graduate and professional women in the same residence hall, and the second, her limited budget of $200.00 for student activities. Slowe recommended—once again—additional personnel for her office and new, more-appropriate academic programs for all students, especially women.

Slowe championed women's education. In her Annual Report for 1935–1936, she was explicit. There can be no mistake that her recurrent themes included awakening women to the responsibilities that would rest upon them when they returned to their several communities. She credited the extra-curriculum as the resource that could train the young women by providing opportunities for a variety of leadership and volunteer service. She took great pride in the fact that a woman student "came within 30 votes" of being elected president of the Student Council. Known for her emphasis on character education, she argued that it was incumbent upon

226 Faithful to the Task at Hand

Howard to be a laboratory for the growth and maturation of strong moral values. She wrote that

> [t]he unfavorable economic conditions through the country continue to affect the welfare of students at Howard University and to place a very heavy burden upon those of us whose work has to do with the personal problems of students. So many students have been working part-time this year that there has been danger of impairment to health and of neglect of vital aspects of their education.
>
> In spite of the strain under which many students have labored, there have been evidences of increased interest on the part of the women in educational activities of varied kinds and a general awakening to the responsibilities which will rest upon them as they return to their several communities.
>
> Many more women have participated in community activities this year than in other years. Women delegates attended the National Negro Congress, and several conferences held under the auspices of the Young Women's Christian Association; several worked as volunteers in the Social Service Department of Freedmen's Hospital; a large number participated in various programs at several community houses. There has been a quickening of interest on the part of women generally in public welfare and in the more serious side of campus life as noted in the fact that a woman student came within thirty (30) votes of being elected President of the Student Council.[64]
>
> The need for trained women in the field of public service is so obvious that no University can afford to neglect the definite training of women for this service.
>
> Negro women, because of their isolation from the general stream of affairs, need to be trained for the public service and to be brought in contact with those outstanding persons who are making definite contributions to the work of the world. . . . Howard University should develop these methods (institutes, conferences and lectures) of supplementing classroom instruction and, in this way, broaden the outlook of its students.
>
> It seems important to raise continually questions in reference to the responsibility of Howard University for so vitalizing its curricula that the students who graduate from this institution are equipped with that information and experience which will enable them to perform their duty to their fellows in an efficient manner. If a democratic form of government is to prevail careful training in the duties and responsibilities of citizenship is highly necessary.

> As one looks out upon the modern world, he is impressed with the great need for attention to the fundamental moral values which make life safe in a civilized world. The lack of moral standards in public and private life manifests itself in crime, in divorce, in dishonesty, and in the general looseness in the conduct of too many people. This state of affairs places a grave responsibility upon the University to hold up to young people which it trains examples of the highest integrity of those persons whose responsibility it is to reach and guide its students. There can be no moral health in American life save that which comes through intelligent and informed individuals. Howard University should be ever sensitive to this great need of our students both inside and outside the classroom.[65]

Her Final Year at Howard University

The academic year 1936-37 seems to have been one in which there was an overabundance of activities. In her final Annual Report to the President, although Dean Slowe expressed her disappointment with the dishonesty that had occurred in a recent campus election, she proposed a closer alignment of the whole community—including faculty and non-faculty—in trying to cope with character development.

> In reviewing the work with students during the past year, the Dean of Women is impressed with the great need for more self-discipline and for more systematic guidance from the members of the faculty. There is no common understanding among the individuals composing the faculty as to student ideals of conduct, morals and habits of work. . . .
>
> There need to be at Howard University regular faculty-student assemblies for the purpose of developing commonality of purpose and ideals and for building a morale which will weld the University into a real community. . . .
>
> The Dean . . . has noted a general let-down in the moral ideals of students. A conspicuous example of this was the annual student elections. The Faculty Committee on Student Organizations found such gross dishonesty in the voting for officers of the Student Council that the whole election had to be declared void. The most serious feature of the matter was that not a single student, man or woman, expressed any shame for the disgraceful occurrence. There was a disposition to excuse or condone the affair, rather than a desire to correct and prevent its happening in the future. . . .

Students should be made more aware of their responsibilities as intelligent citizens after they leave the University. . . . Howard University has an unexcelled opportunity for preparing a group of liberally trained citizens capable of functioning in our American life.[66]

With obvious pride, Slowe called attention to the visit of Frances Perkins, Secretary of the U.S. Department of Labor, who delivered a speech before an All-University Assembly[67] titled "The College Students' Responsibility for Intelligence on the Problems of the Laboring Man." Although it is not known whether Slowe or someone else invited Perkins to the university, her talk was sure to support Slowe's views concerning the purposes of a college education. Her standing as the only woman member of Roosevelt's cabinet was the kind of role model Slowe wanted to introduce to Howard students.

Appointed by President Franklin D. Roosevelt, Frances Perkins was a very capable and strong-minded woman. She had already helped to usher in programs such as the Civilian Conservation Corps (CCC), for which the Labor Department recruited about two million young men; the Civil Works Administration (CWA) that created four million temporary jobs during the bitter winter of 1933–34; the Works Progress Administration (WPA), that provided jobs for eight million people; and the Federal Emergency Relief Administration (FERA), that spent $4 billion for people in need.[68]

In this last Annual Report, in the section on "Social Development Through Special Organizations," Slowe observed that the student YWCA had been revitalized and had joined the YMCA in hosting the Middle Atlantic Conference of Christian Students, had sent delegates to major conferences at Hampton Institute, Johns Hopkins University, and King's Mountain (a military park in Blacksburg, South Carolina), and had entertained 100 foreign students at the university; and that Zeta Phi Beta Sorority gave a Christmas present to every woman who had attended at least fifty percent of the meetings of the Women's League. Slowe wrote, "These young women deserve the highest commendation for their devotion to the larger interests of women students." She added that the other sororities had given services to the Settlement Houses for colored children in the District.[69]

Summarizing developments in the lives of students who lived in the dormitories, she reported that "[t]he Residence Halls directed by college trained women have been run on the principle of teaching people to live, and develop into more personally responsible and self-directing human beings." The Educational Program included the weekly Coffee Hour, after dinner for sophomores and mornings for freshmen. Students handled the meetings without faculty input. . . . The House Government Association

that year stressed contributions to the development of the larger life in the residence halls rather than punitive measures.[70]

Introspection

Toward the end of her fourteenth academic year at Howard, Slowe had occasion to reflect on her own feelings, thoughts and motives as an administrator. Clearly she had had to deal with sexism—women were underrepresented among administrators and faculty at Howard University.[71] She had had to deal with lack of power that led to absence of influence and authority. It is clear that she recognized how these issues played out in her career and she was comfortable in how she chose to deal with them when she penned a memorandum to Beatrice Clark. Presumably Clark had asked Slowe for information to use in introducing her. Somewhat self-effacing, Slowe wrote that

> [i]f I have been successful in my various occupations, I believe that it has been based upon my attempts to be prepared for my work by constant study and by my practice of continuing to study with experts in my field. I feel also that certain personal qualities which I hope I possess, have been a factor. I have tried to be fair and just in my dealings with people and I have tried to see my subordinates' side of every question as well as my own. I have been frank and open with my colleagues, with my subordinates, and with my superiors. I have had the courage of my convictions even though sometimes I have had to suffer personal discomfort for standing up for them.
>
> In my present position, in a large university, I have had some unusual experiences. I have had opportunity to meet and associate with educators from all over the world and I have had the opportunity to go into some of the finest and largest schools in the country where I have lectured and held conferences with students and faculties. I have also had the rare experience of coming in contact with young people from all over the world who come to Howard University to study and have touched the lives of hundreds of them who are scattered to the four corners of the world. . . .
>
> So far as I can remember, I did not learn in school how to be an executive; indeed, I had very little opportunity to exercise executive ability. I sometimes think that executives are born and that you either can organize and induce people to work with

you or you cannot. I have my doubts about learning techniques which will make one an executive.

Since all of my occupational experiences have been among colored people, I cannot say that race has added or hindered me. I believe that if I had been white that I might have occupied a larger position from a national standpoint, but this is only surmise.

I owe a great deal of what success I have had to the inspiration of the colored teachers in the high school at Baltimore. . . .[72]

Death of Her Sister

On Friday, February 12, 1937, Lucy Slowe's sister, Charlotte, passed away at Baltimore's Providence Hospital following a prolonged illness.[73] Lucy had anticipated Charlotte's passing. Obviously, her death brought back lots of memories; the sisters had been very close. After her mother had died, her sister, Nellie, and her brothers John, Colthrop, and William remained in Berryville, Virginia. But, Charlotte was the big sister with whom she had been moved to Aunt Martha's house in Lexington: the one who had taught her her ABCs after they had to home-school the stubborn little girl, and with whom she had lived at Cousin Lou's in Baltimore.

They had surely had good times on those trips when Aunt Martha would take them back to Lexington in the summertime.

As what seemed to be a hallmark of the Slowe family, Charlotte—like Cousin Lou—was an educator. She had been principal of School Number 22 and later teacher of social sciences in Howard High School of Wilmington, Delaware, where she had resided for the previous sixteen years. She had also served as Supervisor of Schools in Cecil County, Maryland, prior to moving to Wilmington. She had pursued studies at Hampton Institute, Columbia University, and the University of Pennsylvania. An Episcopal funeral celebrated her life on the following Monday, February 15.[74]

The End

Five months later, Lucy Slowe found herself at home, not feeling well at all. Yet, she did take the time to write to her assistant, Joanna Houston who was on leave, stating that she planned to attend a Conference of Personnel Workers at Haverford College in Haverford, Pennsylvania August 21–28. She shared her feelings about the fact that Dwight O.W. Holmes had been elected president of Morgan State College in Baltimore. "I regret very much to see him leave his Alma Mater, but I don't blame him in the

least for making the decision to leave. It might be very refreshing to him to get into a different atmosphere and to work in a place where there is some consideration given for human beings."[75] Slowe seemed to be expressing the frustration she felt at the contempt and obstruction she met at the hand of the Howard University president and trustees. Holmes had been Dean of the Graduate School and Dean of the School of Education, which was discontinued in 1934. The personal vindictiveness of President Johnson is reported to have been the cause of Holmes leaving Howard.[76]

Coincidentally, she received a letter from Holmes, dated October 1, 1937. He apologized for having not written earlier, stating that he had spent considerable time moving into the presidency of Morgan College. Explaining that both he and his wife had been ill also, he wrote, "We both hope by now you are definitely on the way up and that soon you will be your old self again," and added, "Don't rush about it but take your time. The world wasn't made in a day. And you may not recover in a week but what it takes to get up from there, you have. Just don't rush. With best wishes and love, Lu & Dwight Holmes."[77]

The last correspondence between President Johnson and Dean Slowe took place later that summer, when the president, on August 20, advised her that he had recommended a salary increase but that the trustees had not approved an increase for her or for fourteen other persons in the professorial rank.[78] He stated that the matter would be taken up in March of the following year when the 1938–39 budget would be prepared. If she insisted, he said, he would present her claim to the trustees at their next meeting.[79] Slowe replied, a week later that "[s]ince my case is an exceptional one and quite different from that of other persons of professorial rank, I am requesting that you bring this matter to the attention of the Committee at its next meeting."[80]

Earlier that month, because she had contracted influenza, she had gone to Atlantic City to recuperate and was caught in the rain, apparently exacerbating her condition.[81] When she returned to her home, it seems that she was in a much-weakened condition. *The Afro-American* reported on September 18, 1937 that she was "critically ill with pleurisy" and that her relatives had been called to her bedside.[82, 83] As the press continued to monitor her condition, the newspaper reported three weeks later that she had improved.[84]

Probably suspecting that she might not survive, she finalized a codicil to her will on October 13. In it, she confirmed a deed to the property at 1256 Kearney Street, Northeast, Washington, DC to herself and her beloved friend, Mary Burrill, as tenants in common. She gave her surviving sister, Nellie Slowe Hawkes, and her heirs the undivided one-half right title, interest and estate.[85] During this period of rationality, she sent for a trusted and cherished former student and friend, Mary Abrams Gant. When Mary went

to her room, she looked at Slowe and said, "It does not pay anyone to work so hard and to work all the time." Slowe had been passionate about her work, and her zeal probably sustained her. Eight days later, on October 21, 1937, a day that had been cloudy with occasional rain,[86] at age fifty-four, she died at her home at 11:05 p.m.[87] Marion Wright noted, "Because of her depleted physical condition brought on by hypertension which had continued over many years, she succumbed to a cardio-vascular renal disease."[88, 89]

Two days later, newspaper articles announcing her passing began to appear. "Miss Slowe, Dean at Howard U., Dies—Funeral Services will be Held Monday Afternoon in Rankin Chapel" was the headline of an article in the *Washington Star*[90] *The Washington Post* reported "Funeral on Howard Campus Planned for Dean of Women." Yet, Mary McLeod Bethune must have been notified at once, for on October 22, just one day following Slowe's passing, she wrote the following to members of the National Council of Negro Women: "In the passing of Dean Lucy Slowe we have lost a loyal and competent co-worker, an untiring champion of the cause of Negro womanhood. We must carry on in her dauntless spirit."[91]

The depth of the relationship between Lucy Slowe and Mary Burrill became apparent. It is clear that they lived—to use Smith-Rosenberg's[92] terminology—in "emotional proximity" to each other. In addition to the codicil in Slowe's will that left one-half of the Kearney Street house to Burrill, condolences poured in not only to Nellie Slowe Hawkes, but also to Mary Burrill. In tone, the messages suggested that Burrill was Slowe's longtime friend as well as her "companion and confidant."[93] Messages addressed to Burrill included sentiments such as the following from Guy B. Johnson, member of the Board of Trustees: "May I express to you, her good friend, my deepest sympathy. . . ."[94] A message from Mollie T. Berrien stated, "My heart aches for you, for I know you two loved each other as only sisters could. I know life will be sad and lonely without her sweet companionship. . . ."[95] A similar message came from Dorothy Detzer, National Executive Secretary for the Women's International League for Peace and Freedom to Mary Burrill, "As Dr. Slowe's friend and close companion. . . ."[96]

Impressed by the eulogy delivered by Dwight O. W. Holmes at Slowe's funeral, Burrill ordered sufficient copies to be printed and bound so that she could send them to those who knew and revered Lucy Slowe as she did. The document, titled "In Memoriam,"[97] contained a picture of Slowe along with the foreword:

> Because I believe that Time, the unerring appraiser of all human values, will give Lucy D. Slowe a secure place among those great spirits who have wrought mightily for our race; and because the Eulogy by Dwight O. W. Holmes interprets her character and her work with such truth and beauty, I have given it something of permanency in these printed pages.

May Lucy D. Slowe's spirit of helpfulness and courage and devotion to duty abide with us always.

Mary Burrill

Letters expressing appreciation for Burrill's thoughtfulness in sending them copies of the eulogy came from a host of individuals. They included graduate chapters of Alpha Kappa Alpha Sorority, professors at Teachers College, Columbia University, deans of women who were members of the National Association of Deans and Advisers to Girls in Colored Schools, the National Association of College Women, the Howard University Board of Trustees, and persons known to be Slowe's personal friends or former students who had kept close contact with her.[98]

It is obvious that Burrill, as Slowe's confidant, had been incensed by the treatment Slowe received at the hand of Howard University's President Mordecai Johnson, his administration, and the Board of Trustees. This feeling led her to pen a letter, soon after Slowe's death to the Howard University Board of Trustees. The Board had sent a letter of condolence. In thanking them, she excoriated them for the meager funding Slowe received while she was a university administrator. Specifically she mentioned $200 per year for the development of the Dean of Women's social program "for almost one thousand women." Furthermore, she quoted Slowe's pleas for a salary befitting her role as a full professor as well as a dean.[99] (Professor Mabel Carney of Teachers College, Columbia University, who was aware that Burrill was sending such a letter to the Board, requested a copy, and upon receiving it, stated that it would be used in classes on higher education administration.)[100]

Carrying out her responsibility as custodian of Slowe's papers, Burrill presented them for archival purposes to Morgan State College in Baltimore, Maryland. She attached copious notes explaining the sources of various documents or who the writer of a particular piece happened to be. It is assumed that she presented these materials to Morgan rather than Howard for at least two reasons: Dwight Holmes—Slowe long-time mentor—had become president of Morgan, and, furthermore, Slowe had been treated shamefully by Howard. It was not until March 22, 1966 that Morgan donated the Lucy Diggs Slowe Papers to Howard.

Epilogue

On October 26, 1937, the day following Slowe's funeral, a committee representing the Executive Committee of the General Alumni Association met with the Board of Trustees. Time and time again, the Association had submitted grievances to the Board concerning President Mordecai Johnson. This committee—led by Eugene L. C. Davidson, son of Shelby J. Davidson,

who was Lucy Slowe's colleague in the preparations for the Semi-Centennial—clearly disliked the president. They presented a "memorial" (or memo), titled "The Death-Bed Ultimatum" that could well be considered "match point"[101] for Lucy Slowe. The "memorial" contained four accusations, the third of which ". . . dealt with President Johnson's alleged 'hate, ill will, and malice' toward the late Dean Lucy Slowe."

> . . . because of his hate, ill will and malice towards the late and lamented Lucy D. Slowe, Dean of Women for more than fifteen years and one of Howard's outstanding Alumnae and utterly without fair, just or even decent consideration to her or for her caused to be dispatched to her during her last and critical illness a peremptory ultimatum that she should return to her duties immediately or a successor would be in her place in twenty-four hours; that as a result of this uncivil, inconsiderate, discourteous and indecent conduct on the part of the said President Mordecai W. Johnson, the family specially requested of the President that he take no part in the funeral services or even sit on the platform.[102]

The Committee characterized Johnson's request as one that he expected to be obeyed—a "peremptory ultimatum." Support for this view is contained in a letter reported in *The Howard University Alumni Journal*, Special Winter Issue, 1937–38, dedicated to Slowe under the subtitle "The Case Against President Johnson." The article reported that during the latter part of September, 1937, Mrs. Willie B. Wilson, Miss Slowe's secretary, told Mary Burrill, Slowe's housemate, that Johnson had asked her (Mrs. Wilson) "how long Miss Slowe was going to be ill" and "furthermore to get from Miss Slowe a recommendation for some one to substitute in her place as this was an important post." Mrs. Wilson reported that she was asked to say that "he was going to appoint someone to the position within twenty-four hours whether or not the recommendation comes in."[103] Subsequently, Mrs. Wilson was separated from her position.

The Hilltop editorialized in its October 27, 1937, edition that

> Dean Lucy Diggs Slowe's death leaves an unfillable (sic) gap in the University set-up. For years, she has been inseparably connected with faculty and student activities, as Professor of English, Dean of Women and member of the Faculty Committee on Student Activities. . . . During the fifteen years of service to the University, Miss Slowe was always the exemplification of all for which Howard is supposed to stand: loyalty, devotion to duty with a deep seated sympathy so necessary for

one in her office. . . . As an administrative officer, Dean Slowe was extraordinarily efficient, but as a counselor of students, she reached those heights to which only an innate ability can act as a medium of transfer.

Since The Divine Being has seen fit to transfer her to another state of being, it is all that we can do to accept her departure as one of the inevitable moves of fate. With such an attitude, the Hilltop joins with thousands of others across the earth's entire surface, in the deepest aggrievement (sic) over the death of Lucy Diggs Slowe—a scholar and a friend.[104]

The Afro-American, an acknowledged supporter of Lucy Slowe, published an editorial captioned "Says Dean Slowe Dies as Martyr." While praising her for "exemplary womanhood," the writer reviewed the difficulties she had encountered, including a salary not in keeping with her position and also much lower than the salary of friends of the administration. It also mentioned the attempt to get her to move to a "shanty" of a house near the campus and efforts to strip her of all authority. Others who had been recipients of the administration's vindictiveness—including Dwight O. W. Holmes, Emmett Scott, and Albert Cassell—were listed. The writer called the Howard University alumni on the carpet for failing to come to her rescue.[105] The newspaper also featured an editorial cartoon captioned "But her Spirit Lingers On!" that depicted Slowe wearing academic regalia, standing behind her desk with a lone wreath in her desk chair.

Marion T. Wright wrote, "Dean Slowe became a martyr to her ideals for education in general and of student personnel work in particular so that Negro youth might live more wholesomely and more abundantly."[106] It could be said that she was impertinent or, to say the least, disrespectful. She was a lone female administrator in a male world. As was often true of women going into nontraditional jobs, she ". . . had left one social group without being able to gain acceptance in another."[107] She was "extravisible," being the only woman on most of the committees or advisory groups on which she sat. It is not unreasonable to suggest that when she attended a dinner or reception involving administrators, she would be the lone woman among the men, whereas the other women present would be wives. Where the men might have been discussing university matters or sports, the women might have been talking about shopping, or child rearing, or how they folded sheets. To the extent that she did not receive the salary or personnel resources she required, she was invisible.[108] Recalling Lucy Slowe's note, in the end, she made up her mind which self would be articulate: an abrupt, frank, insistent, self-telling truth, though that may not be wise.

8

Shared Interests

> ... someday I may show my better self to the world.
>
> —from Lucy Diggs Slowe's note

Lucy Diggs Slowe did not restrict her life to teaching in Baltimore or Washington or to making the junior high school concept come alive in the District of Columbia. Neither did she spend all of her time creating the Department of Dean of Women at Howard. Rather, she joined and—perhaps more importantly—led organizations, all of which required a day-to-day balancing act.

As far as the deanship was concerned, she affiliated with women's organizations—particularly white mainstream groups—to learn her job and to achieve legitimacy in her field. With the Howard University deanship as a backdrop, she also joined with African-American women to prepare her "sisters" both for a broad range of careers and for the roles of qualified participants in the body politic. She seemed almost intuitively to grasp the importance of banding together with like-minded women to promote social goals, like organizing a sorority for African-American women or joining with them to promote such educational goals as sanctioning the existence of the first junior high school for African-American children in the Nation's Capital. Throughout her life, she raised questions about the barriers imposed by race and gender. Her comment as a youngster barely out of her teens about working her way through college established a pattern as to how she would approach challenging situations: she would be a pioneer!

Her numerous organizations included many on the national level, such as the National Association of Deans of Women, the National Association

of Teachers in Colored Schools, and the National Council of English Teachers. She also joined the Women's International League for Peace and Freedom and the Young Women's Christian Association, and she kept her membership active in her sorority, Alpha Kappa Alpha.[1] On the local level, in Baltimore, she was a member of the Browning Club, the Whist Club, and the Du Bois Circle in addition to the city's chapter of the NAACP. In Washington, she united with her alumni association, local college women and educators in the Columbian Educational Association of the District of Columbia.

Slowe was an exceptional leader of women. Her remarkable qualities enabled her to become an architect of African-American women's organizations. As a college student, she was elected president of student groups such as the Tennis Club and the Christian Endeavor Society. Soon after she was recruited to Washington to teach English, she was invited to join the College Alumnae Club and almost immediately became president. Under her leadership, the Club spearheaded the creation of a new national organization, the National Association of College Women. This latter group led to the formation of the National Association of Deans and Advisers to Women in Negro Schools with none other than Slowe as president. She was so highly regarded by African-American women that she was able to assist Mary McLeod Bethune in the creation of the National Council of Negro Women. On behalf of her responsibilities at Howard, she took on wide-ranging professional responsibilities in a white organization, the National Association of Deans of Women.

She perhaps also had a natural missionary spirit that showed itself in her dedicated work with organizations such as the Young Women's Christian Association and with a variety of strictly community organizations, including the Northwest Settlement House of Washington. If her goal was the fullest participation of African-American women in the mainstream of American life, these were organizations that she believed would lead the way.

Her relationship with Alpha Kappa Alpha Sorority (AKA) is particularly noteworthy. Her Scrapbook contains a program showing that she spoke at the Founders Day Observance for the Upsilon Omega Chapter in Richmond, Virginia, held at the Moore Street Baptist Church on Sunday, February 19, 1933.[2] Moreover, she gave the Founders Day speech for the Phi Omega Chapter in Winston-Salem, North Carolina in 1934.[3] Her correspondence with the AKA's Iota Omega Chapter, located in Norfolk, Virginia, suggests that, as dean of women, she did not want to appear partisan. On November 6, 1923, her sorors (sorority sisters), wrote asking her to allow them to submit her name as a candidate for National Basileus (president). Replying, on the same day, she declined, saying that she had to be the dean "of all the girls."[4] Although AKA was the first sorority for African-American college students, others had formed by this time. Thus,

as dean of women, she did not want to be regarded as partial. At AKA's twenty-fifth anniversary, she gave the banquet speech, in which she urged her sorors to become visionaries.[5]

National Association of Deans of Women—Leadership and Racism

Despite the fact that she would face rigid racial segregation, in order to keep abreast of developments in the education and activities of women, Slowe joined two major white associations: the American Association of University Women (AAUW) and the National Association of Deans of Women (NADW). The latter is the one in which she made major contributions and to which she had the closer affiliation. She joined NADW in 1922 within months of her appointment as Dean of Women at Howard, and she soon gained stature. At the 1931 annual meeting, held at Detroit, Michigan, *The Washington Tribune* reported that she would be ". . . the first colored woman to ever appear . . ."[6] on the Association's program. She spoke on February 19 and she served as a discussion leader on the topic "The Dean of Women and Her Relation to the Personnel Office." She argued that a central personnel bureau could not do justice to the development of women students; they were the province of the dean of women.[7]

Slowe shared her views on the importance of the NADW in a letter she sent on November 29, 1933, to the Dean of Women at Ohio University, a white institution.

> The National Association of Deans of Women is needed more today than ever—1) Women in official positions in many schools are losing ground; 2) Need unity and prestige which comes from having headquarters and someone in charge; 3) Needs are so fundamental that all deans should be willing to make extreme sacrifices to supply them; and 4) Every effort should be made to get the backing of college women, in general, represented by the American Association of University Women.[8]

Although Slowe had gained the respect of NADW members, she was unable to escape the racist policies that were embedded in American society and hence reflected in NADW. Her experiences with the NADW members provide a window on one aspect of racism in America, as witnessed by the preparation for NADW's 1937 Annual Meeting in New Orleans. In view of the rigid adherence to discriminatory practices in the hotels of that city, Slowe wrote on November 11, 1936, to the Dean of Women at Hollins College, a Virginia college for white women, that

> I am not sure that I can attend the meeting with that degree of self-respect which, as an individual and an American, I should have. I understand that the hotels in New Orleans do not permit Negroes to use their passenger elevators. I, also, understand that the Deans of Women pay rent for the meeting rooms. Under these circumstances I do not see how I can go to New Orleans. . . . It appears to me that the educators of America—those who have responsibility for the ideals of our youth, should refuse to hold meetings in any such place as New Orleans where there is a direct insult to a group of American citizens and educators.[9]

In her relationships with this and other organizations that she joined, Slowe refused to succumb to her country's discriminatory and segregationist laws and practices.

In 1936, she served on the NADW Headquarters Committee, a responsibility that brought her into close contact with the national president and staff. The Committee had been responsible for ensuring NADW's survival and growth.[10] Slowe also consulted with the Committee that published the 1937 Yearbook. Whether she was elected or appointed to the Headquarters Committee is not known. What is known is that her presence on this committee resulted from the agonizing racial insults to those African-American members who, like Slowe, had defied racial taboos and joined the organization.[11]

Prior to the 1937 Annual Meeting, NADW's executive secretary had advised African-American members that they were to use freight elevators and the back entrance to the hotel. "Once inside they could join in a reception or a meal in a private room where no other hotel guest could see what was going on. Even the hotel indicated that the staff might not be receptive to serving any Black women."[12]

To Slowe's request for an explanation, she received a callous written reply from Kathryn Heath, NADW's executive secretary.

> NADW accepts the convention city chosen by the Department of Superintendents of the National Educational Association. NADW draws no racial distinctions when it extends the rights and privileges of membership. . . . Since New Orleans does not offer conditions conducive to a large attendance on the part of Negro members, it seems only fair that advice be given of the regrettable conditions which exist . . . namely, that Negroes are not permitted at meal sessions; that they must use the back hotel entrance; that they must use freight elevators; that they must occupy a separate section when they attend joint sessions which are held away from NADW headquarters . . . so that

avoidable embarrassment might not occur. . . . The Association deeply regrets the segregation system which has prompted the writing of this letter.[13]

Because insults to African-American deans continued in NADW, they refused to attend one annual meeting held at a whites-only hotel. "The next year, the white NADW president personally escorted black members through the lobby of the conference hotel."[14]

The same bigotry appeared in NADW's regional groups. In November 1936, the white Dean of Women at Hampton Institute—a predominantly African-American college—asked Slowe if she should bring the African-American Associate Dean of Women to a regional meeting of NADW to be held in Washington. On November 14, Slowe referred the question to the Regional President, Dean Ann B. Cook, who replied by saying that she did not realize that Howard University was for colored people. She wrote that

> I am sure that since you deans have never attended the meetings in the past which I have attended, you will not plan to do so this year, even though you received my form letter and program. . . . This is a courtesy I extended to you not knowing that you represent a colored university. Please inform your co-workers of this, as I would spare you and them any embarrassment as well as our hostess and the American University Group.[15]

An undated document in the Slowe Papers[16] and a two-page typed copy with no author listed suggests a relationship to another incident deriving from rigid racial segregation, this time, on the occasion of the conference of deans of women at American University in Washington, DC.

> On November 22, 1936, a group of students—white and colored—members of the Christian Movement of the Middle Atlantic States, met at Howard University to consider some of the problems vital to youth not only of America but of the world. . . . Sitting as an observer among other faculty members was Lucy D. Slowe, Dean of Women at Howard University. Dean Slowe must have been very thoughtful and puzzled on this particular day as she watched these youth working together in the interest of a better America and of a better world. Why was she so puzzled? On Saturday, November 21, 1936, there met at American University in the City of Washington, the Regional Association of the White Deans of Women. These deans came from schools which sent students to the meeting on the campus of Howard University on November 22, but how different were

the attitudes and practices. No colored deans were permitted to attend the regional meeting of these leaders of American white students. Dean Slowe, inadvertently invited to attend, was informed by the President of the Regional Association . . . that she did not know that Howard University was a colored school when the invitation was sent and that colored deans would not be welcomed. This well-informed leader of white youth might have become even more informed had she arranged her conference of deans after that of the students they were supposed to lead. . . . Out of the mouth of babes . . . thou hast ordained strength . . . and we might add leadership.[17]

Slowe found that racism continued to produce difficulties in NADW. On February 26, 1937—eight months before she died—her fifteenth year as a dean—and her fifteenth year as an NADW member—she wrote Ruth Bartholomew, the white Dean of Women at Paine College, an African-American institution. "I did not attend the NADW Conference in New Orleans because I could not attend and keep my self-respect. The secretary of the Dean's Association wrote me that the local committee expected the colored deans to be segregated, to stay away from all luncheons and dinners and to ride in freight elevators. Under these circumstances I did not go."[18]

Slowe brooked no tolerance for the prevailing racist policies. Repeatedly, she demanded equality of opportunity and resources. Both her professional and her community activities show that she was steadfast.

That she did not hesitate to state her opinion about bigotry to anyone, regardless of race was plain to see. Subsequently, on April 3, 1937, she responded to a letter from Kathryn Heath, NADW's executive secretary, informing her that finally NADW had gone on record with the American Association of School Administrators in opposing racial discrimination in connection with annual meetings.[19] In her response, she said that she was extremely appreciative.

Her Own School for Deans

In all probability, Slowe's experience in NADW and at Teachers College, Columbia University, prompted her to design her own class for the preparation of future African-American deans. *The Hilltop*'s issue of May 15, 1930 reported that Slowe had introduced a course at Howard for prospective deans of women.

At the beginning of the Spring Quarter a new course, designed for the training of Deans, was begun among the women of

Howard University under the guidance of Miss Lucy D. Slowe. The innovation is significant not only for the University alone but for all Negro colleges and secondary schools. This is the first course of its kind to be offered in any Negro college. Eleven young women are taking the course.[20]

With a class of eleven students—one of whom was Margaret Grooms—Slowe used a textbook titled *The Dean of Women* that had been authored by Lois Kimball Mathews, formerly Dean of Women at the University of Wisconsin.[21] Slowe's correspondence indicated that, in the summer of 1930, she had studied at Teachers College with Thyrsa Amos.[22] She also returned to Teachers College the summer after Grooms took the course.[23] Teachers College catalogs for 1927–28 through 1931–32 listed Courses for Advisers of Women and Girls and stated that they were for preparation for work as Dean of Women in colleges.[24]

The next spring, *The Hilltop* reported that "the Dean of Women's Class [at Howard] in 1930–31 had a two-fold program on instruction and socialization. The classroom instruction was conducted by Joanna Houston, Assistant to the Dean, and sponsored by Dean Slowe. The social aspect was worked out by members of the class who organized an experimental club—The Dean of Women's Club—using the campus as a laboratory."[25] (Teachers College, Columbia University used this terminology for its courses for prospective deans.)[26] This was the second year for the course for prospective deans of women. Inclusion of the concept of "The Dean of Women's Club" reflected the influence of progressive education—a Teachers College, Columbia University, theory—that is, that "modes of behavior are most easily learned by actual performance."[27] Slowe had created her own "academy" ("spring training") for the education of future deans of women.

Requests for Advice

As a result of her prominence in NADW, Slowe received repeated requests from other deans, both African American and white, for advice and information. What makes this unusual is not only the strict, carefully observed racist policies regarding enrollment and matriculation of students but also the fact that Slowe was the first—and perhaps only for some time—African-American NADW member. Women who had been appointed to this fledging position had little or no academic preparation for their work. Thus, they looked to those they respected for mentoring. Especially did the African-American deans trust Lucy Slowe, for, as will be seen later, she was the person who convened them and helped to mold them into a professional association. White deans no doubt learned about her work through NADW.

244 Faithful to the Task at Hand

Examples of the host of deans who consulted Lucy Slowe were two requests from African-American colleges—Wilberforce in Xenia, Ohio, and Virginia State College in Ettrick, Virginia. In her January 31, 1931, letter to the dean at Wilberforce University, she wrote:

> In reply to your letter concerning a list of rules and regulations governing the women students of Howard University, I am writing to state that we have decided to hold our revision of rules and regulations in abeyance for the present; in other words our program of activities for the women in our dormitories has been so successful that we have about done away with our rules and regulations and shall probably have only a half dozen or so rules on our new list. . . . I still feel that the successful education of young women involves the education of them outside the classroom in such a way as to have them rule themselves.[28]

An inquiry from Dean Tossie Whiting at Virginia State College about regulations for a new Home Economics Practice House prompted the suggestion from Slowe on January 27, 1931, that weekly conferences should be held with heads of all residence halls and houses where students live.[29]

Slowe heard from Dean Patience Haggard, who, in 1931, had been appointed Dean of Women at a college for white students, the State Normal School, Potsdam, New York. Haggard, a distinguished scholar of Greek mythology, like Slowe, also held the rank of professor of English.[30] Slowe gave her a more detailed policy statement. She wrote:

> I am enclosing a copy of our student manual which will suggest to you what we attempt to do in the way of printed rules. Some of these rules are out-of-date for the manual has not been revised for at least three years, but in the main the contents are current practices.
>
> The longer I remain in this work, the less I am inclined to believe in rules. I know that in a cooperative society, there must be some rules, but I feel that we ought to reduce them to a very few in number. We are attempting, in dealing with women particularly, to get rid of as many rules as possible and depend upon the general tone and atmosphere of the campus, as it is built up through group meetings and general assemblies. We have found that group discussions on matters of procedure and conduct, with appropriate books read and discussed, do more for toning up our student conduct than a long list of rules.[31]

Slowe insisted that a dean's office should keep good records. Little wonder that Dean Roma Hawkins at MacMurray College, a white college,

requested in 1932 copies of the forms Slowe used. Slowe sent the requested material together with a copy of the Student Handbook and the Women's League Constitution. She also suggested that Dean Hawkins get a copy of NADW's Album that contained cards from every major college and university, and she invited her to visit Howard to see the new residence halls and the university plant.[32]

Several deans wanted information concerning specific programs, such as the Mentor System,[33] the establishment of a chapter of Alpha Kappa Alpha Sorority,[34] and the nature of the work of the Dean of Women.[35]

Slowe wrote to the Dean of Women at Southern University, an African-American institution in Baton Rouge, Louisiana, on February 7, 1933, in reply to her request for information and advice concerning social affairs. Concerning dances, she advised that they should be approved for groups with a very large number of students, such as the Student Council, classes (freshman, sophomore, junior, and senior), fraternities and sororities, and the Women's League (which includes all women students on campus). There should not be more than two dances a month. State clubs and academic clubs should not be permitted to give dances. Literary programs, lectures, recitals, and discussions in residence halls should be incorporated in the program. Slowe did not lend credence to general socials because they were difficult to control. Rather, she preferred "small beautifully arranged affairs."[36]

Despite a long list of responsibilities at Howard, she was able to correspond with still other deans. Slowe asked the Dean of Women at the University of Arizona, a white institution, about membership for college girls in the National Panhellenic Council. The Arizona dean replied that, if the Howard girls were interested in membership in the National Panhellenic Congress, it could not be achieved because of certain unfortunate restrictions[37]—that is, the Congress was all-white. On May 3, 1933, Slowe replied, informing the Arizona dean that Howard girls were interested in information to help establish a Sorority Council at Howard and were not interested in joining the National Panhellenic Council.[38] In other words, rather than succumb to discrimination, they would create their own—a response that had characterized African-American attitudes since Emancipation and certainly during Jim Crow. Surely, Slowe was determined to give her Howard girls the best of what everyone else—meaning white girls—had.

Also seeking advice was Lucy J. Franklin, Dean of Women at Boston University, a white institution, who asked for her guidance with a problem involving housing African-American women students. As was the practice at white institutions, African-American students were segregated in housing quarters.[39] In 1931, a whole host of elite white institutions were closed to African-American students. Among them were Bryn Mawr College, Bucknell University, and Temple University. President A. Lawrence Lowell, president of Harvard College—America's leading institution of higher education—in responding to a petition of protest signed by "numerous prominent Harvard

alumni," wrote that "If Harvard were faced by the alternative of either admitting Negroes to the freshman halls where white students are compelled to go or of excluding Negroes altogether, it might be compelled like other colleges, to adopt the other alternative,"[40]—a convoluted ways of saying "No," African-Americans would not be admitted.

In her letter to Slowe, Dean Franklin wrote that

> [t]he Sergeant School of Physical Education has been given to Boston University. Where should the girls be housed? Boston University uses the cottage system with 16–24 girls. There are 8 colored girls specializing in physical education at this time. Efforts have been made to house them with colored families. The girls have suggested a dormitory for colored girls. Several colored organizations think the colored girls should be housed with white girls.[41]

Slowe addressed this affront to African Americans when she replied on November 12, 1930.[42]

> Colored girls should be handled as individuals not on the basis of race. . . . The aim should be to rid girls of prejudice and to show colored girls that they are not different. . . . I feel that a real university could possibly take such a position. There should be no taint of segregation because of race. If the individual is unworthy to be a member of the University family, that individual should be eliminated from the University. . . . When it comes to the practical working out of the principle, I feel you have some valuable precedents.[43]

The "valuable precedents" Slowe referenced were Oberlin, Smith, and Wellesley, all predominantly white institutions. "At Oberlin College . . . there are 2 Negro girls in each of the dormitories. In this college the relationships between white and Negro students are very pleasant and friendly . . . and the liberalizing effect of having Negro students live in the dormitories is very remarkable." Further, she said that at both Smith and Wellesley African-American girls live in the residence halls. She suggested that Franklin place a few African-American girls in each cottage. She gave what to her should be the underlying principle by writing that

> I think that we should keep in mind always in dealing with human beings the fact that first of all they are individuals and that they should be dealt with on the basis of their individual worth rather than on the basis of accident of race. I think that

it is most important for educational institutions to take this point of view, for the primary reason for existing is to develop individuals to their highest degree of excellency. . . .

If the other girls . . . have prejudices it is the business of the University to rid them of these prejudices as a part of their liberal education . . . the Negro girl should be made to feel that the University is a place where all students are considered as individuals and where each individual may contribute whatever there is in him regardless of what race he belongs to. Under no circumstances should the University suggest to the Negro student that it looks upon him in any other way than as a worthy individual who is an integral part of the University family. To suggest that the Negro girl is so different that she cannot live with other students, is to suggest to her that because of race and not because of individual worth or lack of it, she must be set apart.[44]

National Association of College Women

National organizations of African-American women were plentiful during Lucy Slowe's day. Between 1896 and 1935, these women founded over thirty groups that spanned the nation.[45] There was such a great need to create a parallel universe in the face of segregation that they affiliated for all sorts of reasons.

Lucy Slowe knew that she could not promote her ideals for women by restricting her attention to Howard or even to the professional organization in which she had standing. The University was an entity that existed in a much larger milieu. Thus, at a conference held April 6–7, 1923, Slowe's Washington, DC College Alumnae Club, over which she had presided from 1919 until 1922, took the initial step of organizing a national organization of college women, with Slowe giving a major talk titled "The Training of College Women." Slowe's College Alumnae Club of Washington invited to the District of Columbia a number of African-American women college graduates to consider the advisability of extending its reach through a national group rather than simply a Washington club. Sixty-seven women accepted the invitation and fifteen others who could not sent greetings.[46] Esther Popel, the distinguished Harlem Renaissance poet, presided over the meeting of more than 150 delegates representing twenty colleges.[47]

A year later, the second conference was called at the YWCA in Washington, DC. Here the National Association of College Women (NACW) was founded, and Lucy Diggs Slowe was elected its first president. Thus, April 24, 1924, became a memorable day, for the CAC of Washington

became an NACW branch.[48] NACW was incorporated in November, 1924, under the laws of the District of Columbia. At that time, Lucy Slowe was in her second year as the Dean of Women at Howard.

Slowe, in launching NACW, described the College Alumnae Club of Washington—its purposes and activities and the concept of a national club for African-American women. She said:

> There existed in Washington for many years the College Alumnae Club with membership of over one hundred women—a clearinghouse for the exchange of ideas and a medium of cementing the college women of Washington together in a bond of mutual companionship and endeavor.
>
> The Washington College Women, profiting from the benefits derived from their own club, conceived the idea of forming a National Club of College Women. They believed that in bringing together college women from every section of the country, common social and educational standards might be set up for the benefit of the various communities in which these women live and labor—that the right sort of college woman has a tremendous responsibility for improving the social conditions of the community where she lives.
>
> Better houses, better schools, more elevating amusements, better working conditions, better child care are all her business and should be her pleasure. It was with the idea of marshalling and uniting our trained women for effective work in their communities that the Association of College Women was formed.
>
> Aside from the general work of community betterment, it seemed to the promoters of this national organization that there are two or three pieces of specific work which the Association should address itself to, and make its chief reason for existence, now and in the years to come.
>
> The college women should encourage and make possible college training for deserving and capable girls. This means that they should discover in schools throughout the country girls who are worth the time and money investment necessary for a college course, and assist such girls in securing a college education. . . .
>
> Another task and a far more difficult one, which must be a part of the future work of this organization, is that of influencing colleges in which women are trained, to raise their educational standards to meet those of the very best institutions in the land. If a college accepts women students and employs women on its faculty, it should give them the same status as it gives its male students and teachers respectively. Adequate provisions should

be made for housing its women students, for their physical and social development, as well as the training of their minds. . . .

A Dean of Women of unquestionable character, of thorough intellectual training and refined manners should be employed by every coeducational college to centralize and supervise the interests of its women students. If this Association of College Women can be instrumental in effecting the educational reforms suggested above, it will have done one of the most beneficial pieces of work imaginable in the education of our women as a first step towards improvement in college standards; the sponsors of this organization have set an educational standard as high as that of the best organizations of college women, and it is their policy to accept as members of this organization graduates of those colleges that live up to the standard of the best educational groups in the United States.

To the specific tasks mentioned above, this organization must add a third. If there is to be peace and harmony among the races in the United States, the trained men and women of both races must take the lead in bringing this about. . . . This Association must seek to establish better racial relations between white and colored college women.

Slowe concluded by observing that

[i]n launching this organization, then, the founders have high hopes and high ideals for its future development. These hopes and ideals can be realized, however, only through unselfish, devoted, consecrated service on the part of each member of the organization. Those of us charged with the responsibility of laying the foundation have endeavored to lay it solidly, that the superstructure—Service to Humanity—may rise with confidence on a never weakening base. Let us face the future boldly.[49]

This was classic Slowe. The points she stressed revealed a master plan both for her role at Howard and for her eventual leadership of women. The ideas set forth in this speech in 1924 established the guidelines for the Association's activities and for its growth and development. It was imperative, she believed, that the voices and views of African-American women had to be expressed in policy dialogues about all aspects of American life.

One of the Association's first steps was to appoint the Committee on Standards to assess the quality of colleges that educated African-American students. This Committee established an ambitious, long-range plan that included a survey of the educational standards of the institutions and a

careful consideration of the conditions that affected the physical, social, and cultural welfare of the women of the faculty and the student body.[50] The Committee's work had been stimulated in part by a 1916 report authored by Thomas Jesse Jones, a Howard University trustee, titled "Negro Education: A Study of the Private and Higher Schools for Colored People in the United States." It noted that of thirty-three institutions of ". . . supposed college grade, only three were given a college rating; the other thirty were almost equally classed as 'college and secondary institutions' or mere schools in which a few college subjects were taught."[51] NACW members, like many in the African-American community, were influenced by Du Bois' critique of Jones' two-volume report. They, too, regarded it as part of the attempt of the General Education Board to dismantle liberal arts instruction in African-American colleges.[52] At the very least, Jones' report strengthened the resolve of these women to raise the standards.

Taking on another issue, the NACW pursued the case of the Houston Soldiers begun by the Washington CAC. At its first meeting, the national association requested then-U.S. President Calvin Coolidge (CAC had petitioned President Woodrow Wilson) to grant clemency to the incarcerated members of the Twenty-fourth U.S. Infantry. They also endorsed a bill pending in Congress to reorganize the DC public school system and protested to the Board of Education the practice of allowing African-American students from the University of Pennsylvania to practice-teach in DC schools. They argued that white students of the University of Pennsylvania were allowed to practice-teach in the public schools of Philadelphia, while the African-American students were denied that privilege. Since separate schools did not exist in Philadelphia, the African-American students should be allowed to practice-teach there. Washington, they argued, was helping to perpetuate discrimination in a northern city.

The vigilant NACW members detested the broadcasting of stories and jokes calculated to put the African-American citizens of this country in a ridiculous light. They saw the depiction of African-American citizens using the old minstrel show stereotypes of the nineteenth century as racially offensive, and they issued a statement to that end.

They also endorsed the campaign of African-American citizens to unite against attempts at residential segregation in American cities.[53] Each of these issues showed that they were sensitive to any policy that affected the rights and privileges of African Americans, and they were not afraid to say so.

The NACW did something else monumental that first year. They succeeded in getting a woman elected to the Howard University Board of Trustees. Led by the General Alumni Association, considerable discussion took place with the Board about both the number of alumni allowed on the Board and the procedure for electing them. Since all the members of the

Board were men, they also mounted a campaign to place a woman on the Board. Thus, at NACW's meeting in 1924, members endorsed that project. On June 3, 1924, Sara W. Brown, MD, was elected the first woman member of the Board as well as the first woman alumni member.[54] It did not hurt that she was also an NACW member and had served as CAC's fifth president.[55] Lucy Slowe's imprint was unmistakable.

Ever the NACW organizer, Slowe, along with a friend from her Howard University undergraduate days, Vivian J. Cook, established the Baltimore Branch of this group on November 22, 1924. Meeting at the Sharpe Street Community Home, Slowe was so persuasive, that, at the end of her talk, her audience of college graduates was eager to form a permanent organization.[56] Cook became the first president of the Baltimore Branch as well as the third president of NACW.[57]

In 1925, *The Howard Alumnus* reported that NACW had expanded from Washington, DC to twelve other cities, including Baltimore, Maryland, New York City, Cleveland, Ohio, Chicago, Illinois, and Wilmington, Delaware. Also on board were Cincinnati, Ohio, Kansas City, Kansas, Portsmouth and Petersburg, Virginia, Charleston, South Carolina, St. Louis, Missouri, and Los Angeles, California.[58] As an example of the formidable job Lucy Slowe did to assist in the expansion effort, on February 23, 1929, she traveled to New York City to meet with three groups of women who were interested in organizing NACW branches there. The last of these meetings was held "in Recital Hall of Carnegie Hall where she spoke on 'The Responsibility of the College Woman towards Her Community." [59] This was the "the first concerted effort on the part of college women in the east and the middle western states to get together."[60]

Meanwhile, under Slowe's presidency, NACW kept abreast of any significant accomplishments of African Americans, witness the commendations she expressed in April, 1925, to Anna Julia Cooper: "The National Association of College Women during its recent conference in Baltimore voted that a letter be sent you expressing its congratulations to you upon having won the unique honor of a Doctor's Degree from the University of Paris."[61]

Who was Cooper? She had made an impressive journey. She was only the "fourth African-American woman to earn a PhD degree. . . . At the age of sixty-six, she had completed her journey from slavery to the Sorbonne. . . . On December 29, 1925, William Tindall, a DC commissioner, awarded her the degree at Howard University's Rankin Chapel in a ceremony sponsored by the Xi Omega Chapter of the Alpha Kappa Alpha sorority."[62] "She was a feminist and a stoic activist in the struggle for betterment for Black people."[63] She was well-known—a graduate of Dunbar High School and a teacher there and at the M Street School. Later she became the second president of Frelinghuysen University in Washington.[64]

Cooper was an associate of Slowe, having been an organizer of the College Alumnae Club, the predecessor or NACW. It is conceivable that Slowe—now into her third year as Dean of Women at Howard University—actually looked up to Cooper both for her uncompromising pronouncements about the importance of higher education for African-American women and her assertions regarding the need for African-American women to exert leadership for political and social change in the United States.[65]

Slowe kept her hand in NACW activities. According to an April 26, 1926, report in *The New York World* captioned "Negro Women Seek to Better College Living—National Association Begins Campaign for More Desirable Conditions at Universities," the results of the Standards Committee's survey were beginning to be felt in African-American colleges and universities.

> The National Association of College Women, A Negro Organization, is conducting a campaign for more desirable physical conditions and a standardization of institutions of higher education maintained in the interest of the race, having a large female population. Many of its aims are similar to the American Association of College Women.[66]

The reference to AACW recalls the fact that NACW's impetus was the discrimination that AACW fostered by opening membership only to women graduates of white colleges.

Lucy Slowe was expanding her role in the Washington area and moving out into an ever-enlarging national scene. The NACW reelected her president in 1927, and, according to *The Washington Tribune*, on May 6, 1927, in her acceptance speech she pleaded

> ... for unity among all college women throughout the United States. She urged college women to form one organization in every city and town for the purpose of concentrating their influence. She pointed out that colored college women need to present a united front in attacking community problems, whether they are educational, political or social. ... She aroused much enthusiasm by her declaration that "In our effort to get social justice and the privilege of citizens it may be necessary for us to follow in the footsteps of the militant suffragists and to jail if need be, in defense of what is ours by right of our citizenship. ..." She called attention to the part played by Chinese women in defense of their country and in defense of their rights as women and urged colored college women to profit by their example.[67, 68]

As the Standards Committee grew in prestige, it proceeded to establish standards by which the quality of African-American colleges could be judged. Those institutions welcomed the Association to their campuses for their annual meetings; college administrators contacted the group for recommendations of eligible women for deans; and they accepted their suggestions for increasing library facilities as well as for coursework in library and social sciences.

Lucy Slowe had already become imbedded in the white NADW, and she had begun to take graduate coursework at Teachers College, Columbia, with leaders of the student personnel movement in higher education, such as Sarah Sturtevant and Thrysa Amos. She was determined that the colleges for African Americans would rise to the standards she observed for white students. She was the chief architect of the Standards Committee's work, as can be seen in the formation of a group composed of African-American deans (to be described later). With the birth of this organization, she had spearheaded creation of yet a third African-American women's organization, beginning with Alpha Kappa Alpha Sorority when she was just a college student.

The summer of 1929 marked the beginning of the North Jersey Branch of the NACW. So, in June, off to Plainfield, New Jersey, Slowe went to help inaugurate the new local group.[69] This Branch drew members not only from Plainfield but also from nearby Newark, Montclair, Roselle, and Vauxhall.[70] In 1929, after serving as NACW president for five years, Lucy Slowe stepped down and became a member of the Executive Committee.

Turning to the international scene, in her role as NACW's leader, on January 15, 1930, Lucy Slowe sent a letter to yet another U.S. President, Herbert Hoover, expressing her organization's interest in diplomacy—namely, the situation in Haiti. Hoover had requested Congress to appoint a commission to study and review conditions in that nation. The primary question that was to be investigated was when and how the United States was to withdraw from Haiti. The second question was ". . . what we are to do in the meantime."[71]

Why Haiti? Due to civil disturbances and lack of a stable friendly government, the United States had occupied Haiti in 1915. Writing about the Haitian occupation in the October 1915 issue of *The Crisis*, Du Bois titled the editorial "SHAME ON AMERICA," and urged ten million Americans "to write the White House to demand an interracial presidential commission to bring a quick, honorable end to American violation of the republic's sovereignty."[72] According to John Hope Franklin, "Within a year after the beginning of World War I the United States and Haiti negotiated and ratified a treaty that permitted the United States to have control over Haiti's finances and police for a period of ten years. In 1917, the United States

placed the country under complete military rule and forced the extension of the treaty of 1915 for another ten years."[73]

The occupation of Haiti continued after World War I despite the embarrassment that it caused Woodrow Wilson at the Paris peace conference in 1919 and the scrutiny of a congressional inquiry in 1922. By 1930, President Herbert Hoover had become concerned about the effects of the occupation, particularly after a December, 1929, incident in Les Cayes in which marines killed at least ten Haitian peasants during a march to protest local economic conditions.[74]

Haitians had elicited "widespread sympathy" in the United States.[75] Especially did African Americans protest the "violation of that country's sovereignty and territorial integrity; and the killing of several hundred Haitians in order to restore peace and order."[76]

Thus, in writing to President Hoover, Slowe's NACW adhered to Du Bois' appeal for letters and requested that at least one member of the commission be an African American, that members should be experienced in scientific investigation, and that they be conversant in the language of the people.[77] Hoover's secretary, in his reply, indicated that he would place the matter before the president and bring it to the attention of the Department of State officials.[78]

On February 7, 1930, Hoover appointed five Congressmen to the commission, with W. Cameron Forbes of Massachusetts as chairman. Of the four additional appointees to the commission, none was African American. Still, on the same date, after consulting with Forbes, Hoover "requested Dr. R. R. Moton, president of the Tuskegee Institute (an African-American college started by Booker T. Washington)—on behalf of his institution and such other educational affiliations as he might suggest—to undertake an exhaustive investigation into the educational system of Haiti." Moton selected four African-American men, one of whom was Mordecai Johnson. As NACW's leader, on January 15, 1930, Lucy Slowe sent a letter to Hoover, helping in the end to place Johnson on the commission.

Besides the Haitian matter, on June 20, 1930, Slowe expressed NACW's interest in teacher education in a letter[79] to Dr. J. Hayden Johnson, an African-American member of the Washington DC Board of Education, with copies to each member of the Board. John Hayden Johnson's tenure on the District Board dated from 1916. Besides being a "distinguished editor and civic leader," he was a practicing physician in Washington. Born in Washington, he had earned a medical degree at Howard.[80]

It was the College Alumnae Club of Washington—an NACW branch—that originated the letter. Slowe wrote that they were concerned with educational improvement. Before stating the Club's concerns, however, she established the credibility of her members by informing the Board that their membership included graduates of seventeen institutions, including

not only those from Howard and Fisk but also Chicago, Columbia, and Yale universities. In this letter, the group raised questions about plans for teachers' colleges in the District of Columbia inasmuch as the Board of Education had secured legislation authorizing it to organize and develop teachers colleges. They were especially concerned about policies governing the curriculum and standards of eligibility and qualifications of the faculty. They expressed the hope that the Board would adopt accreditation standards issued by the Association of American Universities, the American Association of Teachers Colleges, and the American Council on Education.

Slowe's letter emphasized the need for consistency. She wrote that "When it is recalled that a very high standard of eligibility training has been set by the Board of Education for teachers in the elementary and the high schools—the bachelor's degree in one case; the master's degree in the other—it seems but fair to require more for the faculty of the college. . . . Character and teaching ability should also be stressed."[81]

Other questions concerned the breadth of the curriculum and a liberal amount of content work and whether the teachers colleges would be under the board of regents, directors, or trustees separate from the Board of Education. Moreover, they hoped that the ratio of teachers to pupils would be the same or nearly the same in both colleges.[82, 83]

As a member of NACW's powerful Executive Committee, Slowe held the meetings in her office at Howard. When they convened on February 14, 1931, Juanita Howard, then NACW president, and Sadie Daniel, corresponding secretary, reported that they had made a courtesy call on Ambrose Caliver, who held one of the highest positions of any African-American in the federal government as Specialist in Negro Education in the U.S. Bureau of Education. They wanted to tell him about NACW and its interests. They reported that he asked them to place him on their mailing list for the Association's bulletins and publications, and he advised them to continue "scientific research in the special field of education pertaining to women."[84, 85]

With impeccable credentials, Caliver was highly respected. Like Slowe, he had been born in Virginia. His education in the public schools of Virginia and Knoxville, Tennessee, was followed by collegiate work at Knoxville College, from which he received a BA degree in 1915. Five years later, the University of Wisconsin awarded him an MA degree, and in 1930, he received the PhD degree from Columbia University.

His professional experience began in 1916 when he became a high school principal in Rockwood, Tennessee, and later an assistant principal of Douglass High School in El Paso, Texas. His first appointment in higher education came in 1917 at Fisk University. His progress through the academic ranks was rapid; within ten years of his arrival at Fisk, he became the first African-American Dean of the University, in 1927. In 1930, he was

appointed to a new position in the U.S. Office of Education as specialist in African-American education. His courage, tact, and perseverance garnered financial and professional support for the many projects in which he was interested.[86]

Perhaps Slowe believed that, if she called the issues that worried NACW to an African-American official of Caliver's standing, action would follow, and so it did. At Caliver's invitation, NACW participated in the National Conference on the Fundamental Problems in the Education of Negroes on May 11, 1934, held in Washington, DC, with Eleanor Roosevelt delivering the main address. She said, in part, that

> [t]here are many people in this country, many white people, who have not had the opportunity that they should have, and there are also many Negro people who have not had the opportunity that they should have. Both these conditions should be remedied and the same opportunities should be accorded to every child regardless of race or creed.[87]

Caliver's conference endorsed the recommendation of Aubrey Williams, Assistant Administrator of Federal Emergency Relief, that African-American teachers should always be employed to teach African-American pupils and African-American adults in states maintaining segregated school programs for the two races.[88]

On April 4 through 6, 1931, Slowe was in St. Louis, Missouri, attending the NACW's Eighth Annual Meeting. Her oratory was welcomed as much by her own organizations as it was by other national groups. She was such a dynamic speaker that her own organization looked forward to her addresses. And so, she spoke confidently on "The Education of Negro Women for Social Responsibility." She proposed that the Association continue to investigate opportunities for practical courses in social services in Negro colleges and that they begin to survey the colleges regarding vocational guidance and placement and follow-up of graduates. She advocated that they publish a bulletin showing available scholarships and fellowships for women. She advised the Committee on Standards to maintain its work on deans of women and to incorporate in one report the findings they had produced over the seven-year period.[89]

Making steady progress with her leadership of NACW, Slowe was appointed to the committee to plan future meetings. Her Executive Committee met on February 12, 1932, and took several steps, including writing to three members of the U.S. Congress—Senator Arthur Capper of Kansas, Chairman of the Committee of the District of Columbia, Senator Hiram Bingham III of Connecticut, member of the Sub-Committee on Appropriations, and Congressman Clarence Cannon of Missouri, member of the

House Sub-Committee on Appropriations—requesting what they considered a fair share—that is, one-third—of the appropriations for African-American schools. The letter cited the publication of the Office of Education Bulletin 17 by Ambrose Caliver titled *A Bibliography on Education of the Negro*, and the announcement of a new publication, Howard University's *Journal of Negro Education*. As well, they cited the observance of National Negro Health Week.[90] Formalized in 1915, the week was initially promoted by Booker T. Washington to teach African Americans what to do to aid in improving their deplorable heath conditions.[91]

NACW's activities were on the cutting edge of educational policy and practice. The Executive Committee minutes of November 19, 1932, show that the Committee voted to print and disseminate among eighty-one African-American schools and colleges a folder calling attention to questions of standards for college libraries.[92]

On February 10, 1934, NACW voted to broaden its efforts and outlook from strictly issues associated with African Americans to the wider community. It elected to collaborate with the Joint Commission of the National Education Association on a "study of the present emergency in education"; to study the findings of the World Problems Club of Columbia University in its efforts to improve race relations in northern schools; to oppose the Doctrine of National Self-Containment; to approve the program of the National Housing Association in its efforts to improve housing conditions in America; and to endorse the Anti-Lynching Bill.[93]

What a strategic move it was for NACW to partner with the National Education Association (NEA). Founded in 1857, the NEA had had similar interests, creating in 1908 the New Department of National Women's Organizations, endorsing in 1912 women's suffrage, and in 1914 passing a resolution supporting equal pay for equal work.[94]

It is understandable that NACW would oppose the Doctrine of National Self-Containment, for it hinted of isolationism. This doctrine might well be traced to President Herbert Hoover, who in his 1933 farewell address, included a plea for international cooperation, believing that America's depression was linked to the entire globe's economic welfare. Banks folded across the nation, and Hoover called for adopting an international spirit. Hoover's plans envisioned a peaceful Open Door expansionism and one that excluded the possibility of war among the various nations. He also called for national self-containment if the international plan failed to materialize.[95]

Although NACW was taking on difficult and arduous issues, the next one—endorsing the Anti-Lynching Bill—was easy. It was common knowledge that African Americans suffered grievously under lynch law, as maneuverings associated with the practice illustrate. This inhumane practice prompted the Howard University Student Council, on October 19, 1933,

to send "a letter to President Franklin D. Roosevelt and to the Associated Press protesting the 'lax attitude' of the Federal government with respect to lynching."[96] Efforts in the U.S. Congress to pass anti-lynching legislation were taken up in the 1930s with the Costigan-Wagner Bill, but that was not the first time. Congressman Leonidas Dyer of Missouri first introduced his Anti-Lynching Bill—known as the Dyer Bill—into Congress in 1918.

African Americans were well-aware of this practice, for large numbers of them either knew someone who had been lynched or were aware of a community in which it had taken place. It dates back to at least the close of Reconstruction in the late 1870s. While African-American men were the main target, African-American women were not exempt.[97]

Although lynching declined somewhat in the twentieth century, there were still ninety-seven in 1908 (eighty-nine African American, eight white), eighty-three in the racially troubled postwar year of 1919 (seventy-six, seven, plus some twenty-five race riots), thirty in 1926 (twenty-three, seven), and twenty-eight in 1933 (twenty-four, four). Statistics do not tell the entire story, however. These were *recorded* lynchings; others were never reported beyond the community involved.[98]

The NAACP had supported the passage of the Dyer Bill from 1919 onward; they had not done so initially. Taking the advice of Moorfield Storey, a lawyer and the first president of the NAACP, the Association at first considered the bill unconstitutional. Storey revised his position in 1918, and, from 1919 onward, the NAACP supported Dyer's anti-lynching legislation. The Dyer Bill was passed by the House of Representatives on the 26th of January, 1922, and was given a favorable report by the Senate Committee assigned to report on it in July, 1922, but its passage was halted by a filibuster in the Senate. Efforts to pass similar legislation were not taken up again until the 1930s with the Costigan-Wagner Bill. The Dyer Bill influenced the text of anti-lynching legislation promoted by the NAACP into the 1950s, including the Costigan-Wagner Bill.[99, 100]

An important part of African-American women's contribution to the NAACP campaign for the Dyer Bill was the establishment of an organization that publicized the horrors of lynching and provided a focus for campaign fundraising. The Anti-Lynching Crusaders, founded in 1922 under the aegis of the NAACP, was a women's organization that aimed to raise money to promote the passage of the Dyer Bill and for the prevention of lynching in general.[101]

Turning to NACW's Eleventh Annual Meeting, March 30–April 2, 1934, in Atlanta, Georgia, we see Lucy Slowe on the podium. At the luncheon on Saturday, March 31, she addressed those assembled on "The College Woman and Her Civic Responsibility." She

stressed the close relationship between economic, social and political conditions and pointed out the college woman's need to understand these problems, the workings of the social and economic worlds of which she must be a part, the workings of her government, her relationship to it and how she can assist in influencing it to meet her needs and likewise her need for preparation to assume social and community responsibility.

Furthermore, she noted "the responsibility of our institutions of higher learning to the present day students in fitting them for intelligent participation in these important phases of community life and activity."[102]

According to the NACW president, twenty branches of the organization had been established by 1934, with half of them active. NACW continued to be involved in local and national affairs. Recommendations adopted included creation of an NACW Speaker's Bureau and a central bureau or secretaryship to make sure that permanent important information was filed and circulated. They also supported the proposed "Fellowship Drive" for funds for worthy Negro college women. On national affairs they adopted a resolution to congratulate President Roosevelt and his cabinet for their attempts to get authentic opinions for the interpretation of African-American affairs through their appointments to advisory posts in various administrative offices. Roosevelt had appointed Eugene Kinckle Jones, Robert Weaver, Forrestor B. Washington, H. A. Hunt, J. P. Murchison, and Lawrence A. Oxley. NACW also passed a resolution to protest uncompromisingly the discrimination being practiced in the House and Senate restaurants in the U.S. Capitol Building, and they endorsed with deep appreciation the valiant efforts of Congressman Oscar DePriest to get through Congress the legislative action needed to abolish these practices. They gave robust endorsement to the Costigan-Wagner Anti-Lynching Bill. In addition, they heartily commended and endorsed the fine work of the Joint Committee of the NRA in its efforts to bring to the attention of the National Recovery Administration the discriminating code violations through differentials in wages and hours practiced under NRA Codes against African-American workers, especially in the South.[103]

The men mentioned in NACW's letter to Roosevelt were Presidential appointees and were referred to as Roosevelt's Black Cabinet. Although previous presidents of the United States had appointed African Americans to important federal positions, Roosevelt was the first to appoint more than a handful. Moreover, Roosevelt selected for his appointees individuals who had special expertise in the matters they supervised.[104] Thus, Eugene Kinckle Jones, who had become the first executive secretary of the National Urban League, went to Washington in the early days of the New Deal and, for

a period, was advisor on African-American affairs in the Department of Commerce.[105] Robert Clifton Weaver was the first African American to be the racial adviser in the Department of the Interior.[106, 107]

Forrester B. Washington, founding executive director of the Detroit Urban League, organized to help rural African-American migrants become accustomed to an urban lifestyle. He left Detroit to accept a position as supervisor of the Department of Negro Economics in the United States Department of Labor.[108] Lawrence A. Oxley, a "veteran social worker, was chief of the division of Negro labor in the Department of Labor."[109]

As expected, NACW was happy to see the National Recovery Act enacted. The NRA, created in 1933 under the terms of the National Industrial Recovery Act was the keystone of the early New Deal program launched by President Roosevelt. In the first two years, the New Deal was concerned mainly with relief by setting up shelters and soup kitchens to feed the millions of unemployed. However, as time progressed, the focus shifted toward recovery. It permitted businesses to draft "codes of fair competition," with presidential approval that regulated prices, wages, working conditions and credit terms. Businesses that complied with the codes were exempted from antitrust laws, and workers were given the right to organize unions and bargain collectively. These were policies that promised to address the problems of African Americans whose conditions had been devastated by the Great Depression. Unfortunately, the New Deal programs did not deliver for African Americans.[110] According to African-American leader John P. Davis, Roosevelt's National Recovery Act—NRA—stood for "Negroes Robbed Again."[111]

Pursuing issues on the national scene, NACW's Washington branch (CAC) was so impressed by the political philosophy of Congressman Oscar DePriest that it sponsored a testimonial dinner in his honor on June 2, 1934. When DePriest was elected to the House of Representatives in 1928,[112] there had been no African-American congressman for twenty-seven years. Slowe spoke at the dinner, emphasizing how urgent it was for African Americans to recognize their rights as citizens. Her speech shows how she understood historical events and how she was able to relate them to the world of her day.[113]

In 1935, at NACW's Twelfth Annual Meeting, Slowe reported that she had attended the national convention of the National Association of Deans of Women at Atlantic City, and at that meeting she heard Eleanor Roosevelt give a speech in which she called ". . . upon all college women to consider the problem of the whole community a challenge to their college training." When her members heard this, they rose to thunderous applause because it strengthened and justified the educational policies Slowe had been advocating and placing on NACW's agenda for these many years.

Slowe came away convinced that she was on the right track: "the major responsibility of deans of women was the training of college women for their community, national, and international responsibilities." Deans had to

be "persons with the highest academic training, persons with broad knowledge of the world . . . , persons who can command the respect of faculty, students, and the public, and persons who can influence . . . curricula and policies of the institutions where women are being educated."

Slowe shared with her NACW members the fact that the ideas of several other speakers at the NADW convention had impressed her. Historian Mary Beard urged that "the new feminism" called for women to "use their superior training in bringing a better life to every individual, regardless of his station in life."[115] Dean Virginia Gildersleeve of Barnard College called for changes in college curricula in order to "bring them in line with the social, economic, and political problems of the day." Dr. Mary E. Wooley, president of Mount Holyoke College, challenged the deans to see to it that young people in American colleges "get rid of their provincialism, that they through serious study appreciate the problems of other races and nations and that they lend their voices to solving international problems through reason rather than force."[116] There could be no doubt, according to Slowe that "the function of a dean of women is that of an educator who is a specialist in the education of women."[117] One of the last trips Slowe made was to the Columbia, South Carolina, Branch of NACW that had invited her to speak on April 7, 1935 at its spring meeting. Given her position on education, what does this mean for the education of African Americans, especially women, and their activities in their community? Taking as her topic "The College Woman and Her Community," this is what Slowe said.

> For the past twenty-five years, Negro college women have had almost nothing to say on international matters probably because they seem so remote from them. However, when we consider that in the interest of Negro Americans as well as the interest of other Americans is involved every international problem facing our country today, those of us who hold college degrees should be deeply concerned with this phase of American life. Probably the greatest problem before the world is that of war. For the past ten years, eleven of the largest and most influential women's organizations have met in Washington annually to consider the "Cause and Cure of War." These women realize that the education of public opinion on this subject is the first step in the direction of getting a solution for the problem. Year after year they have presented facts on the enormous cost of war on human life and goods—facts that should appeal to and appall every intelligent man and woman in America. What are college women of our race doing to acquaint our people with the fact that war is the most wasteful, futile and inhuman method of settling international disputes that man has ever tried? What are we doing to connect

ourselves with these general movements and organizations that have as their purpose the turning of the waste of war into the constructive uses of mankind? Ample money could be saved, if war were abolished, to endow enough institutions of learning to meet the needs of every child in the United States. Are we as college women acquainted with the Women's International League for Peace; the National Council for the Prevention of War; the International Federation of University Women and similar organizations? Should we not work actively in these organizations as hundreds of college women are doing? As informed citizens we cannot shirk our responsibility in this field.[118]

Slowe recognized the need for African-American women to play more significant roles in American society. She declared that

[i]n such a period as we are now passing through, every individual must appraise [sic] his life in terms of social usefulness. This is especially true of those who have been exposed to the culture, the intellectual and spiritual heritage of the world. The college woman . . . should be prepared in our troubled times to diagnose and prescribe with some degree of wisdom a remedy for some of the ills that so beset the modern world. Since Negro college women can no more escape this duty and responsibility than other college women, they should be alert to see their task and eager to address themselves to it.

She identified the areas with which African-American college women should be involved.

In a democracy . . . the citizen is the source of power and through this power we can control those influences and policies that mean life or death for us. Have our college women studied carefully the conditions in these areas and used their knowledge and skills in educating the masses to use their latent power through the wise use of the franchise? . . . Government is reaching down into every activity of our lives, but do Negro college women apply their knowledge of political science, their knowledge of history to influence government to the advantage of humble citizens? . . . What in the past twenty-five years have Negro college women done in this field? It seems to me that the first duty of college women is to inform themselves thoroughly on economic and social problems confronting our

citizens and to furnish the masses of our people with guidance in a democratic state.

Apparently, Slowe was urging these women to work for the franchise, which at that time was not available to them in South Carolina.

We must be conscious of the stress and strain which the intricacies of modern life have put upon us. We must recognize that the intelligently trained person must provide for himself a refuge from the perplexities of the present and resources for hours of recreation.

The matter of leisure activities continued to be a matter of major interest to her. She said that

college trained persons must not only be concerned about their own leisure-time activities but should support enterprises that will enrich the life of every community. As we look backward over the 1st quarter of the century and forward to the next, may we not pledge ourselves to work for communities where good government is the passion of all its citizens, where the rule of force in national and international affairs gives way to the rule of reason, and where the healing and inspiring ministry of beauty has opportunity to influence and dignify our common, every-day lives.[119]

Back in Washington, Slowe prepared for NACW's Twelfth Annual Meeting held at Howard University April 19–21, 1935. At that conference, delegates took several critical steps, including committing their organization to be a clearinghouse for matters relating to the education of women. This already impressive organization had achieved the distinction of being listed in the 1935 *Educational Directory, U.S. Office of Education*. While these women were attending their meeting, Eleanor Roosevelt also invited them to a reception in the East Room of the White House as both the president and his wife were especially friendly to African Americans.[120] The organization went on record as supporting the Program of the U.S. Office of Education regarding matters of equality of educational opportunity.[121]

Slowe could not have wished for a more loyal group of supporters than those in NACW. As a case in point, the Standards Committee observed in a December 19, 1936, letter to Slowe the gradual development of the Dean of Women's staff at Howard University. They wrote that

[a]s your staff organization is unique in staff organization and size, the Committee would appreciate any information you may give concerning the several phases of work and distribution of your assignments to your assistants. The Committee is interested in all activities of your staff, including particularly those that bear on guidance.[122]

National Association of Deans of Women and Advisers to Girls in Negro Schools

This organization, known initially as the National Association of Deans of Women and Advisers to Girls in Negro Schools (NADWAGNS), was the brainchild of NACW. The NACW Committee on Standards' comprehensive college survey that was begun in 1924 revealed "glaring *academic, physical* and *cultural* needs."[123] The Committee through personal visits to campuses, questionnaires, letters and reports from, and consultation with, college administrators and rating officials, learned that many schools had not been officially accredited; that differences of policy existed in rating colleges for Negroes, if they were appraised at all and that these colleges were not measuring up to the desired educational requirement. . . .[124]

Although NACW's criteria applied to the institution as a whole, the Association knew that the low levels of operation reflected on the quality of women students' education. To bring about improvements NACW concentrated on those elements of the institution that had the greatest impact on women students. NACW concluded that most of the institutions needed a trained dean of women.

At its annual meeting in Atlantic City in April, 1928, NACW "authorized Slowe, to call the Deans and Advisers to Women in Colored Schools together, using the list of African-American schools in the U.S. Bureau of Education Report of 1928.[125] In order to facilitate reaching their objectives for women, they scheduled a conference for March 1–2, 1929, at Howard University.

As a result of this epochal meeting, the National Association of Deans of Women and Advisers to Girls in Negro Schools came into being.[126]. Despite the recognition of inadequacies in African-American colleges, another factor no doubt precipitated creation of a professional association for African-American deans: the fact that they were not welcome in NADW.[127] Thus, seven years into her own deanship, Lucy Slowe, through NACW, began to professionalize the work of all African-American deans of women. It would take some time, but she now had a directive to reach out to whatever leadership might be providing counseling and advice to women students in African-American colleges.

The next year, on March 21 and 22, 1930, NADWAGNS held its second conference. The group convened at Fisk University in Nashville, Tennessee, with Slowe in the chair. The story of this group includes a litany of name changes. The organization had now changed its name to Deans and Advisers to Women in Colored Schools (DAWCS). Some of the women in this line of work who could not attend the first meeting learned about it and requested information concerning the Nashville gathering. Moreover, those who did attend were so impressed that they recommended annual meetings. Topics they suggested included "The Status of the Dean of Women," "The Distinction between the work of the Dean and that of a Matron," and "How is the Dean to convert our Presidents?" They also recommended "What Institutions are offering courses and giving degrees for the Work of the Deans?" "What is the Outlook for Employment in City Systems for Deans of Girls?" and "To what extent can we yield to the modernistic demands of our girls and yet keep faith with their more conservative parents?" Their list also included "Are students ready for self-government?" Three more topics were "What is the attitude of Negro students toward Deans of Women?," "Social Relations in a Coeducational School," and "Modern Methods of Discipline and Personal Adjustment Problems." Topics like these confirmed the view that, although the job was recently introduced, it was experiencing rough sailing and that these women were just feeling their way and needed help.

Slowe gave the opening talk, in which she emphasized the need to pay attention to the health education of women students, the broad education of women, and women administrators' relationship to the entire school administration. She also commented on the salaries of women, their opportunities for advancement, and whether or not the women students have a chief administrator who is in charge of all affairs that concern them. Interest in these questions led to important findings that were published in the *Journal of the National Association of College Women*.[128]

Slowe, as chair, outlined some of the responsibilities of the organization. She said:

> Women have had very little to say about the policies under which Negro women are being educated. They must begin to offer something in the way of help in constructing the building of a program for women's education. The National Association of College Women must do for Negro women in colleges what the American Association of University Women is doing for white women. A woman administrator must assist in the physical layout of a women's campus or the women's part of a campus in educational institutions and the planning of a curriculum for the training of women students. Homemaking will have some part in the life of 95% of the women. Trying problems of the

campus growing out of unintelligent parenthood show that we have quite a stake in women's education. We must set up the proper conditions for the proper development of women and not write petty statutes on our books regarding minor details of behavior.[129]

NACW appointed Slowe to the committee charged with planning activities for subsequent meetings. She continued as president of DAWCS, with meetings at Talladega, Tuskegee, Hampton, Howard, Wilberforce, and Bennett—all African-American colleges.

The 1931 meeting took place at Talladega College in Alabama, March 20 and 21. Unfortunately, Slowe complained of respiratory problems and was unable to attend.[130]

As NADAWCS's president, though, Slowe was able to handle correspondence. She noted in 1931 the death of Juliette Derricotte, Dean of Women at Fisk University. She had also been Slowe's associate at the national level of the YWCA. *The Afro-American* reported that Slowe wrote, "Miss Derricotte's loss to the leadership of Negro Womanhood, cannot be estimated, for she was one of the few colored women who had had worldwide contacts and who commanded national and international respect by the quality of the work she had done for years through the YWCA."[131]

Traveling by train,[132] Slowe went to Tuskegee Institute in Alabama to attend the Third Conference of the National Association of Deans of Women and Advisers to Girls in Negro Schools (NADWAGNS) from March 17 to 19, 1932. Train travel was one of the many demeaning experiences for African Americans as Jim Crow rules required them to sit in a coach next to the coal-burning engine, which was also separated from white passengers. Yet they endured and attended their conferences.

At Tuskegee, she advised the deans to keep a file of information on every student under their control and to seek adequate clerical help so that their time could be devoted to students' needs. True to her own personal concerns at Howard, she told them that the dean should live in her own home, not in a dormitory, and should not be directly responsible for dormitory administration.[133]

Always gracious, in an April 6, 1932, letter of appreciation for Tuskegee's hospitality, Dean Slowe wrote Dr. Robert Russa Moton, Tuskegee's president.

I do not need to tell you that the education of our women is one of the most important phases of modern education, for you are so familiar with our needs that you know them better than I do. I do wish to enlist your support and sympathy in meeting these needs in our school[s], for I realize that we are still pioneering in the education of women. Our modern life is making

> such demands upon women that those of us who are trying to guide them must do so with very great care, for whatever happens, all the fine characteristics of the home and family must be preserved and our women must be educated to see the relationship of the home and family to larger community life. These two demands upon our educational system made [make] the problem very complex.
>
> I should like at some time when you are in Washington to discuss with you some practical ways of meeting certain physical needs of our women on various school campuses. The women at Tuskegee are comfortably housed and the social life carefully supervised, but there are many places where these two things need to be improved. I know that your great wisdom can be of service to me in my efforts to better conditions wherever there is a need for this.[134]

Because Slowe was aware of Moton's stature as an educator, she had no qualms about calling deficiencies in African-American colleges to his attention and asking for his support. President Moton, a disciple of Booker T. Washington, had become Tuskegee's president following Washington's death. His considerable power had been developed as he headed the National Negro Business League that Washington founded in 1900.[135]

In the spring of 1934, Slowe traveled to Hampton, Virginia, where she attended the fifth conference of the Deans of and Advisers to Women in Colored Schools at Hampton Institute, March 22–24.[136] The 1933 conference—scheduled for West Virginia State College—had been cancelled because the Great Depression had created severe financial conditions.[137] For the Hampton meeting, the members chose as the theme "The Place of the Dean of Women in Training Women for the Modern World." Slowe described the dean of women as

> the person on any campus whose business is to see that the women on the campus are prepared to meet the demands of the modern world. . . . It means that one of our future tasks is to see that we ourselves are prepared to interpret the modern world.
> . . . we are not going to solve any problems by looking at them as Negro problems. Our problems are human problems. If the Negro is to get anywhere, it will be by associating his problem with other problems. . . . Thirdly, we ought to realize that what we are trying to do is intimately related to what other people on campus are trying to do.

Several members proposed that the African-American deans of women meet concurrently with their white counterpart—NADW. Although this

possibility had been explored, Slowe contended that the deans of women in African-American colleges should meet separately for the immediate present due to the nature of their problems and the responsibilities these deans had in their local situations.

The African-American deans of women also rejected an overture for joint meetings from the National Association of College Deans and Registrars (NACDR) an organization of African Americans that had been founded in 1925.[138] Interestingly enough, representatives of the National Association of Colored Graduate Nurses were welcomed as visitors and observers, but not as members. The nurses' organization, NACGN, had been formed in 1908.[139]

The fact that these two groups of professionals even existed, once again, confirms the racist nature of American society, even among professionals. The National Association of College Deans, Registrars and Admissions Officers had been founded to provide a forum for deans and registrars at African-American colleges to discuss mutual problems. Their goal was to improve the quality of education in their colleges and to establish rules for accreditation.[140] Like the deans, registrars, and admissions officers, the National Association of Colored Graduate Nurses was compelled to organize. Because of the color of their skin, African-American nurses were denied adequate training, they were not allowed to serve in the armed forces, hospitals would not employ them, and, when they did find work, they were paid less than white nurses. Consequently, they had founded their own organization the same year that Lucy Slowe graduated from college.[141]

The African-American deans voted at their sixth meeting—held at Howard University in 1935—for a more formal organization, (making it independent of NACW). Slowe was elected president. Reversing their decision of a year ago, they did hold this meeting simultaneously with the Annual Convention of College Deans and Registrars and also with the first meeting of Deans of Men in Negro Schools. Slowe applauded the reasoning behind this move: eventually these groups must have some joint meetings in order to serve the needs of students more intelligently.[142] She said that there is a need to "absorb the strength that comes with connections from other women's organizations that are interested in the same things."[143]

Twenty-eight members from eleven states and the District of Columbia attended the Howard meeting. Prior to the conference, they sent in a list of seven topics they wanted addressed, including housing, administration of dormitories, and organizing social life. They also listed student health, manners, and student responsibility in matters of behavior. Vivian Cook, Juanita Howard, and Ester Popel Shaw represented NACW, and Mabel Staupers of the National Association of Colored Graduate Nurses of New York City spoke on student health.

In 1936, Wilberforce University in Xenia, Ohio, hosted the seventh session where Slowe gave an address titled "The Place of the Dean of Women on the College Campus." She said, in part,

> In the past 50 years women have 1) secured the vote; 2) worked outside the home; 3) changed their home life—no longer the center of the training of the child. . . . The Dean of Women is not a "Lady Cop." . . . The Dean of Women is not the only person on campus to influence campus ideals. . . . The Dean of Women should have academic qualifications; should teach and demonstrate that she has intellect; should be a student of women's education; and should be a person of convictions and a sound philosophy of life concerning those things which are of permanent value to young people.

"The faculty should assume some responsibility for the moral and spiritual life of students as well as their academic life," she said, and suggested that an evaluation of activities on each campus be made by students and faculty to find out:

> 1) the purpose and function of each organization; 2) percent of students inactive; 3) extent the organization challenges students to development and growth; 4) extent of duplication of activities; 5) interrelationship with other organizations; 6) cost of maintenance—within the means of students; 7) relationship to use of leisure time; and 8) Does program meet needs of the individual student?[144]

The 1937 meeting, the eighth, convened on the campus of Bennett College, March 25 through 27, was Slowe's last.[145] Following that meeting, she wrote to Hilda Davis that

> [t]his year we hope to publish "The Deans of Women" monograph, the official publication of the National Association of Deans and Advisers to Women in Colored Schools. We are asking that the papers and discussions of our March Conference at Bennett College be included in the first issue . . . expense of the publication will have to be covered by the registration fees collected at the conference.[146]

In sum, Slowe pioneered in the education of African-American women beginning, with her presidency of the College Alumnae Club of

Washington even as it became a branch of the National Association of College Women. This led to her leadership of NACW and later the presidency of the National Association of Deans and Advisers to Women in Colored Schools. She helped African-American women develop an understanding of the role they had every right to assume in America and in particular in the African-American community. Under her leadership they were able to establish goals and to design strategies for increasing their participation in political, economic, and academic life. She was heartened by the fact that NACW had enabled her to bring together the one group of women whose chief function is to see to it that African-American women "get adequate training to fit them for their place in the modern world."[147]

Governmental Affairs

Prior to the middle 1930s, the primary arena for Slowe's activities had been the private sector. It was not until later that she became involved in government affairs. Several factors might explain this shift, the first being the restricted role of women in local, state, and federal governmental policy centers and the second being the limited exposure of African-American women to social, economic, and political issues of American life. In 1934, Slowe was invited to the White House for a meeting at which First Lady Eleanor Roosevelt presided.

> When Mrs. Roosevelt came to the White House in 1933, she understood social conditions better than any of her predecessors and she transformed the role of First Lady accordingly. She never shirked official entertaining; she greeted thousands with charming friendliness. She also broke precedent to hold press conferences, travel to all parts of the country, give lectures and radio broadcasts, and express her opinions candidly in a daily syndicated newspaper column, "My Day."[148]

This meeting was called to discuss proposed residence "camps and homes for needy unemployed women" and was sponsored, at the urging of Eleanor Roosevelt, by the Federal Emergency Relief Administration. "The problems of unemployed Negro women as they affect her efficiency on the job and as they affect her training for the constructive use of leisure," *The Washington Tribune* of May 4, 1934, reported, "need the attention of all interested community groups and should be very definitely called to the attention of the Emergency Relief Administration." Dean Slowe and Mrs. Vivian Garth Alan, Industrial Secretary of the Colored YWCA in Baltimore, both of whom were in attendance, "discussed these matters with the members of

the Conference and officials of the Emergency Relief Organization."[149] FERA had been created by Congress on the strong recommendation of Eleanor Roosevelt[150] and Harry Hopkins, a social worker and Roosevelt's federal relief administrator, who was convinced that work should be the chief antidote to poverty.[151, 152] At this conference, Mrs. Roosevelt was persuaded that her idea for a nationwide jobless camp for women could be achieved. Civilian Conservation Corps (CCC) camps for men had already been established to aid jobless men, and she was troubled by the male-only focus. Consequently, she lobbied for camps for women and was successful in setting up ninety residential camps that eventually served 5,000 women yearly. "In all, 8,500 women benefited from working at a residential camp in a program that ER [Eleanor Roosevelt] was instrumental in creating."[153]

National Council of Negro Women

The National Council of Negro Women (NCNW), inspired by the national treasure Mary McLeod Bethune, was perhaps the last major national organization with which Lucy Slowe affiliated. Because of the high regard in which Bethune was held nationally, Slowe had called upon her for assistance when she encountered challenges with the president and Board of Trustees at Howard University. Bethune's stature as a leader was recognized by the National Association for the Advancement of Colored People with the award in 1935 of the Spingarn Medal.[154] And, her close friend, Lucy Slowe had sent a letter of congratulations.[155]

On December 5, 1935, Slowe attended the founding meeting of NCNW in New York City. In bringing NCNW into being that year, Bethune envisioned an organization that would enable African-American women to play "a substantive role—as did white men and women and Black men, [also]—in the governmental process undergirding individual and family survival. Bethune believed that she and her sisters could best assume such activities through an overarching organization that encompassed all existing national women's organizations."[156]

A number of prominent African-American women leaders had argued against Bethune's organizing concept because they believed the National Association of Colored Women (NACW)[157]—the leading national organization of African-American women—was serving them well. In addition, there were more than thirty national organizations of African-American women, including sororities and political and religious groups that were doing good work. Bethune wanted to harness the power of all these women—a million strong—for "constructive action;" she felt that the NACW organizational structure was inadequate for that job. Thus, she called upon several key women who were widely respected to serve as NCNW officers, among them

Lucy D. Slowe, who became the first executive secretary. The object was "to quell some of the criticism and to project an image of public unity to thousands of Black women who closely scrutinized the public actions of their leaders."[158, 159] Here, again, Slowe was instrumental in founding another African-American women's organization.

The next year, on June 16, 1936, Slowe wrote to Charlotte Hawkins Brown, another prominent woman who had also been elected to serve as an officer, to advise her that papers of incorporation of the organization had been filed with the Recorder of Deeds of the District of Columbia.[160, 161] Brown—also one of Slowe's good friends—had been Slowe's Women's Dinner speaker in 1929. Slowe told Brown that she had been revising the constitution in accordance with their vote and that Bethune was "very enthusiastic" over the prospect that the organization would "make a worth while contribution to American life."[162, 163]

Later that year, on Thursday, December 17, 1936, NCNW's third meeting convened in New York City at the 137th Street YWCA Branch. Officers elected—in addition to Bethune, who became president—included Clara B. Bruce, 1st vice president, Mary Church Terrell, 4th vice president, and Lucy Diggs Slowe, executive secretary, reported *The Washington Tribune*, on June 1, 1937.[164] Note the women who had also been founding members of the CAC: Mary Church Terrell and Clara B. Bruce.[165] All of these women, distinguished in their own right, had created a network that placed them in the forefront of the African-American women's club movement.

Branching out into a wider national scene, early the following year on January 6–8, 1937, Slowe, representing the NCNW, took part in the National Conference on the Problems of the Negro and Negro Youth held in Washington, DC. Bethune, who was director of the Division of Negro Affairs (in what was called Roosevelt's Black Cabinet), and at the same time president of NCNW, in "her usual style"[166] took control of the Conference. Her report to President Roosevelt showed that Slowe was a member of the Committee on Education and Recreation under the chairmanship of John W. Davis.[167]

Davis' background was complex. In 1922, he had rejected appointment to the U.S. Supreme Court. In 1924, he became the Democratic nominee for president, waging a conservative, high-minded, and losing campaign against Calvin Coolidge. He left the political arena, only reemerging briefly in the 1930s as an organizer of the anti-New Deal Liberty League.[168] He corresponded with Bethune on problems she identified as critical to African Americans, and he participated in her 1937 and 1939 conferences.[169] As a whole, the Conference "advanced pragmatic solutions for immediate implementation, advocating a fair share of federal resources to Black citizens within the legally segregated South rather than insisting upon integration." That meeting produced, through Slowe's committee, a plethora of recom-

mendations under the category "Adequate Educational and Recreational Opportunity." Her committee "asked for an equitable share of federal education dollars and recreational and educational centers as integral parts of all public housing projects."[170]

When the Conference ended, Slowe, writing as NCNW's executive secretary, sent a letter to Aubrey Williams, a white Mississippian[171] who was director of the NYA, to express appreciation. Bethune, from 1936 to1943, was already in the leadership of NYA as director of the Negro division.[172] Slowe said the subject of the Conference—the most pressing difficulties of African Americans in the United States and appropriate government responses—should be called to the attention of the National Administration.

In this letter, dated January 21, 1937, she said, "I am of the opinion that this administration will go down in history as one of the most enlightened, if it does succeed in solving these fundamental problems of employment, of housing, and of education, as they affect the Negro race."[173] Continuing, she said,

> As far as I know this is the first time an official of the Government has called together the heads of organizations and individual leaders to consider a program for the benefit of the Negro race. The significance of this Conference can not be estimated but, in my judgment, it was one of the most important conferences which has ever been held in the United States. . . .The Conference 1) brought together a cross section of the people working to improve the lot of the Negro; 2) provided an opportunity for careful and studied consideration of the problems confronting the Negro by persons whose training made it possible for them to consider these problems intelligently and scientifically; 3) resulted in agreement among the diverse representatives of the basic things that the Government ought to consider its major responsibility.

The next month, on Saturday, February 12, Slowe gave the opening remarks at a testimonial dinner for Bethune sponsored by a committee of citizens at Talley Holmes' Whitelaw Hotel in Washington.[174]

The Washington, DC Community

Because Slowe believed that educated African-American women are obligated to return to their communities and become leaders in improving life in their towns, she practiced what she preached. She actively shared in the work of community and national groups concerned with better lives for

all citizens. Her community involvement in the Washington, DC area was extensive. In her last years, she was active with the Associated Charities/Family Service Association and the Northwest Settlement House.

Associated Charities

Early in her tenth year as Dean of Women, Slowe was informed by the Board of Managers of Associated Charities that she had been elected to the Board.[175] She replaced Mrs. William Stuart Nelson, who had moved to North Carolina with her husband.[176] The organization was concerned with dysfunctional families and families under stress.[177] She remained a member of the group until her death.

On one occasion—February 17, 1937—as a member of the Board, she questioned the participation of the Animal Rescue League (ARL) in the Community Chest after the secretary of the ARL wrote to her concerning its activities.[178] Slowe replied that she did appreciate the work of the League, yet the only question on her mind ". . . was that with so many human beings needing food and shelter, just how far can we go in using community funds for the purposes of the league. With me it was only a question of values."[179]

Family Service Association

Slowe disdained discrimination whenever and wherever she experienced it, even as it was practiced by the Family Service Association. As a member of the Board,[180] she described for her colleagues racist procedures at the Annual Luncheon held at the Wardman Park Hotel on April 22, 1937. A member of the Board, who presumably was directing guests to their seats, sent all the African-American guests to Table 15, at which Slowe was hostess. According to the Board Minutes,

> On May 12, 1937 Dean Slowe brought to the attention of the Board the fact that at the Annual Luncheon on April 22, 1937, some of the colored guests felt discriminated against because they were at first seated at one table together, and that since she is a member of the Board, some of her friends had asked her if she sanctioned such a procedure. She said that she would not have mentioned the occurrence, if she had not been personally involved; but that the *Afro-American* Newspaper was planning to publish a story on the subject and had requested a statement from her. She felt that a brief statement from the Board saying that a mistake had been made and that we had no intention of hurting anyone's feelings would help the situation.[181]

That statement recorded in the minutes does not sound like Slowe, for, in a letter to the director of the Family Service Association, she called attention to the fact that some African-American guests had left before her own arrival. Five days later, she raised the question, "Why were colored guests sent to Table 15 after the first colored group left in protest and the discrimination called to the attention of officials of the Association?" She insisted that the Arrangements Committee of the future must comprise members without prejudice.[182] During her five years on the Family Service Association Board, Lucy Slowe was very active as a member of both the Executive Committee[183] and the Committee on House Warming.[184]

Less than two years after her election to the Board of Associated Charities, Slowe was informed that she had been elected to the Board of the Community Chest[185] of Washington, DC, and later she was advised that she was a member of the Solicitation Committee.[186] She was willing to serve, she said, but she was not effective asking people for money.[187] She was also a member of the Speaker's Unit of the Community Chest and, in 1935, became a member of the Executive Committee.

Northwest Settlement House

One of several centers for varied social services for African Americans, Northwest Settlement House was one of Slowe's favorite volunteer activities. In this agency, she joined an acquaintance, Garnet C. Wilkinson, who was president of the Board of Directors.[188] Not only was she secretary of the Board but she was also a member of both the Executive Committee[189] and the Personnel Committee.[190] Minutes of the Board of Directors' meetings show her regular attendance and full participation in the program in June 1937. Here, too, she despised the apparent unfair treatment of African Americans. As executive secretary of the Board, Slowe wrote in July 22, 1937, to the director of the Foundation of Settlements, an accrediting organization,

> The Board of Northwest House protests the grouping of all Negro houses together. Each house should be considered for membership in the national body on the basis of its individual work and worth. I think it is a vicious practice to group Negroes together when something like this comes up. . . . It seems to me that those of us who are interested in Northwest Settlement House have nothing whatsoever to do with what is going on in other Negro houses. It would be just as logical for them to hold up a house that serves white people until every house was ready for admission.[191]

Despite the fact that the visiting team had approved Northwest House, it had not approved Southwest House. Approval at the national level for Northwest House was delayed pending a second review of Southwest House.

Advisory Committee for the National Youth Administration

On August 29, 1936, Francoise Black, director of the National Youth Administration (NYA) for the District of Columbia, invited Slowe to serve on the District's Advisory Committee.[192] A year earlier, the NYA had been established within the Works Progress Administration (WPA). A product of President Franklin D. Roosevelt's New Deal, it ". . . provided work training based on U.S. citizenship and financial need for youth between ages sixteen and twenty-five."[193] The following year, Slowe's friend, Mary McLeod Bethune, was appointed director of Minority Affairs for the NYA.[194] Slowe's appointment was announced in September, 1936.[195] Although Slowe had hoped that the NYA would create a camp for African-American girls, Black notified her on January 26, 1937, that the proposal for the camp was stymied for lack of a satisfactory location.[196] Later, however, the administrator in charge of African-American activities, "S. G. Mays"—presumably Sadie Gray Mays, the wife of Howard University's Dean Benjamin E. Mays—on June 12, 1937, thanked Slowe on behalf of the District of Columbia Committee #1, Girl Scouts of America, for helping to make training for Day Camp Leadership possible.[197] Training was to take place at Camp Edith Mary, New York. "We are sending two young women to this camp," Mays wrote, "So we believe you would be proud of [us] and we are looking forward and have great faith that the results will be the kind you will enjoy having helped."[198] Despite the fact that the national administration of the NYA prohibited discrimination in what was purported to be the most racially egalitarian of the New Deal programs, ". . . its number of African-American participants never corresponded to the percentage on relief." [199]

Young Women's Christian Association

Lucy Slowe's involvement with the Young Women's Christian Association (YWCA) anticipated the organization's current mantra: "eliminating racism/ empowering women." During the early 1920s, many of her nonprofessional activities had been with national organizations such as the "Y," as it was familiarly known, She knew the organization well. Beginning as an undergraduate at Howard, she had been president of the Christian Endeavor Society and regularly attended the religious services in Rankin Chapel.

Lucy Slowe's Papers contain her copious correspondence with the "Y," including requests for information as well as requests for review and comment. For example, on October 13, 1924, Juliette Derricotte, secretary of

the national student council of the "Y,"[200] sent Slowe a memo attached to a document titled "The Emphasis in the YWCA for 1924–25." Derricotte wrote that "This statement was prepared for a group of Church Board Secretaries. I thought you might be interested in it."[201] Slowe had been a member of the Board of the National Student Council of the YWCA, the body responsible for carrying out plans and policies voted by the National Student Assembly between meetings of the Assembly. The National Student Assembly was the legislative unit on matters of intercollegiate concerns.[202]

The "Y" prepared a "Bibliography for Delegates" to the National Student Assembly in 1924 that carried the notation, "This brief list of books represents different points of view, that the reader may have a chance to form her own unprejudiced opinion." The books were in five groups: Relations of Men and Women; Race Relations (including Du Bois' *The Negro* and Brawley's *A Social History of the American Negro*); Relation of Christianity to Standard of Living; International Relations; and The Christian Way of Life.[203] The Student Assembly in 1924 passed the following racial resolutions. "We, the Student Assembly of the Student Young Women's Christian Association of the United States, believing in a social order based on Jesus' way of love, every individual would find free scope for his fullest development, pledge ourselves to seek anew to know the mind of Jesus in regard to our racial relationships, and to know the students of other races, that we may rid ourselves of prejudice and may promote justice and understanding."[204]

Slowe's interest in the representation of African-American women on national boards is reflected in a letter to Frances Williams, national secretary of the Y, in which she suggests that, for the Interracial Committee, "some Negro graduates of white colleges be added" and recommended Miss Charlotte Atwood, a Wellesley graduate. True to her love of literature, Slowe included an interesting aside in her letter to Williams: "I have listened to the reading of Countee Cullen's prize poem which appears in this month's *American Mercury*.[205] It is wonderful in conception and majestic in expression. To be properly appreciated it should be read aloud, as I think all poetry should."[206, 207]

The Slowe Papers hold extensive materials on routine matters of the Y, such as budget, financial shortfalls, staffing, and program changes. As Slowe sought to establish policies and programs that were more inclusive, she refused to share in anything that savored of discrimination.

The Southern Division of the Council wished to invite African-American students and secretaries to a Regional Conference at a center controlled by the Blue Ridge Association, a group that refused to accept African Americans on an open basis but insisted on segregation in housing and dining. Derricotte, in a letter to a National Board Member, requested the Y to break its contract with the Blue Ridge Association.[208] Slowe wrote Derricotte that she could not understand "how the National Board of a

Christian Association can sanction discrimination of any kind and call itself Christian."[209]

In another incident, Slowe wrote Derricotte that

> I have been very much disturbed by a news article which appeared in the New York Age concerning a young woman who wanted to enter the physical training school of the YWCA. Some of our students called it to my attention and stated that if the YWCA sanctioned such action [she was rejected] on the part of anybody employed by it, they did not care to have any connection with the YWCA at all. You know that our YWCA is very weak anyhow, so that any excuse or reason that students can find for not supporting it will certainly be found.[210]

When the Y faced a decrease in funding, the organization issued a paper titled "Some Reasons for Giving to the Budget of the National Student Council, YWCA." In part, it stated that there existed "More than 10,000 colored women students—the large majority in the southern states. . . . In spite of all the limitations of poor educational facilities, restricted privileges and so on, the girls are catching a gleam of what life really holds for them, from the National Student Council of the YWCA, new interests, new hopes, new faiths, new loves, . . . new women."[211]

Slowe became a member of the executive committee of the Y's National Council in 1924[212] and noted especially the reports of activities in the southern region, including Talladega, Clark, Knoxville, Tougaloo, Mississippi Industrial, Holly Springs, Jackson, and Piney Woods, all African-American colleges. The question of a traveling library was raised.[213] The Derricotte correspondence reports an explosion of youth programs. In one letter, Derricotte posed the issue of standardization of African-American schools and asked if the National Association of College Women would be interested. Slowe was asked to represent the Y at the Foreign Missionary Conference in Washington on January 27 through February 2, 1925, and also at the National Convention on Cause and Cure of War.[214] Slowe served as a delegate at both of the conventions.

The issue of young women's smoking was explored by the Young Women's Christian Temperance Union during 1924. According to the survey, Slowe had written that, at Howard University, she had not discovered any smoking and that she did not believe that the habit existed. She stated that she believed it rested wholly with the mothers as to how prevalent the habit becomes.[215]

Still very much a valued constituent of the Y, Slowe and four Howard University students were invited to attend the Bible Institute under the auspices of the National YMCA and the National YWCA to be held at

Hampton, Virginia, on March 27–29, 1925.[216] However, the Howard Y was unable to send students because of "limited financial reserves,"[217] and the dean did not attend because of a previous obligation to attend a teacher's institute in Martinsburg, West Virginia.[218]

A National Interracial Conference was called by the Commission on the Church and Race Relations of the Federal Council of Churches in New York City and the Commission on Interracial Cooperation of Atlanta, Georgia. The goal of the conference was to enable white and African American people in different *communities* who were wrestling with problems of organization, methods, and programs for the improvement of interracial relations and community welfare that involved white and colored people to exchange experiences with the help of experts. The conference in New York drew favorable reactions from students. They were pleased that the meeting "involved no theorizing or idealizing . . . all very practical. . . . Students felt that they had been sailing in the clouds without knowing what was actually happening in their communities. . . . Consequently, we were very glad to be at the Conference. . . . This Conference really gave us idealists something to button our thinking to and we are hoping that students will increasingly fasten their theorizing to practical problems on campus, in home towns and in the Church."[219]

The Y established a new Council on Colored Work and asked Slowe to become a member,[220] and she accepted.[221] Within weeks, she learned that she had been elected a member of the Executive Committee of the National Student Council.[222] She also represented the Y on the Joint Committee on National Recovery.[223]

Always alert to problems of discrimination, Slowe, in 1931, asked Derricotte for assurance that no problems would arise at the Statler Hotel in Detroit in the light of some earlier problems that had occurred at the Cadillac Hotel at the time of the YWCA and YMCA Conference at Christmas in 1930.[224]

The Howard student newspaper, *The Hilltop,* in its Coed Edition (edited by the Women of Howard University) carried an article about Slowe's work with the Y.

> For the last five years Dean Slowe has served on the Council for Colored Work of the National Board of the Young Women's Christian Association and has met with the Council at its monthly meeting in New York City. The work of this Council is concerned with the interests of girls and women all over the United States and in some foreign countries; consequently it is quite important that those persons who have interest in the education of women should have membership on this Committee. . . . The women students of Howard University are gratified

to know that the National Board of the Young Women's Christian Association appreciates the contributions made to its work by Dean Slowe, for it has reelected her for another year to the Council for Colored Work.[225]

It bears repeating that Slowe's interest in the Student Christian Movement extended beyond the YWCA's national activities; she was one of the sponsors of the Student Christian Conference held at Howard University, December 4 through 6, 1936. Underwritten by the Intercollegiate Christian Councils of Howard University and Lincoln University, the conference grew out of "a desire on the part of a number of students in the Young Women's and Young Men's Christian Associations to discuss at length the . . . problem of religious adjustments as experienced by college people today. Speakers included Reinhold Niebuhr of Yale, who spoke on "The Bases of Religious Faith;"[226] William H. King, national secretary of YMCA on the "Relevancy of Religion to the Problems of the Underprivileged;" and Reverend James H. Robinson of Union Theological Seminary on "Modern Challenge to Christian Idealism." Dr. Howard Thurman[227] was faculty advisor to the Conference Committee.[228, 229]

Slowe presented to the Board a major treatise on the Y and African-American women students. She defined the students' views and challenged the Y to address them.

> Colored youth, no more than other young people are accepting passively or wholesale all that we older folk have handed down to them. They are questioning and exploring, sometimes going too far afield in their eager search. They are driven by an inner urge which many of them would never admit is a searching after God. . . . The membership of 10,000 students is not as a whole definitely conscious of the purposes of the organization. . . . There has been in the past year a marked swing in effort to get at the real reason for the Association's existence. Girls have been examining the purposes, coming to feel that it calls for commitment of life itself to the way of Christ and not just a calendar of novel events; that there might be behind its present wording a deep and eternal meaning inadequately expressed. . . . Students will always cling to the Association because in the majority of cases, it is the only organization that can be said to be really theirs. They jealously guard it as one place where they can develop student leadership, in whatever way seems best to them, acknowledging that they will make mistakes but be willing to profit from them.
> In the minds of administrations, the Association holds no such assured place. In some places it is little more than tolerated,

> in others retained because most schools have it and it does not seem to be wise to be too different. . . . One has always to keep in mind that education plays a bigger part in black American life than it does in white. The progress made since emancipation has been possible only because of the tireless, fearless, farseeing efforts of those who have devoted their lives to Negro education.
>
> The black boy or girl in America goes to school not just for individual advancement, but for the lifting of the whole race; not to step into an assured place in life but to make such a place and raise the millions behind him into it. Education in Negro circles . . . is education in its largest sense, developing the individual in his whole life, from the teaching of the rudiments of personal hygiene to so far reaching a thing as courage and patience in the face of the trying position which is his American inheritance. Education for him is putting on seven league boots to bridge the great gap between the length of his opportunity and that of the race with which he must daily rub elbows.
>
> The Association faces a tremendous task if it would bring the abundant life to the Negro girl. To be effective, it must discover as it has not yet done, just what its contribution can be to Negro education. Its function is educational as becomes true of any activity on a campus.

Slowe then recommended an extensive study of the education of African-American women students—the curriculum, housing, social conditions, student-teacher relationships, student-student relationships, and extracurricular activities.[230] The YWCA must find its place on the campus of a given institution and work with the administration.

> Since our bodies and activities have no excuse for being except as they are media through which our spirits seek expression and find freedom, any task it undertakes in that measure fulfills its real freedom, any task it undertakes in that measure fulfills its real purpose. In other cases, it will perpetuate itself by being no longer present as an Association, losing itself in a campus life of more adequately adjusted and more closely correlated factors which allow full chance for the development of student initiative and leadership. By losing its life it will find it.[231]

Undeniably, The National Board of the "Y" was impressed with Slowe. On several occasions, they asked her to represent the organization at conferences, an example of which was the first National Conference on the Cause and Cure of War. Although she was not eager to attend, she finally

282 Faithful to the Task at Hand

agreed to be a delegate. The Conference was held at the Hotel Washington in Washington, DC, on January 18–25, 1925. In the report she submitted to the National Board, she wrote that

> I felt as I sat in the Conference on the Cause of War and Peace[232] that the YWCA was making a real contribution to the solving of our national and international problems as they concerned misunderstandings between races. It was significant to me to note that of all the women's organizations at the Conference [a total of nine], the YWCA was the only one that included in its delegates a representative of the colored race. It seems to me to be a practical demonstration of the fact that the "Y" is attempting to look at all races as one family and I was very proud of this fact. I do not mean to say that no other organization is liberal-minded, but no other organization demonstrated it in the matter of its delegates except the "Y."
>
> The subjects discussed at this convention were of the very root of misunderstanding, so that if nothing more comes of the Conference than the recognition of these vast women's organizations and the public of some of the roots of racial misunderstanding, we have accomplished a great deal.[233]

Despite her reluctance to represent the "Y" at the first Conference in 1925, Slowe attended the annual conferences until her death in 1937. Although her paper on "Impressions of the Conferences" indicates that the first meeting was to have been in 1926, actually the initial sessions were held in 1925. Correspondence from the National YWCA concerning Slowe's participation began in November 1924, with a note from Constance Ball of the National Board advising Slowe that her credentials were being forwarded.[234] This error in years can be attributed to the fact that there was no conference in 1927. It is not unexpected that Slowe regarded the conferences as an opportunity to make new contacts, to learn the strategies groups used to effect changes, and to develop an understanding of and a position concerning war and peace as they affect the lives of African Americans.

The ninth conference on January 27, 1934, at the Washington Hotel in Washington, DC, was particularly significant. *The Afro-American* reported that out of 500 delegates, Slowe was one of three representing the "Y." Speaking at the conference, President Franklin D. Roosevelt told the delegation that "it was their business to educate the citizens against war, and that they should force their Congressional representatives to use their influence to avoid war."[235] Slowe prepared a two-page typewritten statement of "Impressions" after nine conferences. She wrote:

As I have sat in these nine conferences and watched the activities of this large group of women and listened to their reports of their activities in their several communities, I have been impressed by the fact that, for the most part, the very large bulk of our Negro population is not connected with this movement which is bound to become more and more influential in our American life.

As I have thought the matter over, I have come to the conclusion that very definite and specific steps should be taken to interest large groups of Negro women in the wastefulness of war and its effects upon their daily activities. Negro people are called upon to pay their share of taxes, to furnish their share of soldiers and to assume any obligations in reference to war that other citizens are called upon to assume. Because of their having definite responsibility as citizens for engaging in the defense of their country, they should be vitally interested in any movement that has as its purpose the outlawing of war as a means of settling disputes and of instituting the arts of peace. . . .

In matters which closely affect colored people in this country, I have been impressed with the fact that white women are far better informed than most Negro women. When the vexing question of the occupation of Haiti by United States Marines was under discussion, I found many, many delegates in the conference who could qualify as authorities on Haiti and its problems. The same might be said of the Liberian[236] question and of the general question of the darker peoples of the world. I believe that Negro women and men too, for that matter, should begin to use the same techniques for informing themselves on international matters and of making their voices heard on the problems growing out of war. . . . We can not escape responsibility when war comes and certainly if there is any way that we can add strength to the large groups of people who are trying to outlaw war, we are obligated to do it.

I should like to see round table discussions, institutes, or conferences, wherever numbers of Negroes live, set up for the purpose of giving Negroes information on the causes and cures for war. I was deeply impressed with the words of President Roosevelt when he addressed the delegates at the White House. . . . He expressed the opinion that it was the duty of the women of the nation to educate public opinion against war, and I believe Negro women ought to begin to inform themselves in order that they may join in this movement which will mean, if successful, happiness to their children and their children's children.[237]

Certainly, she shared these impressions with her students in the Women's League at Howard. It was in 1935 that *The Hilltop* reported that she said, "Not only are the brutal physical effects of war considered, but the economic and social effects. Today we are realizing the aftermath of the world turmoil of 1914–1918. The present waste of idle men, stored and rotting material, and starving thousands are growing worse."

She went on to speak of the suffering of minorities. She said that

> [i]n Baltimore, 65% of the Negroes are on relief while in the nation's capital 68% of the Negroes exist on charity. It is the minority group which suffers all over the world. . . . In the munitions marathon, millions of dollars are expended. Money is drawn from educational enterprises, health and public service as a whole. Malnutrition forming a weak foundation of a growing generation will result in wretched and discontented citizens in years to come. The press and world leaders build up hatred among races and nations and the munitions manufacturers prosper with all.[238]

Women's International League for Peace and Freedom

While Lucy Slowe staunchly supported racial justice, she was also involved in the peace movement,[239] and her participation with women's peace organizations was not restricted to the YWCA. Her remark about Liberia in her report on attendance at conferences on the causes and cures of war in all likelihood derived from her role not only in the YWCA but also in both the Women's International League for Peace and Freedom (WILPF) and the International Council of Women of the Darker Race (ICWDR). WILPF—an overwhelmingly white and privileged women's organization—in searching for the perfect African-American peace activist, preferred Slowe over several other nominees; WILPF was impressed with her determination and dedication to various social causes.[240] Slowe's friend, Bertha C. McNeill—who had been her college classmate, a member of AKA, and a founder of CAC—had to persuade her to become an active member.[241] While she had merged into other white organizations, whenever it happens it takes its toll; it is one of the disgusting mind-sets bred by racial segregation. (You know your "place;" that is not your "place.") Breaking barriers aside, she might have been just too busy to take on another duty. Among the first African-American recruits to WILPF were Slowe's CAC colleagues Mary Church Terrell, Charlotte Atwood, and Addie Hunton.[242, 243]

The "Liberian question" to which she referred surfaced as an issue in what has been labeled "enlarged dimensions of racial conflict" in the United States.[244] While some regarded Liberia as a protectorate of Amer-

ica, a complex economic relationship developed in the early 1900s that led eventually to concern about trafficking in native Africans for cheap labor.[245] Peace activists and the NAACP protested loudly.[246] A delegation to the State Department, led by W. E. B. Du Bois, voiced the concerns of peace activists and African Americans in particular. Among many other notable African Americans, Du Bois' delegation included Mordecai Johnson and Addie Dickerson, a member of WILPF and president of ICWDF, Lucy Slowe's organization.

The preceding review of Slowe's membership in a variety of organizations documents how she shared actively in the work of both community and national groups dedicated to the improvement of the lives of all people. Her speeches and writings in the next chapter go even further in giving voice to those concerns.

9

Views and Philosophy

Contrary to what might be thought, the platform posture was excellent. She used few gestures; just a lift of the hand here or there. The effectiveness came through the voice, a sonorous, low, clear one. Whatever lecture notes she used were never noticeable so that she created the impression of speaking directly to each member of the audience and not to a gathering.

—Margaret Jean Grooms (Student)[1]

Lucy Diggs Slowe, who spoke candidly and openly, was skilled in giving formal, ceremonial, and persuasive public speeches. A plethora of groups—from those associated with religious denominations to others devoted to enriching the literary scene—wanted to hear her perspectives on the issues of the day. The values that guided her and the issues about which she was passionate all flow readily from her speeches. Also deep-rooted are the tenets of her faith and, perhaps most important, how she perceived her role in life.

Slowe was an inexhaustible speaker and writer. Examining only the academic year 1933–1934, for example, her annual report[2] notes that she gave seven speeches in Washington, DC, and fourteen in locations across the country. A selection of her speeches reflects her intelligence and integrity as can be seen in those that follow, arranged chronologically under four topics: character, college education, race and politics, and the profession of the dean of women.

On Character

1. Feb 1, 1925: "What Shall We Teach Our Youth?"

In 1925, Lucy Slowe stressed character in an address at the YWCA in Baltimore. Her subject was "What Shall We Teach Our Youth?" She said:

> The most precious thing in the world is the child. . . . Parents and teacher should in the light of their experience and their knowledge of history, teach our young people some very definite lessons. If our young people are to stand the demands of modern life, they need to be trained in the fundamentals of character; they must be trained to exercise self-control, to be truthful and to be strong for what is right. Youth must be taught to respect themselves and to realize that they are valuable. They have been sacrificed for and they must be taught that they are worth that sacrifice only in so far as they make the most of their opportunities.[3]

2. March 1927: "Is It Right?"

At a Women's Day Service at Emanuel AME Church in Norfolk, Virginia, Lucy Slowe spoke on "Is It Right?" She cited "the tendency of people to get things done at whatever cost," but she urged that, in all undertakings, the predominant question should be "Is It Right?" She applied this question to both home life and community life. "In this awful age, the tendency of youth of falling away from high standards of the past was exonerated and the blame was placed on the parents. Parents must in all of their dealings with children have the one question in their minds, 'Is it Right?'"[4]

3. June 5, 1931: Laying the Women's Campus Cornerstone

She was on the program on June 5, 1931, when the cornerstones for Howard University's new dormitories for women were laid.[5] What an exciting moment that must have been for her. She felt as deeply about the dormitories for women as she felt about the university at which they were located. Because her concern about the young women who would move through their halls was unparalleled, she reached back and retrieved her long-held emphasis on moral fiber. She said,

> The great purpose of this educational institution—the awakening of a new spirit of mind, a new mode of thought, a new standard of life, a new vision of light—can be achieved only by putting

in place in the life of each student the cornerstone of unselfishness, generosity, of truthfulness, courage, righteousness and high endeavor. It is for us to lay our spiritual and intellectual cornerstone in the lives of the students of Howard University as artistically, as durably, as this stone is laid today.[6]

Slowe emphasized the importance of the education of youth. She declared that the ultimate purpose of education is experience in harmonious group living on the highest possible plane within the new buildings. Constant building of a more difficult nature must go on.

4. November 13, 1931: "The Teacher-Apostle of the Beautiful."

Her belief in character seemed to have grown deeper as she spoke at Miner Teachers College. Miner invited her to give the main address at its commencement exercises, held at the Armstrong High School. Miner was a Washington, DC institution founded in the late 1800s to train African-American teachers. Its new building, constructed in 1914, abutted Howard but faced in the opposite direction, toward Georgia Avenue. In 1931, it was a normal school with a two-year curriculum. Emphasizing character, Lucy Diggs Slowe chose as her topic, "The Teacher-Apostle of the Beautiful."

> There have been numerous statements of the aims of education and just as many of the teacher's part in achieving these aims; but if history teaches anything, it seems to say that the only permanent thing that the educated man leaves to posterity which is universal in its appeal is beautiful music, architecture, sculpture, pictures, literature or some other form of art. These forms of art which live on and on to inspire and please mankind approach that perfection which is the essence of culture, and which according to that eminent critic and poet Matthew Arnold, it is the business of man to love, study and to make prevail in the world. . . . To inspire a love of the beautiful in art, nature and human relations should be the aim of every teacher who goes forth to be the companion, guide and friend of the youth of our land.[7]

Arnold believed that a new culture "would pursue perfection through a knowledge and understanding of the best that has been thought and said in the world." He attacked the taste and manners of nineteenth century English society, particularly as displayed by the "Philistines," the narrow and provincial middle class. Strongly believing that the welfare of a nation is contingent upon its intellectual life, he proclaimed that intellectual life is

best served by an unrestricted, objective criticism that is free from personal, political, and practical considerations.[8]

As an apostle of the beautiful, Slowe continued, "love beauty yourselves, expose your children to it, help them to create it and thus assist them to become living examples of that perfection which is the essential of all culture and the essence of all beauty. This it seems to me, is the supreme task of every teacher."[9]

According to Slowe, education must provide more than facts and knowledge. It must also assure that positive attitudes and ideals are incorporated in the individual, so that the person's life has goals, standards, and direction. Her address before these graduates succinctly summarized the "Marks of An Educated Man" as the necessity to gain knowledge, the obligation to cultivate toleration of new ideas, the ability to cooperate with others, the responsibility to utilize in the community the techniques of training, and the development of the aesthetic sense.[10]

5. 1933: Commencement at Shaw Junior High School

When she addressed the graduating class of Shaw Junior High School, the institution that she had organized in 1933, she emphasized character again. She said,

> The teachers and I at the very opening of this new school thought very earnestly about the sort of boys and girls we desired to graduate from it. We were anxious that the students whose talents we helped to develop should realize that the end and aim of education is the making of men and women who have information and know how to use it; who will continue to get information and to use it wisely; but above all things who will be trustworthy individuals.
>
> Having decided that we wanted Shaw Junior High School to stand for training in character, as well as training of the mind and hand, we wrote these words as our CREED: The School stands for the development of the highest ideals of character. Wisdom and worth are handmaidens here. Trustworthiness, dependability, regard for one's word, deference to elders, consideration of one's comrades, respect for one's self are the watchwords. Truth is our cornerstone. Character is our completed structure.[11]

6. 1933: "What Contribution Can a Program of Social Activities Fostered by the Institution Make to the Moral and Social Development of Students in Negro Colleges?"[12]

She wrote,

> Henry James once wrote that one of the values of a college education is that it enables us to tell a good man when we see one. . . . I believe that one can find the good men and women much more easily through the extracurricula activities than through curricula activities.
>
> . . . Because the content of the extra-curriculum is so varied, and because participation in it is voluntary, its administration is more difficult than is that of the curriculum. It requires the services of members of the faculty who have the broadest intellectual and deepest spiritual training to direct this part of the students' life. And yet, regardless of the difficulties faced by a college in directing the extra-curriculum, it must promote such a program in the interest of the students' moral and social development if they are to be prepared to take their place in the modern world. Never in the history of mankind has there been as much leisure for every individual as there is today, and it is for the constructive use of this free time that educational institutions must prepare their students. The worthy use of leisure is the chief objective of the college social program.
>
> . . . The first subject to be given a place in the social program of any college should be student government.
>
> Self-government is the goal of all education for character building; therefore, much time and attention should be given to student government bodies in their various forms. . . . Whatever form the student government may take, the objective is the same—the development of individuals who are free to act in keeping with the best interests of the group of which they are a part. While self-government is an individual matter, a thing of the spirit, it is founded on the principle of doing in individual cases only those things which are ultimately good for the group.
>
> . . . [T]he college authorities are obligated first of all to examine with the students those group goals which are desirable. This practice immediately precludes the drawing up and handing down of rules and regulations. . . . It brings the students into participation in the making of the rules by which they are to be governed.
>
> . . . When students assist in drawing up rules by which they are governed, there can be no complaint that restraint was forced on students by faculty.
>
> . . . [T]hey also receive valuable experience in seeing that the laws are properly executed by the officers whom they elect.

They are charged with the definite responsibility for order, justice and wisdom in their relationships on the campus; and this experience is of value to them as citizens of tomorrow.

. . . The social program of the college should contain those recreative activities which refine the taste and broaden the vision of the students. Here, too, faculty and students should work together to achieve . . . that dignity in relaxation which had almost passed out of American life.

. . . If students have creative and artistic ability, these should find expression in the dramatic clubs, the art clubs or the music clubs. Here the college has opportunity through the right sort of leadership to cultivate such standards of good taste as will lead students to be dissatisfied with the vulgar, cheap and tawdry entertainments which form such a large part of our public entertainment. When college graduates have no finer tastes in the drama, in music or in art than the most backward and illiterate person, it is time for the college to examine carefully its training.

. . . [W]ith commercialism ruling stage and screen, the college has a definite responsibility for preserving that which is best in the world's dramatic, musical and fine arts. Shakespeare, Goethe, Aeschylus and Moliere; Beethoven, Liszt, Verdi and Schubert; Michael Angelo (sic), Burne-Jones and Whistler should not be strangers to the vast body of college students.

. . . Probably the matter of taste comes into question more in connection with student dances and their fun-producing activities than in any other type of activity. The college has a real problem in education when it attempts to improve the kind of dancing which seems prevalent, not only on college campuses but in life outside, and when it attempts to regulate the expense of such entertainment.

. . . It frequently happens that students give dances which are in exceedingly bad taste because they do not know any better. Many of them have had no training in social standards; hence, they have no standards of measurement to guide them.

. . . Keeping expenses within a reasonable limit is most desirable in training students. Frequently they spend too much money for their social functions, plunge their colleagues into debt and sometimes impair the credit of the college itself. If social functions were arranged through a faculty-student committee, there is less danger of extravagance and more opportunity for students to learn that keeping within one's income is excellent training for life after college.

. . . One of the most difficult pieces of work that a college social program has to perform is refining of manners. One

wonders whether the college can do much in the development of social grace in a vast number of students with various types of backgrounds. Yet good manners are so important to success in life that some attempt should be made by the college to set up opportunities for students to get training in them.

Since good manners are the manifestations of consideration for other people, many opportunities can be set up by the college for students to get practice in this field. . . . Graciousness and courtesy will mean so much in the success of students that colleges should pay a great deal of attention to giving training in them.

. . . Since students are inexperienced, members of the faculty will co-operate with the students in the building of their extra-curricula program, but will not, through domination, take from the student his opportunity to exercise his judgment and his will. The faculty, through their co-operation, will see the students revealed as they are—fault and virtues—and through this revelation will find their greatest opportunity for improving student morals and taste.

. . . If all of these things form the end and aim of a college social program, its moral and social value cannot be estimated. The famous lines of George Eliot should be kept in mind by all builders of college social programs. She said: "We prepare for sudden emergencies by the accumulated *actions* of our past." It is through giving students opportunity to act that we achieve our final goal—tolerance in human relations, good taste in social affairs, restraint in politics, discretion in expenditure of money and last of all, the building of sound public opinion.

7. 1934: Alpha Kappa Alpha Founders Day

Slowe addressed the Alpha Kappa Alpha Founders Day observance in Winston-Salem, North Carolina, on Sunday, January 21, 1934. Phi Omega Chapter sponsored the event at Atkins High School auditorium. She stressed "the true values of advanced education. She forcefully brought home to her audience the importance of knowledge, skill and virtue. . . . She placed greatest emphasis on assimilation and spread of culture and refinement among the masses."[13]

8. 1937: Fifth Anniversary of the Clark Hall Council

She drew upon the same ideas in a speech on the Fifth Anniversary of the Clark Hall Council. Clark Hall was Howard's residence hall for men. The Clark Hall residents had been especially gracious to the dean. She had challenged them time and time again to uphold the spirit of the University.

She said that

> [i]n thinking of the beginning of the Council, it is well to remember that all good things represent the ideas of one or two persons who have more insight than others and that those prophetic souls have the power to stand for something which is very much greater than themselves. Indeed they know the way in which people use their power to stand for something determines their personal quality. They know that loyalty to some cause greater than themselves increases their personal power and influence for good. The Clark Hall Council at its inception decided that its chief reason for being would be to improve the quality of life on the campus as it affects the men, and indirectly, as it affected everyone. . . .
>
> It has attempted to intensify the interests of young men in their studies. . . . It has attempted, furthermore, to broaden the outlook of the men on our campus. . . . In all of its programs, its ultimate aim has been to dignify the life of students at Howard University and to send them forth into their several communities with a deep devotion to public welfare. . . . This organization can represent concretely for us the courage, the honor, the truth and the devotion to human welfare which should characterize the members of our University community. It appears to me that the safety of the ideals of Howard University is not in rules, regulations, textbooks and buildings, but in scholarly gentlemen like those who have and who now compose the membership of the Clark Hall Council.[14]

This speech is an example of Slowe's concern about the life of all students, not just women.

College Education, Especially of African-American Women

1. 1923: The Conference of College Women

In a talk before the Conference of College Women held at the YWCA in Washington, DC, she listed three prerequisites for the education of a college girl: the kind of girl to be taught; the modern world to which the girl must go when she is trained; and the sort of training that should be provided to fit her for life in the world to which she must go. She contended that "Colleges should survey the modern world, know its problems from the standpoint of the new freedom which women enjoy and deliberately train girls to take their places sanely in the new world."[15]

2. January, 1930: Pastor at Talladega College

Lucy Slowe served as college pastor at Talladega College in January, 1930. *The Talladegan*, under the caption "Dean Slowe at Talladega," reported on her talks, stating that they had been "listened to with much pleasure and profit."[16] In addition to "chapel talks and the Sunday morning address she spoke at the Student Forum, addressed the women students, held conferences, and attended social functions given in her honor."[17]

On Sunday morning, she gave some answers to the question, "What should college do for the student?. . . ." The first objective which she developed was Vision. "Without vision the people perish. Every one needs a vision like that of Solomon, when he built the temple. Going out into the various communities, the college man or woman should have a vision, and his college education should enable him to organize the forces he finds there, for the realization of that vision. The use of leisure, for one thing, is something important, in which people need help."

On Monday the topic was intellectual Curiosity. She quoted, "'By doubting we come to questioning, and by seeking we may come upon the truth.' Keep the way open for truth. . . ."

The next morning an old Eastern proverb and a parallel scripture suggested the objective. The proverb was, "If I have two loaves of bread I will sell one and buy hyacinths to feed the soul."

Independence of character was the topic another morning. "We must not blindly follow the majority but stand for what seems best to us."

The last morning Slowe talked about dreams. "What does the past teach us? What do we want as we look ahead? What shall we see as later we look back? The touch of Midas turned all things to gold, but they lost their value, for he needed other things more. The touch of Christ transforms things and people and they become more beautiful and more valuable. It is for us to decide which touch we shall covet."[18]

3. March 11, 1931: "The Education of Negro College Women for Social Responsibility"

Slowe traveled to New York City in early March, 1931, to lecture on one of her favorite topics: the need for increased involvement of African-American women in their communities. Prior to her speech she was guest of honor at a dinner given by Professor Mabel Carney.[19] She spoke on "The Education of Negro College Women for Social Responsibility" at Teachers College, Columbia University. Her talk was one in a series of ten lectures Teachers College had scheduled on Negro Education and Interracial Relationships in America,[20] and this was the second time Teachers College had invited her to lecture.[21]

She introduced her talk by explaining the opinion of one of her distinguished colleagues at Howard, who "took Negro College Women to task for taking so little part in the life of their several communities, especially the political activities of these communities." She believed that "the Negro college woman is shirking her civic responsibility and spending most of her time earning her living and enjoying herself without giving any thought to the problems of the masses of her people." After detailed consideration of the forces that contributed to the inactivity of Negro college women in community life, Slowe declared that colleges must train the leaders of the masses. Such training required major changes in college curricula. She said,

> Negro college women have a most challenging opportunity for leadership of their people in education and in civic service if their communities and their schools are joined together for the purpose of developing the innate power which so many of them possess. It is my earnest hope that Negro college women will accept their great opportunity for leadership of their people and that they shall obtain from their colleges and from their communities the sort of education which fits one to perform justly, skillfully and magnanimously all the offices which he is called upon to fill.[22]

Slowe pointed out areas to which attention should be directed. Her list included the problem of leisure-time activities of youth in cities and rural sections and the relationship of delinquency to wholesome recreational facilities and the possibility of organizing her people, poor though they were, for some sort of economic independence. She also listed the beautifying of their neighborhoods and the improvement of their health through knowledge of simple rules of living.[23]

She described the factors that might explain the failure of African-American college women to take a more active part in community affairs. She said that

> [i]n considering the education of Negro women there are several points which should be kept in mind; 1) Their social experience in the several communities from which they come. . . . In the majority of places Negroes are not allowed to vote, nor are they permitted to carry any responsibility for the government of the city, town, or state. . . . They have practically no influence in civic affairs. . . . Many of these girls come from homes in which extreme conservatism concerning women's place in the world prevails. . . . Many of them have been brought up in fundamentalist homes where they have been taught to believe

that God solves our problems with little effort on our part except the effort of having faith that all will be well if we wait patiently. . . . 2) Their own psychology as a result of this experience—the psychology of inaction rather than that of aggressively attacking problems with a view to changing unsatisfactory conditions. . . . 3) The philosophy of education of the colleges to which they go. . . . The Boards of Trustees, the Presidents, and the Faculties are predominantly male. It is the rarest exception that women have any part in the making of policies, or the management of any division of the school except supervision of dormitories and dining halls and even here they sometimes have little real authority. . . .

Citing the survey conducted by the NACW Standards Committee, she said,

In only a few schools was there a well trained Dean of Women who had little opportunity to influence the policies of the schools in the interest of developing independence and leadership in the women students. The Association [National Association of College Women] found very few women teachers of professorial rank and little opportunity of gaining administrative experience.

These women are educated in schools almost exclusively administered by men; they can not develop social consciousness, unless these men are willing to accept the changed status of women in the modern world. . . . In far too many of our schools women students are hampered by useless rules and regulations designed to control their conduct, but not designed to give that necessary opportunity for making independent choices without which real freedom of action can not be developed.

4) The vocations open to them after graduation. . . . Is the whole world of occupations for women open to them? . . . Train as she will, when she applies for a position with a business firm, her color will almost invariably preclude even an interview. This condition drives almost all of our women into the teaching profession.

Slowe insisted that teachers were obligated to be leaders in their communities and that colleges must train women to assume those roles. "For this present day life demands that women must be ready to make their contribution not only to the home but also to the economic, political and civic life of the communities." She called for curriculum changes, with an emphasis

298 Faithful to the Task at Hand

on the social sciences—sociology, economics, political science, hygiene of environment, problems of industry and of rural life, etc.

> I know of no more pressing need of the masses of our people than that they shall become politically articulate. . . . Each Negro college should use as its laboratory the community surrounding it, founding in the most disadvantaged sections of such communities—college settlements—where students could be brought face to face with the real conditions in the race; where they might supplement their theory by practical work and where they might learn the joy and value of service.

Slowe realized that the education of African-American women for leadership required the full support of all Americans. "When educated white people assist Negroes in coming to an understanding of the common problems of the masses and join with them in solving these problems, it will be much easier for the schools to send out students imbued with the ideals and technique of service."[24]

4. 1932: "The Education of Negro College Women for Social Responsibility"

Early in 1932, Dean Slowe went up to Baltimore to address the Baltimore Public Forum on the topic "Is the College Graduate Today Living Up to His Responsibility?" reported *The Afro-American* on January 9, 1932. "Tracing the development and semi-degeneration of political, educational and religious leaders in this country and linking this development to the problems that confront the student coming out of college," Slowe observed that 'the college graduate in the cities of America is not an asset in the community in which he goes to accomplish his life's work. . . . I am not sure that schools and colleges turn out leaders. Thinking is the way out,' according to Slowe, 'but there are very few people in this world who think. Real leadership undertaken by intelligent men and women is necessary.' "[25] Her speeches show that she reinforced the themes of previous talks and introduced still new perspectives.

This talk was consistent with views expressed by a Baltimore resident whom she might have known. William N. Jones was a pillar of the Baltimore community and managing editor of *The Afro-American*. Jones regularly wrote a column titled "Day by Day."[26, 27] In his article, Jones wrote,

> Our educational systems are producing a kind of mental slavery, far more insidious and harmful than physical slavery. We are educating men and women with the philosophy and ambitions

of the majority group when they must lead a minority. And when we add to this, that if colored students expect to get a hearing in art, in literature and in social philosophy, they must make peace with the majority controlled publishers and art institutions and fit their thinking to suit. . . . Underneath the froth and foam of our stirring times there is the hot liquid of general endeavor and in this surging liquid of youth lies our hope of leadership.[28]

Because Jones' article had no date, it is not known whether it preceded or followed Slowe's speech.

5. 1933: "Higher Education of Negro Women."

In 1933, Lucy Slowe, at age fifty, was ten years into her deanship at Howard University, having served first with Durkee and then Johnson. She had been championing the education and role of girls and women practically all of her adult life. She was a keen observer of society and the world in general and of the plight of African Americans and of college management and programs. Because she had staked out her role as a spokesperson for women and for higher education—beginning with her 1924 speech at the founding of NACW—she meticulously researched what African-American coeducational institutions were doing about educating their girls to prepare them for what they were going to face after college, and she related the results she found to her strongly held beliefs.

Convinced that the world was changing with respect to the roles women were expected to play—that is, "to live in and make their contribution to a changed economic, industrial, and political order"—she sent questionnaires to seventy-six institutions that were "doing work of college grade." She published her views and results for an academic audience in *The Journal of Negro Education* under the title "Higher Education of Negro Women."[29]

In this *magnum opus*, Slowe painted a daunting picture of the psychological effects of sexism under which these college girls lived in their hometowns, in their churches, and in their colleges. Not only did she indict the colleges for doing a poor job of educating them to break out of these oppressive conditions, but she also laid out a prescription for what women's education ought to include in the areas of self-direction, initiative, marriage, and motherhood. She championed these ideals in her program at Howard. She wrote,

> The great question before college administrators today is whether or not the curricula of their several schools have been organized

to meet the needs of women who must live in and make their contribution to a changed economic, industrial, and political order.

The modern world, she argued, required course work in political science, economics, psychology, and sociology.

The classical courses followed by practically all college students up to the very recent times, important though they may be, must be supplemented by those social sciences which enable one to understand the world in which one lives.

Slowe maintained that women students needed to be trained "to exercise initiative, independence, and self-direction while in college." She contended that it was intolerable that less than fifty percent of the colleges answering her questionnaire gave their students any part in their own government. If they were going to become leaders in their communities, they had to learn how to govern themselves while in college.

She held that colleges had to understand the psychological effects of sexism under which these college girls had lived in their hometowns, in their churches and in their colleges. She wrote that

[w]hen Negro women go to college, they go usually from segregated communities where neither they nor their parents have had much experience in the civic life of the community. In many places they have not had the right to vote, nor have they been permitted to participate in the responsibilities of government in their city or state. They have paid taxes but have had no voice in deciding how taxes should be spent. They are accustomed to stand by and see policies of government worked out or not worked out, without help from them.

Frequently, Negro college women come from homes where conservatism in reference to women's place in the world of the most extreme sort exists. . . . many parents still believe that the definition of woman found in an eighteenth century dictionary is true today: "Women, the female of man. See man." Regardless of the wish of many parents that their daughters become adjuncts of "man," modern life forces them to be individuals in much the same sense as men are individuals. . . .

. . . [M]uch of the religious philosophy upon which Negro women have been nurtured has tended toward suppressing in them their own powers. Many of them have been brought up on the antiquated philosophy of Saint Paul in reference to women's place in the scheme of things, and all too frequently have been

influenced by the philosophy of patient waiting, rather than the philosophy of developing their talents to the fullest extent.

She carried these views about the subjugation of women over to the administration of the colleges themselves. She wrote that

> [t]he absence of women or the presence of very few on the policy-making bodies of the colleges is also indicative of the attitude of college administrators toward women as responsible individuals, and toward the special needs of women. . . . Reliable sources also point to the fact that few women achieve administrative positions in co-educational colleges, consequently, little stimulus comes to women students from outstanding examples of women who have achieved high rank in their institutions

Although she emphasized the importance of new attention to the social studies, Slowe did not retreat from her stand on "cultural subjects." To this point, she wrote,

> Education must fit Negro women . . . for the highest development of their own gifts; but whatever those gifts, they will not be able to exercise them unless they understand the world they live in and are prepared to make their contribution to it.

Finally, she addressed the relationship between higher education and marriage. Regardless of the fact that women are the "conservators of the race," she wrote, and they are its "real educators," they had to be trained to assume their responsibilities as citizens. She concluded that

> college women must be trained along the lines of their individual talents, and at the same time must be made conscious of the fact that the world will expect from them practically the same sort of contribution that it expects from men—the contribution of an individual so disciplined that she can direct herself, so informed that she can assist in directing others in this intricate modern world.[30, 31]

6. May 23, 1933: "Women's Contribution to the Social Order"

Slowe returned to her views about character when, on May 23, 1933, she directed her message to church women at a Women's Day Program at Nineteenth Street Baptist Church—an historic African-American church in Washington, DC. "The confusion in our social order is due to the fact

that men and women do not deal justly, and honorably and kindly with each other in the spirit of the philosophy of Jesus who we pretend to follow." Taking as her subject "Women's Contribution to the Social Order," her message was unmistakable when she said it is the special business of women to keep the conscience of the world sensitized to the claims of justice and righteousness. She argued that all the laws on the statute books will be of no avail unless there is behind them worthy men and women. "If men and women thought of the value of human beings more and less of the value of things, the world would be a better place in which to live."[32]

7. 1933: Address Delivered at the Annual A.K.A. Boule Banquet

At its twenty-fifth anniversary in 1933, Alpha Kappa Alpha Sorority invited Slowe to deliver the main address at the banquet. Here she shows her ability to inspire and challenge. She said,

> Twenty-five years ago a group of eight young women came together in a small room in Miner Hall, the women's dormitory of Howard University, to form the first Negro women's college fraternity in the United States. These young women hardly knew the significance of what they were doing, for they could not have imagined in their wildest dreams this scene, tonight, with over four-hundred delegates from various chapters of Alpha Kappa Alpha sitting at dinner in the International House of the University of Chicago. They had no idea that their small number would, in twenty-five years, grow to over two thousand members of this Sorority scattered all over the United States.
>
> Probably the older people of the faculty and administration thought those eight young women irresponsible and silly for wanting to found a secret society; but as so frequently happens, what appeared to be only an organization of a few irresponsible young people has turned to be a nationwide society of intelligent and outstanding women.
>
> Birthdays, it seems to me, ought to be times for looking backward and also looking forward. As we stand here celebrating our twenty-fifth birthday, we ought to examine very carefully our past program to see whether or not it fits present conditions and whether or not it will advance the interests of college women in the future. Unless we constantly examine our activities and improve upon them, we are not making the most of our capacity for growth and development. If there is a crying need among Negro college women today it is the need for using our training for improving the status of education as it concerns colored

women in our colleges. One of the first things I should like to see Alpha Kappa Alpha do in various parts of the country is to examine what is going on among the present generation of women students in our many colleges and universities. It is my belief that women ought to have a great deal more to say about the education of themselves than they have had to say in the past. It seems to me that we have been entirely too complacent in the face of needed changes in our philosophy of education of Negro women.

I suspect that very little opportunity is given in many Negro colleges for individual development of women students. If we should examine for instance, the rules and regulations under which those women live, we would find that their progress was curtailed entirely too much and that very little chance is given for women students to exercise initiative and judgment. I believe that one of the finest pieces of work that Negro college women graduates have to do is to examine the institutions from which they have graduated with a view to changing out-worn policies and procedures and of making it possible for women students to prepare themselves for their rightful places in the modern world.

In the second place, I believe that we college women ought to have a great deal to say about national affairs as they affect women in general and as they affect colored women in particular. We should see to it that Negro colleges are prepared to participate efficiently in their own government and in formulating of economic and social policies which affect our national life. I should see a large number of Negro women prepared as experts in political science, in economics, and public affairs generally; for I believe that more and more women will have something to do with the shaping of national policies for these policies must affect very intimately Negro women. It is my belief that college women had had too little to say on matters of this sort.

It seems to me that a matter that should claim the attention of our college women is our international relations. It is impossible for us to lead a life so segregated that it does not touch in some respect the lives of other people in other countries. It matters not how much our conservative leaders may advocate national isolation, the fact remains that nations throughout the world are being drawn closer and closer together. Means of rapid communication and transportation have made the whole world intimately related. We college women ought not to feel satisfied with the fact that those who know most about such countries

as Liberia, Haiti and Santo Domingo are white people rather than Negroes. I feel that Negro college women ought to be just as interested in international affairs as white women are for we cannot live to ourselves any more than other people can. In centers where any considerable number of college women live we ought to arrange institutes, discussion groups and reading groups acquainting ourselves with international matters. Moreover, we should be more interested in such international organizations as the Foreign Policy Association, the Women's International League for Peace and Freedom and many others with similar purposes. Our organization, containing as it does, hundreds of members ought to look, on this twenty-fifth birthday, to the future with some such large program in mind as I have suggested. We ought not to be satisfied with our past performances, but ought to reach out with more determination for larger worlds to conquer. My wish for you on this twenty-fifth anniversary is that you shall make a rich contribution to our American life because the large vision of its needs that you possess. After all it is vision and imagination that enlarge our purposes and that keep us progressing all the time.

In closing, I am reminded of a story that impressed itself most vividly upon me and which seems to be appropriate here.

Once upon a time there was a man who had three sons that he loved very dearly. One day he took them to the foot of a mountain and said to them: "I am going to make a valuable gift to the one of you who will climb this mountain and bring back its richest gift."

The three boys set out—one went a third of the way up the mountain and found a beautiful dower which seemed to him to have been the most valuable thing on the mountain. So he brought it back to his father. The second went a little higher on the mountain and brought back a many-colored stone—luminous and sparkling. He thought it must be the most valuable and beautiful thing on the mountain. The third boy went all the way to the top of the mountain and looked out as far as he could see on an expanse of lovely blue water. It was the first time he had ever seen the sea. He stood gazing for a long time and letting his imagination run as he watched the large expanse of water. What world must lie beyond that vast sea! He descended the mountain and said to his father: "I have brought you the most valuable gift on the mountain, for I have seen the sea." His father praised him for climbing to the very top of the mountain and for getting a vision that he had never had before.

It is my wish that we in this organization shall climb to the top of a very high mountain and there get a vision of the sea and that its beauty and its vast expanse will be the measure of our imagination and of our purpose for our future work.[33]

8. 1934: "The College Woman and her Community"

Slowe gave the opening address at the meeting of the National Association of College Women, held at Atlanta University in April, 1934. She said, in part that

> [i]n educating the college woman for community responsibility, every institution of learning must take into consideration the present economic, social, and political conditions which exist throughout the country. The curriculum which is pursued . . . must take account of the fact that they will, upon leaving college, enter a world torn by the most profound upheaval in its history. The women students . . . must be prepared to shoulder the responsibility first of all for making a living because they are definitely committed in the modern world to developing their own individual talents and of being responsible for their own lives. Even if they marry, there is no guarantee that they will not be called upon to earn their own living. This fact, immediately brings us face to face with our whole economic order as it relates to the individual's employment, and no college is doing justice to its women students unless it prepares them to understand the economic world of which they must become a part.
> . . . Indeed, much of the education of the future must be designed to prepare them for the worthy use of leisure. Here the college has its finest opportunities for training women in the art of spending their spare time in such as way as to develop more fully their moral, spiritual, and intellectual natures. . . . The college cannot hope to send out into the communities women prepared to assume community responsibility and personal responsibility without seeing to it that they get ample opportunity for the practice of such responsibility in college. . . . College women should be prepared to go into their communities and enrich the life of the communities through their knowledge of proper recreational and cultural activities.
> . . . No college is doing its duty . . . unless it adds to the traditional subjects . . . those specific subjects which fit the students for intelligent participation in the economic, political, and social life of their community.[34]

9. No Date, Handwritten: "Some Problems of Colored Women and Girls in the Urban Process"

This essay illustrates Slowe's deep concern for and understanding of the plight of African-American families that migrated from the South to big northern cities. And she suggests remedies, writing that

> [u]rban conditions which affect human welfare have their roots primarily in the economic conditions of the people, whether they be black or white. Where men and women have steady employment at good wages, where they are able to rent or purchase homes, where there are opportunities for wholesome recreation, practically few problems which demoralize human beings arise. On the other hand, where wages are small, where unemployment abounds, where shelter must be had anywhere it can be found, where no provision exists for leisure time activities of a regenerative sort, there you will find crime, disease, delinquency, broken homes and all the evils which accompany unstable family life. . . .
>
> The major shift of Negroes from rural to urban sites may be attributed to a large extent to the desire to improve their economic status and to live where they can give their children better school facilities. . . . These migrants were faced by many problems for which they could find no solutions. The major problems of women and girls are: 1) maintaining a home. The houses are old, lacking proper sanitation, in surroundings not conducive to wholesome living. 2) Most of the Negro women must work in domestic service—away from home all day—children unsupervised; and 3) another problem relates to wholesome recreation.

She suggested five approaches to the problem.

> 1) a group of church women—white and colored—should obtain information about how the lowest class Negro women live; 2) work with the housing committee of the city to call to the attention of the privileged citizens their responsibility for improving the living conditions of Negroes; 3) work to improve the employment status of Negro women; 4) work to provide desirable leisure time activities; and 5) develop increased awareness of the plight of colored women and girls by collecting information and disseminating it.[35]

10. 1937: "The Colored Girl Enters College: What Shall She Expect?"

The survey results she published in 1933 appeared again, this time in an article in *Opportunity* under the title "The Colored Girl Enters College: What Shall She Expect?"[36] As a sidebar, the editor commented, "The distinguished Dean of Women at Howard University outlines what the college should do for the Negro girl who enters as student, and points out the importance of certain extra-curricular activities."[37]

Appearing one month before she died, this article reinforced everything Slowe had published in *The Journal of Negro Education*. She characterized African-American girls as growing up in segregated communities where they did not have the right to vote and could not take a stand on government policies and where often their parents had limited education. She wrote that

> [m]any of them have been brought up on the antiquated philosophy of Saint Paul in reference to women's place in the scheme of things, and all too frequently have been influenced by the philosophy of patient waiting, rather than the philosophy of developing their talents to the fullest extent.[38]
>
> . . . [I]f the college is going to do for the girl what the community and the girl herself has a right to expect, it must provide opportunities not only for her intellectual development, but for the development of her powers of initiative and self-direction.

Sharing the results of her survey of the college coursework taken by women, Slowe reported that very few were studying political science, economics, or sociology—disciplines that she regarded as "fundamental to the understanding of life or fundamental to understanding the modern world and to living intelligently in it."[39] The college girl should expect to receive "more guidance in the choice of majors so that she could go out into life ready to meet its problems and to have some techniques for solving them." The colleges' obligation was to "give women information which they need on the work of the world in order that there may be a group of trained Negro women integrated into the general life of America."[40]

She pleaded for extracurricular activities. "Activities, arranged so that the student can demonstrate her ability to carry responsibility and to work harmoniously with the group, can be the means of strengthening character and of bringing out true moral worth."[41] She cited the advantages of the large events she had promoted at Howard, such as the Women's League, Christmas Vespers, and the Women's Dinner. However, she did not exclude wholesome use of leisure time by learning to enjoy activities such as music, art, and drama.[42]

She concluded by writing,

> Students grow into well-rounded women through doing those things that challenge their whole being. Their infancy should not be prolonged by the college, but they should be taught to think and to act while there, in order that when they leave they may be ready to assume the responsibilities which life, whether they will it or not, will place upon their shoulders.[43, 44]

Race Relations and Politics

1. 1925: Lecture at Teachers College, Columbia University

Ingrained in Lucy Slowe was her drive to seek the elimination of racism—the establishment of equality between white and African-American citizens. One of her earliest published comments appeared in February 1925, when she lectured at Teachers College, Columbia University. She had great historical sensibility, and so she talked about race relations at a gathering of women who were studying in the master's degree program to become deans of women. The *New Haven Union* reported that

> Dean Slowe made a plea before the women who are in training to become deans of women . . . for better race relations between colored and white college women in this country. Dean Slowe contended that only through the process of investigation, curiosity and openmindedness could white and colored people learn to know one another. Prejudice can be dissipated by turning the light of knowledge upon those who suffer from it, as well as upon those who impose it. . . . Colleges should be places where students of all races would come together for the purpose of discovering what is good in members of different racial groups, in order that misunderstanding due to ignorance might not arise.[45]

2. 1930: "The Effect of Race Prejudice on the Negro Student's Thinking"

In June, 1930, she gave a talk at the Third General Interracial Conference of Church Women at Oberlin College in Oberlin, Ohio. Held under the auspices of the Commission on Race Relations of the Federal Council of Churches, it was called to consider what church women could do to bring about more Christian attitudes regarding race relations.[46] The Federal Council of Churches of Christ, composed of the larger Protestant denominations in the United States that had been organized in 1908, strove to represent Protestant opinion on religious and social questions.[47]

Slowe's topic was "The Effect of Race Prejudice on the Negro Student's Thinking." The June 27, 1930, issue of *The Washington Tribune* reported on the Oberlin speech in which Slowe reflected her positive regard for humanitarian ideas. She said that "The Negro student lives in a country which has a two-fold challenge for every citizen. America is supposed to be a democracy. America is supposed to be a Christian country."

She proceeded to identify four problem areas.

1. The Problem of Making a Living. Not only does his color bar him from the majority of gainful occupations, directed by private enterprise, but even the government itself bars him from its departments because he is black instead of white. The Civil Service Commission demands a photograph of those who present themselves for examination. It is the general belief among Negroes that these photographs are used to keep them out of Government Service. Can the Negro student think enthusiastically and sincerely that America is a land of opportunity for every individual, when he knows from experience that it is a land of "white" opportunity?
2. Civic Thinking. Can he enter into the civic life of his town as every other citizen does? Does he have the right to liberty as a free man?
3. Religion and Prejudice. The Negro student knows that organized religion has taken very little part in the dissipation of race prejudice.
4. Cultural Opportunities. Students at Howard find it almost impossible to indulge their taste for music and drama.

> Since the Negro student encounters race prejudice in every major interest of his life, his attitude toward his white fellows in every walk of life is one of cynicism, questioning, distrust and disgust.... And finally I should like to ask, what effect does race prejudice and its attendant injustices have upon the character of white youth? ... It seems to me that if civilization and Christianity are not to perish they must take on a form as concrete as my hand. In the words of Lord Russell [referring to Bertrand Russell], we have summed up for us an immortal definition of civilization. Its true signs are thought for the poor and suffering, chivalrous regard and affection for women, the frank recognition of human brotherhood, irrespective of race, or color or nation or religion, the narrowing of domain of mere force as a governing factor in the world, the love of ordered freedom, abhorrence of what is mean and cruel and vile, ceaseless devotion to the cause of justice![48, 49]

3. 1931: "Education and Race Relations"

During the academic year 1930–31, Slowe delivered six speeches in Washington and six out of town.[50] She gave one at the Home Missions Institute in Chautauqua, New York, conducted by the Council of Women for Home Missions during the Council's twenty-first annual session.[51]

Speaking on Wednesday, August 19, on the topic of "Education and Race Relations," she showed how passionate she was about the need to improve race relations in America. Without question, she had given a great deal of thought to efforts African Americans themselves could put forth to address their situation. The *Chautauqua Daily* of August 19, 1931, reported that she emphasized the need to build a civilization characterized by

> respect for human personality and by high standards of fair play, of sympathy, justice and openmindedness; the need for education for racial appreciation, sensitivity to the claims of justice, authentic information on the contributions of the Negro to American History and the realization that every racial group has some qualities and achievements which are of universal value and therefore transcend the bounds of race. The intellect must replace emotions, according to Slowe. "Racial antipathy cultivated as it has been in America will lead to the disintegration of American character."[52]

She challenged African-American women to work to improve race relations. Citing three illustrations of racial attitudes of whites toward colored people, Slowe raised questions about how racial attitudes develop. She said that

> [w]e know that racial attitudes are not inherited, but are acquired. . . . We know that these acquired attitudes can be modified, changed, eradicated; and better still they need not be developed. . . . Children brought up in an environment free from racial prejudice do not develop it.
>
> On the other hand we know how easy it is not only to acquire it but how assiduously some people cultivate it in their children. It is no exaggeration to say that all over America today the majority of white people are either directly or indirectly teaching their children that white people as a group are superior to colored people as a group. This being the case, it is not surprising to find race proscription in every division of American life, civic, political, industrial, and even religious.
>
> If these conditions do exist, and you and I know they do, can we out of them build for the future in America a civiliza-

tion characterized by respect for human personality and by high standards of fair play, of sympathy, justice and openmindedness? Can a civilization endure on any other basis? . . . When we realize that character is the result of one's daily acts as well as the result of one's environment to a very large degree, we should examine with very great care the actions of most Americans toward colored people. Can we be unfair, cruel and inhuman to any man without having our characters sullied?

In the same speech, *The Journal of the College Alumnae Association* quotes her as adding,

It is because I believe that racial antipathy cultivated as it has been in America will lead to disintegration of American character that I urge upon homes, schools and churches a concerted effort at education for racial appreciation instead of education for racial hatred. . . . If . . . we wish to change the prevailing attitude of American white people toward the Negro, we must do two fundamental things; we must make individuals more sensitive to the claims of justice in dealing with people regardless of race; . . . we must set up opportunities for getting authentic information, and for counteracting misunderstanding in matters affecting the two races. If in schools the contribution of the Negro to American history could be studied, what a different point of view many Americans [would] have. The intelligent, open-minded way of finding out what all classes of Negroes think and do should be our mode of breaking down prejudice, of dissipating ignorance. . . . In the interest of all the people of our land and country; in the interest of saving our moral integrity; in the interest in the preservation and improvement of our social order, we should deal with Race Relations in a scientific and dispassionate manner; the intellect must replace the emotions in dealing with this subject and this calls for the thought of our finest educators.[53]

4. Unpublished Paper: "Prejudice"

In an unpublished paper titled "Prejudice," Slowe described the scourge of racism. She wrote about how it affects both white people and African Americans. Prejudice makes whites hypocrites, makes it easy for whites to be unfair, and has made and is making whites cruel and hardhearted. Among the African Americans, race prejudice breeds a distrust and hatred of whites, makes it difficult to believe in Christianity, and results in a loss of spirituality.

312 Faithful to the Task at Hand

She wrote "Our souls need feeding ... if educational institutions bar us, if humanitarian institutions bar us, if the Church of God bars us, how can we feed our souls?"[54]

5. 1933: "Reality in Race Relations"

The Afro-American reported on March 4, 1933, that Slowe spoke on the topic "Reality in Race Relations" at the Lincoln Day event at the Central YWCA in Rochester, New York. She emphasized what she labeled four realities.

> 1) White and colored people should face the reality that people should be considered for their individual WORTH RATHER THAN BECAUSE THEY BELONG TO ANY PARTICULAR RACIAL GROUP [Capital letters used by Slowe]; 2) Groups of white and colored people should consistently work together on the concrete problem of extending suffrage to every citizen in the Republic who is old enough and intelligent enough to use the ballot; 3) It is my sincere belief that we shall continue to sow the dangerous seed of racial hatred as long as we are committed to the policy of separate education for white and colored people; 4) Negroes must earn their living. ... It is very difficult for Negroes to find placement in our industrial and commercial life.[55]

6. March 19, 1933: "The Negro in the New Order"

The Mu-So-Lit Club of Washington, a musical, social, and literary society, invited Slowe to address its Forum.[56] Although it was established by prominent African-American professional men in 1905, both men and women were members by the time Slowe spoke. The Club's annual Lincoln-Douglas Debate Dinner became an important cultural event in Washington. According to Barbara Brooks Jackson, a native Washingtonian and long-time resident, it gave Washington African-American intelligentsia—the crème de la crème—of which Slowe was then a part—a welcomed gathering place.[57]

Mu-So-Lit was said to be "exclusively Republican" and "its programs, featuring distinguished speakers, were far more political than cultural."[58] Speaking soon after the inauguration of Franklin D. Roosevelt, a Democrat, as the thirty-second president of the United States, Slowe's topic was "The Negro in the New Order." In her talk, she reinforced her views about the importance of economics and the social science disciplines for the welfare of African Americans. She lauded Roosevelt's concrete efforts to raise the economic condition of African Americans that had been far too long largely embedded in sermonizing. She said that

> [i]n the past two weeks America has gone from a representative form of government to a dictatorship. No bloodshed. . . . They have given to President Roosevelt unprecedented power—due to our need for greater economic security. . . .
>
> These events ought to mean a great deal to the Negro as far as his political philosophy is concerned. . . . His welfare is wrapped up in the welfare of every other insecure group. . . . He must join hands with other groups to secure the means by which he shall live. The Negro has placed entirely too much dependence in the past, in what might be termed "inspirational leadership."
>
> Since the troubles of the Negro, in my judgment, are almost entirely economic, it is necessary to develop: experts in collecting data on the Negro's economic welfare and interpreting the information; experts in political science, in sociology and in every other field that has to do with his economic security; experts as spokesmen for the Negro and what they say should be based on scientific inquiry, scientifically interpreted.[59]

7. 1936: National Negro Congress

On Feb 7, 1936, *The Washington Tribune* reported that Slowe gave the keynote address at the mass meeting of the Washington Sponsoring Committee of the National Negro Congress (NNC).[60] NNC represented a

> vigorous effort of Negroes to present a solid front against the confinements to which their color apparently condemned them. It consisted of more than five hundred Negro organizations and represented a large cross section of Negro life. Its protests against various forms of discrimination and segregation were vehement.[61]

The NNC emerged from a conference on the economic status of African Americans that had been held at Howard in May, 1935. "This conference was held under the joint sponsorship of the Division of Social Sciences at Howard and the Joint Committee on National Recovery, which was formed during the early days of the New Deal to safeguard the rights of the Negro in the policy making of federal agencies."[62] The congress was a major civil rights coalition whose sponsors included Alain Locke of Howard and Ralph Bunche, a Howard University lecturer, A. Philip Randolph of the Brotherhood of Sleeping Car Porters, James Ford of the Communist Party, John P. Davis of the Joint Committee on National Recovery, Lester Granger and Elmer Carter of the Urban League, and Charles Houston of the NAACP. . . . Also, Howard University English professor Alphaeus Hunton, Jr., helped to form the organization.[63] The formation was noteworthy in two respects:

It represented one of the first sincere efforts of the 20th century to bring together under one umbrella black secular leaders, preachers, labor organizers, workers, businessmen, radicals, and professional politicians, with the assumption that the common denominator of race was enough to weld together such divergent segments of black society. It also signaled the Communist Party's movement into the mainstream of black protest activity. In particular, the evolution of the National Negro Congress dramatized the growing convergence of outlook between Communists and activist black intellectuals that had taken shape in the protests of the early Depression years and reached full fruition during the years of the Popular Front.[64]

The first big NNC meeting had been held in February, 1936, in Chicago . . . with more than 800 in attendance.[65] The Washington Sponsoring Committee solicited the support of African Americans living in Washington, DC.[66, 67]

Slowe's speech reflected how closely she adhered to the forceful militancy of W. E. B. Du Bois. Admittedly, she was subscribing to the notion that African Americans were justified in trying to rise above what Franklin called "the proscriptions that were thrown around their community."[68] Her address reinforced the remarks she had made at the testimonial dinner for Oscar DePriest. In her spirited talk, she urged her audience to

> sacrifice the things they want for the things they need and pay for their freedom. . . . All movements for the organization of the Negro race have fallen through because the race is not willing to pay for their wants. . . . If we had a budget with only fifty cents in it, we should include one cent in that budget for freedom. . . . Negroes must pay for their freedom from money obtained from their own pockets. This must be done if self-respect is to be maintained. . . . We cannot organize to lambast those who withhold our freedom and constitutional guarantees and then expect to beg for funds from the pockets of those we lambast.

Becoming more pointed, Slowe said

> People who want freedom of any kind must work for it themselves and not expect people to give it to them. . . . To get what you want you must mold public opinion and sentiment. This can only be done by procuring the facts and then subjecting them to the public gaze. . . . To place the facts before the people we must have a specialist who knows what he is talking about. To

do this he must be full-time employed, which means he must be paid and the money should come from the Negro race. It is more important that one thousand Negroes give one dollar each than to have one white person make a donation of one thousand dollars. . . . The thing we appreciate most is the thing in which we have placed our money. The thing we will work for hardest is the thing in which our money is placed.

Although she emphasized the need for financial support for NNC,[69] perhaps becoming more radical, she called for self-help through substantial organizations with paid staff. It is clear that Slowe was not alone; others were speaking out on the same issues.

8. 1937: Radio Address on Segregation and Discrimination in the Nation's Capital

On April 24 1937, Slowe, who by now had become acclaimed for her ability to articulate the plight of her race, spoke on a nationwide radio hookup through WJSV about how rampant racial segregation and discrimination were in the Nation's Capital. Her talk, under the auspices of the Federation of Churches of the District of Columbia, emphasized how the liberty of African-American citizens was truncated in the District. "In the few minutes allotted to me, I wish to point out some of the handicaps to good citizenship suffered by those Negroes who through education and character have earned the right to enjoy those advantages open to other people of similar education and culture." Slowe stressed the inability of colored citizens to move about Washington

> with the freedom enjoyed even by aliens. . . . Those of us who are deeply concerned about the future of our country and who are trying to develop dependable citizens out of our youth find it increasingly difficult to inculcate that respect for government and law which is the safeguard of our institutions. The snobbery, the disdain, which many of our white citizens show for Negroes regardless of their personal worth is germinating in both groups seeds whose fruit will eventually destroy all of (us) unless rooted out before they come to fruition. . . . In Negroes, who are naturally friendly, there is a growing hatred of those responsible for the insults heaped upon them and a growing disrespect for a government that does little or nothing to correct these evils. . . .
>
> In America we have set up for ourselves two ideals which we should seek constantly to guard—the ideal of Christian brotherhood and "the ideal of individual freedom under democracy . . .

I ask you citizens who love your country and wish to see its ideals of Christianity and democracy preserved, if you have acted either as Christians or as true lovers of freedom in your treatment of our colored citizens of Washington. . . . The evils which grow out of your disrespect for the personalities of Negroes are not new, nor easy for some people to overcome, but a new intelligence must discern them and Christian humanity must remedy them if our country is to endure as one nation indivisible. . . . Those of us who believe in the ideals of a Christian democracy must constantly test our own ideals and through ceaseless devotion to the philosophy of the brotherhood of man and the fatherhood of God make real what now exists only in the ideal.[70]

She went into considerable detail to describe Washington, DC as a community of unyielding racial segregation.

The dome of the Capitol, birthplace of the laws by which we are governed, rises majestically to the open sky and symbolically says: "All men are free and equal and have the right and opportunity to enjoy the fruits of their labors!" . . . Is the Capital a place where every man is a man? So far as the colored citizens are concerned this is not true. No Negro, however cultured, however bravely he and his fathers have fought for the preservation of this democracy can move about in this fair city with the freedom enjoyed even by aliens. . . . If a Negro goes into the restaurant of the Capitol building itself, he is denied the right to purchase a meal. Here, under the dome of what should be the Hall of Justice, he finds himself an outcast in his own country.

If he attempts to board a sightseeing bus to visit those shrines which should thrill the heart and inspire the spirit of every true American he finds himself barred. Starting from the heart of this city to journey to the birthplace of the Father of his country, he finds himself Jim Crowed on the last three seats of the trolley car. . . . In this city, fast becoming one of the cultural centers of the world, he is denied entrance to places where music, drama and the arts are enjoyed not only by white Americans, but by the citizens of every other country who happen to be sojourning within our gates. . . . No colored person, unless he looks like white, can get admission to any downtown theater in Washington. The situation is doubly tragic when it is realized that not a colored public school in this city has an up-to-date, adequately equipped stage where first class amateur performances can be seen by Negro children. On the other hand,

> two of the best equipped stages in the United States are found in the McKinley and Roosevelt white high schools provided by public funds, while, at Dunbar, Armstrong and Cardozo, attended by colored children, the stage equipment is either outmoded or else most painfully inadequate.
>
> Negroes . . . have great difficulty securing admission to concerts and recitals at music halls in this Capital city . . . It might be urged that the cultural activities of the city are in the hands of private individuals over whom the government has no control, but the government itself discriminates against colored citizens in the District. Pending now before the House of Representatives is the appropriation bill carrying funds for public schools. Although the Negro citizens form 33% of the population of Washington, only 17% of the money to be appropriated for school buildings and grounds for the next fiscal year has been allocated to colored schools.
>
> The snobbery, the disdain which many of our white citizens show for Negroes regardless of their personal worth is germinating in both groups seeds whose fruit will eventually destroy all of us unless rooted out before they come to fruition. . . . The evils which grow out of your disrespect for the personalities are not new, nor easy for some people to overcome, but a new intelligence must discern them and Christian humanity must remedy them if our country is to endure as one nation indivisible.[71]

Slowe did not speak euphemistically when she talked about the inequities that she witnessed in the United States. *The New York Age* of May 8, 1937, picked up her speech and reiterated points she made about the Nation's Capital, stating they are true. She asked, if

> the Capital of the United States is a place where every man is a man? So far as the colored citizens are concerned this is not true. No Negro, however cultured, however bravely he and his fathers have fought for the preservation of this democracy, can move about in this fair city with the freedom enjoyed even by aliens.

Slowe's comments were so pertinent that *The New York Age* singled them out, repeating that she cited the inability of Negroes to purchase a meal in the Capitol Building. "Negroes cannot board a sightseeing bus to visit shrines. . . . No colored person, unless he looks like white, can get admission to any downtown theater in Washington. . . . No public school in this city has an up-to-date adequately equipped stage where first class amateur performances can be seen by Negro children."[72]

Slowe was denouncing inequities that had been mandated by court order as early as 1896 when the Supreme Court ruled that separate-but-equal facilities were constitutional on intrastate railroads. For fifty years, the *Plessy v. Ferguson* decision upheld the principle of racial segregation. Across the country, laws mandated separate accommodations on buses and trains and in hotels, theaters and schools.

All of her entire life Aunt Martha's niece had come face-to-face with segregation and discrimination. The agony she experienced in the capital of the United States was simply one more sign of the times. In 1936, African Americans were cheering because Jesse Owens won four gold medals at the Berlin Olympics, an achievement that was unimaginable for a person of his race. In 1937, Joe Louis became the heavyweight champion by knocking out James J. Braddock, a white man, another unpredictable achievement for an African American. Even prior to Louis' achievement, African-American Jack Johnson's defeat of Tommy Burns at Sydney, Australia, for the heavyweight championship in 1908, had precipitated white outrage. Yet neither Owens nor Louis or Johnson was accorded the privileges of their fellow white citizens in theatres or on buses and trains.

The Position of Dean of Women

Because Lucy Slowe was regarded by many authorities in the field of college student personnel work as one of the most effective deans of women—and unquestionably the outstanding dean of women in African-American higher education—her views on the position of dean of women are extremely worthwhile. It was following her appointment as dean at Howard that the following speeches and writings appeared.

1. 1931: "The Dean of Women and her Relation to the Personnel Office"

In 1931, she made a forceful case for the position of dean of women versus a central personnel bureau. When she served as a discussion leader at the annual meeting of the National Association of Deans of Women (NADW), her session title was "The Dean of Women and her Relation to the Personnel Office." Setting the stage for the discussion, she said that

> [i]n order to know the individual students it is necessary for the dean to have complete personal and academic records of each woman. To do this she must have the co-operation of those offices in the university which compile records and also must have the means of getting such personal information as she needs in her daily contacts. . . . In the bureau a staff of women must be

maintained to interview and counsel women students. What is to be gained by having counseling done in the general personnel bureau rather than in the office of the dean of women?[73]

She believed that the dean of women must be able to deal with the whole student, whose academic success could be affected by a variety of problems, such as unsatisfactory home conditions, health and finance (including employment), and loans and scholarships. She conceded that a "personnel research bureau" could conduct research that the dean did not have time to do, but it could not replace the person who deals with women students as complete human beings—a dean of women.[74]

2. 1933: "The Dean of Women in a Modern University"

In an article, "The Dean of Women in a Modern University," Slowe noted that the first dean of women was appointed by the president of the University of Chicago, William Rainey Harper, who selected for the position Alice Freeman Palmer, former president of Wellesley College. The fact that President Harper selected an experienced educator as Dean of Women at the University of Chicago shows that he realized the need in a coeducational college for the women's point of view in the task of preparing women for their place in the modern world. Surely Alice Freeman Palmer, college graduate, professor, and administrator, was chosen neither to be a campus policeman nor a dormitory matron, for a woman of lesser attainments could have performed these duties. The first Dean of Women in America was an educator of the highest rank, and her successors in all first-class colleges should have been chosen with this fact in mind.

> No woman, who must assist in training young women for intelligent and efficient service in the world, can perform this task unless she, herself, has been trained on the broadest possible line. If she is to inspire young women to love and to seek learning, she must be a scholar, if she is to encourage them to use their learning for the public good, she must use her own training for this purpose. A Dean of Women should be, first of all, a well trained educator with a broad outlook on the world and its problems. . . . The social changes brought about by the industrial and political revolution of our day have wrought tremendous changes in the mode of life for women who look to the college to prepare them to meet adequately and bravely the new order of things. The Dean of Women in a modern college is expected to survey the modern world and be able to suggest ways of preparing college students to meet their obligations in it.

> One of the most important tasks of the Dean of Women ... is to advise the administration, the faculty, and the women students themselves on those aspects of education peculiar to women, if they are to be prepared to take their places in
> the social order as it exists today. ... College women in general, and Negro college women in particular, need training in the science of government, of economics and community organization especially as they affect the lives of children who, after all, are women's particular interest.
> College women need guidance in their choice of vocations in the light of the realities which they will face after they leave college, and it is the business of the Dean of Women to see that such guidance is furnished. ... The Dean of Women should be in close touch with the academic policies of the college and should be in a position to advise the administration on curriculum matters of special interest to women.

Slowe then mentions four specific activities of the Dean of Women: 1) housing of students; 2) seeking and supervising part-time employment of students who need financial assistance; 3) developing some form of self-government; and 4) activities related to community life in order that students may realize their social responsibility.[75]

3. No Date: "The Business of Being a Dean of Women"

In "The Business of Being a Dean of Women," Slowe said that the personal, psychological, and social traits necessary for an effective dean of women are a general interest in people, accompanied by faith in young people, and a belief in the mutability of human nature; respect for the personality of those with whom she deals; a spirit of optimism; and a love of life in all its aspects. She believed that the possession of these traits should not be considered in terms of absolutes but rather as goals one could strive to live by.

> We can admit our failures when practices belie our beliefs and redouble our efforts to live up to what we believe. ... The first school for the Dean of Women must be "The School of Life" experience. I do not believe, however, that she must have attained great years before she can be of service. Travel and much reading are broadening influences. Contact with life on various levels should be a part of the training. The Dean of Women who has lived a narrow life circumscribed by the limits of a small group will not be prepared to cope with all of the problems which she will meet with girls of the many varied backgrounds.

The Dean of Women should have some scholarly interest and should be well prepared for some academic activity, as she is concerned not only with the moral life but with the educational life of women students. She needs contact and status with the faculty if she is to be able to help direct the education of young women. . . . The Dean of Women through her academic studies and life contacts should have developed emotional poise before she attempts to help others gain this very necessary personal trait. The activities of the Dean of Women fall into several groups which may be listed as administrative, academic, social and personnel. . . . The personnel function of the Dean of Women is most important. It involves the supervision of the participation of women students in the extra-curricular activities, guiding the women students in vocational choices, administering self-help employment for girls, directing the housing arrangements for the women and counseling with individual students on personal problems. . . . Some college presidents have misunderstood the relation of the Dean of Women to the housing of young women and have exacted other duties of matron or housekeeper, in addition to the many tasks which fall her lot. This should not be. The Dean of Women should be director of the housing system for young women; she should have the general responsibility of the activities of the staff in each dormitory, but should not be expected to have direct charge of any particular building. In connection with the housing of women students may be mentioned that other function so necessary to the welfare of the students—the feeding of women students. It is highly desirable that a trained dietician be a part of the staff of the Dean of Women.

The work of counseling the students on individual problems tests the real fibre of the Dean of Women. Techniques cannot be definitely set up as "the way" to proceed, for each individual will probably require a treatment different, even though so slightly, from that used with someone else. . . . The Dean of Women should make use of all available information. . . . She should proceed cautiously and with the consent of the student in gathering information about the student from other individuals. The policy of dealing honestly with students demands this. The Dean of Women must be sagacious enough to know when to direct a student to a specialist or to someone who can be of greater help than she can. . . . The personal interview is the Dean of Women's chief instrument for counseling. . . . The interview should not be an inquisition or a confessional. . . . The Dean

of Women should never force a confidence. . . . She must be absolutely impartial and flexible enough to meet new conditions. She must "be friend of all; the foe, the friendless. She must "look up, laugh, and love, and lift." She must keep her cultural and spiritual tone at the highest level. To do this she must find time for rest and spiritual and mental refreshment.[76]

4. No Date: "What Contribution Can a Program of Social Activities Fostered by the Institution Make to the Moral and Social Development of Students in Negro Colleges?"

This is a somewhat different version of the speech with the same title presented under "Character." Here it addresses the job of the dean of women, ending with a reference to the English Victorian novelist, George Eliot, an obvious reflection of her love for English literature.

How does a dean of women put theory into practice? Can programs of activities in colleges contribute to the development of moral and social traits of college students? Slowe was optimistic. "What Contribution Can a Program of Social Activities Fostered by the Institution Make to the Moral and Social Development of Students in Negro Colleges?"

> Outside of the classroom, where restraint is removed, where no marks are given and no credits earned, the real man or woman is revealed; and here in my judgment, the college has one of its greatest opportunities for education. . . . The worthy use of leisure is the chief objective of the college social program. . . .
> The first subject to be given a place in the social program of any college should be student government. . . . Student government is the goal of all education for character building. . . . While self government is an individual matter, a thing of spirit, it is founded on the principle of doing in individual cases only those things which are ultimately good for the group. . . . If this principle is a sound one, the college authorities are obligated first of all to examine with the students those group goals which are desirable. This practice immediately precludes the drawing up and handing down of rules and regulations by administration and faculty. It brings the students into participation in the making of the rules by which they are to be governed . . . rules should be guides for behavior and not compulsory measures. . . .
> Not only do students get valuable practice in seeing the need for orderly group government when they participate in the making of rules but they also receive valuable experience in seeing that the laws are properly executed by the officers whom they

elect. They are charged with the definite responsibility for order, justice and wisdom in their relationships on campus; and this experience is of value to them as citizens of tomorrow. . . . Any college which builds up and conducts successfully associations in which responsibility for fine conduct is placed squarely on the students themselves, has done more to strengthen moral fiber and to develop restrained, self-reliant men and women than all the rules formulated by the faculty could possibly do.

The social program of the college should contain those recreative activities which refine the taste and broaden the vision of the students. Here, too, faculty and students should work together to achieve on our college campus that dignity in relaxation which has almost passed out of American life. . . . When college graduates have no finer taste in the drama, in music or in art than the most backward and illiterate person, it is time for the college to examine carefully its training.

The philosophy underlying any social program in a college is based on the ultimate development of the character and personality of the individual student through giving him opportunities to choose for himself those activities which he will engage in. Since students are inexperienced, members of the faculty will cooperate with the students in the building of their extra-curricula program, but will not, through domination take from the student his opportunity to exercise his judgment and will. The faculty, through their cooperation, will see the students revealed as they are—faults and virtues—and through this revelation will find their greatest opportunity for improving student morals and tests.

All good schools are moving toward a philosophy of life which stimulates [in] people the will to do the useful and desirable thing. The accumulated acts of our students—their daily attitudes, purposes and ideals—must be unified and integrated into a central scheme of values. . . . The college makes those values concrete and definite for the individual if it first, gives the student opportunity to become self-directing through his participation in governing himself; second, if it gives opportunity to find joy for leisure hours; . . . third, if it assists him in getting pleasure from those purely social events; fourth, if it shows him how to enjoy himself without extravagance in the expenditure of money; fifth, if it makes opportunity for the student to be gracious and thoughtful of others. . . .

If all of these things form the end and aim of a college social program, its moral and social value cannot be estimated.

The lines of George Elliot should be kept in mind by all builders of college social programs. She said, "We prepare for sudden emergencies by the accumulated actions of our past." It is through giving students opportunity to act that we achieve our final goal—tolerance in human reactions, good taste in social affairs, restraint in politics, discretion in the expenditure of money, and last of all the building of sound public opinion.[77]

This treasure trove of Lucy Slowe's speeches constitutes a fraction of the enormous legacy she left. Its significance is reflected in the manner in which her life was celebrated.

GUESTS AT DEAN LUCY D. SLOWE'S ANNUAL GARDEN PARTY

THE HOSTESS SMILES GRACIOUSLY IN THE RECEIVING LINE.

28. GARDEN PARTIES AT DEAN SLOWE'S HOME: (1) Guests at Dean Lucy Slowe's Annual Garden Party. (2) The hostess, Dean Lucy Slowe, smiles graciously in the receiving line. (Source: Moorland-Spingarn Research Center, Howard University)

29. Students who registered for Lucy Slowe's first course for Deans of Women at Howard University. Spring Quarter, 1930. Dean Slowe, fourth from left; Joanna Houston, third from left (Source: Moorland-Spingarn Research Center, Howard University)

30. Members of the National Association of Deans of and Advisers to Women in Colored Schools, meeting at Wilberforce University, Xenia, Ohio, March 1936. From left to right: Myrtle Teal (Wilberforce University), Ann J. Heartwell (Kentucky State College), Nancy Leubers, Thelma Rambo (Fisk University), Roberta Peddy, **Lucy Slowe** (sixth from left), Eugenia Dorce, Oralee B. Mitchell (Dillard University), Alida P. Banks, Joanna Houston, Joanna Smith. (Others not identified.) (Source: Moorland-Spingarn Research Center, Howard University)

31. Romiett Stevens, a professor with whom Lucy Slowe studied at Teachers College, Columbia University. (Source: The Gottesman Libraries at Teachers College, Columbia University)

10

A Celebration of Life

Lucy Slowe must have understood that, from the minute you are born, you are dying, and learning this lesson must have influenced her approach to life.

Lucy Slowe's death set off a wave of mourning coupled with arrangements for her burial. Her funeral was held in Andrew Rankin Memorial Chapel on the Howard University campus on Monday, October 25, 1937. As she had requested, Charles Harris Wesley[1]—professor of History at Howard[2] and past national president of Alpha Phi Alpha Fraternity[3]—officiated. The crowd was enormous. The Chapel, according to *The Afro-American*[4] "proved too small to accommodate the throng of trustees, family members, students, and friends who sought entrance to pay their last respects to the deceased." Benjamin E. Mays, Dean of the School of Religion,[5] offered prayer, and Howard Thurman, Dean of the Chapel,[6] read condolences and expressions of sympathy. R. Todd Duncan,[7] the operatic baritone, rendered a musical selection, as did Elizabeth Ellison and the University Choir, under the direction of Lula V. Childers. Thomas Anderson, Albert I. Cassell, Professor of Physics Frank W. Coleman, Thomas Hawkins, Reverend George Parker, and Frederick D. Wilkinson, university registrar, served as pallbearers.[8] Cassell had been Architect in Charge and Supervisor of Works upon completion of the new residence halls for women.[9,10] Frank Coleman was a founder of Omega Psi Phi Fraternity.[11] Parker was Chaplain of the General Alumni Federation.[12] Hawkins had been appointed assistant to the dean of men in 1933 and had drawn "particular inspiration" from Lucy Slowe.[13]

Floral tributes covered the rostrum and the bronze casket and were so numerous that two cars were required to transport them to Lincoln Cemetery in Suitland, Maryland, where she was buried.[14]

According to The Afro-American,[15] Slowe had asked that President Johnson have no role on the program. The Washington Tribune reported that Johnson "entered the chapel alone and sat near the front with other officials of the school."[16] Additional reports of her funeral appeared in the Philadelphia Tribune under the caption "Dean Lucy D. Slowe Buried; Had Been Howard University Official for Fifteen Years." In like manner, The New York Amsterdam News went with the headline "Mourn Demise of Dean Slowe," whereas the Norfolk, Virginia, Journal and Guide simply carried the caption "Dean Passes."[17]

The way friends and associates celebrate the deceased is often revealed by the way they say goodbye. They remember her, praise her, and mourn her passing. Because Slowe had a work ethic and style that gained her the respect of numerous organizations and individuals, messages of praise poured in from the highest echelons of the groups and persons she touched. The color line was crossed, for people of both races—African American and white—revered her, and said so. The gender line was crossed, for both men and women praised her. Praise poured in from her academic world, from the press, and from former students—all. And so they celebrated her life, putting into words the essence of this woman in ways that reveal a portrait of Lucy Diggs Slowe as a person, a fighter, a leader, and a humanitarian.

Presented here is a selection of tributes to Dean Slowe taken from three sources: the *Journal of the National Association of College Women* (1938), *The Journal of the College Alumnae Club* (1939), and responses to an inquiry organized by Marion Thompson Wright (1962).

Organizations

The president of the National Association of College Women wrote that

> [t]hrough Miss Slowe's interest in education and her work in the organization, she was able to influence the philosophy of training and the standards of educating Negro women. Because of her broad interest and ever-increasing contacts, she could not only bring to the Association a keener understanding of the techniques of bettering human relationships, but could also interpret the ideas of the organization to groups removed from us.
>
> Few people of Dean Slowe's type, however sincere, have the power of stating so clearly to others their convictions as she had.

We have lost a speaker who combined superlatively clear thinking with force and dignity. Hers was a dynamic personality.[18, 19]

We, the National Association of College Women, wish to express our appreciation of Dean Lucy D. Slowe. From the time of the inception of the idea of an association in 1923, she supported and encouraged it. As its first president, from 1924 until 1929, Miss Slowe guided the formulation of policies of the organization. From 1929 until her death she was a member of the Executive Committee.

From the National Association of Deans of Women, "Miss Slowe was one of our outstanding members, and a pioneer for her race. . . . During her long fellowship with the groups, she did more than any other person to develop a spirit of sympathetic understanding between the two races within the Association."[20]

The executive secretary of the American Association of University Women sent condolence. She wrote,

Magnanimity was the keynote of the character of Lucy D. Slowe. Recognizing and allowing for its necessary diversities, she held a large view of life and the importance of higher education. Welcoming and cherishing new educational ideas and interests, coupled with generosity of spirit—such were her qualities. . . . Dean Slowe was rightfully ambitious for the women students for whom guidance and leadership were her responsibilities. She sought those resources of her own and others to make sure that her task would be thoroughly done.[21]

The National Board of Directors, Women's International League for Peace and Freedom, passed a resolution: "A courageous leader for economic and social justice for all groups, she has definitely influenced the thinking of both individuals and institutions, and we deeply feel the great loss to her immediate community and the country at large"[22]

For the College Alumnae Club, the president wrote, "Miss Slowe's influence was broad and effective. Her fine sense of the fitness of things. Her brave stand for what she believed to be right, her vision; her force, her balance; these traits endeared her to those whose lives she touched. . . . Her memory will be a moving force for good."[23]

The Howard University women students paid homage to Dean Slowe: "We cannot say of her all that is in our hearts to say. Living with her and working with her, we have come to love and to appreciate the understanding and sincerity that we found in her. She is a part of Howard and will live forever within these walls."[24]

Lucy Slowe worked closely with the YWCA for a number of years, so it is fitting that an official of the National YWCA would celebrate her.

> In any period of unusual growth and vitality of a struggling social group whether that group be a racial minority or a class division, there are always those men and women who, by the clearness of their vision, the integrity of their approach, and the zeal and ardor with which they undertake work, give leadership to that group which directs its energy and conserves every bit of gain. Lucy D. Slowe, Dean of Women at Howard University, was such a leader among the leaders [of] the Negro people of the last quarter century. While it is true that the greater part of her energies were directed toward the work with women and girls, it limits the total effect of her efforts to describe all that she stood for and fought for as a leader in university and educational circles. All of her many labors at the university, in the organizations which she founded or helped to found, and the many causes which she supported were based upon her conviction that Negro young men and women could and must assume their rightful place in American life and that they would do so only as they placed the greatest value on all that is meant by that old-fashioned word "character" and self-directed work for known and worthy ends.[25]

The president of the National Association of Deans of Women and Advisers to Girls in Negro Schools honored Slowe's contribution to that organization.

> In our participation in the National Association of Deans of Women we younger Negro deans were aware always that in the admiration and respect which Dean Slowe commanded the professional status of our group had advanced. It was she who raised the issue and it was her friends in the National Association who fought through to its participation in the activities of a national convention of the Association. . . . For seven years deans of women and advisors of girls in Negro schools were convened by Dean Slowe to discuss their particular problems, many of which are different from those discussed in the National Association meetings. From these meetings a number of Negro women who had not been able to acquire professional training for their positions received their first clear insight into the demands of their work and some practical suggestions for effective functioning. Then three years ago, when the group desired some permanency,

she helped organize the Association of Deans of Women and Advisors to Girls in Negro Schools and served until her death as its first president. . . . In all of my association with Dean Slowe, I found her a strong, courageous, independent woman and a friend whose understanding and generous spirit of giving herself to advance others or a cause knew no bounds. . . . We, her associates on whom has been thrust the task of carrying on the work which she began, recognize the genius of this woman.[26]

Ten months following Slowe's death, *The Afro-American* reported how the American Tennis Association honored her memory.

As a tribute to her life and contributions to the development of tennis and sportsmanship, 2000 spectators, players and officials stood for thirty seconds in a silent prayer to the memory of the late Lucy D. Slowe of Howard University at Lincoln University. . . . Joining in the tribute to Dean Slowe, the first women's single champion of the American Tennis Association was Tally Holmes of Washington. . . . As a member of the Monumental Tennis Club of Baltimore and a pioneer of the National Tennis Association, Dean Slowe won the first championship tournament held in Baltimore in 1917. Undaunted by three successive years of defeat by Miss M. Rae, Dean Slowe again won the women's single title in 1921. She retired from competitive tennis in 1924, when her duties as a teacher required her time.

Edmund H. Burke, chairman of the Tournament Committee, read the organization's resolution: "Lucy Slowe will long be remembered as one of the great educators of her time. Her life and work will ever live in the memory of those who knew her and our young women will do well to emulate the sterling qualities of this champion of women."[27]

Individuals

Marian Thompson Wright interviewed one of the graduates of the Class of 1935, who recalled, "I have definite recollections of the late Dean Slowe which time can hardly efface." She recounted a meeting of the officers of the Women's League at Dean Slowe's home, which was followed by cocoa and a raid of the dean's icebox. "We concluded the evening only after we had sampled all her jelly, tasted rather generously all leftovers, quarreled over who was to have some particular delicacy that she remembered was in an out of the way place, and then as though that were not enough, we

tramped through the house on a personally conducted tour of inspection." She added, "I frequently needed a firm but gentle hand to administer tactful rebuke. Dean Slowe knew just how."[28]

The tributes to Slowe vary with the kinds of interaction the individuals had with her. Thyrsa Amos, Dean of Women at the University of Pittsburgh, stated that

> I count knowing Lucy Slowe one of the pleasantest experiences of my life. She is the first Negro woman leader whom I came to know well, and with whom I could talk freely about the constructive relationship of our two races. So I owe her much for teaching me tolerance and human sympathy. She did much for me, too, through her gracious and pleasing personality which was above race. Her kindness, her generosity, her unselfishness, her loyalty were inspiring.[29]

Professor Sarah W. Sturtevant, arguably the "dean of professors" in the preparation of deans of women at Teachers College, Columbia University, put it this way:

> I first came to know Lucy Slowe by reputation when I was a student at Teachers College. She, too, had studied with Professor Romiett Stevens, who was at that time teaching classes for those professionally interested in work as deans of women. Professor Stevens singled her out for commendation as a person universally gifted and of noble character. When later I knew her personally, and worked with her through the years, I realized increasingly how true was that appraisal of the quality of her womanhood.
>
> Miss Slowe was one of those rare souls to whom has been given the privilege and pain of taking leadership along comparatively new paths of human progress. She put her intelligence and the power of her personality behind the ideal of high standards of education and achievement, and of personal living for the women of her race. As the dean of women in Howard University, and a recognized leader not only in that institution but in all Negro education, she struggled against great difficulties, some of which came from within her own racial group and some from without.[30, 31]

Mary McLeod Bethune, president of the National Council of Negro Women, sent a message of condolence,[32] as did Mabel Carney who was at Teachers College, Columbia University.[33] A former student, Isabelle W.

LaMay, who had become secretary of the Phyllis Wheatley Branch of the YWCA in Roanoke, Virginia, noted, "The life of Dean Lucy D. Slowe reminds me of nothing so much as a string of pearls."[34]

Communications from Howard University officials reveal the esteem in which colleagues held Dean Slowe. Kelly Miller, the distinguished lecturer, teacher, journalist, and scholar, wrote under the headline "The Passing of an Eminent College Woman."

> The Deanship of Women is perhaps the most important, as it is the most difficult and delicate position on any coeducational faculty. When Dean Slowe assumed her function at Howard University, she was given a skiff to sail an untried sea without chart or compass. She at once entered upon her task with determination to solve this new problem in education."[35]

At its meeting on October 26—several days following Dean Slowe's death—the Howard University Board of Trustees adopted a Resolution. Dr. Peter Marshall Murray presented it for the Committee on Instruction and Research.

> Whereas, it has pleased Almighty God to remove from our Administrative staff and faculty, by death, our esteemed Dean of Women, Dean Lucy D. Slowe, who for so many years has occupied a prominent place in Howard University and has contributed so largely to the development of Negro Womanhood both within and without the University;
> Therefore, Be it Resolved. that in the death of Dean Slowe, our University, Faculty, Alumni, and students have sustained the loss of one of its ablest professors and inspiring personalities, whose fellowship it was an honor and privilege to enjoy, that we bear testimony to her many virtues, her clear thinking and unquestioned probity of life, her influence in Negro education and in the advancement of the standards for the education of Negro women in particular; that we offer to her family, our students, faculty, and mourning friends, over whom sorrow now hangs, our heartful condolence and earnest hopes that the distinguished and unselfish service which she has rendered in this institution and to her race may be the bright star which will shine clearly as we stand within the Shadow of the Grave. . . .[36]

Among the Howard administrators who sent expressions of grief and condolence to the family was Dr. Louise C. Ball, a trustee. V. D. Johnston, university treasurer, with whom Dean Slowe had numerous unpleasant

encounters, wrote, "I join with other friends of Dean Slowe at this time in expressing to you and those most intimately associated with her my very great respect for her unusual abilities, and the sympathy I have for you and her other intimate friends in the loss caused by her unexpected death."[37]

President Johnson, in a handwritten letter dated October 24, 1937, to Dean Slowe's sister, Nellie Hawkes, stated,

> Thank you for the copy of the Memorial Service Program. All arrangements have been made in accordance with your wishes.... Here I enclosed five telegrams expressing high esteem for Dean Slowe and sympathy with the University in her loss. I am sure that the family and friends will wish to see them.... If there is anything further which you may wish to have done in connection with the Funeral, please let me or Mr. Hill know. We shall be glad to see that it is done. With warmest sympathy.[38]

Hardly a warm of ringing endorsement, according to friends; a telegram and this letter were the lone expressions received from President Johnson.

Dr. Verna Dozier, a distinguished scholar, layperson, and theologian in the Episcopal Church, who graduated from Howard University during Lucy Slowe's sojourn there, expressed her grief and her tribute under the title "Challenge: To the Memory of Dean Slowe."

> Daughter of Howard, she was. When she came to take her chair on the University faculty, she came as no stranger in our midst. Rather she came as a child returning home.... Her Howard was necessarily different from our Howard. Physically her Howard was not our Howard; but spiritually, it was the same—the acme of Negro education on the crest of a hill! She walked the same paths we walk, rested where we rest. Can we not see her as she "with brow serenely high and the fiery heart of youth" strides down the long walk? ... Daughter of Howard, she was. Sons and daughters of Howard, we are. We are one with that great soul.... Know that the higher one member of a group goes, the higher she calls the others on. Higher, sons and daughters of Howard: higher is the clarion call she sounds to us. She was fighting a great fight she did.... She threw the torch. Be ours to hold it high![39]

Dwight O. W. Holmes, who had become president of Morgan State College at the time of Slowe's death, delivered the eulogy. He said that

> Lucy Slowe lived her eulogy every day, openly and loudly so that the whole world might see and hear. Her life is one of the very

finest examples of cultured, sincere and successful womanhood that I have known during a long and somewhat varied experience.... And I, who have known her as girl and woman for thirty-five years, as her teacher, her colleague and her friend, am happy and honored to perform this simple task; for it is a duty of mingled joy and pain, tempered by a great admiration and warm personal affection.[40]

I wandered by the open door of her class-room years ago when she was teaching in Baltimore as she was drilling her section on a poem which they were to recite in unison at the assembly next day. And as I passed, I heard the first stanza from Babcock's well-known poem which might well be considered the theme-song of her life, or better possibly, the text of her epitaph:

> "Be strong. We are not here to dream to drift.
> We have hard work to do and heavy loads to lift.
> Shun not the struggle. Face it. 'Tis God's Gift."[41]

... She inherited a keen mind; she acquired habits of industry; she developed respect for ideals; and she received from somewhere the gift of rare courage—a combination of qualities more to be desired than color or rank or much fine gold. Thus equipped, she grappled with life, laughed at difficulties, fixed her eyes upon the peak and climbed to the rare atmosphere of high places, never faltering, though often weary, never losing her way, though sometimes confused—eyes clear and unblinking at the brightness of her glorious vision, chin up, head held high, sometimes bloody but always unbowed.... She gave the last full measure of devotion that girls, all girls, might live more abundantly.

As I have experienced the spell of her keen mind working to help solve the real problems of existence, I have gained increasing respect for intelligence rightly applied. And Lucy Slowe's mind was keen and her logic merciless. Woe unto her antagonist who came with invalid premises or employed faulty reasoning ... her almost fanatical idealism manifested itself as a living, flaming thing, worthwhile to her only if translated into action.... To her, ideals were not decorations, but objectives to be actually achieved. As I have from time to time felt the pressure of her persistence in what she considered to be a holy cause, I have gradually come to realize the source of the great power of prophets and seers who shut their eyes to the easy ways of life and press on to goals that to the less worthy seem visionary. When I have witnessed her sublime and unflinching courage in the face of disaster and defeat, I have learned

to despise cowardice anew. Because of these qualities, she was strong and much sought after where things were to be done; and sometimes, as every leader knows, misunderstood and hindered. But she carried with her a great moral authority. And because I have known her so intimately and so long I recognize the source of that authority. Like Galahad's her strength was as the strength of ten, because her heart was pure.[42]

Continuing the celebration of her life, *The Journal of Negro History*, in its section on personal notes, published a summary of Lucy Slowe's life.[43] The Philadelphia *Friends Intelligencer*, a publication of the Society of Friends, noted on November 20, 1937 that Lucy D. Slowe ". . . was one of the outstanding colored women in the United States. . . ."[44]

Not quite two weeks following the dean's death, she would have been presiding at the Howard University Annual Women's Dinner. Instead she was being honored at special services organized by the women of the university to temporarily replace the dinner that had been held for many years on the first Friday in November. They conducted this service at 8:30 in the evening in Frazier Hall on the Women's Campus.[45]

One year later—in November 1938—Mary McLeod Bethune, national director of the Negro Division of the National Youth Administration (NYA) ". . . paid tribute to the late Dean Slowe in an address before nearly 500 women at the sixteenth annual women's day dinner . . ." held on the Howard University campus.[46]

The offerings of celebration from such a host of individuals reveal the high regard in which Lucy Slowe was held and show her to have been the people's dean.

Epilogue

Two Buildings Named for Slowe

Although Howard University currently owns a residence hall named for Lucy Diggs Slowe, it was acquired as a gift eleven years after her passing and sixteen years after Kelly Miller called for recognition of this kind. In 1942, it was the federal government that constructed Lucy D. Slowe Hall at 1919 Third Street, Northwest, in Washington, DC, as housing for single African-American women working for the U.S. government during World War II. The Art Deco building was partially designed by African-American architect Hilyard Robinson.[47] The university named Louis Justeman as architect.[48] It is paradoxical that the system of segregation that Lucy Slowe abhorred led to its construction. African-American government women who were moving

to segregated Washington in droves were desperate for affordable housing. Most "were not allowed to room in the city's many temporary housing blocks on the Mall, which were reserved for white workers only."[49] In announcing the project, *The Afro* referred to Slowe as the "beloved feminist leader of Howard University." It was erected as a new defense project, and Defense Coordinator Robert Taylor was named as responsible for the building.[50] At long last, a building on the campus of Howard University named for Slowe became the property of the university when, in 1948, the federal government gave the structure to the university "for use as a dormitory under a bill approved . . . by a House subcommittee headed by Representative J. Harry McGregor (R., Ohio)."[51]

It is equally fitting that located in the Brookland section of Washington is an elementary school at 14th and Jackson Streets, Northeast, that also bears her name.[52] It is noteworthy that the Lucy D. Slowe Elementary School is located directly across the street from the Brookland home of John P. Davis, a sponsor—in 1935—of the National Negro Congress, a group before which Slowe had given a rousing speech in 1936. The connection between Davis and the Slowe School is fortuitous. "In 1943 the first lawsuit challenging segregated schools in the (sic) Washington, DC, was brought in Michael D. Davis' name by John P. Davis. . . . The U.S. Congress in response to John P. Davis's suit appropriated federal funds to construct the Lucy D. Slowe elementary School. . . ."[53] Furthermore, John P. Davis' father was Dr. William H. Davis, the principal who hired Lucy Slowe to teach at Armstrong High School in 1915.

Twenty-Five Years Later

In the early 1960s, Marion Thompson Wright collected the opinions of colleagues and Howard graduates twenty-five years after Slowe's death. Her special concerns were Slowe's input to their lives and to Howard University.

Thelma Preyer Bando[54]

She was a very good example of a woman with depth in her thinking and a keen insight and understanding of human nature and a person with deep and sensitive convictions about what makes for finer womanhood. She stressed character, culture, and refinement at all times.[55]

Marion T. Wright

Former students speak of her as an inspiring, stimulating and creative teacher of English. Colleagues describe her as a conscientious and insightful administrator dedicated to high principles in the performance other duties.[56]

Vivian E. Johnson Cook[57]

From her early years as a teacher in a public high school, to her recognized leadership in a respected educational organization to her final professional service as dean of women in a large university, Lucy Diggs Slowe revealed herself as a woman of high purpose, great industry and marked power. Her record is unique—her contribution rich and lasting.[58]

Kathryn G. Heath

Perhaps it would be closest to the mark to say that it was the fineness and warm-heartedness of Dean Slowe which helped make her such a remarkable person. She was a noted educator in the nation. And she could draw a circle which took others in even though some might try to draw one with her out.[59]

Attached to Heath's letter to Wright is the following excerpt from a poem by Sir Philip Sidney, the first verse of "PSALM VIII. Domine, Dominus noster."[60]

> Lord, that rul'st our mortal lyne,
> How through the world Thy name doth shine;
> That hast of Thy unmatched glory
> Upon the heavns engrav'd Thy story.

Because Sidney was an Elizabethan poet, one could speculate on the one hand that Heath and Slowe had a love in common for this poet. On the other, Heath might have simply seen in Sidney's lines, an appropriate approbation for her friend, Lucy Slowe.

Joanna Houston Ransom

How does one speak or write coherently, consistently, and adequately about a life that had so many facets, such educational and spiritual depth, such warmth and concern for her people, such unfathomable resources for good, and such tireless devotion to any task at which she worked?[61]

※

In sum, these statements attest to Slowe's imprint. She was a woman with a mission—she knew where she was going, what she was doing, and why. She was not concerned about the personal cost. She moved forward despite the risks, always seeking to realize her vision: a finer womanhood.

Slowe was among the vanguard of women demanding full rights for participation in policymaking in community and national affairs. She

encountered major problems as she pursued her goals, but she would not be deterred. Few individuals are now aware of the activities of this remarkable woman, who was decades ahead of her time. In any significant movement, there are unsung heroes, those who make incredible sacrifices to initiate the activities essential for laying the enterprise's foundation. Lucy Diggs Slowe was such a person. She was a pioneer and a trailblazer whose mark was made through courage and determination.

The Highest Compliment

A stained glass window in Andrew Rankin Memorial Chapel on the campus of Howard University is dedicated to the memory of Lucy Diggs Slowe. Funds for the window were generated in 1943 when the Howard Women's Club of Washington, under the direction of Adeline Smith,[62] circulated a letter asking "each daughter of Howard" to contribute at least $1 to the Lucy Diggs Slowe Memorial Window.[63] This memorial was designed by the artist James A. Porter, the renowned Howard University Professor of Art. Porter's path might have crossed Dean Slowe's at two junctures. He had been a student at Howard during her deanship, graduating in 1927.[64] Earlier, he had completed high school work at Armstrong,[65] where Lucy Slowe had been a teacher. How fitting it was that he should be commissioned to design this lasting memorial.

The Porter design is crowned by a Grecian lamp created to reflect for American youth the "light of the setting suns." Its flame is symbolic of the Promethean fire that burns in the hearts of each generation, giving light to its pathway and high hopes for its adventure.

THIS WAS INDEED THE SPIRIT OF LUCY DIGGS SLOWE.

In 1986, recognition of the exceptional career of Lucy Slowe was on the program at the 70th anniversary convention of the National Association of Women Deans, Administrators, and Counselors (successor to NADW). Dr. Lucille Piggott, retired dean of students at North Carolina Agricultural and Technical College in Greensboro, North Carolina, was responsible for the presentation.

11

The Things One Keeps

Her Scrapbook

Just as the kinds of memorabilia one accumulates reveal much about an individual's ambitions, ideals and aspirations, so the items one collects disclose likes and dislikes, attitudes, and philosophy of life. According to Helfand, "The scrapbook was the original open-source technology, a unique form of self-expression that celebrated visual sampling, culture mixing, and the appropriation and redistribution of existing media. . . . Combining pictures, words, and a wealth of personal ephemera, the resulting works represent amateur yet stunningly authoritative examples of a peculiar strain of visual autobiography. . . ."[1] And, so it is with Lucy Slowe's scrapbook. The Manuscript Division of the Moorland-Spingarn Research Center at Howard University houses her scrapbook that covers the years 1926–1934. The collection begins with the first year of the presidency of Mordecai Wyatt Johnson and ends during Slowe's continuing effort to develop and maintain the concept of the dean of women as a professional person. Presented here is a review of that collection.

Most of the items in the Scrapbook are newspaper clippings, programs, and invitations. They focus on perceptions of life, international relations, racial discrimination, and news reports of her speeches, higher education, and women's activities.

Her Deep Thoughts

Beginning with a group of articles that reflect what seem to have influenced her deepest thoughts, one of the first clippings is titled "Defending Critics

We Despise"[2] by Glenn Frank, whose writings she especially liked. Frank was an American editor and educator born in 1887 in Queen City, Missouri. A graduate of Northwestern University, in 1925 he was appointed president of the University of Wisconsin, where he initiated the university's celebrated Experimental College and instituted changes in the teaching of agriculture.[3] In one of the Frank clippings, he wrote that

> Critics are the advance agents of progress. . . . This means, for the individual, that he must be sensitive to criticism without being touchy toward critics. . . . It means, for the nation, that we must realize that a man can, with entire consistency, defend the rights of a minority, although he differs from and despises its view. . . . It means, further, that we must realize that the safety as well as the progress of a nation depends upon our defending the right of a critic to criticize.[4]

In another, Frank wrote about what he called "The Adding Machine Soul," in which he raised the question of quality versus quantity for colleges and universities. "Are youth who are trained within its walls honest lovers of the truth? Do they acquit themselves with credit in public service? Have they the power of enjoying literature, music and art? Are they eager to enlarge their knowledge? Are they useful, courteous, cooperative citizens, in all relations of life?"[5] The points he made in raising these questions were identical to the ones Slowe championed repeatedly.

Slowe also subscribed to Harry Emerson Fosdick's views. Fosdick was pastor at the First Baptist Church in Montclair, New Jersey, from 1904 to 1915. At Union Theological Seminary, he was a lecturer on Baptist principles and homiletics beginning in 1915, and he was professor of practical theology. He also spent six years, starting in 1919, as associate minister at the First Presbyterian Church in New York. From 1929 to 1946, he served as pastor of the Park Avenue Baptist Church in New York City, which was later renamed Riverside Church.[6] A Fosdick sermon is the subject of one of Slowe's clippings.[7] He listed six tests of goodness—"the test of common sense, of sportsmanship, of one's best self, of publicity, of our most admired personality, and of foresight."

Slowe must have liked an article titled "One Woman's View: Youth Needs Its Dreams," in which the author pointed out that "Youth no longer has dreams of friendship and the endurance of love and that honor and not wealth is man's greatest possession and that there are certain precious things in existence that can not be bought with gold."[8]

An article from the *New York World*, "A Few Prophets Badly Needed Today," conveyed similar ideas. "The foundations of a sane and sound and wholesome society are neither industrial supremacy nor world-wide trade

nor hoarded wealth; they are personal honor, clean living, fearlessness in action, self-reliance, generosity of impulse, good fellowship, obedience to law, reverence and fear of God."[9]

The emphasis on a need for moral standards is clear in the recommendation for the establishment of summer camps for adults as "a means of enabling them to recapture the self-control, moral standards and qualities of leadership needed for the proper upbringing of their children."[10] These are qualities that Slowe considered essential for a meaningful life.

Regarding racial discrimination and the YMCA, Slowe kept a *Herald Tribune* piece reporting that the White Plains, New York, YMCA had dropped two African-American residents from the Board of the "Negro Branch" after they moved into a white section of the city. The YMCA declared that the men were retired, but the men charged neighborhood reprisals.[11]

Most of her clippings dealt with colleges and universities—their purposes, their faculty, and student life. One stated that

> [i]t is the university that must teach us, in its syntheses, higher than either physical science or the arts alone, what we can accomplish. Less than a school of philosophy, a university can not be and still be a university, and its philosophy must include the arts "which make for beauty" and the science "which makes for truth." So the two become one, art being "the true and happy science of the soul;" searching for spiritual influences as science for "comforting powers."[12]

Another piece echoed a related theme: "A college or university has a far greater responsibility for the social attitude and sense of obligation of its students, than for their intellectual development." The writer called for

> a return to the old-fashioned virtues—honesty, thrift, character, friendship, and an appreciation of beauty regardless of efficiency. . . . In the homes, the schools and colleges, the future must be assured by the return of instruction to the humanities of life and not exaggerated emphasis on the mechanistic and ruthlessly practical.[13]

Slowe kept articles about religion on college campuses, specifically at Syracuse University and Lehigh University in Bethlehem, Pennsylvania.[14] She might have known that Lehigh's mission was to educate young people who could combine practical skills with theory, judgment, reasoning, and self-discipline: traits that she admired.[15] Moreover, she might have known that the Methodist Episcopal Church led to the chartering of Syracuse.[16]

Dean Virginia C. Gildersleeve of Barnard College was quoted in a clipping as saying that "The greatest need in education today is the development of the character and wisdom of man."[17]

Scrapbook articles about student issues of the day include one in which the president of Bennington College raised questions of student freedom in matters of speech, publication, and assembly. He maintained that oppressive devices do not suppress. "I am arguing only for the wisdom of recognizing free student speech, publication and assembly, as an agency of sound education and as a policy of administrative prudence."[18]

Students at St. Augustine's College in Raleigh, North Carolina—a school founded by prominent Episcopal clergy for the education of freed slaves,[19] walked out of the dining room on the grounds that the dietician was suffering from a contagious disease. No college rules were broken; this action showed the effectiveness of the silent demonstration method.[20]

The next three clippings reflect Slowe's interest in the intellectual and moral development of students. *The New York Herald Tribune* carried an article on November 8, 1931, that Syracuse University had expanded a tutor-adviser plan.[21] According to the *New York Times*, Harvard freshmen were to be greeted early, with receptions and conferences.[22] The *New York Times*, November 27, carried an article that the chapter house tutor system at Cornell University "promotes scholarship, creates a better cultured and moral atmosphere and results in better intellectual attitudes."[23] Yet her Scrapbook also contained articles about college and university admission policies, coeducation, student loans, fraternities and sororities, dormitories, curfews, and student activities.

Although it might be guessed that her major concern was students, she also paid attention to faculty issues. She kept a July 29, 1931, article about an attack on tenure and the emphasis on research in universities by a former president of the University of Michigan;[24] the faculty controversy on prohibition at Dartmouth;[25] an April 20, 1932, student newspaper's request for less emphasis on research and more on teaching;[26] and the appointment of an individual without a degree as dean at Johns Hopkins University.[27]

It is no surprise that the Scrapbook included pieces about African Americans. The Pastor of the Community Church of New York—apparently John Haynes Holmes—in an address before the NAACP Convention, declared that the future belongs to the "colored race." "The passing of the long supremacy of the white man and the rise of the "colored race" to a position of full equality and dignity with their fellows—this constitutes the outstanding world event of our age." There follows a description of changes affecting the non-white peoples. "The colored peoples throughout the world are destined to be free and thus to enter at last upon their heritage."[28] Some regard Holmes as the greatest multitalented minister of religion of

the twentieth century: pacifist, orator, churchman, social service organizer, racial and social justice pioneer, pastor, adult educator, political participant and leader, poet and philosopher, all at once![29]

Other news releases refer to Howard University. *The Afro-American* on February 27, 1934, reported on the DePriest Amendment requiring Howard University to return funds if the School of Engineering were abolished.[30] The May 13, 1933, edition reported on the dissolution of the College of Education and the change of the School of Religion to a Graduate School.[31] *The Washington Tribune* on April 24, 1937, noted the Vocational Guidance Conference for Women at Howard, with Ambrose Caliver, specialist in the U.S. Office of Education in the education of African Americans, as keynote speaker.[32]

There is only one reference to President Mordecai Wyatt Johnson. It is the report of a dinner held in Chicago for President Johnson at the Wabash Avenue YMCA, a major social and educational center in the center of Chicago's African-American culture in the early 1900s.[33] Of the 150 guests, only three alumni were present. After two hours, "President Johnson and four other individuals retired to a corner for a 'chew and chat.' Johnson discussed the Congressional Appropriation for Howard, but refused to comment on DePriest's statement that communism existed on Howard's campus."[34]

Several articles focus on women. Mrs. Ogden Reid, a graduate of Barnard College, was Chairman of the Board of *The New York Herald Tribune*.[35] She spoke before the Women's Intercollegiate News Association at Barnard College, urging women to seek top positions in the newspaper field. According to the *New York Times* of December 11, 1932, she said,

> Do not try for subordinate positions alone and do not be content to stop along the way. Women in the past have not tried hard enough to project themselves to the top jobs and as a result have kept an atmosphere of inferiority. . . . There is a tremendous need for women in newspaper work. . . . College women might even take up the mechanical side of publishing, there is a definite field for the woman typesetter. . . . It is the force of women on public opinion that has changed the pattern of the newspaper today, making news more human and more interesting then ever before.[36]

A clipping about a speech delivered at an American Women's Association Conference stresses the need for women to assume a leadership role for economic recovery. "The women of today must plan for the future with courage, with intelligence, with initiative. But we must remember that we must not let this new world we are coming into be based only on economic returns."[37]

There are no items in the scrapbook from the last three years of Slowe's life, the years when she was most active nationally. As the items collected used only two-thirds of the book, one might assume that one of the reasons for no late listings was the fast-paced life she was leading.

This summary of Slowe's Scrapbook reveals a woman with a wide range of interests and activities, a person with genuine and intensive concern for the individual regardless of sex, age, race, social class or religion, and a leader who pleaded with women to become involved in community and national affairs. Her parameters were sound moral and spiritual principles. Because she insisted that college graduates be prepared to assume leadership roles equipped with the knowledge, skills, understandings, and attitudes that would assure the effectiveness of their activities, she collected articles that addressed college and university policies and practices regardless of whether they concerned students directly. She was convinced that all facets of a university must function as a whole for the proper development of its graduates. Above all, she was an avid reader.

12

Conclusion

Be strong!

Lucy Diggs Slowe was a woman of numerous and diverse talents who in the early decades of the twentieth century, became a legend in educational, social service, community, sports, and world affairs. Despite many challenges—including white racism and male chauvinism—she engaged in unrelenting efforts to elevate the standing of women in higher education and to give an authoritative voice to the social and educational conditions of African Americans. She rose to become a leader of African-American women, and a leader in the field of student personnel administration. If she were to be epitomized, the two labels that would best describe her would be "pioneer" and "strong;" "pioneer" to characterize her determination to work her way through college despite the fact that it was not popular among girls, and "strong" to recall the poem mentioned in her eulogy—the poem she insisted that her pupils learn.

By ordinary standards, she would not have been expected to go far in life. She was born in the aftermath of the Civil War in the state of Virginia where all sorts of factors were stacked against her: orphaned at age six, consigned to a status of inferiority because of her race, relegated to a substandard educational system, and possessed with a strong streak of obstinacy. Instead of letting these negative characteristics hold her back, she overcame them and—as if by an unexplained force—became a leader in nearly everything she touched. She graduated from both high school and college with honors. She helped to bring into being a sorority for African-American women where there had been none. Playing tennis, she became the first African-American woman champion in any sport. She created the first junior high school for African-American children in the District of

Columbia. She paved the way for African-American women administrators in American higher education when she occupied the position of the first Dean of Women at Howard University. This little girl from Berryville, Virginia, grew up to preside over the founding of the National Association of Dean and Advisors to Girls in Colored Schools, to lead the National Association of College Women, to lecture at Teachers College Columbia University, and to create the women's campus at Howard University. Her life was so extraordinary that the federal government named a building after her, as did the public school system of the District of Columbia. Her life story is at once unbelievable and an inspiration.

What shaped her? She was fortunate in having an aunt who raised her to believe in family, in education, and in Christian teachings, and who held on to this little obstreperous girl until she became a woman. In addition to Aunt Martha, she had powerful mentors. The importance of pioneering and trailblazing became a part of her early life. There is no question that she grew up learning about people like Frederick Douglass, W. E. B. Du Bois, Sojourner Truth, and Booker T. Washington. Maturing in Lexington, Virginia, Baltimore, Maryland, and Washington, DC, she was immersed in powerful efforts designed for African-American uplift. Unfortunate and underprivileged citizens were the recipients of help not only from churches but also from the growing number of women's charitable organizations. During her childhood the quest for education was almost an African-American obsession for it promised to enable them to escape the humiliation brought about by racial segregation and discrimination. It is not surprising that working her way through college posed no problem for her. The importance of becoming socially self-sufficient loomed large. She responded positively to life at a university that was regarded as the "Capstone of Negro Education." That institution was replete with celebrated thinkers who groomed her to excel and to lead. She attended the Presbyterian Church—although as a child she railed against church-going—and sang in the choir. Later she earned a master's degree in French bourgeoisie literature. All of these encounters—combined—formed her as a human being with a distinctive outlook on life.

With respect to her thoughts about the plight of African Americans, she was devoted to W. E. B. Du Bois's ideas. She believed that, if racial discrimination were to be eradicated and the ends of democracy to be achieved, it would be imperative for white people and African Americans to work together. She held that segregation in the schools had to be eliminated, for it alone created hatred. She lamented that prejudice was detrimental to both white people and African Americans. In later years, she would refine her views to suggest that the onus was upon communities to lead in improving the status of African Americans. She argued that because economics was the key to freedom, African Americans had to be trained in financial matters, and she urged her people to make monetary sacrifices for their freedom.

She believed that people should let the tenets of the Christian faith be their guide. Deep down in her heart, she knew that character education was essential. Early on, she accompanied her call for high moral values with a scornful suspicion of indolence. Thus, she focused on cultural experience and the use of leisure time. Not only should African Americans be prepared for the worthy use of leisure, which is so essential for the well-being of individuals but, as she argued, they must also be given opportunities for enlightening experiences.

Dean of Women Lucy Diggs Slowe was—what in educational parlance of the early 1920s was known as—a student personnel worker. (Rather than student personnel work, the profession is currently labeled "student affairs.") It was her career in this field that Marion Thompson Wright planned to write about. Although Carroll L. L. Miller sought to enlarge Wright's scope by examining the wider ranging aspects of Slowe's life, being a student personnel worker was undeniably one of her defining characteristics.

Regarding her profession, she was convinced that a dean of women should be a well-trained, experienced educator with a broad outlook on the world and its problems. A dean should serve as liaison between the faculty, the women students, and the administration, and give advice on the education of women. Moreover, she must love life, and she must inspire young women to develop an integrated personality so that they could be prepared to play significant roles in life. She understood the founding principles of student personnel work—that the dean's work with students should be based on a belief in the individual—that each person has worth; that each must be respected; and that each, regardless of race, must have equal opportunity to develop. Epitomizing the characteristics of early student personnel people,[1] her philosophy and approach were pivotal in setting the tone for the work of women deans in coeducational colleges and universities, both African American and predominantly white.

Research on the characteristics of student personnel workers who might have held office when Slowe was a dean identified motivations to enter the work as the opportunity to work with college-age students and interest in making a significant contribution to society. An idea espoused more and more by persons who entered this field in years gone by held that the social good is promoted to the extent that each individual is allowed to develop. This suggests that student personnel practitioners—like Slowe— must have believed they are engaged in work of considerable social import. They understood their role to be one of serving the humanizing needs that higher education originally called upon student personnel work to meet. Their satisfactions derived from the opportunity to help students develop to their fullest.[2] It appears that Slowe found the perfect fit.

Taking part in the African-American women's club movement, she issued what might be regarded as a manifesto on college education. She

argued that the ultimate goal should be preparation for leadership. College coursework should include not only the liberal arts but, even more essential, the social sciences, sociology, economics, political science, the environment, and rural and urban life as well.

Consistent with the opportunities afforded by working in the student personnel field, the issue Slowe sensed most deeply and on which she worked tirelessly was the education and roles of African-American women. She insisted on high-quality education and—among women—unity and interracial cooperation. She maintained that young women be educated to participate fully in democracy. Their education had to take place both inside and outside the classroom if they were to learn civic responsibility. Women were obligated to assume leadership roles in their communities and the nation in order to, first, reverse the trend toward the deterioration of the status of African Americans and, second, become an integral part of this democracy. It was only through self-government and self-control that African-American college women could develop the will to be responsible citizens.

To say the least, Slowe's relationship with Howard University President Mordecai Johnson was discordant. It qualifies as one of the most blatant examples of sexism that has been recorded in the annals of higher education administration. Where she pushed for the authority and status demanded by her position, he and the Board of Trustees tried to push her back into the prevailing subjugated position women of that time were expected to hold, that is, to be seen but not heard—to be passive rather than self-assertive. That girls at Howard should be on an equal footing with the boys was just as heretical to the university administration as was the respect for women. Even her disputes with a male faculty member accused of sexually inappropriate teaching style in the presence of young women was minimized. Despite such an administrative culture, she continued on doggedly, helping to pave the way for more positive experience for African-American women administrators.

Slowe's leadership style conforms most clearly to what has been characterized as a social justice model.[3] She seemed to interpret her role as a spiritual vocation that serves the greater good and one that provides students with the moral and social assistance needed to ensure their success.

Among the tangible legacies she left are the three women's residence halls she established at Howard University—Truth, Crandall, and Frazier. They have become—with the addition of Baldwin and Wheatley Halls—the foundation for what is now the Harriet Tubman Quadrangle—a group of five residence halls. The "Quad" houses approximately 640 freshmen women students.[4] The Lucy Diggs Slowe Hall, the residence hall constructed by the federal government and given to Howard University, is a coeducational residence hall housing approximately 300 students.[5] The Howard University School of Social Work, of which Slowe was a "strong advocate," is now an

autonomous professional school, offering the master's and doctoral degrees.[6] The School has a history of "eradicating social injustice both inside and outside of the profession."[7] The Greek-letter organization for which she drafted the initial set of bylaws—Alpha Kappa Alpha Sorority—celebrated its 100th anniversary in 2008. With a membership of more than 200,000, it has undergraduate chapters in colleges all over the United States, and graduate chapters in several foreign countries. Lucy Slowe would be proud of its signature program initiatives that address leadership, health, human rights, social justice, and global poverty, and its Educational Advancement Foundation that was designed to enable them always to have funds to assist individuals who aspire to further their education.[8] The Lucy Slowe Elementary School property is now occupied by the Mary McLeod Bethune Public Charter School in the District of Columbia.[9]

The poem Lucy Diggs Slowe was heard teaching her students in an English class was the first verse of Babcock's[10, 11] poem titled "Be Strong:"

> Be strong!
> We are not here to play, to dream, to drift;
> We have hard work to do, and loads to lift;
> Shun not the struggle, face it 'tis God's gift.

The remainder of the poem epitomizes her entire life:

> Be strong!
> Say not the days are evil—who's to blame?
> And fold the hands and acquiesce—O shame!
> Stand up, speak out, and bravely, in God's name.
> Be strong, be strong, be strong!
> Be Strong!
> It matters not how deep entrenched the wrong,
> How hard the battle goes, the day, how long;
> Faint not, fight on! Tomorrow comes the song.
> Be strong, be strong, be strong!

As Babcock ended his poem, so Slowe came to the end of her life. She did not faint. She fought on, or as Aunt Martha said to her when she was a child, "Only lazy people rest before their work is done."

She was endowed with family, with mentors, with ability; she was endowed with determination and, perhaps most important, she was endowed with courage to complete the tasks at hand.

32. Stained glass window honoring Lucy Diggs Slowe in Andrew Rankin Chapel, Howard University. This memorial was designed by the artist James A. Porter, the renowned Howard University Professor of Art. (Source: Personal Collection: Anne S. Pruitt-Logan)

33. Lucy Slowe wearing a string of pearls. The last known photograph of Lucy Slowe, taken circa 1936. This is how she looked at the time of her death. (Source: Moorland-Spingarn Research Center, Howard University)

Notes

Preface

1. Finally published in three volumes: Edward T. James, Janet Wilson James, and Paul S. Boyer, eds., *Notable American Women 1607–1950: A Biographical Dictionary* (Cambridge, MA: Belknap Press of Harvard University Press, 1971). See "Slowe, Lucy Diggs," 299–300.

2. Walter G. Daniel. "A Tribute to Marion Thompson Wright: A Valedictory Note," *The Journal of Negro Education* 32 (1963): 308–310.

Chapter 1

1. Lucy D. Slowe, Information concerning Lucy's early life is limited. However, three papers she wrote as class assignments at Columbia University reflect incidents in her early life. Mary P. Burrill, Lucy Slowe's friend, wrote: "These sketches were personal experiences in the life of Dean Slowe. They were written as exercises in Composition, Columbia University, July 27, 1917." Lucy Diggs Slowe Papers. Box 90, Folder 1; Manuscript Division, Moorland-Spingarn Research Center, Howard University.

2. Slow, without the "e," is the early spelling of the family name. Marriage records and census data show the spelling of the family name to be "Slow." It is not known when the "e" was added to create the spelling "Slowe."

3. Death notice appeared 4-17-1884 in a Clarke Co. newspaper; taken from a compilation of abstracts. "Died Sat pneumonia; mail carrier between PO and RR depot. Slow, Henry (colored) well known . . . son John survives." Mary Thomason Morris. *Connections and Partings: Abstracts of Marriage, divorce, death, and Legal Notices from Clarke County, Virginia, Newspapers 1857 through 1884*. Athens, GA: Iberian Publishing Co. 1992.

4. Don and Mary Royston, *Cemeteries of Clarke County Virginia*. Athens: New Papyrus Publishing. Courtesy Barbara Dickson, Archives Assistant, Stewart Bell Jr. Archives Room, Handley Regional Library, Winchester-Frederick County Historical Society. This document shows that Henry Slowe was born in 1824 and died in 1884. His wife, Fanny, was born in 1842 and died in 1889. Also buried there are two daughters, Martha and Mary, who were born in 1873. Mary lived one year and her sister passed away the following year. Information authenticated: Cemetery,

352 Notes to Chapter 1

located in Josephine City—part of Berryville—visited by Anne S. Pruitt-Logan, October 26, 2010.

5. Ancestry.com—Clarke County, Virginia Births, 1878–96, p. 1. http://search.ancestry.com/cgi-bin/sse.d11?db = clarkeval878&gsfn = &gsln = slow&gsco = 2%2cUnited+States. Additional source: Notary's Affidavit, United States of America, County of Philadelphia, ss. BE IT KNOWN, That on the day of the date hereof, before me, the undersigned, a Notary Public, for the Commonwealth of Pennsylvania, residing in the City of Philadelphia, personally appeared Nellie Slowe Hawkes who being duly sworn, according to law, did depose and say, that her sister, Lucy Diggs Slowe, was born July 4, 1883 at Berryville, Clark County, Virginia. Signed—Nellie Slowe Hawkes, 62—N 36th St, Phila., PA. Sworn and subscribed before me this 2nd day of August A.D. 1932. John W. Harris, Jr., Notary Public, My commission expires Feb. 4th, 1933." Lucy Diggs Slowe Papers. Box 90-1, Folder 1; Manuscript Division, Moorland-Spingarn Research Center, Howard University.

6. It is not known when the middle name "Diggs" was inserted into Lucy Slowe's name. Her papers contain a book titled *Chilham Castle. B.C. 55–A.S. 1916*. This book was sent to Dean Slowe by a white woman of Virginia—a Miss Helen Pendleton—who claimed that Dean Slowe was a descendant of her family, and that her family was a branch of the Digges family of England. Sir Dudley Digges, Master of the Rolls under King James I built the modern mansion of Chilham Castle, A.D. 1616. Lucy Diggs Slowe Papers. Box 1, Folder Biographical Data 1; Manuscript Division, Moorland-Spingarn Research Center, Howard University.

7. Charlotte Slowe's obituary, February 1937. Lucy Diggs Slowe Papers. Box 90-1, Folder 21; Manuscript Division, Moorland-Spingarn Research Center, Howard University.

8. Dee A. Buck, *Marriages Clarke County, Virginia 1865–1890*.Athens: Iberian Publishing Co., 1994. "Slow, Henry, 42 years of age, single, born in Louisa Co, VA, living in Clarke Co, VA, Restaurant Keeper, parents David & Penny Slow, married on 15 Jan 1867 in Berryville, VA to Fannie Potter, 22 years of age, single, born & living in Clarke Co, VA, parents George & Ann Potter, African-American Couple."

9. Rockbridge County Births, 1853–1877, abstracted by Dorthie and Edwin Kirkpatrick, Athens, GA: Iberian Publishing Co, 1992.

10. Marion Thompson Wright papers (hereafter MTW). Coralie Cook's description of Lucy Slowe's reminiscences of her childhood.

11. MTW papers. Coralie Cook's recollections of Lucy's conversations at Howard University.

12. "S.S.Class" might refer to Sabbath School. A biography of Stonewall Jackson notes that he was a "church deacon, a Sabbath-school teacher." http://www.Southern Heritage411.com/truehistory.php?th = 066.

13. http://www.vmi.edu/archives/archivephotos/Search.asp.

14. Louis R. Harlan, *Separate and Unequal: Public School Campaigns and Racism in the Southern Seaboard States 1901–1915*. (New York: Atheneum, 1969), 137.

15. Theodore C. DeLaney, Jr. "Aspects of Black Religious and Educational Development in Lexington, Virginia, 1840–1928," *Proceedings, Rockbridge Historical*

Society, 10 (1980–89): no page number. In 1872 the Randolph Street school had been deeded to a board of trustees "for the colored people" of Lexington, and the Town of Lexington rented it for a modest sum.

16. Evidently she received no credit for being ahead of the others.

17. See note 1 above.

18. U.S. Census Bureau, Population of the United States in 1880. (Washington, DC: Government Printing Office, 1884) Lexington, Rockbridge, VA. Born about 1873, mulatto. Listed as being in school.

19. Strabismus or tropia are the medical terms for eye conditions commonly called by various names: eye turns, crossed eyes, cross-eyed, wall-eyes, wandering eyes, deviating eye, etc.

http.www.strabismus.org/strabismus_crossed_eyes.html.

20. Lerone Bennett, Before *the Mayflower: A History of Black America*. (Chicago: Johnson, 1969), 240.

21. Theodore DeLaney, no page number.

22. Slowe, ibid.

23. Although the community wanted a high school for African Americans, one would not open until 1899. DeLaney, ibid.

24. Bennett, *Before the Mayflower*, 184.

25. Harlan, *Separate and Unequal*, 3.

26. John H. Franklin. *From Slavery to Freedom: A History of Negro Americans*. 4th ed. (New York: Knopf, 1974) 57.

27. Ibid., 54.

28. Ibid., 234.

29. http://www.pbs.org000_About/002_03_h-godeeper.htm.

30. Franklin, 275.

31. Bennett, *Before the Mayflower*, 240.

32. Ibid., 240–241.

33. New Perspectives on the West: Events in the West, 1883. http://www.pbs.orgthewest/events/1880_1890.htm.

34. www.historyplace.com/speeches/dpuglass.htm.

35. MTW Papers. Coralie Cook on Lucy Slowe's reminiscences of Lexington.

36. http://pages.baltimorecounty.com/history.htm.

37. Franklin, *From Slavery to Freedom*, 319.

38. Oberlin College Archives. Celebrating 175 Years of African American Heritage at Oberlin College. http://www.oberlin.edu/accept/oberlin_history.html.

39. Franklin, *From Slavery to Freedom*, 421.

40. U.S. Census Bureau, Population of the United States. Twelfth Census of the United States, Schedule No. 1—Population, June 5, 1900 the family resided at 1116 Division St., Baltimore, MD. In 1929–30, the census shows that the family resided at 252 Robert Street, Baltimore, MD.

41. MTW interview.

42. Franklin, *From Slavery to Freedom*, 320.

43. Ibid.

44. Rayford W. Logan, *Howard University: The First Hundred Years. 1867–1967* (New York: New York University Press, 1969), 94.

45. Pratt Library. http://www.prattLibrary.org/locationsindex.aspx?id = 4448.
46. http://womhisst.binghamton.edu/bywca/intro.htm.
47. *Afro-American Ledger*, September 28, 1901.
48. Ibid., September 20, 1902.
49. MTW papers, 8.
50. Several years later, Alethea H. Washington and Dwight O. W. Holmes—both having earned doctorate degrees—would be colleagues with Professor Lucy Slowe at Howard University.
51. Logan, *Howard University*, 134.
52. Maryland State Archives. http:www.mdarchives.state.md.us/megafile speccol/sc2900/sc2908/000001/000516.
53. Sunday Schools, or Sabbath Schools, as Thomas J. (General "Stonewall") Jackson called them, had been organized to teach the gospel to slaves and later ex-slaves. DeLaney, ibid.
54. Ibid.
55. MTW papers, 8.
56. Kingwood College Library. http://kclibrary.nhmccd.edu/19thcentury1890.htm.
57. MTW papers, 9.
58. Dwight O. W. Holmes, "Eulogy: In Memoriam," (October 25, 1937) 11.
59. Interpretation suggested by William H. Chafe, *Private Lives/Public Consequences: Personality and Politics in Modern America* (Cambridge, MA: Harvard University Press) 2005.

Chapter 2

1. *Afro-American Ledger* (Baltimore), 12, no. 43, June 25, 1904.
2. Ernest T. Pascarelli and Patrick T. Terenzini. *How College Affects Students: Findings and Insights from Twenty Years of Research*. (San Francisco: Jossey-Bass, 1991), 60.
3. Rayford W. Logan, *Howard University: The First Hundred Years*. (New York: New York University Press 1969), 28.
4. Duke Ellington's Washington. http://www.pbs.org/ellingtonsdc/vtScjools.htm.
5. Logan, ibid., 14.
6. Ibid.
7. Walter Dyson, *Howard University: The Capstone of Negro Education, A History: 1867–40*. (Washington, DC: The Graduate School, Howard University, 1941), 442.
8. Rolfe Cobleigh, "A New Day for Howard University: Progress and Needs of a Great University." *The Congregationalist*, July 27, 1922, 108.
9. Ibid., 109.
10. Logan, ibid., 14.
11. Ibid., 140.
12. Ibid.
13. Ibid., 112.

14. Ibid., 95.
15. Ibid., 143.
16. *First Hundred Years*.
17. David L. Lewis, *W. E. B. Du Bois 1868–1919: Biography of a Race* (NY: Holt, 1993) 317.
18. Logan, ibid., 139.
19. Ibid., 140.
20. *Howard University Journal*, September 28, 1906.
21. Logan, ibid., 32–33.
22. Library of Congress, Manuscript Division. http://memory.loc.gov/ammem/awhhtml/awmss5/afro_amer_schools.html.
23. Ethel H. Lyle. "Sorority's Dramatic, Historical Highlights." *Ivy Leaf* (1948). 33, cited in Earnestine G. McNealey, *Pearls of Service: The Legacy of America's First Black Sorority, Alpha Kappa Alpha* (Chicago, IL: Alpha Kappa Alpha Sorority, Inc., 2006) 17.
24. Meyer Weinberg, *A Chance to Learn: The History of Race and Education in the United States*. (Cambridge: Cambridge University Press, 1977) 323.
25. Ibid., 323, quoting John P. Davis, "Unrest in the Negro Colleges," *New Student*, 8 (January 1929) 14.
26. Logan, ibid., 165.
27. 1906–1912.
28. Logan, ibid., 111–112.
29. Ibid., 127.
30. Ibid., 112.
31. NAACP. Black Studies Research Sources. http://www.lexisnexis.com/documents/academic/upa_cis/1448_PapersNAACPPart16SerA.pdf
32. Lewis, ibid., 530.
33. Gwendolyn Etter-Lewis, "Baha'i Faith," in *Black Women in America: An Historical Encyclopedia*, eds. Darlene C. Hine, Elsa B. Brown and Rosalyn Terborg-Penn, 63 (Bloomington: Indiana University Press, 1993) 1:63.
34. *University Journal*, March 30, 1906.
35. Logan, ibid., 111–112.
36. Ibid., 145.
37. The Free Resource: Timeline of the History of Woman in Sports (1406–2010). http://www.thefreeresource.com/timeline-of-the-history-of-woman-in-sports-1406-2010.
38. Sean Lahman, Baseball Archive. http://www.baseball1.com/baseball-archive.
39. About.com. Women and Tennis in America. http://www.womenshistory.about.comtenniswomen_tennis.htm.
40. D. Margaret Costa and Jane A. Adair, "Sports," in *Black Women in America: An Historical Encyclopedia*, ed. Hine et al., ibid., 1099.
41. David L. Lewis. An "Aristocracy of Color." American Experience, America 1900. http://www.pbs.orgamexfilmmore/reference/interview/lewis_aristocracyofcolor.html.
42. Logan, ibid., 172.
43. *First Hundred Years*.
44. Logan, ibid., 124.

45. Ibid., 215.
46. Ibid., 173.
47. Ibid., 95.
48. *First Hundred Years.*
49. *Hilltop*, December 11, 1930.
50. The Free Dictionary. Chrisitan Endeavor, Young People's Society of. http://www.thefreedictionary.com/Christian%20Endeavor,%20Young%20People's%20Soci.
51. *University Journal*, January 4, 1907.
52. *University Journal*, December 6, 1907.
53. *University Journal*, February 1, 1907.
54. Logan, ibid., 151.
55. *University Journal*, November 30, 1906.
56. Logan, ibid., 150.
57. *University Journal*, January 14, 1907.
58. *University Journal*, March 25, 1908.
59. *University Journal*, March 30, 1906.
60. Logan, ibid., 150.
61. *University Journal*, Howard University, March 30, 1906.
62. Margaret F. Holmes, "Our Founders in Retrospect—by One of Them," *Ivy Leaf*, 6, no.4, (Nov 1928) 37.
63. Holmes, ibid.
64. McNealey, ibid., 21.
65. Ibid.
66. McNealey, ibid., 23.
67. Marjorie Parker, *Alpha Kappa Alpha Through the Years—1908–1988* (Chicago: Mobium, 1990) 10–11.
68. Anna E. Brown, "A Brief History of the Founding of Alpha Kappa Alpha," typewritten. AKA Archives, Moorland-Spingarn Research Center, Howard University.
69. McNealey, Ibid., 18.
70. *University Journal*, May 10, 1908.
71. MTW notes.
72. Also known as the National School of Elocution and Oratory and the Shoemaker School of Oratory.
73. New York Life: The History of Jim Crow: Women and Jim Crow: Virginia. http://www.jimcrowhistory.org/scripts/jimcrow/women.cgi?state = Virginia
74. Etter-Lewis, ibid.
75. MTW papers. Coralie Cook's recollections of Lucy's conversations at Howard University.
76. Patricia H. Collins, "Feminism in the Twentieth Century" in *Black Women in America: An Historical Encyclopedia*, ed. Hine et al. (Bloomington: Indiana University Press, 1994) 1:419.
77. Mary L. Grimes, "Re-constructing the Leadership Model of Social Justice for African-American Women in Education." *Advancing Women in Leadership Online Journal*, 19, fall 2005. http://216.239.51.104/search?q = cache:Hqy35KKVrJ4J:www.advancingwomen.com/awlfall2005/19_7.html.
78. Gwendolyn Etter-Lewis, "Baha'i Faith," in *Black Women In America: An Historical Encyclopedia*, ed. Hine et al., ibid., 63–64.

79. Ibid.
80. MTW papers. Manuscript submitted by Vivian Cook to Marion Thompson Wright, 29–30.
81. Vivian Johnson Cook Papers. Box 191-19, Folder 4; Manuscript Division, Moorland-Spingarn Research Center, Howard University.

Chapter 3

1. MTW Notes, typewritten, 20.
2. Memorandum to Miss Beatrice Clark, May 22, 1936. Lucy Diggs Slowe Papers. Box 90-1, Folder 1; Correspondence. Manuscript Division, Moorland-Spingarn Research Center, Howard University.
3. Long Star College-Kingwood Library. American Cultural History: The Twentieth Century. http://kclibrary.nhmccd.edudecade00.html.
4. MTW Papers. Wright talked with some of Slowe's pupils who revealed their views of Slowe:

> A teacher of superior excellence who was earnest in approach, purposeful in action and dedicated in spirit.
>
> The principles she advanced—she practiced. The standards she set, she maintained. What she taught her pupils learned: to study, to value knowledge, to transfer learning to effective and cultural expressions.
>
> A strict disciplinarian. . . . Her pupils were motivated to do their assignments.
>
> Her pupils for the most part, came to class with their work prepared and made few attempts to fake their way through. They were stimulated to want to study.
>
> Tall, stern (sic) stature. . . . When instruction began, the sternness faded and they found her to be a patient, understanding teacher who was very competent and thorough with a keen sense of humor.
>
> A lady of the first order in teaching . . . the epitome of poise, exactitude and forbearance.
>
> Her examples of leadership, her unquestioned integrity, her sincerity, and her untiring devotion in bringing wisdom and clarity of understanding to her work made their impact upon students.
>
> Inspired us to achieve well that we may find diligence in goodness of behavior and thus bring forth a competent Christian Life.
>
> Created high quality desires in my work: desires to develop the ability to think clearly, to practice courtesy and to maintain cleanliness in mind and body.

Impressive examples Miss Slowe set: to read well, to try to communicate ideas with clear and concise written and vocal expression as becomes one living in a democracy such as America.

5. Twelfth Census of the United States, Baltimore, Maryland, 6th precinct, June 1900.

Notes to Chapter 3

6. Fourteenth Census of the United States: 1920-Population, Baltimore City, Ward 14. http://content.ancestry.com/Browse/pring_u.aspx?dbid = 6061&iid = MDT625_663-1100.

7. This quest for education was shared by her sister Charlotte, who studied at Hampton Institute, Columbia University and the University of Pennsylvania. Charlotte E. Slowe's obituary, typewritten. Lucy Slowe Papers. Box 90-1, Folder 21; Manuscript Division, Moorland-Spingarn Research Center, Howard University.

8. Meyer Weinberg, *A Chance to Learn: The History of Race and Education in the United States*. (Cambridge: Cambridge University Press, 1977), 290.

9. E-mail to Anne S. Pruitt-Logan from Megan A. Hibbitts, archivist, Columbia University Archives and Columbiana Library, October 12, 2005.

10. E-mail to Richard Weibl from Bill W. Santin, Columbia University, Transcripts Dept. Oct. 4, 2005.

11. http://www.enotes.com/barber-seville/28329.

12. Catherine Johnson, "Dykes, Eva Beatrice (1893–1986)" in *Black Women In America: An Historical Encyclopedia*, ed. Hine et al., ibid., 2:372; Catherine Johnson, "Simpson, Georgiana (1866–1944)" in Hine et al., ibid., 2:1039.

13. "Aristocrats of color" is a term used to describe class in America by Willard B. Gatewood, Jr., "Aristocrats of Color: South and North. The Black Elite, 1880–1920." *Journal of Southern History*, 54, No. 1, (Feb, 1988): 1.

14. Gatewood, ibid., 13–14.

15. Rayford W. Logan and Michael R. Winston. *Dictionary of American Negro Biography* (New York: Norton, 1983), 560; Linda M. Perkins, in *American National Biography*, 20, ed. J. A. Garraty and M. C. Carnes, 110 (New York: Oxford University Press, 1999).

16. http://www.answers.com/topic/edmond-hoyle

17. MTW Papers, typewritten, 24. Odd Fellows Hall was owned by the fraternal organization of the same name. Located on Cathedral Street in Baltimore.

18. MTW notes.

19. http://www.blackpressusa.com/history/Article_Archive.asp?week = 35& Article = 1&NewsI.

20. The Du Bois Circle celebrated its 100th anniversary in 2006. Per Anne Davis, for president, telephone interview, 111.

21. *Baltimore City Paper*. Tom Chalkley. Charmed Life: Circle Unbroken. http://www2.citypaper.comstory.asp?id = 2328.

22. David L. Lewis, *W. E. B. Du Bois: Biography of a Race: 1868–1919*. (New York: Holt, 1993) 43.

23. Franklin, ibid., 328.

24. Ibid., 129.

25. Lerone Bennett, Jr., *Before the Mayflower: A History of Black America*. 4th ed. (Chicago: Johnson, 1969), 28.

26. Ibid.

27. David L. Lewis: An "Aristocracy of Color." American Experience, America 1900. http://www.pbs.orgamexfilmmore/reference/interviews/lewis_aristocracyofcolor.html.

28. David L. Lewis, *W. E. B. Du Bois: Biography of a Race: 1868–1919*. (New York: Holt, 1993) 468.

29. Cited in Lewis, ibid., 201.

30. Ibid., 418.
31. Women's International Center. Women's History in America. http://www.wic.orghistory.htm.
32. Upper-class African Americans are reported to have favored the Du Bois camp, according to Gatewood, ibid., 16.
33. Maryland State Archives. Baltimore NAACP. http://www.mdarchives.state.md.us/megafilespeccol/sc2900/sc2908/0000.
34. *Afro-American*, October 24, 1915.
35. Lewis, ibid., 418.
36. *Afro-American*, November 8, 1915.
37. E-mail from Bill W. Santin, Columbia University, Transcripts Dept. to Richard Weibl, Oct. 4, 2005.
38. Ibid.
39. The formal name of the school was Armstrong Manual Training High School.
40. MTW papers, 47.
41. Logan, ibid., 179.
42. Franklin, ibid., 334–5.
43. Women enews.org. http://www.womenenews.org/article.cfmaidcontext/archive.
44. Franklin, ibid., 357.
45. Johnson is the author of "Lift Every Voice and Sing," known as the Negro National Anthem.
46. Logan, ibid., 188.
47. Information about Washington in the next 4 pages PBS. Duke Ellington's Washington: Other Land Marks. http://www.pbs.org/ellingtonsdc/vtOtherLandMarks.htm.
48. http://www.pbs.org/ellingtonsdc/vtDChistory.htm.
49. Moorland was one of two African-American international secretaries of the YMCA Colored Men's Department who had led fund-raising campaigns for $100,000 buildings in Chicago, Washington and Philadelphia. Bundles, A'lelia. *On Her Own Ground: The Life and Times of Madam C. J. Walker.* (New York: Washington Square, 2001), 112.
50. Sam Smith, A Short History of Black Washington: Progressive Review. http://prorev.com/dcblackhist.htm.
51. Paul L. Dunbar, "Negro Society in Washington," In Herbert M. Martin and Ronald Primeau (eds.) *In His Own Voice* (Athens: Ohio University Press, 2002), 195.
52. Michelle D. Davis, The John P. Davis Collection: John P. Davis. http://www.johnprestondavis.global.attitudes.org-The Davis Family.
53. http://www.pbs.org/ellingtonsdc/vtSchools.html.
54. Lewis, ibid., 118.
55. Spartacus Educational: Booker Taliaferro Washington. http.www//.spartacus.schoolnet.co.uk/USAbooker.htm.
56. Michelle D. Davis, The John P. Davis Collection: Dr. William H. Davis. http://www.johnpdaviscollection.org/davishistory.html.
57. Ibid. Davis had opened a night school—The Davis Business College—in the basement of the family's home. . . . Though many students could not afford the school's modest tuition, he turned no promising young man or young woman away.

58. Davis became secretary to the Presidential Commission investigating the economic conditions in the Virgin Islands. Michelle D. Davis, The Davis Collection. http://www.johnpdaviscollection.org/about9.html.

59. MTW Papers, 63–64.

60. Maryland State Archives. Archives of Maryland Online. The First Colored Professional, Clerical and Business Directory of Baltimore City, 6th Annual Edition, 1918–1919. http://aomol.net/000001/000498am498—105.html.

61. Ibid. Thurston was listed as superintendent.

62. *Evening Star*, September 13, 1919.

63. *Evening Star*, September 19, 1919.

64. Statement of one of the original students of the school.

65. MTW Papers. A pupil in this principal's school, 57.

66. MTW Papers. Statement of one of the original teachers, 57.

67. MTW Papers. Statement of a former student, 57.

68. Henry L. Gates, Jr. defines a "race man" as a person of letters who writes about African-American culture. Breena Clarke and Susan Tifft/Durham. Time: A Race Man Argues for a Broader Curriculum: HENRY LOUIS GATES JR. http://www.time.commagazine/article/0,9171,972763,00.html.

69. *Washington Bee*, October 11, 1919.

70. Ibid.

71. From the beginning Dunbar offered a classical education. Since its inception, it has graduated many of the well-known figures of the twentieth century, including Charles R. Drew, the discoverer of blood plasma, William H. Hastie, the first African-American federal judge, Robert C. Weaver, the first African-American cabinet member, and Benjamin O. Davis, the first African-American general. Among its principals was Anna Julia Cooper, who became principal in 1906. Faustine Childress Jones-Wilson, *Encyclopedia of African-American Education*, 149. Books.google.com/books?id = xs5zylm3k14c+pg = PA149&sig3

72. MTW papers, 61.

73. The senior author, Carroll L. L. Miller, was a student at this junior high school during the three years of Slowe's tenure.

74. *Washington Tribune*, Saturday, June 17, 1922.

75. Teachers College, Columbia University: Historical Timeline. http://www.tc.columbia.edu/studenthandbook/detail.asp?id = Historical+Timeline&pic = about.

76. Answers.com. John Dewey, Philosopher, Educator. http://www.answers.comntquery;jssionid = 7nhmepOg5058q?method = 4&dsid = 2039&dekey = Dewey-Jo&gwp = 8&cl.

77. University of Vermont. John Dewey Project on Progressive Education. http://www.uvm.edu/~dewey/articles/proged.html.

78. MTW papers. Testimony of former students and teachers of the junior high school, 63.

79. As early as 1906, it had been designated as the university's official organ. Logan, ibid., 150.

80. Lucy Diggs Slowe. "The Junior High School: An Opportunity," *Howard University Record*, 15 no. 6 (1921):361–366.

> When the Board of Education organized in September 1919, a Junior High School for the Colored boys and girls of Washington, it believed

that such an organization had distinct advantages. Those boys and girls who were far-sighted enough to come to the Junior High School have benefited in several different ways.

First, the pupils of the seventh and eighth grades have been placed in a building to themselves where they have more freedom than they could have in a building with children in the primary grades. Boys and girls in the upper grammar grades are old enough to begin assuming some responsibility for their own conduct, and mature enough to assist in the management of their school; consequently, the faculty of this school has given the pupils a voice in governing themselves which privilege affords them excellent training in the duties of good citizenship. Every class has its own officers who preside over the meetings held in the various section rooms every Monday morning. At these meetings, the pupils after discussing ways of improving the conduct, attendance and scholarship of all members of the school, formulate rules and regulations for their guidance. These rules submitted to the principal through the class presidents who meet her in conference once a week, form the basis for the laws of the school.

Second, the pupils in this school have the advantage of gradually becoming accustomed to the methods of the senior high school before entering it. In the grammar school, the pupil has had one teacher for all subjects, but in entering the senior high school, he has a different teacher for every subject. Adjusting himself to so many instructors sometimes confuses and discourages the pupil to such an extent that he fails in his first year and as a result drops out of school. In the Junior High School he changes gradually from the one-teacher system by having the homeroom teacher instruct him the first hour every day, and by not having more than two or three teachers in his major subject. By the end of his last year in the Junior High School, having become accustomed gradually to being instructed in different subjects by different teachers, he has "bridged the gap" between the grammar school and the junior high school and the senior high school. Thus, he has a greater chance to succeed.

Third, the pupils in this school have the advantage of being offered a choice in the work they may do. The course of study enriched by several new subjects permits each student to do the things which he, under the direction of his teachers and parents, seems most fitted to do. Pupils have a chance to begin a foreign language two years before entering the senior high school, they may begin Latin or science one year before entering and if they desire, may devote extra time to shop work. These advantages are of special value to those pupils who expect to go to college for they have a longer, therefore, a more thorough period of preparation. Moreover, those pupils who must leave school before they finish the senior high school have the advantage of at least one year of high school training if they attend the Junior High School.

Still another advantage of being in the Junior High School is that of being promoted by subject rather than by grade. The student who fails, for example, in mathematics is not required to repeat other

subjects in which he has passed satisfactorily. Such a flexible arrangement is often the means of saving valuable time.

81. Only the first and last issues published during Slowe's principalship were available.
82. *Junior High School Review.* 1:1–2, May 1920.
83. Howard Arnold Walter's poem, My Creed: "I would be true, for there are those who trust me; I would be pure, for there are those who care; I would be strong, for there is much to suffer; I would be braver, for there is much to dare. I would be friend of all—the foe, the friendless; I would be giving, and forget the gift. I would be humble, for I know my weakness; I would look up—and laugh—and love—and lift." Walter was a young man—an English teacher in Japan when he wrote this poem and sent it home to his mother. She was responsible for sending it to Harper's magazine. Walter later became a Congregational minister and worked for the YMCA in India.
J. Todd Vinson. My Creed. http://www.jtoddvinson.com.
84. *Junior High School Review*, ibid., 4.
85. Ibid., 5.
86. Logan, ibid., 152.
87. Ibid.
88. *Junior High School Review*, December 1920.
89. *Junior High School Review*, November 1921.
90. Ibid., 13–14.
91. Wilberforce University is located near Xenia, Ohio. The nation's oldest private, historically African-American university, was founded in 1856, and later purchased by the African Methodist Episcopal Church in 1863. Wilberforce University: About WU—History. http://www.wilberforce.edu/welcome/history.html.
92. David L. Lewis, ibid., 176.
93. Sanford L. Davis, Buffalosoldier.net: Colonel Charles Young. http://www.buffalosoldier.net/CharlesYoung.htm.
94. *Junior High School Review*, June 1921, 8.
95. Ibid.
96. *Junior High School Review*, December 1920, 9.
97. Ibid, p. 7.
98. Wayne Shirley, Access My Library: The coming of "Deep River" (African-American spiritual). 1297. http://www.accessmylibrary.com/article-1G1-20633039/coming-deep-river-african.html.
99. *Junior High School Review*, December 1920, 8.
100. A one-act play that opened on Broadway in 1923. Internet Broadway Data Base. Three Pills in a Bottle. http://www.ibdb.com/production.asp?ID = 9238.
101. http://bahai-library.com/?file = francis_gregory_biography.html.
102. http://www.plametbahai.org/articlesar022803a.html.
103. http://www.special-ideas.com/images/vt-rac.jpg.
104. http://bahai-library.com/?file = francis_gregory_biography.html.
105. *Junior High School Review*, December 1920, 9.
106. MTW notes, typewritten, 45.
107. http://www.civilwarhome.com/shawbio.htm.

108. http://www.civilwarhome.com/shawbio.htm.
109. *Junior High School Review*, June 1922, 10.
110. http://www.en.wikipwdia.org/Origins_of_baseball.
111. Schlagball (German for "hit the ball") seems to be an obscure sport perhaps played primarily in physical education classes. Source: http://www.retrosheet.org/Protoball/Fat.2.06.htm.
112. The High School Cadet Competition Program, June 1922.
113. *Junior High School Review*, June 1921.
114. Ibid., November 1921.
115. Ibid., December 1921.
116. Ibid., April 1922.
117. Ibid., June 1922.
118. MTW notes, typewritten, 46.
119. *Afro-American.* April 1, 1921.
120. Ibid.
121. The Columbian Educational Association of the District of Columbia celebrated its 25th anniversary in 1946. P0054. The Historical Society of Washington, DC. Collection of African American History. http://www.historydc.orgAfrican_American_History_Resources.pdf.
122. *Washington Post*, January 18, 1917.
123. Logan, ibid., 175: Roscoe Conkling Bruce was Assistant Superintendent of Public Schools in the District of Columbia; Benjamin Brawley was Dean at Morehouse College; Kelly Miller was professor at Howard University.
124. Logan, ibid., 174–176.
125. Du Bois's speech which was to have been printed in the March 1918 issue of the *Howard University Record* is not available. Ibid., 178.
126. Ibid.
127. Franklin, ibid., 336.
128. http://64.233.161.104/search?q = cache:8Ink2rDyNbMJ:en.wikipedia.orgDeclaration_of_war_by_the_United_States+World+War+I+date+declared&hl = en&gl = us&ct = clnk&cd = 1.
129. David L. Lewis, ibid., 540.
130. Dorothy Salem, "World War I," in *Black Women In America: An Historical Encyclopedia*, ed. Hine et al., (Bloomington: Indiana University Press, 1994), 2:1284.
131. Franklin, ibid., 350.
132. Dorothy Salem in *Black Women in America: An Historical Encyclopedia*, ed. Hine et al., ibid., 2:1289.
133. Ibid., 1287.
134. "The Story of the National Unfolds," *Journal of the National Association of College Women*, XVIII (1941) 6.
135. Dorothy Salem, "National Association of Colored Women" in *Black Women in America: An Historical Encyclopedia*, ed. Hine et al. (Bloomington: Indiana University Press, 1994), 2:842.
136. Gloria. B. Moldow, "Brown, Sara Winifred (b. 1870)" in *Black Women in America: An Historical Encyclopedia*, ed. Hine et al., ibid., 1:184.
137. Dorothy Salem, "World War I," in *Black Women in America: An Historical Encyclopedia*, ed. Hine et al., ibid., 2:1284.

Notes to Chapter 3

138. Franklin, 395.
139. http://www.mdarchives.state.md.us/megafilespeccol.sc2900/sc2908/000001/000503am503—92.html.
140. Logan, ibid., 97.
141. Sharon Harley, "Beyond the Classroom: The Organizational Lives of Black Female Educators in the District of Columbia 1890–1930," *Journal of Negro Education* 51, no.3 (1982): 256.
142. Ibid.
143. David L. Lewis, ibid, 568.
144. Dorothy Salem in *Black Women in America: An Historical Encyclopedia*, ed. Hine et al., ibid., 2:1290.
145. Story Unfolds, ibid., 6. "CAC's other sponsors and members during that first year were Miss Charlotte Atwood [teacher at Dunbar High School]. (Source for all persons listed as teachers at Dunbar High School: http://www.mdarchives.state.md.us/megafilespeccol/sc2900/sc2908/000001/000503am503—92.html), Miss Julia E. Brooks [teacher at Dunbar High School], Dr. N. Fairfax Brown, Dr. Sarah W. Brown [a physician who later became the first alumnae trustee of Howard University], Mrs. Sterling N. Brown [wife of the distinguished Professor Sterling Brown of Howard], Mrs. Harriett Shadd Butcher, Miss Lula V. Childers [Instructor in Music at Howard University], Mrs. W. H. Connor, Mrs. Anna J. Cooper [former principal of the M Street High School and fourth African American woman to earn a PhD degree], Mrs. Arthur U. Craig, Miss Mary E. Cromwell [supervisor of the hostess house for African American soldiers during World War One at Fort Dix, New Jersey. (Salem in Hine, 2:1288)] Miss Otelia Cromwell [teacher at Dunbar High School and an organizing member of the Association of Deans of Women and Advisers to Girls in Negro Schools, (Hilda Davis and Patricia Bell-Scott, "Association of Deans of Women and Advisers to Girls in Negro Schools," in *Black Women in America: An Historical Encyclopedia*, ed. Hine et al. (Bloomington: Indiana University Press, 1994), 1:49], Miss Jessica R. Fauset [the novelist], Miss Ida Gibbs Hunt[who attended the Pan Africa Conference in Paris in 1919 and the International Congress of Women in Zurich to inform women of the world about racism in the United States (Salem in Hine, 2:1290)], Mrs. Ethel H. Just [wife of eminent biologist and Howard faculty member Ernest Just], Miss Rosa B. Lane, Mrs. Harriet Gibbs Hunt, Mrs. Harriet Gibbs Marshall [founder of the Washington Conservatory of Music and School of Expression, Doris E. McGinty, "Marshall, Harriett Gibbs (1868–1941)," in *Black Women in America: An Historical Encyclopedia*, ed. Hine et al. (Bloomington: Indiana University Press, 1994), 2:747)], Mrs. Alice Wheeler McNeill, Miss Bertha C. McNeil, Miss Clara Shippen, Miss Georgiana R. Simpson [teacher at Dunbar High School, German scholar, in 1921, one of the first African-American women to earn a PhD degree; Howard University faculty in 1931. Catherine Johnson, "Simpson, Georgiana (1866–1944)," in *Black Women in America: An Historical Encyclopedia*, ed. Hine et al. (Bloomington: Indiana University Press, 1994), 2:1038–9)], Mrs. Mary Anderson Smith, Mrs. Ethel C. Williams and Miss Maude Young."
146. Willard B. Gatewood, "Aristocrats of Color: South and North The Black Elite, 1880–1920," *Journal of Southern History* LIV, no.1 (1988): 3–20.
147. Ibid., 5.

148. Ibid., 10.
149. *Washington Bee*, May 30, 1914: Mary Church Terrell to Robert H. Terrell, June 25, 1902, Terrell Papers. Cited in Gatewood, ibid., 11.
150. http://webcache.googleusercontent.com/search?q = cache:3xaAvLZYEzcJ: press-pubs.uchicago.edu/founders/documents/v1ch15s60.html+the+rich+the+beautiful+well+born+adams&cd = 2&hl = en&ct = clnk&gl = us&source = www.google.com.
151. *Washington Bee*, 11.
152. Ibid., 7.
153. *Thirteenth Census of the United States: 1910-Population*, Bureau of the Census. Department of Commerce and Labor—State: Maryland. Baltimore City, enumeration district no. 23. Druid Hill Ave., # 3218.
154. Logan, ibid., 134.
155. Cromwell Family Papers—24, Box 8, Folder 88; Manuscript Division, Moorland-Spingarn Research Center, Howard University.
156. Proceedings of the Conference of the College Alumnae Club, April 6–7, 1923.
157. Marion T. Wright, "Slowe, Lucy Diggs." In Edward T. James, Janet Wilson James, and Paul S. Boyer (eds.) *Notable American Women: 1607–1950 A Biographical Dictionary*. (Cambridge, MA: Belknap Press 1971), 300.
158. http://www.aauw.org/museum/history/index.cfm.
159. Geraldine J. Clifford (ed.) *Lone Voyagers: Academic Women in Coeducational Institutions, 1870–1937* (New York: Feminist Press at City University of New York, 1989) 13, citing Lulu Holmes, *A History of the Position of Dean of Women in a Selected Group of Co-Educational Colleges and Universities in the United States* (New York: Teachers College, Columbia University Contributions to Education, no. 767, 1939) 25–26.
160. Clifford, ibid. 13, citing Jane L. Jones, *A Personnel Study of Women Deans in Colleges and Universities*. Teachers College, Columbia University Contributions to Education, no. 326. New York (1928): 12, 23–24.
161. Story Unfolds, ibid., 7.
162. Franklin, ibid., 340.
163. W. E. B. Du Bois, in the January 1918 issue of *The Crisis* had ". . . condemned the Wilson administration for hanging thirteen of the Houston soldiers without even the formality of appeal." Lewis, ibid., 545, ". . . forty-one were imprisoned for life, and forty others were held pending further investigation," Franklin, ibid., 340. MTW papers.
165. *Hilltop*, December 11, 1930.
166. American Tennis Association. http://www.afn.orgatanav.htm.
167. Jim Crow History. http://www.jimcrowhistory.org/resources/lessonplans/hs_es_sports.htm.
168. American Tennis Association. http://64.233.161.104/search?q = cache: CbBnvP5ZZvcJ:www.atanational.com/about.htm+Lucy+.
169. Ibid.
170. http://www.dartmouth.edu/~speccol/studentforum/blackgreens/t_holmes.html.
171. *Afro-American*, September 16, 1916.

366 Notes to Chapter 3

172. American Tennis Association. http://www.afn.orgaboutxt.htm.
173. D. Margaret Costa and Jane A. Adair. "Sports," in *Black Women in America: An Historical Encyclopedia*, ed. Hine et al., ibid., 2:1099.
174. *Afro-American*, September 8, 1917.
175. *Howard University Journal*, November 9, 1917.
176. *Crisis*, October 1917, 315.
177. http://college.hmco.com/history/readerscomp/womenwh_035200_sports.htm.
178. Margaret Mead, *Sex and Temperament in Three Primitive Societies*. New York: Morrow. 1935, 300.
179. Gertrude Ederle, History of Women in Sports, Part 2, 1900–1929. St. Lawrence County Branch AAUW. http://www.northnet.org/stlawrenceaauw/timeline2.htm.
180. *Afro-American*, September 13, 1918.
181. *Afro-American*, September 12, 1919.
182. *Afro-American*, September 3, 1920.
183. *Afro-American*. July 18, 1922.
184. *Afro-American*, August 27, 1938. Tribute by American Tennis Association following Slowe's death. Lucy Diggs Slowe Papers. Series B Box 90-1, Folder 9; Manuscript Division, Moorland-Spingarn Research Center, Howard University.
185. Wilkinson to F.W. Ballou, July 5, 1922. Lucy Diggs Slowe Papers. Box 90-4, Folder 99; Manuscript Division, Moorland-Spingarn Research Center, Howard University.
186. Cultural Tourism. Board of Education. http://www.culturaltourismdc.org/infourl3948/infourl_show.htm?doc_id = 212985&attrib_id = 7972.
187. A decade later, Roscoe Conkling Bruce had become Head of Colored Schools in Washington, DC. He would write about Lucy Slowe in a letter dated May 15, 1933 in which he said "Selected to organize and direct the first junior high school for colored children in the District of Columbia, she exceeded my every expectation. She is not only a born teacher with modem (sic) training and experiences, but a highly gifted administrator."

Bruce came by his name in a remarkable way. Blanche K. Bruce, his father, in 1874 had been elected to the United States Senate from Mississippi. This was during the period of Reconstruction when Negroes were participating in Southern politics. Yet, sentiment was so strong against colored people that when he was to take his oath of office his colleague from Mississippi refused to escort him to the front of the house as was the custom in the Senate. An embarrassing silence fell over the chamber until Senator Roscoe Conkling of New York jumped up and, extending his arm to Bruce, escorted him forward. Bruce was so grateful that he named his only son for the gentleman from the Empire State. Harvard University. http://64.233.161.104/search?q = cache:AyJkCK9NWf4J:www.news.harvard.edu/gazette01.18/32-timecapsule.html+Roscoe+Conkling+Bruce&hl = en.

188. Lucy Diggs Slowe Papers. Series F letter March 12, 1936 Box 90-4, Folder 102; Manuscript Division, Moorland-Spingarn Research Center, Howard University.
189. Ibid., Letter April 6, 1936.
190. Lucy Diggs Slowe Papers. Series C Box 90-1, Folder 14; Manuscript Division, Moorland-Spingarn Research Center, Howard University.

191. Ibid.
192. Boyd's Directory of the District of Columbia. Washington, DC: R. L. Polk and Co.
193. Ibid.
194. Kathy A. Perkins, "Burrill, Mary P. (c. 1884–1946)" in *Black Women in America: An Historical Encyclopedia*, ed. Hine et al., (Bloomington: Indiana University Press, 1994), 1:198. Ancestry.com.1900 United States Federal Census [database on-line]. Provo, UT, USA: My Family.com, Inc., 2004, gives Burrill's birth year as 1882.
195. Perkins, ibid.

Chapter 4

1. News item for release on and after November 1, 1937, dated Oct. 26, 1937.
2. Minutes of the Board of Trustees, June 1, 1915. Rayford W. Logan, *Howard University: The First Hundred Yeas 1867–1967* (New York: New York University Press, 1969), 193.
3. Ibid., 170.
4. Ibid.
5. By 1900, a sizeable number of school systems did not permit teachers to marry. Teaching was being regarded as a "spinster profession." (Jackie Blount. *Fit to Teach: Same-Sex Desire, Gender, and School Work in the Twentieth Century* (Albany: State University of New York Press, 2004), 45. http://www.historycooperative.org/journals/heqbr_4.html.
6. Logan, ibid., 126.
7. Ibid., 167.
8. *Washington Bee*, June 14, 1919.
9. University Catalogs, 1918–1922.
10. Logan, ibid., 151.
11. Ibid., 164.
12. http://www.simpson.edu/president1800.html.
13. Logan, ibid., 198.
14. Richard J. Herdlein, "Thyrsa Wealtheow Amos: The Dean of Deans." *NASPA Journal*, v. 41, No.2, winter 2004, 338. Herdlein cited Holms (1939): L. Holms(1939). A history of the position of dean of women in a select group of coeducational colleges and universities in the United States. (New York: Columbia University), Herdlein cited L. K. Mathews, *The Dean of Women*. (Boston: Houghton Mifflin 1915).
15. Geraldine J. Clifford, ed., *Lone Voyagers: Academic Women in Coeducational Universities 1870–1937*. (New York: Feminist Press at City University of New York, 1989), 13, per Mary L. Fibley, "The Early History of the Deans of Women, University of Illinois, 1897–1923." Unpublished paper, University of Illinois, 1969, 6.
16. Ibid., Citing Lulu Holmes, *A History of the Position of Dean of Women in a Selected Group of Co-Educational Colleges and Universities in the United States*. (New York: Teachers College, Columbia University Contributions to Education, no. 767, 1939), 25–26.

17. *Washington Post*, January 18, 1917.
18. Durkee to Slowe, Jan. 21, 1922. Lucy Diggs Slowe Papers. Box 90-2, Folder 52; Manuscript Division, Moorland-Spingarn Research Center, Howard University.
19. Clifford, ibid., 20.
20. Slowe to Durkee January 26, 1922. Lucy Diggs Slowe Papers. Box 90-2, Folder 52; Manuscript Division, Moorland-Spingarn Research Center, Howard University.
21. WeatherBook.Com. The Knickerbocker Snowstorm—January 28–29, 1922. http://www.weatherbook.com/knickerbocker.html.
22. Durkee to Slowe March 2, 1922. Lucy Diggs Slowe Papers. Box 90-2, Folder 52; Manuscript Division, Moorland-Spingarn Research Center, Howard University.
23. Logan, ibid., 209.
24. Raymond Wolters, *The New Negro on Campus: Black College Rebellions of the 1920s* (Princeton: Princeton University Press, 1975), 103.
25. H. V. Church, ed., *Seventh Yearbook of the National Association of Secondary-School Principals*, 1923, 29.
26. Logan, ibid., 210.
27. Slowe to Durkee, March 9, 1922. Lucy Diggs Slowe Papers. Box 90-2, Folder 52; Manuscript Division, Moorland-Spingarn Research Center, Howard University.
28. Slowe to Durkee March 10, 1922.Lucy Diggs Slowe Papers. Box 90-2, Folder 52; Manuscript Division, Moorland-Spingarn Research Center, Howard University.
29. For choice makers, see Renita J. Weems, *What Matters Most: Ten Lessons in Living Passionately from the Song of Solomon*. (New York: Warner, 2004), 94–95.
30. Durkee to Slowe, May 9, 1922. Lucy Diggs Slowe Papers. Box 90-2, Folder 52; Manuscript Division, Moorland-Spingarn Research Center, Howard University.
31. Slowe to Durkee, May 31, 1922. Lucy Diggs Slowe Papers. Box 90-2, Folder 52; Manuscript Division, Moorland-Spingarn Research Center, Howard University.
32. Logan, ibid., 199.
33. The original Trustees' minutes are not available, but a page from the papers of Carroll L. L. Miller shows that he obviously transcribed this information.
34. Slowe to Durkee, June 15, 1922. Lucy Diggs Slowe Papers. Box 90-2, Folder 52; Manuscript Division, Moorland-Spingarn Research Center, Howard University.
35. Logan, ibid., 198.
36. David L. Lewis, ibid., 542.
37. In October 1917, Scott had appointed William H. Davis, who had been Slowe's principal at Armstrong, as his "special assistant and manager of his five-person War Department staff." http://www.johndaviscollection.org/davishistory.html.
38. Susan Altman. Emmett Scott, Administrator of a Dream. The Encyclopedia of African American Heritage, 1997. Facts on File, Inc. New York. http://www.aaregistry.com/african_american_historyEmmett_Scott_administrator_of_a_dream.
39. Lucy Diggs Slowe Papers. Series F Box 90-2, Folder 39 Correspondence Memorandum to Miss Beatrice Clark, May 22, 1936. Manuscript Division, Moorland-Spingarn Research Center, Howard University.
40. *Washington Post*, June 16, 1922.
41. *Washington Bee*, June 16, 1922.

42. *Washington Tribune*, Saturday, June 17, 1922. Lucy Diggs Slowe Papers. Series N Box 90-11, Folder 207; Manuscript Division, Moorland-Spingarn Research Center, Howard University.

43. "In 1904 President Gordon referred to Howard University as the capstone of Negro education." Walter Dyson, *Howard University, The Capstone of Negro Education: A History: 1867–1940*. (Washington: Graduate School, Howard University, 1941), 442.

44. *Washington Tribune*, Saturday, June 17, 1922.

45. Logan, ibid., 187.

46. Walter Dyson, *Howard University: The Capstone of Negro Education—A History: 1867–1940*, 397.

47. Logan, ibid., 187.

48. Logan, ibid., 192–193.

49. Ibid., 199.

50. Ibid., 211.

51. Ibid., 212.

52. Ibid., 213.

53. Ibid., 214.

54. Rolfe Cobleigh, *The Congregationalist*, The Education Number, July 27, 1922.

55 Rolfe Cobleigh, "A New Day for Howard University: Progress and Needs of a Great Institution." *The Congregationalist* 107, No. 30 (July 27, 1922) Education Number, 108.

56. Prior to the federal government's association with the University, Howard had close ties with the federal government that derived from the act of chartering. It was through an appropriations act, 1891, that Congress for the first time directed the "proper officers" of Howard University to submit an annual report to the Secretary of the Interior on the way in which the appropriation was expended. Logan, ibid., 26.

57. Ibid., 108.

58. A more recent commentary notes, "J. Stanley Durkee deserves recognition as one of the significant presidents in the history of the institution." Maceo C. Daily, *Emmett Jay Scott: The Career of a Secondary Black Leader*, PhD Dissertation, Department of History, Howard University, 1983.

59. Logan, ibid., appendices 589–593.

60. Annual Catalogue of Howard University, 1 no. 1 (June 1920–21) 50–51, 89–90.

61. The Annual Report of the president of Howard University to the U.S. Secretary of the Interior for the academic year 1922–23 included basic information about the university, including the fact that the net enrollment had for the first time passed the 2,000 mark.

> Other items of significance in that same report were: 1) three programs in the School of Commerce and Finance (insurance, finance and accounting) and a new publication by the students in the School of Commerce and Finance—a monthly magazine called *The Commercial Outlook*; 2) an art course offered for the first time; 3) the School of Music with 14 recitals and performing groups that included Vested Choir, Young

Men's Glee Club, Young Women's Glee Club, Symphony Orchestra, and Choral Society; 4) a School of Public Health and Hygiene opened that was responsible for student health and included the Department of Physical Education and ROTC; 5) the first issue of the *Howard Review*, a journal devoted exclusively to research; 6) in Education the apprenticeship, observation and practice teaching program begun in 1921 with two cooperating teachers had 15 in 1922–23; 7) Miner Normal extended observation privileges to students interested in institutions for the training of teachers. There were 316 graduates in 1923. The Library held 40,274 books, with 653 accessioned in 1922–23—233 gifts and 420 purchased. Evening classes existed and the first summer session was offered in 1923.

The Annual Catalogue for 1922–23 carried a description of student activities.

The University maintains several literary societies and debating clubs which through exercises, debates, oratorical contests and dramas provide a training of great importance. It also furnishes from time to time lectures which all students may attend.

The Kappa Sigma Debating club is composed of students in the College. Its purpose is to foster debating and to develop ready and useful speakers. Intercollegiate debates are held under its auspices.

The Classical Club . . . has as its purpose the study and interpretation of the life and thought of Ancient Greece and Rome as revealed in the literature and other extant monuments of their civilization.

Der Deutsche Verein is an organization under the general supervision of the Department of German. . . . Its aim is to supplement classroom instruction . . . ,

Le Cercle Francais aims to develop acquaintance with French letters and institutions.

The Stylus is a society organized for the encouragement and development of original literary expression. . . . Its membership is determined by competitive writing contests.

The Forum is an organization composed of young women for the encouragement of public discussion and debate.

The Howard Players represent the dramatic interests of the students of the University. The organization presents annually a series of plays which are staged entirely by students. In the workshop, the scenery and costumes for these performances are designed and made. The players aim to develop the dramatic possibilities of the Negro race and to be the nucleus of a movement for the establishment of a National Negro Theater.

The Pestalozzi-Froebel Society is an organization of the School of Education.

The Maynard Literary Society of the School of Religion discusses topics in the field of religion, sociology, and practical life.

Additional information described the band, The Chamber of Commerce, and the various fraternities and sororities:

> A full band of fifty pieces is attached to the ROTC. This band is composed of members of the Reserved Officers Training Corps and is open to any student possessing musical training, talent, or aspiration. The instruments are furnished by the United States Government under the same conditions as all other property and equipment of the ROTC. Instruction on any instrument is given free to members of the band.... It is rapidly developing into what promises to become a military band well adapted to the highest forms of instrumental music.
>
> The Chamber of Commerce is an organization composed of students in the School of Commerce and Finance. This organization aims to give its members practical training in business and economic enterprises through its affiliation with the businessmen of the country. It publishes a monthly journal entitled "The Commercial Outlook."
>
> The following fraternities have chapters at the University: for college men, Alpha Phi Alpha, Omega Psi Phi, Phi Beta Sigma and Kappa Alpha Psi; for college women, Alpha Kappa Alpha, Delta Sigma Theta and Zeta Phi Beta; for student [sic] of law—Tau Delta Sigma; for medical men, Chi Delta Mu; for dental men, Cusp and Crown Fraternity; for medical women, Rho Psi Phi.

Because Lucy Slowe found it necessary to work during her college days, the question arises as to what provisions for student work existed 14 years after her graduation. Excerpts from the 1922–23 Catalogue describe the status of student employment.

> Although Howard University offers a number of places in the aggregate for students to earn in part their way in college, most of the positions are engaged beforehand by those who have already attended. Many of our students are engaged outside of the University in Washington, in such work as waiting in hotels, boarding houses and restaurants, caring for houses, furnaces, walks and yards, running elevators.... An employment bureau is maintained in the Office of the Secretary of the YMCA.... The above information applies to young men. There are only a very few positions in Miner Hall for young women to earn part of their expenses. These are engaged long in advance. There is practically no opportunity for young women to earn part of their expenses by working in the city, except with personal friends.

As to religion and morals, the Catalogue notes

> The charter contains no religious test or limitation. The University, however, is distinctly Christian in its spirit and work. It is not denominational.... Daily devotional exercises and Sunday vespers are held in the University chapel. A general prayer service is held every Wednesday evening.... Students attend their choice in the city, and some of them engage actively in religious and philanthropic work in

372 Notes to Chapter 4

>social settlements, the Christian Associations of the University and in other organizations.
>
>The Young Men's Christian Association is the organization within the University which aims at (1) the promotion of religious life of men students by devotional exercise, systematic Bible study, individual work for life surrender to Christ and social service; (2) the securing of employment for students; (3) the providing of wholesome recreation and social life as a substitute for undesirable resorts in the city. A member of the new student committee will be glad to meet any new student at the station who writes to the Registrar, stating the time of his arrival.
>
>The Young Women's Christian Association is an affiliated branch of the National Association and aims to develop among the young women of the University high standards of character and conduct. Devotional meetings throughout the school year are held. . . Bible and mission study classes are carried on during the Winter Quarter.

Additional notes on the practices and policies of Howard University as they relate directly to students reveal the breadth of activities with which Dean Slowe had to interact.

>The Health of students in the University is given consideration. All students except those in the professional schools . . . are required to take physical education and exercise in the gymnasium.
>
>Candidates for places on the various athletic teams will be required to take a physical examination and give evidence of fitness by making strength tests. Students not candidates for teams will be required to take a physical examination for the purpose of ascertaining defects which may be overcome by corrective physical training.
>
>Provision has been made for the bestowal of scholarships upon students of high standing in the several departments of study. . . .
>
>It is preferred that the student be competent to handle his own financial matters as the experience thus acquired becomes an important part of his training for life and gives him as well an understanding of his college expenses.
>
>The rooms in the dormitories are furnished with bedspread, mattress, chairs, tables and bookcase and in the men's dormitory, sheets and pillowcases. All other furnishings, such as towels, blankets and pillows, and in the young women's dormitory, sheets and pillowcases must be supplied by the students.

62. William A. Robson, "A Visit to a Negro University," New Student 2 (10 February 1923): 2. Cited in Wolters, ibid., 72.

63. Dyson, Ibid. 104.

64. Quoted in Slowe's letter to Ralph J. Bunche, November 2, 1931. Lucy Diggs Slowe Papers. Box 90-2, Folder 34; Manuscript Division, Moorland-Spingarn Research Center, Howard University.

65. DC Washingtoniana Collection. Washington DC Public Library. General Assessments of Washington, DC, compiled by M.C. Fitzgerald, Assistance Assessor,

DC. Rudus S. Lusk, Publisher. Washington, DC. 1923–24 (Roll 12) through 1937–38 (Roll 20) Lucy D. Slowe lists as owner of 1256 Kearney Street, Northeast.

66. http://www.culturaltourismdc.org/information2550/information.htm?area = 2518.

67. Slowe letter to Abraham Flexner June 2, 1933. Lucy Diggs Slowe Papers. Box 90-3, Folder 58; Manuscript Division, Moorland-Spingarn Research Center, Howard University.

68. Margaret Jean Groomes, "Lucy Diggs Slowe, First Dean of Women of Howard University 1922–1937." Typewritten. No date. Lucy Diggs Slowe Papers. Box 90, Folder 116; Manuscript Division, Moorland-Spingarn Research Center, Howard University.

69. T. L. Taylor, Clipping, *Afro-American*, March 2, 1929. Lucy Diggs Slowe Papers. Box 90 Folder 234; Manuscript Division, Moorland-Spingarn Research Center, Howard University.

70. Ibid.

71. Daisy Douglas, Class of 1938, telephone interview by Anne Pruitt-Logan, February 9, 2008.

72. MTW Papers, 117–118.

73. Logan, ibid., 229.

74. *Howard University Record*, 17; 7 November 1922.

75. *Howard University Record*. 17–49; 7 November 1922.

76. Lucy D. Slowe, Annual Report of the Dean of Women to the President of Howard University—1922–23, 1.

77. John H. Schuh., "Foundational Scholarship in Student Affairs: A Sampler," *NASPA Journal*, 39, no.2, (Winter, 2002):110.

78. American Council on Education Studies. *The Student Personnel Point of View*, 1 no.3 (June 1937): 1. http://www.bgsu.edu/colleges/library/cacpages/1937STUDENTPERSONNELnew.pdf.

79. Correspondence to Anne S. Pruitt-Logan from Diana R. Maul, Registrar, Teachers College, Columbia University, March 21, 2006.

80. Ibid., no date available.

81. MTW notes, typewritten, 59.

82. *Howard University Record*, 17:430, June 1923.

83. *Washington Post*, May 13, 1923, 16.

84. *Howard Alumnus*, March 1924, 79.

85. Logan, ibid., 194, 230.

86. *Hilltop*. March 15, 1924.

87. "Slowe speaks at Columbia University." *New Haven Union*. February 22. 1925.

88. Arthur I. Gates, Esther M. Hemke and Dorothy Van Alstyne. "Problems in Beginning Reading: Suggested by an Analysis of Twenty-one Courses." *Teachers College Record*, 1925. "Advisers of Women." http://www.tcrecord.org/content.asp?contentid = 5978.

89. *Howard Alumnus*, 3 (1925): 137.

90. *Howard University Record*, 17 (1922): 51–52.

91. *Hilltop*. February 25, 1926.

92. Ibid.

93. MTW papers, 125.

94. Ibid.
95. *Howard University Record*, 17 (1922): 88.
96. *Howard University Record*, 17 (1922): 86.
97. Ibid., 17:88 December 1922.
98. Ibid., 17:89, December 1922.
99. Ibid., 17:90, December 1922.
100. Ibid., 18:148, December 1923.
101. *Hilltop*, November 14, 1924.
102. There is no record of the content of Davis' or Miller's comments.
103. Following graduation in 1925, she would go on to a distinguished career as "a dean of women, professor of English, mental health administrator, and leader of educational, women's, civic, and religious organizations. . . . She . . . waged a struggle for race and sex equality throughout the twentieth century." She would follow Dean Slowe as the "second elected president of the Association of Deans of Women and Advisers to Girls in Negro Schools after the death of its founder, Lucy Diggs Slowe. Patricia Bell-Scott, "Davis, Hilda Andrea (1905–)," in Hine et al. (eds.) 1:309–10.
104. Miller's wife was Annie May Butler Miller. Scott W. Williams, The Mathematics Department of The State University of New York at Buffalo. Special Articles: Kelly Miller. http://www.math.buffalo.eduspecial/miller_kelley.html.
105. *Howard University Record*, 86 (1923).
106. *Hilltop*, January 22, 1924.
107. Logan, ibid., 230.
108. Joanna H. Ransom, "Innovations introduced into the women's program at Howard University by the late Dean Lucy D. Slowe." *Journal of the National Association of College Women*, XIV (1937): 52.
109. *Hilltop*, January 10, 1930.
110. Mark Connolly, "The Other Wise Man." Spirituality.org. http://www.spirituality.org/issue05/page13.html.
111. Slowe to Durkee, January 22, 1923. Lucy Diggs Slowe Papers. Box 90-2, Folder 52; Manuscript Division, Moorland-Spingarn Research Center, Howard University.
112. Slowe to Durkee, January 23, 1923. Lucy Diggs Slowe Papers. Box 90-2, Folder 52; Manuscript Division, Moorland-Spingarn Research Center, Howard University.
113. *Washington Tribune*, February 3. 1923.
114. Minutes of the Academic Council, October 17, 1922.
115. Ibid.
116. Letter from Student Council to the Academic Council, Minutes of the Academic Council, November 1, 1922
117. Ibid.
118. MTW papers, 147.
119. Ibid., 150–151.
120. Ibid., 152.
121. Ibid., 152–53. Wright wrote these lines in the early 1960s.
122. Ibid., 153.
123. Minutes of the Academic Council, February 13, 1923.

124. Ibid.
125. Minutes of the Academic Council, February 16, 1923.
126. Minutes of the Academic Council, April 4, 1923.
127. Student reaction to this decision is unknown. Dr. Muse, University Archivist, states because of the nature of student-run organizations, minutes of these organizations were not kept. The Archives does not have any minutes from the Student Council.
128. Minutes of the Academic Council, May 14, 1923.
129. MTW notes, typewritten, 69.
130. MTW papers, 162.
131. Minutes of the Academic Council, June 2, 1923.
132. Ibid. Just what was done beyond this is not indicated because no further minutes of the Academic Council were located. MTW Papers, typewritten, 69.
133. Ibid., 166.
134. *Hilltop*. 1, no.5, March 15, 1924.
135. Ibid., 1 no. 6, March 29, 1924.
136. Minutes of the Academic Council, April 16, 1924.
137. Ibid.
138. Minutes of the Academic Council, May 24, 1924.
139. Logan, ibid., 220.
140. Ibid.
141. Ibid., 221.
142. Weinberg, ibid., 323–324.
143. A month prior to the strike at Howard, Du Bois, ". . . as Chairman of the Executive Committee of the Intercollegiate Fisk Clubs, sent a telegram from the office of the *Crisis* urging the President and Trustees of Howard University to permit the seniors who were on strike at Fisk to enroll at Howard." Logan, ibid., 219.
144. Annual Report of the Dean of Women—1922–23, p. 5.
145. *On January 12*, 1927, Congress finally appropriated a fund of $150,000 for three dormitories for women. Logan, ibid., 255.
146. Annual Report of the Dean of Women—1922–23, 5.
147. http://www.pbs.org/ellingtonsdc/vtTheaters.htm.
148. Logan, ibid., 218.
149. Cultural Tourism—DC: Lincoln Colonnade. http://www.culturaltourismdc.org/info-url3948/info-url_show.htm?doc_id = 204988.
150. Explosion of recordings of African American musicians; Bessie Smith, Ida Cox, Joe "King" Oliver, Louis Armstrong, Jelly Roll Morton, Sidney Bechet, many others make their first recordings. http://www.alanskitchen.com/TRIVIA/Music/01-25/07-Year_Music_1923.htm.
151. Encyclopedia. The Free Dictionary: Films—1922. http://encyclopedia.thefreedictionary.com/1922%20in%20film.
152. "Correspondence to Miss Bernice Sanborn of the Institute of International Studies NYC from the Howard University Secretary of the President," November 8, 1926, Mordecai W. Johnson's Presidential Papers. Box S, Folder 1926–27. Correspondence: Office of the President Mordecai Johnson, Howard University Archives, Washington, DC.

153. Durkee to Slowe, June 7, 1923. Lucy Diggs Slowe Papers. Box 90-2, Folder 52; Manuscript Division, Moorland-Spingarn Research Center, Howard University.
154. Scott to Slowe, June 13, 1923. Lucy Diggs Slowe Papers. Box 90-2, Folder 90; Manuscript Division, Moorland-Spingarn Research Center, Howard University.
155. Memorials of the Teachers of the Academic Faculty to the Board of Trustees, November 15, 1924.
156. Dyson, ibid., 182.
157. Logan, ibid., 200.
158. Eventually she did get a telephone. Date unknown.
159. Logan, ibid., 231.
160. *Hilltop*, May 8, 1925.
161. Slowe to Durkee, June 17, 1923. Lucy Diggs Slowe Papers. Box 90-2, Folder 52; Manuscript Division, Moorland-Spingarn Research Center, Howard University.
162. There is no evidence that Durkee rescinded the order, nor is there evidence of the Cooks' moving.
163. *Howard University Record*, 86 (1923).
164. *Washington Tribune*, January 24, 1925. Lucy Diggs Slowe Papers. Box 90-11, Folder 207; Manuscript Division, Moorland-Spingarn Research Center, Howard University.
165. Slowe to Martha McAdoo, Executive Secretary, YWCA, January 13, 1925.
166. Wilkinson to Slowe, January 13, 1925. Lucy Diggs Slowe Papers. Box 90-4, Folder 99; Manuscript Division, Moorland-Spingarn Research Center, Howard University.
167. Slowe to Wilkinson, January 14, 1925. Lucy Diggs Slowe Papers. Box 90-4, Folder 99; Manuscript Division, Moorland-Spingarn Research Center, Howard University.
168. Editorial, *Washington Tribune*, January 24, 1925.
169. Gatewood, ibid., 12.
170. *Washington Tribune*, February 7, 1925.
171. Editorial, *Washington Tribune*, February 7, 1925.
172. Gatewood, ibid., 12.
173. *Chicago Defender (National edition)* (1921–1967); Jan.31, 1925; ProQuest Historical Newspapers.
174. Scott to Slowe, June 19, 1925. Lucy Diggs Slowe Papers. Box 90-2, Folder 90; Manuscript Division, Moorland-Spingarn Research Center, Howard University.
175. Slowe to Executive Committee of the Board of Trustees, June 20, 1925. Lucy Diggs Slowe Papers. Box 90-2, Folder 53; Manuscript Division, Moorland-Spingarn Research Center, Howard University.
176. Slowe to Executive Committee of the Board of Trustees, June 20, 1925. Lucy Diggs Slowe Papers, Box 90-2, Folder 53; Manuscript Division, Moorland-Spingarn Research Center, Howard University.
177. Wheaton, MA College. Archives: Histories, Officers, Deans. http://www2.wheatonma.edu/Archives/Histories/Officers/Deans.html.
178. Lawrence University. Milwaukee-Downer College: Milwaukee-Downer Woman: Mina Kerr. http://www.lawrence.edupubs/mdwoman/daily.shtml.

179. Lawrence University. Milwaukee-Downer College: About Traditions, http://www.lawrence.edu/about/trads/mdc.shtml.
180. Kerr to Durkee, June 26, 1925.
181. H. L. Horowitz, *Alma Mater: Design and Experiences in the Women's Colleges from Their Nineteenth-Century Beginnings to the 1930s*. (Amherst: University of Massachusetts Press, 2nd ed. 1984), 179–197.
182. Ibid., 181.
183. Ibid., 185.
184. Ibid., 187.
185. Walter Dyson, *Howard University, The Capstone of Negro Education: A History: 1867–1940*. (Washington: Graduate School, Howard University, 1941), 413–418.
186. Slowe to Durkee—undated. Referred to in Durkee's letter to Slowe, December 9, 1925. Lucy Diggs Slowe Papers. Box 90-2, Folder 52; Manuscript Division, Moorland-Spingarn Research Center, Howard University.
187. Ibid., 2.
188. Ibid., 3.
189. Durkee to Slowe, December 9, 1925. Lucy Diggs Slowe Papers. Box 90-2, Folder 52; Manuscript Division, Moorland-Spingarn Research Center, Howard University.
190. Logan, ibid., 187; Dyson, ibid., 397.
191. Logan, ibid., 238.
192. Dyson, ibid., 397.

Chapter 5

1. Logan, Ibid., 242–243.
2. Ibid., 248.
3. Ibid., 247–248.
4. Ibid., 249.
5. Ibid.
6. Even-Yisrael (Steinsalz). Translated by Dr. Isaac Y. Hayutman The HOPE: The Messiah Complex. http://members.tripod.com/~TheHOPE/mescompl.htm.
7. Logan, ibid., 250.
8. Ibid.
9. Clifford Muse, Howard University Archivist, personal conversation, August 2006.
10. Logan, ibid., 250.
11. Y. Moses (1997) "Black Women in Academe: Issues and Strategies," in L. Benjamin, (ed.), *Black Women in the Academy: Promises and Perils*, 23–37. (Gainesville, FL: University Press of Florida) Cited in Mary L. Grimes. 2005. "Re-Constructing the Leadership Model of Social Justice for African-American Women in Education" *Advancing Women in Leadership* Online Journal, 19 (2005). http://216.239.51.104/search?q. = cache:Hqy35KKVrJ4J:www.advancingwomen.com-fall2005/19_7.htl.
12. Robert B. Stepto, *Blue as the Lake: A Personal Geography*. Boston: Beacon, 1999, 130 in Jonathan S. Holloway, *Confronting the Veil: Abram Harris Jr.,*

Notes to Chapter 5

E. Franklin Frazier, and Ralph Bunche, 1919–1941 (Chapel Hill: University of North Carolina Press, 2002), 29.

13. Logan, ibid., 251.
14. Logan, ibid., 257.
15. Logan, ibid., 284.
16. Logan, ibid., 284–291.
17. Logan, ibid., 292.
18. Ibid.
19. Slowe to Johnson, April 10, 1929. Lucy Diggs Slowe Papers. Box 90-3, Folder 69; Manuscript Division, Moorland-Spingarn Research Center, Howard University.
20. Johnson to Slowe, April 11, 1929. Lucy Diggs Slowe Papers. Box 90-3, Folder 69; Manuscript Division, Moorland-Spingarn Research Center, Howard University.
21. Slowe to Johnson, January 30, 1930. Lucy Diggs Slowe Papers. Box 90-3, Folder 69; Manuscript Division, Moorland-Spingarn Research Center, Howard University.
22. The name of the student newspaper had been changed from *Hill Top* to *Hilltop*.
23. *Hilltop*, November 24, 1926.
24. Margaret J. Grooms, Lucy Diggs Slowe, First Dean of Women of Howard University 1922–1937. Typewritten. No date. Lucy Diggs Slowe Papers. Box 90, Folder 116; Manuscript Division, Moorland-Spingarn Research Center, Howard University.
25. Ibid., 2.
26. Ibid., 5.
27. MTW notes, typewritten 14.
28. Alice Jennings Archibald, Interview. Recorded by Rutgers Oral History Archives, March 14, 1997. http://oralhistory.rutgers.edu/Interviews/archibald_alice.html.

Permission granted by Sandra Stewart Holyoak, Director, March 7, 2011.

29. Slowe Memorandum on the Mills Case, undated. Lucy Diggs Slowe Papers. Box 90-5, Folder 116; Manuscript Division, Moorland-Spingarn Research Center, Howard University.
30. Logan, ibid., 201.
31. Clarence H. Mills, Letter to Dean Slowe January 11, 1927. Lucy Diggs Slowe Papers. Box 90-4, Folder 80; Manuscript Division, Moorland-Spingarn Research Center, Howard University.
32. Alton Pollard, III, Director of Black Church Studies, Candler School of Theology, Emory University, quoted in *NY Times National*, January 21, 2006.
33. Trudier Harris, ""The Yellow Rose of Texas": A Different Cultural View." *Callaloo*—20, no. 1 (1997) 8–19.
34. Mary H. Washington," Introduction." In Henry L. Gates, Jr., General E.d *The Schomburg Library of Nineteenth Century Black Women Writers: 40 Volume Set.* Anna J. Cooper. *A Voice from the South.* (Xenia, OH; Aldine, 1892). Republished. (NY: Oxford University Press, 1988): xlvii.

35. Slowe Memorandum on the Mills Case, 1 undated . . . Lucy Diggs Slowe Papers. Box 90-5,. Folder 116; Manuscript Division, Moorland-Spingarn Research Center, Howard University.

36. Ibid.

37. Clarence H. Mills to Slowe, January 13, 1927. Lucy Diggs Slowe Papers. Box 90-4, Folder 60; Manuscript Division, Moorland-Spingarn Research Center, Howard University.

38. Slowe Memorandum on the Mills Case, 2. Undated. Lucy Diggs Slowe Papers. Box 90-5, Folder 116; Manuscript Division, Moorland-Spingarn Research Center, Howard University.

39. Patricia Bell-Scott labels the Mills Case ". . . one of the earliest written accounts of sexual harassment involving Black women in the academy. . . ." Patricia Bell-Scott, "To Keep My Self-Respect: Dean Lucy Diggs Slowe's 1927 Memorandum on the Sexual Harassment of Black Women." *NWSA* (National Women's Studies Association) *Journal*, 9 no 2, summer (1997):71.

40. Slowe, Memorandum.

41. Logan, ibid., 256–7.

42. Slowe, Memorandum, 2.

43. Grooms, ibid., 7.

44. *Hilltop*, November 22, 1927.

45. Talladega College. History. http://www.talladega.edu/historyof the college. htm.

46. *Norfolk Journal and Guide*, n.d. Source: Talladega College Archives, Savery Library.

47. *Talladegan* 46, no.1, November (1927):11. Source: Talladega College Archives, Savery Library.

48. Ibid., 12.

49. Walter Dyson, *Howard University: The Capstone of Negro Education: A History: 1867–1940.* (Washington, DC: Howard University Graduate School, 1941), 414.

50. Jean Cazort, "Derricotte, Juliette," in *Black Women in America: An Historical Encyclopedia*, eds. Darlene C. Hine, Elsa B. Brown, and Rosalyn Terborg-Penn, (Bloomington, IN: Indiana University Press, 1993) 1:332.

51. Letter to President Johnson from Marion V. Cuthbert, January 27, 1930.

52. Maxine D. Jones and Joe M. Richardson. *Talladega College: The First Century.* (Tuscaloosa: University of Alabama Press, 1990), 282, Footnote 45. The *Talladega College Catalog*, 1934–35, 22, reported that Weekday and Sunday chapel attendance was required.

53. Slowe to Flexner, June 2, 1933. Lucy Diggs Slowe Papers. Box 90-3, Folder 58; Manuscript Division, Moorland-Spingarn Research Center, Howard University.

54. Grooms, ibid., 3–4. Lucy Diggs Slowe Papers. Box 90, Folder 116; Manuscript Division, Moorland-Spingarn Research Center, Howard University.

55. Esther Lloyd-Jones and Margaret R. Smith, *Student Personnel Work as Deeper Teaching* (New York: Harper, 1954), 122.

56. *Hilltop*, January 27, 1927.

57. *Hilltop*, October 7. 1927.

58. *Hilltop*, October 18, 1927.
59. Logan, ibid., 278.
60. Grooms, ibid., 2.
61. Kathleen Thompson, "Brown, Charlotte Hawkins (1881–1961)," in *Black Women in America: An Historical Encyclopedia*, ed. Hine et al. (Bloomington: Indiana University Press, 1994), 1:173.
62. Ibid.
63. *Hilltop*, November 7, 1929.
64. Slowe to Brown, April 27, 1937. Charlotte Hawkins Brown Collection. Folder A-146/M-92. Schlesinger Library, Radcliffe Institute for Advanced Study, Harvard University.
65. *Hilltop*, January 10, 1930.
66. Grooms, ibid., 2.
67. Logan, ibid., 280.
68. Grooms, ibid., 2.
69. http://nla.gov.au/nla.mus-an10836425.
70. *Hilltop*, April 30, 1930.
71. *Hilltop*, May 15, 1930.
72. Grooms, ibid., 5.
73. *Hilltop*, October 9, 1930.
74. See Chapter 3.
75. Grooms, ibid., 2.
76. Slowe Scrapbook, Lucy Diggs Slowe Papers. Box 90-13, Folder 234; Manuscript Division, Moorland-Spingarn Research Center, Howard University.
77. Scott W. Williams, Mathematics Department of the State University of New York at Buffalo. Special Articles: Robert Moats Miller. http://www.religin-online.org/showarticle.asp?title = 1933.
78. Report Smoking, YWCTU, March 4, 1925.
79. Logan, ibid., 282.
80. Ibid.
81. *Hilltop*, November 7. 1929.
82. Ibid., November 21, 1929.
83. Grooms, ibid., 5.
84. Ibid., 2.
85. Ibid.
86. Logan, ibid., 292.
87. Slowe to Johnson January 30, 1930. Lucy Diggs Slowe Papers. Box 90-3, Folder 70; Manuscript Division, Moorland-Spingarn Research Center, Howard University.
88. *Hilltop*, May 15, 1930.
89. http://www.uvm.edu/~dewey/articles/proged.html.
90. *Hilltop*, December 11, 1930.
91. Elizabeth Griego, "The Making of a 'Misfit': Clelia Duel Mosher 1869–1940" in *Lone Voyagers: Academic Women in Coeducational Institutions, 1870–1937*, ed. Geraldine J. Clifford, (New York: The Feminist Press at the City University of New York, 1989): 149–182.

92. Mary B. Ritter, *More Than Gold in California, 1849–1933*. (Berkley: Professional Press, 1933): 201–4, cited in Clifford, ed., ibid., 11.

93. Clifford, ed., ibid.

Chapter 6

1. *Afro-American*, March 21, 1931.

2. Scrapbook November 12, 1931, 1. Lucy Diggs Slowe Papers. Box 90-13, Folder 234; Moorland-Spingarn Research Center, Howard University.

3. *Bison*, 1931, 17.

4. Richard J. Herdlein, "Thyrsa Wealtheow Amos: The Dean of Deans," *NASPA Journal*, 41, no. 2, (2004): 344.

5. Slowe. Annual Report of the Dean of Women, 1930–31, 7.

6. The Mentor System was still in effect when the author, Anne S. Pruitt-Logan, was an undergraduate. She was elected toward the end of her junior year to be a mentor for freshman women beginning in the fall of 1948.

7. Daniel J. Grier, "The New Student Arrives at College" in *Student Personnel Work as Deeper Teaching*, eds. Esther Lloyd-Jones and Margaret R. Smith (New York: Harper, 1954), 46–61.

8. Annual Report of the Dean of Women—1930–31, 6.

9. Ibid.

10. Ibid., 11.

11. Carroll H. Miller, *Foundations of Guidance*. (New York: Harper, 1961), 45.

12. Annual Report of the Dean of Women—1930–31, 12–14.

13. Ibid., 14–15.

14. *Hilltop*, February 3, 1933.

15. Mordecai W. Johnson's Presidential Papers. Box S, Folder 1930–31 Correspondence: Office of the President Mordecai Johnson, Howard University Archives.

16. http://www.spartacus.schoolnet.co.uk/USAWmcdowell.htm.

17. Logan, ibid., 284.

18. Slowe to Johnson, February 28, 1931. Lucy Diggs Slowe Papers. Box 90-3, Folder 71; Manuscript Division, Moorland-Spingarn Research Center, Howard University.

19. Joanna Houston (Ransom) was assistant to Dean Slowe and instructor in English. (*Journal of The National Association of College Women*, VIV, 1937, 51.) Nine years earlier, she had also been Grand Basileus of Zeta Phi Beta Sorority. (http://www.uiowa.edu/-pbsigma/phherit/03.shtml).

20. Slowe to Johnson, March 17, 1931. Lucy Diggs Slowe Papers. Box 90-3, Folder 71; Manuscript Division, Moorland-Spingarn Research Center, Howard University.

21. Johnson to Slowe. Lucy Diggs Slowe Papers. Box 90-3, Folder 71; Manuscript Division, Moorland-Spingarn Research Center, Howard University.

22. Slowe to Johnson, March 24, 1931. Lucy Diggs Slowe Papers. Box 90-3, Folder 71; Manuscript Division, Moorland-Spingarn Research Center, Howard University.

Notes to Chapter 6

23. Slowe to Executive Committee, March 24, 1931. Lucy Diggs Slowe Papers. Box 90-3, Folder 71; Manuscript Division, Moorland-Spingarn Research Center, Howard University.

24. Commentary on this letter by Patricia Bell-Scott. Bell-Scott, Patricia. "The Business of Being Dean of Women: A Letter From Lucy Diggs Slowe to Howard University Board of Trustees," *NWSA Journal*, v. 9, no 2, summer 1997. 70–76. "The tone and content of this letter reflect Slowe's assertive personality, her commitment to women's education, and her demand for professional autonomy and equitable treatment."

25. The twenty-year program was officially titled the Twenty-Year Plan (Logan, ibid., 356–357). "The 'basic assumption underlying the twenty-year plan' was that in view of inequitable education for Negroes in the Southern states, 'the Federal Government ought to make up the differential in part by support of a National university for Negroes, that Howard University should be that university . . .' (Logan, ibid., 203–4). Representative Louis C. Cramton of Michigan, in 1928—a member of the Appropriations Committee—had played the leading role in the passage of the "Substantive Act of Congress"—H.R. 9635—authorizing annual Federal Appropriations to Howard University. Earlier, appropriations had to be authorized each year (Ibid.). The "twenty-year program" to which Slowe referred was captioned "The Twenty Year Plan"—a strategic plan for the University. It had been ". . . submitted by the Special Committee on Financial Support to the Board of Trustees on November 15, 1930. The report pointed out that an adequate financial program was a 'prime essential' for the future development of the University. . . . President Johnson, in his Annual Report for 1930–1931 to the Secretary of the Interior, had expressed on behalf of the Board of Trustees deepest appreciation to the Secretary of the Interior and to his associates in the Office of Education for the far-reaching 'twenty-year program' for Howard recently finished by that Office" (Logan, ibid., 273–4).

26. Slowe to Johnson, March 25, 1931. Lucy Diggs Slowe Papers. Box 90-3, Folder 71; Manuscript Division, Moorland-Spingarn Research Center, Howard University.

27. Dr. E. L. Parks had been appointed the first Dean of Men May 1919; Lucy Slowe's appointment was approved June 6, 1922. Logan, ibid., 198–199.

28. Grooms, ibid., 7.

29. Slowe to Amos. Lucy Diggs Slowe Papers. Box 90-3, Folder 23; Manuscript Division, Moorland-Spingarn Research Center, Howard University.

30. Slowe had also taken a course with Amos at Teachers College Columbia during the summer of 1930.Lucy Diggs Slowe Papers. Box 90-2, Folder 23; Manuscript Division, Moorland-Spingarn Research Center, Howard University.

31. Slowe to Amos, December 12, 1930. Lucy Diggs Slowe Papers. Box 90-3, Folder 23; Manuscript Division, Moorland-Spingarn Research Center, Howard University.

32. Amos to Slowe, December 17, 1930. Lucy Diggs Slowe Papers. Box 90-3, Folder 23; Manuscript Division, Moorland-Spingarn Research Center, Howard University.

33. Richard J. Herdlein, "Thyrsa Wealtheow Amos: The Dean of Deans," *NASPA Journal*, 41 (2004): 336–355.

34. Cassell to Johnson, March 13, 1931. Lucy Diggs Slowe Papers. Box 90-3, Folder 71; Manuscript Division, Moorland-Spingarn Research Center, Howard University.

35. Dyson, ibid., 141.

36. Smithsonian Anacostia Museum and Center for African American History and Culture. *The Black Washingtonians: The Anacostia Museum Illustrated Chronology*. (Hoboken, NJ: 2005), 348.

37. Logan, ibid., 269.

38. Lucy D. Slowe, On the Occasion of the Laying of the Comer Stone of the Women's Dormitories, Howard University, June 5, 1931. *Journal of the College Alumni Club Memorial Edition*, January 1939, 37–38.

39. Slowe to Members of the Faculty Women's Club, December 1, 1931. Lucy Diggs Slowe Papers. Series J, Box 90-5, Folder 109; Manuscript Division, Moorland-Spingarn Research Center, Howard University.

40. *Hilltop*, December 10, 1931.

41. Slowe. Annual Report of the Dean of Women 1931–32. Lucy Diggs Slowe Papers. Series K, Box 90-5, Folder 10; Manuscript Division, Moorland-Spingarn Research Center, Howard University.

42. Ibid., Significant Achievement in the Department of the Dean of Women, Howard University—1931–32.

43. Ibid., 17.

44. David L. Lewis, ibid., 289.

45. Miller to Johnson, February 9, 1932. Lucy Diggs Slowe Papers. Box 90-3, Folder 72; Manuscript Division, Moorland-Spingarn Research Center, Howard University.

46. Scott W. Williams, Mathematics Department of the State University of New York at Buffalo. Special Articles: Kelly Miller. http://www.math.buffalo.eduspecial/miller_kelly.html.

47. "In 1925, Howard conferred upon Mrs. Caldwell-Frazier the Honorary Degree of Master of Arts. She died in May 1929. On April 11, 1933, the Board voted that one of the new girls' dormitories be named in her honor. Those students, especially the young women who know of her dedication to the teaching profession and to civic activities, they wrote, must find inspiration—and perhaps motivation—in her distinguished career." Logan, ibid., 98, citing Rudolph, Frederick. *American College and University: A History*. New York: Knopf, 1962, 266–268, 331–334, 338–343.

48. Logan, ibid.

49. Slowe. Annual Report of the Dean of Women, 1931–32, 18.

50. *Afro-American*, August 20, 1932.

51. Dean of Women, Spelman College, to Slowe. November 12, 1931.

52. Hayes to Slowe, April 16, 1932.

53. American School & Society. About. http://www.asumag.com/about/#top.

54. Slowe to Hayes, April 20, 1932.

55. Scurlock Photo "Delegates of 16th Anniversary Session of National Association of Deans of Women visit Howard University. Lucy Diggs Slowe Papers. Box 90, Folder 15; Manuscript Division, Moorland-Spingarn Research Center, Howard University.

Notes to Chapter 6

56. "Howard University Sixty-Fifth Birthday: President Expresses Appreciation of Alumni Corporation," Mordecai W. Johnson's Presidential Papers. Box S, Folder 1932–33 Correspondence: Office of the President Mordecai Johnson, Howard University Archives.

57. Johnson to Slowe, December 12, 1931.

58. Slowe to Johnson, December 16, 1931.

59. Slowe to Johnson, December 16, 1931. Lucy Diggs Slowe Papers. Box 90-3, Folder 73; Manuscript Division, Moorland-Spingarn Research Center, Howard University.

60. University Council was a standing committee of the university of which the university president was chairman. *Annual Catalog of Howard University Washington, DC for 1931–1932 with Announcements for 1932–1933*, Vol. XI, No. 10, October 1932, 50.

61. There is no record of how the men on the Council responded. Clifford Muse, Howard University archivist, stated that the minutes of the University Council are not in the Archives.

62. Slowe to Johnson, February 25, 1932. Lucy Diggs Slowe Papers. Box 90-3, Folder 73; Manuscript Division, Moorland-Spingarn Research Center, Howard University.

63. Anne Pruitt-Logan interview of Barbara Brooks Jackson, long-time resident of Washington and Howard University graduate, January 27, 2006.

64. Raymond Wolters, *The New Negro on Campus: Black College Rebellions of the 1920s*. (Princeton: Princeton University Press, 1975) 71.

65. Houston to Johnson, May 19, 1932.

66. Ibid.

67. Slowe to Johnson, May 25, 1932. Lucy Diggs Slowe Papers. Box 90-3, Folder 73; Manuscript Division, Moorland-Spingarn Research Center, Howard University.

68. Johnson to Slowe, May 26, 1932.

69. Walter Dyson, *Howard University The Capstone of Negro Education: A History: 1867–1940*. (Washington, DC: The Graduate School, 1941): 68.

70. Presumably Tancil had been at West Virginia State College, per a letter from Tancil to Slowe, January 29, 1930. Lucy Diggs Slowe Papers. Box 90-8, Folder 169; Manuscript Division, Moorland-Spingarn Research Center, Howard University.

71. Slowe to Johnson, November 11, 1932. Lucy Diggs Slowe Papers. Box 90-3, Folder 73; Manuscript Division, Moorland-Spingarn Research Center, Howard University.

72. Slowe to Sturtevant, November 25, 1932.

73. Carolyn Terry, *"Stalwart Women": A Historical Analysis of Deans of Women in the South*. (New York: Teachers College Press, 1999), 101.

74. Dyson, ibid., 416.

75. Logan, ibid., 172.

76. Franklin, ibid., 280.

77. "The Story of the National Unfolds," *Journal of the National Association of College Women*, 18 (1941)10. Presumably NACW was citing T. Jones, (ed.) *Negro Education: A Study of the Private and Higher Schools for Colored People in the United States*. (New York: Arno Press and the New York Times 1917) 2 vols.

Notes to Chapter 6 385

78. Logan, ibid., 269–270.

79. Johnson to Slowe, July 5, 1932. Lucy Diggs Slowe Papers. Box 90, Folder 72; Manuscript Division, Moorland-Spingarn Research Center, Howard University.

80. "The struggle of the teachers of the University to secure adequate salaries, to forestall unjust reductions in salaries and to insure an equitable distribution of all money appropriated for salaries, was persistent. . . ." Dyson, ibid., 343

81. Flexner to Slowe, November 25, 1932.

82, Slowe to Johnson, December 1, 1932.

83. No date or newspaper indicated. Lucy Diggs Slowe Papers. Box 90-13, Folder 234; Manuscript Division, Moorland-Spingarn Research Center, Howard University.

84. Logan, ibid., 310.

85. http://reference.allrefer.com/encyclopediaFlexnerA.html.

86. "Annual Meeting, Board of Trustees," April 12, 1932 Minutes of the Board of Trustees Howard University, Washington, DC. February 1930–October 1936, Microfiche, Slide 2 of 5.

87. Logan, ibid., 310.

88. http://special.lib.umn.edu/findaidymca/yusa0007.phtml.

89. Logan, ibid., 293–294.

90. Logan, ibid., 195.

91. Johnson to Slowe, February 24, 1933. Lucy Diggs Slowe Papers. Box 90-3, Folder 73; Manuscript Division, Moorland-Spingarn Research Center, Howard University.

92. Slowe to Johnson, February 24, 1933. Lucy Diggs Slowe Papers. Box 90-3, Folder 73; Manuscript Division, Moorland-Spingarn Research Center, Howard University.

93. Flexner to Catlett. February 24, 1933.

94. Catlett to Flexner, not dated.

95. Editorial, Friday, March 24, 1933. Source not given. Vertical Files, Moorland-Spingarn Research Center, Howard University.

96. Slowe Memorandum to Board of Trustees, February 3, 1933.Lucy Diggs Slowe Papers. Box 90-5, Folder 113; Manuscript Division, Moorland-Spingarn Research Center, Howard University.

97. Johnson to Slowe, February 16, 1933.Lucy Diggs Slowe Papers. Box 90-3, Folder 73; Manuscript Division, Moorland-Spingarn Research Center, Howard University.

98. Logan, ibid., 290.

99. Slowe to Johnson, February 16, 1933. Lucy Diggs Slowe Papers. Box 90-3, Folder 73; Manuscript Division, Moorland-Spingarn Research Center, Howard University.

100. Slowe to Johnson, March 11, 1933. Lucy Diggs Slowe Papers. Box 90-3 Folder 73; Manuscript Division, Moorland-Spingarn Research Center, Howard University.

101. Logan, ibid., 200.

102. Lucy Diggs Slowe Papers. Box 90-5, Folder 113; This is the same letter as the March 24, 1931 letter. The 1933 letter, however, shows the handwritten date

of "March 24, 1933." Manuscript Division, Moorland-Spingarn Research Center, Howard University.

103. African American Registry. Jesse Moorland: Civic Leader and Much More. http://www.aaregistry.com/african_american_historyJesse_Moorland_civic_leader_and_much_ more.

104. A'Lelia Bundles, *On Her Own Ground: The Life and Times of Madam C. J. Walker*. (NY: Washington Square Press, 2001) 112.

105. Johnson to Slowe, March 27, 1933.

106. Slowe to Johnson April 3, 1933. Lucy Diggs Slowe Papers, Box 90-3, Folder 73; Manuscript Division. Moorland-Spingarn Research Center, Howard University.

107. In this letter, Dean Slowe has moved away from the genteel style used in earlier communications to somewhat more muscular language. Recall Johnson's ". . . anger, witnessed by many Administrators and Faculty members, was sometimes furious and frightening. . . ." (Logan, ibid., 250), and, indeed, it precipitated a like response from the Dean of Women.

108. Flexner to Slowe, April 7, 1933. This is Board interference with administration. It is not known if Johnson agreed with it.

109. Logan, ibid., 308–9.

110. Slowe to Flexner, April 8, 1933. Lucy Diggs Slowe Papers. Box 90-3, Folder 57; Manuscript Division, Moorland-Spingarn Research Center, Howard University.

111. Flexner to Slowe, April 14, 1933. Lucy Diggs Slowe Papers. Box 90-3, Folder 57; Manuscript Division, Moorland-Spingarn Research Center, Howard University.

112. Slowe to Flexner, April 18, 1933. Lucy Diggs Slowe Papers. Box 90-3, Folder 57; Manuscript Division, Moorland-Spingarn Research Center, Howard University.

113. Flexner to Slowe, April 24, 1933. Lucy Diggs Slowe Papers. Box 90-3, Folder 57; Manuscript Division, Moorland-Spingarn Research Center, Howard University.

114. It is also reasonable to assume that Slowe included in the materials she sent Flexner a book titled *The Dean of Women*, written by Lois Kimball Mathews. This book was the text used in the class she initiated at Howard to train deans. Margaret Jean Groomes, Lucy Diggs Slowe: First Dean of Women of Howard University 1922–1937, 4. (MSRC). Mathews published a book in 1915 titled *The Dean of Women*, based on her experiences at Madison. It is said to be the first guidebook of its kind. http://72.14.203.104univwisc?q = cache:tQExC2KqzGoJ:digicoll.library.wisc.edu/cgi-binUW-idx%3Ftype%3Dturn%26entity%3DUW001800180027%26isize%3Dtext++Dean+of+Women+Mathews&hl = en&gl = us&ct = clnk&cd = 1&ie = UTF-8. She had been Dean of Women and Associate Professor of History at the University of Wisconsin. Flexner cited Fisk University because it was a highly regarded—some would say, elite—coeducational institution attended by African Americans and was often thought of as on a par with Howard. It began as Fisk Free Colored School, one of several schools founded for freedmen during the Union military occupation of Nashville. In October of 1865, the American Missionary Association, the Western Freedmen's Aid Commission, and the U.S. Bureau

of Refugees, Freedmen, and Abandoned Lands opened the school to help fulfill the educational needs of freed slaves. http://www.tnstate.edu/library/digital/FISKU.HTM.

115. Flexner to Slowe, April 24, 1933. Lucy Diggs Slowe Papers. Box 90-3, Folder 57; Manuscript Division, Moorland-Spingarn Research Center, Howard University.

116. Flexner to Slowe, April 27, 1933. Lucy Diggs Slow Papers. Box 90-3, Folder 57; Manuscript Division, Moorland-Spingarn Research Center, Howard University.

117. Slowe to Flexner, draft letter, undated. Lucy Diggs Slowe Papers. Box 90-3, Folder 57; Manuscript Division, Moorland-Spingarn Research Center, Howard University.

118. Flexner to Slowe, May 11. 1933. Lucy Diggs Slowe Papers. Box 90-3, Folder 57; Manuscript Division, Moorland-Spingarn Research Center, Howard University.

119. *Afro-American*, Week of May 13, 1933, 1ff.

120. *Afro-American*, Week of May 13, 1933, 42 year, No. 32, 1 and 3.

121. Flexner to Slowe, May 12, 1933. Lucy Diggs Slowe Papers. Box 90-3, Folder 57; Manuscript Division, Moorland-Spingarn Research Center, Howard University.

122. Slowe to Flexner. Box 90-3, Folder 57; Manuscript Division. Moorland-Spingarn Research Center, Howard University.

123. Slowe to Johnson May 12, 1933. Lucy Diggs Slowe Papers. Box 90-3, Folder 57; Manuscript Division. Moorland-Spingarn Research Center, Howard University.

124. Young Women to Slowe, May 17, 1933.

125. Wilkinson to Slowe, May 19, 1933. Lucy Diggs Slowe Papers. Box 90-4, Folder 99; Manuscript Division. Moorland-Spingarn Research Center, Howard University.

126. *Washington Tribune*, October 26, 1933. Library of Congress Newspaper R M.

127. Scott, secretary of the Board, to Slowe, May 3. 1933.

128. Slowe to Flexner, May 6, 1933. Lucy Diggs Slowe Papers. Box 90-3, Folder 57; Manuscript Division, Moorland-Spingarn Research Center, Howard University.

129. Slowe to Carney, May 12, 1933. Lucy Diggs Slowe Papers. Box 90-2, Folder 37; Manuscript Division, Moorland-Spingarn Research Center, Howard University.

130. Carney also thanked Slowe for a newspaper clipping reporting that the Howard University "School of Education" would be demoted. She said Drs. O'Rear and Cottrell (Floyd B. O'Rear and Donald P. Cottrell) were associate professors at Teachers College, Columbia University. (Source: *Teachers College Bulletin 1932–33* per October 4, 2006 e-mail to Pruitt-Logan from Jeffrey Walker, Library Associate, Gottesman Libraries, Teachers College, Columbia University.) Dean Slowe had recommended that the College of Education continue and ultimately become a graduate division. Continuing, she wrote that according to O'Rear, Dr. Flexner favored this idea, and O'Rear did not understand why things had taken such a turn. The Trustees had adopted a plan for reorganization of the University on April 28, 1933 which was regarded as President Johnson's radical restructuring of the University (Logan,

ibid., 274). It ". . . was based. [in-part] upon a survey by two professors of Teachers College, Columbia University" [presumably O'Rear and Cottrell] as well as explorations done by a committee of the College of Liberal Arts in addition to recommendations from a special Trustee Committee of Reorganization (Ibid.,). Although the College of Education had been established by the board in 1919, this reorganization ". . . reduced it to a department of study in the School of Liberal Arts" (Dyson, ibid., 194). Among the other recommendations to come out of this reorganization plan was one "requiring" the President ". . . to make every effort possible to reduce the cost of administration and maintenance. . . ." (Logan, ibid., 175).

131. http://www.culturaltourismdc.org/info-url_show.htm?doc_id = 205004.

132. It is not known whether the university owned the Miller House at this time. Upon retirement Miller sold his house to the trustees of the university for $40,000. Kelly Miller was born in 1863. (Dyson, W., ibid., 371). He retired in 1934 at age 71. (Logan, ibid., 340).

133. Source of Cook address. May 12, 1933 letter from Mrs. Cook to Slowe. Lucy Diggs Slowe Papers. Box 90-2, Folder 40; Manuscript Division. Moorland-Spingarn Research Center, Howard University.

134. Slowe to Johnson, May 16, 1933.

135. Flexner to Slowe, May 18, 1933. Lucy Diggs Slowe Papers. Box 90-3, Folder 57; Manuscript Division, Moorland-Spingarn Research Center, Howard University.

136. Letter from Coralie Franklin Cook, May 12, 1933.

137. Etter-Lewis, in Hine et al., ibid., 1:63.

138. Bruce, To whom it may concern, May 15. 1933. At the time Bruce was Resident Manager of Paul Laurence Dunbar Apartments Inc. Lucy Diggs Slowe Papers. Box 90-2, Folder 33; Manuscript Division. Moorland-Spingarn Research Center, Howard University.

139. Letter from Sturtevant, May 15, 1933.

140. Ibid.

141. Slowe to Carney, May 11, 1933. Lucy Diggs Slowe Papers. Series F, Box 90-2, Folder 37; Manuscript Division, Moorland-Spingarn Research Center, Howard University.

142. Ibid., Carney to Slowe, May 31, 1933.

143. Slowe to Amos. Lucy Diggs Slowe Papers. Series F Box 90-2, Folder 23; Manuscript Division. Moorland-Spingarn Research Center, Howard University.

144. Amos on Slowe's work at Howard, May 19, 1933.

145. Slowe to Flexner, May 20, 1933. Lucy Diggs Slowe Papers. Box 90-3, Folder 57; Manuscript Division, Moorland-Spingarn Research Center, Howard University.

146. Logan, ibid., 285.

147. Logan, ibid., 287.

148. Logan, ibid., 288.

149. Logan, ibid., 285–292.

150. Flexner to Slowe, May 24, 1933. Lucy Diggs Slowe Papers. Box 90-3, Folder 57; Manuscript Division, Moorland-Spingarn Research Center, Howard University.

151. Slowe to Flexner, June 2, 1933. Lucy Diggs Slowe Papers. Box 90-3, Folder 57; Manuscript Division, Moorland-Spingarn Research Center, Howard University.

152. Young Women to Dean Slowe, June 9, 1933.

153. Logan, ibid., 273.

154. Dyson, ibid., 414.

155. Logan, ibid., 310.

156. NAACP. Academic Guides. http://www.lexisnexis.com/academic/guides-naacp16a.pdf#search = %22George%20W.%20Crawford%20and%20NAACP%2.

157. David L. Lewis, *W. E. B. Du Bois: Biography of a Race 1868–1919*. New York: Holt, 1993, 437.

158. Lewis, ibid., 530.

159. Logan, ibid., 292.

160. Letter from Corman re: conversation with Crawford, 633. Lucy Diggs Slowe Papers. Box 90, Folder 24; Manuscript Division, Moorland-Spingarn Research Center, Howard University.

161. Corman to Amos, June 16. 1933.

162. Amos to Slowe, June 19, 1933.

163. Slowe to Amos, June 30, 1933.

164. Slowe to Johnson, June 26, 1933. Lucy Diggs Slowe Box 90-5 Folder 73; Manuscript Division, Moorland-Spingarn Research Center, Howard University.

165. "Mrs. Allen" was perhaps Maryrose R. Allen, Head of the Department of Physical Education for Women who had been at the university since 1925 (Logan, ibid., 491). She resided at 603 Howard Place, Northwest. (*Annual Catalog 1934–35 with Announcements from 1935–1936*: Howard University, Washington, DC, 24). Professor Tibbs, no doubt, was Roy W. Tibbs, Head of the Department of Organ and Piano and a member of the faculty since 1912 (Logan, ibid, 383). His residence was 601 Howard Place, Northwest. (*Annual Catalog 1934–35 with Announcements from 1935–1936*: Howard University, Washington, DC, p. 20).]

166. Flexner to Slowe, July 8, 1933. Lucy Diggs Slowe Papers. Box 90-3, Folder 57; Manuscript Division, Moorland-Spingarn Research Center, Howard University.

167. Slowe to Moorland, July 5. 1933.

168. Moorland to Slowe, July 10, 1933.

169. Slowe to Crawford. August 17, 1933.

170. Regarding Dr. Slowe—no information could be located concerning this brother. It could have been either John, Coltrop, Preston, or William.

171. Letter from Clyda Jane Williams, August 23, 1933.

172. Patricia Hill Collins, in Hine et al. eds., ibid., I:419.

173. *Afro-American*, July 22, 1933.

174. Logan, ibid., 284–285.

175. Slowe to Moorland, August 3, 1933.

176. Slowe to Johnson, August 18. 1933. Lucy Diggs Slowe Papers. Box 90-3, Folder 73; Manuscript Division, Moorland-Spingarn Research Center, Howard University.

177. Slowe to Johnson, September 22, 1933. Lucy Diggs Slowe Papers. Box 90-3, Folder 73; Manuscript Division, Moorland-Spingarn Research Center, Howard University.

390 Notes to Chapter 6

178. Letter from Atwood September 25, 1933. Lucy Diggs Slowe Papers. Box 90-2, Folder 25; Manuscript Division. Moorland-Spingarn Research Center, Howard University.

179. Maryland State Archives. The First Colored Professional, Clerical and Business Directory of Baltimore City, 11th Annual Edition, 1923–1924, v. 503, p. 92. Faculty Dunbar High School: Miss Charlotte Atwood. http://www.mdarchibes.state.md.us/megafilespeccol/sc2908/000001/000503am503—92.html.

180. Atwood, ibid.

181. Wright to Tobias, October 11, 1933.

182. Wright had graduated from Howard in 1927 and accepted an appointment as an instructor in education the following year. At the time of this letter she was residing in New Jersey and studying full-time at Columbia University. (Daniel, Walter. "A Tribute to Marion Thompson Wright: A Valedictory Note," *Journal of Negro Education* 32 (1963): 308–310.

183. Holmes to Flexner, October 4, 1933. Lucy Diggs Slowe. Papers. Box 90-3, Folder 59; Manuscript Division, Moorland-Spingarn Research Center, Howard University.

184. Flexner to Holmes, October 11, 1933. Lucy Diggs Slowe Papers. Box 90-3, Folder 59; Manuscript Division, Moorland-Spingarn Research Center, Howard University.

185. Williams to Flexner, October 18, 1933. Lucy Diggs Slowe Papers. Box 90-3, Folder 59; Manuscript Division, Moorland-Spingarn Research Center, Howard University.

186. Flexner to Williams, October 20, 1933. Lucy Diggs Slowe Papers. Box 90-3, Folder 59; Manuscript Division, Moorland-Spingarn Research Center, Howard University.

187. *Hilltop*, September 25, 1933.

188. *Washington Tribune*, October 19, 1933.

189. *Hilltop*, October 27. 1933.

190. *Hilltop*, February 16, 1934.

191. Slowe Memorandum on Department of the Dean of Women, October 9, 1933.

192. NACW Minutes of the Executive Committee, October 14. 1933.

193. NACW to Board of Trustees. Howard University, October 17, 1933.

194. Ibid.

195. Elaine M. Smith, "Bethune, Mary McLeod (1875–1955)" in Hine et al., eds. ibid., 1:118.

196. Smith, ibid., 121.

197. Dyson, ibid., 415.

198. Lewis, ibid., 486.

199. Lewis, ibid., 547.

200. Encyclopedia.Com. Dr. James Hardy Dillard. http://www.encyclopedia.comD/Dillard.asp.

201. Bethune to Slowe, November 18, 1933. Lucy Diggs Slowe Papers. Box 90-2, Folder 28; Manuscript Division, Moorland-Spingarn Research Center, Howard University.

202. Slowe to Bethune, November 20, 1933. Lucy Diggs Slowe Papers. Box 90-2, Folder 28; Manuscript Division, Moorland-Spingarn Research Center, Howard University.

203. Bethune to Slowe, November 29. 1933. Lucy Diggs Slowe Papers. Box 90-2, Folder 28; Manuscript Division, Moorland-Spingarn Research Center, Howard University.

204. Slowe to Bethune. November 29, 1933. Lucy Diggs Slowe Papers. Box 90-2, Folder 28; Manuscript Division, Moorland-Spingarn Research Center, Howard University.

205. For inner-directed woman, see Renita J.Weems, *What Matters Most: Ten lessons in Living Passionately from the Song of Solomon.* (New York: Warner, 2004): 96–97.

206. Annual Report of the Dean of Women, 1932–33.
207. Ibid., 1.
208. Summary, Annual Report of the Dean of Women, 1932–33.
209. *Howard University Bulletin* XI, no. 1 (1932): 31.
210. Ibid., 22.
211. *Hilltop*, October 27, 1932.
212. *Hilltop*, October 27, 1932.
213. District of Columbia Public Library. Biographies: Sterling A. Brown. http://www.dclibrary.org/blkrenbrownsa.html.
214. *Hilltop*, November 10, 1932.
215. Annual Report of the Dean of Women, 1932–33, 19.
216. Slowe is credited as a driving force in the creation of the Howard University School of Social Work. Social work Web site.
217. Annual Report of the Dean of Women, 1933–34, 1–2.
218. Ibid., 4.
219. Ibid., 7.
220. Ibid.
221. Ibid., 31.
222. Ibid., 25–26.
223. Ibid., 26–28.

Chapter 7

1. Slowe to Johnson, January 6, 1934. Lucy Diggs Slowe Papers. Box 90-3, Folder 74; Manuscript Division, Moorland-Spingarn Research Center, Howard University.

2. The Dining Hall reverted to its status as a student center until the University Center (Blackburn) was built.

3. Logan, ibid., 290.

4. Houston to Slowe, January 3, 1934. Lucy Diggs Slowe Papers. Box 90-3, Folder 65; Manuscript Division, Moorland-Spingarn Research Center, Howard University.

5. Slowe to Johnston, January 11. 1934.

392 Notes to Chapter 7

6. Slowe to Tobias, March 6, 1934. Lucy Diggs Slowe Papers. Box 90-2, Folder 94; Manuscript Division, Moorland-Spingarn Research Center, Howard University.

7. Slowe to Tobias, August 4, 1934. Lucy Diggs Slowe Papers. Box 90-2, Folder 94; Manuscript Division, Moorland-Spingarn Research Center, Howard University.

8. Logan, ibid., 292.

9. Slowe to Sturtevant, May 4, 1934. Lucy Diggs Slowe Papers. Box 90-2, Folder 92; Manuscript Division, Moorland-Spingarn Research Center, Howard University.

10. Slowe to Thomas Jesse Jones, April 2. 1936. Lucy Diggs Slowe Papers. Box 90-3, Folder 75; Manuscript Division, Moorland-Spingarn Research Center, Howard University.

11. Jones to Slowe, June 1, 1936. Lucy Diggs Slowe Papers. Box 90-3, Folder 75; Manuscript Division, Moorland-Spingarn Research Center, Howard University.

12. Slowe to Johnson, October 3, 1934. Lucy Diggs Slowe Papers. Box 90-3, Folder 74; Manuscript Division, Moorland-Spingarn Research Center, Howard University.

13. Annual Report of the Dean of Women, 1934–35, p. 3.

14. Ella Murphy to Slowe, March 25, 1936. Lucy Diggs Slowe Papers. Box 90-3, Folder 82; Manuscript Division, Moorland-Spingarn Research Center, Howard University.

15. Slowe to Moorland, May 27, 1936. Lucy Diggs Slowe Papers. Box 90-3, Folder 81; Manuscript Division, Moorland-Spingarn Research Center, Howard University.

16. Logan, ibid., 288.

17. *Washington Tribune*, March 16, 1935, p. 1.

18. Logan, ibid., 303.

19. Logan, ibid., 297.

20. Logan, ibid., 310.

21. Logan, ibid., 299.

22. Scott to Slowe, April 20, 1935. Lucy Diggs Slowe Papers. Box 90-4, Folder 90; Manuscript Division, Moorland-Spingarn Research Center, Howard University.

23. Logan, ibid., 310, 303.

24. Logan, ibid., 292.

25. Slowe to the Finance Committee, January 15, 1936. Lucy Diggs Slowe Papers. Box 90-3, Folder 74; Manuscript Division, Moorland-Spingarn Research Center, Howard University.

26. Scott to Slowe, April 24, 1936. Lucy Diggs Slowe Papers. Box 90-4, Folder 90; Manuscript Division, Moorland-Spingarn Research Center, Howard University.

27. *Washington Tribune*, April 24, 1936.

28. Parks' retirement year is not noted by Dyson, but it is presumed to be 1926. Dyson, ibid., 356.

29. Frederick S. Weaver, "Johnston Alone in Fight For High Fees At H.U.; Under Fire By Committee for Rate Raise: Deans of Schools and Colleges at HU Take Lead in Protesting Rise in Student Fees for Room and Board," *Washington Tribune*, April 24, 1936.

30. Slowe to Bryan, April 29, 1936. Lucy Diggs Slowe Papers. Box 90-2, Folder 33; Manuscript Division, Moorland-Spingarn Research Center, Howard University.

31. *Hilltop*, November 2, 1934, p. 1.
32. National Park Service, U.S. Department of the Interior. Civil Rights: Dunbar Apartments. http://www.cr.nps.govtravel/civilrights/ny2.html.
33. Home to Harlem.Com. Harlem: History. http://www.hometoharlem.com/HARLEM/hthcult.nsf/harlem/HarlemHistorydoc.
34. Ibid., http://www.hometoharlem.com/HARLEM/hthcult.nsf/harlem/Harlem Hisotrydoc.
35. *Hilltop*, November 17, 1934 "Dean Slowe At Forum November 11: Open House Discussion Followed Address," Lucy Diggs Slowe Papers. Series N, Box 90-11, Folder 215; Moorland-Spingarn Research Center, Howard University.
36. *Hilltop*, November 28, 1934.
37. *Hilltop*, February 15, 1935.
38. *Hilltop*, November 13, 1935.
39. Daisy Douglas, Class of 1938, interviewed by Anne S. Pruitt-Logan February 9, 2008.
40. Slowe to Mrs. Howard Thurman, December 14, 1935. Lucy Diggs Slowe Papers. Box 90-4, Folder 93; Moorland-Spingarn Research Center, Howard University.
41. Fernanda Perrone, Biographical Sketch of Frances Grant. MC 671, Special Collections and University Archives, Rutgers University Libraries. http://www2.scc.rutgers.edumanuscripts/grantb.html.
42. Soleman Abu-Bader, Howard University School of Social Work. About the School of Social Work—History of Social Work Education at Howard University. http://www.howard.edu/schoolsocialworkabout.html.
43. Report, Student Christian Conference, Howard University, December 4–6, 1936, 2 pages typewritten.
44. Howard University Library System. Divinity Library. Home: Dr. Howard Thurman, 1900–1981. http://www.howard.edu/library/Divinity_Library/thurman.htm.
45. Thurman resigned from Howard in 1946 because of a "blunt remark" by President Johnson: in an unidentified meeting Rayford Logan attended ". . . Howard University was not to be '. . . used as a basis of operations.' Persons in the employ of the University owed their primary obligation to Howard." After the meeting, Thurman said Johnson was talking about him. Logan, ibid., 379.
46. Program, Mother-Daughter Banquet, March 6, 1936. Lucy Diggs Slowe Papers, Box 90-13, Folder 234; Manuscript Division, Moorland-Spingarn Research Center, Howard University.
47. Grooms, ibid., Lucy Diggs Slowe Papers. Box 90, Folder 116; Manuscript Division, Moorland-Spingarn Research Center, Howard University.
48. *Washington Tribune*, April 3, 1936.
49. *Hilltop*, November 11, 1936.
50. *Washington Tribune*, November 13, 1936.
51. *Evening Star*, October 9, 1937.
52. Copy of the Invitation to the Dean's Garden Party. Lucy Diggs Slowe Papers, Box 90-5, Folder 109; Manuscript Division, Moorland-Spingarn Research Center, Howard University.
53. Thank you note, Amos to Slowe June 19, 1933. Lucy Diggs Slowe Papers. Box 90-2, Folder 24; Manuscript Division, Moorland-Spingarn Research Center, Howard University.

54. Grooms, ibid. Lucy Diggs Slowe Papers. Box 90, Folder 116; Manuscript Division, Moorland-Spingarn Research Center, Howard University.

55. Helen L. Horowitz, *Campus Life: Undergraduate Cultures from the End of the Eighteenth Century to the Present* (New York: Knopf, 1987).

56. H. Whyte Cameron to Slowe, October 24, 1936. Lucy Diggs Slowe Papers. Box 90-2, Folder 37; Manuscript Division, Moorland-Spingarn Research Center, Howard University.

57. Slowe to Cameron, November 20, 1936. Lucy Diggs Slowe Papers. Box 90-2, Folder 37; Manuscript Division, Moorland-Spingarn Research Center, Howard University.

58. Alexander to Slowe, November 24, 1936. Lucy Diggs Slowe Papers. Box 90-2, Folder 22; Manuscript Division, Moorland-Spingarn Research Center, Howard University.

59. Annual Report of the Dean of Women, 1934–35, p. 6.

60. Mrs. Holmes was the wife of her mentor, Dwight O. W. Holmes; Benjamin Brawley who had been considered one of the "noteworthy" scholars at Howard, "master teacher of English and author of note," had resigned from the University in 1912, per Logan, ibid., 140, 168. Born in 1882 he was an historian and literary critic. http://www.answers.com/topic/benjamin-brawley)

61. Ibid., 8.

62. Ibid., 12–13.

63. Ibid., 15–17.

64. Freedmen's Hospital, located on the grounds of Howard University, had been established during the Civil War to address the needs of thousands of African Americans who poured into the city seeking freedom. An initiative of the federal government, it was later incorporated into Howard University. (Logan, ibid., 121–122.)

65. Annual Report of the Dean of Women (Abstract) 1935–36, 1–3.

66. Annual Report of the Dean of Women—1936–37, 1–4.

67. Ibid., 1–4.

68. United States Department of Labor. Secretary Frances Perkins. http://www.dol.govfrances/frances.html.

69. Annual Report of the Dean of Women. 1936–1937, 22–23.

70. Ibid., 25–29.

71. Sydney H. Barksdale, 2007. "The Untold Story: African American Women Administrators' Alchemy of Turning Adversity into Gold." *Forum on Public Policy Online.* v.2007, no1. http://forumonpublicpolicy.com/archive07/barksdale.pdf.

72. Slowe, memorandum to Miss Beatrice Clark, May 22, 1936. Lucy Diggs Slowe Papers. Box 90-1, Folder 4; Manuscript Division, Moorland-Spingarn Research Center, Howard University.

73. *Evening Star,* Feb 13, 1937.

74. She was buried at Lincoln Memorial Cemetery, Washington, DC. *Evening Star,* ibid. Lucy Diggs Slowe Papers. Series E Box 90-1. Moorland-Spingarn Research Center, Howard University.

75. Slowe to Houston, July 27, 1937. Lucy Diggs Slowe Papers. Box 90-3, Folder 65; Manuscript Division, Moorland-Spingarn Research Center, Howard University.

76. Logan, ibid., 338.

77. Holmes to Slowe. Lucy Diggs Slowe Papers. Box 90-3, Folder 64; Manuscript Division, Moorland-Spingarn Research Center, Howard University.

78. This information could not be verified. Searches were made of Minutes of the Board of Trustees, Howard University, Washington, DC April 1937–October 1940 [Microfiche], Minutes of the Executive Committee/Board of Trustees, Howard University Washington, DC, January 1934 to December 1937 (Inclusive) [Microfiche], and Minutes of the Executive Committee of the Board of Trustees September 1931 to June 13, 1941 [Microfiche]. The sources listed above are all the pertinent Trustee minutes in the University Archives.

79. Johnson to Slowe, August 20, 1937. Lucy Diggs Slowe Papers. Box 90-3, Folder 74; Manuscript Division, Moorland-Spingarn Research Center, Howard University.

80. Slowe to Johnson, August 25, 1937. Lucy Diggs Slowe Papers. Box 90-3, Folder 74; Manuscript Division, Moorland-Spingarn Research Center, Howard University.

81. The more intimate details of her last days are from Marion Thompson Wright's notes.

82. *Afro-American*, DC edition, September 18, 1937. Note: pleurisy is inflammation of the membranes surrounding the lungs.

83. Mayo Clinic Staff. Mayo Clinic: Pleurisy. http://www.mayoclinic.com/health/pleurisy/DS00244/DSECTION = 2.

84. *Afro-American*, October 16, 1937, 1.

85. Registrar of Wills for the District of Columbia, Clerk of Probate Court, District Court of the United States for the District of Columbia.

86. *Evening Star*, Oct. 22, 1937.

87. Ibid.

88. Statement of Marion T. Wright, 1961, 4.

89. Marion T. Wright, "Slowe, Lucy Diggs" in Edward T. James (ed.) *Notable American Women 1607–1950: A Biographical Dictionary* (Cambridge, MA: Belknap, 1971) 3:300.

90. *Washington Star*, Oct. 23, 1937. Howardiana Vertical File, Morgan-Spingarn Research Center, Howard University.

91. Bethune to Vivian J. Cook, October 22, 1937. Vivian Johnson Cook Papers. Box 191-19, Folder 4; Manuscript Division, Moorland-Spingarn Research Center, Howard University.

92. Carol Smith-Rosenberg. "The Female World of Love and Ritual: Relations between Women in Nineteenth-Century America." *Signs* 1 (1975): 24. "Eighteenth- and nineteenth-century women . . . lived in emotional proximity to each other. Friendships and intimacies followed the biological ebb and flow of women's lives. Marriage and pregnancy, childbirth and weaning, sickness and death involved physical and psychic trauma which comfort and sympathy made easier to bear. Intense bonds of love and intimacy bound together those women who, offering each other aid and sympathy, shared such stressful moments."

93. Manuscript Division, Moorland-Spingarn Research Center, Howard University. Box 90-1, Finding Aid, scope note, p. 2.

94. Lucy Diggs Slowe Papers. Box 90-1, Folder 2 A-E; Manuscript Division, Moorland-Spingarn Research Center, Howard University

396 Notes to Chapter 8

95. Ibid.
96. Ibid.
97. Dwight O. W. Holmes. "*Eulogy . . . at the Obsequies of Lucy D. Slowe*" (Washington, DC: Susie B. Green, Printer, 1214 U Street).
98. Lucy Diggs Slowe Papers. Box 90-1, Folder 2; Manuscript Division, Moorland-Spingarn Research Center, Howard University.
99. Ibid.
100. Ibid.
101. In tennis, Slowe's favorite sport, the final point needed to win a match.
102. *Howard University Alumni Journal*, 3 (Special Winter Issue 1937–38).
103. Ibid.
104. Editorial, *Hilltop*, October 27, 1937.
105. *Afro-American*, Washington DC edition, October 30, 1937.
106. Statement of Marion T. Wright—1961, 4.
107. Geraldine J. Clifford, citing Sandra Aker, "Women, The Other Academics," *Women's Studies International Forum* 6 (1983): 194.
108. Clifford, ibid., 28.

Chapter 8

1. *Hilltop*, Dec. 11, 1930. Typewritten, 2. Lucy Diggs Slowe Papers. Box 1, Folder Biographical Data 1; Manuscript Division, Moorland-Spingarn Research Center, Howard University.
2. Scrapbook. Lucy Diggs Slowe Papers. Box 90-13, Folder 234; Manuscript Division, Moorland-Spingarn Research Center, Howard University.
3. See speeches in Chapter 9.
4. Lucy Diggs Slowe Papers. Box 1, Folder 26; Manuscript Division, Moorland-Spingarn Research Center, Howard University.
5. "Address Delivered by Soror Lucy D. Slowe at the Annual A.K.A. Boule Banquet," *The Ivy Leaf* 11 (1933): 19–20. AKA Archives, Moorland-Spingarn Research Center, Howard University.
6. *Washington Tribune*, Feb. 13, 1931. Lucy Diggs Slowe Papers. Box 90-13, Folder 234; Manuscript Division, Moorland-Spingarn Research Center, Howard University.
7. Executive secretary in a tribute at the time of Dean Slowe's death; printed in *NADW 1931 Yearbook*, 111–112; per Ann Bowers, Center for Archival Collections, 5th Floor, Jerome Library, Bowling Green State University, Bowling Green, Ohio 43403.
8. Slowe to Irma E. Voigt, November 29, 1933.
9. Slowe to Ms. Leslie Blanchard, November 11, 1936.
10. Carolyn T. Bashaw, "*Stalwart Women:*" *A Historical Analysis of Deans of Women in the South*. (New York: Teachers College Press, 1999): 100.
11. Ibid., 106.
12. K. G. Heath (1975). Our heritage speaks (Audiotape of speech delivered at the annual meeting of NAWDAC, 1975). Bowling Green, OH: Bowling Green State University.

13. Kathryn Heath to Slowe, January 7. 1937.

14. It is not known what year this occurred. L. Eisenmann, "A Time of Quiet Activism: Research, Practice, and Policy in American Women's Higher Education, 1945–1965." *History of Education Quarterly*, Spring 45 (2005): 16. http:www.historycooperative.org/journals/heqeisenmann.html. Citing Ruth Brett, Edna Calhoun, Lucille Piggot, Hilda Davis and Patricia Bell-Scott. "A Symposium: Our Living History: Reminiscences of Black Participation in NAWDAC," *Journal of the National Association of Women Deans, Administrators, and Counselors* 33(2) (Winter 1979): 49–51.

15. Ann B. Cook to Slowe, November 14, 1936.

16. Lucy Diggs Slowe Papers. Box 90-10, Folder 193; Manuscript Division, Moorland-Spingarn Research Center, Howard University.

17. Author not indicated—Two-page typed statement—not dated. Lucy Diggs Slowe Papers. Box 90-10, Folder 193; Moorland-Spingarn Research Center, Howard University,

18. Slowe to Ruth Bartholomew, February 26, 1937.

19. Slowe to Heath, April 3, 1937.

20. *Hilltop*, May 15, 1930.

21. Grooms, ibid., 4.

22. Lucy Diggs Slowe Papers. Box 90-2, Folder 23; Manuscript Division, Moorland-Spingarn Research Center, Howard University.

23. Diana R. Maul, Registrar, Teachers College, Columbia University, to Anne S. Pruitt-Logan, March 21, 2006.

24. *Teachers College Bulletin 1927–28*, p. 116–118; *Teachers College Bulletin 1929–30*, p. 137–140; *Teachers College Bulletin, 1931–32*, pp. 122–126.

25. *Hilltop*, May 14, 1931.

26. Arthur I. Gates, Esther Hemke, and Dorothy Van Alstyne. Problems in Beginning Reading: Suggested by an Analysis of Twenty-one Courses. *Teachers College Record*. 26 Number 1, (1925): 572–591. http://www.tcrecord.org ID Number: 5978.

27. Bartleby.com. Progressive Education. http://www.bart;eby.compr/progrsved.html.

28. Slowe to Washington, Wilberforce University, January 13, 1931.

29. Slowe to Whiting, Virginia State College, January 27, 1931.

30. St. Lawrence County, NY Branch of the American Association of University Women: Women of Courage: Potsdam Normal School—Pioneer Women Educators—Patience Haggard. http://www.northnet.org/stlawrenceaauw/normal.htm.

31. Slowe to Haggard, State Normal School, Potsdam, New York, December 29, 1931.

32. Slowe to Roma Hawkins, January 12, 1932.

33. Slowe to Juanita Sadler, November 16, 1933.

34. Slowe to Dean of Women, University of Arizona, December 5, 1933.

35. Slowe to Dean Willie M. King, October 2, 1931.

36. Slowe to Dean of Women, Southern U., February 7, 1933.

37. Dean of Women, University of Arizona, to Slowe May 3, 1933.

38. Slowe to Dean of Women, University of Arizona, May 9, 1933.

39. Meyer Weinberg, *A Chance to Learn: The history of race and education in the United States*. (Cambridge: Cambridge University Press, 1977): 300.
40. Quoted in Weinberg, ibid., 302 from *New York Age*, June 24, 1922.
41. Franklin to Slowe, November 7, 1930.
42. Source of both letters Lucy Diggs Slowe Papers. Box 90-3, Folder 60; Moorland-Spingarn Research Center, Howard University.
43. Slowe to Dean Franklin, November 12, 1933.
44. Ibid.
45. Bettye Collier-Thomas, "National Council of Negro Women," in *Black Women in America: An Historical Encyclopedia*, ed. Hine et al. (Bloomington: Indiana University Press, 1994), 2:854.
46. *National Association of College Women Journal*, 7 (1941).
47. Cromwell Family Papers—24. Box 8, Folder 90; Moorland-Spingarn Research Center, Howard University.
48. Ibid.
49. Lucy D. Slowe, "The Future of the Association of College Women," *Journal of the College Alumnae Club*, (1939): 17–20.
50. "A Report of the Activities and Findings of the Committee on Standards, National Association of College Women, 1923–1933." *Journal of the National Association of College Women*, 18 (1941): 74.
51. Ibid., 10.
52. David L. Lewis, ibid., 546–547.
53. First Annual Meeting—1924—National Association of College Women.
54. Logan, ibid., 206.
55. She remained on the Board for 24 years. Logan, ibid., 209.
56. "Baltimore Sets Up Her Own," *Journal of the National Association of College Women*, 18 (1941): 25.
57. "The Story of the National Unfolds," *Journal of the National Association of College Women*, 18 (1941): 9.
58. *Howard Alumnus*, 3 (1925):149.
59. "The College Woman and Her Community" was also given at Atlanta University, April, 1934 and published in the *Journal of College Alumnae Clubs* (1939): 20–21.
60. "The Story of the National Unfolds," *Journal of The National Association of College Women*, 18 (1941): 14.
61. Slowe to Anna J. Cooper, April 21, 1925.
62. Louise D. Hutchinson, "Cooper, Anna Julia Haywood." In Darlene Clark Hine, Elsa Barkley Brown, and Rosalyn Terborg-Penn (eds.), *Black Women in America: An Historical Encyclopedia*, (Bloomington, IN: Indiana University Press, 1994), 1:279–280.
63. Ibid. 281.
64. Ibid., 280.
65. Anna J. Cooper, *A Voice from the South*. (Xenia, OH: Aldine, 1892.) Henry L. Gates, Jr., General ed. *Republished Schomburg Library of Nineteenth-Century Black Women Writers* (New York: Oxford University Press, 1988).
66. *World*—April 26, 1926.
67. *Washington Tribune*, May 6, 1927.

68. "Negro Women Seek to Better College Living—National Association Begins Campaign for More Desirable Conditions at Universities." *Washington Tribune*, May 6, 1927.

69. "North Jersey Scenes Unfold," *Journal of the National Association of College Women*, 18 (1941): 27.

70. "The Story of the National Unfolds," *Journal of the National Association of College Women*, 18 (1941): 16.

71. Slowe to Hoover, January 15, 1930. Lucy Diggs Slowe Papers. Box 90-3, Folder 64; Manuscript Division, Moorland-Spingarn Research Center, Howard University.

72. Lewis, ibid., 522.

73. Franklin, ibid., 315.

74. Global Security.org. Military. http://www.globalsecurity.org/militaryhaiti19.htm.

75. Franklin, ibid., 315.

76. Ibid.

77. Slowe to President Herbert Hoover, January 15, 1930.

78. Lawrence Rickey to Slowe, January 17, 1930.

79. Slowe to J. Hayden Johnson, June 20, 1930.

80. Explore DC.org. Dr. J. Hayden Johnson. http://www.exploredc.org/index.php?id = 310.

81. Slowe to J. Hayden Johnson, ibid., 2.

82. College Alumnae Club to J. Hayden Johnson, June 20, 1930.

83. No record of Hayden's response was found.

84. Minutes of the Executive Committee, NACW, February 14, 1931.

85. Officers and Chairmen of the National Association of College Women During the Years from 1924–1941, *Journal of the National Association of College Women*, 18 (1941): 72.

86. 2 Souls.com. Knowledge Warehousr: Ambrose Caliver. http://www.2souls.comKnowledge%20Warehouse/Caliver/caliver.htm.

87. New Deal Network. Selected Writings of Eleanor Roosevelt. The National Conference on the Education of Negroes. Originally printed in *Journal of Negro Education* 3 (October 1934): 573–575. http://newdeal.feri.orger04.htm.

88. Minutes, Executive Committee, NACW, February 9, 1935.

89. Minutes of the 8th Annual Meeting of NACW, St. Louis, MO, April 4–6, 1931.

90. Minutes of the Executive Committee, NACW, February 12, 1932.

91. University of Pittsburg. Minority Health Archive. Sandra C. Quinn and Stephen B. Thomas. The National Negro Health Week, 1915 to 1951: A Descriptive Account. http://minority-health.pit.edu/archive/00000541National_Health_Week.pdf.

92. Minutes of the Executive Committee, NACW, November 19, 1932.

93. Minutes of the Executive Committee, NACW, February 10, 1934.

94. NEA-National Education Association. NEA Timeline. http://www.nea.org/neatimeline/html.

95. University of Houston, Department of History. Betsy Morin. http://vi.uh.edu/pages/buzzmat/gardner3.htm.

96. Logan, ibid., 278.

400 Notes to Chapter 8

97. Joyce A. Hanson, *Mary McLeod Bethune and Black Women's Political Activism*. Columbia: University of Missouri Press, 2003, 14.

98. University of Illinois Champaign-Urbana. Department of English. Poets: Robert Zangrando: About Lynching. http://www.english.uniuc.edupoetsynchint/lynching.htm.

99. Binghamton University, State University of New York. Thomas Dublin and Kathryn K. Sklar. Women and Social Movements, 1600–2000. 1997. http://womhist.binghamton.edu/lynch/doc1.htm.

100. Congress never passed an anti-lynching act.

101. http:womhist.binghamton.edu/lynch/intro.htm.

102. Report, Annual Meeting of NACW, March 30–April 2. 1934.

103. Ibid.

104. Franklin, ibid., 401.

105. Franklin, ibid., 402.

106. Ibid.

107. Weaver was later to become the first African-American Presidential Cabinet member 1966–68 as U.S. Secretary of Housing and Urban Development. Born in Washington, DC, he was successively adviser to the Secretary of the Interior (1933–37), special assistant with the Housing Authority (1937–40), and an administrative assistant with the National Defense Advisory Commission (1940). http://www.infoplease.compeople/A0851710.html.

108. Wayne State University. Detroit African-American History Project. Detroit Historical Events. 1916: Forrester B. Washington. http://www.daahp.waybe.edu/1900_1949.html.

109. Franklin, ibid., 402.

110. Joyce A. Hanson, *Mary McLeod Bethune and Black Women's Political Activism*. Columbia: University of Missouri Press, 2003, 126–127.

111. Michelle D. Davis, The John P. Davis Collection. National Recovery Act. http://www.collection.johnpdaviscollection.org/gpage.html.

112. Franklin, ibid., 396.

113. Slowe's Speech at Testimonial Dinner for Oscar DePriest, June 2, 1934, *Journal of the College Alumnae Club*, January 1939, 21–22.

114. Slowe, "Some Impressions from Two Conferences of Deans of Women." *Journal of the National Association of College Women* (1934–35), 38–41.

115. Ibid.

116. Ibid.

117. Ibid.

118. Slowe, "The College Woman and Her Community," Speech before the Columbia, SC Branch, National Association of College Women, April 7, 1935. *Journal of the College Alumnae Club of Washington*, January 1939, 8–11.

119. Ibid., 10–11.

120. Franklin, ibid., 398.

121. Report, Annual Meeting of NACW, April 19–21, 1935.

122. Letter to Dean Slowe from NACW, December 19, 1936.

123. *Journal of the National Association of College Women*, 1941, 9.

124. "The Story of the National Unfolds," *Journal of The National Association of College Women*, 18 (1941): 10.

Notes to Chapter 8 401

125. Report, Annual Meeting of NACW. 1928.
126. Ibid., 10–11.
127. L. Eisenmann, ibid., 16.
128. Minutes of the National Association of Deans and Advisors to Women in Colored Schools, March 21–22, 1930.
129. Ibid.
130. Slowe to Viola W. Goin, Acting Dean of Women at Fisk University stating that she had "a very severe attack of the grippe"(a viral infection sometimes called influenza). Lucy Diggs Slowe Papers. Box 90-8, Folder 171; Moorland-Spingarn Research Center, Howard University.
131. *Afro-American*, November 14, 1931.
132. Slowe sent train schedules to all attendees. Lucy Diggs Slowe Papers. Box 90-8, Folder 171; Moorland-Spingarn Research Center, Howard University.
133. Minutes of Fourth Conference of Deans of Women and Advisers to Women in Colored Schools, Tuskegee Institute, March 17–19, 1932.
134. Slowe to Dr. Robert R. Moton, Tuskegee Institute, April 6, 1932.
135. African American Registry. Robert Russa Moton: A Vigorous Educator. http://www.aaregistry.com/african_american_historyRobert_Russa_Moton_a_vigoro.
136. Lucy Diggs Slowe Papers. Box 90-8, Folder 173; Moorland-Spingarn Research Center, Howard University.
137. Lucy Diggs Slowe Papers. Box 90-8, Folder 172; Moorland-Spingarn Research Center, Howard University
138. The name has since been changed to National Association of College Deans, Registrars, and Admission Officers. National Association of College Deans, Registrars, and Admission Officers. http://nacdrao.com/main.htm.
139. African American Registry. National Association of Colored Graduate Nurses: Founded. http://www.aaregistry.com/african_american_historyNational_Association_of_Colored_Graduate_Nurses_founded.
140. Virginia State University. National Association of College Deans, Registrars and Admission Officers. http://www.vsu.edu/include/nacdrao.htm.
141. Marie Mosley, "National Association of Colored Graduate Nurses," in *Black Women in America: An Historical Encyclopedia*, ed. Hine et al. (Bloomington: Indiana University Press, 1994), 2:840–841.
142. Ibid.
143. Report of the 6th Conference of the National Association of Deans and Advisers to Women in Negro Schools, Howard University, March 28–29, 1935.
144. Report, 1936 Meeting of the National Association of Deans and Advisers to Women in Colored Schools, Wilberforce University, March 19–21, 1936.
145. Meeting agenda. Lucy Diggs Slowe Papers. Box 90-8, Folder 176; *New York Times*, March 26, 1937, article titled "Dean Slowe Conducts Meeting, Presides Over Conference in Session at Bennett College. Box 90-11, Folder 209. Manuscript Division, Moorland-Spingarn Research Center, Howard University.
146. Lucy Diggs Slowe Papers. Box 90-2, Folder 43; Manuscript Division, Moorland Spingarn Research Center, Howard University.
147. Ibid.
148. The White House, President Barack Obama. Our First Ladies: Anna Eleanor Roosevelt. http:www.whitehouse.gov/about/first-ladies/eleanorroosevelt.

149. *Washington Tribune*, May 4, 1934.

150. Allida M. Black, *Casting Her Own Shadow: Eleanor Roosevelt and the Shaping of Postwar Liberalism*. (New York: Columbia University Press, 1996), 29.

151. Answers.com. Harry Hopkins. http://www.answers.com/topic/harry-hopkins?method = 22.

152. Hopkins rose to prominence during the Great Depression as one of President Roosevelt's closest advisors. During his first Hundred Days, Roosevelt signed the Federal Emergency Relief Administration into existence and named this Grinnell College graduate as its chief officer. Hopkins acted in many capacities—as director of the Civil Works Administration from 1933–1934, and with the Federal Surplus Relief Administration and the Works Progress Administration from 1935–1938. At all times, Hopkins favored opportunities to produce jobs rather than provide direct financial relief. Hopkins had asked his former schoolmate Hallie Flanagan to take charge of the Federal Theatre Project, but could not defend the project before the Dies Committee because he feared Congress would eliminate funding for the WPA. Time and again, Hopkins endured criticisms for overspending and boondoggling. Roosevelt reinstalled him instead as Secretary of Commerce from 1938 to 1940. Until his death in 1946, Hopkins acted as an unofficial advisor on foreign affairs who attended many of the European wartime conferences like the Teheran Conference of 1943. http://newdeal.feri.orgbio7.htm

153. National Park Service. Eleanor Roosevelt: CCC camps for women. http://www.nps.gov/archiveglossary/she-she-she-camps.htm.

154. Spingarn Alumni "S" Club, Inc. The Spingarn Medal. 1935: Mary McLeod Bethune. http://Spingarn.k12.dc.us/SClub/medal.html.

155. Slowe to McLeod-Bethune, June 12, 1925. National Park Service; Mary McLeod Bethune Council House National Historic Site; DcWaMMB; National Council of Negro Women Armistead Research Center Papers of Mary McLeod Bethune 1923–1948. Box 2, Folder 5.

156. Elaine M. Smith, "Bethune, Mary McLeod (1875–1955)" in *Black Women in Ameria: An Historical Encyclopedia*, ed. Hine et al. (Bloomington: Indiana University Press, 1994), 1:120.

157. Not to be confused with National Association of *College* Women.

158. Bettye Collier-Thomas, "National Council of Negro Women" in *Black Women in America: An Historical Encyclopedia*, eds. Darlene C. Hine, Elsa B. Brown, and Rosalyn Terborg-Penn, 855–856 (Bloomington, IN: Bloomington University Press, 1994).

159. Audrey T. McCluskey and Elaine M. Smith. *Mary McLeod Bethune: Building a Better World. Essays and Selected Documents* (Bloomington, IN: Indiana University Press, 2001), 170. Lucy Slowe was one of ten women who wired "hearty approval of such an organization." She "Wired her approval and hearty cooperation and desire to push it to the top."

160. Slowe to Charlotte Hawkins Brown, June 16. 1936.

161. Certificate of Incorporation. Signed by Mary McLeod Bethune, Mary Church Terrell, and Lucy D. Slowe, executive secretary. National Park Service; Mary McLeod Bethune Council House National Historic Site; DcWaMMB; National Council of Negro Women Records, Series 1, Box 1, Folder 1, July 25, 1936.

162. Note: In a personal aside, Slowe extended both her sympathy on the death of Brown's father and her understanding of the responsibility she had for the care of her semi-invalid mother. She confided that she had been under similar strain on account of the illness of her sister—presumably Charlotte. She added, ". . . we do have to smile and bear these things along with our daily duties and I am trying along with you to bravely bear my share."

163. Tentative By-Laws of the National Council of Negro Women, 9 April 1936. National Park Service; Mary McLeod Bethune Council House National Historic Site; DcWaMMB; National Council of Negro Women Records Series 1, Box 1, Folder 1.

164. *Washington Tribune*, June 1, 1937.

165. Elaine M. Smith, "Bethune, Mary McLeod (1875–1955)," in Hine, et al. eds., ibid., 1:120.

166. Joyce A. Hanson, *Mary McLeod Bethune and Black Women's Political Activism*. (Columbia: University of Missouri Press, 2003), 147.

167. Report of National Conference on the Problems of the Negro and Negro Youth submitted by Bethune, January 22, 1937.

168. Washington and Lee University School of Law. Faculty History: John W. Davis (1873–1955). http://lawlibrary.wlu.edu/faculty/history/davis.htm.

169. Mary McLeod Bethune Papers: The Bethune Foundation Collection.

170. Elaine M. Smith, "Bethune, Mary McLeod (1875–1955)" in Hine, et al. eds., ibid., 1:123.

171. Franklin, ibid., 405.

172. Elaine M. Smith, ibid., 1:124.

173. Slowe to Aubrey Williams, January 21, 1937.

174. Lucy Diggs Slowe Papers. Box 90-13, Folder 234; Program in Scrapbook Moorland-Spingarn Research Center, Howard University.

175. Letter to Slowe, January 14, 1932.

176. William Stuart Nelson became president of Shaw University in Raleigh, North Carolina in 1931. He had been a member of the Howard University faculty. Franklin, ibid., 378.

177. Family Service Association began designing programs that work to meet the needs of families in 1896. http://www.fsadayton.org/.

178. Teresa J. Norris to Slowe, February 17, 1937.

179. Slowe to Teresa J. Norris, February 24, 1937.

180. Family Service Association began designing programs to meet the needs of families in 1896. Family Services. About. http://www.fsadayton.org.

181. Minutes of the Board of Directors, Family Service Association, May 12, 1937.

182. Slowe to Director, Family Service Association, April 27, 1937.

183. Minutes of the Board, Family Service Association, March 27, 1935.

184. Minutes of the Board, Family Service Association, January 9, 1935.

185. Community Chest is a cooperative organization of citizens and social welfare agencies in a city.http:www.encydopedia.comcl/communit-ch.asp.

186. H. O. Atwood to Slowe, November 4, 1933.

187. Slowe to H. O. Atwood, November 7, 1933.

404 Notes to Chapter 8

188. Wilkinson to Slowe, June 18, 1937. Box 90-4, Folder 99 and Correspondence from Wilkinson to All Members of the Board of Directors, July 7, 1937, Box 90-4, Folder 99; Moorland-Spingarn Research Center, Howard University.

189. Wilkinson to Slowe, June 18, 1937.

190. Wilkinson to Slowe, June 25, 1937.

191. Slowe to the National Federation of Settlements, Inc., July 22, 1937.

192. Francoise Black, Director of NYA for DC to Slowe, August 29, 1936.

193. Oklahoma Historical Society and Oklahoma State University Library Electronic Publishing Center. Encyclopedia of Oklahoma History and Culture: National Youth Administration by Tally D. Fugate. http://digital.library.okstate.edu/encyclopedia/index.htms.

194. Hanson, ibid., 4.

195. Announcement of Appointment of Slowe to NYA Advisory Committee, September 17, 1936.

196. Black to Slowe, January 26, 1937.

197. Sadie Gray Mays was a teacher and social worker. She was one of the two first part-time instructors in Social Work at Howard University. She served as instructor and lecturer from 1935 to 1940. Logan, ibid., 368.

198. Mays to Slowe, June 12, 1937.

199. Oklahoma Historical Society and Oklahoma State University Library Electronic Publishing Center. Encyclopedia of Oklahoma History and Culture: National Youth Administration by Tally D. Fugate. http://digital.library.okstate.edu/encyclopedia/index.htms.

200. In 1924 Derricotte was also a member of the general committee of the World's Student Christian Federation. Jean Cazort, "Derricotte, Juliette: 1897–1931" in *Black Women in America: An Historical Encyclopedia*, ed. Hine et al. (Bloomington: Indiana University Press, 1994), 1:332.

201. Derricotte to Slowe, October 31, 1924.

202. YWCA, Report on By-Laws, May 25, 1922.

203. YWCA, Bibliography for Delegates to the National Assembly, April 17, 1924.

204. YWCA, Racial Resolutions, May 12, 1924.

205. Countee Cullen (1903–1946) was an African American poet. His poem, "The Shroud of Color," *The American Mercury*, 3 no. 11, (1924) 306–308.

206. Slowe to Frances Williams, YWCA, October 30, 1924.

207. American monthly literary magazine known for its often satiric commentary on American life, politics, and customs. It was founded in 1924 by H. L. http://www.britannica.com/needmore Mencken and George Jean http://www.britannica.com/needmore Nathan.

208. Derricotte to Mrs. George E. Haynes, October 30, 1924.

209. Slowe to Derricotte, November 3, 1924.

210. Ibid.

211. YWCA Memo, November 5, 1924.

212. Chairman of Executive Committee to Slowe (letter), November 11, 1924.

213. Frances Williams to Council Members, November 20, 1924.

214. Derricotte to Slowe, December 8, 1924.

215. Report—YWCTU—Smoking—March 4, 1925.

216. Humbles to Slowe, March 11, 1925.
217. Slowe to Humbles, March 20, 1925.
218. Slowe to Humbles, March 11, 1925.
219. National Interracial Conference Report, March 25–27, 1925.
220. Executive Committee, YWCA, to Slowe, May 4, 1925.
221. Slowe to Executive Committee, May 6, 1925.
222. National YWCA to Slowe, May 15, 1925.
223. National YWCA to Slowe, December 2, 1925.
224. Slowe to Derricotte, January 27, 1931.
225. *Hilltop*, May 14, 1941.

226. Niebuhr was teaching theology and Christian ethics at Yale. He was a leading twentieth-century American Protestant theologian and churchman. http://www.hds.harvard.edu/librarybms00630.html.

227. Howard University called Thurman to become its first Dean of Andrew Rankin Chapel, and to radiate from that high citadel of learning, a "conscience" for the nation's capital. http://www.howard.edu/library/Divinity_Library/thurman.htm. Thurman was also Professor in the School of Religion. Logan, ibid., 379.

228. Report, Student Christian Conference, Howard University, December 4–6, 1936, 2 pages typed.

229. Thurman, a sought-after speaker, resigned from Howard in 1946. Probably one reason for his action was a "blunt remark by President Johnson that Howard University was not to be 'used as a basis of operations.' Persons in the employ of the University owed their primary obligation to Howard." After the meeting Thurman said Johnson was talking about him. Logan, ibid., 379.

230. Slowe, Report to YWCA Board on The YWCA and Colored Women Students, 1–3.

231. Ibid., 4.

232. Probably "Cause and Cure of War."

233. Slowe to Leslie Blanchard, executive secretary, National Student Council, February 11, 1925.

234. Constance Ball to Slowe, January 16, 1925.

235. *Afro-American*, week of January 27, 1934.

236. Slowe was a member of the International Council of Women of the Darker Races along with Mary Church Terrell, Addie Hunton, Mary Talbert, and Mary Waring. J. Blackwell, *No Peace without Freedom: Race and the Women's International League for Peace and Freedom, 1915–1975*. (Carbondale, IL: Southern Illinois University Press, 2004): 128.

237. Statement: Dean Slowe Gives Some Impressions on the Conference on the Cause and Cure of War, 1934, 4. Typewritten.

238. *Hilltop*, February 15, 1935.

239. J. Blackwell. *No Peace without Freedom: Race and the Women's International League for Peace and Freedom, 1915–1975*. (Carbondale, IL: Southern Illinois University Press, 2004): 41.

240. Ibid, 51.

241. Ibid. An error in Blackwell's report states that McNeill invited Slowe—age 53—to a WILPF meeting at which she agreed to join in March 1938. In point of fact, Slowe was 53 years old in 1936, not 1938; she died in 1937.

242. Blackwell, ibid., 10.

243. Later, prominent African-American members included Marian Anderson, Dr. Flemmie Kittrell, and Sadie Daniel St. Claire. Blackwell, ibid., 41.

244. J. H. Franklin, *From Slavery to Freedom: A History of Negro Americans.* 4th ed. (NY: Knopf, 1974): 304.

245. Blackwell, ibid., 125.

246. Because serious economic dislocations of World War I made it impossible for the Liberian government to pay its debt to Britain [http://www.indiana.edu/~league/1921.htm], ". . . American officials advised the Liberian government to seek a loan from . . . 'a private source,'" in this case the Firestone Rubber Company of Akron, Ohio. "Liberia borrowed $5 million on the condition that Liberia would give to the company two thousand acres of land for experimental purposes, that the company would be given the opportunity to lease up to 1 million acres of rubber land, and that the company would construct a harbor at Monrovia out of its own funds and with its own engineers" [Franklin, ibid., 316]. Subsequently, it was revealed that trafficking in native Africans for cheap labor was occurring [Blackwell, ibid., 125]. "Thus began the biggest and most public 'black scandal' in the history of both Liberia and America.

This event aroused the consciousness of African Americans to the point of organized movements to end European and American presence in one of the last black nations on the African continent" [Blackwell, ibid., 122]. Peace activists became involved as they likened "America's race problem to Liberia's race problem" [Blackwell, ibid., 127]. In 1933, Undersecretary of State William Phillips met with a delegation composed of African Americans to discuss the Liberian situation. Included in the group was Addie Dickerson, a member of WILPF and president of ICWDR, of which Slowe was a member. [Blackwell, ibid., 128]. Inherent in the delegation's criticism of America's policy toward Liberia, voiced by W. E. B. Du Bois, was their concern for "racial solidarity" [Blackwell, ibid., 128].

Chapter 9

1. Margaret J. Groomes, "Lucy Diggs Slowe: First Dean of Women at Howard University 1922–1937. Typewritten, 7. Lucy Diggs Slowe Papers. Box 90, Folder 116; Manuscript Division, Moorland-Spingarn Research Center, Howard University.

2. Annual Report of the Dean of Women 1933–34.

3. "What Shall We Teach Our Youth?" Address at YWCA, Baltimore, Sunday, February 1, 1925.

4. *Norfolk Journal and Guide*, March 26, 1927.

5. Logan, ibid., 269.

6. Slowe, speech on the Occasion of the Laying of the Corner Stone of the Women's Dormitories at Howard University, June 5, 1931. *Journal of the College Alumni Club* Memorial Edition, January 1939, 37–38.

7. Echoing her love for literature, she referenced Matthew Arnold, a British author and poet of the nineteenth century. (http:www.victorianweb.org/authors/Arnold/bio.html.

Notes to Chapter 9 *407*

8. http://www.bartleby.comar/Arnold-M.html.

9. Slowe. Commencement Address, Miner Teachers College at Armstrong, "The Teacher-Apostle of the Beautiful," *Journal of the College Alumnae Club*, ibid., 32–33.

10. Slowe. "The Teacher—Apostle of the Beautiful," Slowe at Miner Teachers College. Lucy Diggs Slowe Papers. Box 90-6, Folder 144; Manuscript Division, Moorland-Spingarn Research Center, Howard University.

11. Slowe. Speech, Shaw Junior High School, June 21, 1933, *Journal of the College Alumnae Club*, Memorial Edition, January 1939, 34–35.

12. *Quarterly Review of Higher Education Among Negroes*, v.1, no.2, April 1933, 11–13. Also *Journal of the College Alumnae Club of Washington Memorial Edition*, January 1939, 43–47. Lucy Diggs Slowe Papers. Box 90-7, Folder 158; Manuscript Division, Moorland-Spingarn Research Center, Howard University.

13. *Pittsburgh Courier*, Saturday, February 3, 1934. Lucy Diggs Slowe Papers. Box 90-13, Folder 234; Manuscript Division, Moorland-Spingarn Research Center, Howard University.

14. "What are You Standing For?," Slowe's speech at Fifth Anniversary of the Clark Hall Council, Howard University, *Journal of the College Alumnae Club of Washington* Memorial Edition, January 1939, 35–37.

15. *Howard University Record*, 17 (1923): 375–76.

16. *Talladegan*, 48, no 2: 11.

17. Ibid., 11.

18. Ibid., 11–12.

19. *Dunbar News*, March 11, 1931.Lucy Diggs Slowe Papers. Box 90-13, Folder 234; Manuscript Division, Moorland-Spingarn Research Center, Howard University.

20. *Dunbar News*, The Dunbar Apartments, New York, March 11, 1931.

21. She first lectured at Teachers College, Columbia in February 1925. See Chapter 4. Lucy Diggs Slowe Papers. Box 90-6, Folder 130; Manuscript Division, Moorland-Spingarn Research Center, Howard University.

22. Slowe. "The Education of Negro Women and Girls," Delivered at Teachers College, Columbia University, March 11, 1931, *Journal of the College Alumnae Club of Washington*, January 1939,11–17.

23. Ibid.

24. Ibid.

25. *Afro-American*, January 9, 1932.

26. Slowe's Scrapbook. Lucy Diggs Slowe Papers. Manuscript Division, Moorland-Spingarn Research Center, Howard University.

27. Jones had organized the first evening class in journalism ever conducted in a colored high school. He was president of the Baltimore Century Club, affiliated with the Baltimore Association of Commerce; vice-president of the Baltimore Urban League, a member of the Executive Committee of the NAACP, a member of the State Central Committee of the Progressive Party, a member of the Boy Scout Council, and a member of the Association for the Handicapped. (*The First Colored Professional, Clerical and Business Directory of Baltimore City*, 15th Annual Edition, 1928, Volume 505, 3).

28. *Afro-American*, Day-by-Day, Dean Slowe's Scrapbook, 16.

29. Lucy D. Slowe, "Higher Education of Negro Women," *Journal of Negro Education*, A Survey of Negro Higher Education, 2, no.3 (1933): 352–358.

30. Ibid., 358.

31. Founded at Howard, *Journal of Negro Education* was in its second year of publication as a refereed, scholarly journal when Slowe's article appeared.

32. Women's Day, Nineteenth Street Baptist Church, Washington, DC, May 23, 1933.

33. "Address Delivered by Soror Lucy D. Slowe at the Annual A.K.A. Boule Banquet," *Ivy Leaf*, 11, no. 4, (1933): 19–20.

34. Slowe. Some Problems of Colored Women and Girls in the Urban Process, Handwritten, n.d. Lucy D. Slowe Papers. Box 6, Folder 143; Moorland-Spingarn Research Center, Howard University.

35. "The College Woman and the Community." *Journal of The College Alumnae Club*, Memorial edition, 1939, 20–21. Opening speech at the National Association of College Women at Atlanta University, April 1934.

36. *Opportunity*, Sept. 1937, 276–279.

37. Ibid., 276.

38. Ibid.

39. Ibid., 277.

40. Ibid., 278.

41. Ibid.

42. Ibid., 279.

43. Ibid.

44. *Opportunity* magazine was published from 1923 to 1949 by the National Urban League. Much of the writing was directed to the sociological and economic aspects of African Americans' relation to American life. http://www.findarticles.comarticles/mi_g1epc/is_tov/ai_2419100920/print.

45. "Slowe speaks at Columbia University," *New Haven Union*, February 22. 1925.

46. *Chronicle Telegram (Elyria, Ohio) Record*, June 18, 1930.

47. http://www.infoplease.com/ce6society/A0816730.html.

48. *Washington Tribune*, June 27, 1930.

49. In 1950, Russell was made a Nobel Laureate in Literature, "in recognition of his varied and significant writings in which he champions humanitarian ideals and freedom of thought." "The Nobel Prize in Literature 1950." Nobelprize.org.27 Jan2011. http://nobelprize.org/nobel_prizes/literature/laureates.

50. Slowe. 1930–1931 Annual Report.

51. Brochure, 1931 Home Missions Institute, Chautauqua, NY, August 16–21, 1931. Twenty-first Annual Session conducted by Council of Women for Home Missions, 105 E. 22nd St., NY. Theme: The Present Change. Lucy Diggs Slowe Papers. Box 90-13, Folder 234, Scrapbook; Manuscript Division, Moorland-Spingarn Research Center, Howard University.

52. "Slowe's Education and Race Relations speech, Chautauqua, N.Y., August 19, 1931," *Chautauquan Daily*, August 19, 1931.

53. Slowe's Education and Race Relations." Speech at Chautauqua, NY, August 19, 1931, *Journal of the College Alumnae Club*. June 1939, 23–26.

54. Prejudice, Unpublished paper.

55. *Afro-American*, March 4. 1933.

56. *The Guide to Black Washington: Places and Events of Historical and Cultural Significance in the Nation's Capital.* (New York: Hippocrene Books, Inc., rev. illustrated edition, 2001) 146.

57. Smithsonian Anacostia Museum and Center for African American History and Culture. *The Black Washingtonians: The Anacostia Museum Illustrated Chronology.* (Hoboken, NJ: John Wiley, 2005), 139. *Afro-American*, week of March 25, 1933. Source: Library of Congress Newspaper R M.). (Note: Mu-So-Lit owned a house—boasting a bronze plaque on the door—in the LeDroit Park section of Washington. (Note: 1938 Third Street, Northwest.) It is reputed to have given African-American intelligentsia a welcomed gathering place. (Source: Interview with Washington resident Barbara Brooks Jackson, February 22, 2005.) Located south of Howard University, the LeDroit Park neighborhood was one of the many racially segregated residential areas in the District of Columbia and the center of African-American intellectual and cultural life in the first half of the twentieth century. People who lived in the picturesque style frame and brick houses included prominent lawyers, physicians, educators, clergy, businesspersons and government officials. Lucy Slowe's friends Anna Julia Cooper and Mary Church Terrell resided in the area. (http://www.exploredc.org/index.php?id = 83; http://www.culturaltourismdc.org/info-url3948/info-url_show.htm?doc_id = 212040&attrib...22005).

58. *Guide to Black Washington: Places and Events of Historical and Cultural Significance in the Nation's Capital* (revised illustrated edition). No date. No page number. Viewed April 17, 2006.

59. Lucy D. Slowe, "The Negro in the New Order," Speech before the Mu-So-Lit Club of Washington, March 19, 1933.

60. *Washington Tribune*, February 7, 1936.

61. Franklin, ibid., 428–429.

62. E. Franklin Frazier, *The Negro in the United States*. (New York: Macmillan, 1949), 534.

63. Smithsonian Anacostia Museum and Center for African American History and Culture, *The Black Washingtonians: The Anacostia Museum Illustrated Chronology.* (Hoboken, NJ: John Wiley, 2005), 194.

64. http://www.lexisnexis.com/academicAaas/ManuscriptSchomburgCenter_pf.asp.

65. http://www.freepress.org/fleming/fleming84.html.

66. http://www.freepress.org/fleming/fleming84.html.

67. John H. Franklin, *From Slavery to Freedom: A History of Negro Americans*, 4th ed. (New York: Knopf, 1947). After 1940 the NNC ". . . disintegrated rapidly as many members withdrew because they believed the congress was becoming a Communist front." p. 429.

68. Ibid., 428.

69. Lucy D. Slowe, Speech at Mass Meeting of the National Sponsoring Committee of the National Negro Congress, *Washington Tribune*, February 7, 1936.

70. Lucy D. Slowe, Radio Address, Nation Wide Hook-Up, WJSV, April 24, 1937, *Journal of the College Alumnae Club*, June 1939, 29–32.

71. Ibid.

72. *New York Age*, May 8, 1937.

73. Executive secretary in a tribute at the time of Dean Slowe's death; printed in *NADW 1931 Yearbook*, 111–112; per Ann Bowers, Center for Archival Collections, 5th Floor, Jerome Library, Bowling Green State University, Bowling Green, Ohio 43403, 111.

74. Ibid.

75. Lucy D. Slowe, "The Dean of Women in a Modern University." *Howard University Alumni Journal*, December 1933, 9–10. Also in *Journal of the College Alumnae Club of Washington Memorial Edition*, January 1939, 38–42. Lucy Diggs Slowe Papers. Box 90-7, Folder 158; Manuscript Division, Moorland-Spingarn Research Center, Howard University.

76. Lucy D. Slowe, "The Business of Being a Dean of Women." *Journal of the College Alumnae Club of Washington Memorial Edition*, January 1939, 59–65. Lucy Diggs Slowe Papers. Box 90-7, Folder 158; Manuscript Division, Moorland-Spingarn Research Center, Howard University.

77. Lucy D. Slowe, "What Contribution Can a Program of Social Activities Fostered by the Institution Make to the Moral and Social Development of Students in Negro Colleges," *Journal of the College Alumnae Club*, January 1939, 43–47.

Chapter 10

1. *Afro-American*, October 30, 1937.

2. Walter Dyson, *Howard University The Capstone of Negro Education A History: 1867–1940*. (Washington: Howard University Graduate School, 1941), 484.

3. http://www.answers.com/topic/charles-h-wesley607.

4. *Afro-American*, ibid.

5. Dyson, ibid., 67.

6. Dyson, ibid., 68.

7. Slowe attended one of Duncan's performances in New York City. Duncan was the original "Porgy" in "Porgy and Bess" on Broadway in 1935. Lucy Diggs Slowe Papers. Box 90, Folder 234; Moorland-Spingarn Research Center, Howard University.

8. *Washington Afro-American*, 46th Year, No.12, October 30, 1937, 1 and 15, Library of Congress, Madison Building, Newspaper and Current Periodical Reading Room.

9. Logan, ibid., 306.

10. Note: In 1936 Cassell had been rejected by the Board of Trustees for the contract to construct the men's dormitories. This apparently resulted from vindictiveness on the part of President Johnson, and ". . . it was used by the General Alumni Association in one of its major onslaughts on Johnson. . . ." Logan, ibid., 333 and 339.

11. http://omega.rso.wisc.edu/THE_FOUNDING_FATHERS_OF_OMEGA_PSI_PHI.html.

12. Logan, ibid., 333.

13. Marion T. Wright, in Edward T. James (ed.) *Notable American Women 1607–1950: A Biographical Dictionary*. (Cambridge, MA: Belknap Press of Harvard

Notes to Chapter 10

University Press, 1971) 3:300. [Note: Thomas H. Anderson, a judge, might have been a trustee of the university from 1903 to 1916 (Dyson, W., ibid., 413).

14. R. W. Logan and Michael R. Winston, in *Dictionary of American Negro Biography*, (New York: Norton, 1983), 560. Pruitt-Logan located the grave at Lincoln Memorial Cemetery in Section D, Lot #72, Grave #7.

15. *Afro-American*, ibid.

16. Washingtoniana. Bio.Slob-Slz, *Washington Tribune*, October 30, 1937.

17. Howardiana Vertical File, Moorland-Spingarn Research Center, Howard University.

18. *Journal of the National Association of College Women* 14 (1937): 4.

19. *Journal of the National Association of College Women*, 18 (1941): 5. The *Journal* dedicated page 5 to Lucy D. Slowe.

20. Ibid., 49.

21. Ibid., 50.

22. *Journal of the Washington College Alumnae Club*, Lucy D. Slowe Memorial Issue, January 1939, 70. Lucy D. Slowe Papers. Series M Box 90-7, Folder 158; Manuscript Division, Moorland-Spingarn Research Center, Howard University.

23. Ibid., 68.

24. Ibid., 69.

25. Ibid., 70–71.

26. Ibid., 72–73.

27. *Afro-American*, August 27, 1938.

28. *Journal of the Washington College Alumnae Club*, ibid., 74.

29. *Journal of the National Association of College Women*, 14 (1937): 50.

30. Ibid., 50–1.

31. The writings of Romiett Stevens, Associate Professor of Education at Teachers College, Columbia University, who had developed the first course for deans of women in the United States, inspired Lucy Slowe in her quest for information about the deanship. http://www.geocities.com/betaupsilon1938/slowe.

32. Bethune letter of condolence December 8, 1937. Lucy Diggs Slowe Papers. Box 10, Folder A-E; Manuscript Division, Moorland-Spingarn Research Center, Howard University.

33. Carney letter of condolence October 23, 1937. Lucy Diggs Slowe Papers. Box 10, Folder A-E; Manuscript Division, Moorland-Spingarn Research Center, Howard University.

34. La May letter of condolence. Lucy Diggs Slowe Papers. Box 10, Folder A-E; Manuscript Division, Moorland-Spingarn Research Center, Howard University.

35. News item for release on and after November 1, 1937, dated Oct. 26, 1937.

36. Howard University, Department of Public Information Release.

37. V. D. Johnston, treasurer, Howard University, Oct. 22, 1937, letter of condolence. Lucy Diggs Slowe Papers. Box 10, Folder A-E; Manuscript Division, Moorland-Spingarn Research Center, Howard University.

38. Letter from President Mordecai Wyatt Johnson to Mrs. Hawkes, sister of Dean Slowe, October 24, 1937. Lucy Diggs Slowe Papers. Box 10, Folder A-E; Manuscript Division, Moorland-Spingarn Research Center, Howard University.

Notes to Chapter 10

39. Verna Dozier, Challenge: To the Memory of Dean Slowe, Lucy D. Slowe Papers. Box 90-1, Folder 10; Manuscript Division, Moorland-Spingarn Research Center, Howard University.

40. D. O. W. Holmes, *In Memoriam: Eulogy at the Obsequies of Lucy D. Slowe*, Howard University, October 25, 1937, 8.

41. Ibid., 8–9.

42. Ibid., 10–11.

43. *Journal of Negro History*, January 23, no. 1 (1938): 136–137.) [downloaded JSTOR;http://jstor.org/sici?sici = 0022-2992%28193801%2923%3A1%3C11 2%3AN% 3E2.0.CO%3B2-Z.

44. *Friends Intelligencer*, Nov. 20, 1937. Howardiana Vertical File; Moorland-Spingarn Research Center, Howard University.

45. *Washington Times*, Nov. 5, 1937. Howardiana Vertical File; Moorland-Spingarn Research Center, Howard University.

46. *Hilltop*, Nov. 21, 1938. Howardiana Vertical File; Moorland-Spingarn Research Center, Howard University.

47. http://www.culturaltourismdc.org/info-url3948/info-url_show.htm?doc_id = 213185&attrib...405. http://en.wikipedia.orgHilyard_Robinson52010.

48. H. G. Robinson, III, and Hazel R. Edwards, *The Long Walk: The Placemaking Legacy of Howard University*. Howardiana Vertical File; Moorland-Spingarn Research Center, Howard University.

49. "Scenes from the Past. . . ." In Towner, Feb. 2004, 13.

50. "To Name New Dorm for Dean Lucy Slowe." *Washington Afro-American*, March 21, 1942.

51. "Bill Approved to Give Howard 2 Dormitories." *Washington Post*, April 22, 1948.

52. http://www.culturaltourismdc.org/info-url3948/info-urlshow.htm?doc_id = 213185&attrib

53. http://www. johnpdaviscollection.org/about10.html.

54. Bando, a Howard University graduate who went to Teachers College in 1936 to study student personnel work, became Dean of Women at Morgan State College in 1942. Linda M. Perkins, "Lucy Diggs Slowe Champion of the Self-determination of African-American Women in Higher Education." *Journal of Negro History*, 11996. http://www.highbeam.com/library/doc3.asp?DOCID = 1140185&num = 8&ctrlInfo = Round18.

Slowe was one of Bando's professors. She would leave Bando ". . . in charge of the class whenever she left for a conference." Although she wanted to be an English teacher, ". . . Slowe advised her to consider majoring in guidance" at Teachers College, Columbia. Slowe helped her to select her graduate courses at Columbia. . . . *Ivy Leaf*, 86, 3, (Fall 2007): 41.

55. Statement from Thelma P. Bando to Marion T. Wright, 5.

56. Statement of Marion T. Wright, 1.

57. Cook graduated from Howard and earned a master's degree from Columbia. She taught at Tuskegee Institute and in high schools in Cincinnati and St. Louis before relocating to Baltimore. She became principal of Dunbar High School, the largest high school in Maryland. She made enormous contributions to civic life in

Baltimore.http://www.casbs.org/newsletters/NewsletterSummer04.pdf?PHPSESSID = 6142455c6093db58.

Mary McLeod Bethune wrote to Cook following Slowe's death, telling her to take over where Slowe left off. Vivian Johnson Cook Papers. Box 191-19, Folder 4; Manuscript Division, Moorland-Spingarn Research Center, Howard University.

58. Statement of Vivian E. J. Cook to Marion T. Wright, 5.
59. Kathryn G. Heath to Marion T. Wright, September 6, 1962, 2.
60. "Thou has in thine unmatched glory Upon the heavens engraved thy story" Sir Philip Sidney. More accurate transcription. http://www.uoregon.edu/~rbear/sidpsalms.html.
61. Statement of Joanna H. Ransom to Marion T. Wright, 1962, 1.
62. MTW notes.
63. Correspondence from Adelene Smith and Grayce Hawkins, March 29, 1943, Lucy Diggs Slowe Papers. Box 90-1, Folder 3; Manuscript Division, Moorland-Spingarn Research Center, Howard University.
64. http://www.artnoir.com/index.porter.html.
65. http://www.as art.com/biography.asp?ID = 26512.

Chapter 11

1. Jessica Helfand, *Scrapbooks: An American History*. New Haven: Yale University Press, 2008, p. xvii.
2. *New York Times*, 1926, n.d.
3. http://view.atdmtiview/trblfvon00700100von/dirrct/781690344?click = http://a.tri.
4. Slowe Scrapbook, 1.
5. Ibid., 2.
6. http://www.cyberhymnal.orgffosdick-he.htm.
7. Ibid., 10.
8. Ibid., 1.
9. Ibid., 2.
10. Ibid., 35.
11. *Herald Tribune*, n.d.
12. No source, n.d.
13. Newspaper and date not given.
14. Slowe's Scrapbook, 22.
15. http://www3.lehigh.edu/about/lupast.asp.
16. "Syracuse University." Encyclopedia Britannica.2005. Encyclopedia Britannica Premium ServiceFeb.2005. http://www.britannica.comarticle?tocid = 9002095.
17. No source, n.d.
18. Date and source not given.
19. http://www.st_aug/boutus/boutus.htm.
20. Date and source not given.
21. *New York Herald Tribune*, November 8, 1931.
22. *New York Times*, September 13. No year, 6.

414 Notes to Chapter 12

23. *New York Times*, November 27, No year, 5.
24. *Herald Times*, New York, July 29, 1931.
25. *New York Times*, April 22, year not given.
26. *New York Herald-Tribune*, April 20, 1932.
27. *Baltimore Sun*, n.d. Scrapbook, p. 3.
28. Source and date not given.
29. Holmes was among the founders of several of the most important organizations for social justice: the National Association for the Advancement of Colored People, with W. E. B. Du Bois; The American Civil Liberties Union, with Roger Baldwin; The League for Industrial Democracy, with Harry Laidler; The Planned Parenthood Movement, with Margaret Sanger. A few of the others are The Fellowship of Reconciliation, The War Resisters League, and The India League of America. Holmes was a regular speaker on Town Hall Tonight, radio's great first public forum. http://www.harvardsquarelibrary.org/unitarians/holmes.html.
30. *Afro-American*, February 27, 1934.
31. *Afro-American*, May 13, 1933.
32. *Washington Tribune*, April 24, 1937.
33. http://www.cr.nps.govtravel/Chicago/c21.htm.
34. Slowe Scrapbook, 3.
35. http://www.empireclubfoundation.com/details.asp?SpeechID = 2781&FT = yes.
36. *New York Times*, December 11, 1932.
37. Slowe Scrapbook, 20.

Chapter 12

1. Anne S. Pruitt, "Characteristics of College Student Personnel Workers," *Journal of College Student Personnel* 7 (1966): 159–166.
2. Anne S. Pruitt, "The Differential Rewards of Student Personnel Work," *Journal of the National Association of Women Deans and Counselors* 30 (1966): 40–45.
3. Gaetane Jean-Marie, "The courage to lead, black women administrators speak," *Women in Higher Education* (2003). Cited in Mary L. Grimes, "Re-Constructing the Leadership Model of Social Justice for African-American Women in Education" 19 (2005):4. http//216.239.51.104/search?q = cache:Hqy35KKVrJ4J:advancingwomen.comfall2005.
4. Located at 2455 Fourth Street, NW, Washington, DC. 20059.http://www.howard.edu/residencelife/reshalls/Tubman.htm
5. Located at 1919 Third Street, NW, Washington, DC 20001. http://www.howard.edu/residencelife/reshalls/Slowe.htm
6. Located at 601 Howard Place, NW, Washington, DC 20059-1019. http://www.howard.edu/schoolsocialworkabout.htm
7. http:www.howard.edu/schoolsocialwork/Newsletter.pdf
8. http://www.aka1908.com
9. Located at 1404 Jackson Street, NE, Washington, DC 20017. http://www.greatschools.org/modperl/achievement565

10. Maltbie D. Babcock, "Be Strong!" The words are from *The Bible*, 1 Chronicles 22:13: "Be strong, and of good courage." http://www.cyberhymnal.orgbbestrong.htm

11. Maltbie D. Babcock was a Presbyterian minister. "In 1886, he was called to Brown Memorial Church, Baltimore, Maryland, where he often counseled students at Johns Hopkins University. . . . Though he published nothing during his life, his wife, Catherine, collected and published many of his writings. . . ." His verse is published in *Thoughts for Every Day Living*, 1901. http://www.cyberhymnal.orgbbabcock_md.htm.

Bibliography

2 souls.com. *Knowledge Warehouse: Ambrose Caliver.* http://www.2souls.comKnowledge%20Warehouse/Caliver/caliver.htm.
About.com. *Women and Tennis in America.* http://womenshistory.about.comtenniswomen_tennis.htm.
Abu-Bader, Soleman. *Howard University School of Social Work: About the School of Social Work—History of Social Work Education at Howard University.* March 22, 2004. http://www.howard.edu/schoolsocialworkabout.html.
African American Registry. *Emmett Scott, Administrator of a Dream.* 1997. http://www.aaregistry.com/african_american_historyEmmett_Scott_administrator_ of_a_dream.
———. *Jesse Moorland, Civic Leader and Much More.* http://www.aaregistry.com/african_historyJesse_Moorland_civic_leader_and_much_more.
———. *National Association of Colored Graduate Nurses—Founded.* http://www.aaregistry.com/african_american_historyNational_Association_of_Colored_Graduate_Nurses_founded.
———. *Robert Russa Moton: A Vigorous Educator.* http://www.aaregistry.com/african_american_history/1100Robert-Russa_Moton_a_vigoro.
American Association of University Women. *History.* http://www.aauw.org/museum/history/index.cfm.
American Council on Education Studies, Series 1, V.1., No.3. *The Student Personnel Point of View.* June 1937. http://www.bgsu.edu/colleges/library/cacpages/1937STUDENTPERSONNELnewpdf.
American School & University. *American School and University: About.* http:www.asumag.com/about/#top.
American Tennis Association. *About ATA.* http:www.afn.orgatanav.htm.
———. *About ATA.* http://www.afn.orgaboutxt.htm.
———. *ATA: About.* http://64.233.161.104/search?q = cache:CbBnvP5ZZvcJ:www.atanational.com/about.htm+Lucy+.
Ancestry.com. *Ancestry.com-Clarke County, Virginia Births, 1878–96,* p. 1. http://search.ancestry.com/cgi-bin/sse d11?db = clarkeva1878&gsln = slow&gsco = 2%2cUnited+States.
———. *Edmond Hoyle.* http://www.answers.com/topic/edmond-hoyle.
———. *John Dewey.* http://www.answers.comntquery:jssionid = 7nhmepOg5058 q?method = 4&dsid = 2039&dekey+Dewey-Jo&gwp = 8&cl.

———. *Harry Hopkins*. http://www.answers.com/topic/harry-hopkins?method = 22.
Archibald, Alice J. *Rutgers University. Rutgers Oral History Archives, New Brunswick History Department: Interview with Alice Jennings Archibald.* March 14, 1997. http://www.oralhistory.rutgers.edu/Interviews/archibald_alice.html.
artnoir.com. *Biography: James Amos Porter.* http://www.artnoir.com/Biography.asp?ID = 26512.
As art.com. *Biography: James A. Porter.* http://www.as art.com/biography.asp?ID = 26512.
Babcock, Maltbie D. "Be Strong?" http://www.cyberhymnal.org/htm/b/e/bestrong.htm.
Baha'i Library. *Baha'i Library.com: Francis Gregory Biography.* http://www.bahai-library.com/?file = francis-.
Baha'i Library. *Baha'i alibrary.com: Francis Gregory Biography.* http://www.bahai-library.com/?file = francis_gregory_biography.html.
Baltimore Immigration Memorial (BIM) Foundation. *Historical Timeline.* http://www.immigrationbaltimore.org/historical_timeline.htm.
Bartleby.com. *Progressive Education.* http://www.bartleby.compr/progrsved.html.
Bashaw, Carolyn T. *Stalwart Women: A Historical Analysis of Deans of Women in the South.* New York: Teacheers College Press, 1999.
Bell-Scott, Patricia. "To Keep My Self-Respect: Dean Lucy Diggs Slowe's Memorandum on the Sexual Harrassment of Black Women." *NWSA Journal*, 1997.
Bennett, Lerone. *Before the Mayflower: A History of Black America.* Chicago: Johnson, 1969.
Black Press USA.com. *Dr. Dubois Dead at 95.* http://www.blackpressusa.com/history/article.asp?week = 35&Article = 1&NewsID = 1141.
Blount, Jackie. *History Cooperative: Fit to Teach: Same-Sex Desire, Gender, and School Work in the Twentieth Century.* Albany: State University of New York Press, 2004, 45. http://www.historycooperative.org/journals/heqbr_4.html.
Buck, Christopher. *Alain Locke Centenary: "Race Amity" & the Baha'i Faith.* 2007. http://www.christopherbuck.com/Buck_PDFs/Buck_Locke_Centenary.pdf.
Buck, Dee A. *Marriages Clarke County, Virginia 1865–1890.* Athane: Iberian Publishing Co., 1994.
Bundles, A'Lelia. *On Her Own Ground: The Life and Times of Madam C. J. Walker.* New York: Washington Square Press, 2001.
Cappon, Lester J. (ed.). *The Founders' Constitution*, v1, Chapter 15, Document 60: John Adams to Thomas Jefferson. http://www.press-pubs.uchicago.edu/founders/ documents/v1ch15s60.html.
casbs.org. *Newsletters, Summer 04: Vivian Johnson Cook.* http://www.casbs.org/newsletters/NewsletterSummer04.pdf?PHPSESSID = 6142455c6093db58.
Cazort, Jean. "Derricotte, Juliette." In *Black Women in America: An Historical Encyclopedia, v. 1.* Edited by Darline C. Hine, Elsa B. Brown, and Rosalyn Terborg-Penn, 332–333. Bloomington: Indiana University Press, 1993.
Chalkley, Tom. *Baltimore City Paper: Charmed Life. Circle Unbroken.* June 18, 2003. http://www2.citypaper.comstory.asp?id = 2328.
Clarke, Breena, and Susan Tifft/Durham. *Time: A Race Man Argues for a Broader Curriculum: HENRY LOUIS GATES JR.* April 22, 1991. http://www.time.commagazine/artucle/0,9171,972763,00.html.

Clifford, Geraldine J. (ed.). *Lone Voyagers: Academic Women in Coeducational Institutions, 1870–1937*. New York: The Feminist Press at the City University of New York, 1989.

Cobleigh, Rolfe. "A New Day for Howard University: Progress and Needs of a Great University." *The Congregationalist*, 1922: 108–109.

Collier-Thomas, Bettye. "National Council of Negro Women." In *Black Women in America: An Historical Encyclopedia*, v. II. Edited by Darlene C. Hine, Elsa B. Brown, and Rosalyn Terborg-Hine, 853–864. Bloomington: Indiana University Press, 1993.

Collins, Patricia H. "Feminism in the Twentieth Century." In *Black Women in America: An Historical Encyclopedia*, v. I. Edited by Darline C. Hine, Elsa B. Brown, and Rosalyn Terborg-Penn, 418–425. Bloomington: Indiana University Press, 1993.

Connolly, Rev. Mark. *Spirituality.org:"The Other Wise Man."* February 25, 2005. http://www.spirituality.org/issue05/page13.html22005.

Costa, D. Margaret, and Jane A. Adair. "Sports." In *Black Women in America: An Historical Encyclopedia*, v. II. Edited by Darlene C, Hine, Elsa B. Brown, and Rosalyn Terborg-Penn, 1099–1102. Bloomington: Indiana University Press, 1993.

Cultural Tourism—DC. *Lincoln Colonnade*. http://www.culturaltourismdc.org/info-url3948/info-url_show.htm?doc_id = 204988.

Cultural Tourism DC. *DC Public Schools*. http://www.cultourismdc.org/infour13948/infour_show.htm?doc_id = 212985$attrib_id = 7972.

———. *Kelly Miller Residence Site*. hppy://www.culturaltourismdc.org/info-url_show.htm?doc_id = 205004.

———. *Langston Terrace Dwellings/Hilyard Robinson, African American Heritage Trail*. http://www.culturaltourismdc.org1229.

Cultural Tourism DC.org. *Lucy Diggs Slowe Residence, African American Heritage Trail*. http://www.culturaltourismdc.org/info-url13948/info-url_show.htm?doc_id = 213185&attrib...405.

Cyberhymnal.org. *Biography: Maltbie Davenport Babcock. 1858–1901*. http://www.cyberhymnal.orgbbabcock_md.htm.

———. *Harry Emerson Fosdick. 1878–1969*. http://www.cyberhymnal.orgffosdick-he.htm.

Dartmouth College. *Special Collections: Talley Holmes*. http://www.dartmouth.edu/-speccol/studentforum/blackgreens/t_holmes.html.

Davis, Hilda, and Patricia Bell-Scott. "A Symposium: Our Living History: Reminiscenses of Black Participation in NAWDAC." *Journal of the National Association of Women Deans, Administrators, and Counselors* 33 no. 2 (3 Winter, 1979): 49–51.

Davis, Michelle D. *John P. Davis Collection: John P. Davis*. http://www.johnprestondavis.global.attitudes.org-The Davis Family.

———. *The John P. Davis Collection: Dr. William H. Davis*. http://www.johnpdaviscollection.org/davishistory.html.

———. *The John P. Davis Collection: Dr. William H. Davis*. http://www.johnpdaviscollection.org/about9.html.

Davis, Stanford L. *Buffalosoldier.net:Colonel Charles Young*. 2000. http://www.buffalo-soldier.net/CharlesYoung.htm.
DeLaney, Theodore, Jr. "Aspects of Black Religious and Educational Development in Lexington, Virginia, 1840–1928." *Proceedings, Rockbridge Historical Society* 10 (1980–89), no page number.
District of Columbia Public Library. *Biographies: Sterling A. Brown*. http://www.dclibrary.org/blkrenbrownsa.html.
Duffy, Michael. *First World War.com*. 2009. http:www.firstworldwar.com/features/declarationsofwar.htm.
Dunbar, Paul L. "Negro Society in Washington." In *In His Own Voice*. Edited by Herbert and Ronald Primeau Martin. Athens: Ohio University Press, 2002.
Dyson, Walter. *Howard University: The Capstone of Negro Education 1867–40*. Washington, DC: The Graduate School Howard University, 1941.
Ederle, Gertrude. *St. Lawrence County AAUW: History of Women in Sports Timeline—Part 2—1900–1929*. http://www.northnet.org/stlawrenceaauw/timeline2.htm.
Eisenmann, L. "A Time of Quiet Activism: Research, Practice, and Policy in American Women's Higher Education, 1945–1965." *History of Education Quarterly* 45 no. 1 (Spring 2005).
Empire Club Foundation.com. *Speech: Mrs. Ogden Reid*. http://www.empireclubfoundation.com/details.asp?SpeechID = 2781&FT = yes.
Encyclopedia Britannica.com. *Article: Syracuse University*. http://www.britannica.comarticle?tocid = 9002095.
Encyclopedia. The Free Dictionary. *The Free Dictionary: Films—1922*. http://www.encyclopedia.the freedictionary.com/1922%20in%20film.
Encyclopedia.Com. *Dr.James Hardy Dillard*. http://www.encyclopedia.comD/Dillard.asp.
Enoch Pratt Free Library. *African Americans in Maryland—Firsts and Facts*. http://www.pratlibrary.org/locationsindex.aspx?id = 4448.
eNotes. *The Barber of Seville*. http://www.enotes.com/barber-seville/28329.
Etter-Lewis, Gwendolyn. "Baha'I Faith." In *Black Women in America: An Historical Encyclopedia v. 1*. Edited by Darlene C. Hine, Elsa B. Brown, and Rosalyn Terborg-Penn, 63–66. Bloomington: Indiana University Press, 1993.
Even-Yisrael, Rabbi Adin (Steinsalz). Translated by Dr. Isaac Y.Hayutman. *The Hope: The Messiah Complex*. March 21, 1999. http://www.members.tripod.com/-TheHOPE/mescompl.htm.
Explore DC.org. *Explore Washington, DC: Dr. J. Hayden Johnson*. http://www.exploredc.org/index.php?id = 310.
Explore DC.org. *Mu-So-Lit Club*. http://www.exploredc.org/index.php?id = 83; http://www.culturaltourismdc.org/info-url3948/info-url_show.htm?doc_id = 212040&attrib....
Family Services. *About*. http://www.fsadayton.org.
Fourteenth Census of the United States:1920–Population, Baltimore City, Ward 14. http://content.ancestry.com/Browse/pring_u.aspx?dbid = 6061&iid = MDT 625_663-1100.
Franklin, John H. *From Slavery to Freedom: A History of Negro Americans*, 4th ed. New York: Knopf, 1974.

Bibliography *421*

Free Press.org. *Reflections on Black History (Part 84): The National Negro Congress of 1936 by Thomas C. Fleming.* September 22, 1999. http://www.freepress.org/fleming/fleming84.html.

Gates, Arthur I., Esther Hemke, and Dorothy Van Alstyne. "Problems in Beginning Reading: suggested by an Analysis of Twenty-one CoursesTeachers College Record," *tcrecord.org.* 26 no. 1 (1925): 572–591. hppt://www.tcrecord.org ID Number: 5978.

Gatewood, Willard B., Jr. "Aristocrats of Color: South and North. The Black Elite, 1880–1920." *Journal of Southern History* (1988).

Geocities.com. *Beta Upsilon. 1938 Lucy Slowe.* http://www.geocities.com/betaupsilon 1938/slowe.

Global Security.org. *Military.* http://www.globalsecurity.org/militaryhaiti19.htm.

Goldsmith, James. *Planet Baha'i: Alain Locke.* February 28, 2003. http://www.planet-bahai.org/cgi-bin/articles.pl?article = 172.

Greatschools.org. *Mary McLeod Bethune PCS-Slowe.* http://www.greatschools.org/washington-dc/washington/565-Mary-McLeod-Bethune-PCS—Slowe/.

Hanson, Joyce A. *Mary McLeod Bethune and Black Women's Political Activism.* Columbia: University of Missouri Press, 2003.

Harlan, Louis R. *Separate and Unequal: Public School Campaigns and Racism in the Southern Seaboard States 1901–1915.* New York: Atheneum, 1969.

Harley, Sharon. "Beyond the Classroom: The Organizational Lives of Black Female Educators in the District of Columbia 1890–1930." *Journal of Negro Education* 51 no. 3 (1982).

Harvard University. *Harvard Gazette: Roscoe Conkling Bruce.* http:www.64.233.161.104/search?q = cache:AyJkCK9NWf4J:www.news.harvard.edu/gazette2001/01.18/32-timecapsule.html+Roscoe+Conkling+Bruce&hl = en.

Harvard University. Harvard Divinity School Library. *Richard Niebuhr.* http://www.hds.harvard.edu/librarybms00630.html.

Herdlein, Richard J. "Thyrsa Wealtheow Amos: The Dean of Deans." NASPA Journal, 41 (2004): 336–55.

Home To Harlem.com. *Harlem History.* http://www.hometoharlem.com/HARLEM/HTHCULT.NSF/HARLEM/hthcult.nsf/harlem/HarlemHistorydoc.

Horowitz, Helen L. *Alma Mater: Design and Experience in the Women's Colleges from Their Nineteenth-Century Beginnings to the 1930s,* 2nd ed. Amherst: University of Massachusetts Press, 1984.

Howard University. Residence Life. *Residence Halls: Slowe Hall.* http://www.howard.edu/residencelife/reshalls/Slowe.htm.

———. Residence Life. *Residence Halls: Tubman Quad.* http://www.howard.edu/residencelife/reshalls/Tubman.htm.

———. Schools. *School of Social Work: History of Social Work Education at Howard.* March 22, 2004. http://www.Howard.edu/Schoolsocialworkabout.htm.

———. Schools: *School of Social Work Newsletter.* http://www.howard.edu/schoolsocialwork/Newsletter.pdf.

Internet Broadway Data Base. *IBDB: Three Pills in a Bottle.* http://www.ibdb.com/production.asp?ID = 9238.

Jackson, Barbara Brooks. Interview by Anne S. Pruitt-Logan. *Mu-So-Lit* (January 27, 2006).

James, Edward T., Janet W. James, and Paul S. Boyer (eds.). *Notable American Women 1907–1950: A Biographical Dictionary*, v.3. Cambridge, MA: Belknap Press of Harvard University, 1971.

Jean-Marie, Gaetane. "The courage to lead, black women administrators speak," Women in Higher Education (203). Cited in Mary L. Grimes, "Re-Constructing the Leadership Model of Social Justice for African-American Women in Education" 19(2005):4. http//216.239.51.104/search?q=cache: Hqy35KKVrJ4J:advancingwomen.com/awl/fall2005.

Jim Crow History. *Sports:Tennis*. http://www.jimcrowhistory.org/resources/lessonplans/hs_es_sports.htm.

John Dewey Project on Progressive Education. *A Brief Overview of Progressive Education*. January 30, 2002. http://www.uvm.edu/-Dewey/articles/proged.html.

Johnson, Catherine. "Dykes, Eva Beatrice (1893–1986)." In *Black Women in America: An Historical Encyclopedia*. v.1, Edited by Darlene C. Hine, Elsa B. Brown, and Rosalyn Terborg-Penn, 372–373. Bloomington: Indiana University Press, 1993.

Jones, Maxine D., and Joe M. Richardson. *Talladega College: The First Century*. Tuscaloosa: University of Alabama Press, 1990.

Journal of Negro History. *Journal of Negro History* 23, no. 1 (January 1938): 136–137. Personal Notes: Lucy Slowe. http://www.jstor.org/sici?sici = 0022-2992%28193801%2923%3A1%3C112%3AN%3E2.0.CO%3B2-Z.

Kirkpatrick, Dorthie, and Edwin Kirkpatrick. *Rockbridge County Births, 1853–1877*. Athens: Iberian Publishing Co., 1992.

Lahman, Sean. *Baseball Archive*. 1995. http://baseball1.com/baseball-archive.

Lawrence University. *Milwaukee-Downer College.Milwaukee-Downer Woman:Mina Kerr*. http://www.lawrence.edupubs/mdwoman/daily.shtml.

———. *Milwaukee-Downer College: About Traditions*. http://www.lawrence.edu/about/trads/mdc.shtml.

Lehigh University. *About. Past*. http://www3.lehigh.edu/about/lupast.asp.

Lewis, David L. *W. E. B.Du Bois 1868–1919: Biography of a Race*. New York: Holt, 1993.

LexisNexis.com. *Schomberg Center. Manuscripts. National Negro Congress*. http://www.lexisnexis.com/academicAaas/ManuscriptSchomburgCenter_pf.asp.

Library of Congress, Manuscript Division. *American Women*. http://www.memory.loc.gov/ammem/awhhtml/awmss5/afro_amer_schools.html.

Lloyd-Jones, Esther, and Margaret R. Smith. *Student Personnel Work as Deeper Teaching*. New York: Harper, 1954.

Logan, Rayford W., and Michael R. Winston. *Dictionary of American Negro Biography*. New York: Norton, 1983.

———. *Howard University: The First Hundred Years. 1867–1967*. New York: New York University Press, 1969.

Long Star College-Kingwood Library. *American Cultural History: The Twentieth Century*. http://www.kclibrary.nhmccd.edudecade00.html.

Lyle, Ethel H. "Sorority's Dramatic, Historical Highlights." In *Pearls of Service: The Legacy of America's First Black Sorority, Alpha Kappa Alpha*, by Ernestine G. McNealey, 17. Chicago, IL: Alpha Kappa Alpha Sorority, 2006.

Maryland State Archives. *Archives of Maryland Online: The First Colored Professional, Clerical and Business Directory of Baltimore City 6th Annual Edition, 1918–1919*, v. 498. p. 105. hyyp://www.aomol.net/000001/000498am498—105.html.

———. *Mary Church Terrell.* http://www.mdarchives.state.md.us/megafilespeccol.sc2900/sc2908/000001/000503am503—92.html.

———. *NAACP Baltimore Branch.* http://www.mdarchives.state.md.us/megafilespeccol/sc2900/sc2908/0000.

———. *The First Colored Professional, Clerical and Business Directory of Baltimore City, 11th Annual Edition, 1923–1924: Faculty Dunbar High School—Miss Charlotte Atwood.* http://www.mdarchives.state.md.us/megafilespeccol/sc2908/000001/000503am503—92.html.

———. *The Road From Frederick to Thurgood: Black Baltimore in Transition 1870–1920.* December 5, 2001. http://www.msa.md.govstagser.s1259/121html/1000.html.

Mead, Margaret. *Sex and Temperament in Three Primitive Societies.* New York: Morrow, 1935.

Miller, Carroll H. *Foundations of Guidance.* New York: Harper, 1961.

Mitchell, Reavis L., and Haywood Farrar. *Fisk University (1866-).* In *A Profile of African Americans in Tennessee History.* Edited by Bobby L. Lovett and Linda T. Wynn. December 15, 1985. http://www.tnstate.edu/library/digital/FISKU.HTM.

Moldow, Gloria B. "Brown, Sara Winifred (b. 1870)." In *Black Women in America: An Historical Encyclopedia, v. 2*, Edited by Darlene C. Hine, Elsa B. Brown, and Darlene Terborg-Penn. 184. Bloomington: Indiana University Press, 1993.

Morris, Mary T. *Connections and Partings: Abstracts of Marriage, Divorce, Death, and Legal Notices from Clarke County, Virginia 1857 through 1884.* Iberian Publishing Co., Athens, GA, 1992.

Moses, Y. Cited in Benjamin, L. (Ed.). *Advancing Women in Leadershsip Online Journal, Dr. Mary L. Grimes: Re-Constructing the Leadership Model of Social Justice for African-American Women in Education. Black Women in Academe: Issues and Strategies.* Fall 2005. http://www.216.239.51.104/search?q = cache: Hqy35KKVrJ4J:www.advancingwomen.comFall2005/19_7.htl.

NAACP. *Academic Guides.* http://www.lexisnexis.com/academic/guides/naacp16a.pdf#search = %22George%20W.%20Crawford%20and%20NAACP%2.

———. *Black Studies Research Sources.* http://www.lexisnexis.com/docyments/academic/upa_cis/1448_PapersNAACPPart16SerA.pdf.

National Association of College Deans, Registrars, and Admission Officers. *Welcome.* http://www.nacdrao.com/main.htm.

National Association of College Women. "The Story of the National Unfolds." *Journal of The National Association of College Women*, (1941): 6–23.

National Park Service. *Chicago: A National Register of Historic Places Travel Itinerary: Wabash Avenue YMCA.* http://www.cr.nps.govtravel/Chicago/c21.htm.

———. *Civilian Conservation Corps. Women.* http://www.nps.gov/archiveglossary/she-she-she-camps.htm.

National Park Service, U.S. Department of the Interior. *Civil Rights: Dunbar Apartments.* http://www.cr.nps.govtravel/civilrights/ny2.html.

NEA—National Education Association. *NEA Timeline.* http://www.nea.org/neatimeline/ html.
New Deal Network. *Selected Writings of Eleanor Roosevelt: The National Conference on the Education of Negroes.* Originally printed in *Journal of Negro Education* 3 (October 1934): 573–575. http://www.newdeal.feri.orger04.htm.
New York Life. *The History of Jim Crow: Women and Jim Crow: Virginia.* http://www.jimcrowhistory.org/scripts/jimcrow/women.cgi?state = Virginia.
Oberlin College Archives:. *Celebrating 175 years of African American Heritage at Oberlin College.* http://www.oberlin.edu/archive.
Oklahoma Historical Society. Oklahoma State University Library Electronic Publishing Center. *National Youth Administration* by Tally D. Fugate. 2007. http://www.digital.library.okstate.edu/encyclopedia/index.htm.
Oklahoma State University. Digital Library. *National Youth Administration.* http://www.digital.library.okstate.edu National Youth Administration.
Omega Psi Phi Fraternity, Inc. *The History of Omega Psi Phi Fraternity, Inc.: The Birth of Omega.* http://www.omega.rso.wisc.edu/The_ Founding_Fathers_of_ Omega_Psi_Phi.html.
Optometrists Network. March 19, 2011. http://www.strabismus.org/strabismus_crossed_ eyes.html.
Orenstein, David. *Brown University, Ethel Robinson '05 shared gifts of education, sisterhood.* February 16, 2011. http://www.news.brown.edu/features02/robinson.
Parker, Marjorie. *Alpha Kappa Alpha Through the Years—1908–1988.* Chicago: Mobium, 1990.
Pascarelli, Ernest T., and Patrick T. Terenzini. *How College Affects Students: Findings and Insights from Twenty Years of Research.* San Francisco: Jossey-Bass, 1991.
PBS. *Africans in America: Judgment Day. The Meaning of July Fourth for the Negro.* http://www.pbs.orgaia/part4/4h2927.html.
———. *American Experience. America 1900. David Levering Lewis: An"Aristocracy of Color."* http:www.pbs.orgamexfilmmore/reference/interview/lewis_aristocracyofcolor.html.
———. *Duke Ellington's Washington. Virtual Tour: Theaters—Howard.* February 7, 2000. http://www.pbs.orgellingstonsdc/vtTheaters.htm.
———. *Duke Ellington's Washington: Other Land Marks.* http://www.pbs.org/ellingtonsdc/vtOtherLandMarks.htm.
———. *Duke Ellington's Washington: Virtual Tour—Schools.* February 7, 2000. http://www.pbs.org/ellingtonsdc/vtSchools.htm.
———. *Duke Ellington's Washington: Virtual Tour—Howard Theater.* http://www.pbs.org/ellingtondc/vtTheaters.htm.
———. *New Perspectives on The West.* http://www.pbs.orgthewest/events/1880_1890.htm.
Perkins, Kathy A. "Burrill, Mary P. (c. 1884–1946)." In *Black Women in America: An Historical Encyclopedia,* Edited by Darlene C. Hine, Elsa B. Brown, and Rosalyn Terborg-Penn, 198. Bloomington: Indiana University Press, 1993.
Perrone, Fernanda. *Special Collections and University Archives, Rutgers University Libraries. MC671: Biographical Sketch of Frances Grant.* April 2000. http://www2.scc.rutgers.edumanuscripts/grantb.html.

Pruitt, Anne S. "Characteristics of College Student Personnel Workers," *Journal of College Student Personnel* 7 (1966):159–166.
———. "The Differential Rewards of Student Personnel Work," *Journal of the National Association of Women Deans and Counselors* 30 (1966):40–45.
Ransom, Joanna H. "Innovations Introduced Into the Women's Program at Howard University by the late Lucy D. Slowe." *Journal of the National Association of College Women* XIV (1937): 51–52.
Retro Sheet.org. *Protoball*. http://www.retrosheet.org/Protoball/Fat.2.06.htm.
Salem, Dorothy. "National Association of Colored Women." In *Black Women in America: An Historical Encyclopedia, v.II*, Edited by Darlene C. Hine, Elsa B. Brown, Rosalyn Terborg-Penn, 842–851. Bloomington: Indiana University Press, 1993.
———. "World War I." In *Black Women In America: An Historical Encyclopedia, v. II*. Edited by Darline C. Hine, Elsa B. Brown, and Rosalyn Terborg-Penn, 1284–1290. Bloomington: Indiana University Press, 1993.
Sargent, Dudley A. *Ladies Home Journal,1912: "Are Athletics Making Girls Masculine?."* http:www.college.hmco.com/history/readerscomp/womenwh_035200_ sports.htm.
Schuh, John H. "Foundational Scholarship in Student Affairs: A Sampler." *NASPA Journal* 39 no. 2, Winter, 2002.
Shirley, Wayne S. *Access my Library: The Coming of "Deep River" (African-American spiritual)*. December 22, 1997. http://www.accessmylibrary.com/article-IGI-20633039/coming-deep-river-african.html.
Sifakis, Stewart. *Civil War Biographies: Robert Gould Shaw (1837–1863)*. http://www.civilwarhome.com/shawbio.htm.
Simpson College. *Past Presidents 1866–1892: Edward L. Parks*. http:www.simpson.edu/president1800.html.
Slowe, Lucy D. "On the Occasion of the Laying of the Corner Stone of the Women's Dormitories, Howard University, June 5, 1931." *Journal of the College Alumni Club Memorial Edition*, 1939: 37–38.
Smith, Sam. *A Short History of Black Washington: Progressive Review*. http://www.prorev.com/dcblackhist.htm.
Smith-Rosenberg, Carol. "The Female World of Love and Ritual: Relations between Women in Nineteenth-Century America." *Signs* 1 no. 1 (Autumn, 1975): 1–29.
Smithsonian Anacostia Museum and Center for African American History and Culture. *The Black Washingtonians: The Anacostia Museum Illustrated Chronology*. Hoboken: John Wiley & Sons, 2005.
Southern Heritage 411.com. http://www.southernheritage411.com/truehistory.php?th = 066.
Spartacus Educational: Booker Taliaferro Washington. http://www.spartacus.schoolnet.co.uk/USAbooker.htm.
Spartacus. *Women's Suffrage: Mary McDowell*. http://www.spartacus.schoolnet.co.uk/USAWmcdowell.htm.
Spingarn Alumni "S" Club, Inc. *The Spingarn Medal: 1935—Mary McLeod Bethune*. http://www.Spingarn.k12.dc.us/SClub/medal.html.

St. Augustine's College. *About Us.* http://www.st_aug/boutus/boutus.htm.
St. Lawrence County, NY Branch of the American Association of University Women. *Women of Courage Profiles:Potsdam Normal School Home of Pioneer Women Educators—Patience Haggard.* http://www.northnet.org/stlawrenceaauw/normal.htm.
Staff, Mayo Clinic. *Mayo Clinic: Pleurisy.* hppt://www.mayoclinic.com/health/pleurisy/DS00244/DSECTION = 2.
Sweet, Leonard I. *Religion-online: Liberalism and Lost Days: A Re-evaluation of Fosdick.* From *The Christian Century,* December 18–25, 1985, pp. 1176–1179. Prepared by Ted and Winnie Brock. http://www.religin-online.org/showarticle.asp?title = 1933.
Talladega College. *Talladega College: History.* http://www.talladega.edu/history of the college.htm.
Teachers College, Columbia: Historical Timeline. http://www.tc.Columbia.edu/studenthandbook/detail.asp?id = Historical Timeline.
The Free Dictionary. *Christian Endeavor, Young People's Society of.* http://www.thefreedictionary.com/Christian+Endeavor%2c+Young+People's+Society+of.
The Free Resource. *Timeline of the History of Woman in Sports (1406–2010).* http://www.thefreeresource.com/timeline-of-the-history-of-woman-in-sports-1406-2010.
The Historical Society of Washington, D.C. *Collection of African American History: Columbiana Educational Association of the District of Columbia: 25th Anniversary.* 1946. http://www.historydc.orgAfrican_American_History_Resources.
The White House. President Barack Obama. *Our First Ladies: Anna Eleanor Roosevelt.* http://www.whitehouse.gov/anout/first-ladies/eleanorroosevelt.
Thompson, Kathleen. "Brown, Charlotte Hawkins (1881–1961)." In *Black Women in America: An Historical Encyclopedia, v. I,* Edited by Darlene C. Hine, Elsa B. Brown, and Rosalyn Terborg-Penn, 172–174. Bloomington: Indiana University Press, 1993.
U.S. Census Bureau. *Population of the United States in 1880.* Washington: Government Printing Office, 1884.
United States Department of Labor. *Secretary—Frances Perkins.* http://www.dol.gov-frances/frances.html.
University of Houston, Department of History. *Betsy Morin.* http://vi.uh.edu/pages/bussmat/gardner3.htm.
University of Illinois, Champaign-Urbana. English. *Poets: About Lynching. Robert L. Zangrando.* http://www.english.uniuc.edupoetsynchint/lynching.htm.
University of Illinois, Champaign-Urbana. English. *Poets: About Lynching. Robert L. Zangrando.* http://www.webcache.
University of Oregon. *The Psalms of David. Philip Sidney.* Transcribed by Risa S. Bear. January, 2007. http://www.uoregon.edu/-rbear/sidpsalms.html.
University of Pittsburg. Minority Health Archive. *National Negro Health Week, 1915 to 1951* by Sandra C. Quinn and Stephen B. Thomas. September 1, 2006. http://www.minority-health.pit.edu/archive/00000541 National Health Week.pdf.
University of Vermont. *A Brief Overview of Progressive Education.* January 30, 2002. http://www.uvm.edu/-dewey/articles/proged.html.
University of Wisconsin Library. *Dean of Women Mathews.* http://www.72.14.203.104univwisc?q = cache:tQExC2KqzGoJ;digicoll.library.wisc.edu/cgi-binUW-

idx%3Ftype%3Dturn%26entity%3DUW001800180027%26isize%3Dtext+ +Dean+of+Women+Mathews&hl = en&gl = us&ct = clnk&cd+1&ie = UTF-8.
View.atdmt. *Frank, Glenn.* http://www.view.atdmtiview/trblfvon00700100von/direct/ 781690344?click = http;//a.tri.
Vinson, J. Todd. *My Creed.* http://www.jtoddvinson.com.
Washington and Lee University School of Law. *Faculty: History—John W. Davis (1873–1955).* http://www.lawlibrary.wlu.edu/faculty/history/davis.htm.
Wayne State University. *Detroit African-American History Project: Detroit Historical Events. 1916: Forrester B. Washington.* http:??www.daahp.wayne.edu/1900_1949.html.
WeatherBook.Com. *The Knickerbocker Snowstorm—January 28–29, 1922.* http://www.weatherbook.com/knickerbocker.html.
Weinberg, Meyer. *A Chance to Learn: The History of Race and Education in the United States.* Cambridge: Cambridge University Press, 1977.
Wheaton College, MA. *Wheaton College:Archives—Histories: Officers, Deans.* http:// www2.wheatonma/Archives/Histories/Officers/Deans.html.
Wikipedia. *Origins of Baseball.* http://www.en.wikipwdia.org/Origins_of_baseball.
Wilberforce University. *Wilberforce University: About WU—History.* http://www.wilberforce.edu/welcome/history.html.
Williams, Scott W. *Mathematics Department of The State University of New York at Buffalo.* Special Articles: Kelly Miller. May 28, 1999. hyyp://www.math.buffalo.eduspecial/miller_kelley.html.
Wolters, Raymond. *The New Negro on Campus: Black College Rebellions of the 1920s.* Princeton: Princeton University Press, 1975.
Women and Social Movements, 1600–2000. http://womhist.binghamton.edu/byywca/intro.htm.
women enews.org. http://www.womenenews.org/article.cfmaidcontext/archive.
Women's International Center. *Women's History in America.* http://www.wic.orghistory.htm.
Wright, Marion T. "Slowe, Lucy Diggs." In *Notable American Women:1607–1950 A Biographical Dictionary.* v.III. Edited by Edward T. James, Janet W. James, and Paul S. Boyer, 299–300. Cambridge: The Belknap Press of Harvard University Press, 1971.

Index

Abu-Bader, Soleman, 417
"Achievement," 15
Ad Hoc Committee on Women Students in the District of Columbia: Alice Nelson Williams and, 195
Adair, Jane A., 419
African American Registry, 417
Afro American, 4, 44, 45, 65, 73, 74, 93, 149, 162, 179, 192, 193, 231, 235, 266, 274, 282, 312, 325, 326, 329, 335, 343; William N. Jones, editor, 298
Afro-American Ledger, 18, 19
Alexander, Sally, 223
Allen, Maryrose R., 190, 389n165
Allen, Vivian Garth, 270
Alpha Kappa Alpha Sorority, 2, 4, 32–33, 238–239, 245, 253, 284, 302–305, 356n62–69, 369–371n61; Alpha Chapter, Howard University, 32–33; Anna Julia Cooper and, 251–252; Condolences on Slowe's death, 233; Founders: Anna Easter Brown, 32, Beulah Burke, 32, Ethel Hedgeman, 32–33, Lavinia Newman, 32, Lillie Burke, 32, Lucy Diggs Slowe, 32, Margaret Flagg-Holmes, 32, Marie Woolfolk Taylor, 32, Marjorie Hill, 32; Founders Day, 293; Marjorie Parker and, 32; 100th Anniversary, 349; Slowe as first President of, 32–33; Vivian Johnson Cook and, 37
Alpha Phi Alpha Fraternity, Howard University, 33, 369–371n61
Alpha Phi Literary Society, 30

Alumni Association (*See* Howard University)
AME Church, 15
AMEZ Church, 15
American Association of College Women, 252
American Association of Schools of Social Work, 220
American Association of Teachers Colleges, 255
American Association of University Women, 70, 125, 239, 265; Condolences on Slowe's death, 327
American Council on Education, 255
American Mercury, 277, 404n207
American School & University, 163
American Tennis Association, 2, 72, 74; Condolences on Slowe's death, 329; Slowe's first African American woman to win a championship, 74
American Women's Association Conference, 343
Amos, Thrysa, 158–159, 167, 189–190, 222, 243, 330; National Association of Deans of Women and, 3, 97–100, 151, 173, 185–186, 222–230, 253, 382n30–33
Anderson, Marian, 144
Anderson, Thomas, 325
Andrew Rankin Memorial Chapel, 5, 25, 27, 142, 221, 337
Anti-Lynching Crusaders: NAACP, 258
Anti-lynching legislation: Costigan-Wagner Bill, 258; Dyer Bill, 258
Archibald, Alice Jennings, 134, 418

Architects: Albert I. Cassell, 158–159, 235, 325, 378n28, 410n10; Hilyard Robinson, 334; William A. Hazel, 159
"Aristocrat of Color," 41, 358n13
Armstrong Manual Training High School: 2, 45, 46, 48–50, 52, 289, 335, 359n39, 360n57–58; Booker T. Washington and, 2, 45; Frederick Douglass and, 49, 50; Slowe as Lady Principal/Dean of Girls, 50; Slowe as first Vice Principal, 50; Teaching position in English, 46; William H. Davis and, 49, 50
Associated Charities/Family Service Association, 274–275
Association of American Universities, 255
Association of Collegiate Alumnae, 68, 82
Association Tennis Club, 73
Atwood, Charlotte, 195, 277, 284
Aunt Caroline, 8; Aunt Martha (see Price)

Babcock, Maltbie D., 349, 415n10–11, 418
Baha'i faith: Alain Locke, 58; Coralie Cook and, 59, George William and, 59, Gregory, Louis and, 59; 418, 420
Ball, Louise C., 331
Ballot, 43–44, 47
Ballou, Frank W., 59, 64
Baltimore, MD, 1, 26, 346, 353n40, 357n4–5; Baltimore's Browning Club, 42; Colored High School of Baltimore, 2, 19, 20, 22, 30, 39, 45, 52, 138; Colored Young Women's Christian Association (CYWCA), 18; Foster Whist Club, 41, 238; Lexington Savings Bank, 18; Madison Street Presbyterian Church Choir, 41; Slowe's move to, 17–18; St. Francis Catholic Church Choir, 41, Students' perception of Slowe, 48, 357n4

Bando, Thelma Preyer, 335, 412n55
Baptists, 15
Barrett, Janie Porter: Locust Street Social Settlement, 17–18
Bashaw, Carolyn T., 418
Basketball, 19
Beard, Mary, 261
Bell-Scott, Patricia, 418, 419
Bennett, Lerone, 418
Berrien, Mollie T., 232
Berryville, (Commonwealth of Virginia), 7, 8, 9, 230, 346; City of Slowe's birth, 351–352n4–5
Bethune, Mary McLeod: Black Cabinet, 259; Channing Tobias and, 199; Condolences on Slowe's death, 232, 330, 334; National Council of Negro Women and, 4, 37, 38, 232, 238, 271–273; National Youth Administration and, 273, 276, 334; Slowe's birthdate, 8, 352n5; Support of Slowe, 198–201
Bingham, III, Hiram (Senator), 256
Bison Yearbook, 150
Black, Francoise, 276
Black Cabinet, 259
Blount, Jackie, 418
Blue Veins Society, 134
Brady, St. Elmo, 117
Brawley, Benjamin, 23, 224, 394n60
Brown v. the Board of Education of Topeka, Kansas, 18
Brown, Charlotte Hawkins: National Council of Negro Women and, 272; Palmer Memorial Institute and, 142; 403n162
Brown, Sara, 210–211; First woman on Howard University Board of Trustees, 250–251, 398n55
Brown, Sterling, 203
Brown, (Mrs.) Sterling, 69
Browning Club, 238
Bruce, Clara B.: Dunbar Cooperative Apartments, 217; National Council of Negro Women and, 272
Bruce, Roscoe Conklin: Associate Superintendent of Colored Schools,

Washington, D.C., 45, 50, 66, 184, 366n187, 388n139
Bryan, Mary deGarmo, 217
Bryce, James, 30
Bunche, Ralph J., 150, 313
Buck, Christopher, 418
Buck, Dee, 418
Bundles, A'Lelia, 418
Burge, Louise, 142
Burke, Edmund H., 329
Burrill, Mary P., 3, 76–77, 93, 106, 142, 231, 232, 233, 234, 351n1; 395n92

Caliver, Ambrose, 255–257; Aubrey Williams and, 256; National Conference on the Fundamental Problems in the Education of Negroes and, 256
Cameron, H. Whyte, 223
Cannon, Clarence (Congressman), 256
Capper, Arthur (Senator), 256
Cappon, Lester J., 418
"Capstone of Negro Education": Howard University as, 23, 87, 369n43
Carnegie, Andrew, 30
Carney, Mabel, 182, 185, 295, 330, 387n130
Carter, Elmer, 313
Cassell, Albert I., 325; Howard University architect, 158–159, 235, 325, 378n28, 410n10
Catlett, Sherwood L.: Howard University Alumni Association, 171–172, 176
Cazort, Jean, 418
Chalkley, Tom, 418
Character, 144, 160, 225, 227, 255, 288–294, 295, 301, 309, 311, 322, 330, 342, 347
Chase, Mamie, 27
Chase, W. Calvin: As "race man," 51, 360n68; Opposition to junior high school in Washington, D.C., 51
Chautauqua Daily, 310
Chavious, A. B., 54

Chi Delta Mu Medical Fraternity, 371, 369–371n61
Childers, Lula Vere, 27–28, 69 111–112, 142, 325
Christian Endeavor Society, 276; Slowe as President of, 29, 238
Christianity, 316
Civic activities, 44
Civic responsibility, 296, 309, 348
Civil War, 16
Civilian Conservation Corps (CCC), 271
Clark, Beatrice, 229
Clarke, Breena, 418
Cleveland Alumnae Club, 94
Clifford, Geraldine J., 419
CME Church, 15
Cobb, James A., 187
Cobleigh, Rolfe, 23, 90–91, 354n8, 419
Coleman, Frank W., 325
College Alumnae Club (CAC), 3, 67–72, 82, 88, 238, 247–248, 252, 269, 284, 364n145; Addie Hutton and, 284, 405n236; Anna Julia Cooper and, 35, 69, 251; Bertha C. McNeill and, 284; Charlotte Atwood and, 195, 277, 284; Condolences on Slowe's death, 327; Ethel H. Just, 69; Ida Gibbs Hunt and, 69; Jessica Fauset and, 69; *Journal of the College Alumnae Association*, 311, 326; Lula Vere Childers and, 69; Lucy Messer Holmes and, 69–70, 223; Mary Church Terrell and, 67–68, 284; Mary Cromwell and, 70; Mrs. E. P. Messer and, 70; Mrs. Sterling Brown, 69
College curricula, 295, 297, 305–307, 320, 323, 348
Collier-Thomas, Betty, 419
Collins, Patricia H., 419
Colored High School of Baltimore, 2, 19, 22, 30, 52, 138; Alethea H. Washington and, 19; Girl's Club Program, 19; Slowe resigned position, 45; Slowe's graduation, 1904, 20; Slowe's teaching position, 1908–1922, 39

Colored Young Women's Christian Association (CYWCA), 18
Columbia University: Slowe admitted to graduate school, 41; Slowe's Master of Arts degree, 41
Columbia University, Teachers College, xiii, 3, 150, 243, 295, 308, 346; Advisers to Women and Girls and, 163; Columbia Extension Center at the Junior High, 88; Condolences on Slowe's death, 233, 330; Courses for Advisers of Women and Girls, 243; Division of Institutional Management, 159, 217; Doctoral program, 2; In-service training for Washington, D.C. school teachers, 52; Mable Carney and, 182, 185, 295 330; Mary deGarmo Bryan and, 217; Racism, 242; Sarah Sturtevant and, 167, 253; Slowe's speech on race relation at, 100, 407n21; Slowe's Summer courses, 99, 253, 382n30; *Teachers College Record*, 100; Thaddeus F. Hungate and, 213
Columbian Education Association of Washington, D. C., 238; Slowe as President of, 65; 363n121
Commission on Race Relations, 308
Communism, 314
Community affairs, 79, 295, 296, 305, 396n7, 411n38
Community Chest, 275, 403n185, 411–412n32–40
Condolences on Slowe's death, 325–337
Confederate States of America, 14

Conference on the Causes and Cure of War, 141, 218
Conference of College Women, 294
Conference of Christian Students of the Mid-Atlantic Region, 228
Congregational Church, 23
The Congregationalist, 23
Connolly, Mark, 419
Cook, Charles C., 29
Cook, Coralie, 2, 21, 27, 34, 37, 38, 75, 193 223, 394n60; Baha'i faith and, 36; District of Columbia Board of Education, 34, 50; Housing for Dean of Women, 118–119, 183–184; Howard University Committee of Sponsors, 105; Howard University Ladies Committee, 80; Miner Hall Superintendent/Matron at Howard University, 27, 38; National Association of College Women and, 34; Women's suffrage and, 34; 356n72
Cook, George William, 2, 23, 24, 26–27, 38, 80; Housing for Dean of Women, 118–119, 183–184
Cook, Vivian Johnson, 37, 38, 336, 412n57–58; Alpha Kappa Alpha Sorority and, 37; National Association of College Women (NACW) and, 37, 251, 268; National Council of Negro Women (NCNW) and, 37
Cooper, Anna Julia, 35, 69, 251, 409n57
Coppin, Fanny Jackson: Institute for Colored Youth, 17
Costa, D. Margaret, 419
Costigan-Wagner Bill (anti-lynching), 258
Cotton, Martin: M Street Junior High School and, 58
Courses for Advisers to Women and Girls Columbia University, Teachers College, 243
Crawford, George W.: Howard University and Talladega College Trustee, 139, 189–191
The Crisis, 42–43, 44, 74, 253
Cullen, Countee, 144
Cultural opportunities, 145, 292, 309, 323, 347
Cusp and Crown Dental Fraternity, 369–371n61
Cuthbert, Marion V.: Talladega College and, 139

Daniel, Sadie, 255, 351n2
Daniel, Walter, xiii
Davis, Carrington, 42

Davis, Hilda, 241, 269, 369n14, 374n103, 419; President of Delta Sigma Theta Sorority, Alpha Chapter, 105, 420
Davis, John P., 260, 313, 335, 359n56–57, 360n58
Davis, John W., 272
Davis, Lonia, 42
Davis, Michelle D., 419
Davis, Stanford, 420
Davis, William H., 49–50, 335, 359n56–57, 360n58
Dean of Men, 157, Edward L. Parks, 80, 111–112, 155, 157, 158, 214, 382n27, 392n28
Dean of Women, Howard University: Academic Council, 108–114; Alumnae, contact with, 206; Annual Reports, 102–105, 114, 201–206, 223–227; Annual Women's Dinner, 114, 120, 150, 196, 204, 217, 219, 222, 272, 307, 334; Appointment as Dean, 3, 79–88, 177; Assistant Dean of Women, 214; Board of Deans, 138, 145, 146, 153–154, 155, 158; Board of Lady Managers, 80; Budget, 213, 225; Center for Negro Children, 204, 206; Christmas Vesper Candlelight Service, 106, 141, 142, 222, 307; Clarence Mills and sexual harassment of women students, 135–138, 145, 186, 190; 378n29–31, 379n37–39; Committee on Discipline, 181; Committee to Study Personnel, 154; Condolences on Slowe's death, 325–337; Contact with parents, 206; Controversies: Dining Hall conversion to Law School, 208, 391n2, Faculty rank, 86, 87, 116, 342, Living on campus, 3, 4, 86, 118–119, 124–126, 177, 182, 183–184, 187–195, 198, 201, 266, 376n162, 389n165, 389n170, Policies pertaining to women, 80, 86, 188–189, 197, Salary dispute, 83–84, 116, 133–134, 145, 157, 197, 199, 213, 231, 235, Women's physician dismissed, 179–181, 197; Course for prospective Deans of Women, 242, 264; Credentials for Deans, 319–322; Cultural Series; 144, 203; Dean of Women's Club, 243; Death of, 232–235, 330, 334, 395n81, 401n130; Department of Social Services, 204, 206, 213, 226; Dietician for dining hall, 188, 197, 321; Discipline of women students, 107–116, 119, 134, 152, 181; Dormitory Directors, 164, 211–212, 214; Dormitory fees and scholarships, 173, 197, 214–216, 225; Dormitory upkeep transferred to University Treasurer, 173–176, 197, 202, 208–211; E. Louise Murphy and, 211; Educational standards, 248; Eleanor Roosevelt and, 256, 260, 270–272; Extra-curricular activities, 27–30, 36, 41–42, 323; Freedmen's Hospital, 226, 394n64; Friendship Circle pin, 219; Funeral of, 4, 79, 232–235, 236, 326–334, 411n14; Garden Party, 222; Harriet Tubman Quadrangle (The "Quad"), 348, 414n4; Health of women students, 115, 119, 127, 147, 179–181, 188, 197, 202, 226; Honor System, 196; Housing for women students, 114–115, 127, 164, 173, 197, 214, 225, 321; Illumination Night, 222; Insubordination of Dean, 176–178, 193; Inter-Sorority Council, 152, 205; Introspection, 76, 229–230; Invitational Conference of Personnel Workers, 230; Invitations to President and Mrs. Johnson, 153; Ladies Committee, 80; "Lady Cop," 269; Lecture Committee, Chair of, 116; Lucy Diggs Slowe Elementary School 335, 414n9; Lucy Diggs Slowe Hall, 334–335, 414n5; Lucy Diggs Slowe Memorial Window, 337; Mary McLeod Bethune and, 198–201, 232, 330, 334; May Week, 143, 222; Miner Hall, 24, 25, 26, 30, 80, 91, 124, 158, 145, 191; Morality

434 Index

Dean of Women, Howard University (*continued*)
of women students, 164–165, 226, 227, 288, 291, 322–323, 341, 342, 347, 348; Mother-Daughter Banquet, 221, 222; Mu Lambda Lambda Debating Sorority, 144; New Women's Campus, 4, 152, 158–164, 202, 211–212, 217, 288, 346, 348; Newspaper coverage, 178, 192, 193; Office help, denial of: 145, 154, 197, 202, 204, 225 234; Petition, 188–189; Philosophy, 117–118, 144, 160, 207, 225, 227, 255, 288–294, 295, 301, 309, 311, 322, 330, 342, 347; Phyllis Wheatley YWCA and Pollyanna Review, 120–124; Physician for women dismissed, 179–181, 188, 197; Position Description, 81–82, 126–128, 174–176, 204, 367n14; Pre-School education, 204, 206; Promoted to Full Professor, 116; Proposed programs for women students, 204, 206, 213, 226; Propriety of public school teachers, 121–124; Public service, 226; Requests for advice from other deans, 244–247; Residence camps for needy/unemployed women, 270–271; Role of Dean of Women, 108, 126–128, 145–148, 156–158, 169, 176, 204, 229, 347, 382n25–28, 386n114, 386n68–109; Salary dispute, 83–87, 116, 133–134, 145, 157, 197, 199, 213, 231, 235, 368n33, 382n26; 385n80; 395n78; School of Social Work, 206, 220, 348; Senior Mentors, 152, 381n6; Sexism, 229; Slowe accused of leaking information to press, 192; Smith, Adeline, 337; Social activities of women on/off campus, 115, 127, 152, 224; Sorority Council, 246; Student self-government, 127, 162, 228, 291, 322, 323, 342, 348; Support for Dean, 182–188 193–195, 387n130, 388n139; Student Council, 102, 103, 108–109, 114, 134, 152, 224; Termination threat of Dean, 177, 185–188, 198; Vivian Garth Allen and, 270; Vocational Guidance Conference for Women, 343; Vocational Information, 115, 127, 152, 202, 224, 320; Willie B. Wilson, 234; Women of the Senior Class reception, 140; Women's Board proposed, 112; Women's Cooperative Council, 102; Women's League, 105–106, 120, 140, 143, 152, 196, 203, 221, 228, 245, 284, 307, 329; Women's Tennis Club, 29; Work Study, 115, 127, 225

Deans of Men in Negro Schools, 268

Death and Funeral of Lucy Diggs Slowe, 232–235, 266, 401n130; Buried at Lincoln Cemetery, 411n14; Charles H. Wesley officiated at funeral, 325; Condolences on Slowe's death, 325–337; Dorothy Detzer and, 232; Dwight O. W. Holmes eulogy at funeral, 4, 232, 332; Guy B. Johnson and, 232; "In Memoriam," 232; Kelly Miller tribute at funeral, 79, 331; Mary McLeod Bethune and, 232, 330, 334; Mollie T. Berrien and, 232; Mordecai Johnson not invited to funeral, 234, 326; Newspaper coverage of funeral, 326–334

Debating, 29, 144, 369–370n61

DeBose, Tourgee, 144

DeLaney, Jr., Theodore, 420

Delta Sigma Theta Sorority, Alpha Chapter: Hilda Davis as President of, 105, 269, 369–371n61

Department of Interior: Communism investigation of Mordecai Johnson, 170–171; Federal appropriations investigation of Howard University, 170–171, 213; Harold Ickes and, 213; Oscar Chapman and, 212; Slowe questioned about being a witness, 170–171

DePriest, Oscar (Congressman), 259–260, 314, 343

Derricotte, Juliette, 139, 276–279, 404n200; Death of, 266
Detzer, Dorothy, 232
Dickerson, Addie, 285
Diggs name, 352n6
Dillard, James Hardy, 199
Disadvantaged women, 306
Discrimination, 44
Dixon, Russell A., 214
Doctrine of National Self Containment, 257
Donovan, Arnold B., 187
Dormitories: Baldwin Hall (The Quad) 348; Clark, 92, 215, 217–220, 222, 293–294, 328, 407n14; Crandall Hall (New Women's Campus), 162, 208–211, 348; Frazier Hall (New Women's Campus), 162, 348, 383n47; Harriet Tubman Quadrangle (The Quad), 348, 414n4; Howard, 91; Miner Hall, 24–27, 30, 35, 38, 80, 91, 124, 145, 158, 191, 369–371n61; New Women's Campus, 4, 152, 158–164, 202, 211–212, 217, 288, 346, 348; Old Main Hall, 92; Slowe Hall, 334–335, 414n5; Thirkield Hall, 92; Truth Hall (New Women's Campus), 162, 348; Wheatley Hall (The Quad), 348; Women's residence halls, 173
Douglas, Daisy: Interview with, 373n71
Douglass, Frederick, 16, 17, 346
Dozier, Verna, 332
Du Bois, W. E. B., 2, 24, 27, 66, 217, 253, 285, 314, 346; Critique of Thomas Jesse Jones, 277, 250; Haiti, 253–254; *The Crisis*, 42–43, 44, 253; Washington-Du Bois controversy, 44, 51; Women's suffrage, 43; 359n32
Du Bois Circle, 2, 42, 43–44, 238, 358n20
Dunbar, Paul Laurence, 48, 420
Dunbar Cooperative Apartments, (New York City), Clara B. Bruce and, 217; Matthew A. Henson and, 217; Paul Robeson and, 217; W. E. B. Du Bois and, 217

Dunbar High School, 50, 51, 52, 195, 360n71, 364n145
Duncan, R. Todd, 325, 410n7
Durkee, J. Stanley, 3, 79–129, 138, 148, 155–156, 158, 175, 177, 192, 201, 299, 369n56–58; "The Compromiser, 89; Resignation, 128–129; Rolfe Cobleigh, 90
Dyer Bill (anti-lynching): NAACP support of, 258
Dykes, Eva Beatrice, 41
Dyson, Walter, 420

Economic status, 313
Ederle, Gertrude. 420
Eisenmann, L., 420
Ellison, Elizabeth, 325
Emancipation Proclamation, 14
Empowerment, 193
Equal rights, 3, 44
Etter-Lewis, Gwendolyn, 420
Europe, M. L.: M Street Junior High School and, 58

Fairfield, F. W., 22, 28
Faith, 5, 287, 297, 347
Family Services Association, 274–275, 403n177
Farrar, Haywood, 423
Fauset, Jessica, 69, 364
Federal Council of Churches, 308
Federal Emergency Relief Administration, 270
Feminism, 193, 261
Feminist, 2, 35
Ferebee, Dorothy: Physician for women students at Howard University dismissed, 179–181
Firsts: African American member of the National Association of Deans of Women (NADW), 3; African American woman tennis champion (1917), 1, 2, 74; Dean of Women at Howard University, 3; Honor student at Howard University, 33; President of Alpha Chapter of the Alpha Kappa Alpha Sorority

Firsts *(continued)*
(Howard University), 32; President of National Association of College Women, 247; Principal of first junior high school for black children in Washington, D.C., 1, 2, 50; To introduce in-service training for Washington, D.C. school teachers, 52–53; Vice Principal of Armstrong High School, 50
Fisk University: Student rebellions, 114, 375n143, 386n114
Flexner, Abraham: Howard University Board of Trustees Chair, 4, 168, 169–172, 177, 179–182, 195; Resignation, 213
Ford, James, 313
Foreign Missionary Conference, 278
Fosdick, Harry Emerson, 340
Foster Whist Club, 41, 238
Frank, Glenn, 340
Franklin, John Hope: Haiti and, 253, 420
Frazier, E. Franklin, 220
Frazier, Julia Caldwell: Frazier Hall at Howard University, 162, 348, 383n48–49
Freedmen's Hospital, 226, 394n64
Friends Intelligencer, 334

Gant, Mary Abrams, 231
Garvin, Charles H., 199
Gates, Arthur I., 421
Gatewood, Jr., William B., 421
Gildersleeve, Virginia, 261, 342
Giles, William D., 27
Goldsmith, James, 421
Gordon, John, 22, 28, 369n42
Graduation from Howard University, 1908: First honor student, 39, Valedictory address, 33
Granger, Lester, 313
Grant, Carolyn V., 142
Grant, Frances, 219–220
Great Depression, 260, 267; Decline in enrollment at Howard University, 167–169, 224; Reduction in salaries for faculty and staff, 168; Elaine Tancil dismissed due to low enrollment at Howard University 167–169, 173, 193, 384n70–71
Great Migration, 17
Grooms, Margaret Jean, 93, 134, 140, 145, 221, 222, 243, 287

Haiti, 253–254, 263: John Hope Franklin and, 253; Mordecai Johnson and, 254; R. R. Moton, 254
Hampton Institute, 241
Hance, John, 11–12
Hanson, Joyce A., 421
Hardwick, Marie, 80, 145
Harlan, Louis R., 421
Harley, Sharon, 421
Harper's Magazine, 54
Harriet Tubman Quadrangle (The "Quad"): Baldwin Hall, 348; New Women's Campus, 348; Wheatley Hall, 348; 414n4
Hatfield, H. D., 111
Hawkes, Nellie Slowe (*see* Slowe, Nellie)
Hazel, William A.: Howard University architect, 159
Heath, Kathryn G., 336
Helfand, Jessica, 413n1
Herald Tribune, 341
Herdlein, Richard J., 81, 367, 381, 382, 421
The Hilltop, 101, 105, 106, 113, 117, 134, 141, 142, 143, 147, 150, 152, 160, 196, 204, 217, 218, 219, 234, 242, 243, 279, 284, 378n22
Hobbies, value of: 62, 117, 144
Holmes, Dwight O. W., 2, 19, 20, 34, 38, 42, 44, 59, 111–112, 230–231, 235; Eulogy for Slowe, 4, 232, 332; President of Morgan State College, 230; Registrar at Howard University, 81; Speaker at M Street Junior High School commencement, 58; Tennis and, 73
Holmes, Eva M., 195
Holmes, John Alexander, 19

Holmes, John Haynes, 342, 414n29
Holmes, Lucy Messer ("Lu"), 69–70, 223 394n60Holmes, Tally, 73–74, 329
Hoover, Herbert (President of the United States): Haiti and, 253–254; Isolationism, 257
Hopkins, Harry, 271, 402n152
Horowitz, Helen L., 421
Houston, Charles Hamilton, 313
Houston, Joanna, 54, 165–167, 208, 230, 243, 336, 381n19, 425
Houston soldiers, 71, 250, 365n163
Howard, Juanita, 255, 268
Howard, Oliver Otis, 22
Howard Alumnus, 100
Howard Theater, 47
Howard University: Abraham Flexner, Board of Trustees chair: 4, 168, 169–172, 177, 179–182, 186–188, 195, 198, 213; Academic Council, 108–114, 374–375n123–128; Alain Locke, 23, 313; Albert Cassell, 158–159, 235, 325, 378n28, 410n10; All-University Assembly, 228; Alpha Kappa Alpha Sorority, 2, 4, 32–33, 238–239, 251–253, 284, 293, 302–305, 349, 369–371n61; Alpha Phi Alpha Fraternity, 33, 369–371n61; Alpha Phi Literary Society, 25, 30; Alphaeus Hunton, Jr., 313; Alumni Gymnasium, 66; Alumni-Senior Charter Day Dinner, 117; Ambrose Caliver, 255–257, 343; Andrew Rankin Chapel, 5, 25, 142, 221, 280, 325, 393n44–45; Annual Reports, 91, 369n61; Annual Women's Dinner, 102–105, 114, 141, 142, 150, 334; Appropriations Act, 1861, 369n56; Architects: Albert I. Cassell, 158–159, 235, 325, Hilyard Robinson, 334, William A. Hazel, 159; Baldwin Hall, 348; Band, 369–371n61; Benjamin Brawley, 23; Benjamin E. Mays, 214, 325; *Bison* Yearbook, 150; Board of Deans, 138, 155–157, 196; Board of Trustees, 4, 26, 153, 158; Budget Committee, 124, 213; "Capstone of Negro Education," 23, 346; Carnegie Library, 92; Chamber of Commerce, 369–371n61; Channing Heggie Tobias, 109–110, 169–170, 195, 199–200, 209–210; Charles C. Cook, 29; Charles H. Garvin, 199; Charles Harris Wesley, 325; Charlotte Hawkins Brown, 142; Chi Delta Mu Medical Fraternity, 369–371n61; Christian education, 369–371n61; Christian Endeavor Society, 29; Christmas Vesper Candlelight Service, 106, 141, 142, 222, 307; Clarence Mills, 135–138, 125, 186, 190; Clark Hall Council, 92, 215, 217–220, 222, 293–294, 407n14; Classical Club, 369–372n61; College of Arts and Sciences, 23, 24; College of Education, 213, 343, 387–388n130; Commencement exercises, 1908, 33; Committee on Discipline, 181; Committee on Instruction and Research, 174, 214, 331; Committee on Scholarships, 225; Committee of Sponsors, 105; Committee on Teachers, 116; Communism investigation, 170–171, 343; Condolences on Slowe's death, 331; Coralie Cook, 27, 34, 38, 80, 105, 118–119, 183–184; Crandall Hall, 162, 208–211, 348; Cultural Series, 144; Culture Club, 30; Cusp and Crown Dental Fraternity, 369–371n61; Day of Prayer for Colleges, 30; Dean of Men, 80, 111–112, 155, 157, 158, 214, 382n27, 392n28; Dean of Women, 1922–1937, 4, 79–422; Delta Sigma Theta Sorority, Alpha Chapter: Hilda Davis, 105, 269, 369–371n61; Department of German, 36–371n61; Department of Physical Education, 369–371n61; Der Deutsche Verein Club, 369–371n61; Dining Department, 214; Discipline of women, 107–116, 181; Division of

438 Index

Howard University *(continued)*
Social Sciences, 313; Dormitories, 173–176, 197, 214–216. *See also* Dormitories; Dormitory Matron, 107, 191; Dorothy Boulding Ferebee, 179–181; Dudley Woodard, 111, 136, 136; Dwight Oliver W. Holmes, 2, 4, 19, 20, 34, 38, 42, 44, 58, 59, 73, 81, 111–112, 230–232, 235, 332; E. Franklin Frazier, 220; E. Louise Murphy, 211–212; Edward L. Parks, 80, 155, 158, 214; Elaine Whitney Tancil, 167–169, 193, 384n70–71; Elizabeth Ellison, 325; Elizabeth Sinkford, 144; Emmett J. Scott, 86–87, 116, 124–126, 182, 187, 212, 213 214, 235, 331, 369n58; Enrollment, 91, 369–371n61; Executive Committee, 17, 29, 155–157, 168, 170, 174, 182, 191, 194, 197, 213; F. W. Fairfield, 22, 28; Faculty Committee on Student Activities, 113, 152, 224, 234; Faculty Committee on Student Organizations, 227; Faculty Women's Club, 160, 205; Federal appropriations investigation, 170–171, 212, 213, 343, 369n56; Finance Committee, 116–117, 124–126, 213, 214; Forum, 369–371n61; Founders Day, 30; Frances Perkins, 228; Frank W. Coleman, 325; Frazier Hall, 162, 348, 383n47; Frederick D. Wilkinson, 325; Freedmen's Hospital, 226, 394n64; Freshman Week, 151; General Alumni Association, 3, 5, 29, 117, 213, 250; George H. Safford, 80; George M. Lightfoot, 24, 29; George Parker, 325; George W. Cook, 2, 23, 24, 26–27, 38, 80, 118–119, 183–184; George W. Crawford, 139, 189–191; Great Depression, 167–169, 173, 193, 384n70–71; H. D. Hatfield, 111; Harriet Tubman Quadrangle (The "Quad"), 348, 414n4; *The Hilltop*, 101, 105, 106, 113, 117, 134, 141, 142, 143, 147, 150, 152, 160, 196, 204, 217, 218, 219, 234, 242, 243, 279, 284, 378n22; House Government Association, 228; *Howard Alumnus*, 100, 251; Howard Hall, 91; Howard Players, 144, 369–371n61; Howard Thurman, 221, 280, 325, 393n44–45, 405n228–229; Howard University Alumni Association, 65, 171–172; *Howard University Alumni Journal*, 234; *Howard University Bulletin*, 202; Howard University Drama Club, 115; *Howard University Record*, 103, 105, 119; *Howard University Review*, 53, 369–371n61; Howard Women's Club 5, 337; Illumination Night, 222; Inabel Lindsay, 132; Intercollegiate Christian Councils, 221; Intercollegiate debating, 29, 144, 369–371n61; J. Stanley Durkee, 3, 79–129, 148, 155–156, 158, 175, 177, 188, 192, 201, 299, 369n56–58; James A. Cobb, 187; James A. Porter, artist, 337; James Hardy Dillard, 199; Jeremiah E. Rankin, 26; Jesse E. Moorland, 174, 191, 198, 212, 213; Joanna Houston, 54, 165–167, 208, 230, 243, 336, 381n19, 425; John Gordon, 22, 28, 369n43; *Journal of Negro Education*, 299, 307, 408n31; *Journal of Negro History*, 334; Kappa Alpha Psi Fraternity, 371, 369–371n61; Kappa Sigma Debating Club, 369–371n61; Kelly Miller, 23, 24, 55, 66, 91, 105, 111–112, 161–162, 212, 334, 388n132; Law School, 133, 208, 391n2; LeCercle Francais Club 369–371n61; Lecture Committee, 116; Lewis B. Moore, 23; Literary Club, 42; Louis Justeman, 334; Louise C. Ball, 331; Lucy Diggs Slowe Hall, 334–335, 348, 414n5; Lucy Diggs Slowe Memorial Window, 337; Lula Vere Childers, 27–28, 69, 111–112, 142, 325; Marie Hardwick, 80, 145;

May Week, 143; Maynard Literary Society, 369–371n61; Medical School Endowment Fund, 133; Men of Howard, 102–105; Men's Glee Club, 144, 369–371n61; Miner Hall, 24–25, 26, 30, 35, 80, 91, 124, 158, 191, 145, 369–371n61; Mordecai Wyatt Johnson, 3–5, 128, 131–235, 299, 339, 343, 348; Moorland-Spingarn Research Center, xii–xiii, 153; Mother-Daughter Banquet, 221, 222; National Negro Congress, 313; National Student League, 208–211; New Women's Campus, 4, 152, 158–164, 202, 211–212, 217, 288, 346, 348; Old Main Hall, 92; Oliver Otis Howard, 22; Omega Psi Phi Fraternity, 425, 369–371n61; Oscar DePriest, 259–260, 314, 343; Pestalozzi-Froebel Society, 369–371n61; Peter Marshall Murray, 331; Phi Beta Sigma Fraternity, 369–371n61; Physical education, 369–371n61; Physical examinations for students, 369–371n61; Physician for women dismissed, 179–181, 188; Position Description for Dean of Women, 81–82, 126–128, 174–176, 367n14; Presidents of Howard University, 3–5, 22–23, 26, 28–29, 30, 33, 79–129, 131–235, 254, 299, 332, 339, 343, 348; Probationary period for teachers, 213; R. Todd Duncan, 325, 410n7; Ralph J. Bunche, 150, 313; Registrar, 81, 181, 214; Rho Psi Phi Medical Sorority, 369–371n61; Robert A. Pelham, 65; Role of Deans of Men and Women, 174, 214; ROTC, 369–371n61; Russell A. Dixon, 214; Sadie Gray Mays, 276, 404n197; Salary Committee, 200; Sara Brown, 210–211, 250–251, 398n55; School of Commerce and Finance: The Commercial Outlook, 369–371n61; School of Dentistry, 23; School of Education, 369–371n61; School of Liberal Arts, 369–371n61; School of Medicine, 23; School of Pharmacy, 23; School of Public Health and Hygiene, 369–371n61; School of Religion, 133, 343, 369–371n61; School of Social Work, 206, 220, 348, 391n216, 404n197; School of Theology, 23; Semi-Centennial, 65–66, 74, 234; Senior Mentors, xiv, 150–151; Shelby J, Davidson, 65; Sherwood L. Catlett, 171–172, 176; Slowe Hall, 334–335, 414n5; Special Committee on Financial Support, 188, 382n25; St. Elmo Brady, 117; Standards Committee, 197; Sterling Brown, 203; Student activities, 91–92, 369–372n61; Student Christian Council, 221; Student Council, 108–109, 114, 205, 218, 224, 227, 375n127; Student employment, 369–371n61; Student housing, 114–115; Stylus, 369–371n61; Sue Bailey Thurman, 220; Tau Delta Sigma Law Fraternity, 369–371n61; Termination threat of Dean of Women, 177, 185–188; Thaddeus F. Hungate, 213; The Academy, 23; Thirkield Hall, 92; Thomas Anderson, 325; Thomas Hawkins, 325; Thomas Jesse Jones, 182, 211, 250; Tourgee, DeBose, 144; Treasurer, 4, 80, 86–87, 116, 124–126, 173–176, 182, 187, 208–211, 212, 214, 331; Truth Hall, 162, 348; Twenty Year Plan, 382n25; U. S. Department of Interior investigations, 170–171, 212–213, 343; University Choir, 27; University Council, 164, 384n60–61; *University Journal*, 27, 30; University physician, 147; Virginias D. Johnston, 173–176, 208–211, 213, 214, 331 411n38; Vocational Guidance Conference for Women, 343; Washington, D.C. Alumni Association, 65; Wheatley Hall, 348; William A. Hazel, 159; William B. West, 214; Women's

440 Index

Howard University *(continued)*
 Cooperative Council of Howard University, 102, 103, 114; Women's Glee Club, 144, 369–371n61; Women's League, 105–106, 120, 140, 141, 218, 284, 307; Women's Loan Fund, 143; Women's Tennis Club, 29, 72; Zeta Phi Beta Sorority, 228, 369–371n61, 381n19
Howard University Alumni Journal, 234
Howard University Bulletin, 202
Howard University Record, 103, 105, 119
Howard University Review, 53
Human rights, 207
Hungate, Thaddeus F.: Howard University Board of Trustees Chair, 213
Hunt, H. A., 259
Hunt, Ida Gibbs, 69
Hunton, Addie, 284, 405n236
Hunton, Jr., Alphaeus, 313

Institute for Colored Youth: Fanny Jackson Coppin and, 17
International affairs, 303, 348; Haiti, 253–254, 283, 304; Liberia, 283, 304; Santo Domingo, 304
International Council of Women of the Darker Race, 284, 405n236
International Federation of University Women, 262
International Student Service, 153
Interracial Conference of Church Women, 308
Introspection by Slowe, 76, 229–230

Jackson, Barbara Brooks, 312, 421, 384n63, 409n57
James, Edward T., 422
Jean-Marie, Gaetano, 422
Jim Crow, 14, 17, 40
Johnson, Catherine, 422
Johnson, Guy B., 232
Johnson, J. Hayden: Teacher education, 254; Washington, D.C. Board of Education, 50

Johnson, Jack, 318
Johnson, James Weldon, 47, 359n45
Johnson, Mordecai, 3–5, 128, 131–235, 343, 348; Academic freedom for Howard University faculty, 133; Accreditation issues at Howard University, 133; Biography of, 131–132; Dean of Women and, 131–235, 332, 299 339; Haiti, 254; Howard University Law School and, 133; Howard University Medical School Endowment Fund and, 133; Howard University President, 131–235, Messianic complex and, 132; Howard University School of Religion Endowment and Building Fund, 133; Salary conflicts with Howard University faculty, 133–134
Johnston, Virginius D., 173–176, 208–211, 213, 214, 331, 411n38
Jones, Eugene Kinckle, 259
Jones, Maxine D., 422
Jones, Thomas Jesse, 182, 210; Du Bois critique of, 250
Jones, William N.: *Afro American*, editor, 298, 407n27
Journal and Guide, 326
Journal of the College Alumnae Association, 311, 326
Journal of the National Association of College Women, 265, 326–327
Journal of Negro Education, 299, 307, 408n31
Journal of Negro History, 334; Kelly Miller and, 23, 24
Junior High School Review, 53, 55, 56, 58, 59, 61, 117
Just, Ernest Everett, 91
Just, Ethel H., 69
Justeman, Louis: Lucy Diggs Slowe Hall and, 334

Kappa Alpha Psi Fraternity, 371, 369–371n61
Kilpatrick, Dorthie, 422
King, William H., 221, 280
Knights of Pythias, 15

Ladies Anti-Slavery Society, Rochester, NY, 16
Ladies Home Journal, 74
Lahman, Sean, 423
Leadership, 298, 299, 343, 348
LeDroit Park, 409n57
LeMay, Isabelle W., 330–331
Lewis, David L., 358, 423
Lexington, (Commonwealth of Virginia), 1, 7, 9–13, 19, 26, 35, 36, 230, 346, 352n15, 353n18; Family moved to Baltimore, 13; Randolph Street School, 11, 13, 352n15; "The Athens of the State," 9
Liberia, 283, 284, 406n246
Lightfoot, George M., 24, 29
Lincoln Memorial Cemetery: Burial ground of Lucy Diggs Slowe, 411n14
Lincoln University: Intercollegiate Christian Councils, 221
Lindsay, Inabel: Called "Daughter Lindsay" by Mordecai Johnson, 132
Lippincott's Monthly, 74
Lloyd-Jones, Esther, 422
Locke, Alain, 23, 58, 313
Logan, Anne Pruitt, 351–352n4, 381n6
Logan, Rayford W., 422
Lotus Street Social Settlement: Janie Porter Barrett and, 17–18
Louis, Joe, 318
Lucy Diggs Slowe Elementary School, 335; Mary McLeod Bethune Charter School, 349, 414n9
Lucy Diggs Slowe Hall, Howard University: Federal government gives building to Howard University, 335, 348; Housing for women during World War II, 334; J. Harry McGregor (State Representative) and, 335, 414n5
Lucy Diggs Slowe Memorial Window, Howard University, 337
Lucy Diggs Slowe Papers: Morgan State University, xii, 233; Moorland-Spingarn Research Center, xii–xiii, 153, 339; Slowe's Scrapbook, 339–344

Lyle, Ethel H., 422

M Street Junior High School, 50–59, 360–362n80; A. B. Chavious and, 54; Class trips, 59; Clubs, 58; Creed of the School, 54–55, 362n83; In-service training for teachers, 52–53; *Junior High School Review*, 53, 55, 56, 58, 59, 61, 117; Louise Jefferson, 59; Musical/Theater Productions, 58; Name changed to Shaw Junior High School, 59–64; Opposition to junior high school, 51; Race Amity Conference, 58; Speakers at the school, 57–58
Madison Street Presbyterian Church Choir, 41
Mary McLeod Bethune Charter School, 349, 414n9
Mason, Paul: M Street Junior High School and, 58
Masons, 15
Mays, Benjamin E., 214, 325
Mays, Sadie Gray, 276, 404n197
McGregor, J. Harry (State Representative), 335
McNeill, Bertha C., 284
Mead, Margaret, 423
Methodists, 12, 22
Migration to the North, 306
Miller, Annie, 105, 374n104
Miller, Carroll H., 423
Miller, Carroll L. L., xii–xiii, 347; M Street Junior High School and, 58, 423, 360n73
Miller, Kelly, 23, 24, 55, 66, 91, 105, 111–112, 212, 388n132; Condolences on Slowe's death, 79, 331; Proposal naming Howard University New Women's Campus after Slowe, 161–162, 334
Miller, Paul B.: M Street Junior High School and, 55
Mills, Clarence, 135–138, 145, 186, 190, 378n29–31, 379n37–39
Milton Valley Cemetery (VA): Burial ground for Slowe's parents, 8, 351n4

Miner School for Free Colored Girls, 25
Miner Teachers College, 289, 369–371n61
Miss Rae, 75
"Miss Slowe," 2, 40
Mitchell, Reavis L., 423
Moldow, Gloria B., 423
Monumental Tennis Club of Baltimore, Maryland, 73
Moore, Lewis B., 23
Moorland, Jesse E., 49, 174, 191–192, 198, 212, 213, 359n49; True Reformers Hall and, 48
Moorland-Spingarn Research Center: Lucy Diggs Slowe Papers, xii–xiii, 153, 233, 339–344
Morgan, Clement Garnett, 24
Morgan State College: Lucy Diggs Slowe Papers, xii, 233; Dwight O. W. Holmes becomes President of, 230, 332
Morris, Mary T., 423
Moses, Y., 423
Mossell, Sadie Tanner, 41
Moton, Robert Russa, 266; Haiti and, 254
Mu-So-Lit Club, 312, 422, 409n57
Murchison, J. P., 259
Murphy, E. Louise, 211–212
Murray, C. M.: M Street Junior High School and, 58
Murray, Peter Marshall, 331

National affairs, 303
National Allied Democratic Advisory Council: Federal appropriations investigation, 171
National Association for the Advancement of Colored People (NAACP), 2, 4, 24, 27, 42, 68; Anti-Lynching Crusaders and, 258; Dyer Bill (anti-lynching), 258; Martin Cotton and, 58; Mary White Ovington's visit to Howard University, 165–166; Niagara Movement, 24; Slowe as Baltimore Branch Assistant Secretary of, 44, 238
National Association of College Deans, Registrars and Admission Officers, 268, 401n138
National Association of College Women (NACW), 3, 4, 37, 168, 181, 197–198, 238, 247–264, 265, 270, 305, 346, 363n134–135, 384n77, 398n55, 424; Ambrose Caliver and, 255–257; Anti-lynching legislation and, 258; Appropriations for African American schools, 256; Arthur Capper (Senator) and, 256; Clarence Cannon (State Representative) and, 256; College accreditation, 268; Committee on Standards and, 249, 250, 252, 253, 256, 263, 278, 297; Condolences at Slowe's death, 233, 326–327; Coralie Cook as a Founder of, 34; Educational standards and reform, 248–250, 262–263; Ester Popel Shaw and, 268; Executive Committee, 253, 256; Fellowship Drive, 259; Franklin D. Roosevelt and, 259–260; Herbert Hoover and, 253; Hiram Bingham, III (Senator) and, 256; Housing of women college student, 249; *Journal of the National Association of College Women*, 265, 326–327; Juanita Howard and, 255, 268; Lucy Diggs Slowe as first President of, 247, 253; Lynching, 258; NACW Speaker's Bureau, 259; National Conference on the Fundamental Problems in the Education of Negroes and, 256; National Education Association and, 257; National Recovery Administration and, 259; Offensive stereotypes in minstrel shows, 250; Practice teaching in Washington, D.C. and Philadelphia, 250; Racial relations between races, 249; Sadie Daniel and, 255; Sara Brown and, 250–251; Service to Humanity, 249; Social services courses and,

256; Teacher colleges, 255; Teacher education, 254; U. S. Office of Education, 263; Vivian J. Cook and, 251 268; Vocational guidance, 256
National Association of Colored Graduate Nurses: Mable Staupers and, 268
National Association of Colored Women, 34, 68, 271
National Association of Deans of Women, 237, 238, 383n55, Condolences on Slowe's death, 327 337, 396n7, 410n73; Hampton Institute Dean denied membership, 241; Proposal rejected for joint meeting with, 267–268; Racism, 239–242, 397n14; Racism toward African American members, 3; Sarah Sturtevant and, 97, 167, 184–185, 210, 330; Slowe as first African American member, 3; Student personnel work, 97; Thyrsa Amos and, 3, 97–100, 151, 158–159, 167, 173, 185–186, 222, 253, 330
National Association of Deans of Women and Advisers to Girls in Colored/Negro Schools, 4, 195, 238, 264–270, 318, 346; Condolences on Slowe's death, 328–329; Course for prospective Deans of Women and, 264; Proposal rejected for joint meetings with National Advisers to Deans of Women, 267–268; National Association of College Deans and Registrars and, 268; National Association of Colored Graduate Nurses and, 268
National Baptist Convention, 12
National Business League, 15
National Conference on the Causes and Cure of War, 141, 261, 278, 281–282
National Conference on the Fundamental Problems in the Education of Negroes: Aubrey Williams and, 256; Ambrose Caliver and, 256; Eleanor Roosevelt and, 256

National Conference on the Problems of the Negro and Negro Youth, 272–273
National Council for the Prevention of War, 262
National Council of English Teachers, 4, 238
National Council of Negro Women (NCNW) 4, 271–273, 402n159–161; Charlotte Hawkins Brown, 272; Clara B. Bruce and 272; Condolences on Slowe's death, 232; John W. Davis, 272; Mary Church Terrell, 272; Mary McLeod Bethune and, 4, 37, 238; Vivian Johnson Cook, 37, 38
National Education Association, 257
National Industrial Recovery Act, 260National Interracial Conference, 279
National Negro Business League, 267
National Negro Congress, 226, 313–315; A. Philip Randolph and, 313; Alain Locke, 313; Alphaeus Hunton, Jr. and, 313; Charles Hamilton Houston and, 313; Elmer Carter and, 313; Howard University, Division of Social Sciences and, 313
National Negro Theater, 369–371n61
National PanHellenic Council, 245
National Park Service, 424
National Recovery Administration, 259
National Student Assembly: Young Women's Christian Association (YWCA) and, 277
National Student Conference, 141
National Student Council: Young Women's Christian Association (YWCA) and, 277
National Student Federation of America, 141
National Student League: Treasurer granted permission to use Howard University Dormitory #2, 208–209
National Tennis Championship Tournament: Edmund H. Burke and, 329; Florence Brooks and, 74; John

National Tennis Championship Tournament *(continued)* Wilkerson and, 73–75; Lucy Diggs Slowe and, 73; Miss M. Rae and, 75, 329; Sylvester Smith and, 73; Talley Holmes and, 73–74, 329
National Youth Administration, 334; Advisory Committee, 276, 404n195; Day Camp Leadership training, 276; Francoise Black and, 276; Mary McLeod Bethune and, 273; Sadie Gray Mays and, 276
Negro Tennis Clubs, 73
"Negroes Robbed Again": National Recovery Act, 260
Nelson, (Mrs.) William Stuart, 274, 403n176
New Deal, 259–260, 276, 313
New Haven Union, 100, 308
New Windsor Conference on International Relations, 141
New York Age, 317
New York Amsterdam News, 326
New York City (NY): Sugar Hill, 217–218
New York Herald Tribune, 342, 343
New York Times, 342, 343
New York World, 252, 340
Niagara Movement: Clement Garnett Morgan and, 24; William Monroe Trotter and, 24
Niebuhr, Reinhold, 221, 280, 405n226
19th Amendment, 47
North Carolina Mutual Benefit Insurance Company, 15
Northwest Settlement House of Washington (D.C.), 238

Odd Fellows,The Independent Order of, 15 41, 358n17
Omega Psi Phi Fraternity, 425, 369–371n61
Opportunity, 307, 408n44
Orenstein, David, 424
Ovington, Mary White, 66, 165–166
Owens, Jesse, 318
Oxley, Lawrence A., 259–260

Palmer Memorial Institute: Charlotte Hawkins Brown and, 142
Parker, George, 325
Parker, Marjorie, 424
Parks, Edward L., 80, 155, 158, 214, 382n27, 392n28
Pascarelli, Ernest T., 424
Peace activist: Slowe as a, 4, 218, 284, 285
Perkins, Frances, 228
Perkins, Kathy, 424
Perrone, Fernada, 424
Phi Beta Sigma Fraternity, 371, 369–371n61
Philadelphia Tribune, 326
Phyllis Wheatley YWCA: Pollyanna Review, 120–124
Plessy v. Ferguson, 17, 318
Poem, by Lucy Diggs Slowe: *Heroes Unrequited*, 30–31
Politics, 308–317
Pollyanna Review: Phyllis Wheatley YWCA, 120–124
Porter, James A., artist: Stained glass window in Andrew Rankin Chapel, Howard University, 337
Prejudice, 308–309, 311
Price, Louise ("Lou") (Slowe's cousin), 9, 13, 17, 18, 40, 230
Price, Martha (Slowe's aunt), 1, 7, 9, 10, 12, 13, 17, 19, 20, 25, 40, 63, 87, 217, 230, 318, 346
Price, Robert (Slowe's uncle), 10
Price, Tom (Slowe's cousin), 10
Price, Will (Slowe's cousin), 10
Priestly, James, 203
Pruitt, Anne S., 425

Race Amity Conference: Alain Locke, 58
Race man, 51, 360n68
Race relations, 100, 185, 308–318
Racism, 308
Randolph, A. Philip, 313
Randolph Street School (Lexington, Virginia), 11, 13
Rankin, Jeremiah E.: Frederick Douglass funeral and, 26

Ransom, Joanna Houston: See Houston, Joanna
Reconstruction, 14
"The Red Summer," 47
Reed, Elizabeth, 210
Reid, (Mrs.) Ogden, 343
Religious leader: Slowe as a, 4
Residence halls (See dormitories)
Residence in Northeast Washington, D.C., 93, 372–373n65
"The Revolt of Negro Intellectuals," 24
Rho Psi Phi Medical Sorority, 369–371n61
Robinson, Hilyard, architect: Howard University Lucy Diggs Slowe Hall, 334
Robinson, James H., 221, 280
Roosevelt, Franklin D. (President of the United States), 258; 282; Black Cabinet and, 259–260
Roosevelt, Eleanor, 256, 260, 270–271
Roosevelt, Theodore (President of the United States), 30
Russell, Bertrand, 309, 408n49

Safford, George H.: Howard University Treasurer, 80
Salem, Dorothy, 425
Santo Domingo, 304
Sargent, Dudley A., 425
Schuh, John H., 425
Scott, Emmett J., 116, 124–126, 182, 187, 212, 213, 214, 235, 331, 369n58; Howard University Secretary-Treasurer-Business Manager, 86–87
Scrapbook in Lucy Diggs Slowe papers, 339–344
Segregation, 44, 246, 346; Public schools and, 18
Senior Mentors, Howard University: *xiv*, 150–151, 381n6
Sexism, 44, 299, 300, 348
Shaw, Ester Popel, 268
Shaw, Robert Gould, 2, 60
Shaw Junior High School, *xiii*, 60–64, 87, 147, 290, 345; High School Cadet Competition, 61; *Junior High School Review*, 53, 55, 58, 59, 61, 117; Name changed from M Street Junior High School, 60; Resignation of Slowe as principal, 75; Schlagball, 61, 363n111; Tennis club, 61; Track team, 60
Sidney, Sir Philip: PSALM VIII, 336, 413n60
Sifakis, Stewart, 425
Simpson, Georgiana, 41
Sinkford, Elizabeth, 144
Slow (spelling of name), 7, 351n2
Slowe, Charlotte (Slowe's sister), 1, 7, 8, 17; Death of, 230, 352n7, 358n7, 394n74
Slowe, Coltrop (Slowe's brother), 8, 230
Slow(e), Fannie Potter (Slowe's mother), 7, 8; Ann Potter (Slowe's grandmother), 8; George Potter (Slowe's grandfather), 8; Milton Valley Cemetery, 8, 351n4
Slowe, Henry (Slowe's father), 8; David Slow(e) (Slowe's grandfather), 8; Penny Slow(e) (Slowe's grandmother), 8
Slowe, John (Slowe's brother) 7, 8, 230
Slowe, Lucy Diggs: Birth of, 8, 425, 352n5
Slowe, Nellie (Slowe's sister), 8, 230, 231, 232, 332
Slowe, Preston (Slowe's brother), 8
Slowe, William (Bill) (Slowe's brother), 8
Smith, Emory, 117
Smith, Sam 425
Smith-Rosenberg, Carol, 425
Social sciences, 298, 300, 312
Social Work, School of (See Howard University)
Sorority Council, 245
Spaulding, C. C., 15
Speeches and writings: "The Business of Being A Dean of Women," 320–321; "The College Woman and Her Civic Responsibility,"

Speeches and writings *(continued)*
258–259; "The College Woman and Her Community," 261, 305; "The College Woman's Responsibility in Race Relations," 100; "The Colored Girl Enters College: What Shall She Expect?" 307; "The Dean of Women and Her Relation to the Personnel Office," 318; "The Dean of Women in a Modern University," 319–320; "Education and Race Relations," 310; "The Education of Negro Women for Social Responsibility, 256, 295, 298, "The Effect of Race Prejudice on the Negro Student's Thinking," 308–309; "Have You a Hobby?" 62, 144; "Higher Education of Negro Women," 299; "I Came to Do a Job," 96; "Is It Right?" 288; "The Junior High School: An Opportunity," 53; "Marks of an Educated Man," 290; "The Negro in the New Order," 312; "The New Howard Woman," 95–96; "On Work Well Done," 61; "The Place of the Dean of Women on the College Campus," 269; "The Real Christmas Spirit," 63; "Reality in Race Relations," 312; "The Relationship of the National Association for the Advancement of Colored People to the Suffrage Movement," 44; "The Responsibility of the College Woman to Her Community," 100, 251; "Some Problems of Colored Women and Girls in the Urban Process," 306; "The Teacher-Apostle of the Beautiful," 289; "Three Years," 64; "The Training of College Women," 247; "A True Education," 20; "What a Howard Man Ought to Be," 100; "What Are You Standing For?" 404n14; "What Contribution Can a Program of Social Activities Fostered by the Institution Made to the Moral and Social Development of Students in Negro Colleges?" 290, 322; "What Does a Dean of Women Do?" 147; "What Shall We Teach Our Youth?" 288; "Women's Contribution to the Social Order," 301

Spiritual development of Howard University students, 221, 348
St. Francis Catholic Church Choir, 41
Staupers, Mabel, 268
Stevens, Romiett, 330, 411n31
Stuart, James, 13, 18, 40
Stuart, Louise: *See* Price, Louise
Stuart, Mable, 40
Stuart, Martha (Doali), 18, 40, 210
Student Christian Conference, 28, 280
Student personnel work, 99, 345, 347
Sturtevant, Sarah W., 173330; Columbia University, Teachers College, 97, 167, 184–185, 253
"Suffering Suffragettes," 45
Sweet, Leonard I., 426

Talbert, Mary, 405n236
Tancil, Elaine Whitney: Dismissed due to low student enrollment at Howard University, 167–169, 193, 384n70–71
"The Talented Tenth," 24, 43
Talladega College: George W. Crawford and, 139; Juliette Derricotte and, 139 Slowe as Pastor of, 295; Marion V. Cuthbert and, 139
Teachers College Record, 100
Teachers colleges, 255
Tennis, 1, 2, 28, 74, 345; American Tennis Association, 2, 72, 74, 329; Association Tennis Club, 73; Dwight O. W. Holmes and, 73; Florence Brooks and, 74; George Lightfoot and, 29; John Wilkerson and, 73–74; Miss Rae and, 75; Monumental Tennis Club of Baltimore, 73–74; National Tennis Tournament, 73; Negro Tennis Club, 73, 238; Sylvester Smith and, 73; Tally Holmes and, 73–74, 329; Women's Tennis Club, Howard University, 29, 72

Terrell, Mary Church, 36; College Alumnae Club and, 67–68, 284, 409n57; International Council of Women of the Darker Races, 405n236; National Association for the Advancement of Colored People (NAACP) and, 68; National Association of Colored Women and, 68; National Council of Negro Women (NCNW) and, 272; War Camp Community Service and, 68; Women's suffrage and, 68; Women's Wage Earners Association and, 68
Terrell, Robert Heberton, 68
The Talladegan, 295, 379n52
Thirkield, Wilbur, President of Howard University: 22–23, 26, 28–29, 30, 33
Thompson, Kathleen, 426
Thurman, Howard, 221, 227–228, 280, 325, 393n44–45, 405n228–229
Thurman, Sue Bailey, 220
Tibbs, Roy W.: Slowe proposed his home as the on campus home for Dean of Women, 190, 389n165
Tobias, Channing Heggie, 169–170, 195, 199–200, 210
Trotter, William Monroe, 24
Truth, Sojourner, 35, 44, 346
Tubman, Harriet, 43
Tuskegee Institute: Student rebellion, 114

University Journal, 27, 30
Urban League, 259–260
U. S. Census Bureau, 426
U.S. Department of Interior, 131; Investigations of Howard University, 171, 213, 343; Ray L. Wilbur and, 171

Values, 5, 226, 323
Vinson, J. Todd, 427
Virginia, Commonwealth of: Berryville, 7, 8, 9, 230, 346; Lexington, 1, 7, 9–13, 36, 230, 346, 352n15, 353n18
Vision, 295, 304, 336

Walter and Theodora Daniel Endowed Educational Research Fund, *xiii*
Waring, Mary, 405n236
Washington, Alethea H.: Colored High School of Baltimore, 19
Washington, Booker T., 15, 24, 43, 267, 346; Death of, 49; Washington-Du Bois controversy, 44, 51
Washington, Forrestor B., 259–260
Washington, D. C., 346, 409n57; Armstrong Manual Training High School, 2, 45, 46, 48–50, 52, 289, 335; Associated Charities/ Family Service Association, 274–275; Community Chest, 275; Discrimination in funding for public schools, 317, Dunbar High School, 50–55; Howard Theater, 47, 115; LeDroit Park, 409n57, Lincoln Colonnade, 115; Lincoln Theater, 120–124; Lucy Diggs Slowe Elementary School, 335; M Street Junior High School, 50–59, 360–362n80; Mary McLeod Bethune Charter School, 349 414n9; Miner School for Free Colored Girls, 25; Miner Teachers College, 289, 369–371n61; Mu-So-Lit Club, 312, 409n57, 422; Nineteenth Street Baptist Church, 301; Northwest Settlement House of Washington, D.C., 238, 275–276; Phyllis Wheatley YWCA, 120–124; Racial segregation and discrimination, 315–318; Slowe moved to, 46; True Reformers Hall, 48; 12th Street YMCA, 48; U Street, 47, 115; U.S. Capitol building discrimination in restaurants, 259; Whitelaw Hotel, 47, 273
Washington Bee, 49, 50, 51
Washington Evening Star, 25, 232
Washington Post, 232
Washington Tribune, 87, 88, 108, 120, 122–123, 196, 212, 214, 221, 222, 239, 252, 270, 272, 309, 313, 326
Weaver, Robert, 259–260, 400n107

Weinberg, Meyer, 427
Wells-Barnett, Ida B., 36
Wesley, Dorothy Porter, xii
West, William B., 214
Whist Club: See Foster Whist Club
Wiggins, Anne, 153
Wilberforce University, 57, 362n91
Wilbur, Ray L., 171
Wilkinson, Frederick D., 181, 214, 325
Wilkinson, Garner C.: Assistant Superintendent of Public Schools in Washington, D.C., 75, 85, 87, 121–124, 275
Williams, Alice Nelson, 195
Williams, Aubrey: Proposed African American teachers teach African American children in segregated schools, 256, 273
Williams, Clyda Jane, 192
Williams, Frances: Young Women's Christian Association, 277
Williams, James (Slowe's childhood friend), 7, 8
Williams, Scott W., 427
Wilson, Willie B., 234
Wilson, Woodrow (President of the United States): Discrimination against African Americans, 46, 67
Wolters, Raymond, 427
Women's club movement: Slowe and, 1, 347
Women's International League for Peace and Freedom, 4, 238, 262, 284–285, 304, 405n241; Addie Dickerson and, 285; Condolences on Slowe's death, 327; 384n241–243
Women's League, 105–106, 120, 140, 143, 152, 196, 245, 284, 329

Women's rights, 35
Women's suffrage movement, 2; Mary Church Terrell and, 68; Mary McDowell and, 153; Susan B. Anthony and, 34; W.E.B. Du Bois support of, 43
Women's Wage Earners Association, 68
Woodard, Dudley, 111–112, 136
Wooley, Mary E., 261
Works Progress Administration (WPA), 276
World War I, 66–67
Wright, Marion Thompson, xi–xiii, 33, 40, 41, 109–111, 141, 195, 232, 235, 326, 329, 335, 347, 427, 351n2, 352n10–11, 390n183

Young Men's Christian Association (YMCA), 48, 170, 359n49, 369–371n61
Young Women's Christian Association(YWCA), 3, 127, 142, 196, 226, 238, 266, 294, 312, 326, 369–371n61; Condolences on Slowe's death, 328; Council on Colored Work, 279; Foreign Missionary Conference, 278; Frances Williams and, 277; Juliette Derricotte and, 276–279; National Student Assembly, 277; National Student Council, 277–278
Young Women's Temperance Union, 144

Zeta Phi Beta sorority, 228, 369–371n61, 381n19